Baby, Let's Play House

Baby, Let's Play House

ELVIS
~~PRESLEY~~
and the
WOMEN
WHO LOVED HIM

Alanna NASH

!t
itbooks
AN IMPRINT OF HARPERCOLLINS *PUBLISHERS*

HarperCollins books may be purchased for educational, business, or sales promotional use. For information please write: Special Markets Department, HarperCollins Publishers, 10 East 53rd Street, New York, NY 10022.

FIRST EDITION

Designed by Susan Walsh

Library of Congress Cataloging-in-Publication Data has been applied for.

ISBN 978-0-06-169984-9

10 11 12 13 14 WBC/RRD 10 9 8 7 6 5 4 3 2 1

For Rockin' Robin Rosaaen,
Queen of all Elvisness, TCB

The world is so full of a number
 of things.
I'm sure we should all
 be as happy as kings.
 —Robert Louis Stevenson
 "Happy Thought," from *A Child's Garden of Verses*

CONTENTS

INTRODUCTION

No matter if he were young and thin, a vision in gold lamé, or middle-aged and paunchy, stretching the physical limits of his gabardine jumpsuit, Elvis Presley never failed to affect his female audiences the same way: He drove them crazy. The mere sight and sound of him made women around the world drop all inhibitions, and to publicly behave as they never would otherwise, giving in to screams, fainting, and wild exhibitions of frenzy.

Sometime during the 1970s, when Elvis was a Las Vegas staple, Jean Beaulne, who had started his entertainment career in the 1960s as one-third of Les Baronets, Montreal's answer to the Beatles, was flabbergasted to see the reaction of one woman who attended Elvis's dinner show at the Las Vegas Hilton.

In between songs, some twenty-five minutes into the performance, as Elvis shook hands and kissed the women who crowded up near the stage and hoped to receive one of the multitude of scarves he ceremoniously dispensed, "We heard a woman yelling in the back of the room, and then we turned to see her hopping from one tabletop to the other to get up to Elvis.

"He was so surprised! He made a face, like, 'Wow, what happened?' Everybody in the room was laughing. Then she put her arms around his neck and kissed him. He smiled and gave her a scarf, and then she turned around and did the same thing, jumping from one table to the other. Everybody started to applaud."

Yet Elvis was never more potent than at the beginning of his career, before the patently routine scarf offering, when he was dangerous, revolutionary, and nobody knew what to expect.

On November 23, 1956, two days after the nationwide release of *Love Me Tender,* Elvis's first film, a high school photographer named Lew Allen covered a Presley concert in Cleveland and was astonished at what he saw.

"There was a row of policemen standing in front of the stage, and girls would start at the back of the auditorium with their eyes on Elvis, and run as fast as they could [toward the stage]. They'd bounce off these policemen's stomachs, and then bounce back four or five feet and land on their rear ends. And they would still have their eyes on Elvis. It was amazing. They did it repeatedly, like flies running into a light bulb."

Allen may have been dumbfounded, but as blues songwriter Willie Dixon teased, "The men don't know/But the little girls understand."

"Nineteen fifty-six was a great year," remembers Presley's seminal guitarist, Scotty Moore. "The crowds had gotten very large, and it would get so loud that it would just cancel out all the sound onstage. The best way I can describe it is like when you dive into the water and you hear the phasing, the rush of the water. Actually, on most songs, if we couldn't hear him, we'd know where he was at by his body language. We were the only band I know literally directed by an ass."

As Elvis worked out his own private fantasies onstage, an entire nation would take his directive, even if it was initially slow to accept it.

"Elvis's sexual history," the rock critic Robert Christgau has written, "inflects the myth of a feral young Southerner whose twitching hips were the point of articulation for a seismic shift in American mores."

The exact moment of that shift, according to some Elvisologists, arrived on June 5, 1956, when the twenty-one-year-old Presley appeared on *The Milton Berle Show.* It was not Presley's television debut. But in his previous network appearances, when his guitar had largely restricted his movements, Elvis relied more on "attitude, sinking eyelids, a curled lip, sideburns, and a husky voice that rose from somewhere below the waist," as newsman Peter Jennings later put it, to convey his libidinous intent. Now on the Berle show, performing a lascivious rendition of "Hound Dog," he moved in a way that was completely unfathomable for a white boy of the 1950s, punctuating a drawn-out, half-time ending with the burlesque bumps and grinds of a female stripper. At one point in the flurry of sexual shakes and shimmies, he seemed to hump the microphone, and in a futuristic salute to his would-be son-in-law, Michael Jackson, almost grab his crotch.

The following day, newspapers across the nation bellowed their outrage at

this obscene purveyor of the fledgling art form called rock and roll, Ben Gross of the New York *Daily News* decrying that popular music had "reached its lowest depths in the 'grunt and groin' antics of one Elvis Presley."

Forty years later, in his book, *Elvis After Elvis: The Posthumous Career of a Living Legend,* Gilbert B. Rodman, an assistant professor of communications at the University of South Florida, would label Elvis's performance on the Berle show "a message so shocking that it seemed that Western civilization could not possibly survive its utterance," and call it the moment when rock and roll was "recognized as a threat to mainstream U.S. culture."

Such intellectual hand-wringing brings to mind the old black-and-white film clips of grim-faced men warning of the dangers of rock and roll, urging decent, God-fearing Americans to smash any copies of the Devil music they could find, lest the nation's youth be corrupted and damned to hell.

Yet despite on which side of the moral fence one sits, there is no arguing that if Frank Sinatra was the first popular singer to make women swoon with the thoughts of romantic love, Elvis moved those obsessions lower, to erotic regions no mainstream performer had dared acknowledge with such ferocious abandon.

Today, Elvis's movements seem tame to younger generations raised on incendiary films and videos. But "few rock and rollers of any era have moved with such salacious insouciance," writes Christgau. In 1956, the cantilevered poetry of Elvis's swiveling midsection, coupled with the eye-popping sight of his left leg working like a jackhammer, quickly led journalist Pinckney Keel of the *Jackson* [Mississippi] *Clarion-Ledger* to dub him "Elvis the Pelvis," a term Elvis despised, calling it, "One of the most childish expressions I've ever heard coming from an adult."

That same year, on August 6, 1956, Tampa journalist Paul Wilder, a crony of Elvis's nefarious manager, Colonel Tom Parker, conducted one of the few, and most famous, interviews with Elvis for *TV Guide.* Backstage before the show in Lakeland, Florida, Wilder got Elvis's dander up when he read him a review from the *Miami Herald* that criticized both his voice and his guitar playing. "What remains, unfortunately," the article concluded, "are his pelvic gyrations. And that's the core of the whole appeal—sex stimulation."

"Any answer to that one?" Wilder asked.

"Well, I don't roll my—what'd he call it—pelvic gyrations," an indignant Elvis replied. "My pelvis had nothin' to do with what I do. I just get kinda in rhythm with the music. I jump around to it because I enjoy what I'm doin'. I'm

not tryin' to be vulgar, I'm not tryin' to sell any sex, I'm not tryin' to look vulgar and nasty. I just enjoy what I'm doin' and tryin' to make the best of it."

It was a fib, of course. Even then, he knew the power he had onstage and off, the way he could "charm the pants off a snake," in novelist Bobbie Ann Mason's Southern expression.

> She touched my hand, what a chill I got
> Her lips are like a volcano that's hot
> I'm proud to say she's my buttercup
> I'm in love
> I'm all shook up
> Mm, mm oh, oh, yeah, yeah!

· · · · · ·

For a man who was literally pawed, groped, scratched, and had his clothes ripped away by women for his entire twenty-three-year career, Presley demonstrated a remarkable tolerance for his audience. He rarely seemed to resent their overexuberant physical presence, their endless requests for autographs, or worse, the way their desire to possess him kept him a virtual prisoner in hotel rooms and at home in his beloved Graceland. In that regard, he stands almost alone in the pantheon of great rock stars, many of whom despise the very people who made them.

"He enjoyed the feel of being with fans," remembers photographer Alfred Wertheimer, who gained unprecedented access to Presley in 1956 and captured some of the best-known images of young Elvis. "He loved being with girls. Later on, I found out whether the girls were eight years old or eighteen or sixty-five or seventy, he just liked women."

Hank Saperstein, the merchandiser who plastered Elvis's likeness on everything from panties to record players to lipstick in Tutti Frutti Red and Hound Dog Orange in 1956, noticed that both women *and* men responded equally to Elvis's sneer. "His sneer was all-important. It was a good-looking, lovable sneer." But if both sexes inherently embraced the cruelty and playfulness in that curl of the lip, why did only women faint at Presley's concerts?

The word *fan* comes from *fanatic,* of course. But a more interesting focus is the origin of *hysteria.* A Greek medical term, *hysterikos,* it means dysfunctional or "wandering" uterus. Hippocrates coined the word, believing that madness

overcame women who adhered to sexual abstinence, and that the uterus wandered upward, compressing the diaphragm, heart, and lungs.

There's poetry in the fact, then, that Elvis learned certain of his stage moves from women, one of the surprises of this book. And it suggests that part of his potency was not just his ability to translate precisely what turned women on, but to mimic their actions back to them.

However, so much of what made Elvis *Elvis* sprang from his assimilation of black culture, both in his native Tupelo, Mississippi, and in his adopted hometown of Memphis.

This was true both of his music—a greasy, intense union of white and black in its mix of country and blues and gospel and pop—and in the fur-trimmed flamboyance of his personal style. His "sexual savagery" onstage challenged the traditional view of white masculinity, particularly as he arrived on the national consciousness in the staid, button-gloved Eisenhower era, dominated by the bland orchestras of Mantovani, Hugo Winterhalter, and Percy Faith. Everything about him—from his exotic looks (hooded eyes giving way to an impossibly pomaded ducktail) to his sound (the haunting spookiness of "Heartbreak Hotel")—suggested an alien inexplicably fallen to earth.

"People wonder why everyone impersonates the old Elvis," says Kevin Eggers, the founder of Tomato Records, who met Presley at a touch football game in Beverly Hills, California, as a teenager. "But if a young person could do the young Elvis, they'd be a superstar. That raw talent, that incredible creature came onstage and changed everything."

Including, to some degree, the perception of male beauty and the acceptance of androgyny, since Elvis crossed the sex barrier just as he had the race barrier. From the first, he wore eye shadow and mascara to accentuate his likeness to his mother, Gladys (and to emulate Rudolph Valentino, the silent screen star once accused of the "effeminization of the American male"). And by his early Las Vegas incarnation, Elvis personified the glam rock movement that was then burgeoning in the United Kingdom, blending the sex appeal of men and women in his choice of flowing stage wear.

Perhaps not surprising, Elvis's contemporary appeal does not stop with heterosexual women. Female Elvis impersonator Leigh Crow, aka Elvis Herselvis, who identifies as a drag king, predicts that Elvis will become a lesbian icon just as Marilyn Monroe is for gay men. "Like k.d. lang," she says, "the whole image that she's got . . . that's where it came from." And lang bears it out: "He was the

total androgynous beauty. I would practice Elvis in front of the mirror when I was twelve or thirteen years old."

.

For so many reasons, then, "Elvis swims in our minds, and in the emotions, all through time," offers film director David Lynch. "There's the word *icon,* and I don't think anybody has topped that . . . not one single person has ever topped Elvis." Except financially. In 2006, Kurt Cobain bested him on the *Forbes* "Top-Earning Dead Celebrities" list, only to have Elvis take back his crown in 2007, the thirtieth-year anniversary of his death, hauling in $52 million. But in 2009, he slipped to fourth place, with $55 million, dwarfed by Yves Saint Laurent ($350 million), Rodgers and Hammerstein ($235 million), and Michael Jackson ($90 million). Still, $55 million is more than many of the music industry's most popular living acts command. "For a dead man," writes author Rodman, "Elvis Presley is awfully noisy."

In the spring of 2007, I received a call from an editor at *Ladies' Home Journal,* who wanted an Elvis story for the August issue to mark the anniversary. But exactly what kind of article she didn't know. Since it was a women's magazine, I suggested what I thought was the obvious—an oral history of some of the women in Elvis's life, both platonic and romantic, from girlfriends to family members to actresses to backup singers. I wanted to know how his status as one of the greatest sex symbols of the twentieth century informed his stage act and his interactions with the opposite sex.

The resulting article, "The Women Who Loved Elvis," was one of the best-read features in the magazine, and spawned a segment on *The Early Show* on CBS. Not long after, I was in Memphis, writing a story about Graceland for another publication. Staying in the Heartbreak Hotel across the street from the mansion's sprawl, I stared at the photos on the wall of my suite. In each of them, Elvis held the luminous gaze of one of his Hollywood costars. I thought of the millions of women who had loved him from afar, the hundreds who had physically known that embrace, and how he had died alone at home on the bathroom floor, a woman sleeping in his bed as the life ebbed out of him at the age of forty-two.

How could Elvis Presley, one of the most romantic icons of his time, never have enjoyed a long-lasting, meaningful relationship with a woman?

That was the question I pondered as the idea for this book took shape. It was particularly puzzling since, for all his maleness, Elvis was a very woman-centered

man. It was women he could really talk with, and from whom he drew much of his strength.

The answer, of course, is that it was simply easier for a man as complex as Elvis to have a relationship with the masses, who asked nothing of him and provided unconditional positive regard.

"Bottom line," says Kay Wheeler, who headed Presley's first national fan club, "the most successful love affair was obviously between Elvis and his fans. And it has not died."

Elvis's sexual history, that great Pandora's box on which Christgau and Rodman lifted the lid, held fascinating surprises.

—Alanna Nash

Baby, Let's Play House

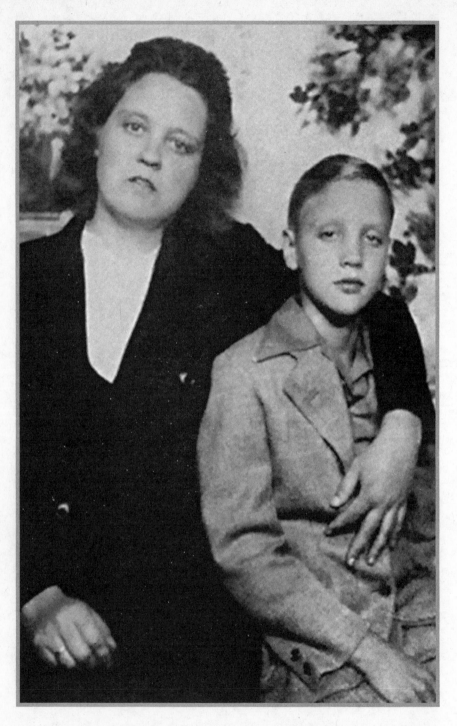

Gladys and Elvis, circa 1946. In future photographs, as in this one, the two would almost always be touching. *(Courtesy of David Troedson/Elvis Australia)*

ONE

.

"My Best Gal"

Gladys.

In rock-and-roll mythology, she is the proud, all-suffering Madonna, the commoner who birthed a king and died too soon, knocking his world off its axis. Like her famous son, her first name is all that's needed. Elvis called her "my best gal," but in the deepest psychological sense, she was not only his best gal, but also his only one.

In the well-known images from the late 1950s, she appears a defeated figure, her eyes sad and ringed by bruised circles, her mouth perpetually turned down and set in a sorrowful scowl. At the height of her son's notoriety, when she was ensconced in Graceland, the home and farm Elvis bought for her, surrounded by the kind of luxury she had never really wanted and rarely enjoyed, she spent her days as she always had—dipping snuff, drinking beer from a paper sack, staring out the window, and for a short time, until Elvis's record company complained it wasn't seemly, feeding her chickens out back. The hot-tempered woman who had been known to dump a pot of steaming beans on her husband's head when he crossed her was now a fearful soul, afraid for Elvis's safety ("She is always worried about a wreck, or . . . me gettin' sick"), the way the women mauled him at his shows, and worse, how his stratospheric career had changed everything so fast, wrenchingly pulling him away from her and from everything they had always known. As if to reverse it all and find some comfort, she made monthly visits to the area surrounding the small town of Tupelo, Mississippi, where she had grown up.

Earlier in her life, she had been an outgoing girl, a happy, joking person with a lifelong love of dancing. The Gladys of old had a light in her eyes, a future in

her smile, and "could make you laugh when nobody else could," remembered Annie Presley, the wife of Sales Presley, a first cousin to Elvis's father, Vernon.

That Gladys vanished once Elvis became famous. But one thing remained a constant: Gladys had always been so entwined with her son that it was hard to know where she left off and he began, even for the two of them. It came both from circumstances beyond their control, and from a need that was so great and pervasive as to be encoded in their DNA.

She was born April 25, 1912, in rural Pontotoc County, Mississippi, the daughter of Robert Lee Smith and Octavia Luvenia Mansell Smith. Gladys's mother was known by the name of Lucy and the nickname of Doll for her slim frame, porcelain skin, oval face, and small features. Not uncommon in farming families, the Smith children numbered eight, Gladys's arrival falling after the first three girls, Lillian, Levalle, and Rhetha, and before Travis, Tracy, Clettes, and John. (A ninth child did not survive.) Her parents romantically gave Gladys the middle name of Love.

At two, Tracy, who was already mentally impaired, contracted whooping cough and lost his hearing. But the real invalid of the family was Doll, Gladys's mother, who had been diagnosed with tuberculosis as a child. Doll, everyone knew, was a relentless flirt, and having been babied by her parents for her affliction and her birth order—she was the youngest of seven—expected the same from everyone around her. When she finally chose to marry, at age twenty-seven, she picked a younger mate, her first cousin Bob, a handsome man with dark, deep-set eyes that attested to his mix of Scots-Irish and Indian ancestry through the marriage of William Mansell and Morning Dove White, a full-blooded Cherokee.

Gladys's roots would prove even more fascinating.

White Mansell, the son of John Mansell and grandson of William Mansell, was an Alabaman who moved to northeast Mississippi at eighteen to homestead. There, in 1870, marking an X for his signature, he married Martha Tackett, whose mother, Nancy J. Burdine Tackett, was Jewish. Among their children was Doll, Gladys's mother. Since by Jewish orthodoxy the mother continues the heritage, Gladys was technically Jewish.

Like many southern broods, the Smith family was strongly matriarchal. Doll's illness rarely allowed her to leave her bed, but she ruled the family with her sickness. Her feelings of entitlement allowed her to keep a comb and mirror hidden beneath her pillow, while her children slept together on the floor on a mattress padded with crabgrass, held their flimsy shoes together with metal rings culled from the snouts of slaughtered hogs, and fashioned toothbrushes from

the branch of a black gum tree. When the Smiths moved, as they often did, dotting the communities around Tupelo in Lee County, "She would be carefully carried on a trailer in a supine position, like a priceless artifact in a traveling exhibit," as Elvis biographer and psychologist Peter O. Whitmer wrote in *The Inner Elvis*.

Her husband, Bob, desperate to scratch out a living from a land where poverty was the norm, demonstrated no love of farming, especially tenant farming, by which he fed his family. He also relied on handouts. Mertice Finley Collins remembered her mother, Vertie, would say to the Smith children, "Bring a bucket," and then "she'd put the leftovers in it for the Smith children to eat." Years later, once Elvis became famous, the press labeled the whole Presley clan "white trash." The Smiths still bristle at the term, even though rumor had it that Bob provided the extras Doll wanted from a less respectable trade.

"Just because you're poor doesn't mean you're white trash, even if you're a sharecropper," insists Billy Smith, Gladys's nephew through her brother Travis, a hard drinker with a violent streak for fighting. "I guess you couldn't be the son of a bootlegger and not drink. Because that's what my granddaddy Robert was, a bootlegger, even though he farmed, too."

It wasn't just Bob who catered to Doll, but her children, too. Though Lillian, somewhat Gladys's rival, reported her sister to always be "lazy as a hog," shirking her housework, she could rise to the occasion. By her teenage years Gladys was industrious, making her own clothes on her friend Vera Turner's sewing machine when she wasn't taking care of her mother or the crops. The harsh reality of life in Tupelo—the year Gladys was born, the town had only one short expanse of sidewalk, and no paved streets, let alone electricity—made death, religion, and sheer survival in unstable times the central themes of existence.

The late Janelle McComb, a lifelong Tupelo resident, remembered the kinds of tenets that helped most folks cope. "Old Dr. [William Robert] Hunt who delivered Elvis was my Sunday school teacher, and he was one of my granddaddy's best friends. When I was a little girl, he told me one day that I was going to heaven, and that I would walk upon streets of gold and have a mansion. I walked a dirt path, so I couldn't imagine that. My granddaddy ran a grocery store, so I walked in there and I said, 'Granddaddy, Dr. Hunt says that when I die I'm going to heaven, and I'll have a mansion.' Then I looked up and said, 'But, Granddaddy, how am I going to *get* there?' He closed the store and he walked outside with me. There was a chinaberry tree in the yard, and he put my hand on it and he said, 'My child, the timber you send up is what your mansion

will be made of. Don't ever send up bad timber.' That stayed with me all the days of my life."

Still, what got most people through day to day was the rural code of solidarity.

"This tiny impoverished community somehow survived by mutually sharing good fortune," the late Elaine Dundy, author of *Elvis and Gladys,* said in 2004. "The one existing home-owned Kodak became the communal camera, as did the few radios on the streets." If a few folks chafed at the idea, they hid it well and maintained their standing "by practicing the art of good manners with an almost ritualized politeness and having an attitude of optimism in spite of everything."

Dave Irwin, his son Len, and wife, Lily Mae, ran a general store in East Tupelo, and remembered that though the Smiths might be poor, they still found money to buy things—especially after Bob got a loan from the bank and moved the family to an untenanted farm of thirty acres and a house with hedge roses growing around the front door. To Len, "It seemed like the Promised Land to him." Gladys, particularly, held her head high. She looked nice—showed off her new homemade dresses—kept her clothes clean, and seemed to come into the store sixty times a day, often in the company of her younger sister, Clettes. First it might be a box of snuff to keep hunger at bay, then next trip maybe a rope of licorice or a Nehi soda, and on subsequent visits a bottle of Grove's Chill Tonic for Doll, and then perhaps some peppermint sticks.

By all accounts, Gladys was a lively, passionate young woman who hoped to make a good impression and be accepted by others. She loved to buck dance for the neighbors on Saturday night and dreamed of being either a singer like Mississippi's own radio star Jimmie Rodgers, or an actress like Clara Bow, whose new talking pictures Gladys watched on a makeshift movie screen on the back of a flatbed truck. But for all her gaiety, her ire could flare like a firestorm, and no one wanted her wrath. Gladys had inherited not only her father's deep-set eyes, but also his irritability.

"Everybody in that family was scared of Gladys and her temper," says Lamar Fike, a member of Elvis's entourage, the Memphis Mafia, who came to know Gladys well. "She ran all those kids, even her eldest sister Lillian. Everybody knew not to mess with her much. With a couple of exceptions, the Smith family was just wilder than goats. By God, they were tough! Tougher even than the Presleys, and they were violent people."

Coupled with her muscular build, her big, wide shoulders making her resemble a man at times, Gladys's temper made her a force to be reckoned with,

even as a child working on Burk's farm, where sharecroppers, "getting a little for themselves and making a whole lot more for someone else," as Billy Smith puts it, were regarded as little more than animals.

"Aunt Gladys was a strong-willed individual. If you scared her real bad or made her mad, she'd lash out at you. In Tupelo, they still talk about when she was sharecropping with her family. The guy who owned the farm come by on a horse with his high-topped leather boots and a whip. And he jumped on her father and her sisters with it. Gladys was ten or eleven years old, but she ripped a plowshare off and took the point and hit him in the head with it. Damn near killed him."

Still, Gladys had her vulnerabilities, most of them emotional. Though she attended religious services—worshipping at the Church of God and Prophecy—Gladys held to primitive superstitions, and not even her faith could completely quell the anxiety and impulsivity that plagued her from the time she was a small child. In Lillian's view, the young Gladys was "very highly strung, very nervous . . . She was frightened by all kinds of things—by thunderstorms and wind. She was always hearing noises outside at night and imagining there was someone in the bushes."

In time, her uneasiness with life would escalate to full-blown phobias. Once she moved to East Tupelo—which sat across Town Creek from the more prosperous Tupelo proper—she had all the bushes around her house cut down, terrified that "dark things" were moving in them. Her anxieties came and went without warning. She seemed better with the promise of social outlets, when she had something to look forward to, something that would take her mind off the dreariness of existing hand to mouth.

And one of the things that most stirred her imagination was the opposite sex. As a young child, Gladys seemed scared of boys. Her sister Lillian recalled that the first time a boy asked if he could walk her home from school, Gladys took off her shoes and ran. When he caught up with her, he walked way on one side of the road, and she way on the other. Such an extreme reaction may have been in response to her parents' teachings, as her father forged a rigid code of courtship, ruling that the boys who came calling on his daughters go no further than holding hands. Kissing was strictly forbidden, as it inevitably led to other things.

By her late teen years, Gladys was well over her fear of boys, and now it was she who chased them. Years later, Pid Harris, who dated her in her youth, reported she was "fast" and "liked to play," which, of course, was a scandal. He

remembered her fighting with another girl, the two of them slapping and hitting—"We had to pull them off of each other"—evidently over a man. But one by one, her older sisters were leaving home to marry, and now Gladys felt the pressure. Her impulsiveness—coupled with her desire to escape the oppression of toiling the fields and caring for her mother and younger siblings—led her to elope with a young farmer when she was in her late teens. Her embarrassment knew no bounds when she learned the man was married. In two days' time, she was back, morbidly ashamed and heartbroken.

Gladys's emotional state grew more fragile in 1931 with the tragic and sudden death of her father from pneumonia. The family was stunned with disbelief—Doll had always been the sickly one—and so unprepared they had to borrow a winding sheet from Mrs. Irwin, the coproprietor of the general store, to wrap the body for placement in an unmarked grave in Spring Hill Cemetery. But rather than stepping up and taking charge, nineteen-year-old Gladys seemed to crumble. Coming so soon after her failed elopement, the loss of her father was a double blow. Bob Smith had been the one stable man in her life.

His death immeasurably increased Gladys's responsibilities with her mother, three younger brothers, and twelve-year-old sister. But try as they might, they could not bring in the crop, and the family's sudden reversal of fortune meant that they would lose the new house and farm. Worse, the family would be split up, with Doll going to live with Levalle and her husband, Ed. Gladys, feeling responsible for the rest of the family, would have to find a full-time job in a town that offered little employment outside of the cotton mill and textile plant.

In the weeks that followed, Gladys fell into a complete and total collapse. At first, she seemed to revert to the lethargy that had so annoyed Lillian when Gladys was an adolescent. But then she began displaying the classic symptoms of what psychologists call conversion hysteria, in which grief becomes manifested in physical ailments. A friend remembered she became so anxious that she could not walk. "Gladys got herself into such a state that her legs would start shaking every time she was fixing to go out of the house." Finally she took to the safety of her bed, unable to move without the help of others, replicating the state that her mother had manifested for decades.

"Conversion hysteria acts to block the mental pain from conscious awareness, and also provides the benefit of allowing its victims to avoid unwanted responsibilities," wrote psychologist Whitmer.

In short, Gladys, overburdened with grief and unable to deal with reality, infantalized herself.

Ten years later, in the winter of 1941, she had a similar reaction to another tragedy. This time, conversion hysteria rendered her mute. Annie Presley, Gladys's cousin and neighbor, heard a knock and opened the door to find Gladys in such a high state of anxiety that "she could not move. She just stood there, saying nothing. Tears were streaming down her cheeks. She was wringing her hands over and over." It was only from a neighbor that Annie learned that Gladys's older sister, Rhetha Smith Loyd, had died a terrible death.

"Back in them days, we had woodstoves, and she went to build a fire in the stove to cook dinner, and thought she had got all of the sparks out from the one before. She poured a little coal oil in it, and it flamed up and caught her on fire and burned her." Rhetha lingered a few agonizing hours before expiring.

In both instances, the only thing that freed Gladys from psychological paralysis and restored her to normalcy was her religious faith, particularly after she began participating in Pentecostal services at the tiny Assembly of God church in the economically deprived East Tupelo, sharply divided from Tupelo by a levee and cotton fields. There, in a tent pitched on a neighborhood lot, some thirty worshippers gathered each Sunday to pray, sing, and feel the spirit take hold way down inside them. Later they moved to an old building up on the highway. Annie Presley termed it a tabernacle.

"Just a roof and a couple of sides. Didn't even have a front. No pews or chairs. Just things set up with long planks across them. They called 'em benches." The congregation also met in an old movie house, ironic, since the Assembly of God frowned on picture shows, if not music.

"In all of our church services, music and singing were very meaningful parts," recalled Reverend Frank W. Smith, who became pastor at the church about ten years later. "We would always begin our services with congregational singing. Not loud singing, but worship singing. We had a song leader, and everyone would join in and sing along together. Sometimes there would be no worshipful expressions during this part of the service, just singing."

As in other Pentecostal churches, the Assembly of God revered speaking in tongues as evidence that the Holy Spirit talked through the parishioners. Both the speakers and the interpreters of the sounds, variously called "the barks," "the jerks," and "the Holy laugh," were held in the highest esteem.

Four months after the horrific trauma of Rhetha's death, Gladys attended yet another tragedy and demonstrated previously unseen emotional strength. Annie's third baby, Barbara Sue, delivered at home, died eight hours after birth from asphyxiation from too much mucus in her lungs.

"Gladys was in and out all day, but she had been there from about five o'clock on that evening, because the baby was strangling pretty bad, and we called Dr. [Robert] Pegram about three times, and he wouldn't come. By the time he got there, she was dead. Gladys was the one that took the baby out of my bed and put it over on another bed when she died. She stayed right with me."

Annie, only nineteen, was too weak and distraught to go to the graveyard, so Gladys stayed with her then, too, while everybody else went. "Your belief in God will get you through," Gladys told the devastated mother over and over. "Look to God."

.

Gladys's faith in a higher power brought her more than spiritual salve, however, for it was in that East Tupelo church in the spring of 1933 that Gladys Love Smith, who had just turned twenty-one and operated a sewing machine at the Tupelo Garment Company for two dollars a day, first laid eyes on Vernon Elvis Presley. He was blondish, fine featured, well mannered around women, and with full lips that curled into an easy sneer, he looked like a backwoods Romeo straight out of *Tobacco Road,* Erskine Caldwell's classic novel of sex and violence among the rural poor.

They eloped two months after they met, on June 17, 1933, in Pontotoc County, where Vernon, barely seventeen but looking every bit a full-grown man, could pass as one. He borrowed the money for the marriage license, which spelled his name "Virnon," either because the clerk made an error, or because Vernon, who was only semiliterate throughout his life, knew no better. Both he and his bride lied about their ages, Vernon adding five years, for twenty-two, and Gladys subtracting two, for nineteen. In a photograph taken of them about that time, they can hardly conceal their hunger for each other, their heads pressed together, Gladys snuggled up to him from behind, her arm around his shoulder.

Yet it was not precisely love at first sight. Initially, Gladys dated Vernon's older brother, Vester, while her younger sister, Clettes, went with Vernon. "Gladys didn't like my attitude much," Vester said years later. "I was too wild in those days. So Gladys quit seeing me and we quit seeing the Smith girls for a while." But soon it was a foursome again, as Clettes married Vester after Gladys wed Vernon—two brothers marrying two sisters. To further entangle the family tree—rooted in the first-cousin union of Bob and Doll Smith—Travis and John Smith, Gladys's brothers, also married sisters. "So their kids and my brother,

Bobby, and me were double first cousins," explains Billy Smith. "You've got double first cousins on the Presley side, too."

Gladys's family was large, sprawling, and financially unstable, but in some ways, the Smiths were high-minded and genteel compared to the Presleys, another matriarchal southern clan. None of that was lost on the locals.

As Tupelo historian Roy Turner recounts, "When Mertice Finley Collins told her mother she had bumped into Gladys Smith in town and learned she had married Vernon Presley, her mother replied, 'One of the Presleys *above the highway,*' which was to distinguish where in the East Tupelo hierarchy they were. Even as Tupelo looked down on East Tupelo, East Tupelo was divided into two sects—the more prosperous below the highway, and the less fortunate above the highway. The highway being 78."

Vernon's grandmother, Rosella Presley, was the daughter of Dunnan Presley Jr., a Confederate army deserter and bigamist who abandoned the family when Rosella was a baby to return to his first wife and child. Rosella, who never knew him, grew up independent and freethinking, and continued the tradition, bringing ten illegitimate children into the world by various men who never stayed long enough to know their offspring. A sharecropper, she died at sixty-three without ever identifying the fathers of most of her children. But her youngest son, Joseph Presley, would say a man named Steele, part Cherokee Indian, sired at least a few of her brood.

"She was a very strict disciplinarian, but a loving mother. Despite the hardships, she always managed to give each of us a little present at Christmas—even if it was only a piece of candy or a secondhand pair of shoes." Though she had no real education, she wanted better for her children, and saw to it that they attended school.

Two of them exemplified the best and worst of the family and set themselves up as passionate rivals, in the tradition of John Steinbeck's *East of Eden.* Noah Presley, the "good" son, moved to East Tupelo, where he ran a grocery store and drove a school bus. Civic minded, with a soft spot for children (he had thirteen of his own), he regularly took the kids of East Tupelo to the zoo in Memphis on Sundays. In 1936, when he ran for mayor of East Tupelo—then little more than a wide spot in the road, and considered inferior to the larger town of six thousand citizens—he was handily elected, gaining praise for improving East Tupelo's physical facilities.

On the other end of the scale was Jessie Presley, also known as J.D. His

mother had bestowed a gift upon him that she'd withheld from the rest of her children—honoring him with his real father's surname, McClowell, in addition to her own. A sharecropper on Orville Bean's dairy farm, Jessie had five children—Vernon, Vester, Gladys Earline, Nasval Lorene (also known as Nashville, or Nash), and Delta Mae—with wife Minnie Mae Hood, a tall, skinny, peppery woman from Fulton, Mississippi, whom he tried to dominate. Like his son, Jessie had married at seventeen, wedding an older woman (Minnie Mae was eight years his senior) of higher social standing.

In contrast to his brother, Jessie D. McClowell Presley was as self-centered and parsimonious as Noah was generous. Everyone in East Tupelo talked about how mean he was, particularly when he drank. They clucked about his habit of locking up his whiskey so Minnie Mae couldn't get to it, and laughed at his stinginess in dictating how many pieces of cheese she could slice or biscuits she could serve when guests came calling. Remembered one relative, "When that was gone, you was out, so we didn't ever go back no more for dinner. We went somewhere else if we wanted to eat."

Still, Jessie has his defenders. "Was he being stingy, or were the times just hard and he was being careful?" asks Tony Stuchbury, an Elvis aficionado from England who often visits Tupelo to gather information for his Web site. "To judge him on that is a little bit unfair. I don't think he's the bad apple that people have painted him to be."

Yet Jessie's relationship with Vernon was also often strained, and when the boy was fifteen, his father sent him away for a year to sharecrop on the farm of a relative, likely as a disciplinary action. But Jessie also may have been jealous of Vernon's physique and good looks, and considered him a sexual threat, for Jessie took pride in his own appearance and was known around the county as a womanizing dandy.

"When he'd get off of work on Friday," Annie Presley remembered, "you'd see him go home and take a bath and dress to a T, and then you wouldn't see him 'til Sunday evening late."

Given to dapper suits, he cut such a handsome figure that women were said to stare at him as he strutted down the road.

Jessie may have also seen something else of himself in Vernon, as Vernon was the "bad" son to Vester's "good," just as Jessie had been compared with Noah. But Vernon did, in fact, demonstrate an aversion to three things: responsibility, conflict, and work. For a while, he and Vester—shorter, scrawnier, and no competition with the ladies—tried farming a little truck patch together, planting

cotton, corn, and soybeans. But Vernon hated getting up before the sun and soon resorted to odd jobs, including working for Orville Bean.

Gladys's paycheck kept them going, and Minnie Mae, who called Vernon her favorite, saw how they struggled to get by. They needed a house of their own, Minnie told her husband, and they could build it right next to theirs on East Tupelo's Old Saltillo Road, on Bean's property, located above Highway 78, which shuttled travelers between Tupelo and Birmingham, Alabama. Vernon borrowed $180 from Bean to buy lumber for a little two-room, wood-frame shotgun house, with the understanding that he would pay him rent to retire the loan with interest. Jessie, who was a skilled carpenter, helped his son with the construction, as did Vester. The three, mindful of the floods that raged through the area in the spring, raised the little house off the ground with stone piles. When it was finished, in 1934, it resembled housing constructed for mill villages around the area and was solid enough to last a hundred years or so, if not especially fancy, with no indoor plumbing or ceiling, just the roof. The two families shared a cow and some chickens out back.

The image of the Presleys' first house would be seared in Elvis's mind forever. In the fifth grade, he would write a poem in a classmate's autograph book:

> Roses are red, violets are blue,
> When a chicken gets in your house,
> You should say, "Shoo, shoo, shoo."
> When you get married and live in a shack,
> Make your children clothes out of toe sacks.

· · · · · ·

By the end of June 1934, Gladys realized she was pregnant, and around her fifth month she told everybody she was having identical twins. Not only was she uncommonly large, all swollen up and heavy, and her legs hurting her, but also with time, she could feel two babies kicking inside her. Besides, twins ran in the family on both sides—Gladys had identical twin cousins, Elzie and Ellis Mansell, and Sales Presley had a fraternal twin, Gordon. Annie and Sales's daughter would also have twins, and Travis and Lorraine Smith would sadly lose a set of twins. For her baby shower, Gladys received the usual items that comfort newborn infants, but also two sheets and thirty dollars in cash. Her friends and family were concerned that Vernon would drink it all up.

Gladys had always wanted a house full of children, all of them around her all

the time, and she and Vernon were giddy with the news. ("Vernon thought he was a stud," remembers Lamar Fike. "Elvis used to say that Vernon knew when Elvis was conceived, because afterwards, he blacked out.") They picked out rhyming names—Jessie Garon for the firstborn, and Elvis Aaron. "Jessie" was to honor Vernon's father, and "Elvis" came from Vernon's middle name. They chose "Aaron" for Aaron Kennedy, Vernon's best friend. The "Garon" simply rhymed with "Aaron."

In the predawn morning of January 8, 1935, Gladys awoke to intense labor pains, and rallied her husband from sleep. "Vernon," she said, shaking him. "I think it's time. You'd best get your mama over here. And go call the doctor." Vernon lit the oil lamp, took one look at his wife's face, beaded with sweat, and then raced across the yard to his parents' house and pounded on the door. "Mama! Papa! Come quick! Gladys is in labor!"

Minnie Mae and Jessie rushed over in their nightclothes, Jessie still hung over from the night before. Minnie Mae asked Gladys some questions, and then also implored her son to get the doctor. He took off running to Highway 78 and the nearest telephone, dialing the four numbers that connected him to sixty-eight-year-old Dr. William Robert Hunt, the poor man's physician, who had been practicing in Tupelo since 1913, the year he received his Tulane University medical degree. Minnie Mae somehow sent word to the midwife, Edna Robinson, and began boiling a large pot of water on the wood-burning stove.

By the time Dr. Hunt arrived, steering his Model T Ford the mile and a half across the levee to the Presley home, Gladys was about to deliver. Jessie Garon appeared first, around 4 A.M. Then a hush fell over the room, and Dr. Hunt announced that the child was lifeless, stillborn. Gladys let out a long, piercing wail as the midwife carried the dead infant out into the back room.

Vernon, too, was crying, but according to the story Billy Smith heard down the years from the family, "Jessie, drunk out of his mind, thought Vernon was laughing. He went in and said, 'Gitchy, gitchy, goo!' And 'Oh, ain't it a beautiful baby!' The baby didn't respond, of course. So Jessie just kept going 'Gitchy, gitchy, goo!' Vernon was hurt to the bone, so finally he yelled out, 'Oh, goddamn, Daddy! The baby is dead!' Jessie got this funny look on his face and just said, 'Oh, oh!' About the time all that was happening, about 4:35 A.M., Elvis was born."

Precisely what happened to Jessie Garon is open to speculation. Vester wrote in his book, *A Presley Speaks,* that Gladys and Vernon had been in a car accident just months before the twins were born, and that, in fact, they'd paid the rent on their little two-room house with their settlement money. Might Jessie have been injured in the accident?

And then there's front porch gossip. According to the oft-repeated story, Dr. Hunt had his coat on to leave when Gladys insisted there was another baby. But a doctor who was about to record his 919th and 920th births would have recognized the signs of a second child, particularly the fact that Gladys's uterus was still swollen. One variation of the tale has it that the first baby could have lived, that Dr. Hunt was, indeed, surprised by the second birth and had spent too much time attending to Elvis when something as routine as clearing Jessie's windpipe might have saved him.

Vernon, in a story he told for the rest of his life, saw the tragedy as God's will. Just before the births, he said, there were two identical medicine bottles setting on the mantel of the fireplace. Just as Gladys was giving birth, one of the bottles inexplicably burst, while the other remained intact. After Jessie was pronounced dead, Vernon interpreted the exploding bottle as a sign from heaven. When Jessie died, he said, Elvis took over his soul and spirit.

No matter what the cause of the baby's death, Gladys, friends said, looked "more than half dead" from blood loss, and Dr. Hunt, who billed the Presleys only fifteen dollars as a "labor case," sent her to the Tupelo Hospital, where she would stay for two weeks. Elvis, who was being breast-fed, went with her. The weekend after Elvis's birth, Dr. Hunt announced in church that the Presleys had had twins, and that one had died. The community may have been poor, but it looked after its own, Janelle McComb reported. "Some of the congregation went to visit and took things."

A few days after the delivery, a still exhausted Dr. Hunt recorded the births in his ledger, misspelling Elvis as "Evis" (probably following Vernon's pronunciation), and transposing the *i* from "Jessie" into "Garion." He similarly erred on baby Jessie's death certificate, recording the date of birth as January 7 and listing him only as the nameless "infant of Vernon Pressley," repeating the original family spelling. Dr. Hunt's daughter, Sarah Hunt Potter, would later say that she wasn't certain that 4:35 A.M.—Elvis's time of birth as recorded in the ledger— was correct, since her father had waited so long to enter it.

However, a bigger mystery than the exact time of Elvis's birth is the location of his dead twin's grave. For decades, it was said that on January 9 Vernon had climbed the hilly terrain of East Tupelo's tiny Priceville Cemetery in the bitter cold with the little coffin, a minister, and an undertaker from W. E. Pegues at his side. There, in the Presley plot, they supposedly carried out their grim task, burying the infant in an unmarked grave that all but disappeared when the grass grew in.

But Priceville has been questioned in later years. Billy Smith says that Jessie was, indeed, buried in an unmarked grave, but in another cemetery closer to Saltillo. One of Elvis's classmates insists the twin was buried in a cemetery by St. Mark's Methodist Church across from the birthplace. And Joe Savery, who owns the original death certificate, has said that "nobody really knows where that child is buried. . . . Later on, Elvis tried to find out. . . . You would think that somebody in the family would have known where they buried that child, but I have never known anybody that does."

However, Roy Turner believes Priceville is the burial spot after all. Someone put a small marble foot marker there years ago that sets near the grave of Noah Presley. "When I stumbled on what I thought was Jessie's grave, because of the chronology of the surrounding Presley graves—then a space for two more that was never used—I assumed this was the spot. A lot of people in that era were not able to afford tombstones. When I first saw the grave, there was only a concrete chunk marking the spot and some artificial flowers."

Becky Martin, one of Elvis's favorite fifth grade classmates, confirmed it as Jessie's final resting place and remembered the Presley family usually put flowers on the grave when they visited the cemetery each decoration day, which at Priceville is the first Sunday in August.

Jessie's death certificate also lists Priceville Cemetery as the burial site, as does the receipt at Pegues for the coffin. Some years back, "I was doing a documentary on the [1936] Tupelo tornado and interviewed Mr. Pegues, wanting to know how many deaths they handled," continues Roy Turner. "While he was going through his records, he said, 'You might be interested in this.'" The book contained records from the 1930s, and the funeral director showed Turner where Vernon bought and paid for the coffin, and for Pegues to handle the burial.

"People say, 'Why didn't they just move Jessie to Graceland the way they did Elvis and Gladys?'" asks Billy Smith. "There wasn't anything to move. They had a little wood coffin for the baby and all. But there couldn't be anything to move but a hunk of dirt. The little coffin's rotted and gone. Baby's gone. Maybe bones. We don't really know. Why bother? Leave it in its resting place."

Today, the Presley gravesites in Graceland's Meditation Garden include a small plaque for Jessie, as J. D. Presley spelled it, not "Jesse," as is so often written.

· · · · · ·

From the moment Elvis was born, mother and son demonstrated a remarkable closeness, almost as if Gladys had been Elvis's twin and not Jessie. She tended to

the infant's every need, refusing to hand off care to a relative or even her husband for a single afternoon's respite. "Gladys had a one-track mind," offered a female cousin. "She would hold that baby so tight I thought he might suffocate. She wouldn't let nobody carry him around but her, not even Vernon."

In fact, Vernon, who had so held his young bride's affections, would in short order seem more like a boarder in the house, as he would for the remainder of the Presleys' life together.

As Lamar Fike says, "Gladys ruled her house when she married. But when Elvis came along, he and Gladys ruled that roost together. You had a wife who dominated the whole thing, a husband who didn't like to work, and an only child who was doted on by his mother. A child who listened to his mother and father argue all their lives. That's what molded Elvis into what he was. It was one of the most dysfunctional families I've ever seen."

Any mother who lost one of her twin babies as Gladys had would have naturally feared losing the surviving child, as Gladys did as long as she lived. Leona Moore, a former nurse at the Tupelo Hospital, told author Elaine Dundy that Gladys miscarried another child when Elvis was seven. Billy Smith doubts it, saying he would have heard that in the family. But true or not, Gladys apparently was not capable of having other children, which further contributed to her overprotection of Elvis. "My mother," the adult Elvis would say. "I suppose since I was an only child that we might've been a little closer than . . . I mean everyone loves their mother, but . . . Mother was always right with me all my life."

During Elvis's formative years, a number of events collided to cement her relentless hold on him, more for her comfort and solace than his.

The first occurred nine months after Elvis's birth, when Gladys's grandmother, Ann Mansell Smith, mother of Bob and the matriarch of the Smith family, died. Far worse, in a matter of weeks, Gladys's own mother, the tubercular Doll, expired at fifty-nine. Her passing marked three deaths in the immediate family in eleven months, reawakening Gladys's fears, phobias, and abandonment issues. She clung to her son tighter than before, almost as if he were a shield against a treacherous and mercurial world, where disaster could strike at any second and take away all that mattered.

Such a calamity came dangerously close on April 5, 1936, when the fourth deadliest tornado in United States history roared through Tupelo, taking 235 lives, injuring another 350 residents, and decimating forty-eight city blocks.

"It sounded like a bunch of freight cars running together," Magnolia Clanton

remembered. "It just hit and you heard people screaming in the streets and you didn't know which way you were going or which way you were going to go because you went crazy."

As the storm first gathered, the winds tearing through the trees and the sky darkening to an ominous shade, Noah Presley ran for his school bus. He drove to Jessie and Minnie Mae's home, gathering his parents and then Vernon and Gladys next door, so they could all be together at his house, which was stronger and larger than anyone else's. Gladys held one-year-old Elvis close up against her, climbed on the bus, and the family then hurried to the Baptist church, where Vernon's sister, Little Gladys, as he called her to differentiate her from his wife, was in worship. Jessie rushed to the back of the church and issued the storm warning to the congregation, and then they were off to Noah's.

There, the men braced themselves along the planks on the south wall for added strength while the women prayed. In a comical scene, Minnie Mae fainted, then came to, and fainted again, over and over, while Gladys huddled in the corner, too frightened to speak, a death grip on her blond-haired, blue-eyed baby. However she, too, nearly lost consciousness when she returned home. The Methodist church directly across the street had been totally leveled, yet the storm had left the little homemade house untouched.

Again Gladys turned to her faith to sustain her, and to praise God for her family's being spared. The following year or so, she gave thanks for a new place to worship when her uncle, Gaines Mansell, became the preacher at the newly built Assembly of God church, about a block from the Presleys' home. One day Gladys testified to a vision she'd had, in which Elvis was going to amount to something special. More than that, he would be a great leader of men.

She told her family the same thing and believed it with all her heart. He was special, having the power of two people because of the dead twin. Elvis would be infused with all the positive attributes that Jessie might have had, as well as his own. That gave him twice the looks, twice the personality, twice the talent, twice the intelligence, and twice the spiritual connection.

Precisely what kind of charismatic services the Presleys attended at the new Assembly of God church is largely left up to the imagination, except for Annie Presley's description.

"The services would start about seven, seven-thirty at night. Sometimes you got home long after midnight. They'd have the altar call and after that, they'd pray for two or three hours and shout and sing. You'd be praying and you'd just get so happy till you'd just jump up and go to shouting. Some of them would get

to talking in tongues. There'd be shouting all over the building. 'Praise the Lord!' 'Hallelujah!' 'Glory!' 'I love you, Lord.' Anything like that."

In the early 1980s, when Roy Turner assisted author Elaine Dundy in tracing Gladys's path in Tupelo, Corene Smith, the wife of Reverend Frank W. Smith, who took over the church when Elvis was ten or eleven, suggested that if the researchers wanted to see religion the way Elvis experienced it, they would have to go to the county—the city churches had become too sophisticated. And so Turner and Dundy drove out to Pontotoc County.

"After about three hours of the service in hot, Mississippi, humid, July weather in a little church with ceiling fans whirling and windows opened, we left," Turner recalls. "The service continued until way into the night. The people had danced around the entire sanctuary, shouting, writhing, fainting, wailing to exhaustion. Elaine remarked, 'I feel like I have been to an Elvis concert.'"

Dundy was, in fact, witnessing the grassroots of the entire Elvis Presley phenomenon, from the music to the reaction of his fans. And it took hold early. Once Elvis became famous, Gladys would recall one particular Sunday in the Assembly of God church when two-year-old Elvis, normally a quiet and reserved child, squirmed off her lap to make his way up on the platform to try to sing with the choir. Soon it got to be his habit. "It was a small church, so you couldn't sing too loud," the grown-up Elvis said.

"Gladys used to laugh about it," Harold Loyd, Rhetha's son, remembered. "The preacher and all of 'em thought it was cute, so they got to where they would let him stand up there and sing with 'em."

Psychologist Whitmer, an expert on twinless twins, or twins who have lost their mirror image, whether fraternal or identical, isn't surprised. "While pregnant, Gladys spent hours every single day at the Assembly of God church. If you look at in-utero imaging, in the last trimester you see twins hugging, punching, kicking, and dancing to music. Sound is incredibly important."

Elvis, then, instinctively began moving to music before he was born. He learned to communicate, to feel good, through instruments and voices. While he was still in the womb, music became a dynamic and primary way of expressing himself in his relationship with his twin, his mother, and all that defined his world.

· · · · · ·

At the end of 1937, just before Elvis's third birthday, another seminal event oc-curred in the Presley family, one that had tragic consequences for all involved. On November 16, 1937, Vernon, along with Gladys's brother Travis Smith and

their friend Lether Gable, were criminally charged with "uttering a forged instrument." The story goes that they had altered a four-dollar check from Vernon's usurious landlord and part-time employer, Orville Bean, in payment for a hog. Vernon was enraged—the hog was worth at least fifty dollars, and he'd been expecting the much larger sum. Besides, he needed the money. And so the three talked it over.

Exactly what happened next has been muddied through the years. Aaron Kennedy always said that Vernon changed the amount to either fourteen or forty dollars, but the courthouse records do not include the details. However, in a newly discovered letter from 1938, Orville Bean said that Vernon allowed the two others to copy Bean's signature and forge checks on him, Vernon receiving fifteen dollars for his trouble and silence.

"They were drinking, and just did it on a whim," says Billy Smith, Travis's son. "Vernon got to thinking about it, and the more he thought about it, the madder he got. And they said, 'Well, we'll fix him.' And Daddy was always ready to do any and everything, and he was easily persuaded by people.

"From what my mama told me, they lived high for a time. Daddy and Lether went down to Texas to try to find a job. Mama said Daddy had this idea he was really going to be 'Mr. It.' But all they came back with was a new shirt, a new pair of pants, and a big hat. And as soon as he stepped off the train, they were waiting for him, and hauled him right on off. They'd already gotten Vernon by this time. He was in jail."

Initially, none of the three men could post bail, set surprisingly high at $500 each. Then on January 4, 1938, two bonds were filed, the first for Lether, and the second for Travis. As no record exists for Vernon's bail, he was apparently left to cool his heels for six months in custody awaiting trial. But the galling news was that Vernon's own father had gone in on the bail for Travis. Whether he feared angering his landlord Bean, whose land he still sharecropped, isn't known. Annie Presley believed that Noah Presley eventually posted bond for Vernon, but J.D. first intended to let his son rot in the Lee County jail, later having a change of heart.

"Maybe J.D. thought he was going to teach Vernon a lesson," muses Billy Smith. "But to be honest, I think he just liked Daddy better than he did Vernon. Vernon was likable, but my daddy, you couldn't help but like him. He was a whole lot like Aunt Gladys."

At the trial, emotions still ran high. Bean shouted out at one point, calling Vernon "long hungry," local slang for a glutton who'd steal from the mouths of

his own family to gorge himself. There was no greater insult, and Elvis would hear it the rest of his days.

On May 25, 1938, Vernon and Travis were sentenced to three years in the Mississippi State Penitentiary at Parchman, the legendarily cruel institution where prisoners were routinely bullwhipped and put on chain gangs as terrifying lessons in the evils of defying authority. Yet surprisingly, Vernon got a reprieve, of sorts. Shortly after he arrived on June 1, the warden made him a trustee, which afforded him a room at the warden's house for conjugal visits, according to Annie Presley. While Gladys, with Elvis in tow, would make the five-hour trip whenever she could—Noah Presley drove them every third Sunday—Vernon's time away would be a watershed event.

By the time he returned, all three Presleys would suffer from sleepwalking, or "action nightmares," as one cousin put it in southern parlance. And Vernon would be but a stick figure in the lives of his wife and child. Elvis and Gladys would be so fatalistically close that anyone else amounted to an intruder. Elvis belonged to her, and Gladys to him. They were one. And no one else would ever make the other feel whole again.

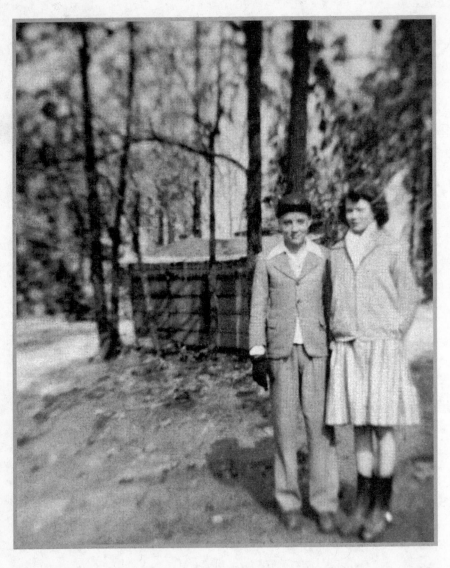

Elvis and Magdalene Morgan, outside her home in Tupelo, after Sunday church, date unknown. The wooden building in the background had once been her playhouse. *(Courtesy of David Troedson/Elvis Australia)*

TWO

.

An Ideal Guy

Vernon would be released from Parchman with a six-month suspension of his sen-tence on February 6, 1939, largely because he demonstrated good behavior and an appropriate degree of remorse for his crime. He had served nine months. Gladys had done her part, too, literally walking door to door in Lee County, gathering signatures on a petition to vouch for his character, and cajoling Orville Bean into writing a letter to Governor Hugh White pleading for leniency: "The money was repaid to me and this man realizes the mistake he has made and I believe he has been sufficiently punished. He is a splendid young man. . . ." (See endnotes.)

Gladys also wrote at least two missives, both on lined tablet paper, lobbying for a pardon or a six-month parole. She insisted Vernon had never been in any trouble with the law ("he has never even been drunk in his life"), and that he had simply been "persuaded into selling some boys a signature off of a check" and didn't understand the consequences. In the first letter, on October 29, 1938, she argued on behalf of herself and Minnie Mae. ("His mother is sitting here broken-hearted beside me.") But in the second, dated November 25, 1938, she spoke powerfully about her own personal hardship. ("My health is bad and . . . I have no mother or daddy and no one to look to for a living. I have a little boy three years old. Please send [my husband] home to his wife and baby.")

Until Vernon returned, however, Gladys went back to work in the fields. By each September, the cotton crop was in, and Gladys would hire out along with nearly everybody else in East Tupelo, her fingers bleeding as she picked the soft white bolls from the prickly burrs, her back bent into the stalks, two rows at a time. It was grueling work, especially when the sun beat down upon her.

But it paid real money—$1.50 per hundred pounds of cotton. And she could take her baby with her—little Elvis, wearing overalls and a brimmed hat to shield him from the sun, riding on her six-foot duck sack as she pulled it along the rows. He never forgot it, saying years later he had seen her put stockings on her arms or pour buttermilk on them to quell the sunburn when she went into the fields.

But no matter how much cotton she picked, or sewing or laundry she took in, Gladys couldn't keep up the payment schedule to Orville Bean. ("He wouldn't wait on you—if you didn't have the rent, he'd tell you to move right quick," remembered one resident.) Before long, she and Elvis would have to leave. "Aunt Gladys made the rounds, staying at different people's houses," Billy Smith recounts. At one point, she moved in with her first cousin Frank Richards. Elvis, clutching his teddy bear, Mabel, would sit on the porch "crying his eyes out because his daddy was away," a relative recalled. Gladys, too, suffered mightily, a friend said. "After [Vernon] went to prison, she was awful nervous."

Before the move, at night, in the front room of the house her husband and father-in-law had built with their own hands, she and her son would share the little iron bed that the three of them had occupied when Vernon was there, Elvis tucked under her arm. Awaiting sleep, after a spare supper of beans, potatoes, and maybe a little side meat, they would lie there and listen to the battery radio as a light breeze blew through the curtains. Gladys would speak of Jessie, telling Elvis of the brother he never knew.

From an early age, "He'd run up to you as soon as you'd come into the house," Annie Presley remembered. "He could tell you right quick, 'I had a brother.' "

• • • • • •

During the months that Vernon was incarcerated, Elvis and Gladys bonded in the unhealthy state that psychologist and Elvis biographer Whitmer terms "lethal enmeshment, a normal developmental reality for the twinless twin." Several factors contributed to it, starting with the fact that Elvis and Gladys slept in the same bed. While such a practice was hardly unusual in impoverished households of the South, the end result was that Elvis could never differentiate from his mother, and that he remained a part of her. Such nonsexual or covert incest contributed to a sense of shame, sexual confusion, and conflict.

Shame was something that the three-year-old was already grappling with on two other fronts. While Vernon would never be a strong father figure, his absence, and Elvis's witnessing his father in the frightening prison garb at Parch-

man during family visits, would have left such a sensitive child with a sense of disgrace. Elvis's Tupelo playmates report that he never discussed his father's incarceration as he grew older. As a tiny child, only his mother's comfort could have alleviated his anxiety.

However, the larger sense of shame—and guilt—would have come from the death of his brother, or more specifically Elvis's having survived when his mirror image died. While he would have taken pride in the fact that he had triumphed, that he was the stronger one, the superior one, and been singled out, "Twinless twins blame themselves for their sibling's death," writes Whitmer in *The Inner Elvis*. To win Gladys's love, Elvis knew "he must grieve for the dead twin." Jessie's death was yet another trauma that mother and son shared, and Elvis would have felt fear and pain that he had "denied" his mother her other child.

As if to make it up to her and assuage his own feelings, Elvis reversed the role of parent and child—behavior typical of twinless twins whose mothers are smothering and overprotective. At the age of three, with Vernon out of the house, he felt responsible for her happiness and became Gladys's caretaker, substitute spouse, and primary source of intimacy. Robbing himself of his childhood, he tried to fill her emptiness in every way. Visitors were often surprised that such a small boy was so solicitous of his mother, Elvis repeatedly asking her if she needed a glass of water or a chair, or otherwise seeing to her every creature comfort.

In a bizarre scenario that clearly demonstrates how boundary violations occurred in the family, the toddler would become both parentified and sexualized. As Lillian Smith recalled, "Elvis was just learning to walk and talk. He would walk very, very fast through the house, and every time he came to Gladys, he'd reach up and pat her on the head and call her *baby.* 'There, there, my little baby,' he would say."

It was a term he would use for her all her life, and, in fact, he referred to both his parents as his "babies" well into his early fame. In a sense, by including Vernon, he desexualized his father as his competition for Gladys's affections.

All of these factors would have collided to influence Elvis's sexuality. With trauma that comes early, and is both prolonged and extreme, biochemical changes can occur in human development, particularly in sexual dimorphism, or the biochemical determinants of masculinity and femininity, the estrogen-androgen balance, which results in the physical differences between the sexes.

Elvis would grow up to be a beautiful, not a rugged man, with softer, somewhat female characteristics—full lips, sleepy eyes, and very little body hair, especially chest hair—that in part accounted for his androgynous sex appeal. Socially he

would also behave in ways that didn't fit the contemporary norms of the times. He gave himself Toni home permanents, went to a beauty shop instead of a barber, and sometimes modeled eye makeup in his teens, even before he was regularly onstage. In the 1960s he often wore pancake makeup when he wasn't making movies.

Whether Gladys introduced him to makeup ("You're the prettiest thing on the face of the earth—put a little eye color on"), Elvis wasn't homosexual. His testosterone levels, coupled with his grounding in the importance of the southern male, never tempted him to act out sexually with another man. Furthermore, he was wonderfully capable of compartmentalizing all of his behavior and building walls. The adult Elvis saw no conflict in his desire to wear mascara (or dye his eyelashes) and carry a gun—the symbolic phallus—at the same time.

While the toddler Elvis and Gladys symbiotically turned to each other to meet nearly all their emotional needs, Elvis had more to work out through the relationship. He took the fact that he had a "twin toe"—a bit of webbing or extra skin that connects the second and third digits into nearly one unit—as a sign that he had been an identical twin. His grief for his brother grew into a yearning for a sense of completeness with another human being.

As Whitmer writes, "Given what is known about the lifelong importance of intrauterine bonding, the enmeshed relationship that gradually became obvious between mother and son had its origins before birth. Elvis simply and naturally transferred all his tactile and sensory needs from Jesse [sic] and invested them in his mother. . . . His sense of being joined with Jesse was replaced by being 'one' with Gladys."

In other words, Elvis shifted all of his feelings for his twin onto his mother. These emotions would have been symbolic because they occurred before the acquisition of real language.

Yet Elvis and Gladys would come to communicate in a secret language all their own. Milk, for example, was "butch." Ice cream was "iddytream." And Elvis's pet name for his mother was Satnin', which according to Billy Smith means "a real condensed round of fattening. Elvis would pat her on the stomach and say, 'Baby's going to bring you something to eat, Satnin.'" Gladys, for her part, called him "Elvie," and sometimes "Naughty," as in, "You're a naughty boy."

They kept it up for life. In the late 1950s, when Lamar Fike would be with the Presleys at Graceland, "Elvis would rip through a paragraph of that, and I couldn't make heads or tails of it. But Gladys could. And Vernon could, and Elvis would baby talk him, too. I used to sit at that breakfast bar and wouldn't

understand a damn word they said, especially since Elvis had that little stutter. It was like a foreign language."

Indeed, twin language is often described as "like speaking in tongues," indecipherable to anyone but the twins themselves. Such behavior is not uncommon—in fact, surviving twins develop a secret language more often than not. And if the other twin isn't there, the lone twin will speak it with anyone with whom he has a close, meaningful relationship, including his mother.

Even as a small child, Elvis would have had a moral uneasiness with his relationship with Gladys, precisely as he felt responsible for her. It would have left him always needing to be under the control of someone else and yet wanting to be in control of himself and others.

His perpetual need for imposing control also probably resulted from stuck grief, a phenomenon in which an individual, for whatever reason, is incapable of getting over a tragic event, such as the death of a relative or spouse. Such individuals show the same profundity of emotion over time and through the stages of grieving, as delineated by the Swiss-born psychiatrist Elisabeth Kübler-Ross, author of the pioneering book *On Death and Dying*.

Elvis's grief for his dead twin and his lethal enmeshment with Gladys left him incapacitated to develop in a normal way, so that he became psychologically truncated in his ability to take on true adult responsibilities. "He couldn't do it on his own, because he didn't know who he was—he'd never been able to individuate," as Whitmer put it in an interview. The grown-up Elvis would always need to rely on someone else to really help out—first Gladys, then his manager, Colonel Tom Parker, his entourage the Memphis Mafia, and various women in his life. In short, at the core, he wanted to be infantalized, to regress, if not back to the womb then back to childhood, to be cared for and nurtured. Says Lamar Fike, "Elvis's thing with women was that they had to baby him and take care of him."

This, of course, would play eternal havoc with his relationships with the opposite sex. He would forever be insecure with females his own age—feeling safer and more comfortable around younger people in general—and not really know how to interact socially or recognize the proper boundaries and borders. Because of his stuck grief, particularly after Gladys's death in 1958, he would always feel as if a part of himself were missing. This would become the most important motivator in his life.

As psychologist Whitmer explains, "It's not so much the idea that being with another woman meant he was cheating on the mom. It's more the whole issue of, 'Mom had control of me. I enjoyed Mom's having control of me. I enjoyed being

enmeshed with my mom, and by the way, that's why I can never emotionally mature to anything more than fourteen or fifteen years old. I just can't go any further.'"

On the surface, for the first half of his life, Elvis could push himself to behave like a normal teenager, positioned somewhere from fourteen to eighteen years old. But his own self-perception, his default, was about fourteen or sixteen. As such, he continued to be attracted to fourteen-year-old girls up until his death at age forty-two, though for the most part, he saw them as innocents to be protected and wanted them to remain virgins.

Unconsciously, he felt fourteen-year-old girls were replications of himself, and he believed they constituted his missing part. But on a more conscious level, Elvis saw most women as either mothers or playthings. One part of his mind felt and experienced sexual energy as locked in with the concept of procreation—a woman was there for making children. The other half of his mind perceived women just as toys, or as little more than hormonal releases.

"Because of this fact," says Whitmer, "Elvis could never, ever develop any kind of serious, deep, meaningful relationship with anybody else. It's as if he said, 'I cannot stay in a marital, loving relationship with anybody but Gladys.'"

Many twinless twins dwell on the sidewalk of life and have high incidences of divorce and sexual and psychological difficulties. "It all goes back to issues of control," Whitmer asserts. "They just don't have a sense of identity that can be joined with someone else in a significant higher union. They all say, 'I am my best friend' or 'My dead twin is my best friend.' They think, 'I can't really be married. It just doesn't work.' And many of them do get married and many of them stay married, but it's a very superficial, tangential relationship."

The stillbirth of his twin, and his unnatural closeness with his mother, then, rendered Elvis a hopelessly poor mate for life.

.

When Vernon returned home from Parchman in early 1939, some folks around Tupelo regarded him as a criminal, shaking their heads and remembering when he was a deacon in the church. "Back then, people were leery and they were not as forgiving," says Billy Smith. "If you were in jail, you were an outcast. Friends thought, 'It's best not to socialize, because people will think you're a lot like him.' It made it very difficult."

But Vernon also took advantage of his situation, going off with Travis fishing, shooting, and jelly beaning around while Gladys was forced to get a job at

Long's Laundry. Vernon was just "vaccinated against work," in the view of his friend Aaron Kennedy. "Never sick a day in his life, just sick of work." Gladys and Vernon fought rounds about it, and finally, she shamed him into applying to the Federal Works Project Agency, a New Deal program, where he was assigned to the Sanitation Project in Lee County. By that summer, he'd be reclassified as a skilled carpenter on the project and bring home $52 a month. His continued good behavior after Parchman resulted in another suspension—this one for ninety days in August—and the governor granted him an indefinite suspension of his sentence that November.

With such a weight off the family's shoulders, the Presleys spent a lot of time with relatives, getting together for potluck suppers, where Gladys would sometimes churn ice cream in an old-time freezer. They also made their own entertainment with after-dinner singings, or simply listening to the Grand Ole Opry on Saturday nights. Sometimes they had overnight guests, Elvis sleeping on a little pallet on the front floor with his parents, and the guests on a makeshift bed in the kitchen.

It was about this time, age four, that Elvis began to recognize a connection between music and sex, and demonstrate the sexual power that music had over him.

"I remember one night we went up to Gladys and Vernon's," Annie Presley said. "We were all sitting around singing, and Elvis was singing with us. Elvis had his little hand in his pocket, dangling his ding-a-ling. Vernon all at once just stopped singing. He could say anything and never crack a grin. So Vernon said, 'Son, if you'd just quit playing with that thing a little bit, you might could sing.' Embarrassed that kid to death! We all just hollered."

Another incident from that era shows how young Elvis linked dancing and sex.

"When he was four or five," Billy Smith reports, "my mama and Aunt Clettes were dancing together to some music. They were up on a trunk, waving their skirts around, so they were flying up. Elvis was in the room. And the more they danced, the more excited he got. He grabbed my mama by the leg. And he said, 'Oh, my peter!' Well, Gladys went wild. She yanked him up and yelled out, 'You all quit that damn dancing!' She pointed at Elvis and said, 'Look what you're doing to him!' When my mama told me that, I liked to died."

That formative memory would lead to one of Elvis's strongest sexual charges as an adult, that of two women together. And as he grew older, he would have a new name for his penis: Little Elvis.

.

In the fall of 1941, Elvis entered first grade, attending Lawhon Elementary School on Lake Street, where he would spend the first years of his education. Starting school is a huge and often traumatic step for any child, and for Elvis, it was doubly hard being separated from Gladys for most of the day, especially since Vernon had lost his Federal Works Project job and traveled throughout Mississippi, Alabama, and Tennessee on construction jobs, working mostly as a carpenter.

Elvis never really knew when his father would be home—the family was now living in a rental house on Maple Street in East Tupelo—and Vernon's absence, along with the experience of leaving his mother during school hours, bound mother and son anew. They often visited Jessie's grave together. Relatives would recall that Gladys urged and joined her young son in talking with the lost twin, a practice that originated from her daily prayer to Jessie for guidance. He became her mental embodiment of perfection, first in her mind alone, and then in Elvis's.

After such sad outings, Gladys, wanting to cheer Elvis up, often bought little treats for him and made him cakes with butter frosting. He had his special cup, glass, and eating utensils, too, and sometimes refused to use any other.

Part of it had to do with a phobia about germs, particularly about eating food that anyone else had touched. Even as an adult, Elvis would drink from the side of a coffee cup, near the handle, thinking it was cleaner, since most people drank from the middle. He routinely refused to eat if someone else reached over and got something off his plate, even if it was an immediate member of his family, as Billy Smith noted.

"Elvis used to carry a knife and fork in his back pocket because he didn't like to eat with anybody else's. He'd eat from your dishes, but not with your silverware. He didn't break that habit until he went into the army. Used to take that knife and fork to school with him. He didn't eat or drink after anybody and he didn't want you to drink after him."

Attending school and meeting new children opened Elvis up to a new world—something he desperately needed, given his insular family situation and the fact that he was a shy, dreamy child. Yet being with so many boys his age would have naturally underscored his grief in not having Jessie by his side. Sometime after Elvis started school, but before he was old enough to know the facts of life, Gladys inadvertently pulled a cruel trick on him, perhaps not realizing how it would affect him.

Barbara Hearn, who dated Elvis during his early fame, first became a family

friend when the Presleys lived on Alabama Street in Memphis. She and Gladys found an easy friendship, sitting and talking. "If you were shelling peas or something, you'd get into some pretty deep conversation," she relates. One day Gladys told her about the time in Tupelo when she was sick and the doctor paid a house call.

"Elvis saw the doctor leaving, and he came running into her bedroom, saying, 'What's the matter? What's the matter?' Gladys had doubled a pillow up and put a blanket around it, and she said, 'Oh, Elvis, come and look what the doctor's left!' It looked just like a baby lying there, and he was so happy. He broke out in a big smile and ran over there, but when he saw that she was playing a joke on him, he was so disappointed and angry. It made him furious, because he really thought there had been a baby. She probably wouldn't have done it if she had thought about it a while, particularly after she saw how upset he got. I'm sure she was sorry afterward."

· · · · · ·

By 1943, Vernon was working hard to stabilize his family's finances and to establish himself as a worthy citizen after his incarceration at Parchman. He continued to travel to find work—moving the whole family to the Mississippi Gulf Coast town of Pascagoula that May, where he and his cousin Sales Presley, Annie's husband, signed on at the Moss Point Shipyard. But by the end of June, all the Presleys were homesick and returned to Tupelo. Vernon found a job as a driver for L. P. McCarty and Sons, a wholesale grocer, and the family continued to enjoy what must have seemed like prosperity, compared to so many other stressful periods of their lives.

The following year, Elvis started fourth grade at Lawhon Elementary. It was a significant time in the young boy's life, as it was probably this year that he "courted" his first real girlfriend, Elois Bedford. (Caroline Ballard had earlier won his heart, but the "relationship" was short-lived.) After Elvis became famous, Elois would forget precisely when their "romance" started, but she never forgot his smile, more a perpetual silly grin than anything else. "I can close my eyes now and still see him walking toward me," she said in the early 1990s. "I picked him out of all the boys. He picked me out of all the other girls. As far as dating, we didn't. We were too young."

Theirs was a typical interaction for children of their age—they wrote notes to each other in class, called each other "boyfriend" and "girlfriend," and spent time together at various events, particularly the Halloween carnival, where they

entered the cakewalk. Elois remembered him as a loner—quiet and well mannered, wearing "very common clothes," either overalls or khaki pants and shirt, but always clean. Elvis was already starting to distinguish himself with his singing.

"What I remember most about him was his singing in chapel [at school]. I can still see him singing 'Old Shep.' It was so pretty. He had such a beautiful voice back then. I remember our fourth grade teacher, Mrs. Dillard, saying, 'One of these days he is going to be on the radio.'"

"Old Shep," Red Foley's mournful story of a boy and his dog, was the kind of tearjerker that made up the backbone of country music of the era. But the tragic saga would have strongly resonated with a child who had experienced his own painful loss, and Elvis's friend Becky Martin recalled that he imbued it with such emotion that some of his schoolmates cried when he sang it.

Elvis was still stuck on the song the following year, impressing his fifth grade teacher, Mrs. Oleta Grimes, the daughter of Orville Bean, who was once more doing business with Vernon, having just sold him a new four-room house on East Tupelo's Berry Street. Mrs. Grimes found Elvis to be such a promising singer ("He sang so sweetly") that she took him to the school principal, J. D. Cole, who agreed with her—the boy had talent. Mrs. Grimes spoke with Gladys, and they agreed to enter Elvis in the talent contest on Children's Day at the annual Mississippi–Alabama Fair and Dairy Show at the Fairgrounds. The first-place winner would receive a trophy and a $25 war bond, and even the runners-up could go home with a smaller trophy, or at least $2.50 worth of fair rides. Ten-year-old Elvis, wearing eyeglasses, a necktie, and suspenders to hold up his pants, climbed up on a chair for yet another a cappella rendition of "Old Shep."

For decades, the story circulated that Elvis won second place, but in fact, he did not. Nor did he win third or fourth, but rather fifth. Shirley Gillentine, who belted out "My Dreams Are Getting Better All the Time," secured first place. And Nubin Payne, who wrote her own song, "Someday," and accompanied herself on guitar, came in second. A rare photograph shows Shirley holding the largest trophy, Nubin the second largest trophy, and Hugh Jeffries, an East Tupelo boy who played the Hawaiian guitar, the third-place prize. Elvis, a defeated look on his brow, stands empty-handed.

Elois Bedford was proud of him all the same. But later that year, another girl captured Elvis's attention, and now he had to break the news. "I was just about to get on the school bus and go home that afternoon," Elois remembered, "and Elvis handed me a note."

It was short but not sweet, saying only: *I have found another girl.*

"Her name was Magdalene Morgan," Elois continued. "I lost him that day."

The event was meaningful in the larger scheme of things—moving from Elois to Magdalene was perhaps the last time Elvis limited himself to sequential girlfriends. In years to come, and especially once his recording career caught fire, his love interests would be both many and concurrent. This was behavior he learned from both his grandfather, J.D., and to some extent Vernon.

Maggie Morgan was a far more important figure in Elvis's life than Elois Bedford, as their interest in each other spanned several years and ran deeper on every level. And although neither of them could have known it at the time, Maggie was an archetype for so many women to come: She was a stand-in for Gladys.

With dark hair and eyes, and standing a good three inches taller than her new beau, Maggie had known Elvis since the third grade at Lawhon Elementary. But it was at the Assembly of God church that her infatuation simmered. Already the church pianist by eight or nine, she played behind the budding singer as he performed the old hymns—"Amazing Grace," "The Old Rugged Cross." Vernon and Gladys did not attend church regularly, Aaron Kennedy said years later, and no one could depend on them to take a lead there. But Elvis and Maggie rode the church bus together as Christ Ambassadors—a youth group that traveled the nearby towns of Saltillo, Corinth, and Priceville. And the two were paired off together in the Christmas pageants, Elvis playing Joseph to her Mary.

Gladys and Maggie's mother were friends as well, and the women visited in each other's homes. During such times, Elvis and Maggie would sneak out of the house together to be alone.

"We would walk in the woods and hold hands and talk, dream aloud about the future and what we wanted to be. Elvis always wanted to be a singer. That was his dream even then. And he always said [the girl] he would marry would have to be a lot like his mother."

On one visit, Elvis and Maggie ventured out into the woods behind his house, and Elvis carved a heart into the side of a tree, carefully cutting out their initials and the words LOVE FOREVER beneath them. Later, he did the same thing on a stack of lumber. The two had an understanding—they were sweethearts and belonged to each other, and as Maggie remembers, "We were so close at that time I just thought we would always be together."

Elvis didn't precisely say the same, since he wasn't much of a talker. At school, in fact, he stood out only for being an especially giving child who wanted to please. His grades weren't remarkable—arithmetic and geography, especially, proved nearly fatal. And his features had not yet formed into a handsome face,

his high cheekbones, part of his Indian ancestry, just barely discernible, and his hooded eyelids looking more droopy than dreamy. It was only when he turned to music that he seemed to shine. In Maggie's view, he was just a nice polite boy, her "ideal guy."

With boys, Elvis wasn't as restrained. On Berry Street, he played with the son of Lether Gable, Vernon's partner in crime in the check-forging caper, who was now the Presleys' next-door neighbor. The boys were wrestling one day, getting rougher than they intended, when Elvis somehow snapped his playmate's hip. He felt terrible about it and, according to Annie Presley, "went and sat with him every day and visited while he was laid up." And while he didn't play hooky, sass his parents, or talk back to his teachers, "Elvis was a lot like his daddy in one respect," his cousin Bobby Roberts offered. "Both of them were always joking." The company of men and boys, sitting around and telling stories, relaxed him.

"One night one of his uncles was visiting, and he was telling us never to mess with women, that women would eat you up like blue cheese, or something like that. When he said that, Elvis fell on the floor laughing. He got a big kick out of that."

Still, most of his friends were females, like Becky Martin or Barbara Spencer, and he didn't mind babysitting for his relatives' children, toting them on his hip the way a girl might do. Gladys remained his whole world, as his role model, friend, companion, and protector. "I could wake her up any hour of the night," Elvis said in 1958, "and if I was worried or troubled by something, well, she'd get up and try to help me."

For too many years, she walked him to school every day, and legend has it she continued such hovering behavior long after Elvis was old enough to walk on his own, or with other children his age. Annie Presley dispelled that, insisting, "She didn't walk him to school. She'd walk him to the highway and see him across, and then she'd come back home. Lots of evenings, we'd just sit on our porch and watch for 'em and see 'em get close to the highway. Then one of us would go and see 'em across the road."

Oleta Grimes, Elvis's fifth grade teacher and a neighbor to the Presleys, also refuted the myth that Gladys accompanied Elvis to school, both at Lawhon Elementary, and later at Milam Junior High.

"Being a neighbor," she told author Bill Burk in 1991, "I walked with the children, and I don't remember Mrs. Presley walking Elvis to or from school, particularly during the fifth grade. He and the others walked with me most days."

However, Gladys still watched her son like a hawk, even when he was play-

ing with other children. Many of them, like first cousin Harold Loyd, who lived with the Presleys for a while in East Tupelo, feared her and nearly prayed that nothing would happen to Elvis while they were together.

"I always played with Elvis real gentle when he was a kid, 'cause I knew how Gladys was. Many times I heard him say, 'Mama, can I go out and play?' And she would say, 'Yeah, you can go out and play in the yard, but don't you get too far away that you can't hear me if I call you.' The rest of us would wander off, go down in the bottom, and go swimming in the channel, all except Elvis. He couldn't do that. He had to stay right there close to the house."

"My mama never let me out of her sight," Elvis confirmed in 1965. "I couldn't go down to the creek with the other kids. Sometimes when I was little, I used to run off. Mama would whip me, and I thought she didn't love me."

Eventually Gladys loosened the reins enough that Elvis and his friend James Ausborn could go to Tulip Creek to fish and swim.

For the most part, Elvis chose devotion to Gladys over popularity with his peers. But occasionally he would challenge her in larger ways, either because the pull of joining in with the others got the best of him, or because he desperately needed to find and prove his own identity. His cousin Bobby Roberts recalled Gladys would tell Bobby not to let Elvis climb a tree, "But he'd climb the tree anyhow, just like all boys do. He would climb right to the top of the tallest tree. She was always worried about him falling and hurting himself."

Elvis also held his own in fistfights as he grew older, knowing the other kids would run over him if he didn't risk the occasional black eye or a bloody nose. Even that proved problematic with a mother like Gladys, reported playmate Odell Clark.

"I remember some folks next door jumped on Elvis one day, and Gladys wore two or three of them out with her brush broom—parents and all."

It was not an isolated incident. Another time, remembered Christine Roberts Presley, Elvis's great-aunt and the wife of J.D.'s brother Noah Presley, Gladys got a stick after a child who came to play. "He said something about Elvis, and boy, Gladys picked up a broomstick. That boy ran and hid. She said, 'You come out of there, or I'll whip you 'til you can't even walk!'"

Yet Gladys would also discipline her son. His friend Guy Harris remembers the day he and Elvis decided to dig up some wild rosebushes, getting sunburned in the process. "We got sun-blistered pretty bad. She fixed our lunch, and Elvis

claimed he was too blistered to eat. He was trying to stay outside and away from her as much as he could, 'cause he didn't want the old switch."

"I used to get very angry at her when I was growing up," the adult Elvis admitted. "It's a natural thing when a young person wants to go somewhere or do something and your mother won't let you. You think, 'Why, what's wrong with you?' But then later on in the years you find out that she was right—that she was only doing it to protect you, to keep you from getting in any trouble or getting hurt. And I'm very happy that she was kind of strict on me, very happy that it worked out the way it did."

· · · · · ·

On January 8, 1946, Elvis's eleventh birthday, Gladys accompanied her son to the Tupelo Hardware Store to buy him a present. Memories conflict as to just what he picked out—some say a bicycle—but evidence points to a .22-caliber rifle, which he wanted more for target practice than for shooting animals. Once when Vernon had offered to take him hunting, a southern rite of father-son bonding, Elvis begged off. "Daddy," he said, "I don't want to kill birds."

Now Gladys turned to the salesman, Forrest Bobo, who lived in East Tupelo and knew the Presley family.

"Is this a dangerous thing?" Gladys asked.

"Sure, it's dangerous. It's a twenty-two. You could kill somebody with it, or you could get killed by it."

And so, only a few months after Elvis's competition at the Tupelo Fair, Gladys tried a different tack.

"Son," she suggested, "wouldn't you rather have a guitar? It would help you with your singing, and everyone does enjoy hearing you sing."

According to Billy Booth, who owned the store and heard the story directly from Bobo, Elvis threw a temper tantrum—he didn't want a guitar. He wanted a rifle. Gladys threatened a spanking for such a public scene, and then she told him he'd get nothing for his birthday if he didn't straighten up. Bobo, by his account, went back and brought out a midgrade guitar that Elvis would later identify as a Gene Autry model.

"The papers always said it was $12, but it wasn't—you got a real good guitar back in those days for $12—but this was only $7.75, I believe. Of course, we had a two-cent sales tax."

Bobo handed it to him, and then took Elvis behind the counter and sat him

down on a shell box. Elvis tried to pick out "Old Shep" and reckoned he would have it after all.

"He got the bike, too, later on," Billy Smith remembers. "Then he wrecked it and broke his arm, so he couldn't play the guitar for a while." He also got a rifle, though it had probably been grandfather Jessie's to start with, as the initials JD were carved on the stock. But Elvis took full ownership, carving his own initials, EAP, as well as the name of a mysterious young lass: JUDY.

· · · · · ·

*After Elvis became famous, numerous people around Tupelo took credit for teach-*ing him the guitar, including his uncle Johnny Smith and Hubert Tipton and Hubert's brother, Ernest. Reverend Frank Smith, the new pastor at the Assembly of God church, recalled that Elvis already had a lesson book to show him where to put his fingers between the frets to form the chords. "From there," the minis-ter said, "I taught him to make his runs."

In contrast to Gaines Mansell, "a real humble type of seller who just tried to lead you to God, but didn't try to make you do nothing," as Annie Presley put it, Reverend Smith was outspoken in his belief of the twin poles of sin and salvation. And one thing Elvis did not learn from Smith or anyone else connected with the Assembly of God church, the pastor emphasized, was his sexually suggestive stage moves. "We had some body movements, very outgoing demonstrations, but noth-ing like what Elvis did. He did all that himself. He never copied anyone."

The statement was not precisely true, though Reverend Smith might not have known it. Elvis would have a number of influences, starting in July 1946, when Vernon, who struggled to make the payments on the Berry Street house, was forced to deed it over to his friend Aaron Kennedy. It was then that the Presleys moved from East Tupelo into Tupelo proper.

At first they settled on Commerce Street but then moved to Mulberry Alley, a tiny lane that ran near the Fairgrounds, the railroad tracks, the city dump, and—of incalculable importance to Elvis's musical development—the black neighborhood of Shake Rag. Just as the whites divided their social strata by Highway 78, there was a similar split in the black section of Tupelo. The pros-perous blacks dwelled "on the hill," reports Roy Turner, while the rowdier, less fortunate lived "across the tracks," in Shake Rag.

The sounds that young Elvis heard coming from the black porches—the wails, the bent notes, the low king snake moans of the blues, and the high-pitched

gospel hosannas—meshed to form half of the bedrock of his musical education. But the nasal whines of Nashville's Grand Ole Opry and of local country singer Mississippi Slim on radio station WELO also found a place in Elvis's heart, especially as Slim, aka Carvel Lee Ausborn, whose music bridged the blue yodel of Jimmie Rodgers and the honky-tonk of Ernest Tubb, had encouraged Elvis's own singing. He studied him, along with Roy Acuff, Hank Snow, and early crooner Gene Austin.

About that time, Mertice Finley Collins remembered, "Elvis would pick up and sing in front of the Tupelo Hotel, which was almost across from the radio station on South Spring Street. People would give him five cents, ten cents, or sometimes a twenty-five-cent piece. When he got a quarter, he would run down to the laundry where his mother worked and give the quarter to her, then hurry back to the hotel."

The idea of making money from music, particularly so his mother wouldn't have to work, became the engine of his dreams.

"Elvis's biggest fantasy in Tupelo was to one day be big enough to have his own radio show on Saturday mornings on WELO, just like his idol Mississippi Slim," said Bill Burk, who covered Elvis's career for the Memphis *Press-Scimitar* and wrote extensively of Elvis's roots in Mississippi.

But the records of the black Sister Rosetta Tharpe, who took the Lord's songs from the choir and congregation to the nightclubs and cabarets, enchanted Elvis in a different way. It was Tharpe, with her sharp talk about "backsliding," or sinning, and the calculated way she used her guitar that particularly ignited young Elvis.

Whether playing single-note solos as deftly as any male, or wielding the instrument as a prop, she used the guitar both as an extension of herself and as a vehicle for sexual innuendo ("Come on, daddy . . . plug me in," she said once electric guitars became the vogue). Outrageous in every way, a spiritual cousin to Elvis's future manager Colonel Tom Parker, she hawked perfume and stockings as well as records, and charged admission to her wedding. Musically, she also pioneered—crossing the lines from gospel to blues, to jazz to boogie, to big band to country—and she did it all with greasy aplomb.

"She would dye her hair flame-red, giving her the onstage appearance of a constantly exploding corona or a halo from hell," Peter O. Whitmer wrote. "She would wear blue jeans and high heels, or wrap herself in fur boas and billowing caravan robes. And whenever she took the stage, she carried her guitar, slung over her shoulder, and perfected a style of bending notes and phrasing words that was inimitable."

This original soul sister was, in short, Elvis's most important musical role model, as influential for her personal style as for her genre-bending sound, her appearance setting up an androgynous ideal in a young boy's heart.

.

In September 1946, Elvis entered the sixth grade at a new school, Milam Junior High. His classmates remember him as an odd boy in overalls who didn't fit in anywhere, not with the "in" group with money, or even the "out" group, which was poor. The girls considered him crazy because he flirted with nearly all of them, particularly Carolyn Brewer, whom he nominated for the "Most Beautiful" contest. Elvis was such a pest in that regard that some of the girls starting leaving home early for school to try to avoid seeing him on the street, and pleaded with their sixth grade teacher, Mrs. Camp, to make him behave. "Anyone wishing to provoke a little girl to tears of rage had only to chalk 'Elvis loves—' and then the girl's name on the blackboard when the teacher was out of the room," Elaine Dundy wrote. "The very idea that this goof, this clodhopper, would single you out for his affection was intolerable."

Yet again, Elvis stood out for his passion for music, whether it was hymns or hillbilly tunes. Maude Dean Christian remembered that the teachers closed the door and all the windows when he sang, even during the hot months, so the other kids wouldn't hear him playing guitar and want to come and listen. He trotted out "Old Shep," of course, and performed it so often that it got to be something of a joke. When he'd take his place in front of the group for the morning prayer program, several of his classmates would yell out, "Oh, no! Not another round of 'Old Shep' today!" Still, he persisted. At recess, classmate Shirley Lumpkin noticed, he would go out to the bicycle shed and sit and pick the guitar, almost always by himself. Elvis knew he was powerful only when he sang, and that he would have to win over tough audiences in the future if he was really going to be a singer.

The family was experiencing a number of changes, and few of them good. By 1942 Elvis's grandfather, J. D. Presley, had deserted his wife, the flinty Minnie Mae, going first to Mobile, Alabama, and then settling in Louisville, Kentucky. Now, four years later, he filed for divorce, claiming Minnie Mae had deserted *him* in the fall of 1942, and that he'd begged her to join him in Louisville, where he worked primarily as a carpenter.

Minnie Mae refused to take it lying down and answered the divorce petition with a letter written in longhand.

Dear Sirs:

I am writing to you about the letter I received from you last week concerning a divorce. I didn't desert my husband. As a matter of fact, he deserted me, and has been living with another woman and he hasn't sent me any money in over a year, and I am not able to make a living. We have five children and they are all married and have families of their own, and I have to depend on them for a living. I want you to send me the Papers to fill out and if you want my husband's record, you can write to the Chief of Police Elsie Carr of Tupelo, Miss.

Sincerely yours,
Mrs. Jessie Presley

Two months later, their daughter, Delta Mae Biggs, took exception with Jessie's petition in equity, and wrote a letter of her own in scrawled penmanship.

Dear Sir:

I am writing in behalf of Mrs. Minnie Mae Pressely [sic], which is also my mother. Tell Pressley [sic] he can have a divorce if he will give Mama $200 cash. She won't ask for alimony. If he doesn't want to do that she will not give him a divorce. He told a falsehood about several matters to you. He has (5) children not (3). He also deserted Mama.

Thanks,
Delta Mae Biggs

When the divorce became final in 1948, Jessie seemed to reform. He stopped drinking, became active in his Baptist church, building the pulpit there, and married a retired schoolteacher, Vera Kinnard Leftwich, with whom he'd live the rest of his days. His stepgranddaughter, Iris Sermon Leftwich, considered them a good match. "They used to play little tricks on each other, and had a lot of fun. They each brought out the youth in the other." Jessie and Minnie Mae stayed at loggerheads—she never called him by name, only "that son of a bitch"—but he mended his relationship with Vernon, who kept in touch by phone and letter, and visited with him on numerous occasions, especially during Jessie's illnesses.

Once Elvis's career took off, he, too, resumed relations with J.D., and the

two exchanged birthday cards and notes. During a trip to Louisville for an ap-
pearance in 1956, Elvis bought his grandfather a snazzy new two-tone Ford
Fairlane and a television, and peeled off a crisp $100 bill to go with them.

Jessie, liking a taste of fame, made a three-song record of his own, "The
Roots of Elvis," and in 1958, he won a spot on the television show *I've Got a Se-
cret.* There, the sixty-two-year-old, seated in a rocking chair, sang "The Billy
Goat Song" in a high, thin tenor as host Garry Moore backed him on drums.
The elder Presley, who would last work as a night watchman at the Louisville
Pepsi-Cola plant, told a Toronto newspaper reporter that he didn't like rock and
roll, preferring the religious and working songs he learned picking cotton in
Mississippi. And no, he didn't want Elvis to help him. "I want to make it on my
own," he said. Elvis was amused, and the two remained friendly until J.D.'s
death from heart disease in 1973.

Jessie's desertion meant that Minnie Mae had nowhere to go but to her chil-
dren. By 1946 she was living with Vernon, Gladys, and Elvis, whom she adored.
The feeling was mutual. With her dry wit, laconic manner, and elongated body,
she resembled, if not a James Agee character, then certainly a Walker Evans
Depression-era photograph come to life. Gladys was glad to have her help ("She
did all the work," in Lillian Smith's view), and Elvis found her a comical figure.

One day he was playing ball and overthrew his pitch, missing her face by a
fraction of an inch. He promptly nicknamed her "Dodger," a term of endear-
ment that stuck throughout her life. The living arrangement also took hold.
Vernon counted her a dependent on his 1947 tax return, and she never left the
Presley household again. Minnie Mae would reside under the same roof as Elvis
all her life and outlive her famous grandson by three years.

· · · · · ·

By the time Elvis entered seventh grade in 1947, his mind was seldom on his stud-
ies. His grade point average was about 70, making him a C– student. But the
twelve-year-old felt confident enough about his musicianship to take his guitar to
school with him almost every day, practicing chords and working on new songs
during lunch. Classmate Roland Tindall remembered that he announced to the
class more than once that he was going to sing at the Grand Ole Opry. If the ma-
jority of his fellow students ignored him or smirked at his bid for attention—a
group of bullies, intolerant of another rendition of "Old Shep," would cut the
strings off his guitar at some point—others knew he had a shot at stardom.

"Most people wouldn't believe this," a classmate said years later, "but I went

up to him and I told him, 'Elvis, one of these days you're gonna be famous.' And he smiled at me and said, 'I sure hope so.'"

Maggie Morgan also supported his ambition. She'd gone with him to perform on WELO, where he still gazed motionless at hillbilly singer Mississippi Slim, and as far as she was concerned, theirs was a serious relationship. He'd told her he loved her, and she'd whispered back, "I love you, too." And they'd shared three kisses—one during the carving of the heart on the tree, another on the swing on his parents' front porch, and the third in the car en route to a church rally.

"I didn't expect my life to end or go anywhere without Elvis. He was my love. He was my man."

But if things were going well for the young couple, Vernon Presley was just about at the end of his rope. Living in a "colored" neighborhood on Tupelo's North Green Street, where Elvis heard early R & B, jump blues, and swing tunes throbbing through the walls at the nearby juke joints, the family was deeply in debt. Vernon was still driving a grocery truck and scraping to make a living ("There's a story that he pretty much got kicked out of Tupelo for moonshining," says Billy Smith), and Gladys brought in a little money as a seamstress. But the bank was threatening to foreclose on a loan, and the Presleys were buying everything on time and borrowing money where they could. Gladys remembered her son's concern.

"Elvis would hear us worrying about our debts, and he'd say, 'Don't you worry none, baby. When I grow up, I'm going to buy you a fine house, and pay everything you owe at the grocery store, and get two Cadillacs—one for you and Daddy, and one for me.'"

Vernon and Travis Smith had already gone to Memphis scouting for work, returning after three weeks with no prospects. Now they decided to try again, Vernon saying, "There has to be more than this."

In the fall of 1948, when Elvis was thirteen, the Presley and the Smith families packed everything they owned into Travis's eleven-year-old green Plymouth and left overnight for Memphis to start life anew.

Maggie hadn't seen Elvis since he moved to Green Street, but she was shattered at the news.

"It broke my heart when the Presleys announced they were moving to Memphis. For a long time after that, I cried. I missed [Elvis] so much. I even kept missing him after I got married and had children. I know in my heart we would have gotten married. We were very young, but we were very much in love."

Secretly Elvis, too, fantasized about their future. In 1994 his estate auctioned

Vernon and Gladys's marriage license, and on the back, in a child's hand, was a testimony to a mock marriage between Elvis Presley and "Magdline" Morgan. Elvis's signature, in pencil, was authentic, though Maggie's was not. Elvis, who had never learned to correctly spell his beloved's name, had scrawled it all out in a grand romantic gesture on September 11, 1948, just as the family was preparing to leave Mississippi. Before he signed his next marriage license, nearly twenty years later, Elvis would become far more callous about romance.

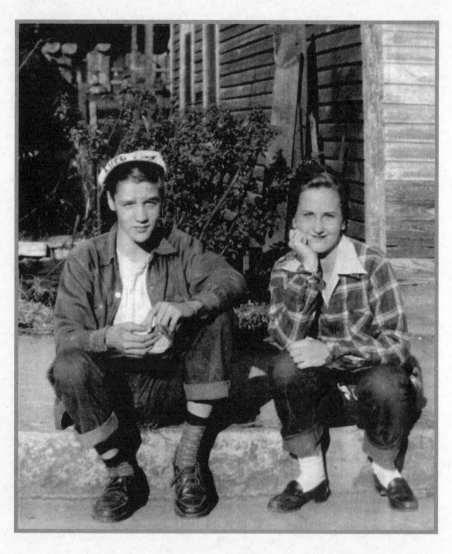

Elvis and Betty Ann McMahan, Lauderdale Courts, circa 1949. Gladys introduced them through her mother. She broke his heart in choosing an Arkansas boy over him. *(Margaret Cranfill/from the author's collection)*

THREE

· · · · · · · · · · · · · · · ·

Blue Heartache

With a population of 237,000, Memphis was the largest city in the mid-South, and a serendipitous destination for the Presley family. King Cotton had built this town from the lazy banks of the Mississippi River, but in the post–World War II years, Memphis looked like a country boy in his first zoot suit, as urban and rural cultures came together to bolster the city as a regional hub of commerce and culture, and to move it from an agricultural to an industrial mecca.

Though middle-class jobs were not yet plentiful, opportunity crackled in the air, as if change itself were a seed in the fertile Mississippi Delta. And the mere size of the city meant that an ex-con like Vernon could reinvent himself with new friends and employers, and perhaps even with his wife. Gladys was so energized by the move that she seemed to enjoy her husband's advances, an early friend of Elvis remembering that Vernon "was always hugging her and kissing her and showing her affection. He could never keep his hands off her."

For Elvis, thirteen and just coming into puberty, everything was exciting and new. Still burning with the fire to be a singer, he was exhilarated to find himself smack in the home of the blues, historically a woeful or triumphal form of musical salvation, summoned in the cries and the catharsis of the worried and the worn-down. Before long, he would be poking around on Beale Street, staring at the photographs in the window of the Blue Light Studio, his ears tuned to the music—solo guitarists, wailing vocalists, harmonica players, or maybe just guitar and drum groups—pouring out of the smoky clubs. Music was everywhere on Beale Street. Men even played saxophone in the park.

Sometimes he'd meander over to North Main, every now and then summoning the courage to walk into the Green Owl, a black beer joint, where people

spilled out onto the sidewalk on weekend nights. Elvis was wide-eyed at the city slickers and the pimped-up dandies in their bright Lansky Brothers clothes, and even more so at the women whose illegal turns helped buy them. He was also enthralled by the musicians, slack-jawed blacks who played with their eyes closed, a cigarette or something stronger tugging at the corners of their lips. And he especially got a kick out of the guy who made a bass out of a five-gallon bucket and a broom handle. Though he was too young to be in there, it was worth a rough little reprimand to hear the wild, wanton sounds of the blue notes, and to feel his own libido ripple down below.

When they first arrived in the Bluff City, the Presleys (Vernon, Gladys, Elvis, Minnie Mae) and the Smiths (Travis, Lorraine, Bobby, Billy) stuck together like immigrants in a new land, clutching their few belongings, fearful of the loud sounds of the city, and straining their ears at the oddity of the new language. Elvis had been there before on Noah Presley's bus trips to the zoo and for picnics and concerts at the Overton Park Shell. But in a sense they were all just that, strangers in a strange land. Memphis was only ninety miles northwest of Tupelo, but it might as well have been a thousand.

Pooling their resources—Travis had sold two cows and killed a hog to get just over a hundred dollars—the families found lodging in a cheap wooden rooming house at 370 Washington Street in north Memphis in the Pinchgut district, a haven to newcomers since the Irish settled there in the 1820s, the Jews joining them in the early 1900s. The Smiths took the upstairs apartment and the Presleys the downstairs, and they shared the communal bath. Rent for each family: eleven dollars a week.

Tough and slummy, with prostitutes mixing with flatboat traders along the streets lined with delicatessens, five-and-dime stores, and brawl-house bars, the neighborhood derived its funny name from the saying that the Irish were so starved, their stomachs so taut from hunger, that you couldn't pinch any loose skin on their middles. Later, the name got shortened to "Pinch."

Billy Smith, eight years younger than Elvis, remembers that the situation was nearly as dire for the Presleys and the Smiths when the families settled in. "Daddy and Vernon spent weeks looking for work. They had to put cardboard in their shoes to cover the holes." For months, it seemed, they survived on turnip greens, seasoned with part of the salt pork from the slaughtered hog. Then five-year-old Billy discovered that the produce stand next door threw rotting fruit and vegetables into the trash cans each night.

"I remember going through there and finding bruised bananas to eat. When

you're that poor, you scavenge for what you can get. Elvis loved to tell about the time I fell into one of the fifty-five-gallon trash cans. I was so little that he had to pick me up by my legs and pull me out. But I wasn't turnin' a-loose of them damn bananas."

For a while, the families pondered moving back to Mississippi. But then both Vernon and Travis found employment at the Precision Tool Company on Kansas Street in south Memphis. (Soon Elvis's uncle Johnny Smith moved up from Tupelo and was hired there, too.) And Gladys, calling on her seamstress skills, took a part-time job in a drapery factory, Lorraine finding work at a laundry.

Precisely when Elvis started going to school in Memphis is open to question. Gladys's sister, Lillian, said he attended the Christine School for a short while, though there is no evidence to support it. What is known is that on November 8, 1948, Elvis Aaron Presley enrolled in the eighth grade at L. C. Humes High School, a traditionally white institution in a rough neighborhood in a mostly segregated city. It already had a bad reputation. Vernon walked him to school that first day and was astonished to see his son back home shortly after, "so nervous he was bug-eyed," as Vernon put it. But he soon adjusted. Records show he was present 165 days that year, and absent 15, but never tardy. His grades improved from Tupelo, Elvis bringing home an A in language; a B in spelling, history, and physical education; and a C in arithmetic, science, and music.

The C in music would have pierced his ego. Elvis seemed more reticent about performing in public once the family moved to Memphis, perhaps because the town was full of music, a Mississippi blues man on every corner, a tip jar at his feet. Even at home, he insisted that the lights be off so nobody could see him when he practiced his guitar. "I was ashamed to sing in front of anybody except my mother and daddy," Elvis would say in 1956. He never did learn much more than a few major chords and a couple of easy runs, but they did the trick, and he could beat on the guitar with the meat of his palm for a percussive sound.

He was trying different songs now, Kay Starr's pop ballad "Harbor Lights" and "Molly, Darling," a hillbilly number made popular by Eddy Arnold, whose career was taking flight under the guidance of his new manager, a former carny who went by the name of Colonel Tom Parker. Sometimes at night, Elvis would take his guitar outside to see how it all sounded in the evening air, and Vernon and Gladys would spread an old quilt down on the ground so they could sit and listen, even though Elvis's voice, quavering slightly, seldom rose above a whisper.

In spring 1949 both the Presley and Smith families were still struggling financially. Vernon applied for public housing and left Precision Tool for a job at United Paint Company, which was closer to home. "He stayed there longer than

anywhere," says Billy Smith. "Usually, he'd get a couple of paychecks, and that would be about it." At the time, with everybody working, the two families made a combined total of about $120 a week, Vernon bringing home $40.38 at 85 cents per hour. The Presleys and the Smiths soon split up for nearby rooming houses, one on Adams and the other on Poplar. But with no one else to depend on, the family held tight. Soon they would welcome Gladys's sister Levalle and her husband, Edward Smith, and their children, Junior and Gene, up from Mississippi.

In June 1949 Jane Richardson, a home service adviser for the Memphis Housing Authority, followed up on Vernon's application and visited the Presleys' rented room, for which they paid $9.50 a week. With Vernon at work, Miss Richardson met with Gladys and Elvis, noting that the family shared a bathroom with other residents and cooked on a hot plate. Miss Richardson went back to her office and wrote her report, indicating that the Presleys' application had merit. She added that Mrs. Presley and her son seemed "very nice and deserving." That November, they moved into Lauderdale Courts, right around the corner from where they were living, and paid thirty-five dollars a month for a two-bedroom, first-floor unit at 185 Winchester Street. With 689 square feet, apartment 328 had a living room, bathroom, and walk-in kitchen.

Residents were expected to keep the apartments clean, and inspectors came around once a month to make sure of that, and to see that no one had accumulated too many material goods, as any sign of affluence would put them at risk for eviction. Lauderdale Courts, consisting of sixty-six red brick buildings on twenty-two acres, was one of the first U.S. housing projects, and most occupants felt fortunate to be there, even as they hoped not to stay. Its motto: "From slums to public housing to private ownership."

Billy Smith saw how thrilled Gladys was with the place. "I have this vivid memory of going over to Lauderdale Courts one summer when Elvis was at Humes. They were playing music, and Gladys was dancing and they were having a ball. She was always jolly then, always laughing and carrying on."

The Presleys were one of seventeen new families who moved into the Courts around that time, though they differed in that most were single-parent households. Elvis, at fourteen, began quietly making new contacts, playing guitar with a group of older boys under the trees at Market Mall, the path that bisected the housing development. For the most part, he stayed in the background, watching and listening to see what he could pick up from the more experienced musicians, and then went home and sat on his bedroom windowsill and practiced, sometimes going down to the basement laundry room so no one would hear him.

He was making personal friends, too, especially with three other boys from the Courts about his age—Buzzy Forbess, Paul Dougher, and Farley Guy. The trio became so close that they were seemingly inseparable, but it was Buzzy, and not George Klein or Red West, who become Elvis's best friend during his years at Humes. They banded together to do odd jobs, cutting grass with a push mower and a hand sickle for two dollars a yard, and walked up on Main Street to the movies at the Suzore No. 2 or the Rialto out on Jackson. ("Man, we really liked Victor Mature in *Samson and Delilah*," Buzzy remembered.)

Sometimes they played pool at the Odd Fellows Hall, Elvis liking eight ball and rotation. Mostly, they played corkball with a cut-off broom or mop handle, adhesive tape wrapped around a simple cork to serve as a ball. One day, Farley spit on the corkball stick, trying to emulate Buzzy's habit of spitting through his teeth. Elvis didn't see him—didn't realize what he was doing—though when he picked up the stick he instantly realized what was on it. By his teen years, Elvis had developed a hair-trigger temper, and in a second, he had Farley in the air.

"I grabbed a peach soda bottle on the way up," says Farley. "I told him, 'Elvis, if you don't put me down, I'm going to crown you with this bottle!'"

Suddenly, all hell broke loose, Gladys shouting out of her window, and Farley's mother, too. Elvis hauled off and hit Farley hard, and as his little sister, Doris, remembers it, "Farley said, 'Okay, you've hit me. Now it's my time to hit you.' And Mrs. Presley came running out there yelling, 'Don't hit my boy!' Later that day, she told my mother, 'We can't have Farley going around hitting my boy,' but my mother told Mrs. Presley that boys would be boys and it was best if grown-ups did not get involved. She was one domineering woman."

Elvis and Farley shook hands and were friends again, but Elvis was gaining a reputation as a boy who could take care of himself. When one of his uncles got in trouble in a bar, it was Elvis he called. And once when Humes played a rival school, Treadwell, Elvis coldcocked a Treadwell player who cursed the Humes coach, "knocking him all the way back into the bus," as Buzzy recalls.

It was a way for him to work off steam and deal with the hormonal pull of puberty, if not to distance himself from Gladys. Now that they lived in the big city, she wanted to walk Elvis to school again, fearing for him when he crossed the street by himself. For a little while, she simply followed him, darting behind bushes so Elvis wouldn't see her.

Sometimes at night, in foreshadowing how the adult Elvis would interact with his entourage, the boys played tag on their bikes, Buzzy remembering that they raced at one another full force. ("It's a wonder we didn't get killed.") If they

could scrape together ten cents, they went swimming at Malone Pool. But Elvis liked to save his money for pinball at a beer joint up at Third and Jackson, or for special occasions like the Cotton Carnival. Once they saw burlesque entertainer Gypsy Rose Lee there, Elvis frozen in his tracks, watching as if transfixed.

Often they made their own entertainment. When his parents were out for the evening, Elvis sometimes held dances in the Presleys' apartment with a phonograph and the few records the kids had between them. Each boy pitched in twenty-five cents for himself and his date, just enough for popcorn and Cokes. "None of us was rich enough then to just have a quarter," Buzzy remembered, "so we would save all week—a nickel a day—to get up enough money to go to the dance in Elvis's apartment."

Elvis, trying to overcome his shyness, pulled out his guitar and sang—he was working on Hank Williams's "Kaw-liga"—and initially, he brought a girl from the third floor named Betty Ann McMahan, also fourteen. She was his first love in the Courts. Gladys had met her even before Elvis, through her mother. The two women struck up a conversation outside one warm evening and continued it most nights in the McMahans' lawn chairs, Betty soon sitting in. Elvis, though, was too shy to join them. "Finally one night, I guess, she just forced him to come outside and sit with us and talk," as Betty remembered it.

One day, their neighbor Margaret Cranfill took a photograph of Elvis and Betty sitting on the curb on Winchester, both of them in dungarees with the hems rolled up into neat cuffs: twins. In it, the dark-haired Betty, her arm propped up and her chin in her hand, offers a closed smile for the camera. But a melancholy Elvis looks as if Betty has just told him good-bye. And perhaps she had. Their romance ended when a boy from Arkansas stole her affections, though Elvis's attraction to women whose appearance was remarkably similar to his was to be a nearly constant feature in his future choice of companions.

In the early days of his career, Elvis told a reporter he'd gotten his heart broken in high school—a gal he thought a lot of suddenly quit seeing him. For that reason, he said, he'd had trouble allowing himself to be fond of just one girl.

Whether that was Betty McMahan or her successors, Elvis began seeing Billie Wardlaw before Betty broke up with him. Billie, Betty's next-door neighbor, moved in with her mother, Thelma, in 1950, the year she turned fourteen. She was already so tall and pretty, with her long dark hair, that before she moved from her native Sardis, Mississippi, her grandmother had warned, "Now, Billie, you better not go up there to Memphis and get pregnant and embarrass your mother!"

Billie had never even heard the word *pregnant* before and didn't know what

it meant, but when she immediately turned the heads of all the boys in the Courts, she took heed.

"All the kids kept trying to get me to leave our third-floor apartment and come down and play with them, but I would just hang out the window and talk to them. I told them the reason I couldn't come down was because I didn't have any clothes to wear. I would just keep hanging out the window and talking."

Elvis, by now fifteen, was smitten with the mysterious girl peering down from above, especially since she'd teased that she had no clothes. He'd told her his name and exchanged pleasantries ("I'm from Mississippi, too"), and after a few weeks, while the other boys waited her out, treating her like a princess in some fairy-tale tower, Elvis took matters in hand. One day Billie heard a knock on the door and opened it to find him standing there, holding something behind his back. They giggled a bit the way teenagers do, nervous in the first throes of courtship, and then Elvis shifted the package in his hands and held it out to her. "Here," he said. "I brought you something."

"I opened the package, and it was a pair of blue jeans, the first pair of blue jeans I ever had. Elvis said, 'Now you can come down and play with us.'"

Elvis's idea of "play" was the old kissing game of spin the bottle, and as the kids of the Courts numbered about thirteen, and always hung out together, the game was almost evenly split between boys and girls. Farley's little sister, the tomboy Doris, joined in, as did Luther Nall's kid sis, Jerry. She was always photographing Elvis with her little camera and had a mad crush on him, even though he thought of Jerry as his little sister, popping her with a wet towel at the pool one day and accidentally scarring her leg. When dark came and somebody suggested spin the bottle, all the girls got excited, including Billie: "Elvis was a great kisser. We always hoped the bottle would land on him!"

From the start of their relationship, Elvis was possessive. He'd had other flirtations with Jo Ann Lawhorn, and another Jo Ann over at Bickford Park, who came to some of the group parties at the Courts with him. He'd tried to get something started with Carolyn Poole at school. And he tried with Georgia Avgeris, too, throwing wadded-up gum wrappers at her in class to get her attention, but she was Greek Orthodox and not allowed to date outside her religion. Besides, his feelings for Billie were different. One day they had a spat, and she began flirting with Farley, who found himself in a tough spot: "Elvis didn't like that at all, and we had a 'discussion' over it." But it all blew over quickly.

"I think she just thought of him as a friend," Farley's sister, Doris, said. And since Elvis had a deathly crush on Billie, he enlisted Doris's help. "He was all the

time getting me to go up and knock on her door and ask her to come down. Sometimes he would take his guitar into the courtyard and sing to her under her window, sort of like a modern-day Romeo and Juliet. He was crazy about her."

Billie confirmed it years later: "We really liked each other, but I think he liked me just a little more than I liked him." Her mother worked nights some, and Elvis would come up to Billie's apartment, but she never let him in while she was alone—everybody knew who did what and when and how at the Courts. So the two just sat on the steps and talked. One night, she asked him to teach her how to play the guitar, and he brought it up and showed her where to put her fingers on the fretboard to make the chords.

Elvis tried to deepen her affection, proffering a box of cherries, and then a necklace and bracelet that Billie always suspected he'd bought for Betty and took back when they broke up. He went to great lengths. One day, Billie's little sister peered out the window and couldn't believe her eyes: "Look at that. Elvis is climbing up that sign across the street!" Billie shook her head. Why was Elvis being so silly? Her sister thought she was cruel, but Billie refused to acknowledge him. "I wanted him to grow up."

They walked to school together to save a dime, and sometimes went to the movies at the Suzores. Elvis loved the dreamy escapism of the movies, his interests maturing from watching cowboy pictures to studying Tony Curtis, with his shiny black hair and knack for winning the girls. In the fall of 1950 Elvis applied for his Social Security card, and shortly after, he and Luther Nall got night jobs as ushers at Loew's State movie theater on South Main, where they wore uniforms to work. The job promised the delicious perk of letting them see the movies free. But like all twinless twins, Elvis had a fascination with uniforms and loved wearing his usher suit. It not only gave him an air of authority, but also made him look like Luther and all the other male employees, making him feel as if he belonged to a special group.

That's one reason he joined ROTC at Humes that year, in the tenth grade. Fannie Mae Crowder, who saw him in the halls a lot, noticed, "About every time I saw him, he was wearing his ROTC uniform, as if that was all he had to wear." And Doris Guy remembered how proud he was of it, all dressed up, and how he needed to show it off, organizing all the younger kids in the Courts as his soldiers, making them march back and forth, back and forth, all around in the courtyard when he got home in the afternoons. The only drawback was that his ROTC duties sometimes cut into the time he hoped to spend with Billie.

But Billie, too, had responsibilities, working after school and on weekends at Britlings's Cafeteria, where both her mother and Gladys had also been employed,

Gladys eventually leaving that job to become a nurse's aide at St. Joseph's Hospital. Working around everybody's schedule curtailed the young couple's outings, so most of what they did was right around the Courts.

Their romance was chaste ("We were never doing anything we shouldn't have been doing," she said), even after sixteen-year-old Elvis took his driver's test in 1951 in his uncle Travis's 1940 Buick. Now that he had his license, he borrowed cars for double-dates with his cousin, Gene, or Luther, or the other guys around the Courts. He was growing up fast, getting handsome, and gaining confidence in himself. That summer, he took a job operating a spindle drill press and making rocket shells at Precision Tool, where Travis still worked. Each Friday, he came home and gave his paycheck to his father, taking out only a little for dating.

If he had any money left over, he would go to Lansky Brothers on Beale Street and buy flamboyant clothing. Gladys had always made sure that his clothes were neat and clean ("He may not have had many clothes, but what he had was nice, and pretty much up-to-date," says Billy Smith), but his interests now ran along the lines of hepcat threads—two-tone pants and shirts with crazy piping, yellow, or maybe pink.

In an era of crew cuts, he also attempted to grow sideburns and paid obsessive attention to his hair, which had darkened to a dull, pale blond in puberty. The girls at the Courts teased him about looking in the mirror all the time, and they said his hair was so long and straight that it hung down to his chin when he combed it forward. Elvis would grin and explain that's *why* he was combing it, to keep it from falling down on his face. He finally styled it into a goopy wall of rose oil tonic, Vaseline, or Royal Crown pomade, which made it all look darker. In time, building on the Tony Curtis look and the hero of his comic books, Captain Marvel, Jr., he would sculpt a perfect pompadour, which curled into a greasy ducktail at the nape of his neck.

The family was now paying forty-three dollars a month for housing at the Courts, but Vernon was out of work, claiming a bad back. He used the excuse to let Gladys and Elvis support him much of the time, and that led to strained relations between father and son, Elvis sometimes talking back to his father, but never his mother. He acted out in other ways, too, getting in trouble for skipping school to go swimming in Wolf River with Luther, and earning a paddling from school principal T. C. Brindley.

Still, in the summer of 1952, just before Elvis's senior year at Humes, Vernon staked him to a 1941 green, two-door Lincoln that Elvis and Luther found in a junk car lot. The cost: thirty-five dollars.

"My daddy was something wonderful to me," Elvis would say about the car, since it was a rarity for a high school boy to have his own wheels, especially one whose family lived in government housing. Buzzy remembers Elvis driving him to Tupelo to show him where he'd grown up, just to have something to do. He took Luther one time, too, even though the tires were so thin on the old Lincoln that Luther didn't think they'd make it down and back.

One night, Elvis drove the whole gang down to Mississippi, this time to Water Valley, where Billie's relatives lived. She "was having some kind of party down there," as Farley remembered it. But try as he did, Elvis couldn't seem to impress any of Billie's family except her mother, who told him he sang well enough to be on the radio. Elvis blushed and stammered and finally said, "Mrs. Rooker, I can't sing."

Once, the couple rode the bus to the end of the line to have dinner with Billie's older sister. Billie was embarrassed at Elvis's table manners, since he ate everything with a spoon and never touched his fork, "not then and not at any meal I had with him later." It was bizarre, she thought, and she noted that when they ate with his parents, he had a special platter, "and he wouldn't eat from anything but that platter."

The boy was odd, yes, but so many of the silly things he did seemed like kid stuff. Even though she was younger, she thought she had simply matured faster, and it bothered her. Then she began to see his temper, as on the day he spotted another boy's picture in her purse and just went wild. "He grabbed it out, and without saying anything, he threw that picture on the ground and began stomping it and grinding it into the ground with the heel of his shoe."

Billie had never seen Elvis like that, and it shocked and frightened her.

They'd been going together for a year and a half by now, and more and more, Billie found things about Elvis she didn't like, including the fact that he didn't dance. He and his friends may have held parties in the Presleys' apartment, but the truth was he *couldn't* dance, not really. He could slow dance—everybody could do that, drape yourself onto a partner and inch around in a circle—but he couldn't fast dance with a girl, and he didn't know the sophisticated dance steps for big-band music. And dancing, it turned out, was something Billie really wanted to do. After work, she and her mother walked by the USO club on Third Street on their way home, and now she began asking permission to stay at the club for a few hours and dance with the military men.

Elvis noticed her hanging out with other guys, particularly a sailor she'd met there, and he was furious. For a boy who'd gotten his first erection watching his

aunts dancing to fast music, it was all too intimate, a betrayal of the most treacherous sort, even if there was no actual sex involved. His head swirled with emotions, and he could hardly get his words out. They tumbled all over one another in a cascade of pain. Billie couldn't take it another second.

"I finally had to tell him, 'Elvis, I am going to begin seeing other boys.'" His reaction surprised her.

"He started crying. Until that night, I had never seen a man, or a boy, cry. He told me, 'Billie, I was going to ask you to marry me!'"

Billie was stunned. Marriage certainly wasn't on her mind, and she had no idea it was on his. But now there was nothing to do but break up, even as Elvis kept tabs on her—just happening to show up at the cafeteria, for instance, and at the Cotton Carnival the same night she went. "Look, there's Elvis!" her girlfriend said. The way he looked, he was impossible not to notice. But Billie acted as if she didn't see him, though there was no escaping him at the Courts.

The trauma of losing Billie triggered his sleepwalking again. One night he woke up on the stairs outside his apartment, wearing only his underwear. Suddenly, he heard Billie come in with her date, and he ran and hid, crouching, afraid to move while she kissed the boy good night.

For a while they tried to be friends, but Elvis's heart was broken, and there was no fixing it, not even after Billie moved back to Mississippi.

Though she is a minor name in the Elvis saga, Billie Wardlaw was a progenitor for many of the women to follow. Her coloring, particularly her dark hair, would have made her seem like his twin, a female version of himself. It's one reason he spent money well beyond his reach for a pair of blue jeans for her, as they matched his own, as Betty's had. And her size—she was big boned, though not overweight—would have reminded Elvis of the young Gladys, which is why he had intended to propose marriage, to complete his psychological circle.

"At an unconscious level, we are always seeking resolutions to childhood dilemmas," writes psychologist Charlotte Davis Kasl in her groundbreaking book, *Women, Sex, and Addiction: A Search for Love and Power.* "On some level, we're looking for a second chance, to get what we missed the first time around. By attracting people similar to those in our families, we are given a chance to heal ourselves, to learn the lesson inherent to our childhood situations."

In courting Billie, Elvis was attempting to separate himself from his mother and the pain of having lost his twin, even as Billie represented both. A happy relationship with her would have allowed him the chance to obliterate the guilt

of surviving when Jessie did not, as well as quell the eternal loneliness of losing his twin, and the pain Jessie's death had caused their mother. It also would have blunted the sexual shame of covert incest. The fact that Billie spurned him only added to his core belief that he wasn't lovable. He would have felt terribly empty and rejected, not just as a boyfriend, but also as a person.

Finally, his violent outbursts at finding another boy's picture in Billie's purse and his tears at learning she was dating a sailor were predictable escapes. As an adult, still dealing with the seeds of destruction planted in childhood, Elvis would turn that violence inward, deflecting his loneliness and fear with prescription drugs and overeating.

· · · · · ·

At the start of his senior year, in the fall of 1952, Elvis was being stretched in all directions, practicing his music, trying to keep up a C average, and working long hours, first for the Upholsterers Specialties Company, and then for MARL Metal Products, a furniture manufacturer, on the 3 P.M. to 11 P.M. shift, using hand tools and an electric screw drill to make plastic tables. The strain started to show—he was falling asleep in class—and so Gladys had him quit.

However, the family faced a greater dilemma that November, when the Memphis Housing Authority sent the Presleys an eviction notice and ordered them to vacate by the end of February. The reason: With a combined income of $4,133, they had exceeded the limit allowed for residents of subsidized housing.

In January 1953 they left the Courts and moved to 698 Saffarans Street, across from Humes. Three months later, they packed up again, this time landing in an apartment in a large, two-story brick home at 462 Alabama, an integrated street where they would pay $50 a month in rent, plus utilities. Minnie Mae bunked on a cot in the dining room, and Elvis slept on the sofa. The Presleys were now out of government housing, but the move to Alabama Street could not be considered upward mobility for the family in any way, as the apartment consisted of a couple of small rooms and a large kitchen. They still weren't doing all that well financially, and the Courts were located right across the street.

In March, Elvis visited the Tennessee State Employment Security office, saying he would like to work as a machinist. The interviewer took his information, and then noted on his application that his appearance as a "rather flashily dressed playboy type [is] denied by fact [he] has worked hard past three summers [;] wants a job dealing with people."

Elvis had never really found his place in high school, but now, in his senior

year, he was about to have two powerful supporters. The first was George Klein, who he'd met in music class the year he started at Humes. They had two things in common: They were both eaten up with music, and they shared a worshipful love of radio, George hoping to make a career in it. Elvis had impressed him that first year by performing "Old Shep" and "Cold, Cold Icy Fingers" for his classmates. When Elvis raised his hand and asked permission, "There were a few laughs in the class because it just wasn't cool in 1948 to do that in front of anyone. I was blown away because I'd never seen a kid get up and sing like that." As they approached their senior year, George became class president and thus had some political clout. The two wouldn't really become close until after they graduated, but George paid attention to him, and Elvis never forgot it.

His second ally was Robert Gene West, nicknamed "Red" for his carrot-colored hair, buzzed into a crew cut. An all-Memphis football star, Red was a year behind Elvis, who had quit the team almost immediately after he joined: To start with, at 145 pounds, he was too light, which made him self-conscious about school sports. Besides, he didn't like to wear the helmet—it messed up his hair—and he needed to get an after-school job. Sometimes he didn't have the fifteen cents for lunch, and Coach Rube Boyce would give it to him.

Red West, taut and muscular, had a reputation for being a quick man with his fists, and in the late summer–early fall of 1952, Elvis needed a little protection. While everyone else wore jeans and T-shirts, Elvis favored dress pants, and just to be different, he often wore a scarf fashioned into an ascot, like a movie star. Everything about his appearance made him a natural target.

Red had stopped at his locker to get his football gear one afternoon just after the bell rang and saw Elvis leaning against the wall. They had spoken before, but the hierarchy of high school had prevented them from becoming friends. Now Elvis could use one. Red could tell that something was up, and Elvis spilled it out: "There's three guys outside who are going to beat me up." Red nodded and said, "Let's go check on it." Outside, Red had a persuasive talk with the ringleader and all ended peacefully.

The following day, Elvis caught him after class and gave him a bashful smile. "Thanks a lot for yesterday." Red smiled back. "Forget it, man."

Not long after, Red walked into the boys' bathroom and found Elvis in trouble again. Three guys had him pushed up against the wall, taunting him about his hair and threatening to cut it. Red saw a "look of real fear on his face . . . like a frightened little animal." He knew the guys from the football squad, and laid it on the line. Elvis liked his hair like that, and if they cut it, they'd have to cut

Red's, too. "They did it just to make themselves feel big, and I intervened and stopped it, and I guess it stuck."

That April Elvis learned that Red had a musical side, when they both performed in Humes's annual Minstrel Show, a variety program featuring the school band and various soloists, from the Arwood Twins, billed as twirlers, to dancer Gloria Trout. A fund-raiser, the show was scheduled for a Thursday evening and was not expected to change anybody's life. Elvis, listed sixteenth on the program, and identified as "Guitarist . . . Elvis Prestly" [sic], told only a couple of friends about it, and even then, they thought he might bow out. He'd sung once at a Christmas party in biology class, but that was about it. Now he was ready to go in Buzzy's red flannel shirt. He'd accidentally torn a hole in it when he put it in the closet, and he'd rolled up the sleeves so it wouldn't show.

Red, who played trumpet, had put together a little trio with a guitar and bass, and he'd just finished his act when he saw Elvis come out with his guitar. "I never thought he would have the guts to get out there in front of those people," Red wrote. "I never even knew he sang."

When Elvis first ambled out onstage, he looked the least prepared of all the performers. He seemed unsure of what to say or even do. He fumbled around with his guitar, and then with the lights bothering him, turned his head sideways, eyeing the audience through slits. He stood there too long for anyone's comfort—at least a full minute, as if he might bolt. Finally, waves of talent and ambition crashed inside him, and he launched into his first number, Teresa Brewer's new chart topper, " 'Til I Waltz Again with You."

Quietly, Elvis had been doing more than working on his ballads—he'd been experimenting with fast numbers, jumping around a little, just enough to put some pizzazz into it all. The teens in the Courts danced to a one-two-three bop beat, but Buzzy watched Elvis develop his own "crazy" rhythmic step, adding four-five-six to the one-two-three. He tried it out in front of eight or ten kids at the jukebox in the grocery store that Farley's brother-in-law owned.

He also practiced in front of his family, Billy Smith remembers. "We got a piano that Christmas, and Elvis came over to our house. He started playing something fairly fast, what little he could play piano, and then he got to moving around a lot, and it was a sight to see! I thought, 'Gosh, that's weird to see him jump around like that and sing.' He just done it for a few minutes, and he quit. He was trying to find something that fit him. And when he did, all at once, it just broke loose what was inside him."

Now, onstage at the Minstrel Show, he started his second song. Nobody

seems to remember what it was, but Frannie Mae Crowder swears it was the moment when the real Elvis was born. "He was moving all over that stage. And his movements didn't start with his hips. They started with his knees and worked their way up."

And then in a flash it was over. "At first," Red remembered, "he just stood there, surprised as hell." The audience, too, seemed stunned. Nobody had ever seen a guy move like that. What was he doing? And how did he do it, this dunce with the impossible hair? The place went crazy.

"It was amazing," Elvis said later, "how popular I became after that."

He performed every chance he got, toting his guitar to school. All the same, some of the girls thought he was just too over-the-top, and when he would start to sing, they'd whisper, "Not again!" He still had few real friends at Humes aside from Red and George.

In early 1953 he went to a birthday party a few blocks from the Courts and ran into Regis Wilson, fourteen, who was there with two girlfriends, Carol McCracken and Judy Gessell. Regis, a petite girl with blond hair and a big smile, had formerly lived at the Courts for six years with her divorced mother and five siblings, including her brother Jim, who was Elvis's age, and hung out with him around the complex.

Regis had a crush on Elvis, who she considered "a gentle soul, but all boy—he kind of had this swagger to him." She used to see him playing football in the Triangle, the grassy open field at the complex. But she'd never spoken to him, and never thought he'd paid any attention to her—he seemed too interested in Betty or Billie. Of course, he was a weird dresser, in his yellow sport coat with brown trim, and he had a case of teenage acne. But from day one, she remembers, "I thought he was cute."

She lived in a rooming house on Merriweather Street, a bus ride away, and hadn't expected to see Elvis again. But there he was, and he was talking to her. And he still had those sideburns she'd always liked. "He was a loner, a looker. Very sexy, with slicked-back hair."

They played spin the bottle that night, and Regis's girlfriends, miffed that she had kissed a boy they liked, went off and left her by herself when their ride came. Regis was stranded. "I didn't have anybody I could call to come pick me up, because by then my four older siblings had left home and my mother didn't have a car." Elvis offered to drive her, and she nervously agreed. She'd never been alone in a car with a boy before, and in fact, she'd never dated—she was a ninth grader at the all-girl Holy Names, "the poorest Catholic school in Memphis." But when

they got to her front porch and Elvis asked for her phone number, "I knew I wanted to see him."

Though he was eighteen, the four-year age gap didn't bother either one of them. "Growing up in housing projects with a single mom, five [other] kids, and a very dysfunctional family background, I pretty much raised myself," says Regis. "So I was fourteen, but I was a very mature fourteen." And Elvis, still stinging from Billie's cruel rebuff, found the relationship with Regis finally put him in a position of control and made him feel like something of an older brother.

Psychologically, his attraction to her was more complex. Because his stunted emotional growth left him unable to move much past fourteen, Regis wasn't just a little buddy but a replication of himself. Unconsciously, fourteen would now be the magic age for so many of his future romantic interests.

When they first began dating, Elvis worked at night part-time, ushering at Loew's. (At some point, he was fired after an altercation with another usher, who complained that a concession stand girl gave him free candy.) His usual habit would be to drop by Regis's place in the afternoon, sometimes waiting for her when she got home from school. But she never knew exactly when he was coming, and she never invited him in: "My mother had had another child—and still no husband—and I was left at home with this two-year-old. My family life was so chaotic that I just couldn't talk about it to him."

Regis was also embarrassed that her family didn't actually own the house, an immaculate, large brick home with flowers in the yard, but simply lived in one rented room. Pretty soon she couldn't tell him, because Elvis thought otherwise, and his imagination had run away with him. "He used to say, 'One of these days, I'm going to buy my mama a house like this.'" And he told her about his twin.

Often they simply sat in the glider on the screened-in porch and talked ("His humor was the type that he could just come out with funny remarks"), and sometimes he sang to her with his guitar, just strumming and humming. He was working on a new ballad, "My Happiness," and he sang that to her, too, his baritone, melancholy and soft, floating on the humid air. She was amazed that someone as shy as he was could put his heart on the line like that. "He sang it so tenderly. It seemed like it held a lot of emotion for him."

> Evening shadows make me blue,
> When each weary day is through,
> How I long to be with you,
> My happiness . . .

Soon he began courting her in the evening, too. His worn-out Lincoln had a little seat in the back, and sometimes his cousin Gene Smith and his girl would double-date. They made the usual teenage excursions: riding over to West Memphis, Arkansas, for a drive-in movie and popcorn, or the "Teen Canteen" at McKellar Lake for hamburgers and shakes. Sometimes they just went tooling around. "He was a very simple, sweet person. He thoroughly enjoyed just sitting there watching the Mississippi River roll by, and he loved driving cars."

As he had been with Billie, Elvis was a consummate gentleman. His looks completely belied his behavior. ("If you were to see him on the street, you'd probably think he was a hoodlum.") At fourteen, she didn't think she could really be in love with someone, but she liked him a lot. She kissed him every night from the second date on, and she had her expectations. Carol and Judy still hung out around the Courts, and reported he was a good kisser, "and I wanted to see for myself." She had heard he knew how to kiss in that deep way, but that presented a dilemma.

"The nuns at my school told us we shouldn't allow boys to kiss us with their mouths open. So I'll just say Elvis gave me long kisses. You could say we made out. But he never tried to go farther. He wasn't like that."

Regis knew he was serious about music, but he was so modest he never even mentioned his big success at the Humes Minstrel Show. One of his favorite things to do was to take her to the All-Night Gospel Singings at Ellis Auditorium, where the Statesmen and the Blackwood Brothers would perform.

"About two in the morning, I couldn't keep my eyes open any longer, and we'd leave." But Elvis could have lasted until dawn. "Some of those spirituals had big, heavy rhythm beats like a rock-and-roll song," he would remember in 1965. "That music didn't hurt anybody, and it sure made you feel good." Sitting in the audience, he sang right along with everyone onstage, trying to hit all the high and low notes. Regis scrunched down in her seat. "I would look at him like he was crazy, but that didn't stop him from going right on singing."

Regis didn't know it, but he afforded their dates by working the auditorium's concessions, particularly on Monday nights when the hall staged professional wrestling. Guy Coffey, the concessions manager, hired him and other Humes students to sell Cokes, and on a good night Elvis earned three or four dollars. He loved the magic of the place, and he fantasized playing there one day, standing on the same stage as all the greats.

"Sometimes after the night's event had ended and the Humes kids had settled up financially," Coffey remembered, "Elvis would go up on the stage and

play to imaginary crowds, bowing to their applause. I would have to tell him, 'Come on now, Elvis, we have to close the place up.' And he would say, 'Yes, sir,' and we would walk silently out of the building."

Regis enjoyed the gospel sings, for which Elvis always got dressed up in his good clothes, as if he were going to church. But Elvis never invited her to services anywhere, perhaps because he only sporadically attended, and his parents had never become members anywhere once they moved to Memphis. He also knew that there was significant prejudice against the Assembly of God church. In fact, Regis's own family referred to Pentecostal groups as "Holy Rollers," and as she remembers, "I got the impression that the Presleys were religious, but I would have to say that he didn't talk about [the Assembly of God] because it was snickered about. It was something he wouldn't have told many people."

If Elvis felt like an alien among other teenagers most of the time, he was never so out of place than on the night of his senior prom at the swanky and segregated Peabody Hotel in downtown Memphis. Now, at the end of the school year and four months into his courtship of Regis, he asked her to be his date. Precisely why he went is a mystery, but he felt some kind of pressure to go, and to give the evening a special flair. "It was the most exciting thing I had ever done," Regis says. "I felt like Cinderella getting ready to go to the Royal Ball."

The fourteen-year-old hurried to Lerner's to pick out a strapless pink taffeta dress for $14.98, and then, her budget blown, accessorized it with the pink shoes she'd gotten at Easter. Someone suggested she could get her hair done free at the beauty college right across the street from the Peabody, and she quickly made an appointment. She'd never even been in the Peabody before, and as she sat in the beauty chair, looking at the hotel through the window, she said to herself, "Just think, in a few hours from now I will be back here all dressed up."

Elvis was also grooming his hair—his sideburns were now extra long—and choosing his outfit. Regis wondered what he would wear, since "he would show up in outfits that were so flashy I would open the door and blink my eyes." But he passed on the idea of a white jacket like the other boys wore and decided on a conservative dark blue suit and blue suede shoes. He showed up at her door in a shiny rented Chevy, also dark blue, paid for by money he had saved from ushering. Shyly, as Regis blushed, he pinned a pink carnation corsage on her dress.

As they entered the Continental Ballroom at the Peabody, the band was playing, and couples were already out on the floor. But Elvis steered Regis to a seat and offered to get her a Coke.

Given Billie's rejection and his embarrassment at not knowing how to dance,

Elvis would have been enormously uncomfortable at his prom, and tortured at the idea of getting out on the floor in front of his peers. Finally, in case Regis was wondering, he told her.

"I can't dance," he said, cracking a self-conscious grin and perspiring under his jacket.

Regis took it that he didn't dance because of religion, and simply said, "That's all right." And so they sat out the entire night, talking and sipping on soda pop and watching all the other dancers, Elvis's dark blue suit, the color of heartache, further setting them apart. Finally, they lined up with all the other couples for the grand march, stepping through a mammoth heart as their names were called, and had their picture taken. In it, Regis manages a half-smile, but Elvis looks as stiff as a soldier, peering solemnly into the camera. Regis saw it as part of his humor, like the way he curled his lip into a sneer.

He made no attempts to socialize, and no one, not Buzzy, or George, or Red, approached them. But Elvis promised Regis they'd have more fun afterward at Leonard's Barbeque, where they were to meet some of his friends and go on to a party. They drove out and waited, but nobody ever showed. Regis could tell it bothered him, and finally, chagrined, Elvis took her home.

A few weeks after the prom, Elvis dropped by her house and found the family had simply vanished. Regis's mother, financially strapped, had decided to move in with a relative. And Regis had gone to Florida to help her older sister, who was expecting a baby.

"I jumped at the chance, because going to Florida and living in a stable home was a lot more inviting than staying in Memphis with this fractured family life." Yet she couldn't bring herself to tell Elvis how bad her situation was. They'd moved so many times, and she was embarrassed. Besides, "girls didn't call boys in those days," so she never said good-bye. Like Billie, she just moved off and left. To Elvis, it must have felt as if he'd been spurned three times in a row—by Betty, Billie, and now Regis. He never learned any different.

"I've always regretted that. I just figured he'd find out I had left by driving by the house. I've often wondered if he knocked on the door and saw all these strangers, the other people who rented rooms, and wondered who they were."

In the move, Regis lost her photo of her prom date. But Elvis kept his, and a few years later, Gladys gave a copy to a fan magazine. By then Elvis was a teen heartthrob and a national sensation, with very specific dance moves all his own.

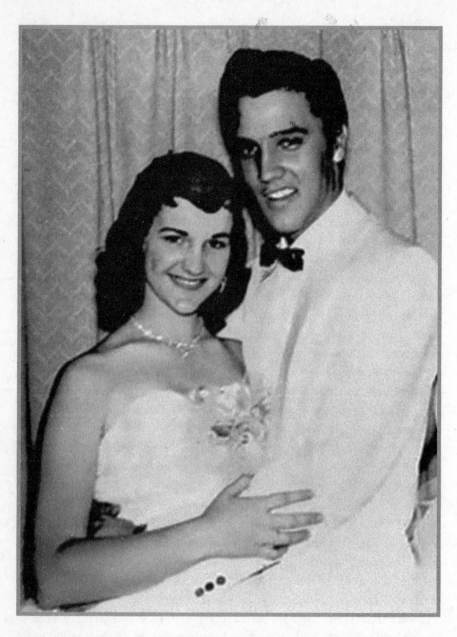

Dixie Locke and Elvis at her junior prom, May 6, 1955. Gladys bought her dress. "I was waiting for her to get out of school so we could get married," Elvis said years later. (Courtesy of David Troedson/Elvis Australia)

FOUR

.

Dixie's Delight

In July 1953 Elvis was reading the afternoon paper, the Memphis Press-Scimitar, when he noticed a lengthy article that seemed to speak his name. Three years earlier, twenty-seven-year-old Sam Phillips had opened the Memphis Recording Service at 706 Union Avenue. It was only about a ten-minute walk from the Peabody Hotel, where Phillips and one part-time assistant, a woman named Marion Keisker, worked for Memphis's top radio station, WREC. Phillips had become an announcer there in 1945, but he held a number of duties, including engineering the big-band broadcasts of Tommy and Jimmy Dorsey and Glenn Miller on a network hookup from the Peabody Skyway each Saturday night.

It was glamorous, mirrored ballroom kind of work. But in his new outlet, the Florence, Alabama, native who had grown up destitute on a tenant farm alongside black workers, intended to spotlight the opposite end of the social strata. Largely through his burgeoning Sun Records, located in the same small building, Phillips hoped to create a commercial market for rhythm and blues, the real rhythm and blues, the kind they sang over in West Memphis, Arkansas, in the cotton fields, and in the back parlors of Beale Street. Phillips would later say he was looking for "Negro artists of the South" who wanted to make a record but had no place to go. As Keisker noted, "There had never been an opportunity in Memphis for a Negro to get into a record company. Negroes weren't even allowed to perform in white clubs." In essence, Phillips sold hope to people who had none.

"Somehow or another, deep down in my soul, I guess I just had an affinity for music and people, especially people who had the ability to express themselves but didn't have the opportunity to go to New York or Chicago and try to get

somebody to listen to them. I didn't want to work with anybody except untried and unproven talent, and I just had a desire to work with black people."

The idea was both revolutionary and unpopular, and there was vitriol in some of the comments he got from his coworkers at the radio station. "Some of my best friends would kid me, say I smelled that morning when I came in, and ask why I would leave the Peabody and go out and start recording 'niggers.'"

But Phillips had a fiercely independent heart. He began with men whose names would be legendary: B. B. King, Joe Hill Louis, and soon Howlin' Wolf. In 1951, with Ike Turner's band sitting in, he produced singer Jackie Brenston's "Rocket 88," probably the first rock-and-roll record.

Phillips lived for the creativity of the studio. He loved seeing what people would come up with in the exchange of energy in the room, in getting sound down on tape. He could alter sound with acoustics and engineering tricks, and in 1954, using two Ampex 350 recorders, developed a tape delay echo, or "slapback" technique to make the music sound "real alive," as he put it. But the dynamics had to be created out of the musicians themselves ("the worst thing you can do is over-produce"), and he could pull things out of them that even they never knew were there. A slight man at the time—he weighed only 125 pounds—the black-haired Phillips was so charismatic that when he got talking in a big way, his rhetoric— half preaching, half reminiscence—had an almost mystical quality.

"None of these people that I recorded had ever had any experience. Some of them had never really seen a broadcast-type microphone. Most of them certainly had never seen a recording studio, and I kind of liked that."

A homespun genius with an integral understanding of the blues, Phillips also had a mission—to cross the racial divide. His idea was to mix the music of the black man with the country sounds he'd grown up hearing all around him in Alabama—the first record his family owned was a 78 rpm of Jimmie Rodgers— and on such radio stations as Nashville's WSM. He knew that great music—and it was great music he was always after—defied easy categorization. And if he could find a musician who wedded southern white and black gospel to country and blues, well, he'd have an act like no other. It might also help him pay the $150-a-month rent on his little twenty-by-thirty-five-foot storefront studio, which was often a struggle, especially with the eight or ten dollars for electricity.

Phillips had come up as the youngest of eight kids, and he lost his father early, seeing his dream of becoming a criminal defense lawyer go up in smoke. But the music business had nearly killed him, too. In 1949 he'd had a nervous breakdown but, "I got off my back after ten shock treatments and I was back

working in a couple of months—less than that—because I had just worked myself to death with a lot of responsibility for a young person."

Now that he had small children, he didn't want to put himself at risk like that again. He needed a commercial act, and he needed it soon. Though it was never really money that drove Sam, Marion knew the refrain. "Over and over I heard Sam say, 'If I could find a white man who had the Negro sound and the Negro feel, I could make a billion dollars.' "

The newspaper story Elvis read on July 15, headlined "Prison Singers May Find Fame with Record They Made in Memphis," focused on Phillips's newest find, the Prisonaires. Phillips had transported the quartet from the Tennessee State Penitentiary under armed guard, bringing them to his studio on Union, where they recorded an original song, "Just Walkin' in the Rain." Phillips would release the song on Sun Records, with its bright yellow label depicting a spindly rooster greeting the day, music notes forming a circle around SUN RECORD COMPANY, and its location, "Memphis, Tennessee."

By 1953 Phillips was already expanding his original intent with Sun, working with white artists, as well as black. Meanwhile, his bread-and-butter business, the Memphis Recording Service, was scrambling, too, advertising that "We Record Anything—Anywhere—Anytime." Phillips wasn't kidding—he'd lug the equipment out to weddings and bar mitzvahs, or make dubs, transfer tapes— in short, do anything to keep the doors open. His first big financial outlay was a neon sign in the window, which he hoped would lure drop-in customers. But parking was always a problem because of the way the streets formed a triangle, the building tucked behind the intersection of Union and Marshall, with Taylor's restaurant next door.

Elvis would have noticed the newspaper story immediately, as would everyone else in his household, both for the word *prison* in the headline—no one could pretend to forget that Vernon had done his time—and for the novelty of such a recording service. Sometime that summer 1953, Elvis, who worked as an assembler at the M. B. Parker Company until the end of July, when the job ran out, took his guitar over to Union and plunked down four dollars to make a two-sided acetate of "My Happiness" and the Ink Spots' "That's When Your Heartaches Begin."

Marion, a bespectacled, blond, thirty-five-year-old divorcée who handled all the distributor relationships, bookkeeping, publicity, billing, and secretarial work ("I was the entire office"), was swamped that day. But she vividly remembered Elvis, a fidgety boy looking for a break.

"He came on a Saturday afternoon, a very busy afternoon. For some reason, I happened to be alone at the time. The office was full of people wanting to make personal records. I told him he would have to wait, and he said he would. Of course, he had his guitar, so while he was waiting, we had a conversation. He [asked] if anybody needed a singer. He said, 'Somebody out there must want to hear me.' I said, 'What kind of singer are you?' He said, 'Well, I sing all kinds.' I said, 'Who do you sound like?' And he said, 'Like nobody. I don't sound like nobody.' It was true, of course, but it seemed so impossible."

Marion went back to make the ten-inch acetate, and halfway through the first side, she thought she heard what Sam was looking for, "this Negro sound" in a white man. Quickly, she grabbed a piece of recording tape and threaded it through the two-track Ampex. "This was not something we did with drop-in business, but I wanted Sam to hear this. He was out at the time, and the only tape I could find was crumbly, and it was broken by the time I got it set up. I got maybe a third of the first song and all of the second song.

"When Sam came back I played it for him, and he was impressed and said he would do something, but the boy would take a lot of work. He said, 'Did you get his name and address?' and I said, 'Yes.' I had the slip for many years. It said, 'Elvis Presley, good ballad singer.'"

Sam would remember the events differently than Marion did, saying he was there that first day and set up the disc-cutting machine himself. The boy was so unsure of himself that Sam found it hard to believe he'd ever performed before an audience. "He tried not to show it, but he felt so inferior. . . . Elvis was probably, innately, the most introverted person that ever came into that studio."

He liked Elvis's recording, though, and told him he was about to go over to the penitentiary in Nashville to see about the Prisonaires. He'd visit publisher Red Wortham while he was in town, and if Sam found any material he thought was fitting for Elvis, he'd give him a call.

Whether Sam confused his second visit with the first, Elvis returned to the Memphis Recording Service in January 1954 to make a second acetate, this time of two country tunes, "I'll Never Stand in Your Way," and "It Wouldn't Be the Same Without You." Again, Elvis got his hopes up, prayed to hear back from Marion or Mr. Phillips—he always called Sam "Mr. Phillips," though he addressed Marion by her first name—but nothing happened.

Marion couldn't get him out of her mind, though. She almost felt as if she had discovered him. He brought out her maternal instincts, and she'd even men-

tioned him to her own mother. "Oh, I've seen him on the streetcar," her mother said. "The kid with the long sideburns. I wondered what in the world he was."

.

That month, as Elvis turned nineteen, he began attending the First Assembly of God on McLemore Avenue, in South Memphis. He'd been there before—the church chartered three city buses on Sunday mornings to ride through the housing projects and bring worshippers to services. Aside from his "schooling" at Ellis Auditorium, it was here that Elvis first learned to love white gospel music, as it was the home church for the Blackwood Brothers quartet. There was also another connection: Cecil Blackwood, a nephew of founding member James Blackwood, lived in the Courts with his new wife, and he was just getting up a sort of apprentice quartet he called the Songfellows. Elvis fantasized about joining them one day, so he figured it wouldn't hurt to show up in the pews.

The church had another draw, too. For the last ten years, Reverend James E. Hamill had presided over the church with firm leadership, growing the congregation to nearly two thousand members. A fire-and-brimstone preacher who encouraged fervent demonstrations of faith such as speaking in tongues, Reverend Hamill was nonetheless well-educated and cautious and thoughtful in his counseling of members for problems big and small. He carried himself with a demeanor that was both serious and benevolent, and his parishioners revered him as a second father, wise, kind, and good. For a boy whose daddy lazed around most of the time and let his wife steamroll him in nearly every way, Reverend Hamill was an appealing figure.

However, it wasn't spiritual soothing Elvis desired in early 1954, but rather romantic salvation. He and his cousin Gene were looking for a way to meet girls. On Sunday, January 24, Elvis, with a wavy new Toni perm in his hair, attended a function at the church. He caught the eye of a young church secretary, the teenage Dixie Locke. She took one look at him and for a minute, almost stopped breathing. "He was the most gorgeous thing I'd ever seen."

Dixie got within earshot, and speaking a little louder than usual to be sure Elvis would hear, made plans with a girlfriend to go skating at the Rainbow Rollerdrome on Saturday night. The next weekend, sure enough, he showed up, but in nobody's idea of a roller skating outfit—a ruffled shirt and black pegged pants with a pink stripe down the sides, topped with a bolero jacket.

At first, Dixie pretended she didn't know he was there, waiting to see if he would approach her. But after he huddled by the rail for too long, it dawned on

her that he couldn't skate! She felt sorry for him now and went over and said, "Hi, I'm Dixie, from church." He got shy on her, said, "Yeah, I know," and looked down for a minute and then tossed his hair back a little. It was the first time they had spoken, but then they almost didn't stop. They got a Coke and talked nearly the night away, telling each other their life stories.

Already they were moony over each other, and when it came time to go home, they extended their date at K's Drive-In for a late night snack. Afterward, Dixie kissed him in the parking lot, and he drove her home—very late now, her father would kill her—in his '41 Lincoln. The next night, and the next, they went to the movies. But she still didn't want her parents to see him. Not yet.

"I had tried to tell my mom and dad about him, that he was a little different from the other guys." But when he arrived at the house the next Saturday night, only a week since they first talked at the roller skating rink, she was not prepared for the reaction.

"My parents were so shocked at the way he looked and dressed that they wouldn't let us leave together." They spent the evening sitting on the front porch with her three sisters and her mom and dad. In time, her family "adored him. He was a perfect gentleman." But one of her sisters kept raising her eyebrows so Dixie could see what she really thought of the guy, and her uncle offered Elvis two dollars to go get a crew cut.

Dark-haired, intelligent, and earnest, Dixie was everything Elvis wanted in a girlfriend. Even her age was right. A sophomore at South Side High, Dixie was fourteen years old. Almost immediately, Elvis gave her his ring and taught her the language ("almost a baby talk") he had with his mother, reverting to a pouty, little boy voice when he used their special words.

● ● ● ● ● ●

When Dixie first saw him at church, "We knew almost immediately he was not one of us. There was a restlessness about him, an air of anticipation, as if he knew he was on the threshold of something wonderful and exciting."

Part of it was his nervousness at what might come of his visits to the Memphis Recording Service, if anything. He hadn't even told Dixie about making the record, and he was glad, because he hadn't heard back from Marion or Sam. But that didn't mean he wouldn't, did it? He had so much unfocused energy. When he sat, he drummed his fingers on the table, and his foot was just going all the time, shaking, tapping, as if he hadn't a second to waste. His leg, too, just bounced, even when he was just sitting in the movie theater. If

anyone commented on it, he'd stammer and say, "Oh, I just do that, I-I-I-just do that."

He was settling into the church now. Partly to be closer to Dixie, he participated in many of the activities, and he hoped to impress her with his singing. Though Dixie found him a shy boy, when he sang, he threw himself into it completely, so much so that she thought he "kind of lost himself . . . And he had this feeling if he could just meet James Blackwood, it would be worth every feeling of insecurity."

He was much more relaxed when they went for walks. He could be playful, too. He'd grab her from behind, his hands around her waist, and hug her up close, snuggling into her back. Dixie would let out a delighted squeal, her dimples showing, and then smile so big folks could probably see it all the way over in Nashville. Soon the young couple was nearly inseparable. Elvis and Dixie were falling in love. "It was serious right away," she says. In fact, they considered marriage. "We knew that that was what was supposed to be. We talked about it from the very beginning."

Elvis, too, would always remember how close the two came to marriage. "I got out of school and was driving a truck," he said in a 1972 interview. "I was dating a girl and waiting for her to get out of school so we could get married."

Yet even so, past loves were still on his mind. Billie Wardlaw, who had moved to Mississippi from the Courts, was back living in Memphis again and going to school at Tech High. Just as before, Elvis started showing up at places he knew she would be. "I came out of Tech one afternoon and there he was, under the trees on campus, picking his guitar."

But Elvis could see Billie still didn't care for him, not with the deep passion he held for her. He knew for sure now that it was time to move on. Two weeks after he and Dixie met, Elvis took her home to meet his parents, and soon after, the Lockes invited the Presleys for dinner.

Dixie was surprised at their family dynamics, at how Vernon, who was on disability a good portion of the time, was almost an outsider. If Elvis ever stepped out of line, she noticed that Gladys handled it, not Vernon.

"If it was okay with Gladys, then it was okay with Vernon. He was not a disciplinarian by any means, and he knew the bond that Gladys and Elvis had for each other—something I felt he was not allowed to be a part of. It almost seemed like Elvis and his mom made more of the decisions, and Mr. Presley just kind of went along. I think he knew that Gladys and Elvis really called the shots."

When Elvis and Dixie first got together, Gladys took a more protective stance, as if to make sure Elvis didn't get his heart broken like he did with Billie

Wardlaw. She saw that Dixie was a quality girl, and as Elvis had suggested, potential marriage material, despite the five-year age difference.

Soon, when Dixie was at the house, Gladys began asking her probing questions about her family and "how high I was up in the church, and have I done this, and where have I gone . . . I felt a little like I was being interrogated."

Dixie's father did the same thing with boys who came to call on her three sisters, so she wasn't offended. In fact, she and Gladys developed a deep friendship. "She told us several times that she would rather he married me than anyone else he had dated." And Gladys wanted him married. She was gaining a lot of weight and not feeling well, and she wanted him settled and happy in case something happened to her.

But Dixie also saw that the bond between mother and son was formidable and not likely to be broken. The Bible teaches that it's God's plan to leave your father and mother. She was well aware of that. "But I don't know that that would have ever happened with them." In retrospect, she believes that had they both lived their full life spans, "They would have been together. I don't think he would have ever left her, regardless of the situation. She would always have been with him." In all probability, Dixie, Elvis, and Gladys would have had a living arrangement much like that of Gladys, Vernon, and Minnie Mae, together until death.

Nonetheless, the four of them, Elvis, Dixie, Gladys, and Vernon, began doing things together, getting a bite to eat and then going to the All-Night Gospel Singings at Ellis Auditorium. Gladys loved the Blackwood Brothers best, but Elvis preferred the more flamboyant Statesmen, thrilling to Jake Hess's forceful lead stylings, and the lake-bottom low notes of bass singer Jim "Big Chief" Wetherington, whose legs often shook inside his big loose pants when he sang.

Elvis just couldn't get enough of music, and he was discovering the wealth of what Memphis had to offer. On Sundays, he and Dixie would sometimes slip away from their own church services to go to the all-black East Trigg Baptist Church just a few blocks away. There they'd sit in the balcony and let the waves of black gospel wash over them, get baptized in the beat of the Lord. Already Elvis was thinking of a way to meld black and white gospel together. But there was no gospel like black gospel, with its near physicality, and East Trigg's pastor, the Reverend Herbert Brewster, was no ordinary preacher. A celebrated civil rights activist and fiery orator, he was also an accomplished gospel songwriter. Mahalia Jackson would record his "Move on Up a Little Higher," and Clara Ward his "How I Got Over."

By spring 1954 Elvis was driving a truck for Crown Electric, delivering supplies for $1 an hour, and training to be an electrician ("Sometimes they would let

me help wire or something"), though, as he said in a 1956 interview, he worried if he were cut out for it. "You had to keep your mind right on what you're doing, you can't be the least bit absentminded, or you're liable to blow somebody's house up. I didn't think I was the type for it, but I was going to give it a try."

Things were looking up, on the whole, and he and Dixie were seeing each other almost every day. That May, they attended the Oral Roberts Crusade, though most of their dates were less serious-minded. They'd climb in the old Lincoln and head off to the movies two or three times a week, or go down to the WMPS Radio studios at the corner of Union and Main for deejay Bob Neal's "High Noon Round-Up" show, where the Blackwoods appeared regularly.

On the other end of the scale, they also loved Dewey Phillips's "Red, Hot, and Blue" radio show for its mix of blues, boogies, and spirituals. The couple would listen to it in Elvis's car, parked at McKellar Lake, or maybe over at his parents' house. Dixie was more a fan of Perry Como and Frank Sinatra, but the WHBQ show was the hottest in town for black and white teenagers alike. Phillips, wild, wacky, and often hopped up on amphetamines, called himself "Daddy-O," and he struck fear in the hearts of legions of God-fearing Memphians. "So many of our Christian parents wouldn't even let [their children] listen to it," Dixie remembers.

Phillips's broadcasts often spurred Elvis to drop by Charlie's Record Shop on North Main to peruse the new R & B records, Dixie in tow. Elvis had gotten brave one day and talked the proprietor into putting his first acetate on the jukebox, and man, that was a thrill! Elvis needed a boost about then, too. He'd tried out for the Songfellows and was crushed at the rejection, hearing over and over in his head that they'd said he couldn't *sing,* when what they had really said was that he couldn't sing *harmony.* And he was rejected as a vocalist with the Eddie Bond band at the Hi-Hat club, Bond telling him to go back to driving a truck. Years later, his words still stung. "Man," Elvis would tell George Klein, "that sonofabitch broke my heart."

It was a delicate period in all their lives. The more time that Elvis and Dixie spent together, the more Dixie sensed that Gladys felt slighted, even though she seemed like a second mother. The two shared recipes and went places together, once to a Stanley Products party (the Tupperware of the early 1950s), or simply spent hours talking. They never had cross words. But even as a teenager, it seemed to Dixie that Gladys was almost jealous of her relationship with Elvis.

"She and I were real close and enjoyed each other. But I think if she had been able to, she would have just kept him to herself. I felt that way myself. I would have kept him just for me, and not let the world have him."

· · · · · ·

Marion Keisker went to work one day in mid-1954 and found that Sam had pulled out the note she'd made months earlier: "Elvis Presley, good ballad singer."

"What's this for?" she asked him and smiled at the funny memo she'd made ("Timothy Sideburns") to remind her what Elvis looked like.

"Oh," Sam said. "That kid was in here again. I liked him, but I don't have time to work with him. I told him I would call him sometime."

As Marion told the story, every time a song would come up and Sam would say, "Who should we get?" she'd say, "The kid with the sideburns. Why don't we give him a chance?" But Sam would invariably say, "Oh, I don't think he's ready yet." Elvis still persisted, though, dropping by periodically.

Finally, in June 1954, he got his break. Sam had a new song from Nashville, a ballad called "Without You." Marion placed the call, and Sam got on the line and gave him the good news. The studio was ten or twelve blocks from Alabama Street, and Elvis ran all the way, Sam said. "I no more than hung up the phone, hardly, and he was there in no time flat." Without a doubt, Sam loved the plaintiveness in his voice, the *yearning* for lost dreams. But no matter how many times Elvis sang "Without You," he never quite got it to Sam's satisfaction. "He sang it well, but I said to myself, 'We just can't do a ballad on Elvis.' "

"We were taking a break," Marion remembered, "and Sam said, 'What can you do?' Elvis said, 'I can sing anything.' Sam said, 'Let me hear you.' So he just started playing snatches—gospel, western, anything. Doing real heavy on the Dean Martin stuff. He must have been convinced if he was going to sound like somebody, he was going to sound like Dean Martin. The three of us stayed there far into the night, just Elvis playing and talking."

Elvis recalled the same thing to Bob Johnson of the Memphis *Press-Scimitar* in 1956. "I guess I must have sat there at least three hours. I sang everything I knew—pop stuff, spirituals, just a few words of [anything] I remembered."

Sam prided himself on his ability to read people and to coax the best out of them. ("There is not a human being on the face of God's earth who could get more out of totally untrained musicians than me.") Now he looked out the control room window and locked eyes with Elvis, who searched Phillips's own for reassurance. Elvis knew the whole thing was a disaster, but maybe they would hit on something.

"You're doing just fine. Now just relax. Let me hear something that really means something to you," Sam said, trying to get the boy to communicate what-

ever was in his heart. "If you make a mistake of any sort, I don't care what it is, I want a big one. If you hold back, you'll kill the feel of the whole damn thing."

.

Three days after Elvis's big audition, his world fell apart. R. W. Blackwood and Bill Lyles of the Blackwood Brothers quartet were killed in a plane crash in Alabama. Elvis drove straight to Dixie's after work, and they cried in each other's arms. To Elvis, Bill and R. W. were more than great singers—they were friends now, from church, but Dixie had known the whole family for years, and these were close deaths. She and Elvis held hands at the funeral on July 2, which was all the more emotional because the Lockes were leaving for a two-week family vacation in Florida the next day. It was the first time Elvis and Dixie would be separated.

They'd talked several times about eloping, and now they discussed it again before she left, since Dixie was scheduled to start her summer job at Goldsmith's department store when she returned. But she was so young, she knew it would break her parents' hearts if they ran away and got married. Of course, they were not intimate—the church frowned on premarital sex—and they wouldn't have done it anyway. They were saving themselves for marriage.

The night Dixie left, Elvis got a phone call from Scotty Moore, a local guitarist whose band, the Starlite Wranglers, had just signed with Sun Records. Elvis had mentioned to Sam that he was looking for a band, and Sam had passed the word along. The Starlite Wranglers already had a lead singer, Doug Poindexter, but Scotty, whose day job was cleaning and blocking hats in his brother's laundry business, had been working with Sam for several months, trying to come up with a record, an artist, a song—anything they could make a buck out of, as Scotty said. Elvis's name came up, and Sam gave Scotty his number.

He showed up at Scotty's house on a Sunday afternoon, the Fourth of July, wearing a black shirt, pink pants with white stripes down the leg, white shoes . . . and "just a lot of hair. I thought my wife was going to go out the back door."

Bill Black, who played bass for the Starlite Wranglers when he wasn't building tires at Firestone, lived down the street, and he came, too, for a few hours. The three sang everything they could think of, though they had little repertoire in common. They made an odd trio—Elvis, nineteen, with grease in his hair, looking like a space-age garage mechanic; Scotty, twenty-three, quiet and unassuming, with sloping features that spoke to a country background; and the jocular Black, twenty-eight, whose soft body nearly ran to fat, and who held his bass together with baling wire.

Afterward, Scotty got on the phone to Sam. "Well, the boy sings pretty good, but he didn't knock me out."

"Well, what do you think? Do we need a song, or what?" Sam said.

Scotty thought for a minute and then replied, "Yeah, with the right song, I think he would be good on record."

The next night, they were all in Sam's little two-room studio for what was supposed to be basically a rehearsal. The first song Elvis put down on tape was the Leon Payne ballad "I Love You Because," and then he sang a couple of country numbers. They were all right but not special, so they took a break, and got some coffee and a Coke while Sam monkeyed with the console.

Then Elvis remembered an old loose-jointed Arthur "Big Boy" Crudup song, "That's All Right (Mama)," that he'd heard on Dewey Phillips's show. Crudup was a man apart. His music didn't follow standard black blues patterns—a mile-wide hillbilly streak ran through it—which is probably what commended it to Elvis. Now he picked up a guitar and banged on it and started singing, keeping the primal energy of Crudup's recording but hopping up the vocal, jumping around the studio in a dance, just cutting up to break the tension. Bill picked up his bass and started slapping the strings, helping the beat along, and clowning, too, and then Scotty tried to get in somewhere with a rhythm vamp. They were just making a bunch of racket, as Scotty saw it, not realizing they were striking rock's seminal lightning bolt.

"The door to the control room was open, and about halfway through Sam came running out, saying, 'Wait a minute! What the devil are ya'll doing? That sounds pretty good through the door.' Everybody looked at each other, like, 'What were we doing?' We said, 'We don't know.' Sam said, 'Well, find out real quick and don't lose it! Run through it again and let's see what it sounds like.'"

"Sam," Scotty said, "it just flipped him. He thought it was real exciting."

They backtracked, playing it twice, once for Sam to get a balance. Elvis ran the words again in his head and changed Crudup's line, "The life you're living, son, women be the death of you," to, "Son, that gal you're fooling with, she ain't no good for you." Then they put it on tape.

That one simple action set the wheels in motion to make Elvis Presley the most important star of all time.

· · · · · ·

The following day, Sam called Dewey Phillips and told him he had an acetate he wanted him to hear. They sat together and listened at the WHBQ studios at the

Hotel Chisca, and Dewey jumped out of his seat, wanting to know who it was. Nobody would believe Elvis was a white boy, not sounding like this. Dewey played the song on the air July 8, and the switchboard lit up, so he spun it over and over, finally calling Gladys and Vernon and asking them to get Elvis into the studio. He wanted to interview him on the air.

Elvis had been too nervous to listen, so he went to the movies to try to take his mind off it. The Presleys went to the Suzore No. 2 and combed the dark aisles, peering into the long rows of faces until they found their son. Down at the station, Dewey could tell how rattled Elvis was, so he just made casual conversation with him, never telling him he was on the air until it was over.

Sam Phillips, awed by the reaction, knew he'd finally found a white man with the black sound, and called the trio into the studio the next night. He needed a second side to release a single, but the problem was finding something in the same vein, as Elvis seemed stuck on ballads. Again, the guys ran through every song they could think of, and then Bill took off on Bill Monroe's bluegrass waltz, "Blue Moon of Kentucky." He rendered it as a kind of goof, souping up the tempo with a rhythm-and-blues feel, and mimicking Monroe's high-lonesome tenor as he slapped the bass. Elvis joined in, scrubbing the rhythm on his acoustic guitar, and then Scotty laid down his clean lines on the electric.

"Hell, that's different. That's a pop song now, nearly 'bout," Sam Phillips famously enthused.

"We just sort of shook our heads and said, "Well, that's fine, but good God, they'll run us out of town!" Scotty remembers. "I think we all knew immediately when this happened that this might be what we was looking for. So we just figured out where to start and stop, and that was it."

· · · · · ·

By this time, Dixie knew that Elvis had been recording at Sun Records, but she was shocked to get a telegram from him on vacation: HURRY HOME. MY RECORD IS DOING GREAT. Then, as the family drove back into Memphis, they heard "Blue Moon of Kentucky" on the radio. It was one thing to hear three guys sitting in the kitchen practicing a song with a couple of guitars, Dixie said, but another to hear it on the airwaves.

"I was totally stunned. But I recognized him immediately. Everybody in the family was just ecstatic. It was the most exciting thing that had happened to me."

Neither of them had any idea of the magnitude of it all ("It was almost disbelief that the disc jockeys would even play it," Dixie said), even though Elvis was

thrilled to be playing the Bon Air club as an extra added attraction with Doug Poindexter and the Starlite Wranglers. "He was still just totally innocent and spontaneous," in Dixie's view. "There wasn't a conceited bone in his body."

In fact, he was still interested in doing the old things, like going to the Humes football games. One night, Charlie Fisher, who remembered him from ROTC, watched him come and sit in front of him at Crump Stadium, named for the congressman and former demagogue mayor E. H. Crump. Elvis was decked out that night, wearing a lavender Ike jacket and matching lavender pants.

"My wife, Steve, took one look at him and said, 'My God, who is that?'"

"I told her, 'I think that's Elvis Presley. He's supposed to be making records these days.'"

The whole town was talking about him, but few had actually seen him, and there was some confusion about what race Elvis was, as Dixie soon discovered. Her mother worked with a couple of young black girls, who mentioned how much they loved "That's All Right (Mama)." Mrs. Locke spoke up and cheerfully said, "My daughter dates him." The girls blinked, incredulous that Mrs. Locke's daughter dated a Negro. She set them straight, told them he was white, but "they couldn't believe it," says Dixie, "because the type of music that he was singing was typically related to a black musician."

Memphis would see for itself on July 30, 1954, when Elvis played the Overton Park Shell, an outdoor stage in the city's leafy park of the same name. Four days before, Sam Phillips, who had just formally signed Elvis to Sun Records, had gone to Bob Neal, the WMPS disc jockey whose noonday show Elvis and Dixie frequently attended. Neal, who also ran a little record shop with his wife, Helen, sometimes promoted country concerts. Now he was bringing in a "hillbilly hoedown," a package show starring Slim Whitman and Billy Walker from the Louisiana Hayride, the live radio show broadcast from Shreveport over KWKH. Since his own show was all requests, Neal was playing Elvis's two songs.

"Why don't you put him on the bill?" Sam said.

Bob, knowing that Sun was a nonunion label, asked if he'd been cleared with the musician's union.

"No, but I'll get him in the union."

"I said, 'Fine,'" Bob recalled two decades later. "'Let's put him on.' It was his first big appearance in a commercial performance."

But Sam hadn't gotten him in the union, and when Elvis arrived at the park, the president of the local Federation of Musicians refused to admit him to the

stage area. Sam quickly scrambled for the money to make Elvis a member, and then the boy mounted the stage.

Elvis went on before Slim Whitman, a big favorite at the time. He launched into "That's All Right (Mama)," and whether from nerves or imitation of his hero, "Big Chief" Weatherington of the Statesmen, he suddenly began to shake, his legs a blur of rhythm and romance. Something like electricity zigged through the audience, and Neal was astonished at what he saw.

"When Elvis came on, he automatically started with a wiggle and a shake. The audience was just screaming and shouting. There was no hype. They were simply reacting to what was on the stage before them. It was almost unbelievable." Of course, this was his hometown, Neal realized. "But still he made a big hit right there. He stole the show right from the first."

When Slim Whitman came on, the audience nearly turned him away. *"Bring back Elvis! Bring back Elvis!"*

Among the enthusiasts was Marion Keisker.

"I'm a very restrained person, and I heard all this female shrieking. One voice just completely stood out. Suddenly, to my chagrin and horror, I realized it was me. Here I am, mother of a young son, on my feet, screaming and whooping like I'd totally lost my stupid mind. I was just transported. But the whole audience was exactly that. He just had that magical, once-in-a-lifetime quality."

Dixie was wild with pride that night, but the extreme reactions of the women shocked and angered her. "I was like, 'Good grief!' I couldn't believe it. Because I wanted to say, 'Hey, he's already taken, so y'all just back away!'"

From then on, Dixie was afraid of how Elvis's new fame would affect their relationship, especially after they married. Elvis told her not to worry. He was just playing the little clubs around town—the Bon Air, and soon, once Scotty and Bill split off from the Starlite Wranglers, the Eagle's Nest. But Dixie still fretted.

"I said, 'I want him to sing, and I want him to be successful, but I want him to go to work at nine o'clock and come home at five. I don't want him to be out all hours of the night in all these clubs.'"

Looking back, she sees that was the dividing line. "After his records got so popular, life was never the same for us."

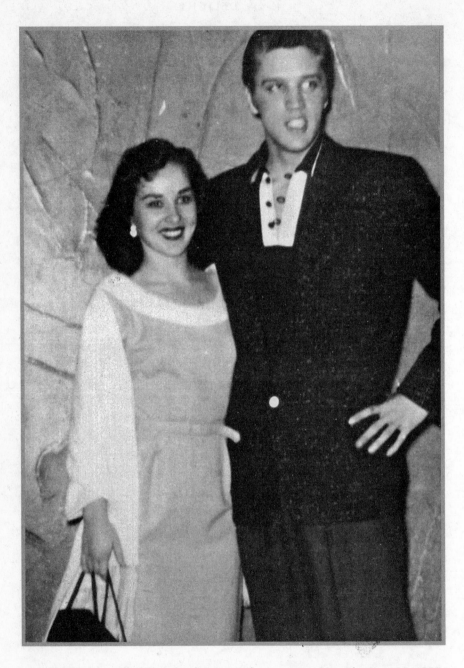

Carolyn Bradshaw and Elvis, backstage at the Louisiana Hayride, June 25, 1955.
"He was just madly in love with her," says fellow Hayride performer Nita Lynn.
(Courtesy of Carolyn Bradshaw Shanahan)

FIVE

· · · · · · · · · · · · · · · ·

"You Need to Be Kissed"

Dixie was too young to go into some of the little bars and clubs Elvis was playing around town, but he continued to spend all his free time with her, taking her wherever he could—to a radio appearance over in West Memphis, Arkansas, and to his performance at the Katz's Drug Store opening, where he sang for a huge crowd of teenagers from the back of a flatbed truck. His high school chum George Klein, by now a gofer for Dewey Phillips, emceed the event.

On September 11, 1954, two days after the Katz opening, Elvis was back in the studio, laying down covers of Dean Martin's "I Don't Care If the Sun Don't Shine," and on the flip side of the dial, bluesman Roy Brown's "Good Rockin' Tonight."

Marion remembered he never came to a session ready, and when he started "I Don't Care If the Sun Don't Shine," he knew only one verse and the chorus, which wasn't enough for a record. Sam was eager to get something down, though, because the Disc Jockey Convention was about to take place in Nashville, and he wanted to be able to promote Elvis's second single. So during a break, Marion sat down and wrote some additional lyrics: "I don't care if it's rain or snow / Driving's cozy when the lights are low."

When the record came out, Marion got a call from the music publisher, saying he'd noticed Elvis's version contained an added verse. Marion said yes, she'd written it, and told him why. ("It's the middle of the night and we've got to get a record out.") That was fine, he told her, but she couldn't put her name on it, or collect any royalties as a writer.

"Every time I turned on the radio I heard someone singing my lyrics, and I was so mad and upset. I wouldn't care if we had gotten some benefit. But that

was just indicative of the way the sessions went. If we needed more hamburgers, somebody went out and got them. If we needed more lyrics, somebody wrote them. With what we lacked in money and resources, we had to be inventive, but I think that's what made the music so exciting and creative."

Sometimes Dixie would go with Elvis to the recording studio—Elvis often dirty and grimy from work at Crown Electric—and Marion found her to be "a very dear girl, quiet and religious, and his number one booster."

Marion was struck by how much in love Elvis and Dixie were, and how genuine their feelings were for each other. Elvis would talk about her and quite often show Marion her picture, which he'd tucked inside his gold wristwatch.

"After Elvis's first record came out, Bob Neal staged a contest asking young ladies to write in to say, 'I would like to be the president of Elvis's fan club because,' in twenty-five words or less. I kept Dixie's letter for years, because it was the most glowing and loving tribute. It meant so much to her for Elvis to succeed and be accepted. But when he started spending so much time away from home, it was inevitable something would change in their relationship."

It was during this time, the fall of 1954, that Elvis first played outside of Memphis, in a high school gym in Bethel Springs, Tennessee, not far from Jackson. In the audience was musician Carl Perkins, who was amazed at the "electric effect" Elvis had on his audience, "particularly the girls."

Bob Neal was booking the trio now, at some point calling Scotty and Bill the "Blue Moon Boys" and Elvis the "Hillbilly Cat." His early morning radio show "just boomed right down the Delta," Scotty recalled, so they started working a lot of schoolhouse shows down through that area, traveling 150 to 200 miles around Memphis in Arkansas and Mississippi. Scotty was Elvis's de facto manager, but Bob would help out and officially assume managerial duties in early 1955. He'd try to get Elvis engagements, help promote him, start the fan club (the stationery was pink and black), advise him on business dealings, and promote his records. It wasn't always an easy thing to do.

"I had problems trying to get his records played. I knew a lot of people in the business, but the country deejays would say, 'We can't play that. He sounds too much like a nigger.' I tried it the other way, sent them to rhythm-and-blues stations. They said, 'No, he sounds like a damn hillbilly.' "

Bob had never managed an artist before, and "it was pretty much a mom-and-pop operation. Helen went along to the shows many times to sell tickets." Because he had a 5 A.M. sign-on time at the radio station, Bob would get in the backseat and go to sleep on the way home. Elvis would drive, and he and Helen

would talk. She was amazed that he was always seeking reassurance and expressing his ambition to become a big movie star.

"Do you think I can make it?" he'd ask. "I've got to make it." As Bob recalled, it seemed to be more about Gladys than his own desire to be big. "He wanted to be able to provide things for his mother, to buy her a nice home and keep her from having to work, because he adored her more than anything." Pretty soon, Elvis was "just like one of our kids," popping in their house anytime he wanted and buddying with the Neals' oldest child, Sonny, who went on the shows and taught Elvis to water-ski on the weekends.

"When Elvis started along, I would emcee the show and tell jokes, and do my act with my little ukulele. Then I'd bring on the headliner. It's rather amusing, but in a lot of towns, Elvis was not the big draw. I was. Uncle Bob was the hero, and people would gather around to talk to me afterward. They regarded Elvis as sort of a strange new creation. Instead of the record building him, he built the record when he made an appearance."

Often when Elvis first came onstage and started performing, audiences didn't know how to react. "They were in shock," as Scotty put it. Bill, the clown of the group, would try anything to get the crowd loosened up—ride the bass, or get a pair of bloomers and put them on. "If we really had to attribute concert success to anyone in the very early days, it would have to be to Bill."

Elvis ran into such a wall on his next big appearance, his one shot on WSM's revered country radio broadcast, the Grand Ole Opry. Sam had set it up with Opry manager Jim Denny, based on Elvis's good showing on the regional *Billboard* charts, and on October 2, 1954, Elvis, Scotty, and Bill drove over to Nashville and appeared on Hank Snow's portion of the program. Backstage, Elvis wandered around, shaking his head at the run-down condition of the Ryman Auditorium, expecting something much nicer. ("Is this what I've looked forward to all my life?")

Marion had high hopes for her protégé's appearance, and slipped over to Nashville on her own to see him. She sat in the audience for a while, and a woman in front of her asked who she'd come to see. "Elvis Presley," Marion said. "Who?" "After the show," Marion replied, "you won't ask me again."

Just before Elvis went on, Hank Snow walked up to him. "Well, kid, you ready?"

"Yes, sir," Elvis said.

The diminutive star looked down at his paper and asked, "What was your name again?"

"Elvis, Elvis Presley."

"No, what's the name you used on your record?"

"Elvis Presley."

Snow went out and introduced him as a bright, new, exciting star, but in Scotty's view, "It was earth-shattering for all involved. They wouldn't let us do but one song, and we had to do 'Blue Moon of Kentucky,' because it was a country song. The audience reaction was very light, and in total, it was a bomb." Elvis was so upset, he left his stage costume in a gas station bathroom and cried all the way back to Memphis.

· · · · · ·

He had a better shot two weeks later at the Louisiana Hayride, the Opry's upstart cousin, broadcast out of Shreveport's Municipal Auditorium over KWKH, another powerful, 50,000-watt station that beamed its signal across the wide expanse of the South. Known as "the Cradle of the Stars," the Hayride had launched the careers of Hank Williams, Webb Pierce, Slim Whitman, and Faron Young, boosting Williams, in fact, near the end of his life when the Opry shut him out.

Sam had again negotiated the tryout, but Elvis had an ally there already in booker/manager/musician Tillman Franks, who brought Elvis's first single to the attention of Horace Logan, the Hayride's producer. Tillman set up a phone call with Sam and Elvis ("Mr. Franks, I understand that you might get me on the Louisiana Hayride?"), and they settled on a fee of $125. Sam made the seven-hour drive to Shreveport with Elvis, Scotty, and Bill, and Elvis was so nervous he could hardly sit still—twitching, drumming, shaking his foot. Their car broke down on the way in, which didn't help matters, and none of them had any money.

Elvis was scheduled to appear after Hayride star Ginny Wright, whose duet with Jim Reeves, "I Love You," spent twenty-two weeks on the *Billboard* country charts. The attractive blonde was sitting on a stool in the wings watching Johnny Horton's performance when Elvis first walked by, a pacing blur in his pink shirt and black pants. She called him over and welcomed him to the Hayride.

"Ginny," he said, biting his fingernails, "how in the world can you be so calm?" She felt sorry for the kid, and he brought out her maternal instincts, even though they were about the same age. "Well," she told him, "you take a deep breath, and if you love it, you just go out there and sing." He gave out a little laugh then and asked her if she'd like one of his new promotional pictures. It was dull and cheap-looking, not glossy like the real stars had, but he was proud

of it, and signed it "To Ginny, love Elvis." She put it in her guitar case so she wouldn't bruise his ego.

Finally, after Ginny's demure rendition of "Tell Me How to Get Married," announcer Frank Page brought him on, building him as an artist whose record "has skyrocketed up the charts." But the Hayride audience—an older, married crowd who needed a place to go on a Saturday night—couldn't get past his out-fit. With Scotty and Bill anchoring him on either side, and house drummer D. J. Fontana holding down the backbeat behind the curtain, Elvis stuttered when he talked, rocked forward on his feet, and "looked like he was about to leap right out into the audience," as Page recalls. He shook his leg a little, more out of nerves than anything, and "showed restraint . . . he seemed at times pinned in, like he was struggling to contain this enormous kinetic force."

Before he knew it, he'd moved through both "That's All Right (Mama)" and "Blue Moon of Kentucky," the audience connecting more with the latter tune, already knowing it from the Father of Bluegrass. And then he was offstage, staff fiddler Dobber Johnson and his "splinter-bustin" hoedown, "Black Mountain Rag," in his place.

Ginny Wright had been watching from the wings.

"I thought he was going to get booed off the stage. Because he didn't even hardly get any applause at all, and he was real worried. They didn't ask him to come back out or anything."

He saw the look on her face.

"Ginny," he said, "is there anyplace we could go get some coffee?"

"Yeah, we got a little restaurant down here. You've got to go down the back steps of the building."

They were on their way when Tillman Franks stopped him and took him by the arm, seeing how nervous he was.

"He really didn't get much of a hand, and I know he and Scotty and Bill talked it over. But I told him, 'Don't worry about what you're doing. They ain't hired you yet. You do anything you want to. Just relax and get with it.' "

Down in the restaurant, Ginny bought him a hamburger and a cup of coffee. He was awful humble and sweet, she thought, and he talked about his mother. "He said, 'Ginny, do you miss your mama and daddy?' Because my mother and father were still in Georgia, running a grocery store. And I said, 'Yeah, I really do. I try to call them once or twice a week.' Then he fidgeted with the spoon, shaking his foot all the while.

" 'Ginny, I didn't get no applause like you got,' he said, his voice downcast.

'Well, Elvis, the Louisiana Hayride is a *country* show. Why don't you get out there sometime and do a country song?' He said, 'Well, I can do that. I can sing "Old Shep,"' and he sang for me there at the table, starting off in whisper: 'When I was a lad and old Shep was a pup. . . .'"

Elvis didn't realize it, but the audience that had given him such a light hand at first wanted more. "The acts they'd come to know as family now seemed distant and boring," Frank Page wrote. "Slowly, they built their enthusiasm for the young trio from Memphis, and when Elvis, Scotty, and Bill were called back out later in the show, the reception was very different."

Taking the stage for the second time, Bill primed the audience, jumping around, being silly, and egging Elvis on to move, to shake that leg and loosen up. The crowd seemed younger now, but whether that was true, as Scotty remembers, "They reacted. I mean they *reacted!*"

"On the second appearance, when Elvis started doing that, the roof come in," said Tillman Franks. "They just went completely wild. After the show, Sam, Elvis, Horace Logan, and Pappy Covington, the Hayride's booking agent, went in a room and started talking."

When they walked out, Elvis had a twelve-month contract as a member of the Hayride cast.

From the beginning of his sixteen-month stint there, Elvis was a favorite of the women stars, though nearly each of them had a different relationship with him, from maternal to sisterly to romantic. Almost all of them found him strangely immature, if fun. Vocalist Jeanette Hicks, like so many women, noticed, "Those eyes! He liked to play peek-a-boo. He used to sneak up behind me backstage, cover my eyes and say, 'Guess who?' in a funny voice. Well, there was no mistaking who it was."

But Betty Amos, a singer-comedienne, found him harder to take. He was always breaking strings onstage and would run up to her and say, "Betty, quick, can I borrow your guitar?" One night he returned it "absolutely thrashed to death, just the whole front busted out," and he didn't do anything about it.

"I was very fond of Elvis, but sometimes I didn't like him very much. He could be sweet, gentle, kind, and thoughtful, but perplexing and aggravating, too. He was sexy, handsome, childish, and at times, downright cruel. He'd hit me and I'd hit him. Looking back, I suppose in all probability I was the closest he ever came to having a sister."

It started with the opposite approach, with flirtation. The first night he was at the Hayride, Amos was backstage, coming up the back steps, when Elvis was

standing on the landing. "I was dressed up, and I had a really good figure—big boobies, little teeny waist. And I had my makeup and high heels on, and I guess I sashayed a little. And when we got face-to-face, he said, 'You're a little doll.' I said, 'No, I'm not. I'm a *big* doll.' And I just went on, and I could feel his eyes boring into me as I continued up the steps."

Not long after, she was in her dressing room when he walked in, gave her a lethal Rudolph Valentino stare, and announced, "You need to be kissed."

He was totally serious, but it caught her so off guard she didn't know whether to say "Hop to it," or to double up her fist and hit him.

"He came over and gave me his best shot, but it just wasn't there. We looked at each other and I thought, '*Ick!* This ain't gonna work!' It was like kissing your brother! We both knew right then that we were better suited for something else. And that's when we started laughing and carrying on with each other."

That humorous beginning set the pace for their whole relationship, one based on affectionate teasing, though their childish pushing and shoving sometimes turned bizarre, as when they visited a small-town radio station. While the deejay was interviewing another act, Elvis and Betty went out on the lawn, where their usual banter and smacking ("We more or less sparred with each other") turned into a wrestling match.

"I was as strong as he was. And we were actually rolling over and over on the grass. I said, 'Will you quit? If somebody sees us out here, this is not going to look good!' We were laughing so hard we couldn't really wrestle. But we just did all kinds of silly things like brothers and sisters do."

Yet Elvis was also establishing another pattern—that of compartmentalization. At home, he was the churchgoing and devoted boyfriend of Dixie Locke and the obedient son of Gladys and Vernon. But at the Hayride, and soon on its package shows on the road, where he traveled as part of a troupe with Maxine and Jim Ed Brown and other stars, he was Elvis Presley, the charming, charismatic performer and girl-teaser supreme. Sometimes three generations of women—a grandmother, her daughter, and granddaughter—sat in the front row with the same look of anticipation and awakening on their faces. The bolder ones in the crowd pawed at him offstage like hungry animals, sending a clear message that they were only too eager to receive his kisses and more.

The boy who so many girls rebuffed in his youth was flattered beyond belief. He loved the attention, but he also loved the company of women, and when they surrounded him, asking for autographs or hugs, he was courteous enough to give them at least a minute of his time, no matter what hour of the day or night.

There were times, though, when he seemed to exude such an exotic vibe that people seemed either afraid to approach him, or were too in awe to do so. Jim Ed Brown remembers such a date in Gilmer, Texas, before Elvis started incorporating his wilder gyrations or began drawing a lot of people on the road.

After the show, as the boys were breaking down the equipment, "There was a piano over in one of the corners. Elvis went over and sat at it. He could play only a little bit, but he played and sang a few things, and the first thing I knew, people started to go over. But they didn't get close. They stood back about ten or fifteen feet, because they didn't know whether to get close or not."

Dixie and Gladys came to a number of the Hayride performances and road shows within a 150-mile radius of Memphis, and in Dixie's view, both of them "were so amazed that the people who came to the concerts were as mesmerized and excited as we had been." But Dixie also saw she was losing her grip on him. Ever since his show at the Overton Park Shell, "I felt I was not a part of what he was doing. He was doing something so totally him . . . and he loved it."

Elvis would call his mother every night, no matter where he was. Sometimes when he was on the road, Dixie would stay with her, sleeping in Elvis's bed at the Presleys' new rental house at 2414 Lamar Avenue. Elvis encouraged the sleepovers—he wanted his parents to keep an eye on her to make sure Dixie wasn't seeing other boys. But he telephoned her at home less and less, particularly as more women became available to him.

"Before long, girls were swarming around him by the hundreds," as Horace Logan remembered, "making him forget his homesickness for Dixie." And also making him push the limit on the Assembly of God's tenets about premarital sex. His mother taught him all his life that a godly person honored himself and his body. But did that go for Hayride stars, too?

"After nineteen years of never being far from his mama's apron strings, he was finally on his own," Logan noted, "and he relished the freedom."

In Shreveport, where he could be a whole new person, the conventional rules of romance and commitment didn't seem so rigid. Not when he was living a life in which the established stars accepted him as a peer, and especially since he was about to dethrone the Hayride's Tibby Edwards as the heartthrob, the little dude, the one who made the women swoon. There were so many girls eager to teach him about sex, about life, about himself. It all fed his ego with a big spoon, especially as he had arrived there as an unknown, very much sheltered and un-schooled about sexual intimacy.

"Everything did a hundred-eighty-degree turn," his cousin Billy Smith says, "when Elvis realized the effect he had on women."

In a sense, Elvis grew up on the Hayride, but his experiences with his female fans left him damaged in his social interaction with women. By the end of his Hayride period, all boundaries would disappear. After a certain point, he wouldn't even have to bother to politely court. He was Elvis.

· · · · · ·

Like many of the stars, Elvis stayed at the low-rent Al-Ida Motel in Bossier City when he played the Hayride, and he usually shared a room with Scotty and Bill. From his second appearance, long lines of teenage girls—1950s groupies—formed outside their room each Saturday night after the show. Some just wanted to see him up close, but others wanted more intimate contact. Sometimes he had three or four girls in his room at once, though he later told his father it was six, laughing that "fourteen or sixteen will get you twenty," meaning having sex with fourteen- or sixteen-year-olds would get you twenty years in jail. As long as the girl had nice legs, a decent face, and a shapely derriere, he was interested. Breasts were secondary, suggesting a touch of androgyny in his libido.

"I sometimes drove by the motel myself before I went home, and personally saw as many as three hundred girls there," Horace Logan wrote. "Elvis scored whenever he wanted. He screwed around with so many girls he'd never seen before and never saw again that I'm surprised he didn't catch something and die."

Maxine Brown was also amazed. "Everybody knew that [the guys] screwed everything in sight. Girls were throwing themselves onto Elvis all of the time. Who's going to resist that? And if Elvis didn't want them, Scotty, or Bill, or Jim Ed did," though women had to push themselves on Scotty, who was married.

Elvis wasn't always having full-out sex, though, and in fact, he was more interested in titillation than penetration. He was nineteen years old, almost a man, but still a boy emotionally. Sometimes he was content with a pillow fight. Because he feared getting a girl pregnant—and so he could technically stay true to Dixie—he held to dry humping as long as he could, both he and the girl keeping their clothes on but getting the rush all the same.

When things progressed beyond that point, he usually stuck to intense foreplay, sometimes asking a girl to masturbate him, and then ejaculating in her hair. If his partner found it degrading, a complete act of submission and

dominance, it also made sense—her head was the farthest point from potential pregnancy.

Elvis's first experience of real intercourse, which came at either age nineteen or twenty, was both traumatic and uninformed. He had met the girl only that day, and before long, he was in the hotel lobby, searching for Scotty and Bill, his face a tangle of confusion.

"The rubber busted," he said. "What do I do now?"

Bill chuckled. "I think you had better marry her—or get the hell out of town."

They left him on his own to solve the crisis, and the next time they saw him, they asked what he had done.

"I took her to the emergency room at the hospital."

"The emergency room?"

"Yeah, I got them to give her a douche."

Soon he vowed to "never break a virgin," and to fool around only with experienced girls.

In truth, he liked everything that led up to intercourse better than the act itself—the kissing, the stroking, the darting fingers, the removal of the blouse. He preferred that a girl keep her panties on, though it drove him wild to see the slightest bit of pubic hair poking around the seams of her underwear. But he respected women, and it was always important that the girl receive more pleasure than he.

Elvis wasn't the only male star on the Hayride running wild, of course, but Maxine Brown never thought about him being sexy. Like Betty Amos, she regarded Elvis as a brother—she was four years older—and she couldn't believe the way the girls hounded him everywhere he went—backstage, at the motel, and on the road once they started touring together.

Though the girls were crazy about him, "Many of the mamas didn't want their daughters hanging out and going to the shows because of the way he wiggled," Maxine remembers. "They thought it was vulgar. But I didn't. I thought it was great. Never thought of anything like that at all."

Elvis still hadn't really broken in the national press, but around the region and even in Memphis, there was talk that what he was doing was unholy, that he was performing the Devil's music. Elvis was stung by it—it made him burn right through his skin—and Marion had to console him.

"I remember very strongly people praying for him in the churches. And I knew what a deeply religious person he was, so I was talking to him one day and something was said about how they felt about him, and his eyes filled up.

He said, 'Well, Marion, the only thing I can say is they don't know me.' Then he laughed and said, 'But it don't hurt to have a few people praying for you.'"

On the other hand, Elvis was soon making more money than he or his parents had ever seen in their lives. It was modest by most entertainment standards—he got only scale for the Hayride broadcasts, and he split his take with Scotty and Bill on the road. But he couldn't believe his good fortune, and in his role reversal, it thrilled him to provide for his parents, whom he saw as his dependents. In late 1954 he wired his parents funds from Houston: HI, BABIES, HERE'S THE MONEY TO PAY THE BILLS. DON'T TELL NO ONE HOW MUCH I SENT. I WILL SEND MORE NEXT WEEK. THERE IS A CARD IN THE MAIL. LOVE, ELVIS.

On December 8, 1954, he went back into the Sun studio with Scotty and Bill, recording the hillbilly blues of "You're a Heartbreaker" and "Milkcow Blues Boogie." He had the confidence now to loosen up and let things roll. ("Hold it fellas. That don't move me. Let's get real, real gone for a change.") There was a different crackle in the air, Marion noted. Sometimes Elvis would get so tickled by Bill's antics in the studio that "he would roll on the floor and kick his heels and laugh."

By early 1955 no act could follow him onstage, and shortly he would be headlining. ("When we started working with Elvis," says Maxine, "we got top billing over him, but that didn't last long.") Once that happened, both Elvis and his fans threw all caution to the wind. On a tour through Texas booked by deejay Tom Perryman, who also managed the Browns, Elvis and Jim Ed's fellow performers "speculated that J. E. and Elvis must be betting on how many girls they could score with in a single night," as Maxine noted. "Some of us eavesdropped and counted them. Tom came by, saw what was going on, shook his head, and said, 'By God, those boys are gonna wear those things out if they don't slow down.'"

Often, on the road, girls would sit in the front row where the stage lights fell, and lift their skirts to expose their naked parts. Gladys was there in Arkansas one night when girls stormed the stage and threw their panties at him, and Elvis had to pay for it. Gladys was appalled that young teens would do this to her son. And Elvis was embarrassed because they did it in front of his mother.

"I'm not sure that she handled that real well," Dixie says of Gladys's emotional reaction to Elvis's becoming a sex star. "Of course, she wanted him to be loved and to achieve the fame and the notoriety that he wanted. But at the same time, there was a side of her that wanted to think that her son was still remaining pure and innocent through the whole thing. Kind of a two-sided coin there."

Gladys always asked Maxine to take good care of Elvis, and Maxine tried her best, paying for his dry cleaning and doing his washing, though he went shy

on her when she asked for his undershorts. He didn't have but a couple of pairs, and he purposely didn't wear any when he performed. The rumor circulated that he wore a toilet paper roll or a sock in his pants to make himself look bigger, but it wasn't true. Sometimes Elvis, who was uncircumcised, got aroused, particularly when his pants rubbed him just so.

One night when Elvis's parents came to the Hayride, he walked offstage after taking a number of encores and just about brought the house down. Gladys grabbed him up by the arm and pulled him over to the side of the stage where no one could hear them. "Elvis," she said sternly, "don't you have any drawers?" He thought fast, and said, "No, ma'am, the only pair I own was dirty, and Maxine wouldn't wash 'em."

"Honey, God, he was huge!" Maxine says. "And it showed. And then when he'd shake his leg, my God! You could tell he had a hard-on. It looked like it. Hell, he knew what he was doing. Bill Black went out and said, 'I'm going to buy Elvis some shorts.' And he thought, 'I'll play a trick on him.' He bought him some silk ones, polka dots. He thought Elvis wouldn't wear them, but Elvis fell in love with them and wouldn't even take 'em off. He didn't want me to wash them. He was afraid somebody would steal them. I guarantee you, he wore silk underwear for the rest of his life, when he wore any at all. He loved them."

Betty Amos also looked out for Elvis, dispensing advice and offering to iron his shirts. "I said to him one time, 'Give me your shirt, and I'll take it over to my room and iron it.' He said, 'That's all right.' I said, 'My God, you're a sex symbol. You're going out onstage with a wrinkled shirt? Give me that thing!' "

In the mornings, after the road shows, she'd see Elvis in the restaurant having breakfast, and he was never alone. "He'd have some little ol' girl over there, his latest. I think a lot of times he didn't care about any of these women he was with. It was just for show. When you're with a different one every day, there's nothing there. But he'd look over at me and I'd look over at him, and I'd raise my eyebrows or shake my head, like, 'That's good,' or 'That's bad,' like a sister is supposed to do. They all looked pretty much the same to me. There were no raving beauties, and there were no ugly girls, nobody who really stood out."

Gladys, frightened by the changes in her son, "wanted him to stay at home and be a gospel singer," Maxine remembers. "She was afraid for him to be out in the world the way he was." But she also thought Betty was the perfect girl for Elvis to pal around with, "because I talked about Jesus and God all the time. And Elvis was completely fascinated by that, and wanted me to talk more about it. I think he wanted to believe really bad."

Betty was a good influence on Elvis, but he was far more interested in Maxine and Jim Ed's comely sister.

Seventeen-year-old Bonnie Brown was a sweet, quiet girl with fair skin, raven hair, and an ample bosom. She, too, was soon performing on the Hayride. The first night, Maxine and Jim Ed introduced her as "our little sister, Bonnie." But as Maxine wrote in *Looking Back to See: A Country Music Memoir,* "When she walked out on that stage, dressed in her tight-fitting outfit, we thought the guys in the audience were going to tear the place down."

In the beginning, Elvis and Bonnie didn't seem interested in each other, but then one day in West Texas, she was relaxing around the motel pool, killing time before a show. Bonnie had her hair in curlers, and Elvis—still so immature he went around handcuffing people to him—came along and pushed her in the pool. She was livid, but after he dived in after her, she joined in the fun, and they were soon together all the time. "He was crazy about her, and she was about him, too," Maxine says.

Bonnie had never been in love before, and it was serious—she was staying out late with Elvis, and one night, she woke Maxine up to tell her that he had proposed. They wanted to get married, she told her, but they'd both decided to put it off for a while, since they were so young.

The Brown family owned a restaurant and supper club in Pine Bluff, Arkansas, called the Trio Club, where Elvis would sometimes rehearse. Now that he was interested in Bonnie, he made a point to stop by more frequently, especially on his way to the Hayride. All the Browns, including Bonnie's parents, Floyd and Birdie, came to regard him as family. Mrs. Brown cooked for him, and, "He couldn't get enough of her banana pudding," Maxine says. "He loved her because she looked kind of like Gladys, and so she took him under her wing."

A lot of times, coming back from the shows, he spent the night with the Browns instead of going on to Memphis. Their baby sister, Norma, would give up her bed, which was situated in Floyd and Birdie's bedroom. The intimacy didn't bother Elvis—in fact, he found it comforting, as it precisely duplicated the sleeping arrangement he'd had with Vernon and Gladys as a child in Tupelo. Maxine knew he didn't sleep much, and noticed his "nervous leg," and how he'd get his toes stuck in the holes of the Browns' bedsheets. "Before morning, they would be torn into shreds. But Mother didn't care. She loved him, and it gave her an excuse to go buy some new ones."

Apart from his pursuit of Bonnie and his professional association with Maxine and Jim Ed, Elvis seemed to relish a stable and secure family atmosphere. He taught little Norma how to play the piano, and a lot of times, when Maxine, Jim

Ed, and Bonnie were on the road, he would come and play baseball in the backyard with her after a helping of Birdie's home cooking.

"On the road," Jim Ed remembered, "he would eat a bacon, lettuce, and tomato sandwich, for breakfast, lunch, and dinner. If he ate three times a day, that is. But that's all he ever ate. His mother was evidently a good cook, and he just waited until he got back home to his mama."

According to Maxine, Elvis's love affair with Bonnie ended as quickly as it began. "One night, she went out to dinner and he was in this booth, all loved up with this other girl. He didn't know Bonnie was there, and she said, 'That's the end of that.' "

In time, Elvis could be cavalier when relationships ended, but he seemed to romanticize any girl who showed him the door. Three years later, before Elvis went into the army, Vernon would tell Maxine that Elvis was still in love with Bonnie, and wanted her to wait for him to return from the service. But though Bonnie pined for him, she wouldn't be burned twice.

"Elvis Presley was a highly sexed young guy," remembered Bill Randle, a top disc jockey in Cleveland, Ohio, who first met Elvis in February 1955 and worked with him several times in the next two years. "He was a randy rooster, actually, in that kind of colloquial terminology. And he was very active sexually. All these very well developed young women and excited groupies would congregate around backstage, and Elvis Presley's car was used not only to sell the records out of the trunk between the intermissions, but also it was a sexual assignation place. There was a lot of activity in that car."

At the Hayride, Elvis wasted no time on a broken heart, and, in fact, from the beginning, he'd set his sights on another girl, an energetic, doe-eyed beauty named Carolyn Bradshaw. With dark hair and eyes, she resembled a glorified Gladys, though she was far smaller, standing only four feet ten inches tall and weighing ninety-five pounds. She took a lot of ribbing about being a shorty. Betty Amos was five foot seven, and when she held her arm out, Carolyn could stand under it. "Cute little thing," as Betty terms her. "Now, I was a big doll, but Carolyn was a little doll." And Elvis wanted to meet her.

"One of the first questions Elvis asked me when I met him was, 'Is Carolyn Bradshaw gonna be on the show tonight?' " Horace Logan remembered. And he had another question: "Is she as good-lookin' in person as she is in her pictures?"

"When he saw her in person," Logan wrote in his book, *Elvis, Hank and Me: Making Musical History on the Louisiana Hayride,* "I think he was even more taken by her."

Carolyn Bradshaw would epitomize three romantic ideals in Elvis's heart, fueling his obsession with virgins, beauty queens, and tiny brunettes with china doll faces. Physically, she was, in fact, the prototype, the first Priscilla.

She was born in Arkansas as the youngest of eleven children of a cotton farmer who died when she was seven. After the eighth grade, she and her mother, Eugenia, moved to Shreveport, where Carolyn's older sister, Jo, was already working. The three shared a small apartment, and on Saturday nights, Carolyn started attending the Hayride. Jo, also a beauty, dated Johnny Horton.

Though she studied acting and dance, Carolyn's real ambition was to be a famous singer. After she belted out Hank Williams's "Jambalaya" onstage with Jim Reeves at the Reo Palm Isle Club in Longview, Texas, the vivacious fifteen-year-old was hooked on both the applause and the attention. "When you come from a family of eleven . . . well, I don't think they knew I was there until I was five years old." Her manager, Fabor Robison, who ran his clients' careers with a steel hand, signed her to his own Abbott label, recording her one Top Ten hit, "The Marriage of Mexican Joe," an answer song to Reeves's "Mexican Joe," in 1953. That same year, at age sixteen, she joined the Hayride cast and went on to win the 1954 Louisiana state title of "Petite Miss Physical Culture."

Her hit song, coupled with her good looks, promised a bright future. She did a tour of California with Reeves, trading her white-fringed cowgirl outfits for cocktail dresses and high heels, and landed a three-month stint on Cliffie Stone's radio and television shows as a fill-in for pregnant girl singer Bucky Tibbs. She was still on Stone's *Hometown Jamboree* when Elvis first came to the Hayride.

"When I left that show and came back to Shreveport, nobody knew I was coming, so I just went backstage to visit with all of the group. The girls were telling me about this new guy on the show, Elvis Presley, who'd been there two or three times by then. They were going on and on about him, and I was thinking, 'Who is this upstart?' And somebody said, 'Well, you just wait and see.' And then the following Saturday night, there he was, and I saw. And boy, did I see. He was magnetic, just awesome, even then."

Carolyn was only an average talent—she relied on a strong regional twang and a fiery delivery to carry a song. But she tried hard and had a lot of guts, and "I had such fun doing it onstage that I don't think people cared whether I could sing or not." Her fresh-faced appeal made her popular with the boys, who greeted her with wolf whistles and queued up for her autograph.

Some of the female cast members were jealous of her, particularly since she'd been dating Tibby Edwards. "He was little, sweet, and cute, and all the girls

went gaga over him," says Nita Lynn, a girl her age and Carolyn's best friend on the show. Carolyn knew how high-tempered women could be, so she didn't let it bother her. But even that hadn't prepared her for the female reaction to Elvis.

"We had our fans at personal appearances and at the Hayride, but they didn't just absolutely lose their mind over any of us, and they did over Elvis. I think I was more in a state of mild shock than anything else. I've never seen anybody, man or woman, with that kind of magnetism."

The first time they spoke, "He looked down at me with this little half-grin and those sleepy eyes, and I just loved it. He had a nervous way of standing, but he was easy to talk to, and he laughed a lot, and I thought, 'Wow, I see what the ladies are talking about!' He was just my type, really sexy. There's just no other word for it."

He kept company with her from that first night, when a group of the Hayride cast—Ginny Wright, the Rowley Trio, and his rival-to-be, Tibby Edwards—went over to Bossier City for a bite after the show. In the next few days, he'd start taking her to all the usual hangouts—Murrell Stansell's Bantam Grill, where he played the pinball machine (and where steel guitar great Jimmy Day teased Elvis about how much Carolyn could eat), and Harry's Barbecue, a favorite of George Jones and Faron Young. Of course, they went to the movies, Elvis, or "El," as she called him, borrowing the Browns' car for a date at the Strand Theatre.

"She really liked him," remembers Shreveport radio personality Louise Alley, who lived across the hall from the Bradshaw family in the apartment house, and bumped into the polite young man ("Excuse me, ma'am") on the stairs as he came to pick her up for a date.

Carolyn always found Elvis "extremely respectful," though affectionate.

"He was an ideal date, almost, and the best kisser. The only thing is that he was very, very restless. There was one movie that I really wanted to see, and he kept getting up and going out. He couldn't even sit still. Finally, I gave up and said, 'Let's just go. You're not enjoying this.' So we left. I've often wondered what created that. I think there was just an emptiness in his life."

When he first took her out, Carolyn excitedly called her friend Nita Lynn. "You will never guess who I'm dating! Elvis!"

Nita was currently on tour with Johnny Horton and Paul Howard and His Arkansas Cotton Pickers, and she hadn't kept up with the news. "Who?"

"Don't tell me you haven't heard of Elvis Presley?"

"I'm afraid not, but the name is enough to choke a horse."

"He's a cat!" Carolyn said, meaning he was a cool cat. "He played the kind of

music that wasn't the three-chord Hank Williams songs we played, and he moved on stage," as Nita later wrote.

Soon, he asked Carolyn to go steady. In her view, "El and I were well-matched. We had a lot of interests in common, and shared things, and talked." Nita believes Elvis would have married Carolyn, "because he was just madly in love with her. You could tell when he was around her." But they didn't have deep conversations, and Carolyn didn't know anything about Dixie Locke, or even about his romance with Bonnie Brown. Confusion arose at the end of 1954 when Carolyn, a one-man woman, heard from Pappy Covington that Elvis was not honoring his promise to her. "That was the one time I was really upset. Pappy was like my own father, and he said, 'I don't want you to get your heart broken, so just understand that Elvis is going to be seeing a lot of women.'"

"All of his romances were short," says Hayride announcer Frank Page. "Carolyn's name kept coming up as being his girlfriend, and I thought maybe she might be something special to him."

But he couldn't seem to change his ways. In fact, once Carolyn's friend Nita got back to Shreveport, Elvis would discreetly try to put his arm around *her* shoulders, but she'd have none of it. "After a few times, I threw his arm from around me and told him, 'Listen, Elvis. You keep your hands to yourself!'" That brought guffaws from the musicians, since most girls encouraged Elvis's affections. But Nita found him cocky, and she didn't like some of his language, either, especially when he took the Lord's name in vain. It wouldn't be long before a high school principal in Mobile, Alabama, stopped Elvis's show because he told an off-color joke.

Carolyn never confronted Elvis about the others, but she wondered what his parents thought about his sexual behavior. She met Gladys and Vernon only once, backstage, and her heart sank when she realized Elvis had never told them about her, that they reacted as if she were just another singer on the Hayride. But she saw how Elvis's dynamic attraction for women troubled his mother. "She was very quiet and reserved and didn't smile very much. His father smiled a little bit more, but neither of them had much to say. If I had been his mother, I would have been very afraid of where it all was leading."

Still, Carolyn forgave him for keeping company with the other girls, because she still wanted to see him. She'd have to be sure that he was dedicated and faithful before she completely gave her heart, though. And coming from a family of "pretty devout Presbyterians, I had some strong moral values." But she tried to keep a positive attitude. She was an independent girl, and if things didn't work out, they could both go on to greener pastures.

"She was very sharp and spunky," offers Ginny Wright. "And her mother watched her real close. Carolyn was still going to school at that time, so her mother wouldn't let her book too much. She told Fabor, 'My daughter's too young to be going out on the road and keeping those hours.' "

But Carolyn did go over to East Texas on the package shows sometimes, and at least one photograph, taken at the Hawkins (Texas) High School gym in December 1954, attests to their few appearances together. The next day, she was either still on the road, or couldn't raise her head off the pillow to go to school. That prompted the truant officer to visit her mother a time or two ("I gave that poor lady such grief"), but she still insisted on being part of it all. With Bill or Scotty behind the wheel, Elvis and Carolyn would harmonize in the backseat, working up gospel songs like "Swing Low, Sweet Chariot." Elvis would sing bass, and something about the way he looked when he sang it tickled her, and they'd tumble with laughter.

"The Memphis Flash," as Horace Logan called Elvis in his Hayride introductions, was still green in his stage prattle ("Friends, I'm too pooped to pop!"), replying he was, "Sick, sober, and sorry," when Logan asked him how he was getting along. But he was already outgrowing the radio show, and soon Elvis would be too big for its package shows, too, particularly after Bob Neal's management contract took effect in January 1955, and the records charted higher, and he toured nearly every day of the year.

Elvis would let Carolyn know when his shows were close enough for her to attend, and he and Scotty and Bill would swing through and pick her up. That posed a problem.

"Mom didn't care a lot about my seeing musicians, and a lot of our dates were en route to and from his appearances. Boy, this almost drove her crazy."

It all made Carolyn's head spin, too. Everything was happening so fast—Elvis was like a comet streaking across the sky. By March, he was headlining, and by May, he created riots wherever he went. By June, he'd outgrown Neal as his solo manager, and by July, he'd hit the national charts. Come October, he would be too big for the little Sun label, and that meant he'd be ready for a national launch in 1956. And where would that leave *them*?

"I think the potential was there for us to fall in love, but the pull of fame, and the reality of how popular he was becoming meant the relationship didn't have a chance to develop. He was getting so busy that I never knew from one time to the other how long it would be until I would see him again."

Finally, she concluded that any time might be the last time. And after a few months, the romance flamed out.

"It wasn't like we broke up or said good-bye. We didn't even get to say good-bye. He was just whisked away and out of my life."

And just as Elvis's career was in its stratospheric rise, Carolyn's stalled.

"She was a beautiful young lady," in the view of Tom Bearden of the Hayride's Rhythm Harmoneers. "She had some projection, and she presented a good entertainer appearance." But she never found the right songs that fit her style, and she was said to rebuff the sexual advances of her manager, who lost interest in the female singers who refused to sleep with him. Without a competent manager, and with her mother limiting her personal appearances on the road, she was never able to advance to the next level.

"At the time, all I wanted to do was sing," she says. But then, after her professional and personal disappointments, she just wanted out. In late 1955, at the age of eighteen, she left the show and her recording career, and moved to Memphis, working at first for Bob Neal.

In recent years, an amateur singer who uses the surname Presley has said that he is one of twin sons of Carolyn Bradshaw and Elvis Presley. But his birth date suggests otherwise, and he has provided no proof of his parentage. Carolyn dismisses his claims in two words: "He's crazy."

According to Shirley Dieu, a friend of Priscilla Presley since the 1970s, "Anybody who's ever claimed that Elvis fathered her child has been tested, and they've all come out negative." Shirley was surprised, and told Priscilla so. "She laughed and she said, 'Can you believe it? I'm just as shocked as you are. You would think there's got to be more children out there. But nope. Never. Not a one.'"

However, that doesn't mean that there isn't a child who hasn't come forward. Horace Logan wrote in his book that he knew of at least one woman in Houston who had a daughter by Elvis during the Hayride days. Houston was one of the first big cities to embrace Elvis, and he appeared around the area frequently on package shows with other of the Hayride stars during that time.

"You're bound to remember me, Mr. Logan," the woman said when she called him twenty years later for help with concert tickets. "Elvis and I were always together when he was playing in Houston in '55." Logan didn't remember the woman, but he didn't doubt her story. And when she told him that her daughter was unaware that Elvis was her father ("I thought maybe if she could see him I might be able to get up my nerve"), he advised her to let sleeping dogs lie.

"I could hear her crying softly," he wrote, "as I hung up the phone."

Ann Raye *(left)*, Elvis, and Mae Axton, at the third annual Jimmie Rodgers Memorial Celebration, Meridian, Mississippi, May 25, 1955. Ann, who turned sixteen the following day, tried to get her father to manage Elvis. "I knew just his looks were going to get him somewhere." *(Courtesy of James V. Roy)*

"A Great, Big, Beautiful Hunk of Forbidden Fruit"

On a mild October night in 1954, Bob Neal invited country music promoter Oscar Davis to the Eagle's Nest in Memphis to see his new act. Davis, a short, silver-haired man who dressed to the nines, was in town promoting an Eddy Arnold show at Ellis Auditorium on behalf of Colonel Tom Parker, Eddy's former manager, who still did some of Arnold's booking. Like Parker, Davis was an old carny who'd seen everything. As a vaudeville promoter, he once even toured a girl "frozen alive" in ice. But the faded impresario hadn't seen anything like Elvis, and he told Neal, "Bob, this guy is incredible. I'd like to meet him." Two nights later, Bob brought Elvis backstage, where Davis told the young singer how impressed he'd been, and that he hoped they could work together.

The next day, Davis returned to Nashville and drove straight out to Madison, Tennessee, to see the Colonel, who was in the middle of lunch with yet another carny, Charlie Lamb, who'd gone legit as a country music journalist.

"It was really Oscar who found Elvis," Lamb says. "He came over and said, 'I saw the darndest act you ever imagined, this kid who does this twisting around and so forth.' The Colonel's eyes popped open, and he said, 'Where was he? Who is he?' And the Colonel got up from the table and pulled his car out and left. He still wasn't back when I went out there the next day."

D. J. Fontana, the staff drummer for the Hayride, sometimes went out on the road with Elvis, and he remembers Parker showing up in Texas and Arkansas. "We would see him walking around, hanging back in the shadows, but he never would say nothing. A lot of people just didn't want to deal with him."

However, Bob Neal, now Elvis's official manager, jumped at the chance. He recognized Parker as a "razzle-dazzle character" but knew the Colonel had

clout, and that he was an uneducated genius, a brilliant tactician. He also saw that Parker could put Elvis on the package tours that he took out to other parts of the country, into New Mexico, for example, beyond the Hayride's reach.

On January 15, 1955, Parker and his lieutenant, Tom Diskin, traveled to Shreveport to watch Elvis—outfitted in a rust-colored suit, a black-dotted purple tie, and pink socks—captivate the Hayride audience. Afterward, at the Captain Shreve Hotel, they met with Neal and hammered out an arrangement by which Parker would work in partnership with Bob on Elvis's bookings.

Already, Parker schemed to take total control of Bob's new sensation. But until Bob's management contract expired the following year, the Colonel was careful not to show his hand, even though it was obvious that Neal didn't know what he had: "I always felt that Elvis was going to be a big artist, but I didn't really realize the true scope. Nobody had ever been that big." On the other hand, Parker, a shrewd dealer with uncanny knowledge of human nature, knew what brought people into the big tent.

Born in Holland as Andreas Cornelis van Kuijk, he had entered the United States illegally in 1929, and after a stint in the U.S. Army, folded into the carnivals at the height of the Depression. It was there, between hawking his now infamous foot-long hot dogs (a hint of meat at each end, with lots of slaw in the middle), that he honed the merchandising and marketing skills he would later apply to the recording industry.

His entrée into the music business was Gene Austin, the 1920s crooner ("My Blue Heaven") who needed an advance man for his tent show, the Star-O-Rama Theater, in the late 1930s, the last hurrah of his career. Parker segued to booking country shows—particularly Pee Wee King and Roy Acuff—while employed as the field agent for the Hillsborough County (Florida) Humane Society in Tampa. Acuff later flirted with the idea of letting Parker manage him. But eventually, the bandleader thought better of it and told Parker to keep his eye on King's young vocalist, Eddy Arnold.

The two teamed up in 1945 ("I was just a poor, hungry guy who owned a guitar," Eddy said), and Parker worked around the clock on his behalf. While continuing to operate out of Tampa, he acted as Arnold's booking agent and manager, using the two-fingered hunt-and-peck system to type letters on flamboyant stationery festooned with Arnold's photograph. Soon the Colonel (his title was honorary, bestowed by Jimmie Davis, the singing governor of Louisiana, in 1948) was prosperous enough to move to a stone house outside of Nashville. Ever the showman, he kept a team of miniature ponies in the backyard.

Their association made Arnold one of the biggest stars ever to come out of Nashville, with a repertoire of number one records, radio shows, and two Hollywood movies. But Parker's brash, rough-hewn style clashed with Arnold's sophistication and polish. And in the early 1950s, Arnold learned that Parker, who took a 25 percent commission for exclusivity, was working with other artists on the side.

Both Arnold and Parker had encouraged Texas fireball Charline Arthur to come to town (Elvis would pay plenty of attention to her wild stage movements, allegedly borrowing a few), and Arnold wasn't threatened by his interest in developing the teenage Tommy Sands. But when the Colonel began booking dates for Hank Snow, Arnold dissolved the majority of their business dealings in 1953, Parker still getting the best of him with a financial settlement.

With his own Jamboree Attractions, the Colonel began booking Grand Ole Opry stars, placing many of them on New York radio and television shows through his association with the William Morris Agency. He also managed the 1954 "RCA Victor Country Caravan," showcasing Chet Atkins, Minnie Pearl, Hawkshaw Hawkins, and the Davis Sisters. Headlining was Hank Snow, already a star but soon to become bigger with the network television appearances that Parker arranged for him. The two made a deal to expand Jamboree Attractions to give Snow part ownership, rechristening the business Hank Snow Enterprises—Jamboree Attractions.

All along, however, Parker saw it as a temporary arrangement. He was always looking beyond country music for the Next Big Thing, someone he could call, in carnival parlance, "my attraction." He found him in 1955.

"When Tom was driving to New York to finalize what he needed to do about Elvis," recalls David Wilds, whose father, Honey Wilds, made up half of the blackface comedy duo Jamup and Honey, "he and [his wife] Marie stopped and spent time with us. I was about eleven, and I remember sitting in our living room and hearing Marie tell Mother, 'Tom's found this wonderful boy, just the most remarkable thing. Honey, he sings sexy hillbilly.' My mother looked kind of bug-eyed, and Daddy thought Tom had lost his mind, being gone over Elvis Presley. He thought it was the biggest mistake Tom ever made."

By the time he hooked up with Elvis, Parker could brag that he was one of country music's premier booking agents and advance men, even as many still saw him as a carny operator out for a quick buck. In addition to Pee Wee King, Roy Acuff, Minnie Pearl, and Jamup and Honey, at one time or another his stable included Ernest Tubb, Benny Martin, Rod Brasfield, the Duke of Paducah,

Clyde Moody, George Morgan, Slim Whitman, and the Carter Family. For a short spell, he also managed June Carter on her own. Now he was only too happy to get as many clients as possible on the Hank Snow Enterprises—Jamboree Attractions tours.

In February 1955, Elvis went back into the recording studio to cut his fourth Sun single, "Baby, Let's Play House." The Arthur Gunter song, heavy on playful innuendo and full of pent-up sexual energy, would be the first Elvis record ever to chart, climbing to number ten on the *Billboard* country and western chart, and number five on the country disc jockey chart, hanging on for a surprising fifteen weeks.

On February 6, three days after his recording session, Elvis realized a life-long dream when he performed two shows at Ellis Auditorium, where he had taken his fantasy curtain calls only a few years before. He was at the bottom of a bill that included hillbilly star Faron Young and gospel great Martha Carson, but the posters boasted "Memphis' Own Elvis Presley," and he was proud to make good in his hometown.

After the first show, he looked up in the autograph line, and there stood Billie Wardlaw. A flood of emotions came over them both, and they laughed to cover them up. Elvis took one of his new Sun Records promotional pictures and thought a minute, finally writing across it, "To Billie, My Little Ex-."

Between shows, Bob Neal arranged a meeting between Sam Phillips and the Colonel across the street at Palumbo's Restaurant. Parker brought his right-hand man, Tom Diskin, and things started off friendly enough with the four of them as they discussed how to further the career of the act that brought them together. Then the Colonel looked at Phillips and dropped the bomb: The boy could not realize his dreams on a small-time label like Sun. In fact, Parker had already met with RCA Victor, where he'd done business for Eddy Arnold and Hank Snow, to see about purchasing Elvis's contract. When Phillips protested, the Colonel turned a deaf ear. The papers might not be signed yet, but it made no difference whether Phillips *wanted* to sell Elvis's contract. The Colonel was now in control, and Elvis was changing labels.

· · · · · ·

On February 16, 1955, Elvis played the Odessa Senior High School Field House in Odessa, Texas, where fifteen-year-old Roy Orbison could hardly believe what he saw onstage. "His energy was incredible, his instinct was just amazing. . . . There was just no reference point in the culture to compare it."

Four days later, Parker sent Elvis out on his second Hank Snow–Jamboree tour of the month, billed as a "WSM Grand Ole Opry" show, with the added attractions of the Duke of Paducah, and Nashville music legend Mother Maybelle Carter and the Carter Sisters, Helen, June, and Anita. They would tour together again for three weeks in May, but Anita never got over his fevered gyrations, or the crowd's reactions to them.

"We went out there and watched him, and I said, 'My Lord!' The boy had talent, but I couldn't believe the audience! It was not just young girls—there were people with gray hair out there screaming. Every night, the girls would try to tear his clothes off of him. His buttons were always gone, and Mama would take the buttons off of all our clothes and put them on his. So we were always buttonless!"

Elvis had a huge crush on Anita, who played stand-up bass and sang soprano. Whenever Anita was around, said Red West, Elvis was like "a kid with six pair of feet." He did anything he could to get her attention.

Meanwhile, Elvis's relationship with Dixie was still limping along, and he had promised to take her to her junior prom on May 6. But he had shows right up until then—the night before, in fact, a pack of girls chased him across a football field in Mobile, Alabama.

"I was so afraid he was not going to get back in town for my prom, and his mom and I had been shopping, and she had bought my dress." However, Dixie was more fearful that they would never realize their plans for the future. One day he was unknown, and then "just overnight he was there. It was phenomenal."

He showed up at her door not in the dark blue suit of his own senior prom, but in a handsome white tuxedo jacket, and in Bob and Helen's brand-new Lincoln, which he'd borrowed for the evening. They double-dated with Dixie's best friend, Bessie Wolverton, and Elvis's cousin, Gene Smith.

It was a storybook evening—he looked like a movie star, and Dixie was proud to show him off to her friends. But she was troubled by the changes in Elvis. She knew in her heart that he had been unfaithful to her, which went against all the teachings of their church. And she didn't like his new friends, especially Red West, and a crowd of guys who had begun to hang around when Elvis was in town. They all smoked and drank and used offensive language, and the surprising thing was that Elvis seemed to want them around.

Why did he need them? It used to be that all Elvis and Dixie needed was each other, and they were hardly ever alone anymore. And what kind of future were they going to have if he was running around the country all the time?

They argued about it, but they had argued before over his possessiveness. Elvis was always jealous of what she might be doing while he was away, though she had more cause to worry than he did. Yes, she went to Busy Betty on Lamar and danced, but she wasn't dating anyone. Was she just supposed to sit home for three weeks while he was away? She wanted to have some fun, too.

Friends on both sides had begun to doubt that they would marry, because "neither one would accept the other's terms," in the words of Barbara Hearn, who went to school with Dixie at South Side and worked with her at Goldsmith's department store.

But each time Dixie gave Elvis back his class ring—once or twice he even asked for it back—they'd both cry and want to make up. Sometimes he would angrily speed off in his car, and before she could even get back in the house, he was there again, and they'd sit on the porch and hold each other, both in agony over their decision. What were they going to do?

"It was kind of a mutual thing. His career was going in one direction, and I didn't feel that I could be a part of it. [It] consumed him, and there wasn't much time for anything else."

They kept patching it up, saying they could work it out, but by the end of the summer, they both knew it was over. She had wanted him to stop at the top and go back to a simpler life. But he said, "No, I'm in too deeply." He was already swallowed up by the myth, by something he couldn't control.

"He felt like there were too many people depending on him, and he couldn't do what he wanted to do. He was told to go here, and go there, and these people can come, and these can't. . . . I knew that it was not ever going to go into anything."

She and Gladys cried about it together, but they would always be friends. They were family almost. And that would never change. Whenever he was back in Memphis, they would see each other, and the respect and love would always be there. Even if Dixie married someone else and Elvis decided to quit the business and stay home and have children with her, well, she would just get a divorce. That's how much he meant to her.

· · · · · ·

Less than a week after Dixie's junior prom, Elvis continued his pursuit of Anita Carter. On May 12 they were at the Gator Bowl Stadium in Jacksonville, Florida. Elvis went on first, and when he came offstage, the Carter Sisters were ready to follow. As usual, Elvis had worked up a sweat—he could literally lose several

pounds in one performance—and as he passed by the Carters, he started stumbling and tottering around, finally collapsing in Anita's arms.

A shout went up, and somebody laid Elvis out and said he was unconscious. Anita held his head in her lap and stroked his forehead, and the Colonel ordered an ambulance to take him to the hospital. Red was worried as hell, as were Scotty and Bill and D. J., who was now working the road with them. They sat around in Red's hotel room, scared to death, wondering if he were dying from some mysterious disease, and awaiting word from the hospital.

About 1 A.M., Red heard a knock on the door, and there stood Elvis, "healthier than a herd of cattle, grinning from ear to ear." They pumped him full of questions, and he told them he was fine. Only when Scotty, Bill, and D. J. went on to their rooms did Elvis say he'd faked the collapse just to get his head on Anita's lap.

It wasn't true. He really was ill, and running a fever from exhaustion. The emergency room doctor gave him a shot and suggested he take some time off. Instead, Elvis asked for a peanut-butter-and-banana sandwich, and concocted the story about faking the collapse out of embarrassment. But clearly he was infatuated with Anita, who faked her own collapse with Elvis sometime later. However, their relationship never really moved beyond flirtation.

Elvis then turned his attention to Anita's older sister, June, whose marriage to country singer Carl Smith was in trouble. But June dismissed him out of hand. "Elvis got a crush on whoever was handy. It was just his thing. He liked women. I decided I wouldn't touch him with a ten-foot pole. Lord only knows where he'd been. He was a sexy man who really thought he could have any woman that he saw. But he couldn't, and I think that was a big shock to his ego."

Elvis wasn't one to give up, though, and on a trip to Nashville with Red, he decided to look her up. As Red recounted the story in *Elvis: What Happened?*, June was off at a gig, and so Elvis and Red simply forced a window in her Madison, Tennessee, house, and broke in to wait for her. They made themselves at home—fixing a meal in her copper pans and skillets (and ruining them in the process), and going to sleep, fully dressed and dirty, in the master bedroom.

Carl came home the next morning, found the forced window and the messy kitchen, and like a scene from some hillbilly rendition of "Goldilocks and the Three Bears," wondered, "Who's been breaking into my house? Who's been eating my food?" And finally, "Who the hell is that sleeping in my bed?"

Elvis woke up and casually said, "Oh, hi, Carl."

"You would have thought he would have chewed us out," Red wrote. "But he gave us a big hello and laughed. He showed us all around the big house."

Smith had seen far crazier behavior from Nashville's honky-tonk crowd, and he took it all in stride. That night when June and her sisters came home, they had a big southern dinner and stayed up half the night talking and singing.

"I kept praying that [story] would never get out," June said. "I saw Red right after he wrote it, and he said, 'June, I should never have put your name in there. I did everything I could so that people would know that you were really a good girl.' And I appreciated Red doing that, but I didn't think it was anybody's business. Elvis was my friend. We had a lot of fun together. We sung late at night, playing the piano, but I wasn't going to run and jump and play with him like the other women, and he knew that. But he also knew that we were just real good friends, and we stayed that way."

June and Carl Smith divorced in 1956, and June went out on the road doing shows with Elvis on her own. She was always sentimental about the experience— "I've got two or three little notes and pictures that Elvis gave me"—but she ended up with more than memories and souvenirs.

"Elvis introduced me to Johnny Cash's music. We would stop in all of the little restaurants down in the South to get something to eat, and he always played Johnny's records on the jukebox. He loved to hear him sing. He tried to sing all of his songs right in my ear, and I heard them over and over and over. Then John walked up to me one night [in 1956] when I had come home from New York to do the Opry. He said, 'I'm Johnny Cash. I know you work with Elvis Presley. He's a friend of mine and I would like to meet you.' And I said, 'Well, I should know you already, and I believe I do. I've had to listen to you enough.'"

Their son, John Carter Cash, says that his mother would get a mischievous twinkle in her eye whenever she mentioned Elvis and told him, "You know, son, your father was always jealous of Elvis."

And so was Carl. Underneath his good humor about the break-in, there was tension: June kept a billboard poster of Smith on which Elvis had drawn a silly mustache and goofy glasses. Below it, he scribbled, "Painting by Presley."

After Carl moved out of the house, June would sometimes let Elvis stay there "to rest" at the end of a tour.

"Like most children," John Carter wrote in *Anchored in Love*, a memoir of his mother, "when I was young, I thought my mother was capable of doing no wrong. . . . I know without a doubt that she was a good person of high standards and solid morals. On the other hand, she was being charmed by one of

the greatest sex symbols of our time. The temptation to give in to his advances, at least in some small way, would have been tremendous. I have a hard time blaming her."

· · · · · ·

*On May 13 the Hank Snow–Jamboree tour was back at the Gator Bowl in Jackson-*ville for a second night, with fourteen thousand screaming fans in attendance, nearly all of them there for Elvis. Two nights earlier, in Orlando, headliner Hank Snow found Elvis a hard act to follow, the girls yelling for Elvis to come back out onstage.

Parker always denied that, insisting, "Hank Snow could follow anybody. He was a great artist." But Charlie Louvin, who with his brother, Ira, played Elvis dates on the Snow shows, remembers it being true. Unlike Bob Neal, who never planted screamers, Parker wasn't just banking on throngs of hormonal teenagers—he helped orchestrate them.

"The Colonel sent Tom Diskin to Woolworth's to give kids free tickets to the shows. The only thing they had to do was scream 'We want Elvis.' A professional act like Hank Snow or the Louvin Brothers couldn't work with a hundred kids hollering 'We want Elvis.' Hank would sing two or three songs and then just say, 'Hell, you can *have* Elvis.' "

Faron Young, also on the Orlando bill, remembered that the announcer tried to subdue the crowd, telling the audience that Elvis was out back signing autographs, only to have the auditorium empty out.

Possibly in deference to Snow, whose ego outsized his small frame, Elvis, sporting a pink lace shirt that looked like a woman's blouse, closed his Jackson-ville set with the crack "Girls, I'll see you all backstage." Before anyone knew how to stop it, a swath of frenzied teenagers broke through the police barricade and chased Elvis into the dugout locker room. Mae Boren Axton, a forty-year-old Jacksonville schoolteacher who handled publicity on the show for her old friend Tom Parker, was sitting with the Colonel as he counted the money from the night's take.

"All of a sudden I heard Elvis's voice shouting, 'Mae! Mae! Mae!' I jumped up and ran down there, and so help me, about five hundred kids had crawled under those pull-up doors. Elvis had climbed on top of the showers, and he was hanging there darn near naked. They'd torn his lace shirt apart, and everybody had pieces of his coat, and they even had his boots and socks off."

By the time the police got things under control, Elvis, clad only in his pants,

looked sheepish and scared. The police helped him down, but Mae found that quieting the crowd was another matter.

"I heard all this screaming, and I went up out of the dugout and saw this girl I had taught. I said, 'Hey, honey, what's the matter?' 'Oh, hi, Miz Axton, boo hoo, hoo, hoo . . .' I said, 'Wait a minute. What is it about this kid Elvis?' And she gave one of the best definitions I've ever heard. She said, 'Oh, Miz Axton, he's just a great, big, beautiful hunk of forbidden fruit.'"

The Jacksonville riot marked the first time the Colonel knew precisely what a gold mine he had in his new client. It also marked a turning point in the young life of thirteen-year-old Jackie Rowland, an Elvis fan who got backstage through the efforts of her grandfather, a policeman.

Lying transfixed on the floor, eating a bowl of peanut butter and jelly mixed together, Jackie had watched Elvis on television. Weight had always been an issue for the five-foot-tall teenager, and when she arrived at the Gator Bowl that night, she weighed 190 pounds. Wearing her blue Kirby Smith High School band sweater and a pair of blue suede shoes, "I'm sure I must have looked like a giant blueberry. Or maybe a grape."

Backstage, Elvis signed her program and introduced her to the Carter Sisters, and then talked to her longer than he did most of the girls. When it was time for her to go, he kissed her on the cheek, "and, of course, I was in love. He was so handsome, and so nice to me, and not condescending about my weight."

It got her thinking, fantasizing about what it would be like to see him again, especially if she could diet herself down to the size of the other girls. If she lost weight, she asked her mother, Marguerite, could she go to Tennessee to see Elvis? "Sure," her mother said. "If you lose the weight, I will take you to Memphis."

Two months later, on July 28 and 29, Elvis was back at the Gator Bowl in Jacksonville, and yet another riot ensued. Fellow performer Marty Robbins, who had joined the bill as a way to repay Colonel Parker for a favor, remembered it vividly. "They really mobbed him. I couldn't imagine that happening. They chased him in the dressing room, underneath the stands in a shower room. He was on top of the showers, trying to get away from people. Guys and girls, alike, were trying to grab a shoe, trying to grab just anything."

Robbins knew for certain that Elvis was going to be completely irresistible to women, because of what happened in the next town, Daytona Beach. "When we went out on the beach to go swimming, the girls were all looking at him like, 'Boy, there is *something*!' He had everything in his favor. He had youth, he had

good looks, he had talent, he was single, and then when he got Colonel Tom Parker on his side, that was it. He was the best manager a person could get."

Mae Axton had also seen the reactions in Daytona Beach and Orlando. She'd worked all three cities after getting calls from Bob Neal and Sam Phillips, asking if she could help establish Elvis in the Florida markets. The daughter of a Texas rancher and confectionery shop owner, she was a big-hearted gal who dabbled in songwriting, freelance magazine writing, and promotion work to supplement her teaching job.

As the mother of two sons, Johnny, eleven, and thirteen-year-old Hoyt (later a singer-songwriter on his own), Mae had a soft spot for young men trying to make their way in the world. She also wanted to help Bob Neal, throwing in fifty dollars of her PR money for Elvis's fee, and arranging for a free motel room in each of the three cities. Elvis called her when he got to the edge of Daytona Beach, and when she met him, she found herself instantly charmed.

"He had a quick, sensual smile that [made him seem] shy and vulnerable at the same time. And he was so sweet and polite and nice that you couldn't help but love the kid. I wanted to make things easy for him."

They visited for awhile, and then she had to do a radio interview, she said, but she told him to wait, that she wouldn't be gone long.

"When I came back, the other guys were down at the beach, looking for the cute girls. But Elvis was leaning over the grillwork on the balcony, staring at the ocean. I said, 'Hi, honey, are you okay?' He said, 'Mae, I can't get over this ocean.' Now, he grew up on the mighty Mississippi, but he said, 'It's so vast, just no end to it. I'd give anything in the world if I had enough money to bring my mama and daddy to Florida and let them see the ocean.'"

It touched her that his priority was his parents, when most twenty-year-olds would think about having fun. Later that year, she and Tommy Durden would write Elvis's breakthrough hit, "Heartbreak Hotel," and she would let the Colonel cut Elvis in for a third of the writers' credit. He hadn't written one word, but just maybe Elvis would see enough royalties to make that Florida dream come true.

.

More and more, Elvis relied on women behind the scenes such as Mae Boren Axton and Marion Keisker to create or advance some fundamental aspect of his career. Both Mae and Marion were mother figures, but not every woman who aided him would fall into that age group.

On May 28, 1955, sixteen-year-old Kay Wheeler and her sister Linda huddled together in the darkness of their bedroom in Dallas, Texas. With their parents asleep, they turned their radio up as loud as they dared, hoping to pick up a rhythm-and-blues station that would let them hear something along the lines of Johnny Ace's "Pledging My Love," or the Penguins' languid "Earth Angel."

The Wheeler girls were white and lived in a typical 1950s brick tract house in a respectable middle-class neighborhood. But after their cousin, Diana, played them "Little Mama" by the Clovers, and Hank Ballard and the Midnighters' more risqué "Work with Me, Annie," they demanded more of their music than the vanilla hits of the day. And so they began making pilgrimages to buy rhythm-and-blues records at the "colored" record store, riding the bus downtown and "walking self-consciously along a street lined with pawnshops, run-down stores, and hip Negro bucks who examined [them] with frank stares and amused grins," as Kay described in her book, *Growing Up with the Memphis Flash.*

Fifty-five years later, she still remembers the thrill. "Here we were, these nice little suburb kids, smuggling these 78 rpm records into our room the way people would do drugs or something. And I guess we were—we were doing rock and roll."

On that late spring night, glued to the radio, the Wheeler girls stumbled on a broadcast of the Big D Jamboree, a country radio hoedown show much like the Louisiana Hayride and the Grand Ole Opry. There, they heard an unknown song from an unknown singer, who delivered a stuttering, hiccuping vocal of sexual threat: "I'd rather see you dead little girl than to be with another man."

The Wheelers caught their breath. That knifepoint guitar! That doghouse bass! It wasn't quite blues, and it wasn't entirely hillbilly, but it sure got them way down deep. Kay turned up the volume to find out who and what it was: "Elvis Presley," with "Baby, Let's Play House."

Kay looked at her sister.

"I think I'm going to faint."

She didn't, but she and Linda talked about him all night, wondering about his name. Had they heard it right? Was he colored, or was he white? Then two weeks later, a girl at school started telling Kay all about how a guy named Elvis played in Gladewater, Texas, and nobody could hear a word he said. He was so good-looking and sexy the girls screamed every single second.

Five months passed before Kay actually saw what he looked like, on a poster at the Melody Record Shop. He was leaning back with his pelvis tilted forward and his mouth wide open. Was he in pain? It was hard to tell. A lock of greasy

hair fell on his forehead, and that cinched it. She had to have it. Kay felt her cheeks burn, but she was a tiny thing, size four, so who would notice? She quickly removed the poster from the wall, put it in her bag, and walked out the door. At home, she and Linda shrieked with delight. God, he was a *dream*! "I'm going to meet him," Kay announced, and that was that.

Her opportunity came a few days later, though it was indirect, unplanned, and would take some time. She was visiting her Aunt Billie, secretary to the president of KLIF, the popular Top Forty radio station in Dallas. They were in Billie's office when deejay Bruce Hayes stopped by with a record in his hand.

"Listen to this name, 'Elvis Presley,'" he said. "Have you ever heard anything so corny in your life?"

Kay couldn't stand it.

"It was like making fun of him. I'd just gotten the poster, and we were flipping out over him, so I just blurted out in my antagonistic teenage way, 'Well, he's going to be big! I've already got a fan club for him.'"

It wasn't true, of course, but when Hayes asked her for her address on that Saturday afternoon, she gave it to him without thinking. And she never heard him announce, "If you want to join the Elvis Presley Fan Club, write to Kay Wheeler. . . ."

The following Tuesday, she wasn't feeling well ("I was good at playing hooky—if I had the least bit of cramps I wouldn't go to school"), and she was in the den lazing around in her robe when her mother called her.

"Kay! There are all these letters on the front porch in stacks, and they're all to you!"

"What?"

There were hundreds of them, bundled together and tied with string, all of them asking about how to join the fan club, or wanting a card or a photo.

"I laid these letters on the floor all across the room, and I just couldn't believe it. I was flabbergasted. It was a crazy moment. A *crazy* moment, especially since I didn't have a fan club."

But soon she would, sanctioned by Colonel Parker's office in Tennessee. ("It was like they courted me.") Bob and Helen Neal had started the first regional fan club, but they didn't have the pink-and-black passion of a teenage girl with a poster of a prominent pelvis. Within weeks, Kay Wheeler would be the president of the first national Elvis Presley fan club. And no one could have guessed at the power of a sixteen-year-old Texas girl to muster the troops, which would soon be growing by the thousands every day.

Elvis joins June Juanico on horseback, Gulf Hills Dude Ranch, July 1956. Gladys considered her part of the family. "I still love Elvis," June says today. "He's never been replaced." *(Robin Rosaaen Collection)*

SEVEN

· · · · · · · · · · · · · ·

Biloxi Bliss

On June 26, 1955, Elvis and the Blue Moon Boys played the Slavonian Lodge in Biloxi, Mississippi. The previous February, Elvis had appeared in two shows at the Jesuit High School Auditorium in New Orleans, on a bill with fifteen-year-old Martha Ann Barhanovich, who briefly recorded for Decca under the name of Ann Raye. Her father, Frank "Yankie" Barhanovich, a district manager for the American National Insurance Company, moonlighted as a talent booker, mostly because Martha hoped to make a career out of singing.

After the Jesuit shows, for which both performers were paid $150, the teen-aged Martha begged her father to bring Elvis to Biloxi, where the Barhanoviches lived. "Daddy was booking all these people not as young as Elvis, and well, I just knew he needed to book him for people my age." And so the elder Barhanovich brought Elvis to the area for three nights that summer, the first at the Slavonian Lodge, named for the people of South Slavic origin, the Croatians who populated the region and dominated the oyster and shrimp trade.

The local newspaper, running a story in advance of the show, reported that it was expected to be a sellout, given Elvis's popularity on the Hayride, and since "the teenagers just love him."

Salvadore "Penue" Taranto, a member of Johnny Ellmer's Rockets, which often brought 300 to 400 kids into the Lodge, was there that night, and he was blown away. He'd heard Elvis on the jukebox, but he was unprepared for a full show of music that would soon be termed rockabilly. "It was so different from any type of music that you couldn't even relate to it at the time. Here was everybody making fun of this guy shaking like he had something wrong with him. But what he did, he did good. When he popped that first hit, he really took off."

The following day, seventeen-year-old June Juanico had just gotten home from work when she got a call from her girlfriend Glenda Manduffy, who had attended the show at the tiny lodge. She was practically screaming into the phone about this guy Elvis Presley and the way he moved, and how it was wall-to-wall females in the place, and she couldn't get close enough to him to really see him. But he was going to be at the Airmen's Club at Keesler Air Force Base that night and the next, and *c'mon,* June, let's *go!*

June thought about it a minute. She had a steady boyfriend, the six-foot-four Norbie Ronsonet, and you were supposed to be eighteen years old to get into this place, but reluctantly she went. She'd already heard other people say "You need to go and see him!" And so she caved. She called Norbie and told him she had to go somewhere with her friend, and that they'd be late getting in.

The first time she'd ever heard of Elvis, she was listening to the radio. "That's All Right (Mama)" came on, and then later, "Good Rockin' Tonight."

"My first thought was that he was a nervous old man, an elderly hillbilly."

When June and her friend got to the club, they saw maybe thirty-five women in a sea of airmen. They picked a table right by the stage, because Glenda kept saying, "Wait 'til you see this guy! He's so good-looking!" To really get a good look at him, June realized they needed to be on the dance floor, since the couples would block their view between the table and the stage. She was skeptical about him—this nervous *old* guy—but when he finally came out, her jaw dropped. "I thought he was the most gorgeous thing I'd ever seen."

Elvis noticed her, too. He picked her out of the crowd, her suntan showing off her white dress as she danced. Still, she didn't go over to him during intermission, when he stood and talked to a clutch of folks, mostly airmen. "Come on, Glenda," she said, orchestrating a game of cat and mouse. "Let's go to the ladies' room."

When they passed by him, he and June exchanged brief eye contact. Then as the girls made their way back to the table, Elvis reached through the swarm and grabbed her by the arm.

"Where are you going? You're not leaving, are you?"

It was the first time she'd really looked into his face, and she just about died. He had those big dreamy eyes, but he didn't look like anyone she had ever seen, either. His voice, laced with Memphis twang, was playful and seductive, a mix of little boy charm and adult sensuality. But he also seemed like a gentleman.

"No," she said. "I'm going back to my table."

"I get through here in about an hour. Will you stay until I get off? Then you can show me the town."

She felt herself getting goose bumps, but she didn't want to show it. She'd never even kissed on a first date, and she didn't want to send the wrong message. She hadn't screamed at his performance like the other girls.

"Well," she said, "Biloxi is such a small town, there's really nothing to see."

"Oh, really. Well, show me what there *is* to see."

He promised he'd take good care of her, and he could see by the look on her face that she thought it was all happening too quickly. He said, "In this business, if I meet somebody and I don't make a fast move, I'm not going to make a move at all. I may never see you again."

She was excited and scared, but she heard herself say okay, and after his second set was over and he loaded up the equipment, he pulled around front in his parents' pink-and-black Crown Victoria with a bass strapped on the top. She'd never seen anything like that—it made the car look like a tank with a gun turret.

"I have to go back to the motel real quick to change clothes," he said, and when they got there, he didn't invite her in ("the room's a mess"). She sat there a few minutes, wondering if she'd done the right thing in even coming, and then Scotty and Bill came out of the room and stood on either side of the car. It frightened her—she didn't know they were just getting the bass down—and then finally Elvis came out and they went to Gus Stevens's restaurant to see co-median Dave Gardner do the floor show. They stayed a long time, just listening to music, but they were both underage—Elvis was still just twenty—so they left before anybody found out, and went and parked at the pier at the White House Hotel.

They talked in the car for a while, and then he wanted to go for a walk. He took her hand, and there was just enough moonlight that she could watch for the cracks in the pier's old boards so her high heels wouldn't get stuck. Suddenly, he stopped. He turned her around so he was behind her and slipped his hands around her waist and kissed her neck. She felt a shock of electricity, and squirmed, but he promised he wouldn't hurt her. He kissed her tenderly, first her forehead, and each eye, then her nose, and finally her lips. She kissed him back in a way that had a future in it.

"Where did you learn to kiss?" he asked, surprised at her passion.

"I was just getting ready to ask you the same thing!" she said, and she still remembers what it was like: "Soft, full lips. Nothing too sloppy. Oh! It was just

marvelous, a little pecking here and there, a nibble, and then a serious bite. It started small, and then got bigger, and then went little again before ending up with a lot of eye contact."

They sat on the end of the pier and talked and smooched and talked and smooched, and said the usual things that young lovers do, about not wanting to be any other place in the world in that minute. Then she thought about what her mother always told her about being in a compromised position, and got her wits about her and asked what time it was. Elvis tried to look at his watch, but the moon was so pale he couldn't tell if it was 1:15 or 3:05. It was definitely past her curfew, though, and she said, "Oh, my God, my mother's going to kill me! I'm always home by midnight!"

They parked outside her mother's house, and it was just supposed to be for a minute. "Do you have to go in?" he asked, his voice saying he hoped she didn't. "Well, not yet," she told him, "but if that light comes on right there in the corner of the house, I've got to run."

The light never blinked, but June knew her mother kept an eye out to see what they were doing. She didn't care. She just wanted to talk to him. It was 6 A.M. when she finally got out of the car, an eight-hour date. By that time, they'd talked about everything. He was shocked that her parents were divorced. He thought of marriage as a lifelong commitment, he said, and when he got married, it was going to last forever. And he told her all about his twin, who died at birth.

"By the way," she said, "what's your real name?"

"What do you mean my real name? My name is Elvis Aaron Presley."

She'd never met anybody quite like him.

Now she couldn't sleep. She kept thinking about his face, the way it looked the first time she saw it up close. She wasn't sure what she was feeling, but it was wonderful, and she wished she could keep it forever.

He said he had shows in Mobile, but he would phone her when he got back to Memphis. But each time he placed his person-to-person call, some guy answered the phone, and Elvis didn't know what was up, didn't realize it was June's brother, Jerry, who didn't tell her that she'd gotten a call and that she was supposed to phone the operator back to be connected. June prided herself on being feisty and independent ("I wasn't staying home monitoring the phone"), and she didn't tell a soul about her date with Elvis. It was too surreal, and deep down, she wanted it all to have meant as much to him as it did to her. She didn't want to make a fool of herself.

Over and over, lying in bed, she heard what he'd said when she asked him

what it felt like to perform like that, to walk out onstage and have the entire place go wild, to shake all over and have all the girls screaming with just a toss of his head. "I can't explain it," he said. "Maybe something like sex, but not exactly." Gosh, she thought. That many orgasms would kill a person!

· · · · · ·

In July 1955 seventeen-year-old country singer Wanda Jackson had just graduated from high school in Oklahoma City, Oklahoma, and already she'd had her own radio show and enjoyed a national hit, "You Can't Have My Love," a duet with Billy Gray, the bandleader for western-swing king Hank Thompson. Her father, Tom, who watched his dreams of becoming a singer crumble during the Depression, managed her, and her mother designed and sewed her stage outfits, which in time went to gold lamé and shimmering sequins. "I was the first one to put some glamour in the country music—fringe dresses, high heels, long earrings," she says.

With a bewitching beauty and a surplus of sass, she was turning heads all across the Southwest. Bob Neal had had his eye on the dark-haired teen for some time, and that summer, he tapped her for a two-day package show with Elvis. When her father accepted the booking—one night in Cape Girardeau, Missouri, and a second in Newport, Arkansas—Wanda had no idea who Elvis Presley was, since Oklahoma City wasn't playing his records. But Tom Jackson, going by what Bob Neal had reported, told her Elvis was "getting popular real fast."

She met him at a Cape Girardeau radio station on the afternoon of July 20, and "I was quite impressed—a real handsome guy." He dressed a little flashier than the guys back home in Oklahoma—yellow coat, for example—and when he left the station, she saw him get into a pink car. "I had never seen a pink car, so I knew that he was different."

The first night, Wanda and her father were in her dressing room when Elvis went on. "All of a sudden, my dad and I started hearing this screaming. I mean really screaming, just constant. My dad said, 'Well, gollee, I wonder if there's a fire or something? Let me go look.'

"I started getting my coat and my purse, and he came back and said, 'No, relax. But you've got to see this for yourself. You'll never believe it.' He took me to the wings, and there was Elvis singing and moving and gyrating, and all these girls standing at the foot of the stage, screaming and reaching for him. We had never seen anything like that. It seemed sexy, but I don't think he was trying to be vulgar, because he was flirty with the girls down front. He'd look at them and

they'd scream, and he'd shake at them, and then they'd squeal. He was just having fun."

They worked together again for four days in August, through Mississippi, Alabama, and Arkansas, and then went out on a weeklong tour in October, swinging through Texas and Oklahoma with Johnny Cash, now one of Sam's Sun artists, and newcomer Porter Wagoner. Wanda found Elvis fun to be around. "On those tours, all us artists would keep something going to make each other laugh, and he laughed all the time. He didn't take himself seriously." Somewhere along the miles, they started dating, finding they had the same appreciation for simple pleasures.

"If we could get in a town early, and it was large enough to have a movie theater, we'd go to a matinee, and then after a show, we'd go out to eat, usually with Scotty and Bill and my daddy. Then sometimes we'd get a hamburger and just drive around the town and talk." Then, after the tour, she'd go home to Oklahoma City, and he to Memphis. But they talked on the phone almost every day. "Being able to know him and know his heart made me admire him a lot. And certainly his entertaining and music abilities knocked me out."

In a sense, they recognized themselves in each other. She had the same sultry eyes and full lips, and "his career was just beginning to blossom, and mine was, too. He was just a fine person. And he was never out of the way at all with me. Treated me just like a lady."

What impressed Wanda most was the fact that Elvis took such an interest in advancing her career. He kept telling her that a lot of girls could sing country—not that she wasn't great at it—but no girl was doing rockabilly, and she should give it a try.

"He was just really eager that I try this kind of music like he was doing. I'd say, 'But Elvis, I'm just a country singer. I can't sing songs like that.' He said, 'You can, too. I know you can. You've just got to try.' So he took me to his home, and we played old black blues records, and he sang to me and tried to show me the feel for it."

Few performers of either gender ever got such specific musical advice from Elvis. The following year, Wanda signed with Capitol Records and took his advice, writing her own spitfire songs ("Mean, Mean Man," "Rock Your Baby") because "no other girls were singing rockabilly. I was the first one."

In time, Wanda would become the preeminent woman of the genre, the Queen of Rockabilly. She fearlessly explored the cracks between country and rock and roll, and in such songs as "Let's Have a Party," she snarled with low-

class abandon about female lust ("The meat is on the stove/The bread's a gettin' hot/Everybody run they got the possum in the pot . . ."). Like Sister Rosetta Tharpe, Elvis's early hero back in Tupelo, she was ahead of her time, carving out a niche as "the first [white] girl to do raunchy rock and roll like the guys did." Her "Fujiyama Mama" even hit number one in Japan.

However, not everyone was ready for such a femme fatale. On her one Grand Ole Opry performance, Ernest Tubb found her bombshell appearance so provocative he forced her to wear a coat over her spaghetti-strap dress.

"I didn't consider myself a rebel at all," she says. "I wasn't even very familiar with the term."

But Elvis, who saw her as his musical peer, if also another replacement for his lost twin, understood it perfectly. She would soon be known as "the female Elvis."

Within a few months of meeting, he gave her one of his rings. "A man's ring. It had little chipped diamonds. He wasn't very rich at that point. We were in Shreveport, Louisiana, and he asked me if I'd step outside with him. We went over and stood by his car, and he asked me if I'd be his girl. I had a crush on him, so I said yes, of course, and I wore the ring for about a year. It was a precious time."

But things were happening so fast for both of them, and by then, there were so many girls—and so many rings—it was almost hard for Elvis to keep them straight.

· · · · · ·

In the fall of 1955 Elvis was back in Biloxi, playing three nights there, two shows at the Biloxi Community House on November 6, and return engagements at the Airmen's Club on November 7 and 8. He'd kept trying to get in touch with June Juanico, but without success—that same guy kept answering the phone, and Elvis kept leaving messages, but June never called back.

Elvis was not the only performer to be playing Biloxi twice that year. Over at the Biloxi Beach Club, a sticky strip joint, seventeen-year-old Tura Satana entertained the men—mostly sailors and winter tourists—with her exotic dance routine. "I had so much fun with those navy men," Tura remembers. "I'd slide up to the end of the stage and say, 'Okay, who's first?' "

Her specialty was tassel twirling. She had such good muscle control she could twirl while lying flat on her back, and even twirl in opposite directions, one at a time, switching off. Sometimes she'd snatch the blushing sailors' hats

right off their heads and twirl them, too, and the whole place would go nuts. "Someday I'm gonna fly if I can get enough rpm's!" she'd yell to whoops and hollers. She would eventually be rated the top tassel twirler in the world.

Tura may have been young, but she had already lived a lifetime. Born Tura Luna Pascual Yamaguchi in 1938, she was the daughter of a silent film actor of Japanese and Filipino heritage and a Native American circus performer. She spent her childhood in Manzanar, a Japanese internment camp near Lone Pine, California, and after World War II, the family relocated to the west side of Chicago. Unlike most Asians, Tura developed a voluptuous figure and blossomed early.

At ten, while walking home from school, she was attacked and gang-raped by five boys in an alley, probably as a hate crime toward the Japanese. One of them, she says, was a cousin of the policeman sent to investigate, and the judge looked the other way. She ended up in reform school "for tempting those boys into raping me" and was classified as a juvenile delinquent.

Afterward, her father taught her martial arts as a way to protect herself, but her anger still festered. She became the leader of a vigilante girl gang ("We had leather motorcycle jackets, jeans, and boots, and we kicked butt"), and patrolled the neighborhood to make sure the streets were safe for women.

At thirteen, and already five foot seven, the geisha beauty married seventeen-year-old John Satana in a union arranged by her parents. Nine months later, she took off for Los Angeles. There, she filled her days modeling bathing suits and posing nude for silent screen comic and 3-D photographer Harold Lloyd, and by night she worked as a cigarette girl at the Trocadero, the famed Sunset Strip celebrity hangout.

Before long, she was back in Chicago, living with her parents and dancing in clubs, first as an interpretive dancer, and then, once she was offered more money to take off her clothes, as a stripper. She quickly perfected her exotic dancing, learning some of her shimmies from her mother, who taught her to fast hula to "The Hawaiian War Chant." Soon she was traveling the club circuit with her elaborately beaded costumes and hand-painted kimonos, all of which eventually came off to reveal a string and pasties. And things got hotter: She carried a prop Buddha whose hands burst into flames when she brushed against his palms.

"When I was dancing," she says, "burlesque was an art—classy and elegant and requiring talent." In time, she would be voted one of the best burlesque dancers of the century and parlay her talents into a film career, most memorably as the leather-clad Varla in Russ Meyer's 1965 cult classic, *Faster Pussycat! Kill*

Kill!, an homage to female violence. Film critic Richard Corliss described her performance, for which she did all her own stunts and fight scenes, as "the most honest, maybe the one honest portrayal in the Meyer canon, and certainly the scariest." Not surprising, the butch villain was a character she helped to create.

The night that twenty-year-old Elvis first returned to Biloxi, he was too keyed up after his shows to sleep and wandered into the rough-and-tumble Biloxi Beach Club. There, he watched the young hootchy-kootchy dancer onstage. Remembering the time he saw Gypsy Rose Lee at the Cotton Carnival in Memphis, Elvis was fascinated by the way Tura moved her body, the way she held the lubricated sailors as sexual hostages. He saw how she tantalized them with each suggestion of undress, and how they lost their minds when she rolled her breasts around in her hands, spinning the little twirlers at the nipples.

Sultry, sassy, and exotic, Tura Satana was nothing like any girl Elvis had known. The Hayride girls were either shy virgins who hoped for a kiss, or hungry country girls who'd had plenty of quick sex out behind the barn. But Tura was a mistress of seduction. And she was gorgeous, her dark hair piled high on her head.

He went backstage to see her and introduce himself, saying he was a performer himself just up the road, in town for only a few days. She was smoking and drinking too freely from a paper cup, and my God, her breasts were still pretty much hanging out, and her derriere, too. She looked like a hooker.

"My mama wouldn't want me in a place like this," he said later. But she seemed like a lady underneath all that, and he wanted to ask some questions about the way she moved. And so, as he had done with June Juanico, he asked if they could take a walk on the beach. Tura sized him up. She liked his features—his beautiful blue eyes and blond hair, greased dark—and he seemed harmless. Besides, she could take care of herself, and so she said yes. He flirted with her along the way.

"It's dangerous for a beautiful lady like you to walk out here alone," he said.

"Oh, it is?" she flirted back.

"Yes, ma'am," he said. "You shouldn't do this alone. Somebody might hassle you."

"Well," she countered. "What about you?"

They were both into it now, though she'd never been called "ma'am" before.

"Nobody will hassle me," he insisted.

"Really?"

"No, nobody will hassle me."

They walked for a long time, and eventually he made his move, some light kissing and touching, but it never got out of hand. Mostly, they sat on the beach and talked until long after the sun came up. He told her about his mother, and said he'd been traveling a lot the last year, meeting a lot of different people. He could hardly believe where a song and a guitar had taken him. Then he asked her about her life, and she told him about all of it, even the nightmare parts. He wanted to know about Hollywood, too, and what it was like out there. And then he asked about her work, about dancing.

She told him she'd been doing it only about a year, working out of New Orleans, but she'd seen some things, too, that was for sure. If the owners of the clubs knew she was underage, they'd have a heart attack. He asked about the men who came to see her, and how she felt about that. She told him she made them part of her routine, that she joked with them, saying, "Okay, where have you got your hands right now?" Of course, there was always one who yelled out, "I wish you were my mother!" And she'd predictably say, "Yeah, and you'd still be a breast baby, wouldn't you?" It always drew a laugh.

Finally she told him, "I have to go. I've got shows tonight." And he said, "I do, too." Then he told her he was in Shreveport most Saturday nights appearing on the Hayride. He asked how to get in touch with her and said he'd invite her to one of the shows. His mom came down sometimes, and he wanted them to meet, though already he was thinking he didn't want Gladys to see Tura as some little tramp. Tura said that she played in Shreveport, too, and it would be great to meet his mother. She sounded like a lovely lady. And he was such a good-looking guy, she thought, and so nice. So, yeah, maybe they would get together. Maybe they would.

· · · · · ·

The fall of 1955 brought so many big changes that Elvis seemed to be in a daze half the time. The Presleys had moved to another rental house, this one at 1414 Getwell, where they paid eighty-five dollars a month. It was right around the corner from where they'd been on Lamar, but Elvis was on the road so much that Vernon and Gladys had to pack the boxes and wrestle with the furniture without him.

The biggest shifts were in his professional life, and Elvis was torn about some of them. His Hayride contract was renewed at $200 an appearance, a jump of more than 1,000 percent. The Colonel didn't want him in that deal and advised against it. But Vernon insisted—who knew how long this gravy train

would run? And Scotty and Bill had convinced him to add drummer D. J. Fontana full-time, and Elvis wasn't sure that was the right thing to do, either, especially since the Colonel hammered him to drop Scotty and Bill altogether.

Even more troubling, Parker had steamrollered everybody in moving Elvis's career forward. The cigar-chomping impresario had pretty much squeezed Bob Neal out of the picture now, though Bob and Helen loved Elvis so much they continued to cosign for what was becoming Elvis's fleet of Cadillacs—some pink, some yellow. And Sam Phillips, too, was about to be left in the dust, the Colonel finalizing his deal to get Elvis off of Sun Records and on to RCA.

Sam was philosophical about it. With a buyout of $35,000—an astronomical and unheard of price at the time—he could sign and promote a number of new artists. He already had several in the wings. Carl Perkins's "Blue Suede Shoes" was about to be released, and Sam was also giving more attention to developing Johnny Cash. He hadn't planned on turning a hundred percent of his talents over to Elvis, especially since every Elvis session was arduous and took a great deal of time.

Besides, tension had been mounting been Sun and the Elvis camp for several months, ever since Colonel Parker's involvement. The Colonel had completely won Vernon over to his side, telling him money would rain from the sky once Parker got Elvis moved to RCA, and Vernon had become antagonistic with Sam and Marion both.

Marion remembered back to the beginning, when Elvis's first release came out, and he stood there with a record in his hand and his eyes full of tears. He was so happy and humble, saying, "To think this has happened to me. This is what I've always wanted all my life, my very own record with my very own name on it." Now, under the suggestions of Colonel Tom, Vernon had become very difficult. And, of course, Elvis didn't want to do anything his father disapproved of, which put him under great stress.

There were other good reasons to let him go, too. Elvis, being young and full of piss and vinegar, seemed accident-prone. He'd already had several wrecks in his Cadillacs, and the 1954 model, which he'd had painted pink, caught fire and burned near Hope, Arkansas, after a rear wheel bearing locked up. Elvis was in the Caddy with a date, and when Bill and Scotty caught up with him, the latter remembers, "He was on the side of the road, frantically emptying the trunk, throwing guitars and amplifiers and clothes."

And now he was riding motorcycles, partly in emulation of Marlon Brando and James Dean, though he'd picked up the habit from Jimmie Rodgers Snow,

Hank's son, with whom he often went riding in Nashville, where people tended not to recognize him. "I had two motorcycles, and he really loved just taking off and going riding a lot," says Snow. But to Sam's point of view, it meant that one day he could have a multimillion-dollar property, and the next day he could have nothing. Once, during a terrible storm, Marion heard someone calling her name. There was Elvis, careening down Union Avenue on a motorcycle with a girl on the back. Didn't the boy have enough sense not to take that thing out in the rain?

Even through the transition, though, Elvis and Marion remained friends. He seemed loath to cut his ties with her and just happened to be in the neighborhood all too often.

Marion was busier than she'd ever been, since Sam planned to use part of his buyout money to realize another of his dreams—to establish an all-girl radio station, WHER. It signed on almost immediately, at the end of October 1955, and Marion oversaw nearly all the operations, helping Sam set it up and making its first announcement on the air. Now she had three jobs and often she fell asleep at her desk. One morning about three o'clock, she faintly heard someone yelling, "Marion! Marion!"

"I looked up and Elvis was standing there absolutely white as a ghost. He was passing by on his motorcycle and had seen me through the blinds, and he was really upset and shaky. He said, 'Marion, I thought you were dead!'" She was going to miss that boy.

On November 21, 1955, all the parties, even Bob Neal, met at Sun and signed the final contract, the Colonel patting Gladys on the back as she gave her son a kiss.

But Gladys didn't trust the Colonel, and he knew it. That's why he sent Hank Snow, his business partner, to sweet-talk Gladys into letting Elvis sign the management contract, having already used Jimmie Rodgers Snow to bond with Elvis for the same goal. "Basically, we were about the same age, and I carried the first good intention contract to Lubbock, Texas, where I met Elvis and was put on the same show with him to discuss the idea of him signing with Jamboree Attractions. I didn't know enough about what was going on to honestly know what was happening, if you know what I mean. I was just a teenager."

The elder Snow assumed, of course, that Presley would be signed to the agency he jointly owned with Parker. But when the Colonel traveled to Memphis, he took two contracts with him that day. One bound Elvis to Hank Snow Enterprises–Jamboree Attractions, but the other exclusively to Parker. It was the

second one the Colonel got the Presleys to sign, effectively swindling Snow out of half of Elvis's earnings for life.

Gladys had no knowledge of any such chicanery: She just wasn't sure which she feared most—what Parker was going to turn the boy into, or what might happen to him on his own. Her fears were not unjustified. Already, the floor had collapsed at a show in Bono, Arkansas, and more than one man had been overheard saying things like, "I'd better not see any girlfriend of mine going up after an autograph from that singer."

Things had gotten much rougher at Elvis's appearance at the Reo Palm Isle Club in Longview, Texas, in August 1955, when a trucker went to the parking lot to look for his wife, who had somehow disappeared after Elvis's performance. They'd been there with another couple, and Elvis had flirted with the women throughout his songs, giving them "that sizzling, sultry look from the stage," as Stanley Oberst and Lori Torrance wrote in *Elvis in Texas: The Undiscovered King 1954–1958*. They giggled like teenagers, their husbands just rolling their eyes.

The trucker thought that perhaps his wife had gotten sick afterward, but she wasn't in the women's room, so in Oberst and Torrance's account, he decided to check the car, his friend following him for a breath of air and a smoke. "As they approached the car, they noticed a stranger glancing out the window and then disappearing. The two increased their speed and ripped open the door. His wife screamed from the passenger side and dove for the petticoats in the floorboard. Elvis fell onto the dirt parking lot, struggling to zip up. The trucker reached down with huge, burly arms and grabbed the skinny frame, shaking the stuffing out of it and driving in a couple of well-placed right hooks.

" 'Not my face, not my face!' the singer yelled, covering the aforementioned location. 'I've gotta go back and play.' The truck driver got in a few more gut busters, then let his quarry flee back to the club."

Grover Lewis, the late master of New Journalism, witnessed a similar, if not the same, situation that year. He was in college at North Texas State and knew Elvis from the Big D Jamboree. As one of "the only serious writers at North Texas at the time" (the other was Larry McMurtry), he was "always looking for guys like [Marlon] Brando and [James] Dean, who spoke uniquely to people our age, our generation, and Elvis qualified. He had that dangerous sense." As such, Lewis became acutely attuned to Elvis's sensual, raw, and bluish music, having grown up with strict segregation in small towns around Dallas and Fort Worth. In 1955, then, he went to a number of Elvis's shows around the region.

Lewis could not precisely remember where he saw Elvis take a beating, though it might have been the M-B Corral in Wichita Falls in April 1955. Nearly forty years later, in 1994, Lewis described it as "a country place somewhere near Wichita Falls—it was one of those places that had . . . a barn dance ambiance, but it was an old World War II hangar that somebody had dragged out into a wet part of the county. If there was a headliner that night, it would have been him. He was dressed like a cowboy country singer, and already driving a Cadillac, [though] old and rusted-out."

The budding reporter was fascinated both by Elvis and by the phenomenon he represented, "because he virtually epitomized the southern high school hood. On this night, and I believe it was a weeknight, he got up and was doing his act, singing country songs, and he began to make eyes at a young woman who was sitting close to the front with her boyfriend. The boyfriend was a big, tough oil-field worker, a roughneck type. One of the guys seated at the table went to the restroom, and Elvis made goo-goo eyes at this girl, and then made signals, which I could follow, to meet him in the parking lot. I suspect he was feeling magically charmed around that time, and there was a recklessness about it. In other words, Elvis was full of his own sexy charisma and thought he could get away with it. And the girl was more than willing."

Lewis trailed Elvis and the girl out to the parking lot just to see what would happen. "I knew very likely that there would be a fight, and, in fact, a fight is what happened. The roughneck came back to the table, discovered that his girl-friend was gone, waited around for her, and then went looking for her." He discovered them out in Elvis's Cadillac, smooching.

"I don't know if it went any further than that, because I didn't get close enough to see. But the guy hauled Elvis out of the car and just literally beat the hell out of him. Just beat him bloody. In fact, he didn't play anymore for the rest of the evening. He got his butt tromped."

Even without jealous husbands and boyfriends, Elvis was getting so big now that anything could happen at any time, even a repeat of the Jacksonville, Flor-ida, riots. Without meaning to, the crowds could tear him apart like jackals on a rabbit. The fan reaction was so intense, so out of control, it was frightening to just be seen with him, even in Memphis. Marion had witnessed it herself.

WHER had a broadcast booth at the Mid-South Fair that fall, and Marion was on her way one day, walking from her home.

"All of a sudden this car pulls over to the curb, and there's Elvis, all shining and resplendent. Since he never passed up a gal walking down the street without

some kind of greeting, he said, 'Hop in, Marion.' So I did. What girl could resist a 'Hop in' invitation from Elvis?

"We decided to go to the fair together, and we parked out in the back and started walking. Suddenly, I realized we weren't alone, and I began to hear these cries of 'It's him!' 'No, it's not him.' 'Oh, it *is* him! I tell you it's *him*!' Well, the crowd started to swell up like sugar candy on a cone. And this one strange little girl was clinging to him. I don't know what she was asking him, but she kept on, 'Will you please, Elvis? Will you *please*?' And she wouldn't let go. Finally I took her hands and said, 'Okay, he promised.' Someone said, 'Who's she?' And Elvis said, 'This is my wife.' It was the wildest thing, and you never heard such a to-do and carrying on.

"As we moved through the Fairgrounds, we picked up a constantly growing entourage. We finally got to a booth where Elvis said he was going to win me a teddy bear. He started pitching balls, and he won me a teddy bear the very first throw. The lady who was operating the stand handed it to me, and before my arms could close around it, the bear went *whish!* All of a sudden it was gone. That little girl snatched it. So Elvis said, 'Okay, I'll win you another bear,' and he did, and the same thing happened. I promptly lost three teddy bears.

"By this time the crowd had closed in, and they were pressing me so hard against the booth that my shinbones were about to crack on the planks that ran across the front. We were in such peril that the owners helped us leap across the counter. We went under the canvas in the back and raced madly for the front gate, and got in a police car. They whisked us around the corner to where Elvis's car was parked, but the whole thing left me bruised and battered, and without any of the teddy bears."

It was certainly a horrible example of what can happen if you're out with a personality like Elvis and get caught up in a fan mob, Marion thought.

"After that, I never wanted to be seen with him in public again."

Elvis and Barbara Hearn, backstage at the Tupelo Fairgrounds, September 26, 1956. She had left his shirt, a gift from Natalie Wood, back in Memphis. Later, she gave him the gold vest he wore with it on *The Ed Sullivan Show*.
(Courtesy of Barbara Hearn Smith)

EIGHT

.

"An Earthquake in Progress"

As history would see it, 1956 would be year one, ground zero in the phenomenon known as Elvis Presley. So much metamorphosis would occur in both his personal and professional lives that 1956 could be seen as a reference point, a time when Elvis would go from being a regional performer to a national sensation, ending his age of innocence. By the end of the year, the shedding of his old skin would be both powerful and complete, and Elvis would be almost unrecognizable as the shy, unassuming boy that fame could never change.

On January 8, he celebrated his twenty-first birthday, flying home to Memphis from a Hayride appearance in Shreveport, and then insuring his 1955 pink-and-black Cadillac Fleetwood. He was taking care of business and being responsible. No one could have known it, but he was precisely through the first half of his short life, destined to die at forty-two.

Though he was now officially a man, a grown-up, he would never reach an adult's maturity in his relationships with women. His fun-loving pranks of handcuffing and wrestling would evolve into more acceptable forms of physical teasing, and he would begin to have more complex relationships. But he would remain the *puer aeternus,* a Latin term for "eternal boy," seen in mythology as a child-god of divine youth, an Adonis who stays forever young.

In pop psychology, the *puer* is seen as being a socially immature adult and suffers from what has entered the lexicon as the Peter Pan Syndrome. The reference is to J. M. Barrie's much-loved novel and play, as well as to Dan Kiley's 1983 book, *The Peter Pan Syndrome: Men Who Have Never Grown Up.* But in analytical, or Jungian, psychology, the *puer* is defined as an older man whose emotional

life remains arrested at the level of adolescence, and who is almost always enmeshed in too great a dependence on his mother.

The life of the *puer* is provisional, since he fears being caught in a situation from which he cannot escape, whether it is with a woman or a job. He fantasizes that he is simply marking time, and that in the future, the real woman, or the right career opportunity, will come along. What he dreads most is to be bound to anything at all, and so he refuses to grow up and face the challenges of life head-on. Instead, he waits for others or divine providence to do it for him.

"He covets independence and freedom, chafes at boundaries and limits, and tends to find any restriction intolerable," writes Daryl Sharp in *Jung Lexicon: A Primer of Terms & Concepts.* "Common symptoms of *puer* psychology are dreams of imprisonment and similar imagery: chains, bars, cages, entrapment, bondage. Life itself . . . is experienced as a prison."

· · · · · ·

On January 10, 1956, Elvis arrived at the RCA recording studio in Nashville, a small building at 1525 McGavock Street, not far from downtown. The label had not yet established its own Nashville facilities, and so the company built the studio with the Methodist TV, Radio and Film Commission. Chet Atkins, the country guitarist who was also RCA's Nashville studio chief, sat behind the console as Elvis recorded his first RCA sides. Yet some of the players were already familiar to Elvis. Both drummer D. J. Fontana and piano virtuoso Floyd Cramer from the Hayride were on the sessions. And among the three songs they cut that day was "Heartbreak Hotel," the morbid and oddly unsettling blues tune that Mae Axton had written with her friend Tommy Durden about a dwelling place for the lost and lovelorn. By April, the single, both eerie and menacing, would sell one million copies, earning Elvis his first gold record.

The song found its genesis when Durden, who followed the ponies, picked up a copy of the *Miami Herald.* He looked at the horse-race entries, and then scanned the rest of the paper. "I just happened to catch a little small thing in there about a man who killed himself. I don't recall any names, but the only thing he left in the way of a suicide note was a sentence, 'I walk a lonely street.' "

Atkins recalled that on one of the livelier songs they recorded that day—either Ray Charles's rhythm-and-blues classic "I Got a Woman," or the Drifters' "Money, Honey"—Elvis "started jumping around, and he split his pants right in the seat. I'll never forget them. They were pink with black piping on the sides. He asked somebody to go back to the motel and get him another pair, and he left

his old ones lying around someplace. The next day, this girl who worked for the Methodists found them. She said, 'What am I supposed to do with these?' I said, 'Keep 'em. They'll be worth a lot of money one day.' She thought that was very funny. But six months later, I heard she was trying to get on *I've Got a Secret.* Her secret was going to be that she got Elvis Presley's pants."

Elvis was all over the television that year, beginning on January 28, when he made his first of six appearances on *Stage Show,* a variety hour produced by Jackie Gleason and hosted by big-band legends Jimmy and Tommy Dorsey. He flew into New York a few days earlier with the Colonel to meet the top brass at RCA, including Anne Fulchino, the Boston-bred national publicity director who had upgraded RCA's pop and country coverage, but always hoped the label would break a big new pop artist. Elvis had been to New York once before, in 1955, when he and Scotty and Bill auditioned for *Arthur Godfrey's Talent Scouts,* where a woman (possibly Godfrey vocalist Janette Davis, who hailed from Memphis and became a full member of the production staff in 1956), turned them down. But it was still all so new to Elvis, meeting all these people who didn't talk like he did, and who didn't seem to share his sense of humor. He didn't really know how to act. When Fulchino extended her hand, she was horrified to find that Elvis grasped it wearing an electric buzzer on his finger.

"My attitude was to make a total star out of Elvis. Not a kid with a one-hit record, but a broad, overall star. So I said to him, 'You know, that may be big in Nashville, but it will never go in New York. Don't ever do it again.' Now, he was a smart kid, and if you caught him doing something that was dumb for the occasion, he absorbed it and he didn't repeat it.

"For example, I took him to Klube's, a German restaurant on Twenty-third Street, just a block across the street from where the RCA office was at that time. I ordered pork chops, and he started to pick his up with his hands. Then suddenly he noticed that I was eating mine with a fork. And he paid attention to where the forks were and what I did with them. This is where I give him great credit. He wanted to get somewhere and he knew he had to do certain things to get there. He was very intelligent. Not the Harvard-type intelligence—the instinctive intelligence."

But it was still a lot to deal with in a short span of time. A few days later, Fulchino and RCA hosted a press reception for Elvis, and reporters, amused by the flash in the pan with the funny clothes and the suggestive stage moves, asked about his reaction to his success. "It scares me," Elvis said. "You know, it just scares me."

By spring, his anxiety about fame seemed just as strong. In Albuquerque,

New Mexico, British reporter Lionel Crane, of the London *Daily Mirror,* asked about the audience reception, "a scream that I thought would split the roof," as Crane put it. "It makes me want to cry," Elvis said. "How does all this happen to me?" Five days later, it was the same in Waco, Texas. His fame "happened so fast," Elvis told a local reporter. "I could go out like a light, just like I came on." By then, the press was calling him "the most talked-about new personality in the last ten years of recorded music."

It was all snowballing now. The Colonel, putting pressure on Harry Kalcheim at the William Morris Agency in New York, got him booked on *The Milton Berle Show* for April, and after a Hollywood screen test at Paramount Studios in late March, producer Hal Wallis signed him to a contract for one motion picture with an option for six more, the money starting at $15,000 for the first film, up to $100,000 for the seventh.

Elvis's acting experience, however, consisted almost entirely of the Christmas pageants in the Assembly of God church in Tupelo as a child. He was understandably nervous, then, for his tryout, especially as he was given the material—two dramatic scenes from *The Rainmaker,* which Wallis was about to begin filming with Burt Lancaster and Katharine Hepburn—only the night before. For a musical number, he lip-synched his new single, a cover of Carl Perkins's "Blue Suede Shoes," while strumming a prop guitar.

The results of the screen test surprised nearly everyone. Steve Sholes, head of RCA's country and R & B divisions, and Chick Crumpacker of the label's promotion staff, viewed the test in New York along with other Victor people, and Crumpacker recalls they could barely believe what they saw. Elvis suggested he had the power to legitimately follow Marlon Brando or his hero, James Dean.

"We went back to the office, and it was the talk of the place, like, 'My God, this guy has all of that natural quality that these other actors have become famous for, because he has that same directness and ability to be himself on the screen.' It looked like he wasn't acting at all. We were stunned."

Screenwriter Allan Weiss, who would later write five Presley pictures, also saw it. In his view, Elvis seemed amateurish in the dramatic scenes, looking like "the lead in a high school play." But once the music was added, "the transformation was incredible . . . electricity bounced off the walls of the sound stage. [It was] like an earthquake in progress, only without the implicit threat."

Elvis was too in demand to have to give up the majority of his Saturday nights for the Hayride now, so the Colonel sent Horace Logan a cashier's check

for $10,000 to buy out his contract, with the promise to appear on a special Hayride charity show in December. Logan was getting a bargain, the Colonel told him. By then, Elvis would be so big they'd have to hold that show someplace other than KWKH—the girls would tear the place down.

The swirl of it all "appears to be a dream to me," Elvis told reporters in Lexington, Kentucky. He was sounding more optimistic now, in part because he had a new ally. Joe Hazen, Hal Wallis's business partner, was excited about Elvis's potential as an actor. He sent a memo to Wallis saying Elvis's "meteoric rise is unquestionably a freak situation, but that still does not detract from the fact that as a straight actor the guy has great potentialities." Elvis, who hoped he wouldn't have to sing in his movies, was beside himself with joy. The former movie theater usher told Wallis, "My ambition has always been to become a motion picture actor—a good one, sir."

In March Elvis, buoyed by a future in films and the Colonel's promise of turning a million dollars' worth of talent into a million dollars, paid $40,000 for a single-story, ranch-style house for himself and his parents at 1034 Audubon Drive, located in a fashionable, upscale neighborhood of doctors and lawyers east of downtown Memphis near Memphis State University. A typical American dream home with pastel green board-and-batten siding, slate gray tiled roof, red brick trim, and black shutters framing white windows, it was the first house the Presleys had owned since leaving Tupelo. Elvis was proud that he could provide it, and he particularly liked the double carport: he and Vernon were constantly jockeying automobiles in the driveway.

The home had three bedrooms, and Elvis used one for his huge collection of stuffed animals, many of them gifts from fans. For his primary bedroom, Gladys chose a remarkably girlish motif, decorating twin beds with pink taffeta dust ruffles and white quilted bedspreads with pink-and-blue flowers. From there, she hung pale yellow wallpaper flecked with blue and orange—white ceramic figures, caught in midleap on black oval plaques, dotted the walls—and installed a dark pink telephone that matched a selection of his pink stuffed animals. In truth, his room looked like something his fans would have wanted themselves, but Elvis seemed not to mind.

That spring, he began seeing Barbara Hearn, a friend of Dixie Locke he had known casually for several years. A dark-haired beauty who bore more than a passing resemblance to Elizabeth Taylor, Barbara exuded sophistication and intelligence. Soon, she would be first runner-up in the Miss Memphis contest, the other contestants voting her "Miss Personality" for her charm and wit.

But Barbara also had a quiet, serious side. Like Elvis, she was an only child and found herself in the same role reversal that Elvis had with his mother, in that sometimes she was the parent. Her mother and father divorced when she was still quite young, and she lived with her grandparents until she was twelve. "My mom was sort of a party animal, and I worried about her a lot, because I would mostly get in before she did."

She had seen Elvis perform once at the Odd Fellows Hall. A friend had called and asked if she wanted to go see the new hillbilly singer. Barbara asked his name. "Elvis," her friend replied. Barbara said, "What's an Elvis?"

The next time she saw him, he was dating Dixie, with whom she went to school at South Side High. At Christmas 1954 they'd both gotten jobs at Goldsmith's department store, Dixie assigned to the basement and Barbara to the main floor bakery, which proved to be a bit beyond her.

"The first person who came up wanted a loaf of French bread, and she said she wanted it sliced. So I put the French loaf in the slicer, and I was supposed to pull the lever and *then* put the bread in and push the button. But I didn't, and I pulled the handle, and it shot that loaf of French bread all the way across Goldsmith's main floor. Quickly, I found myself in the basement with Dixie, in the 'seconds,' in men's underwear and socks."

Barbara and Dixie rode the bus to work, but one day Dixie said her boyfriend was coming to pick her up. She'd see if he would give Barbara a ride, too, since she didn't live far out of the way. When the big Lincoln pulled up ("It was so huge we could have gotten everybody who worked in the basement in there"), Barbara was surprised to see it was Elvis.

From then on, Elvis gave Barbara a ride home many times, and often she would go with Dixie to visit his parents on Alabama Street. Elvis was already appearing on the Louisiana Hayride and doing road shows, so Barbara got to know his family before she really knew him. She liked them all, including Elvis's grandmother. ("She was a great old lady.") Barbara even liked Vernon, who was more standoffish than Gladys, "certainly not outward and friendly like she was." But once when Barbara and Dixie were visiting, Vernon overrode his own frugality and went out and bought a bag of hamburgers for everyone. As far as Barbara was concerned, the Presleys may have had very little, but they were a nice, hospitable family, and she felt comfortable in their modest home.

At the time, Barbara was dating Ronald Smith, the musician who had suggested that Elvis try out for the ill-fated job with Eddie Bond's band. But when she next saw Elvis, in early 1956, much had happened—he and Dixie had bro-

ken up, and she and Ronald, too. She was now working as an advertising copy-writer for a local jewelry store, Perel & Lowenstein, and since she was so photogenic, her boss sometimes asked the nineteen-year-old to do the store's live TV commercials ("standing up and showing off their stuff"), broadcast during the weather and the news.

She was at WMC-TV one night, on the job, when Elvis dropped by the station to visit his friend George Klein, who worked in radio out of the same building.

"Elvis came to the window of the TV studio and poked his head in and watched what was going on. When I came out, the first thing he said was, 'How's Dixie?' I said, 'Well, I don't know. I haven't seen her since we got out of school.' "

Barbara was moved that Elvis still cared enough about Dixie to ask. But Elvis interpreted her comment to mean that Barbara no longer had any special allegiance to Dixie, and that she was free to date whomever she pleased. She had a girlfriend waiting with her at the studio that night, and Elvis suggested the four of them go to the Variety Club. When they got there, they were surprised to find themselves the only people in the place. They had a Coke and sat and talked, and Barbara could tell he was interested in her.

"He said he was going on a tour, and he would call me from there. I said, 'Okay,' and gave him my telephone number. And sure enough, he did." Barbara would become Elvis's first publicly acknowledged girlfriend as he hit the national spotlight, and they would be much photographed together.

Unlike most of the girls Elvis dated, Barbara wasn't mesmerized by his stage movements. She liked the way he kissed, and certainly theirs was a boy-meets-girl attraction, even though "I wasn't carried away by his looks or anything." She didn't think he was strange, as so many did, because she was attracted to unusual people. But she found him surprisingly insecure—that's what all the hair primping and clothes were about, she thought, not vanity. But she also thought he was "very personable," and fun and funny, and he made her laugh. She never knew just what he was going to do.

"Often, Elvis would drive up alongside the bus that I was riding home. He would get the attention of the bus driver and have him stop so I could hop off and continue my journey home with him, sometimes on his motorcycle. Of course, all the other passengers were thrilled to see him."

Their dates included many of the typical activities Elvis had shared with Dixie—going to the Fairgrounds, taking in a movie, riding around and stopping for burgers and Cokes, and driving over to Poplar Tunes and looking through records. They talked by the hour about music, listening to the radio and discussing

the songs and the singers. They would often sit at the organ, and Elvis would play their favorite song, Kathryn Grayson and Howard Keel's "Make Believe," and try to get Barbara to sing with him, teasing her because she couldn't carry a tune.

When Elvis was away, Gladys would often call Barbara and ask her to come out to the house and visit with her, and Gladys sometimes sat at that same organ. "She couldn't actually play, but she would touch the keys, and it seemed to produce the most mournful sounds. A lot of people say she was funny and witty, but I never saw that side. She was interesting and amusing at times, but after Colonel Parker and the fame came into play, I think she was more sad than anything, wishing she could awaken and find life as it was before, knowing it would never be, and just not wanting to accept the definite change."

Things seemed to be closing in around Gladys. The Audubon Drive neighbors wanted a word with her about everything—they didn't like it that she hung out her wash ("This is not that kind of neighborhood"), and they hated the fans who trampled through the grass and clogged the traffic on their quiet street. It all just made her nervous, like the trees she'd had cut down around the property in Tupelo. She started taking diet pills to help with her weight, and like so many in her family, she began to drink heavily, eating onions to disguise her breath.

Her older sister Lillian had spoken to her about it, though Barbara never knew her to be the slightest bit intoxicated. "She was always neat, clean, and meticulously dressed, even in a duster housecoat, and never appeared in hairpins or curlers. She carried herself as a woman who still felt she was the attractive girl she once was."

However, deep down, Gladys was gripped with fear that someone would hurt Elvis. She was gracious to the girls who came to the front door, and handed out face tissues so they could wipe the dust off of Elvis's cars and keep it. But she was obsessed that they would accidentally tear him apart in their love for him, or, after the Texas incident with the roughneck, that their jealous boyfriends would kill him. Young men, angry that their girls had made fools of themselves in charging the stage, were already saying rude things like they wanted a piece of his ass, or they wanted to knock the shit out of this pretty boy, change his face. It made Gladys tremble all over. When Elvis and Barbara went to the movies, "I would telephone her a couple of times during the evening to let her know that we were all right, and that there was nobody threatening around."

Gladys worried so much that she kept herself in a perpetual state of gloom, and her health began to fail. She was often run-down, and her feet swelled from kidney trouble. Her eyes, dark shiners now, took on a frightened look. Overall, she

was proud, anxious, and lost. Elvis thought maybe she needed a pet and got her a tiny lapdog named Sweetpea, after the adopted son of Popeye, the cartoon sailor, but Gladys didn't really like animals all that much, and little seemed to cheer her.

"She was serious and concerned," says Barbara. "She had to be. Goodness knows she was the captain of that little ship, with all the responsibility that entailed."

Vernon, as usual, was virtually no help. He was still nearly a nonparticipant in the household, and besides, he was preoccupied with the idea of Elvis buying him a used car lot ("Presley's Used Cars"). He thought he could make a go of it, and it would get him out of the house.

For the time being, he helped Barbara answer Elvis's fan mail, which arrived in big, bulging canvas sacks, even though much of it had been funneled to Kay Wheeler, the fan club president in Texas, or Colonel Parker's office in Madison. "I wrote most of Elvis's fan letters," Barbara remembers, "and Mr. Presley and I signed his name."

As Dixie had before her, Barbara was becoming like one of the family now, and Gladys sometimes visited her mother, Pearl, a strong, determined, charming woman, at her home on Marjorie Street. For the longest time, Vernon parked on the street, and Gladys huffed and puffed up the long steps to the big Victorian house. Finally, one day Barbara's aunt came out and said, "Mrs. Presley, why don't you just drive up to the back door? There are no steps back there."

Just as Elvis had a way of making every girl feel as if she were the one, Barbara saw that Gladys did the same. "I know she liked me and enjoyed my company. We would go for the proverbial Sunday afternoon drive when Elvis wasn't home, and we sat and talked together a lot. But I think she made all of the girls feel special. I understand why so many say that Mrs. Presley wanted Elvis to marry them. She wanted him to get married, and she wanted lots of grandchildren."

And so Barbara wasn't surprised when Elvis gave her a ring, even though she had mixed emotions about it. They were at Jim's Steak House in Memphis, having dinner with some other people, when suddenly, "He just reached in his pocket and put this little ring box in front of me. My first thought was 'Oh, no! He's going to ruin everything!' Because I truly thought for a second that it was an engagement ring, and getting married at nineteen was way down on my list. When I saw that it was a black onyx with a couple of diamonds around it, I was so happy. I did not want to get married. I wanted him to care for me, and I cared for him a great deal, but I would have been happy to have gone on as we were practically forever."

In retrospect, she and Elvis weren't a great match, because they both came from "a family of worriers—I could give lessons, really, in worrying." While Gladys perseverated about one thing, Vernon stewed about another, usually money. "We were having a meal at their house, and Mr. Presley was going through the bills. He picked one up and looked at it, and he said, 'A hundred and twenty-six dollars!' And then he named a jewelry store. He said, 'What in the world is this for, son?' And Elvis said, 'Oh, Daddy, don't spoil everything for me!' It was my ring, a hundred and twenty-six dollars."

Barbara saw the humor in such a situation, but she was far more troubled by Elvis's jealous streak. One night, they went up to talk to Dewey Phillips, and they came out of the radio studio to find a large crowd had gathered for Elvis. He stopped to talk to people, and Barbara stepped back out of the way. In a moment or two, a young man came up and started making conversation with her.

"Elvis broke away from that crowd, came over, got me by the arm, and marched me like a naughty child down to his car. I thought, 'What in the world is happening here?' I said, 'What's the matter? Are you angry with me?' And he said, 'I don't want you standing around talking to men on the sidewalk.' He went on and on and on, and I was just flabbergasted."

The irony, of course, was that Elvis felt free to do whatever he wanted with other women. "My husband tells everybody that Elvis and I dated steadily for a year. And I say, 'No, I dated *him* steadily for a year. He didn't date anybody steadily for more than fifteen minutes.'"

Their relationship was thoroughly chaste. "Lots of hugging, kissing, and closeness—perhaps activity a lot of girls would have killed to participate in— but nothing sexually explicit. Reputation was a big deal around my house."

Barbara never asked him about it, but she suspected that he divided women into "good girls" and "road girls," the latter of whom were fair game and didn't mean anything to him beyond the moment. "He was very, very respectful to women. If you could see how he treated me, my mother, his own mom, his grandmother. We were people he cared about. The ones who went backstage were in a different category. They were fans."

· · · · · ·

On April 15, 1956, Elvis, billed as "the Nation's Only Atomic-Powered Singer," played the Municipal Auditorium in San Antonio, Texas. There to meet him was Kay Wheeler, the virginal, seventeen-year-old president of the first national Elvis Presley fan club. Kay was in something of a teenage daze. A year earlier,

she hadn't even been able to find a picture of Elvis. But by early 1956, working from her Dallas home and aided by her two sisters, she had built the club into more than 20,000 members, each of whom received a large autographed photo of Elvis, a "Presley pink" membership card, and a four-page monthly newsletter, "The Presley Press." Though the Colonel's office had encouraged her efforts, Kay was as atomic-powered as the object of her affections, and only Colonel Parker matched her devotion and energy in promoting Elvis into a major heartthrob. Campaigning radio stations to play his records, and instructing the flock to do the same, she hardly had any time for homework, let alone her boyfriend, Pat.

At the beginning of the month, Kay had received a letter from Parker's secretary, Carolyn Asmus, telling her that Elvis would be on tour in Texas, and inviting her to attend the kickoff show in San Antonio. Shortly thereafter, she received a telegram from the Colonel himself, authorizing her to go backstage. When the big day came, she chose a clinging, pale beige sheath dress, dangly pearl earrings, and a pair of spike heels. Then she boarded the Greyhound bus for a 270-mile ride that would mark her first trip away from home. "Hell and high water wouldn't have stopped me. I looked out that Greyhound window thinking, 'Oh, my God, I'm going to see Elvis.' "

When she arrived at the auditorium, an old, dirty structure that seemed too unglamorous for what was about to unfold, she flashed her telegram to a guard, who waved her through. Backstage, Tom Diskin, the Colonel's second in command, pointed to an unmarked door and nonchalantly said, "Elvis is in his dressing room. Just go on in."

Kay took a deep breath, straightened her dress, and turned the tarnished doorknob. She hoped he would like her. She thought he might, because even she could see she looked a little bit like his mother.

He was sitting in front of a mirror, smoothing down his dark blond ducktail, and turned to look over his shoulder at her.

Her knees went wobbly. "Hi, Elvis," she managed. "I'm Kay Wheeler, the president of your fan club."

"My fan club president?" he asked. He seemed surprised. Kay thought he knew she was coming, but there wasn't time to think about that now, because he had on a blue satin shirt that matched his eyes, and his voice was soft and sensuous, and he had a mischievous grin on his face, and he was looking straight at her. "If any man ever stepped out of a dream," she thought, "it was Elvis Presley."

He stood up and walked toward her, staring, she thought, as if he were trying to read her mind. The room began swirling, but she could see he was still smiling,

and she thought he was about to say something. Instead, he reached over and put his hands on her shoulders, and then began following her curves. He slid his hands up over her hips, then moved his fingers to her waist, and nearly up to her breasts. Finally, he spoke: "Is all this really you?"

"He pretty much groped me," she says, remembering. "I didn't know what to think. My heart was beating a thousand miles an hour. I was overwhelmed. He came on like Godzilla."

She stepped back until his hands dropped away, and then they were both embarrassed. "Well," he said, and then seemed at a loss for words. "Gee," she murmured. But she loved this "Memphis Flash."

"I was on the same page with him. We were both young and riding the rock-and-roll wave."

Just about then, the door opened, and in came a gaggle of reporters to ask him questions. Kay stood back and watched, thinking what a chameleon Elvis was, "slipping casually out of one skin and into another, depending on the nature of the question asked or who was doing the asking." Then one reporter asked Elvis if he planned to marry.

"Why buy a cow when you can milk it through the fence?" he said, a comment that would be picked up by the national press and spark outrage, even as it was toned down to, "Why buy a cow when you can get milk under the fence?" But he was so charming, breaking into a boyish laugh, that he won over whoever happened to be around. Kay had to admit that his appeal, while intoxicating, was complex. He was so pretty, so androgynous, and he seemed both angelic and thuggish at the same time. Later, she read what a fan told one of the reporters that night—that she liked him "because he looks so mean." She knew what the girl meant. He was just so many emotions wrapped up in one big gorgeous cover.

Suddenly, Elvis saw Kay standing in the corner and motioned for her to come over. Then before she knew what was happening, he grabbed her, turned her around, and pulled her toward him until her back was pressed up against him. He folded her into his arms and held her in a suggestive embrace, kissing the side of her face as photographers snapped away.

Kay didn't know anything about a girlfriend named Barbara Hearn waiting for him in Memphis. Nor did she know one of the pictures would wind up on the cover of a national magazine. She just couldn't believe what was happening. Now, she says, "He should have been under freaking arrest. He's feeling me up in that one picture. Those are some of the most blatantly, sensual poses that I've ever seen him in with a girl."

He kissed her passionately just before he went onstage, pushing against her in a way no boy had ever done before. Then he launched into the first of two shows before six thousand deafening fans, following, among other performers, Wanda Jackson, to whom Elvis had only recently given his man's diamond ring. Afterward, before the second show, he asked Kay if she would come to his performance in Fort Worth later that week. She said she would and asked him to sign some photos for the fans. Then he introduced her to Scotty, Bill, and D. J. and motioned for her to stand beside the backstage curtain so she could get an intimate view of the show.

In her brief exchange with Scotty, the guitarist had asked if she planned her own career in show business. Kay laughed and said that she was no singer, but she could dance. And then, caught up in the moment, she announced that she'd be moving to their music in just a few minutes.

Elvis had no idea that she was an accomplished dancer, and that listening to Hank Ballard and "Sexy Ways," she'd improvised on the current dance steps, melding together the white from rock and the black from bop for a routine uniquely her own. She was so good at it, in fact, that within two years, she would earn a starring role in a Hollywood B picture, *Rock, Baby, Rock It,* doing the dance she called the "Rock & Bop."

Now, during Elvis's performance of "Money, Honey," Kay began dancing her bop in the wings. She was lost in her own moment for a while, but then in the instrumental break, she noticed Elvis, Scotty, Bill, and even D. J. watching her. When Elvis came offstage, he had just one question for her: "Where did you learn how to do that?"

Afterward, he kept her close, and while waiting for the crowd to thin ("He couldn't get out of the auditorium for the throng of fans outside"), he asked for the house organ in the auditorium to be turned on. Then he took off his coat, lit a small cigar, and in a poignant moment, began playing "Harbor Lights," singing just to Kay. Like most teenagers in the thrill of early love, she was transported, feeling a connection to him that seemed to come from some unearthly place. "It was almost like we knew each other from somewhere else, you know?"

Perhaps there was destiny involved after all. Before Kay left that night, sleeping at her friend Teena's house, Elvis asked her more about her "Rock & Bop."

"He asked me to show him the steps, and then Scotty picked up his guitar, and we did a little number together there, the three of us, backstage. Up to that point, all he was doing was the Hillbilly Cat stuff—just shaking both of

his legs and vibrating, not really doing any footwork. I taught him a few of the bop steps that the black people were doing back then and told him to go crazy with it."

Later, she was surprised to see that he had worked it into his stage act. "I don't know if he saw the bop somewhere else, but I do know that he incorporated some of the heel-toe moves after that, because I went back and looked at what he was doing before and after that time."

Teaching him that, being able to give something back to the man who had given her so much enjoyment, was "a nice thing, a nice moment," she says. "We were like crazy kids, just having a ball." It was one of the best days of her life.

And, in retrospect, one of Elvis's. The boy who couldn't dance in high school had just picked up a signature stage move, one that would help define his early style. Somehow, the fact that he learned it from a teenage girl seemed fitting.

.

Near the end of April, Elvis opened a two-week run in the Venus Room at the New Frontier Hotel in Las Vegas. The Colonel had booked Eddy Arnold into Vegas on numerous occasions and considered it his playground. He counted many friends there, some of whom were heavy in the underworld. His connections, coupled with his growing love of gambling, made Vegas seem like a perfect showcase for his new client, especially as he commanded $7,500 a week for Elvis, in advance, and in cash. "They got an atom-bomb testing place out there in the desert," he explained. "What if some feller pressed the wrong button?"

But Parker miscalculated. Elvis was still too immature and unpolished for Vegas. (He introduced his first number one hit as "Heartburn Motel.") And the New Frontier audience was not made up of hormonal teenagers, but an older, jaded crowd, most of whom had come to see bandleader Freddy Martin, whose forte was pop arrangements of the classics. Elvis was scared stiff. Everything about the engagement was wrong—it was his first sit-down gig, and no matter what clothes he wore, even loafers and dress pants and a western-cut jacket, he seemed out of place.

T. W. Richardson, the New Frontier's vice president and part owner, had heard about the singer in Richardson's hometown of Biloxi, and called the Colonel about the booking only a month before. The first night, Richardson invited a clutch of friends to gamble and take in the show, and among the guests was a Houston doctor, Tom Van Zant. According to Gabe Tucker, one of Parker's cronies, when Elvis took the stage, Dr. Van Zant "jumped up from their ringside

table and shouted, 'Goddamn it, shit! What is all this yelling and screaming? I can't take this. Let's go to the tables and gamble.' "

It was a rough debut, attended by only a smattering of applause, and Elvis was devastated. "After that first night," he said in 1959, "I went outside and just walked around in the dark. It was awful . . . I wasn't getting across to the audience."

The Colonel quickly suggested that the hotel add a special matinee on Saturday for teenagers, where, for a dollar, they would see the performance and be served one soft drink. That afternoon, at a reserved table touching the stage, was Nancy Hebenstreit. The thirteen-year-old was in Las Vegas with her parents, Bruce and Ann, who were attending a golf event, the Tournament of Champions. During that time, Nancy would go to seven or eight of Elvis's shows. "He would sing directly to me," she recalled. "He was very appreciative of having a bona fide fan."

She had prayed he would be there. Just eleven days earlier, on April 12, when he played the Armory with Faron Young and Wanda Jackson in her hometown of Albuquerque, New Mexico, Nancy waited outside the stage door after his second show with her friend Carla Singer, a classmate at St. Vincent Academy, a Catholic girls' school. The two stood there with a swarm of other girls about their age, and when Elvis came out to give autographs, Nancy prided herself on being the first one he kissed. The next day, the *Albuquerque Tribune* ran a front-page story about Elvis smooching St. Vincent girls, and Carla, who also got a kiss, was immediately expelled for bringing bad publicity to the school.

It was a life-changing moment for both of them. In time, Nancy began imitating the singer, becoming perhaps the first female Elvis impersonator. ("If anyone did it earlier, they would have to prove it to me.") She combed her hair into a modified ducktail, thickened her eyebrows and lips, added sideburns, and built up her shoulders, turning one of her father's jackets into Memphis cat clothes. Then, curling her lip, she strummed a cardboard guitar and lip-synched the words to "Heartbreak Hotel."

Known today as Nancy Kozikowski, an internationally acclaimed artist whose paintings, tapestry designs, and weavings can be found in museums, public buildings, and private collections, she was captivated as a child by the idea of what it would feel like to *be* Elvis onstage. The next year she got kicked out of St. Vincent for "edging on subversive," and at the talent show at her new school, Washington Junior High, the kids got so caught up in her performance that they forgot she was a girl. She was amazed at how electric the connection felt.

"Because I had seen him perform so closely, it was like I *was* him. The girls screamed. It sort of surprised me." Moreover, she was stunned at the power that even an imitation of Elvis could have over young kids. "It was scary. It didn't occur to me that an imitation would even begin to do anything more than simply amuse people. But they went wild."

However, Nancy had returned from Las Vegas with more than just the inspiration for her act. While checking into the Desert Inn, she saw a friend from Albuquerque, and since her pal had a Brownie camera, Nancy suggested they go looking for Elvis. The New Frontier was right across the street, and they saw him immediately, leaving with Bill Black and Gene Smith. He posed for pictures with them, and Nancy reminded him of that earlier kiss, which earned her another. Elvis was happy to see such a youthful face: "Vegas was where people went to get away from their kids."

She ran into him on several occasions ("He was always nice and flirty"), and one morning, at the Last Frontier Village penny arcade, he was all by himself, killing time. They hung out together, just having fun, popping quarters in the arcade booths. In one, they made a sound recording, a talking record ("Hi . . . ummm," "Hi. Aren't you going to say my name or anything?" "Ummm, Okay. Hi, Elvis. What are you doing here?"), and then they stuffed themselves into the twenty-five-cent photo booth, taking pictures together and alone.

Nancy's enraged boyfriend ("the original Fonz, long hair, leather jacket") would later burn all but one, but the image that remained was a beauty—a black-and-white portrait of a hollow-jawed Elvis, a creature of the Vegas night who looks as spooky as Dracula himself.

By the time she left Las Vegas, Nancy had received a bouquet of Elvis kisses, more than a dozen in all. "Very nice and sweet. He was not a letch." Besides, "I was only thirteen and thought he was too old for me."

.

Elvis was in the lobby of the New Frontier one afternoon when he spotted Judy Spreckels, a comely young woman sitting at a small desk, engrossed in writing a letter. He approached her, struck up a conversation ("How could you not know who he was even then?"), and after a smattering of small talk, Elvis took her to the gift shop to show her a magazine. "He said, 'This says I'm a hillbilly. I'm not, am I?'" Judy looked at him and said, "No, you're a singer." After that, "I was with him . . . all the time. There wasn't a crowd then, just a few guys."

She became the first "sister" he'd had since Betty Amos, and their friendship lasted until the day he died. "Girls come and go, but sisters stay forever. . . . He told me secrets that I never told and will never tell."

At twenty-three, Judy was the divorced sixth wife of sugar magnate Adolph Spreckels II. She had a ranch in Las Vegas but was living at the hotel then, and she offered to be Elvis's "secretary" and aide-de-camp. Soon, she would also come to Memphis. But both of them knew she was too worldly for him, and so they tamped down the obvious sexual spark.

"We were like kids," she says. In the afternoons, they'd ride the bumper cars at an amusement park and then go anywhere to escape the fans.

"He loved the fact that I had a light blue Cadillac, and he bought the same car for his mother in pink. One day we drove my car out into the desert, and his cousin Gene came with us. Elvis drove that car as fast as it could go, and I was in the front seat whooping and screaming and laughing. His cousin was on the floor in the back, he was so scared. But I'd been a stunt player in the movies, and Elvis couldn't go fast enough to scare me."

Now Elvis was learning to love Las Vegas, especially as he could take in a plethora of other shows. He particularly liked Freddie Bell and the Bellboys, whose novelty performance of Big Mama Thornton's rhythm-and-blues hit, "Hound Dog," resonated with him down deep. He also loved meeting other entertainers, including those with whom he had something in common—singer Johnnie Ray, who was so emotive that he seemed to cry all the time, and piano legend Liberace, Gladys's favorite, who also had a twin who died at birth, and whose flamboyance with clothes and rings had long intrigued him. Soon Elvis would start reading a paperback book, *The Loves of Liberace,* picturing the closeted homosexual and a woman on the cover.

However, Elvis was more interested in the showgirls.

One night backstage, he met a bosomy blonde named Gloria Pall, who'd come with her friends, actor Rory Calhoun and his wife, Lita Baron, to see comedian Shecky Greene, who was also on the bill with Elvis and Freddy Martin. She was visiting with Greene and another showgirl she'd worked with previously, her friends teasing her because her 1954 Los Angeles television show, which she'd developed around the character of "Voluptua," had been canceled after seven weeks, viewers citing it as too torrid. Elvis overheard the conversation and looked her up and down in her slinky black halter dress.

He introduced himself ("Hi, ma'am, my name is Elvis"), and then with the

same on-the-prowl look he once gave Betty Amos, he proceeded to take Gloria's right hand to his mouth and suck each of her fingers, rotating his tongue around them one by one.

Gloria, who called herself a "love goddess," had been around, but she was surprised a twenty-one-year-old kid like Elvis would try such a thing.

"Where did you learn to shake hands like that?" she asked him. "You don't provide towels by any chance, do you?"

"I'm from Tennessee, ma'am," he said. "That's how we do things there. No, I don't provide towels because other girls don't try to wipe it off."

"You're something else," she told him, though his brashness turned her off. "You're a corny, horny little hick."

Gloria went back to the Calhouns at the table and told them what had happened. "I tell you," she said. "He's original. I've never had that done to me before. He must have read it in a book somewhere." Finger sucking was a sexually stimulating turn-on, she said, "but not with that kid."

At least one more pretty girl in Vegas was also immune to his charms. During his engagement, the Colonel took him over to visit his friend Milton Prell, the owner of the Sahara Hotel, known as "the Jewel of the Desert," with its plaster camels standing guard at the entrance. Elvis immediately set his sights on eighteen-year-old Joan Adams, who had just won the title of Miss Nevada USA 1957. But more significantly, she was Miss Sahara, and her duties included traveling with the governor to woo convention business.

Elvis made his way over to her, flirted, asked her name, and said he wanted to take her out. But unlike millions of women who swooned at the very sight of him, Joan didn't find him attractive and politely demurred. Elvis, his ego wounded, complained to Colonel Parker.

"He went back like a sick little puppy and told everybody at the hotel that I turned him down. He said, 'Your Miss Sahara and Miss Nevada USA won't go out with me.'" An hour later, Colonel Parker showed up with Milton Prell, along with Stan Erwin, the entertainment director, and Herb McDonald, the publicity director.

But as Miss Sahara, Joan was off-limits. "They weren't allowed to ask me to go out with anyone—not even sit with somebody. But Colonel Parker said, 'Why wouldn't you?' And I said, 'He's a nice man, but he's just not my type.'"

The Colonel offered an insincere smile and narrowed his eyes.

"Elvis is a gentleman. You don't have to worry about him."

"I'm not worried about that," Joan replied. "And I'm very capable of taking care of myself."

Herb McDonald then got on his hands and knees. "Please, Joan. Please go out with Elvis for the publicity we'll get."

Still, she refused, saying she didn't want to lead him on. Finally, Milton Prell, consort of gangsters and all manner of Vegas power, made his plea.

"Joannie, we've done everything you've asked. We haven't made you sit with anybody, or do anything you didn't want to do. Please go out with Elvis."

At last she relented, but only as a favor. "Okay, okay, all of you. Tell him to ask me again and I'll do it."

Elvis went back with his tail between his legs, and this time he talked about motorcycles—someone told him Joan found them sexy—and he offered to rent one and take her for a ride. But even that fizzled. "We had a flat tire and ended up in a Cadillac."

They drove up to Sunrise Mountain. Elvis just wanted to see the lights of the city, he said. Joan had heard that one a hundred times before, and when he put the car in park, she continued to sit in the corner, not wishing to give him the wrong impression. Elvis was running out of tactics now, and so he started singing to her. When she still didn't scoot over close, he said, "You obviously aren't a fan of my music."

"I like to play the cello with my father," she replied, and exasperated, Elvis cut to the chase. He asked her where she lived, and she told him she had an eight-by-forty-foot house trailer. He asked her to show it to him. "No way," she told him. She wouldn't allow anybody in her trailer. More than that, she didn't let anybody get to know her, because she was underage. "I'd lied and said I was twenty-one because I was working at the Sahara."

But Elvis wore her down, as he knew he would. Still, his evening didn't go as planned.

"He was sitting on my couch and kissing me, and then he started to do a little more than kissing. I told him, 'No, no, no,' but he didn't take no for an answer. So I pushed him backward, and he fell off onto a square Formica table."

Elvis hit the corner of it as he fell. Suddenly, he was lying on her floor moaning, "I can't move!" For a terrifying moment, she thought he'd broken his back.

Joan panicked. "I didn't know what to do! I thought, 'Do I call Colonel Parker? Do I call the Sahara? What do I do?' But he said, 'Don't do anything. Just let me lie here.'"

The next day, Elvis and the Colonel showed up at the Sahara "with every record that Elvis ever made. The Colonel said they were from his private collection."

Joan Adams would have a chance to add to that collection in another thirteen years. By that time, she would be married to Alex Shoofey, the man behind Elvis's far more successful Vegas engagements.

· · · · · ·

In the next months, Elvis would begin to make national headlines, with both Time and *Newsweek* running stories on his phenomenal rise, and other publications hurrying to follow suit. Elvis was now firmly in the national spotlight. But criticism over what some considered his lewd behavior began to mount. In May, after his performance in Lacrosse, Wisconsin, the editor of the local newspaper notified FBI Director J. Edgar Hoover that Elvis's act included "sexual self-gratification on stage." Ten days later, there was another riot, this one twenty minutes into Elvis's show in Kansas City, Missouri, where D. J.'s drums and Bill's bass were smashed, and D. J. was thrown into the orchestra pit.

Then on June 5, Elvis made his second appearance on *The Milton Berle Show,* singing "Hound Dog," and making the most of the beat that D. J. had picked up drumming in strip clubs. It was the performance that would come to define him both as a cultural threat, and as an innovative creative phenomenon.

Most critics rushed to thrash him, Jack Gould of the *New York Times* writing, "Mr. Presley has no discernible singing ability," and Jack O'Brian of the *New York Journal-American* deriding his "display of primitive physical movement [that is] difficult to describe in terms suitable to a family newspaper."

Interestingly, it was a woman, gossip columnist Hedda Hopper, who added the vitriol. "I applaud parents of teenagers who work to get the blood and horror gangster stories off TV. They should work harder against the new alleged singer, Elvis Presley. I caught him on Milton Berle's show and was revolted. Dressed like a zoot-suiter, he acted as though he had St. Vitus dance and indulged in bumps and grinds that wouldn't be permitted in the lowest burlesque houses."

Two days later, a nervous Harry Kalcheim at William Morris suggested to the Colonel that perhaps Elvis should do less shaking.

Also on the show that night was twenty-two-year-old actress Debra Paget, a contract player for Twentieth Century-Fox. Elvis took note of her for two reasons: The petite, five-foot-two redhead was just his physical type, going back to Carolyn Bradshaw, and she was talked about to play the female lead in his first motion picture, a western tentatively titled *The Reno Brothers,* set to start filming

in August. Producer Hal Wallis had loaned him out to the rival studio as a kind of test, to see how audiences would respond to him. Even Wallis was concerned about Elvis's negative publicity, but he held fast to the memory of that fine screen test and decided he'd made the right choice in signing him.

In defending his performance on the Berle show, Elvis told the *Charlotte Observer* that he hadn't been any sexier than Debra Paget, who came out in a "tight thing with feathers on the behind where they wigggle the most [and who] bumped and pooshed out all over the place."

Already, she was on his mind. But he'd never forgotten about Dixie, either, and at the end of May, he'd stopped by her house as she returned from a dress rehearsal for her high school graduation. He told her he was seeing her friend Barbara Hearn now. Dixie was fine with it. She was moving on, too. The next night, Elvis was in the seats at Ellis Auditorium to watch her graduate.

He might have tried to resurrect the romance had it not been for an event that came out of the blue. On June 11, 1956, he flew home off the road to attend the funeral of his cousin Lee Edward Smith, who had drowned.

As Elvis and his parents returned home from the service, he spotted a gal in the crowd surrounding the house. It was June Juanico, the Biloxi girl he'd met a year earlier. She was eighteen now and prettier than she'd been when he met her.

Weeks after Elvis repeatedly tried calling her from the road, only to leave messages with her brother, Jerry, June finally found out Elvis had made good on his promise. "Oh, by the way," Jerry said, "some guy with a hillbilly accent called you on the phone." By the time she called the operator back, it was too late—Elvis had long moved on from that number.

She tried not to make a big deal out of it, despite her strong feelings, and purposely hadn't followed his career. In fact, when her friend Marie, a huge Elvis fan who attended a number of his shows, suggested that June join her and a group of girlfriends on a trip to Memphis, June said she'd rather go to Florida. But Marie had the car, so Memphis it was.

When they arrived in town, they drove to Beale Street and stopped at Lansky Brothers, the store where Elvis bought his loud clothing. Marie wheedled his address out of Bernard Lansky, one of the owners, who added that he wasn't supposed to tell people where Elvis lived. But he guessed it wouldn't do any harm to just ride by, because Elvis was out of town.

Marie was upset—they'd come all this way and now Elvis wasn't *home?* But June was secretly relieved. She didn't know if he'd remember her. Now at the house, she could see the construction from the Presleys' new swimming pool in

the backyard. They were all wondering what shape it was going to be in—someone said she bet it was in the form of a guitar—when June said, "Well, let's go take a look."

"I got out of the car, and they all followed me, trespassing. I was standing on the fence looking over, when a big black Cadillac drove up in the driveway. Out stepped Elvis and his mother and father, all dressed in dark clothing. I don't know if he put two and two together, like, 'Marie is from Biloxi, so that's June standing at the fence,' but I turned and had my back to him, and he came up behind me and took me by the waist, and picked me up off the ground and said, 'What are you *doing* here?' "

She explained that she was there with the girls, and he said he'd been looking all over for her, that he'd called and left those messages for her to call back, and why hadn't she done it? They laughed about her nitwit brother, and then he said, "Somebody told me you were engaged to be married," and looked over at Marie.

Well, never mind, Elvis said. He told her she had to stay the week, and his parents would be happy to have her. ("I think I probably was the first female guest on Audubon Drive.") He would show her Memphis, and if his 1956 ivory Cadillac Eldorado Biarritz convertible were ready at the factory, they'd fly down to Houston and pick it up. He had all kinds of plans: They'd go motorcycle riding, they'd go to the movies, they'd see anything she wanted to see. He was so glad she was there, and he had so much to tell her.

There were also so many unspoken thoughts in his head. Now that he was getting a little notoriety, he thought more about his lost twin. He wondered what Jessie would think about all this crazy stuff! But now he had June, at least for a week, and he was going to make the most of it. They wore matching motorcycle caps with bright white bills, and when they walked down the street, people stopped them and asked, "Are the two of you twins?" They just looked so much alike.

Gladys, too, enjoyed June's company. They'd meet in the kitchen in the mornings while Elvis was still asleep and fix food together, sitting and drinking coffee as the sun came up.

"She saw me as domesticated and wise for my young years. Since my mother was divorced and working, I was the lady of the house. When I would get home from school, I would do the cooking, and I used to design and make all my clothes. The first time Mrs. Presley met me she admired my skirt. I said, 'Well, thanks, I made that.' So she started taking it off of me, looking at the zipper. She said, 'You sew really well. You could do this for a living.' I said, 'I don't know, I never did think about it like that.' "

June could see that Gladys needed a confidante, that she had things on her mind. She was worried about this Colonel Parker, this cigar-smoking shyster. He made her nervous. But everything made her nervous of late, she said, even though June thought she seemed awfully calm and wondered about the pills she saw Gladys take from the windowsill in the kitchen.

"I have a fear of waking up one day and all this just being a dream," she told her. She'd had nothing all her life, she said, and she just figured all this was too good to be true. It was happening too fast.

Then the mood lifted, and Gladys was saying, "You've got to pick a name for me other than 'Mrs. Presley,' because you're going to be part of the family one day." June thought for a minute and decided on "Lovey," an affectionate form of Gladys's middle name, Love. Gladys was wild about it, and about this girl.

"She thought I was a good catch for Elvis because I could do all these things, and I was from Mississippi, and I was crazy about her son. I was healthy-looking, too, so she thought I was perfect breeding stock, as we used to say. I was five foot six and a half inches, about 128 pounds. She'd hug me and tell me I was pretty. And she would stroke my face. She was always telling me that Elvis needed someone to take care of him."

And so Gladys didn't balk when Elvis said he was taking June to Houston with him to pick up his car, and that they would be gone overnight. Vernon drove them to the airport, where Elvis bought her ticket under the name of June Prichard, choosing it to protect her identity, and also as a kind of joke—he'd tried to call her from Prichard, Alabama, soon after they met.

When they got to the hotel, they both signed in at the front desk, and he said, "Let's go see your room first, and then we'll go see mine."

He opened the door to her room, "and we hugged and kissed a little bit, and then we left. I don't think I even put my overnight bag down, because he said, 'Take that with you. Come on.'"

She didn't know what to think, or even what to do, and he saw it on her face.

"June," he said. "I'm not going to hurt you. I respect you and love you. I want you to stay with me. I promise I will not touch you. I just want to hold you."

And, she says, "That's what happened. We slept like spoons in the bed the entire night." Then they flew back to Memphis.

That's when she fell in love with him, on the way home.

"We'd spent so much time together, and I'd get lost in his eyes. He was just so very sincere. From then on, I knew I could trust him."

Jackie Rowland in a playful moment with Elvis at the Florida Theatre, Jacksonville, August 1956. During his two-day engagement, he signed an earlier photograph to Jackie and her mother: "My best to you, a bunch of real nice folks, Elvis Presley."

NINE

· · · · · · · · · · · · · · ·

Love Times Three

Elvis was scheduled to appear on The Steve Allen Show *on July 1, 1956, but two* weeks before, the variety show host announced that the pressure to cancel the hip-wiggling sensation had been so strong that if Elvis did appear, he "will not be allowed any of his offensive tactics."

Allen, a savvy show business veteran, considered the controversy "a piece of good luck," he said later. All the media hype and attention "worked to our advantage," and Elvis was never really in danger of being canceled.

The host, who was also a comedian, jazz musician, writer, actor, poet, and television pioneer, had tuned in *Stage Show* one night, where he saw "this tall, gangly, kind of goofy-looking but cute, offbeat kid." He only caught two minutes of him, but "I could see he had something, [and] made a note to our people to 'book that kid.' I didn't even know his name."

Partly to capitalize on the outrage over Elvis's movements on *The Milton Berle Show,* Allen scratched his head for a different way to spotlight him and also keep his movements contained. As he recalled nearly forty years later, "I personally came up with the two ideas that made Elvis look so good that night—the singing 'Hound Dog' to an actual dog, and the Range Roundup sketch with Andy Griffith and Imogene Coca," the latter of which was a spoof on the Ozark Jubilee, the Grand Ole Opry, and Elvis's barn dance home, the Louisiana Hayride.

Some of Elvis's fans were offended at the notion of their idol singing to a live basset hound. But Elvis took it all in stride, even agreeing to be fitted for a tuxedo (the twitchy basset would wear a top hat) for the occasion.

At the morning rehearsal on June 29, Elvis became reacquainted with Al Wertheimer, a young photographer only slightly older than Elvis who had

photographed him during his fifth *Stage Show* appearance. RCA's Anne Fulchino had hired the German émigré as part of her dedication to making Elvis a huge pop phenomenon.

With no budget for publicity—or certainly nothing like the $200 or $300 a day Columbia Records paid freelance shutterbugs—she'd gone in search of "talented, hungry kids who'd work cheap," striking a deal in which the photographers were free to shop their pictures and make a few bucks once she'd finished her campaign. That's the way she worked with Wertheimer.

She picked him over a temperamental photographer she'd originally considered because Al, a quiet, laid-back, easygoing person, "had the right personality" to shadow the singer in close quarters and a variety of circumstances. "I also knew he could handle the Colonel."

She made the right choice. After late 1956, Parker lowered an iron curtain around Elvis, restricting media access to only a handful of carefully orchestrated events. Before that happened, Wertheimer, a night person like Elvis, would travel with him for a week, shooting some 3,800 frames, all unposed and in natural light, to chronicle both his professional and personal life—onstage, backstage, in the recording studio, at home with his parents and friends, and on the road with his fans.

No other photographer would capture such startlingly intimate moments or chronicle such an important phase of Elvis's career. The resulting photos, elegant, eloquent, and iconic, "were probably the first and the last look at the day-to-day life of Elvis Presley," Wertheimer has written. "I was a reporter whose pen was a camera."

While RCA needed images that promoted Elvis as an explosive young singer on the rise, Wertheimer had another agenda. "Basically I was covering the story because Elvis made the girls cry, and I couldn't understand what he had that was that powerful, that brought all that raw emotion to the surface."

As Fulchino predicted, Al was so unobtrusive and good at his job that many of the people who surrounded Elvis hardly knew he was there. And Elvis himself enjoyed being documented, allowing closeness that embarrassed even the photographer, particularly for an image Wertheimer calls *The Kiss,* a brief encounter between Elvis and a fan in the stairway of the Mosque Theatre in Richmond, Virginia.

According to Wertheimer, Diane Keaton, the actress and photographer, has called it "the sexiest picture ever taken in the whole world."

On the afternoon of June 29, after *The Steve Allen Show* rehearsal, Elvis took the train to Richmond with the Colonel and an entourage that now included his

cousins Bobby and Junior Smith, the latter of whom bore the haunted, eerie look of a crazed killer, having come home from Korea with a Section 8. The following day, Elvis was scheduled to perform two shows at the Mosque Theatre, at 5 and 8 P.M.

His date for the day was a well-dressed young woman in a dark, sleeveless dress and cluster pearl earrings. A southern girl, she had a fresh-faced look about her, with her dark blond hair cut in a summer bob. Elvis apparently made her acquaintance in the Hotel Jefferson coffee shop, where only a few minutes earlier, he'd wrapped his arm around the waitress.

He had his script for *The Steve Allen Show,* and "flipping through some of the pages," as Al remembered, "he was trying to impress this young lady whose name I forgot to get. But she remained cool, not wanting to look too impressed. Elvis continued to try and loosen her up with conversation. At one point, he came in close, within three inches of her face, and just shouted, 'Ahhh!' "

Al clicked off some shots, and then Junior said it was getting late and they needed to go to the theater for rehearsal. Elvis invited the blonde to come along, and a trusting soul, she climbed in the cab. On the ride to the theater, Elvis tried to amuse her, pointing out silly things like light fixtures, and cracking jokes. He "continued to be at turns debonair and playful, or stern," Al observed, "wrapping both hands around her neck in a mock ceremony of choking her."

While the other performers took turns onstage, Elvis flirted with her in another part of the theater, leading her into a dark, narrow alcove along the stairway, lit only by a window and a fifty-watt lightbulb. Al, walking from the men's lavatory, which doubled as the musicians' dressing room, was surprised to find the couple there and realized he'd stumbled on an intimate moment. Elvis, dressed in a dark suit and white buck shoes, propped his arm on the stair rail, slouching toward his date, who coyly leaned against the wall. She tipped the lower half of her body, inching toward him, her feet with his, so that the two of them made almost a V-shape standing so close together.

Al was in a quandary. "Do I leave them their privacy or should I be a good reporter? If I shoot this, Elvis may have me fired." Then he took the chance, seeing they were so absorbed. He started shooting, keeping his distance at first, and then moved closer, closer, and closer still, until he was up on the railing of the stairway. He snapped a shot from above, looking down just as Elvis nuzzled the girl's cheek, his arms spread wide, one above her against the wall, the other anchoring him on the railing. It was so sensual, and their bodies so eager, that if the photo were rotated, it would seem as if the two were in bed.

The photographer scarcely breathed. He asked to pass them ("May I get

by?"), but they were so focused they didn't even care. Al pivoted so that the window was behind him, illuminating his subjects with front-end sunlight and fill lighting from the dangling bulb.

"Betcha can't kiss me, Elvis," the girl said, sticking out her tongue.

"Betcha I can," he teased back. And then he made his move, sticking out his own tongue until the two were pressed together, tongues and noses, his waist pushing up against hers. By now, the girl was leaning back on the stair rail, and anything could happen. Al snapped the shutter, capturing the famous image, a distillation of the rock-and-roll road show, and Elvis at his uninhibited best.

The whole thing took a tenth of a second, and then all Al heard was, "We want Elvis! We want Elvis!" A minute later, Elvis sprinted onstage to give four thousand people, mostly women and girls, the performance they had paid to see.

Just who Elvis's date was that day remains a mystery. Since the image appears on commercial products, several women have approached Wertheimer through the years, each insisting she was the one. But whenever the photographer asks them questions about the day before or the day after, their stories never gel. "I think Elvis kissed thousands of girls. He loved kissing girls."

After his shows that night, Elvis climbed back on board a northbound train—flying scared him—for his live appearance with Steve Allen the next evening. It was a Sunday. The show went as planned, Elvis wearing his prom-night blue suede shoes with his tuxedo and performing "I Want You, I Need You, I Love You" along with "Hound Dog."

He would record the latter song the next day at the RCA studios on New York's East Twenty-fourth Street, along with "Don't Be Cruel" and "Any Way You Want Me." Meticulous at getting what he wanted on tape, though, as in his Sun days, still arriving unprepared, Elvis took control of the recording session. ("Try a little more space," he told Scotty at one point.) After several takes of "Don't Be Cruel," he squatted on the floor so his ears were at the same level as the huge speakers in the corner. No, he said. They would need to do it again.

By the end of the day, he had insisted on twenty-eight takes of "Don't Be Cruel," and thirty-one of "Hound Dog." It was excessive, but no one was going to argue with him, because he was an idiot savant in the studio, knowing what would work, even if he couldn't always articulate it quickly. Beforehand, he'd spoken again to the press, saying that "Barbara Hearn of Memphis and June Juanico of Biloxi, Mississippi," were the two girls he dated, Barbara being a good motorcycle date, he threw in. Meanwhile, outside the RCA building, fans held

up signs saying, WE WANT THE REAL ELVIS, and WE WANT THE GYRATIN' ELVIS, not the restrained and sanitized one who appeared on *The Steve Allen Show.*

But New Yorkers had seen two very different aspects of Elvis's personality in an exceedingly short time. At eleven-thirty that Sunday night, little more than three hours after the Allen show signed on, Elvis appeared live on the WRCA-TV interview program, *Hy Gardner Calling!* Gardner, a popular syndicated newspaper columnist, asked his guest the increasingly familiar questions about his critics, his music, and his effect on teenagers. Elvis, on camera at the Warwick Hotel, but holding a telephone to speak with Gardner, took it in good humor, answering a question about his four Cadillacs ("I'm planning for seven") as well as a ridiculous rumor that he had once shot his mother. ("Well, I think that one takes the cake. That's about the funniest one I've ever heard.")

The show was memorable for two reasons—the shot of Elvis on the telephone exposed an ugly and prominent wart on his right wrist, which he would have removed in 1958. (A Georgia fan named Joni Mabe would acquire it and keep it in a jar of formaldehyde, selling T-shirts proclaiming, THE KING IS GONE, BUT THE WART LIVES ON.) What got people talking, though, was Elvis's sleepy eyes and druggy speech.

Two weeks earlier, he had stopped by Wink Martindale's WHBQ-TV "Top 10 Dance Party" to promote his upcoming concert at Memphis's Russwood Stadium, a charity benefit for the *Press-Scimitar*'s Cynthia Milk Fund, and his behavior on the show had also seemed somehow altered. He stuttered more than usual and was nervous in the company of the kids in the studio that afternoon. Then, with a lock of hair meandering on his forehead, he leaned on the jukebox for most of his brief interview, and nearly fell off of it when he went to shake Wink's hand. Elvis had initially resisted coming on the show, saying he didn't feel comfortable doing a live interview, even on local TV. Wink asked Dewey Phillips to speak with him about it, and then Elvis agreed, but only if Dewey appeared with him on camera. Had Dewey, who used Benzedrine to keep himself awake and sedatives to bring himself down, plied Elvis with pills?

Wink later tried to explain it away as growing pains.

"He was very awkward in that era. He didn't seem to know how to act around people. He just didn't know how to be interviewed at that stage of his career."

And maybe that was part of it, along with sleep deprivation. He told Hy Gardner he slept only four or five hours a night, but some of the audience

thought it was more than that. Hy apparently did, too, saying, "Several newspaper stories hinted that you smoked marijuana . . . in order to work yourself into a frenzy while singing." ("Well, I don't know," Elvis replied with a laugh.) In 1956, drug use was mostly relegated to the underground, to bowery dwellers, jazz musicians, and the criminally insane, and mainstream America found it both horrifying and scandalous. In billboarding the guests on the show, Gardner's secretary, Marilyn, announced, "We'll talk with veteran bandleader Ted Lewis; Egyptian dancer Nedula Ace; and the unidentified author of the shocking book titled *I Was a Dope Addict.* And to get right into action immediately with the most controversial entertainer of the year . . . well, you'll hear who."

· · · · · ·

On July 3, Elvis took a cab to New York's Pennsylvania Station and once more boarded a train, this time for a twenty-seven-hour trip to Memphis. There he would enjoy a few hours of Fourth of July celebration with his parents, cousins Junior, Bobby, and Billy Smith, his aunt and uncle Travis and Lorraine Smith, his Memphis girlfriend, Barbara Hearn, and a growing entourage that now included Red West and an overgrown Memphis boy named Arthur Hooten, whose mother had worked with Gladys at Britling's Cafeteria. On the train, he listened to the quick-cut acetates of his three new songs on a portable record player, second-guessing himself, rethinking his vocals, wondering if his voice was too out front from the instruments.

When the coach arrived in Memphis, it slowed just long enough for Elvis to disembark at a small signal stop called White Station. From there, the star of Sunday night's *Steve Allen Show* and *Hy Gardner Calling!* walked home to Audubon Drive with his alcoholic and perpetually shell-shocked cousin Junior. Everybody wondered how he'd do with the fireworks that night, since Junior, a wild and unpredictable personality, had gone berserk and shot a group of civilians in a Korean village.

As usual, the yard was abuzz with fans, who normally contained themselves to the carport, except when Gladys or Vernon invited them inside, which the Presleys did quite frequently, accepting them with calm resolve. The house was especially active on this day, however, and not just for the holiday. A number of fans had traveled to Memphis for Elvis's Russwood Stadium show that night, some of them getting up the nerve to come see where he lived.

Vernon was already in something of a state when Elvis walked in. The family had just had a swimming pool installed in the backyard, but the pool wouldn't

fill. Now Vernon was running a hose from the kitchen sink. Elvis hurried to put on his trunks, and then jumped into all of three feet of water, horseplaying with his cousins for Al's camera.

Inside, Barbara, dressed for the evening event, sat in a taffeta, scoop-neck black-on-white polka-dot dress. Like the girl in Richmond, she, too, wore cluster pearl earrings, with a smart pair of black pumps setting it all off. She waited for Elvis to take his shower, and then half-naked, clad only in his pants and socks, his hair still tousled, he beckoned her into the living room to hear his acetates.

Minnie Mae sat on the couch, craning her neck forward, trying to make out the words to "Don't Be Cruel." But Elvis wanted to know what Barbara thought of all the songs, wanted her compliments and reassurance that he would have a hit. In the end, he needn't have worried. The double-sided single, "Hound Dog/ Don't Be Cruel," sat at the top of the charts for three months and became the most-played jukebox record of the year.

They made an odd pair, Elvis and Barbara. Al Wertheimer, taking note, found her to be "a model of gentility . . . pert, prim, and polite" as a schoolmistress, while Elvis, shirtless, with boils on his back, "looked like the unruly student who spent most of his time leering at the teacher." She sat next to Minnie Mae for a while, just on the edge of the couch, holding her purse on her knees.

"Let's dance," Elvis said. But Barbara didn't want to dance. "No, not now," she answered. She was concentrating hard on the music. But Elvis persisted, pulling her to her feet and then hugging her, moving in for a kiss. Barbara complied, but "I didn't want him to be kissing me in front of his grandmother."

Minnie Mae took the hint, saying she had to get ready for the concert that night. Elvis took Barbara's hand again, and they began dancing in the narrow space between the coffee table and the couch. Her heart wasn't in it, though, and Elvis could tell. Finally she said she just wanted to listen.

"He shrugged, plopped down on the plush chair and sulked," Wertheimer wrote in his book, *Elvis '56: In the Beginning.* "She sat on the edge of the ottoman next to the hi-fi, picked at her pearl-clustered earrings and stared at the carpet. Elvis stared at her, clamped his lips in a pout and glared at a different patch of the carpet. His record filled the room, 'Don't make me feel this way / Come on over here and love me . . .'

" 'How do you like it?' " he asked.

" 'I think it's very good,' she said. She liked all of his music except for 'Old Shep.' "

Then he asked if she wanted to hear the new ballad, "Any Way You Want

Me." She stood, and Elvis folded his arms around her and pulled her to his bare chest. It was an awkward embrace—she was shy with Al there—and Wertheimer knew it was time to explore the rest of the house.

That night Elvis, dressed entirely in black, rode in a police car to nearby Russwood Stadium. Barbara sat with Vernon and Gladys, Minnie Mae, and Elvis's aunt and uncle in a VIP section near the stage. The hometown fans, so proud to have seen him on *The Steve Allen Show,* were already on their feet in the dilapidated old baseball park, and the noise was deafening as Elvis took the stage. "You know those people in New York aren't going to change me none," Elvis told them. "I'm gonna show you what the real Elvis is like tonight."

It was a sentimental and emotional evening all around. Elvis saluted his family from the edge of the stage. And Bob and Helen Neal had come back afterward, bringing their new employee, Carolyn Bradshaw, Elvis's little sweetheart from the Hayride. She and Elvis had never really said good-bye, and now he spotted her. They waved and started toward each other, but it was not to be.

"We didn't get to say anything, because all of a sudden, he was just inundated with people. I don't know where all these people came from, but it looked like he'd never get away, so I just gave up and went on home. That was the last time I ever saw him."

.

Sitting just a few rows from the stage that night was another young girl with stars in her eyes, this one just at the beginning of her relationship with Elvis. Jackie Rowland, the 190-pound "blueberry" from the Jacksonville, Florida, show, had made good on her promise to lose weight, and even though "my mother kept me almost in a bubble," Marguerite had held up her end of the bargain, too, bringing Jackie, now fourteen years old and eighty pounds lighter, to Memphis.

They arrived at the Audubon Drive house on July 3 while Elvis was still in New York. Vernon saw them standing on the sidewalk, watching all the fans milling about, and came out and struck up a conversation. Marguerite explained how they happened to be there, and that Jackie had worked so hard to lose her weight, and just wanted to see Elvis so much. Vernon listened sympathetically.

"He said if Mrs. Presley would let us in, he would come to the side door, and that's what happened," Jackie vividly recalls.

Gladys, whose own weight continued to balloon, liked the personable mother-daughter, even inviting them to spend the night. They politely declined—

they had a motel already—but said they would like to come back the next day, when Elvis was home. So on the Fourth of July, in the afternoon, before the Russwood show, the Rowlands returned to the house to visit.

The five of them—Elvis, his parents, and the Rowlands—sat in the living room, Gladys already in her dress for the concert. While Elvis sat between his parents on the couch, intently reading a story about himself in the newspaper, Jackie snapped his picture. Then Vernon scooted over, seeming even more the outsider, and Jackie sat down beside her idol, who draped his arm around her and held her close, his mouth so near her ear.

Jackie's mother captured the moment in a snapshot. But Elvis does not appear to be a pop star greeting a fan he had met only briefly once before. Instead, both Jackie and Elvis look as natural and relaxed as if they were longtime sweethearts. Though Jackie was an only child "and I had never had a boyfriend and the only males that came near me were my family," neither she nor Elvis seem self-conscious at being so physically affectionate in the presence of their parents. Elvis had a way of putting people at ease, but this was extraordinary.

Yet Jackie says it was not precisely as it seemed.

"I think one of the reasons Elvis and his mother liked me was due to my reaction to his first attempt to kiss me. I was totally innocent and naïve. I told him to stop it and pushed him away. You can see by my expression in the photo."

Though Elvis was told no, it didn't faze or deter him. "He didn't care, he just put his arm around me again and started nibbling my ears." In a lighthearted tone, "He told my mother she needed to take me to a doctor because I wasn't normal. I'm sure he had never met a girl who wasn't all over him."

Elvis demanded complete control in his relationships, but perhaps another reason he persisted was because Jackie looked a bit like him. Their hair color was the same, they had those light eyes, and they were the only surviving children of their parents, their mothers both having lost a baby at birth. For a brief moment, it might have seemed like Jessie and Elvis, reunited. Even Jackie's name, like June's, started with the right letter.

By the time Jackie left the house, "There was definitely some romantic chemistry going on between the two of us. I didn't think about Elvis being a big, famous entertainer. He was just the sweet boy that I was in love with."

Of course, her familiarity with the family had begun the day before. Gladys admired a stick rhinestone pin that Marguerite wore, and Mrs. Rowland "sold" it to her for a penny, and then showed Gladys how to store a set of sterling

silverware Elvis had just bought her. After that, Gladys led Jackie through the house. "I took pictures of Elvis's bedroom, his clothes closet, his messy bathroom—anything that a little fourteen-year-old girl would think to do."

However, twenty-one-year-old Elvis did not treat Jackie as the child she was. He sang his new song, "Hound Dog," and started tickling her ("You know how boys love to tease and pinch girls"), calling her Goosey. From there, it grew more intense. "He said, 'You've got the most beautiful eyes I've ever seen,' and he was really tickling me, kissing me on the cheek and the ears. Something just clicked between us, and that was it."

Gladys, already guessing how Elvis would react to Jackie, had taken her alone that first day, auditioning her, as she did the older girls in whom Elvis took an interest. "She sat me down and asked me if I had a boyfriend, and what kind of grades I made in school, and did I believe in Jesus. She really asked me very personal questions, but, of course, at the time, I didn't think those were personal questions. I answered them, and I was happy to answer them, because I was proud of what I'd done in school and in my church."

Even at fourteen, Jackie had the sense that she was being interviewed to see if she measured up. It was almost as if Gladys were screening Jackie in an attempt to find a younger version of herself for her son. And Gladys was direct with her about her competition.

"She knew about the 'traveling girls,' as I call them, and she explained to me that Elvis hadn't sown all of his wild oats yet. It didn't bother me, because she said I still had time to grow up."

In fact, when Jackie returned to Jacksonville, she was convinced that she would see Elvis again soon, and that he wanted it as much as she did.

In a few weeks, an envelope arrived at Jackie's home. Elvis, who wrote few letters, had invited her and her mother to his show at Jacksonville's Florida Theatre the following month. "This letter was written to Mrs. Rowland and Jackie, and it's signed with Mrs. Presley's name. But it's Elvis's handwriting. He started to sign his own name, but he knew that was improper. You just didn't do things with an underage girl."

* * * * * *

The day after the Russwood concert, Elvis gave himself a well-earned three-week vacation. It was his first real time off since becoming a national sensation. He'd always had trouble sleeping, and now sleep sometimes seemed forever out of reach, his foot just going all the time under the sheets.

He drove down to Tupelo on July 7, and then two days later showed up unexpectedly at June Juanico's door in Biloxi, with Red West, Gene and Junior Smith, and Arthur Hooten in tow. He was living in the moment now, not really planning much of anything, except to hang with his pals, maybe do a little fishing, a little sightseeing. He put the whole party up at the Sun 'N' Sand Hotel Court, and then moved to a villa at the Gulf Hills Dude Ranch resort in Ocean Springs, Mississippi. But after fans keyed messages into the paint of his new car, he rented a private home.

June was walking down Howard Avenue when he arrived, never dreaming he was anywhere near. "There was a group of girls coming up the street, and they saw me and said, 'June! *Elvis Presley's* at your house!' Boy, I took off at a fast pace to go and see."

When she got home, there was no sign of him, only a clutch of schoolgirls in her yard. Her mother, May, told her he'd been there, and that he was really ticked because he didn't have any privacy. He'd left a message for her to call the Sun 'N' Sand. The whole town seemed to be on the phone, though, and when she finally got through, Elvis gave her grief about it: "You told everybody in Biloxi I was coming!" She tossed it right back: "I didn't even *know* you were coming! You arrive in a white Cadillac convertible with a Memphis tag and your sideburns flapping in the wind? C'mon!"

Elvis's presence escalated the rumor flying around Biloxi that he and June were engaged. A New Orleans radio station, WNOE, picked up on it, reporting it on the air, which sent the Colonel into orbit. Parker ordered Elvis to drive to New Orleans immediately and deny it. Unannounced, Elvis walked into the station and did an on-air interview.

"Elvis, how are you?" the interviewer began.

"Fine. How are you, sir?"

"Wonderful. When did you come into town?"

"Well I just came in a few minutes ago."

"You drove up from . . ."

"A few minutes ago. [Laughs] Yeah, I was in Biloxi and I heard on the radio where I was supposed to be engaged to somebody, so I came down here to see who I was supposed to be engaged to." [Laughs]

"Well, just what is the story? Are you engaged to anybody?"

"The girl they were talkin' about, June Juanico, I've dated a couple times."

"Are you . . ."

"We're not engaged."

"Are you serious about anybody?"

"I'm serious about my career right now."

The interviewer gave it a rest, asked about his next release and his career, and then put him in the hot seat again.

"How old are you, Elvis?"

"Twenty-one."

"What age do you think might be the best for you to get married?"

"I never thought much about it. In fact, I have never thought of marriage . . . I'll say this much, I'm not thinkin' of it right now, but if I were to decide to get married at all, it wouldn't be a secret. I mean, I'd let everybody know about it. But I have no plans for marriage. I have no specific loves. And I'm not engaged, and I'm not goin' steady with nobody or nothin' like that."

"Well, you know how this whole thing started last night. We got—"

"Excuse me for buttin' in, but I don't know how it got started, but everywhere I go, I mean, I'm either engaged or married, or I've got four or five kids or somethin' like that."

"But you're not."

"Everywhere I go. Nah."

"You're as free as the breeze."

"That's right."

Elvis's interviewer then tried to move on.

"Well, Elvis, thank you so very much again, and we wish you lots and lots of good luck in your continued meteoric rise to stardom. . . ."

"Thank you very much. I've enjoyed talkin' to you, and I hope that we got the little rumor cleared up, because it's just a rumor and nothin' more. If it wasn't, then I wouldn't care for tellin' anybody. I wouldn't be ashamed of it."

"Why don't you say it just one more time, so people still don't get the wrong idea?"

[Laughs] "Well, I'm not engaged, if that's what it's supposed to be."

He got the heck out of there then, and he and June and the gang went to the Pontchartrain Beach Amusement Park to blow off a little steam before heading back to Biloxi. The next morning, June awakened to a phone call from a reporter from the *New Orleans Item*. "Did I kiss him good night? What do you think? He's wonderful!"

A day or so later, they went deep-sea fishing on the boat the *Aunt Jennie* with June's mother and her boyfriend, Eddie Bellman. Elvis looked out at the blue water and thought about his upcoming tour of Florida. He still wished he could take his parents to see the ocean, but maybe he could get them to come down to

Biloxi now. That way, he could stay down longer with June, too, and not have to worry Gladys. To his surprise, Gladys and Vernon said yes, and the Presleys arrived on Friday, July 13, staying the weekend. Elvis and June took them out on the *Aunt Jennie,* and then to New Orleans to see the sights before they returned to Memphis. When they parted, Elvis embraced his mother.

"She would just dig into him," June noticed. "You could see tears well up in her eyes anytime she left him. His daddy came around the door where his mama was getting in, and he was shaking his daddy's hand. But Vernon was not really that affectionate, not like she was."

Elvis was back in Memphis by July 20, but apparently lovesick, he returned to Biloxi nine days later. He'd talked it over with his mother, and contrary to what he'd told WNOE Radio only ten days earlier, he was serious enough about June to think about marriage. But he wanted her to wait three years. "He said, 'I can't get married right away. I promised the Colonel I wouldn't do anything that would affect my career. Will you wait for me?' "

June hated the "nuisance" of his fame—it was getting so that if they wanted to do anything, they had to wait until the middle of the night to go out so he wouldn't be mobbed. But she was "crazy insane about Elvis," so she said yes, she would wait. Elvis's parents came back down to Biloxi to celebrate.

Now he wanted June to go with him on his nine-day tour of Florida, ending with a tenth day in New Orleans. It was due to start in Miami in just a few days, on August 3. June's mother, May, pitched a fit—it wasn't decent—and said no: Really, what were they thinking?

Only four months earlier, Elvis had spoken with Gladys about asking Barbara Hearn to go with him on his tour of Texas. But it never got any further than that. "It was very embarrassing to stand there and listen to Mrs. Presley," Barbara remembers, "but I loved her for it. She said, 'Her mother will never let her go off like that, and even if she did, I wouldn't let her go. Barbara is a lady, and I want you to treat her like one.' "

But now Gladys spoke with June's mother and promised that Elvis would take "great care" of her daughter. "You can trust him," Gladys said. May weakened, and June packed her bag.

That left the Colonel as the only person not in favor of the arrangement. Elvis knew how he would react, so he didn't even tell him he was bringing June along. But trouble erupted the first night, when Elvis played the Olympic Theatre in Miami. June tried to dodge the Colonel backstage, but the press spotted her, and finding out her last name, called her mother for comment.

"They said, 'How do you feel about your daughter being on tour with Elvis?' Because they made it sound like something nasty. Mother said, 'My daughter has a very level head, and his parents assured me she couldn't be in better hands.' And then she made the fatal mistake of saying, 'Elvis has asked June to marry him.' That's when it really hit the fan.'"

Parker took Elvis aside and sputtered about his "morals," so June told the *Miami News,* "Right now, he's married to his career." And Elvis was instructed to say, "Well, I have about twenty-five girls that I date."

It wasn't much of a lie. And one more old girlfriend hoped to speak with him again. Seventeen-year-old Regis Wilson, his prom date from Humes, the one who had moved to Florida without telling him, was in the audience. Now she wanted to explain that she'd been too ashamed to share her family circumstances with him, and she hoped he forgave her for leaving like that.

She also had some news for him: She was married now, and she wanted to introduce her husband, Herb Vaughn. After the concert, she went to the backstage door, but security wouldn't let her in.

"But I know Elvis," she told the guard. "Sure you do," he said. She was disappointed and somehow knew it was her last chance. But at least a decade later, her brother, Jim Wilson, who was Elvis's age and had known him from Humes and Lauderdale Courts, saw him at the Memphian Theatre. The theater manager, Dickie Tucker, who had also grown up in the Courts, let Jim into one of the singer's private gatherings. Elvis was watching Marlon Brando's *The Wild One,* and Jim made his way over and introduced himself. Elvis remembered him and wanted to know whatever happened to his sweet little girl. "I just wish I had had the nerve to tell him good-bye," Regis says today. "That is something I have to live with."

· · · · · ·

By the time Elvis roared into Jacksonville on August 10, he had cut a swath through Tampa, Lakeland, St. Petersburg, Orlando, and Daytona Beach. Colonel Parker, who'd started out in Florida first as a carny, and then as a young promoter, knew every inch of the state. And with the help of Mae Axton, his crack publicity contact, he turned the tour into the epicenter of the national Elvis Movement. Blanketing the region with promotions that framed Elvis just short of a sideshow attraction, he packed the auditoriums with ticket buyers who ranged from the merely curious to the intently carnal.

Based on the pandemonium Elvis generated the last two times he played Jacksonville, the Colonel booked him for six shows over two days, all at the

Florida Theatre, a medium-size venue that held about 2,200 people. On assign-
ment from *Collier's* magazine was photographer Jay Leviton, who, like Al Wert-
heimer, had almost unrestricted access to the cresting star backstage, onstage,
over dinner, even in bed at the Roosevelt Hotel. ("He was very casual, very
unguarded . . . I was surprised Colonel Parker didn't control things more.") As
Wertheimer before him, Leviton would put poetry in the pictures—particularly
when Elvis would lie facedown onstage, stretching full out on the microphone,
saying things every girl in the audience wanted to hear. June would try to stay
out of Leviton's lens, but he would still find her backstage, along with Red West
and Junior and Bobby Smith.

Also on hand that day was Juvenile Court Judge Marion W. Gooding, a ser-
vant and crusader for all that was good and upright, and who was determined
there would not be a repeat of Elvis's last trips to Jacksonville, when "aroused
fans ripped nearly all [of Elvis's] clothes off." Pressured by community leaders
from Miami and Daytona Beach, who warned that the depraved singer was
swinging his pelvis and heading north, and it was no laughing matter, Judge
Gooding had met with them, as well as with the Optimists Club and the Na-
tional Congress of the P.T.A. All of them were up in arms, "frozen stiff with
outrage and bewilderment" at Elvis's "bizarrely spasmodic and purely sexual"
moves. They saw Elvis as arrogant, sneering, dangerous, and defiant—the very
embodiment of the 1950s juvenile delinquent—and insisted the judge warn him
to tone down his libidinous intensity.

"They really wanted Daddy to shut down his performance," said the judge's
daughter, Marilyn Gooding. "Daddy's heart wasn't in that, but he did want Elvis
to perform clean."

"They had me convinced that no teenage girl was safe around Elvis Presley,"
Judge Gooding said years later, chuckling at the times. "They wanted me to have
him watched at the theater and they wanted his hotel room watched. They had
him pictured to me as a real villain. . . . Looking back on it today, of course, it
wouldn't even stir a ripple. Not a single ripple."

But in 1956 Judge Gooding took his task with the utmost seriousness and
demanded to see the performer and his manager in his chambers before the
show. Photographer Leviton went along, capturing the disdain on Gooding's
grumpy face, and the flushed emotion—part shame, part anger—on Elvis's. The
judge warned him he would be at the first show to make sure Elvis did as he was
told, and that he had prepared warrants charging him with "impairing the mor-
als of minors." He would serve them, too, he said, if Elvis wiggled his hips and

"put obscenity and vulgarity in front of our children." As if for proof, deputies would be stationed in the wings.

Afterward, the singer told reporters, "I can't figure out what I'm doing wrong. I know my mother approves of what I'm doing." And the judge called Elvis a sweet, gentle, kid, "with the sort of good manners that we associate with southern politeness."

Still, the judge attended the first show at three-thirty. Onstage, Elvis opened with "Heartbreak Hotel" and threw his hips out once. "I'm going to put him in jail, sure as anything," Gooding whispered to the lawyer for the theater. But then Elvis caught himself and had his fun. "Wait a minute. I can't do this. They won't let me do this here," he told the audience, and then he wiggled his little finger suggestively in place of his usual movements. It thrilled the crowd, who found "the finger" both hilarious and deeply erotic. "The kids went nuts anytime he did anything," June says. "He could just make a funny face, and they would scream. These teenagers would just go crazy."

The judge went backstage afterward and told Elvis and the Colonel that all was well. Secretly, they'd reached a compromise anyway, the Colonel posting bond and Elvis joining the American Guild of Variety Artists, which also represented exotic dancers.

But Elvis was still wounded.

"It hurt his feelings," June remembers. "Elvis was *not* vulgar. He did not do a bump and grind. He swiveled his hips slightly, but no forward movement. No pelvic thrusts."

Yes, the boy kept his word, the judge told his wife, Eunice. "He went back to his chambers and telephoned me and told me how clean the show was, and he said, 'Tell the girls to line up their little friends, and you can put them in the station wagon and bring them to the next show.'"

So Judge Gooding's wife, their three daughters, and their girlfriends all went down to the Florida Theatre. Even they roared when Elvis dedicated "Hound Dog" to the judge. "Everybody in the audience got the biggest charge out of that," said Marilyn.

At the Roosevelt after the show, Elvis told June all about it: "Baby, you should have been there. Every time D. J. did his thing on the drums, I wiggled my finger, and the girls went wild. I never heard screams like that in my life. I showed them sons of bitches—calling me vulgar. Baby, you don't think I'm vulgar, do you?" She assured him that she didn't. Then to lighten the mood, Elvis put a pair of June's panties on his head and strode around the room.

Gladys, later hearing about Judge Gooding, told her son to never, ever go back to Jacksonville. There was nothing for him there except trouble.

But he had made some new fans.

The judge's grandson, Tony, would grow up to idolize Elvis and plaster Presley posters all over his walls. And the last Christmas the judge was alive, he gave his wife an album of Elvis singing religious songs.

· · · · · ·

At some point during the Jacksonville gig, Elvis was to meet with Andrea June Stevens, of Atlanta, Georgia, who'd won a contest, "Win a Date with Elvis," through Hit Parader *magazine. She'd written an essay about why she wanted to meet him. But when the moment came, the dark-haired girl was nervous standing in the corridor at the hotel. She'd also had wicked cramps on the flight, and the butterflies didn't go away until they opened the door to Elvis's hotel room.*

Then there he was, in black pants and loafers, white socks, and a white shirt with a comb—a couple of teeth noticeably missing—sticking out of his breast pocket. He accented it all with a matching white knit tie, and a white belt, slid over to the side so the buckle wouldn't bump his guitar when he played.

He called Andrea June "honey" and made her feel at ease on the sofa next to him, introducing her to his cousins. She was his age, or thereabouts, and soon she saw he wasn't really so intimidating at all.

After a little while, Elvis stood up and put on his kelly green jacket. They were going out to eat—after all, Andrea June had won a dinner date. But as they left the hotel entrance, the sight of him was just too much for one young girl, who fainted dead away, going down like a bowling pin. Somebody carried her to a couch inside, and Elvis, worried, stayed with her, calling her name and putting her hand up to his face. Finally, she came to—embarrassed that everybody was staring down at her—and Red got a souvenir program for Elvis to sign. It was just for her, Elvis told her. And please, next time she saw him, would she mind not fainting?

Now there wasn't much time left, so he and June ended up just with a quick bite at a diner. He wolfed down a cheeseburger, but Andrea June's tummy still didn't feel right, and so she passed. Back at the Roosevelt, after Elvis's last performance, he called June from the lounge and said, "You've got to get your butt down here! I've told June all about you."

June was confused. "You told June all about me?"

"Yeah, her name is June, too. Get on down here. She knows you're here. We're having a good time."

She went on down to the bar and found a crowd of young people and report-ers. Elvis was playing the piano and motioned for June to sit on the side of the bench with him. Then he excused himself, saying, "Okay, my two baby girls, I'll be right back." Andrea June turned to Elvis's real date. "Do you realize how lucky you are?" she said.

"What do you mean?" June asked.

"Elvis could have any girl in the whole world, and you're the one. He can't shut up talking about you."

June liked her. "Elvis was gone visiting with the guys, so we talked for a good fifteen minutes that night. We got to be good friends and even stayed in touch."

But Elvis wasn't just talking with the guys. He was off seeing about fourteen-year-old Jackie Rowland and her mother, his invited guests. The Colonel had admitted them to an afternoon show via the back door of the theater, and now Elvis had achieved the slick trick of getting two of his three dates to entertain each other while he checked about the third.

The next night, at the theater, Elvis would take Jackie off to a little prop room to show her how to kiss in a grown-up way. ("I had never kissed a boy before. . . . Elvis was a very loving and gentle teacher.") Her mother caught them, but still Elvis had time to say, "You know, when you grow up, you are go-ing to be mine." It was a solemn moment, as Jackie remembers. "I said, 'Yes, I know that.' The moonlight was coming in, and it was so romantic. I still remem-ber his scent and the warmth from his body."

Then it was time for him to go onstage, and he paused a moment and told Jackie "Don't Be Cruel" would always be for her. *"Don't be cruel / To a heart that's true . . ."*

He had invited both of the Rowlands back to the hotel after the show, and when they arrived, he was still upset about Judge Gooding. "He came out of the bar, and tears were running down his face. He was hurt very badly by that situation, and he hugged me, and just held on, and cried on my shoulder. And me being fourteen at the time . . . what can you do at fourteen? You're not a grown woman. You're still a little girl.

"He told my mother that she could go, that he would take very, very good care of me. And my mother said, 'Absolutely not.' He said, 'I really promise, Mrs. Rowland. I will take good care of her. I won't let anything happen to her.' She said, 'And you're going to take her in that bar? No, sir, you are not. She is under-age, and my little girl is going home with me.' Being the obedient child that I was, I didn't open my mouth. But inside I was dying. And so he turned around

and went back into the bar and we left. Of course, I was so embarrassed. I thought, 'I'll never get to see him again.' "

But Jackie would hear from Elvis through the early 1960s. And when she left that night, she had a wonderful souvenir. Her mother had snapped a playful photo of them lost in each other, staring moon-eyed. ("We thought we were alone—we didn't even know she had taken the photo.") And Marguerite slyly got Elvis to sign the back of one of the Audubon Drive photos, later comparing the handwriting to that on the letter purportedly from Gladys.

Jackie and her mother continued to attend numerous Elvis concerts around the area until he went into the army in 1958. Years later, when her mother died, Jackie was stunned to find more letters from Elvis in Marguerite's belongings, one written on pink stationery two weeks after the Florida Theatre shows. Marguerite had kept them from her all those years.

"I really trusted my mother. I thought that either Elvis or Mrs. Presley was *calling* her and inviting us for the different shows and visits. Now I really regret not knowing more. But dating a rock-and-roll star was like a Southern Baptist becoming Catholic."

Though Marguerite was a good chaperone, Elvis and Jackie had other moments where "he and I got off together and had some time to share with one another."

One such event occurred backstage at the Florida Theatre. Elvis and Jackie sat in a pair of chairs and talked while Elvis's scary cousin, Junior, perched on the stairs nearby. Suddenly, everyone noticed that the strap on Jackie's sundress had slipped down and fallen off her shoulder. "Junior made a smart remark, something to the effect of, 'Yeah, baby, take it all off!' Elvis jumped up out of that chair, grabbed him, shook him, and said, 'Don't you dare talk to her like that! She's my girlfriend and she's a lady!' "

Predictably, they never had sex ("We kissed and hugged, but he never touched me inappropriately"), and chances are they wouldn't have, even if Jackie had been willing. Elvis wasn't having intercourse with June, either.

Already, Elvis's reputation as a sex symbol was becoming a burden. In the 1960s, he would tell Larry Geller, his spiritual adviser and a member of his entourage, that in the early days of his fame, he had relations with so many women that he was hospitalized for exhaustion. Whether that was the reason behind his 1955 hospital visit in Jacksonville isn't known. But according to Geller, the incident taught Elvis that he should not live his life as a sex machine, and that sex without love meant nothing, even though he could not always control himself.

Elvis's label as a sex god, then, hampered him psychologically. Women assumed, from his image and his movements onstage, that he was a lover of legendary proportions. But he was insecure about his sexual prowess, and felt inadequate once his lovemaking moved beyond dry humping and other adolescent practices. And since he was brought up to please, and pleasing is part of any entertainer's personality, he feared that he might not measure up to a woman's expectations in bed. His apprehension was so incapacitating that it often made him withdraw from actual intercourse and extend his foreplay instead.

This was also a factor in his gravitation toward thirteen- and fourteen-year-old girls. At that level of sexual development, young teens of his generation were likely to still be innocents, satisfied to simply make out and abstain from intercourse—precisely where Elvis felt most at ease. He wanted virgins—he called them "cherries"—so that he might mold them sexually, but also so they wouldn't have anyone to compare him to as a lover. That way, they would be less likely to critique or pass judgment on his performance.

But Elvis failed to realize the damage that sexual flirtation could have on young girls, especially coming from someone so famous and charismatic. Though Jackie went on to marry, "Once you'd kissed Elvis, it was all downhill after that. . . . I guess you could say the flame still sizzles." Her sentiment is common among women who enjoyed any involvement with Elvis, particularly if he was the first male with whom they were involved, and the divorce rate among them is high. Jackie herself divorced after nearly forty-two years of marriage.

One of the ironies of her story is that Jackie and Eunice Gooding, Judge Gooding's wife, became good friends. While Jackie could see both sides of the issue, Elvis never did. After his last performance at the Florida Theatre on August 11, according to June Juanico, Elvis had a message for the judge and his cronies in attendance. "You know how Elvis always said, 'Thank you very much'? I heard it just as clear as day. He said, 'Fuck you very much. Fuck you very much.' Everybody was screaming, but all the members of his entourage heard it. He did it twice and he looked over at me and grinned." Once they were together in the room, June asked him if she'd heard him correctly. "You heard correctly," he said.

The tour wound up the next day in New Orleans on August 12. In the Big Easy, where almost anything went, Elvis gave his performance without restraint and even received the key to the city. It had been an incredible ten days, during which he'd made $20,000, plus a $7,500 commission on souvenirs.

As usual, his thoughts turned to Gladys after the show. He knew she always

worried about him, even though both Elvis and Gladys had turned June into a surrogate mother. That night he was so exhausted he had chills and a fever. Perspiration gathered in hot beads on his forehead, and then gave way to cold sweats. He was just at the point of collapsing in the bed, but he said, "I have to call my mother before I go to sleep."

When he got her on the phone, as June remembers, "He told her, 'I'll be home in a couple of days. Don't worry about me, Mama. June is right here.' Anytime he called her, he would say, 'Here, talk to her.' So he handed me the phone and she said, 'How is he? Is he getting enough rest? Is he eating? Don't let him run himself crazy, June.' I said, 'Don't worry, I'm right here with him.' "

Still, he was so keyed up and sick that it took its toll. Contrary to his normal routine with June, Elvis was unable to relax and sleep. ("Whenever we went to bed, he just died, he died.") But on this night, he was back to his old restlessness. They had a suite at the hotel, and June moved into the living room so as not to disturb him. But that didn't seem to help, either.

"He sat straight up in his bed and he called, 'June! June! Come in here!' I went in and he was sweating, he was trembling, and he said, 'I had a horrible dream. I was in a coffin and my mother was looking down crying over me!' "

June saw it as more evidence of a premonition he'd had that he was going to die young. He'd mentioned several times, "I'm not going to be here long." Yet the timing was also curious. June had refused a ring, accepting only a radio with rhinestones all over it for her birthday. But it was the first time he'd gotten so close to really committing to a woman. His dream, then, seems more about the death of his lifestyle—about anxiety over marriage, of breaking his bond with Gladys—than about physical demise.

Now, in his fevered state, "He kept saying, 'I can't leave my mother! My mother needs me! I can't leave her! She needs me!' It was a real dream to him."

Things just seemed to be happening quicker than he could absorb them, and there was never any time to think about any of it. He was scared about so many things, scared he might lose it all. He'd even mentioned it to Jackie, a mere child. But he couldn't quit obsessing about it. What if it all just ended tomorrow?

Four days later, on August 16, Elvis would leave for Hollywood to begin his first movie.

Elvis and Debra Paget get better acquainted on the 20th Century Fox ranch during a break from filming *Love Me Tender*, late August 1956. "She's the most beautiful girl in the world," he said. *(Robin Rosaaen Collection)*

TEN

· · · · · · · · · · · · · · · · · ·

Hillbillies in Hollywood

Elvis arrived in Los Angeles with his cousins Gene and Junior, and immediately after checking into his eleventh-floor suite at the Knickerbocker Hotel—a favorite of show business luminaries on their way up or down—the trio went to Long Beach Amusement Park, where they reportedly blew $750. It was a huge sum of money to throw away on bumper cars and crap carnival food in 1956. But Elvis was hardly a young sophisticate. And Gene, never a smart boy, with a speech impediment that made him seem even dimmer, appeared such a bumpkin as to barely be believed. Together, with the eternally bewildered Junior, they were hillbillies in Hollywood, and the film community would nearly fall over itself to see who could make the most derisive comment or the cruelest joke.

Vernon and Gladys also had trouble believing where fate had led them, and Elvis was mystified to explain his success. "I don't know what it is," he said. "I just fell into it, really. My daddy and I were laughing about it just the other day. He looked at me and said, 'What happened, El? The last thing I remember is I was working in a can factory, and you were driving a truck.' And I remember how, after something big happened along the way, I was sitting at home and found my mama staring at me. I asked her why, and she just shook her head and said, 'I don't believe it.' We all feel the same about it still. It just . . . caught us up. But I sure hope it doesn't stop."

Elvis had been to Los Angeles before, both for television and show dates, but now the City of Angels seemed to be one big play lot, offering up the opportunity to fulfill every dream he'd ever had. His producer on *The Reno Brothers* was David Weisbart, who had brought one of Elvis's favorite movies, *Rebel Without a Cause,* starring his idol, James Dean, to the screen. Within four days of his arrival,

Elvis would meet Nick Adams, a close friend of Dean and part of a Hollywood clique of talented but troubled young actors who embraced the "live fast, die young, and leave a beautiful corpse" philosophy.

Elvis had cried when Dean died, and now it looked as if he were about to be welcomed by all of the late actor's acolytes and brethren, the "in" crowd that included Dennis Hopper (Adams's roommate at the time), Russ Tamblyn (another movie hood, then married to Venetia Stevenson, whom Elvis would later date), and Sal Mineo and Natalie Wood (who were still teenagers and going to school). It made his head spin, even though he didn't know that the reckless Adams, who was said to use pills, and who was on probation after being arrested for speeding nine times in one year, hoped to trade on the friendship to win a part in Elvis's film. In fact, Elvis had beat Adams out for the supporting actor role, and most of the larger studios were loath to touch him.

The picture, directed by Oscar winner Robert D. Webb, was cast very late, and though Joanne Woodward had originally been slated for the female lead, by now Elvis knew that Debra Paget had won the part. Elvis was ecstatic. Only months earlier, Elvis had told Milton Berle in a television skit, "Really, Mr. Berle . . . the type I dig is someone like that Debra Paget. . . . She's real gone." She, too, had nice things to say about him, even if she gave him a backhanded compliment: "I'll admit that my impression of Elvis, before I met him, was the same as many others who don't know him. I figured he must be some kind of moron. Now, I think the best way to describe his work is to say it's inspired."

They would circle around each other as principal photography began. In Robert Buckner's screenplay, set in Texas at the end of the Civil War, Elvis plays Clint Reno, snared in a love triangle with his older brother, Vance (Richard Egan), and Cathy, the woman they love (Paget).

It was an odd role in which to make his screen debut, but Elvis gave it his all and tried not to be intimidated by his costars, who included the fine character actress Mildred Dunnock, twice nominated for an Academy Award, as his mother. Critics would pan the novice actor—he was, after all, an easy target— but Dunnock was surprised at his solid performance. "When I came back from making the picture, my friends saw it and said, 'Why Millie, this boy can act!' This rather threw me, because I said I had spent twenty-five years trying to learn how to act, and Elvis Presley hadn't spent twenty-five minutes. So I do not in any way depreciate his value as an actor."

The truth was, Dunnock, a fellow southerner, had taken a shine to Elvis,

and when he confessed to her that he didn't really know what to do, how to make the lines ring true, she took it upon herself to coach him. First the former schoolteacher had to educate him in the art of theatrical projection.

"Elvis would have a line like, 'Can't do it, Maw, can't do it.' And he would say [it] really pleasant and nice. But I'd tell him to say it like he really meant it. And after a certain number of tries he would finally say [with strong emphasis], 'I can't *do* it, Maw, I can't *do* it!' And Mr. Webb would say, 'Shoot.' "

In one of the film's most crucial scenes, the family was led to believe that the Yankees had killed Clint's brother. "He really hadn't been killed," Dunnock remembered, "but my baby Elvis was upstairs, and I was in the kitchen cooking. There was only one line of dialogue in this scene, and it was mine. All the rest was plain action. I was going to say it firmly, so I rehearsed it and rehearsed it. The lighting men decided what they were going to do, and we sat down and drank Coca-Colas and waited for about two hours."

As Dunnock told the story, the director finally said, "Everything seems ready, so let's rehearse it one time." Elvis said, "Yes, sir, Mr. Webb."

Then the director took Elvis through it, saying, "In this scene, the Yankees come by horse up into the backyard, which you can see from your window upstairs. You come down and go to the window and see those Yankees kill your brother. You go to the sideboard, open the drawer, and pull out a gun. You start across that floor to go meet those damn Yankees, and end of scene."

"Yes, sir," Elvis said confidently.

"The Yankees are going to rap on the door," Webb continued. "I'll go, 'Ready, lights, shoot,' then I'll make a knocking sound, and that's your cue to come down those stairs. Understand?"

"Yes, sir."

Webb called for action, and rapped out the knock.

In Dunnock's retelling, "Elvis came down those stairs, went to that sideboard, took out that gun, and when I said my line, 'Put that gun down, son!,' well, he dropped it right away. Mr. Webb said, 'Cut! Cut! Oh, my God, what are you doing? You're supposed to keep on going!' Elvis said, 'She told me to put it down.' "

Most actresses of Dunnock's caliber would have held her head, livid at having to put up with so inexperienced an actor. But Elvis had gotten to the real mother in her, and she chose to frame his blunder as an asset.

"You see, for the first time he *heard* me. Before, he was just thinking about what he was doing and how he was going about it. It's a funny story, [but] I also

think it's a story about a beginner who had the first requirement of acting, which is to believe in what you're doing."

Though Elvis hoped he would play the part as a straight dramatic role, and do no singing, Colonel Parker dashed that dream straightaway. Seeing how Hollywood's *The Blackboard Jungle* spurred the chart-topping success of Bill Haley's "Rock Around the Clock" the year before, the Colonel insisted that Fox and RCA make the most of a similar opportunity. Parker had no faith that Elvis would amount to anything as an actor and got him involved with motion pictures primarily as a vehicle to sell records.

The Ken Darby Trio was part of the session team that replaced Scotty Moore and Bill Black on the soundtrack—the producers found their Memphis sound far too raw—and Darby wrote all four songs for the film, including "Love Me Tender," a massaging of the Civil War ballad "Aura Lee," written by W. W. Fosdick and George R. Poulton. The Colonel, intending to bleed every penny out of the film, insisted that Elvis be cut in as a songwriter. So Darby officially credited "Love Me Tender," which inspired the title change of the picture, to both Elvis and Vera Matson, Darby's wife. The singer hadn't written one bar of it. But he now had a music publishing company administered by Parker's old friends, the brothers Julian and Jean Aberbach.

Critics would point out that Elvis's dance steps during the three remaining songs, "We're Gonna Move," "Let Me," and "Poor Boy," were totally wrong for the period and made the scenes seem out of place. But Elvis fans didn't care—they wanted to see him move. The title track became an instant hit, the single lodging in the number one spot for five weeks in November and December 1956, and the accompanying EP reaching number thirty-five. The Colonel was happy, and Weisbart was, too: The film made back its $1 million budget within three days.

Elvis was proud to do the title song because it showed a side of him that had all but disappeared. "People think all I can do is belt," Elvis told reporter Army Archerd, breaking into a sample of the song. "I used to sing nothing but ballads before I went professional. I love ballads." But he was ticked about not being able to use Scotty and Bill on the record, though they appeared with him on *The Ed Sullivan Show* on September 9. Sullivan had been injured in a car accident in August, and so actor Charles Laughton filled in for him in New York. Still, it was an amazing opportunity for Elvis, especially since Sullivan had publicly vowed he'd never have such a vulgar personality on his program, all the while negotiating with the Colonel, even calling him backstage at *The Steve Allen Show* and shattering the industry price ceiling to get him.

Since the performance came smack in the middle of filming *Love Me Tender,* Elvis was allowed to appear live from the CBS Studios in Los Angeles. More than 80 percent of the national audience watched him sing "Love Me Tender," "Ready Teddy," "Don't Be Cruel," and two verses of "Hound Dog."

Among them was eleven-year-old Priscilla Ann Beaulieu, of Austin, Texas, whose stepfather, Paul, a career Air Force officer, had bought her Elvis's debut album at the PX. "I thought it might be something [she] would like . . . it seemed like music for her generation." But once he and his wife, Ann, heard the music, they didn't have such a high opinion. "Frankly, we forbade her to watch the show," he remembers. But forbidden fruit is that much sweeter, Priscilla would later say. "I cracked open my door just enough to see the television set."

So many extraordinary things were happening for Elvis that he sometimes seemed oblivious to his old way of life. He was having a blast, being a movie star, meeting beautiful women, staying up all hours, and doing and saying whatever he wanted. Nothing inhibited him, or if it did, he didn't act like it. In fact, fame emboldened him. He could be both playful and arrogant and get away with it, even with steely female reporters. Or at least he thought he could. When a young New York journalist came to visit him during the filming, he flirted with her shamelessly.

"A press agent came by to tell me I had had enough time with Elvis," she wrote. "I started to leave and Elvis, who was still sprawled on the couch, darted out his hand and caught my foot. 'Maybe she's shy; maybe she'd like to be alone with me,' he said. The press agent shrugged and left.

"I asked Elvis to take his hand off my foot. 'Okay,' he said, looking up under heavy lids. 'Ah'm just spoofing you.' I asked Elvis how he felt about girls who threw themselves at him. Again the heavy-lidded look. 'Ah usually take them,' he said, watching my face for the shock value of his words. He grinned. 'Hell,' he said, 'you know, Ah'm kind of having fun with you because you're so smart.'"

· · · · · ·

Colonel Parker had used William Morris to broker Elvis's movie deals, building on his relationship with Abe Lastfogel, the diminutive head of the respected talent agency, from his Eddy Arnold days. Lastfogel had assigned Leonard Hirshan directly to Elvis, since as Hirshan puts it, "The three of us negotiated the [*Love Me Tender*] deal with Fox, so I considered that my deal as well as anybody's." But though Elvis was Morris's client, and not Parker, the Colonel never let the

agency deal directly with his star, insisting that everything go through him. Parker particularly didn't trust Hirshan, fearing that he would make himself too powerful with Elvis and get in the Colonel's way. Parker all but banned Hirshan from Presley's movie sets and then went about finding a mole within the agency to report on their plans.

Byron Raphael was a twenty-two-year-old agent-in-training at the Morris Agency in Beverly Hills in 1956, working his way up in the mailroom. One day, he delivered an envelope to Elvis's outsized manager on the Fox lot. The Colonel sized up the small, affable young man and immediately appropriated him ("Tell your bosses you're going to work for me"), and made Raphael his spy—both within the Morris office and inside Elvis's camp. Since Raphael was only a year older than Elvis, and obsessed with music, it was an easy alliance.

On September 10, midway through the shooting, Nick Adams—also believed to be a sentry for the Colonel, reporting on Elvis's comings and goings—arranged for eighteen-year-old Natalie Wood to visit Elvis on the set. Elvis, who had gotten so caught up in her Oscar-nominated performance in *Rebel Without a Cause*, tittered like a schoolboy at the thought of meeting her. Natalie, attracted to bad-boy types and dark personalities, was just as intrigued with him.

But Elvis didn't know she was a deeply disturbed girl, or that she was tormented by the conflict between her real self (born Natasha Zakharenko to Russian immigrants) and the alluring persona of Natalie Wood, a cocreation of Hollywood and her ambitious mother, Maria. Wood learned early to please the grown-ups, and the teenager, who had begun working in films at the age of six, had a wild-child reputation, drinking, casually falling in and out of relationships (like Elvis, she couldn't stand to be alone), and using her sexuality to further her career. Elvis would eventually come to dub her "Mad Nat."

The Colonel asked Byron to walk Natalie over to the soundstage, and "I could tell they were hot for each other the moment they met," Raphael remembered. A devilish grin crossed Elvis's face, and he invited Natalie to visit him in his suite at the posh Beverly Wilshire Hotel that night.

Although Elvis had been in Hollywood only a matter of weeks, his parties, attended by movie royalty and young fans alike, were becoming legendary, whether at the Knickerbocker or the more staid Beverly Wilshire, at the corner of Rodeo Drive and Wilshire Boulevard. Glen Glenn, an aspiring California country singer who became good friends with the band, found that "every time you went to see Elvis up at the Knickerbocker, there would always be two hundred or so girls out in front. They had a special guard that made sure that girls

could not get inside the hotel unless they were actually staying there. They were standing out front, hoping Elvis would come out."

Among them were sisters Sharon and Mary Jo Sheeley of tony Laguna Beach, California, both rabid Elvis fans. Sharon, the older of the two, looked at her sister one day "and just told her that we were going to Hollywood. It was very matter of fact with me." Mary Jo remembered it the same way: "When she got her driver's license, she came into my room and said, 'Josie, come on! We're going to meet Elvis.'"

When they arrived, they were surprised to find that "thousands" of girls had the same idea. "It wasn't quite as easy as I had planned it out to be," Sharon realized. "So I took [Mary Jo] home and said, 'I've got to think of something better than this.'"

The following week Sharon put her hair up, slathered on a generous amount of makeup to look older than her sixteen years, and checked into the Knickerbocker Hotel, sneaking her sister in later. Now, with the first part of their mission accomplished, the Sheeley girls had only to meet Elvis. Sharon again led the way.

"On a very lucky occasion, when there was no guard on his floor, we knocked on his door and they opened [it]. The first thing I saw through the crack was Elvis sitting backward in a chair, straddling it. I looked into those gorgeous blue eyes of his, and I couldn't believe that I was staring eye to eye with Elvis Presley. And he said, 'Well, don't just stand there. Come on in.'"

Sharon strode right into the room, but when she turned to her sister, Mary Jo "was paralyzed behind me. Her legs wouldn't move. And he literally got up and walked over and picked her up."

Now Elvis turned his full attention to fifteen-year-old Mary Jo. "He looked at me and he said, 'Are you a goody-goody girl?' And I said, 'What's a goody-goody girl?' He said, 'Never mind,' and with that he gave me the longest, most passionate, memorable kiss I've ever had. Then he looked me straight in the eyes and said, 'There. If that gets you pregnant, I'll marry you.'"

He invited the teenagers to stay and have hamburgers, and said if they were in town the following week to come back up again. From there, "It just became a regular thing," said Sharon. "Every weekend, we would go and hang out with Elvis Presley." Sharon later parlayed her music contacts into a songwriting career, starting with Ricky Nelson's first number one, "Poor Little Fool." But the thrill of being around Elvis never diminished, at least not for Mary Jo. "Just walking into the room, he had that presence that he had onstage. He was gorgeous, kind, [and had a] great sense of humor." The visits continued for years. In 1957, "He used to

put me on his lap and sing 'Young and Beautiful' to me," Mary Jo remembers, "which not many people can say."

When Natalie Wood arrived at the Beverly Wilshire about nine o'clock on the night of September 10, she found more than a dozen people in the living room, ranging from Elvis's cousins and their dates to the young girls he'd invited up from the fan huddle downstairs. Elvis had just gotten out of the shower after heavy petting with one of the more willing fans, and he was wearing a white smoking jacket with the letters *E.P.* embroidered in gold. He immediately gave Natalie a hug and asked if she'd like to see some of the dailies from the film. She said yes, recognizing the code, and they disappeared into the bedroom.

Twenty minutes later, Byron was surprised to see a furious Natalie storm out the door. "What's the matter with your boss?" she demanded, glaring at him. "Doesn't he know how to screw? He's all hands and no action." Byron fumbled for excuses, but Natalie kept raving. "I thought he was supposed to be the king of the sack! But he doesn't want to screw me!"

Elvis's guests began to scramble, leaving only Gene sitting there as Natalie continued her rant. "What's Elvis going to do, tell his buddies I'm not sexy enough for him?" Byron assured her Elvis wouldn't do any such thing. Natalie glanced back at Gene with a smirk on her face and taunted him. "I think all you guys are homos," she said.

Then, to Byron's amazement, the Hollywood star propositioned the agent-in-training, and he took her up on it. Suddenly, he was on top of her, frantically pulling off her pedal pushers as she worked to remove his pants. She guided him into her, and he pumped fast and furiously, and she did, too. In seconds, they were both glistening with sweat. But she criticized his performance, and he worried that he hadn't used a rubber. Natalie pushed him out of her and quickly dressed.

"You're okay," she said matter-of-factly. "But tell Elvis if he wants to go out with me again, I want to go all the way. You can also tell him I'm the best fuck in town." And then she left. Byron glanced over at the bedroom and saw Elvis standing in the doorway. He didn't know how much he'd witnessed, but the singer simply closed the door and never mentioned it. Later, Elvis made a crude remark to the guys about Natalie's feminine odor—and began exhibiting more tendencies toward voyeurism.

A sexpot like Natalie naturally would have intimidated a man as sexually immature as Elvis, but there was another reason he had not had intercourse with her. Aside from his deep romance with June Juanico and his serious relationship with Barbara Hearn (he was also getting cozy with a female wrestler, Penny

Banner), he had fallen hard for Debra Paget, his physical ideal. "She's the most beautiful girl in the world," he told *Photoplay* magazine.

Many accounts of his infatuation with Debra hold that he couldn't get to first base with her, that she found him the "moron" she alluded to in print, and that his love was unrequited. But in truth, they both fell in love.

Debra, reserved and quiet, found him sweet, kind, and funny. And Elvis was entranced with more than just her perfect cheekbones and fragile beauty. She had two more qualities he admired—she was religious, from a Jewish background, and a virgin. Because Gladys told him to end up with a girl who was pure and untested, "He always said he'd marry a virgin," Debra remembered.

But like Elvis, Debra had a strong, unbreakable bond with her mother, Marguerite Gibson, who was also heavyset and redoubtable like Gladys. The similarities were obvious to both Elvis and Debra, and Elvis even saw a facial resemblance between Debra and the youthful Gladys. To Elvis, who was looking for a virgin who embodied both his mother and his physical twin, Debra became a prize beyond all imagining.

He talked to Gladys about her all the time, going on and on, and she could see he was overwhelmed with her, calling her "Debbie" with a smile in his voice. When a reporter asked if he had a favorite female star, he said, "I love 'em all, but I've got one special gal—and she's the only gal for me. But she keeps me 64,000 miles away!" And who was that? "Debbie!" Elvis blurted.

But there was a larger problem, aside from the fact that Elvis had already publicly declared that he had two girlfriends, Barbara Hearn and June Juanico. Debra's brassy mother, who managed her daughter's career and had been in the theater—some said burlesque, inspiring Debra's routine on *The Milton Berle Show*—wanted her to have nothing to do with him. Elvis couldn't figure it out. His conversations with Debra, both on the set and at her house in Beverly Hills, where he sometimes played with the pet chimpanzee (he'd later get one himself), revolved largely around the topic of God. Yet her father, likewise, found Elvis not up to Debra's standards.

"There were stories going around about him," the actress told Suzanne Finstad, and her mother, fearing the worst, would not let Debra leave the house unchaperoned. Try as he might, Elvis could not convince Debra's parents that he was not the hell-raising hooligan that some of the press made him out to be. As with so many of Elvis's younger love interests, Debra had never been on an actual date, which made her even that more irresistible to him. But because of her parents' virulent reaction, Debra dared not let Elvis know for certain that she returned

his affections. "I was *very* shy then," she continued to Finstad. "I hardly talked . . . I'm not sure I ever told him how I felt, but he could feel it."

Elvis could, indeed, feel it, but he didn't know what to *think*: Talk had it that Debra was seeing Howard Hughes at the same time, and from the cars that came and went at Debra's house, Elvis believed it was true.

A week after the disastrous episode with Natalie Wood at the Beverly Wilshire, Nick Adams took Elvis out to a hotel in Malibu, where Natalie was enjoying a getaway with her bisexual boyfriend, actor Scott Marlowe. Natalie and Scott had spent the time talking, as they had before, about marrying. But both Warner Brothers, where Natalie was under contract, and her mother, Maria, strictly opposed the idea and forced them to break up. Now Elvis, Natalie, and Nick, also rumored to be bisexual, were "almost a threesome, having a lot of fun together," Natalie told newspaper columnist Louella Parsons. They were seen that week at the Iris in Hollywood, watching the trashy B movies *Hot Rod Girls* and *Girls in Prison.*

Tab Hunter remembers how taken she was with him. "Natalie and I were in New York doing *The Perry Como Show,* and we were walking back to her hotel. She was staying at the Essex House, and . . . she was going on and on about Elvis, and I was getting a little annoyed and a little jealous here.

"The hotel sign spelled out E-S-S-E-X H-O-U-S-E all over Broadway, but the lights were out of the first two letters, making it read S-E-X H-O-U-S-E.

"I said, 'Don't tell me he's going to come and visit you at the SEX HOUSE!' And she took her purse and went *wham!,* and just hauled off and belted me. Natalie was crazy about him."

But deep down, Natalie also found Elvis desperately lonely, a lot like herself, even as so much about him mystified her. He acted more like a concerned older brother around her than anything else, and as she told Presley biographer Albert Goldman, he was a little too conventional, almost square.

"He was the first person of my age group I had ever met who said to me, 'How come you're wearing makeup? Why do you want to go to New York? Why do you want to be on your own? Why don't you want to stay home and be a sweet little girl? It's nice to stay home.' We'd go to P.C. Brown's and have a hot fudge sundae. We'd go to Hamburger Hamlet and have a burger and a Coke. He didn't drink. He didn't swear. He didn't even smoke! It was like having the date that I never ever had in high school. I thought it was really wild!"

Natalie's mother encouraged the relationship, even as Natalie herself was still dissatisfied with him in bed. Elvis didn't feel it was any big romance and contin-

ued to see as many women as he wanted. Around the same time, he and Nick spent a Sunday afternoon with Judy Spreckels, and later, the trio went horseback riding at Judy's ranch. Among her many pictures of Elvis is a photograph that freeze-frames the day. "He was laughing. It was just such a fun time." She and Elvis loved each other, all right. "But it was just a really terrific friendship."

Still, no matter what Elvis was doing with anyone else, Natalie was thinking about him. As proof, she had her seamstress make two big, blousy velvet shirts for him, one in romance red and another in heartbreak blue.

· · · · · ·

The shirts would become iconic as the ones Elvis wore on September 26, 1956, at his homecoming appearances at the Mississippi-Alabama Fair and Dairy Show, the blue for the afternoon performance, and the red for the evening. However, the blue one almost didn't make it to Tupelo.

Barbara Hearn was Elvis's date, and early that morning on Audubon Drive, where the Presleys were having remodeling work done, "Elvis handed me something on a clothes hanger with a laundry cover on it. He said, 'Hold this.' There was a bit of confusion, and lots of people around, and I stood there holding it until I thought, 'Gosh, I'm not a closet rod here,' and I laid it on the sofa."

They rode down together in Elvis's new white Lincoln Mark II, and when they arrived at the dressing tent, Elvis suddenly turned to Barbara.

"Where's my shirt? Do you have my shirt?"

"What shirt?"

"The shirt I gave you to hold this morning."

Oh, gosh! She didn't know he meant to bring that shirt! Barbara felt really bad, but Elvis "was very sweet about it. They just quickly called somebody in Memphis who hadn't left yet, and they brought it on down."

Elvis came to Tupelo at the invitation of James Savery, the fair association president. It was a day right out of Horatio Alger, a button-busting, local-boy-makes-good story, with a jubilant parade (the city feared a riot, so Elvis wasn't actually in it), a banner across Main Street (TUPELO WELCOMES ELVIS PRESLEY HOME), and the Rex Plaza, the nicest restaurant in town, serving up "Love Me Tender" steak and "Reddy Teddy" pork chops. Governor J. P. Coleman read accolades from a scroll, calling Elvis "America's Number One Entertainer," and Mayor James Ballard even presented him with a guitar-shaped key to the city. Elvis returned the favor and then some—he signed his $10,000 check back over to Tupelo. "The last time I was here," he mentioned, "I didn't have a nickel to get in."

Some fifty thousand folks came to town for the festivities, the biggest turn-out anyone could remember since Franklin Roosevelt visited during the Depression. Twenty thousand attended the evening show, twelve thousand more than the entire population of Tupelo. (Fourteen-year-old Virginia Wynette Pugh, later to gain fame in country music as Tammy Wynette, was in the front row for the afternoon performance.)

At one point in the matinee, it all became too much for sixteen-year-old Judy Hopper, who'd traveled from Alamo, Tennessee, and jumped the five-foot stage. ("What did I *want*? I wanted *Elvis*!") Later, she got to go back and hug and kiss him. She giggled until she almost hyperventilated, and the two had their picture made together. She already had some leaves out of his yard, and now she had his autograph, too. "It was a *thrill,* it really was," she gushed to the press in a drawl as wide as the Mississippi. "I'd like to go to Hollywood now!" The Tupelo *Daily Journal* captured the mayhem in full. " 'Elvis,' the girls shrieked, tearing their hair and sobbing hysterically, 'Please, Elvis.' "

Local police, county sheriffs, Highway Patrolmen, and even the National Guard stood ready in case there was trouble, but there wasn't any, not really, which was surprising, given the size of the crowd, the intensity of their love for Elvis, and the heat. Though it was late fall, the temperature had risen to such a ghastly degree that Barbara and Gladys melted in their folding chairs, Gladys sweltering in a brocade dress and stockings, a locket with a picture of Elvis around her neck. "It made me feel bad," she later told a friend, "to go back there like that and remember how poor we was."

But clearly the Presley family, nearly run out of town in the late 1940s, had returned in triumph. Eleven years earlier, Elvis had lost the talent contest with "Old Shep" on practically this very spot. And now his first motion picture was due out in November, and his double-sided single, "Don't Be Cruel" and "Hound Dog," was number one and two on the charts.

"I've been looking forward to this homecoming very much," he said in a press conference before the afternoon show. "I've been escorted out of these fairgrounds when I was a kid and snuck over the fence. But this is the first time I've been escorted in." A voice called out: "How about Natalie?" "I worry about her when I'm not there where she is," he said, casually. "I don't think about her when I'm not." The newspaper reported that Mrs. Presley appeared "a little bewildered by all the commotion . . . but smiled pleasantly for photographers."

For Gladys, "Elvis Presley Day" was the validation that her son was just as special as she always knew he'd be. And for Vernon, the ex-con forced to leave

town to find work, the moment was sweet revenge. He was standing outside the big tent in back of the stage when he saw Ernest Bowen, his old boss at L. P. McCarty and Sons, the wholesale grocer. Vernon had a delivery route when he worked for Bowen, and it was his last job before leaving Tupelo. Now Bowen was general manager of the radio station WELO and trying in vain to get into the tent to see about an interview for his announcer, Jack Cristil.

"All of a sudden this guy hollers at me—I didn't even recognize him, but it was Vernon, all cleaned up and greeting me like a long-lost friend," Bowen remembered. "He wanted to know if he could do anything, and I said, 'Yeah, get me in the tent.' He said, 'Just follow me,' and he just parted the waves. I asked Vernon, 'How are y'all doing?' He said, 'Oh, we doing just great.' Said, 'The boy is really taking care of us.'"

When Cristil approached the Presleys that night, an exuberant Vernon, blond and handsome in a dark suit, white shirt, and tie, grabbed the microphone and hardly let it go, saying how proud he was, and how much they appreciated "all the good people who've knocked themselves out being so nice to us." He went on to thank the police department and the Highway Patrol, and he got on such a roll that Cristil finally just talked over him.

But for once Vernon had overshadowed his wife, who barely had room to answer the man's question about her favorite Elvis record. "'Baby, Play House,'" she announced cheerfully, picking the sexiest of all Elvis's songs, though mangling the title. "That's a good one," Vernon said, but Gladys kept going: "And 'Don't Be Cruel.' That's my two favorites."

Cristil also took time to talk to Nick Adams, who had flown to Memphis with Elvis and Gene Smith after the completion of *Love Me Tender* and would stay for a week. The reporter didn't really know who he was. ("And you're a star, I understand, a motion picture star, right?") But Nick was self-effacing and respectful, demurring to talk about his own career, and calling Elvis "the nicest person I've ever met in show business . . . I can't speak too highly about him." Then he bragged on Gladys's fried chicken and started to mention her okra, but he couldn't remember what it was. "Elvis?" he yelled across the way. "What's the name of those things your mother fixed me up? Oker?"

Nick said he had come to Tupelo to support his friend. But he needed some propping up of his own. After a promising start in films, he could barely find work, and he'd spent the funds from his early successes, including *Mister Roberts* and *Rebel Without a Cause*, on houses for himself and his parents. Naturally, in Memphis, he stayed with the Presleys.

"He was just about broke," Barbara understood, "and he came in the house, and honest to goodness, his shoes were falling apart. They were horrible-looking. Mrs. Presley looked at them and said, 'Son, I don't want you coming in my house with those shoes. You're going to have to take them off and leave them outside.' Then she told Elvis to take him out and buy him some new ones."

......

Nick was in the car on the ride home from Tupelo, sitting in the backseat, with Barbara in the front between Elvis and Red West. Elvis was driving faster than he should have been, Barbara thought, when suddenly the hood on the big white Lincoln flew up and totally obscured his vision. Someone had lifted it out of curiosity while the unattended car was in the parking lot—automobiles of that quality were rare in Tupelo—and they hadn't closed it properly.

"The road was single lane, as I remember, with a narrow shoulder. Elvis managed to ease the car to the right and pull over. But what impressed me was that both Elvis and Red, ignoring their own safety, threw their arms around me, as if to prevent me from hitting the windshield." When the car came to a stop ("Son of a bitch!" "Damn, what was that?"), the boys again turned to Barbara. "Are you all right?" they asked. "It wasn't a general 'Is anybody hurt?' but a sweet and gentle concern just for me."

Barbara visited Audubon Drive "all of the time when Elvis was home," and he called her every night from California, both to say hello and to check up on her, the way he had called Dixie, even though he was cheating on her. "I didn't mind him seeing movie stars like Natalie Wood and Debra Paget, because I knew he was starstruck. He couldn't believe he was actually in the same world with them, and probably in his mind, he was in love with everyone he met."

But she had to think that in some ways she just didn't fit in with the whole group. She didn't have musical talent like Red, and while most of the boys cut up all the time, she and Elvis talked about more serious things. She could tell that Hollywood was changing him some, though he insisted it never would. During the making of *Love Me Tender,* Elvis told her on the phone that he had run into Jerry Lewis. It was still a thrill for him to see another star, but Lewis had disappointed him. Elvis told Barbara the comedian "was disgusting, the way he behaved with all of these people around him, his 'yes' men, doing everything for him and hanging on him."

Sometimes Elvis seemed to be living in a movie, and there were times when he appeared to not be able to separate his own identity from that of the Holly-

wood crowd. On October 18, for example, he pulled into the Gulf station at Second and Gayoso and was quickly mobbed by fans. The attendant, Edd Hopper, asked him to leave, and Elvis challenged him, only to have Hopper pull a knife—shades of *Rebel Without a Cause*—and a third man join in the fray. Elvis, who stood six feet only with the help of lifts in his shoes, hauled off and punched the six-foot-three Hopper, giving him a black eye. All three men were arrested for assault and battery, and disorderly conduct.

Barbara was inadvertently at the center of it, as Elvis was supposed to pick her up near her bus stop that afternoon. But he had noticed a gas smell coming through his air-conditioning vents, which prompted the stop at the station. She was still standing waiting for him when a young woman approached her and asked if she were Barbara Hearn. Elvis had sent word about what had happened, and the woman told her that the police had taken him to jail.

Barbara hardly knew what to say. About then, a policeman drove up to get her, and she was so shy, she could barely climb in the back of the cruiser. But when they got downtown, Elvis was already gone, and the officer rode her on out to Audubon Drive. The ordeal had been nearly as hard on Barbara as it had on Elvis. "I was mortified beyond words to be riding across town in a police car! If Elvis ever doubted my sincere regard for him, that should have clinched it."

That night, a newspaper photographer came out and took a picture of Elvis at the organ. Barbara sat near him, holding Gladys's little dog, Sweetpea. "I look so sad and bedraggled because I had been working hard all day while Elvis was showing off his temper downtown."

The next day, the charges against Elvis would be dismissed, while the other two men would be fined. And there was other news: Later that afternoon, June Juanico would arrive from Biloxi for a visit.

Barbara had learned of June from the newspaper. She'd picked up the Memphis *Commercial Appeal* one morning to find Elvis's remarks from the RCA press conference about the two girls he was seeing, along with a big, splashy story about the other women in his life. Once the shock wore off, Barbara took it in stride. "It was really neat that he had named me, but that was the first I'd heard of June." The paper carried a picture of her "own sweet self," of course, along with several rows of photos of Elvis's other dates.

"One was a stripteaser from Las Vegas, and another was a lady wrestler. My family said, 'Well, that's just where you belong, isn't it, Barbara? Right up there with the stripteasers and the lady wrestlers.'"

Kay Wheeler and Elvis, first meeting, backstage at the Municipal Auditorium, San Antonio, Texas, April 15, 1956. She taught him her original dance, the "Rock & Bop," and headed his first national fan club. *(Courtesy of Kay Wheeler)*

ELEVEN

· · · · · · · · · · · · · · ·

Showgirls and Shavers

*Just as Elvis had stayed in constant touch with Barbara through the filming of
Love Me Tender,* he had also heavily romanced June, sending her a lovesick tele-
gram on August 21, 1956: "Hi, wioole [widdle] bitty. I miss you, baby. Haven't
had you out of my mind for a second. I'll always be yours and yours alone to love.
Dreamed about you last night. Love ya. Yea, uh-huh. EP."

As if for proof, June had barely arrived on Audubon Drive when Elvis wanted
to take her to his room. They'd been in there together countless times, but this
one was different. Elvis closed the door. "I told him no, no, no," June remembers.
"I got up and said, 'Keep the door open. I'm not going to stay in here with the
door shut.' "

And so their relationship remained unconsummated.

June's visit coordinated with Elvis's rehearsal for his second appearance on
The Ed Sullivan Show at the end of October. For days, she sat on the floor, en-
thralled at being surrounded by Elvis and the Jordanaires, the vocal backing
group he used in concert and on records. She and Elvis often harmonized in the
car on such songs as "Side by Side" and the old hymn "In the Garden." Now, in
rehearsal with the Jordanaires on "Love Me Tender," she felt free to jump right
in. She'd hang on to Gordon Stoker's ringing tenor, and if Gordon stopped and
she kept on, "Elvis would just look at me and grin."

Before leaving for New York, she and Elvis saw a rough cut of the movie
with his parents. Elvis found it difficult to watch his performance, but then it
was so hard to keep up with all the whirling emotions of fame. *Variety,* the show
business trade paper, had just declared, "Elvis a Millionaire in 1 Year," based on

the projections of his income from the movie contracts, records, song publishing, merchandising, and concerts.

While June was still visiting, Elvis came home with a "big ol' box of cash from the bank in tens, twenties, and hundreds. He sat on the floor and he said, 'June, would you like to see a million dollars?' And he threw it up in the air." Gladys and Vernon walked in, and Vernon held his head. "Are you crazy, son?" he said, and scrambled to pick it all up.

June wondered for a minute if she should grab some, but she knew it wasn't the right thing to do. One reason Elvis liked her, she thought, was because she wouldn't take anything from him.

The money had probably been a test, a suggestion from Parker, who often left people alone with large amounts of cash to see if he could trust them. June, who despised Parker and thought he schemed to keep her and Elvis apart, had been thinking a lot about him lately, wondering why the Colonel and Nick Adams seemed to be so chummy. Nick arrived for yet another visit on October 23, four days into her own stay in Memphis, and he planned to go with Elvis to New York for the Sullivan show.

"He was constantly stuck up Elvis's butt," she fumed. In her heart of hearts, she believed that Nick was on the Colonel's payroll, that he kept an eye out for whatever went on and reported back to him. She also believed the Colonel promoted Elvis's relationship with Natalie Wood for publicity value.

Still, June was stunned to learn that Natalie was coming to Memphis during Nick's extended stay. "Elvis didn't invite Natalie," she says. "Nick did, and the Colonel made all the arrangements." The actor Robert Vaughn, with whom Natalie had just become involved, thought she did it for spite, to make him jealous. Others believe she came because she cared for Elvis and still hoped to spark their romance.

No matter why Natalie agreed to come to Memphis, it was uncomfortable for everyone, even before she got there. Nick kept asking Elvis when June was going to leave. "There's not room for Natalie, if June's going to be here," he said one day in her presence. It got her hackles up. "I said, 'No, Nick, you've got that backward. There's not room for *me.*'"

Elvis stepped in the middle.

"I don't care," he said. "June's going to stay."

Finally, June announced she was going home to Biloxi when Elvis left for New York. Nick seemed relieved. But June disliked him for another reason, too:

"Nick tried to put his hands on me. He came on to me. I said, 'You touch me one more time, you're in trouble.' "

She never told Elvis about it, because "Elvis felt sorry for him. Nick came across as a basically decent kid, but I really think he was bad for Elvis."

She suspected, in fact, that Nick introduced Elvis to prescription drugs, more specifically to speed. She knew that Elvis took No-Doz pills, which contained caffeine, but that was all. "Nick was always up, always wired. Before he got there, Elvis was easy and laid-back. But when Nick got there, Elvis seemed to be wired, too. And you can't get that wired from cola or coffee, and that's about all Elvis drank."

· · · · · ·

Certainly Elvis did not seem himself during Natalie's visit. Or at least Phillip Barber didn't think so. Phillip was a freshman at Memphis State that fall. A native of Dickson, Tennessee, he had decided to go to school in Memphis partly out of his love for Elvis's music. He hoped to practice law in the music business, so enthralled was he with rhythm and blues, and rock and roll. Phillip often hung out at the Cotton Club in West Memphis, Arkansas, where he became entranced with Barbara Pittman, who sang with Clyde Leoppard's Snearly Ranch Boys. A former neighbor of the Presleys from the projects, Barbara was the only female recording artist on Sun Records.

Like Elvis, she'd sung at the Eagle's Nest. And she'd been in love with him ever since they met, remembering how silly he'd been to put black shoe polish on his hair to look like Tony Curtis. ("Look, there is no blond-headed idol except James Dean.") One day, they'd performed together on Jackson Avenue at the Little Flower Catholic Church, and "after the show it started pouring down rain. Black shoe polish was coming out all over Elvis's face. He could almost do an Al Jolson."

They were tight enough that Elvis had taken her Sun publicity picture, and sometimes, if Sam and Marion had to be out, Elvis and Barbara would go down in the afternoons after work and take care of the studio. "A lot of people were talking to Elvis on the phone at that time and never even knew it."

Phillip had been to see Barbara one night that fall, leaving a little after 1 A.M., and then driving over by Elvis's house on Audubon Drive. There was always something going on there when Elvis was in town, but on this night, he was surprised to see Elvis standing out front with a guy he eventually figured out was Nick Adams.

It looked like a loose enough gathering, so Phillip parked his car and walked over and stood on the edge of the "guy contingency," where Elvis was talking to five teenage girls who worked at a Krystal hamburger stand. They were all hanging around the iron gate that closed off the driveway, the girls tittering and laughing and asking Elvis questions.

It was easy for Phillip to join in because "they were very congenial to me," but then the talk turned "really rough, considering the day and time. One of the girls said to Elvis, 'We came by here Monday night. Were you here?' He said, 'Yeah.' And she said, 'Well, what were you doing?' He said, 'Oh, I was sitting in there, watching you all drive by and jacking off.' "

Phillip was shocked that Elvis would use that kind of language ("I came from a small rural town, and boy, you didn't ever say that, not even to men, much less in front of women"), but he wrote it off to the fact that Elvis was now "an urbane, sophisticated, uptown man, an actor in the movies."

Then one of the girls wanted to know about Natalie. "Is she here now?" she asked. "Yeah," Elvis said. "She's in the house asleep."

"We read about you going together," she purred.

"Aw, naw," Elvis told her. "She's just a kid."

By now, the crowd had grown larger, but it was still made up mostly of females and married couples. Then about 2:30 A.M., Phillip noticed a car pull up. "This girl got out, and squealed and ran over and grabbed Elvis, and just kissed him a big wet kiss." Phillip recognized her immediately. She was Barbara Pittman, the singer he'd just been to see. "She just glued herself to him, and then he was pretty much occupied with her for the rest of the night." Later, Barbara would tell Phillip that Elvis called her his "Little Vibrator," because when she got around him, "I'd just get so giddy and wiggly."

When Phillip got ready to leave that night, Elvis said, "Come back tomorrow. We'll be out here." The next afternoon, when Phillip returned, Natalie was in the yard, inside the low fence, signing autographs. Elvis introduced them, and she shook Phillip's hand and smiled, and went on back to signing. But Natalie didn't like such familiarity with fans and was astonished that Elvis permitted them to be so intrusive, even letting them look in the windows. She hadn't known anybody like him, and he mystified her sometimes. They were just so different.

"I hadn't been around anyone who was religious," she said later. "He felt he had been given this gift, this talent, by God. He didn't take it for granted. He

thought it was something that he had to protect. He had to be nice to people, otherwise, God would take it all away."

On the whole, her visit hadn't gone well. Elvis tooled the petite star around town in the white Lincoln, stopping for ice cream at the Fairgrounds. But he didn't really know what to do with her, so he drove her down to Tupelo to show her where he started out, took her over to meet Dewey Phillips, and rode her around on his huge new Harley-Davidson motorcycle. But nobody seemed to be having a good time. Not really. She watched him play touch football in Guthrie Park, where Nick tentatively joined in, but she was bored.

The most exciting part was the inventive way Elvis escaped the fans who'd gathered by game's end: He casually drew a comb from his pocket, waved it through his hair, and then nonchalantly threw it out on the field. When the girls sprang to get it, he and Natalie dashed off the other way for the Harley, speeding off on Chelsea Avenue.

Once during Natalie's visit, he stopped by to see Barbara Hearn. They talked and visited a little while, and then Barbara's aunt went to the window. "Elvis," she said, "who's that out there on your motorcycle?"

"Well, that's Natalie Wood."

"He'd just left her out there in front, waiting for him," as Barbara tells it. "My aunt said, 'Why don't you tell her to come inside?' And he said, 'No, I'm leaving,' and off he went. By then, he wasn't as much in tune with people's feelings. He was a caring, feeling person by nature, but I think that was being taken away from him. He was losing it."

Gladys was also losing it, but in a different way. "Man, Gladys was stoned 'til Sunday morning," said Barbara Pittman. "She couldn't even get up to go to church. I shouldn't say that about Gladys. I loved her very much. But Vernon was a pretty heavy drinker, too. He just enjoyed having all that free booze and free life because he never worked anyway. He always had a 'bad back.' "

Natalie's visit exacerbated everything with Gladys, and it was obvious even to people who didn't know her well. When Wink Martindale and his TV cohost, Susie Bancroft, went out to the house during Nick and Natalie's visit, "We just sang and stood around a lot. . . . I remember his mother being there and seeming so out of place."

It just made Gladys wild. She complained to her sister Lillian that Natalie was "too fond of the men—didn't even finish her meal when Nick Adams and the boys came over." She was so upset that she vented to Barbara, too.

"She didn't like provocative women, and she called me and said Natalie was walking around the house in a flimsy nightgown in front of the men who were working on the house. She thought that was thoroughly bad behavior, and said she would be glad when Natalie left."

Natalie felt the same way. Three days into what was supposed to be a week-long stay, she aborted her visit, flying back to L.A. in tight toreador pants with Nick at her side. Robert Vaughn met her at the airport, and photographers snapped pictures of Elvis's "new girlfriend." Her William Morris agent, Michael Zimring, said, "She looked like a rat that [had] died. I don't think she'd been to sleep for a week."

In her book, *Natalie, a Memoir by Her Sister,* Lana Wood recounts that the family helped Natalie cook up the sudden departure. She'd called home moaning that Elvis's mother was domineering and jealous. "Gladys has wrecked everything," Natalie said. "I don't have a chance. Get me out of this, and fast." It was agreed that Maria would call Natalie back and ask her to come home because of an emergency.

The romance was over.

"God, it was awful," Natalie told Lana later. "He can sing, but he can't do much else."

After that, whenever Natalie's name came up, Elvis laughed. "Heaven help us!" he said. "That girl is crazy!"

· · · · · ·

However, Elvis would have no shortage of entertaining friends, as two days after Natalie's departure, he asked Cliff Gleaves to move into the house as a "gofer" to make things easier for himself and his parents. Gladys accepted him but wished her son would be more selective of his companions. A ne'er-do-well, Gleaves was a flunky deejay from Jackson, Tennessee, and a pal of Dewey Phillips. He looked as if he slept in his clothes. But he had an offbeat and riotous sense of humor, and he wasn't beyond trying any sort of con—gypping restaurateurs out of a huge steak dinner, for example—which amused Elvis no end. In the future, Elvis would suspend him from the group for outrageous grifting and unspeakable hooliganisms, only to take him back. But for now, he had his place.

Through Cliff, Elvis became reaquainted with Lamar Fike, a three-hundred-pound Memphian who'd tried to break into radio through George Klein. Fike, who lived at the YMCA, was comical-looking—he'd soon start wearing yellow

cowboy boots—but he had a first-rate mind, and in time Elvis would invite him into the entourage.

For now, Elvis was still traveling with his cousin Gene Smith, though Bitsy Mott, the Colonel's brother-in-law and a former professional baseball player, had joined him as head of security. On November 8, 1956, the three of them boarded a train for Las Vegas. Elvis needed to shake off all the voodoo from Nick and Natalie, as well as his jitters about *Love Me Tender,* which would open in New York on November 15.

He stayed at the New Frontier, where he had played earlier in the year, and immediately began seeing nineteen-year-old Marilyn Evans, a showgirl at the hotel. He'd walked into the employees-only coffee shop at the casino and sat at her table. "Wow," she thought. "He's beautiful—really, truly."

Within an hour, he had slipped her a scrawled note on the back of a napkin: "Can I have a date with you tomorrow night or before I leave?"

"Elvis told Marilyn he likes her because she doesn't act like a showgirl, because he's real," her mother bragged to her hometown paper, *The Fresno Bee,* at the time. He invited Marilyn to come visit him in Memphis the following month.

But then he met Dottie Harmony, a blond, eighteen-year-old dancer at the Thunderbird who had a friend who worked at the New Frontier. Elvis kept trying to get her attention, sending requests to her table for her to join him, but she ignored him. Then all of a sudden she looked over, "and there was Elvis on his knee, saying, 'Ma'am, you're the most beautiful woman I've ever seen in my life. Would you have a drink with me?'"

From then on, he spent the rest of his vacation with her. They talked a lot—he made her call her mother, like he did every night—but mainly they just hung out, driving to the airport and watching the planes take off, going to the Vegas shows, even helping an old man change a tire one night. She was a little frightened at how jealous Elvis got when other men looked her up and down, and when they fought, he'd get so angry he'd rip the phone out of the wall. "But next thing I knew it was always fixed again."

Even though it was Dottie he liked, on December 4, Elvis made good on his promise to bring Marilyn Evans to Audubon Drive, where "that phone just rang and nobody answered, which was odd." Elvis made no moves on her ("He was extremely honorable"), and treated her to the usual motorcycle rides and eating out. But they quickly realized there was nothing between them. "I always preferred classical music," for starters. "We were just into different things, not that one is better than the other."

Evans would have been a totally forgettable presence in Elvis's life except for one stop they made during her visit. It was at the Sun Studio, where Carl Perkins was recording, with Jerry Lee Lewis playing piano on the session. Johnny Cash also dropped by, and Sam Phillips called the newspaper, which sent over a photographer as the tape rolled. The recordings would become famous as the "Million Dollar Quartet" session (though Cash doesn't really sing). And though Marilyn is often cropped out of the iconic photograph, in the full shot, she's clearly on the right, seated atop the piano. Her voice can be heard on the recordings, requesting a song, "End of the Road." Hearing it now, she says, is "otherworldly . . . out of body."

· · · · · ·

Just over a week later, Elvis had another guest, Hollywood director Hal Kanter, who was set to helm Elvis's next picture *Loving You,* his first for Paramount and Hal Wallis. Kanter, writing with Herbert Baker, would loosely base his screenplay on Elvis's own story—a truck driver with a knack for a song catches the eye of a manipulative press agent, who propels him to fame.

Kanter, a southerner himself, born in Savannah, Georgia, had come to the project after running into Wallis, who said, as the director remembers, "I want you to come see a test of a young man. I want you to see if you can do a picture with him."

"What's his name?"

"Elvis Presley."

"You must be kidding."

"Just look at the test, will you?"

Kanter agreed but surely in vain. "Foolishly, I subscribed to the generation that said, 'He's just a passing fancy, a nasty little boy.'" But he walked out of the screening room with a different attitude. He thought Elvis was "dynamite."

Wallis had a first-draft screenplay, *Lonesome Cowboy,* which Kanter completely rewrote with the title *Stranger in Town.* Then the director went to Memphis to meet Elvis. There, he sampled Gladys's chicken and okra on Audubon Drive, "a modest home . . . decorated in a style that displayed more financial success than taste," he would write in his autobiography, *So Far, So Funny: My Life in Show Business.* He didn't like the meal very much, either.

Afterward, Elvis had a question for him. Was his character, Deke Rivers, required to smile much in the movie?

"What do you mean, do you have to smile?"

"Well, I've been watching a lot of movies. People like Jimmy Dean and Humphrey Bogart and Marlon Brando. Good actors. They hardly *ever* smile. And the women *love 'em,* because they *don't* smile."

Elvis brought the director up short. That had never occurred to him, but Elvis was right.

"He said, 'When I smile, I want it to be an event.' And I said, 'Very well put.'"

Then Elvis told him he didn't think he was much of an actor, but he was working on being true to the words. "I figure if I make people believe the words, that's all that counts." Kanter again told Elvis he was astute, and then Gene Smith goaded Elvis into doing what he called "the piece."

Elvis said, "No, no, no, I don't want to."

"Go ahead, go ahead, Elvis, do the piece for the man! Do the *piece!*"

Elvis stood up, and Kanter expected him to start, "The boy stood on the burning deck . . ." Instead, he was amazed as Elvis recited Douglas MacArthur's "Farewell Address to Congress."

"I'm not a fan of Douglas MacArthur, but it was pretty good."

The next evening, they all left Memphis in a two-car caravan, Kanter riding with Elvis to Shreveport to witness his last appearance on the Louisiana Hayride on December 15. This was the benefit show that Parker had promised as part of Elvis's contract buyout (the Shreveport YMCA would get a new swimming pool out of the deal), and attendance was expected to be so large that the organizers moved it to the largest facility in town, the Hirsch Coliseum, also known as the Youth Center, at the Louisiana Fairgrounds. Every ticket had been sold.

"I observed that concert, and things I saw there I later used on-screen. I re-created some of it. There were some things that happened there that I couldn't re-create, because people wouldn't believe it. It was absolutely unbelievable, the things that I saw."

It was true. Horace Logan had the roof of his 1955 Mercury hardtop stomped in by teenage girls. He'd parked it in the back of the Coliseum, in a place that seemed perfectly safe. But the kids had stood on it, dancing to the music, or used it as a trampoline to try to see through the Coliseum's twelve-foot windows. "It looked like an elephant had danced a jig on it," Logan lamented. "The top was pushed in so far it was practically touching the backs of the seats."

Then there was the child who swallowed her hand, or at least Kanter thought she had. "She appeared to have her hand in her mouth all the way down to her wrist, and I was wondering, 'How can a little girl like this get her whole hand down her throat?' And then at one point she pulled her hand out of her mouth,

and I found out she didn't have a hand at all. She was just sucking on the stump. I thought, 'God, I've got to get that in the picture!'"

At first, however, Kanter wondered if he would even survive the trip to Shreveport.

He sat next to Elvis while Gene, Junior, and Bitsy occupied the backseat. They raced through the chilly night, Elvis singing and cracking jokes until he stopped "for refreshments—a piss, a pop, and some barbequed pork," as Kanter detailed in his book. The restaurant, of course, was the Trio Club, the Brown family's roadhouse in Pine Bluff, Arkansas. Maxine caught Elvis and Bonnie pining for each other, "not saying a word, but kind of smiling and looking sad at the same time." Both of them knew that life was about to change forever, as Maxine put it. He wasn't that big of a star yet, but "the Elvis Presley who left our club that night was not the same as the one the world grew to adore."

Back out on the road, Kanter wrote, "a souped-up Chevy pulled up beside us. Four men and three women were packed into the hot rod, and one of the girls yelled, 'Hey, Elvis!' Elvis slowed his Cadillac and lowered his window to call, 'Howdy, honey,' and Bitsy Mott warned, 'This ain't no time to stop for pussy, boy.'

"The ersatz cowboy driving the Chevy shouted, 'Drag you for a tank of gas, Presley!'

"'Is he kiddin'?'

"Elvis grinned, stomped on his accelerator, and we zoomed from 40 to 90 mph. Elvis loved that. I was terrified, and he loved that, too."

They arrived at the Captain Shreve Hotel about five in the morning, and too soon, Kanter was awakened by shouts of "Elvis! Elvis!" coming from the street below. In just a few hours, he would ride to the Louisiana Fairgrounds with the young star to check the equipment for the evening. Bill Black drove the Cadillac, and Kanter sat in the back. When the car came to a stop, the crowd surrounded the Caddy and started rocking it. Kanter was scared stiff, but Bill just laughed. "Shit, this happens wherever we go."

In town to see the performance was Kay Wheeler, Elvis's fan club president. Several months before, she'd organized a write-in campaign to bring Elvis to Dallas, Texas. "It was so successful—26,500 kids showed up—that we had to get the huge Cotton Bowl, the largest venue for an Elvis show." She was the only teenager, and the only woman, allowed on the field. The next day, she went to Waco to see Elvis's show at the Heart O' Texas Coliseum and got in trouble with Colonel Parker for telling the Associated Press that Waco was "the squarest

town in America," since the sparse crowd "sat on their hands and nobody screamed."

And in November, she'd traveled to Memphis, where she visited with Barbara Hearn at her house, the two of them lying on the floor and leafing through scrapbooks, to Kay's delight. She also spent a day with Gladys, who told Kay she reminded her of herself as a young girl. ("You favor me a little, don't you, hon?") Kay thought Gladys seemed sad, but she didn't dwell on it long, because she was too excited—Elvis had Kay's framed picture by his bed. And Gladys had even offered to give her Elvis's white buck shoes, but Kay turned them down ("I didn't want his ol' stinky shoes in my suitcase"). She wanted the kelly green sport coat he had on in Dallas. "You'll probably have it before the night is over," he promised her suggestively, but that hadn't happened, and then Gladys couldn't find it.

Now, in Shreveport, where she was setting up a new branch of the fan club, Kay attended Elvis's hour-long press conference at the Youth Center. "I wanted to impress him—I knew I had the jet black hair and 'good behind' that Elvis liked," so she wore her tight white sheath dress with silver sparkles and white fur at the cuffs. Even though she stood in the back, Elvis, modeling the famous green coat, spotted Kay right off and stared at her hungrily as she answered a question about the fan club. A few minutes later, Cliff Gleaves approached her.

"Elvis wants you to come back to the hotel."

At the Captain Shreve, Cliff escorted her to what was obviously Elvis's bedroom. "Wait here," he said and then shut the door. She stared at the bed for a while, but after fifteen minutes, when Elvis still wasn't there, she lost her nerve. "I thought, 'I can't go through with this. I'm not this kind of girl. I'm a virgin. This is like something in a bad movie.'"

She got up and walked out into the hall, where Elvis's guys were hanging out in front of another room. Kay stuck her head in to see Elvis on the phone. There was a flurry of activity—someone was taking orders for sandwiches, and everybody was high on something or another, maybe just the excitement of the concert—but Elvis, unbuttoning his shirtsleeves, beckoned her in ("Come here, come here, come here"). She was the only woman in the room, so she walked over and picked up his green coat and put it on, almost for protection. It was all sweaty, but she liked feeling him against her skin, even though the coat was so big that it dwarfed her. Elvis grinned at the sight of her in it.

"You look good in that," he said. "Do you want a sandwich?"

"No, thanks."

"Okay," he said, looking around the room. "Are we going to order?"

Somebody spoke up. "Elvis, what do you want on your sandwich?"

"Mustard, mayonnaise, pickles, and cat shit," he said, laughing at his own joke. All the guys laughed in unison, but the bad language turned Kay off. And as the time wore on and Elvis kept fooling around, she became more disenchanted. Finally, she just eased out the door.

That got his attention, and he chased her down the hall and into the stairwell. She was a little disgusted with him, and with herself, and now they paused by the window at the end of the stairwell and looked down at the street. "I thought, 'Well, I have him right here. Just me and him.'" But she wanted to say something profound, because she didn't want to be just another of the girls.

"Elvis," she said quietly. "What do you think life is all about, really?"

He was standing behind her, very close, his breath warm on the back of her neck. Now he turned her around, and she thought he was going to make a stab at answering her question, or maybe kiss her in that soft, romantic way. But Elvis was not in the mood for subtlety.

To Kay's astonishment, "He got really rough with me. He grabbed me and kissed me so long and hard I thought I was going to suffocate. He wouldn't get off my lips. Then he threw me against the wall and started grinding his pelvis, pushing on me really heavy. It was exactly what he did onstage, his whole performance."

Except that Elvis was genuinely aroused and meant business, keeping Kay in such a hold she couldn't move. She wasn't just turned off now—she was frightened. It was too raw for a seventeen-year-old virgin. "I was not old enough for what he had in mind. And it really disappointed me, because I wanted moonlight and roses. It was one of the biggest letdowns of my life."

She didn't push him away, though, and soon someone started screaming, "Where's Elvis? Where's Elvis?"

Whenever Elvis's guys got separated from him, she thought, "It was like they lost their dancing bear or something. They all went nuts." But the emergency was only that the sandwiches had arrived, and Elvis coaxed Kay back to the room. She stayed for a few minutes, but her stomach hurt, and her head was swimming, and then she just slipped out and went downstairs and got a cab.

"I felt a little bit powerful as I walked out of that hotel. I'd passed some girls, floozy little things, in the hall, and I presumed they'd been set up like I was. I thought, 'I'm not one of you. He'll remember me for *not* doing it.' Because they were flinging their bodies at him en masse. It was just crazy, a mob scene."

It had been even wilder at the show, Frank Page remembering they'd tried to protect Elvis by erecting a fence in front of the stage and setting the chairs back forty feet. But the girls, "nearly 10,000 of them, picked up the chairs and ran to the edge of the stage, so they defeated our purpose of trying to keep them back." Afterward, to get him out of the Coliseum unharmed, the Colonel sent a decoy out one door while Elvis escaped through another, the swarm following the wrong boy. Page, thoroughly shaken, had never witnessed pandemonium like that and hoped he wouldn't again. Ten thousand girls, screaming at the tops of their lungs, made "noise enough to peel paint," as Horace Logan put it. Nobody could tell if Elvis was really singing or not, or even if the band was playing. But nobody seemed to care. The waves of screams washed through the Coliseum like an angry ocean. At the end, "Hoss" Logan, standing there in his sheriff's gear, a pair of real six-guns in his big western holster, would utter the now-famous phrase: "Elvis has left the building."

Barbara Hearn would sometimes stand inside the Audubon Drive house, looking out the window at all the fans. "I'd wonder, 'Why am I on this side of the glass?' It was a bit daunting at times." And it was becoming more so, and not just because of the fame. Sometimes she thought she didn't really know Elvis.

He'd called her one night, saying he'd been over to one of the West Memphis clubs to listen to music, and somehow met some boy she'd dated in high school. She hadn't seen the guy since graduation day, but Elvis went off about what all he was going to do to him if he ever saw him again. He treated Barbara like she'd committed a crime for ever having known the kid. Where did he get off thinking like that, when he had so many girlfriends that the newspaper ran *rows* of pictures?

She tried not to think about it, though, because Christmas was almost on them, and she wanted them to have a nice holiday. No, an extra nice holiday. And she wanted her gifts to be special, too, even though she didn't have much money. One day they were out riding on his motorcycle and he pulled into a used-car lot and bought her a yellow Buick convertible to get back and forth to Memphis State. She didn't have the nerve to tell him, but it broke down all the time ("I never knew whether I was going to get where I was going"), and it just nickel-and-dimed her to death.

She thought a gold lamé vest would be an appropriate Christmas gift, and she knew that he could wear it onstage. So she went down to the seconds department at Goldsmith's, where they sold remnants of material, and she bought the gold lamé and three gold initials and some black taffeta for the lining, and asked her

girlfriend's mother to make it for her. She wasn't sure what to get Gladys and Vernon, but she finally settled on a large, ornate gold Bible with color illustrations. It was out of her price range, really, but she'd splurged because Elvis had had such a remarkable year, and it was truly a Christmas to celebrate.

June Juanico had been thinking about Christmas, too, though she hadn't actually seen Elvis since her strained visit in October. It was getting late in the year now, and neither of them had said anything about whether they would spend the holiday in Memphis or Biloxi, but surely he would call about it any day now, because they were practically engaged, even though she'd never accepted that ring he'd tried to give her. The only thing that worried her was that he was so jealous of all of her friends, wanting to "keep me right next to him, with his arm around me and show people that I belonged to him, and all this kind of crap." It had a smothering effect.

But on Christmas Day, neither Barbara nor June sat at Gladys's holiday table. For the most glorious day of his most magnificent year, Elvis chose Dottie Harmony to be at his side. He hadn't even known her two months.

When June found out, she hit the ceiling. Elvis tried to calm her. "It was the Colonel's idea, baby! Honest! For the publicity. He said it was good for my career!"

She knew that Parker *did* want him linked with actresses and dancers, and Elvis did like legs that went on for days. "But you don't invite a *showgirl* to spend *Christmas* at your *house!*" That was it for her. "If he cared for me, how could he expect me to swallow all these other women in his life? I was going to be his one and only, or I wasn't going to be anything." And now Elvis was saying he couldn't get married, not even after three years. He wouldn't dare do that to the Colonel. He had too much invested in him.

June felt something break inside of her.

And now Barbara would, too. She just kept saying it over and over: Dottie Harmony. A chorus girl. And for Christmas. That was a time for family and special friends, not a newly acquired Las Vegas showgirl.

"If it had been Elizabeth Taylor or somebody, I wouldn't have minded. But this really hurt me."

And there was more hurt around the bend. When Barbara gave Elvis his gold lamé vest, he handed her an unexpected gift: a Sunbeam shaver. Her heart landed with such a thud that for a moment it knocked the breath out of her. She had gone to so much trouble with the vest, and she'd had to put his parents' gift in layaway, since she didn't have the money to buy it all at once.

"It was a pretty shaver, with rhinestones on the little stand and a quilted cover. But it was still a shaver, and certainly not the kind of thing he would have ordinarily gotten for me. It felt like he realized a day or two before Christmas, 'Oh, my goodness, I haven't gotten anything for Barbara,' and threw a few dollars at someone who went out and got it. I didn't need it or want it, and I never used it. I truly believe I had rather gotten nothing than that shaver. I still have the miserable thing, but it was an embarrassment then and is still."

Elvis couldn't win for losing. All his women were either mad at him or breaking off their relationship. Nothing seemed to work. Just nothing. That Christmas, he was driving around, thinking about things, when he spotted Georgia Avgeris, the Greek girl he'd thrown gum wrappers at in high school. She was window-shopping, and he pulled the big Cadillac up next to the curb and got out to greet her.

He was so glad to see her, and no, he hadn't heard she'd gotten married last year. But wow, she looked great, and he hoped she was happy. He'd made a few records since he last saw her. Would she like to have some? He had them in the car.

"Gee, Elvis," she said. "Thanks, but no thanks. I don't have a record player."

Dolores Hart *(left)*, Elvis, and Lizabeth Scott enjoy a friendly game at Scott's home in Hollywood at the completion of *Loving You*. "If there were one thing that I am most grateful for," says Hart, now a Benedictine nun, "it's the privilege of being one of the few persons left to acknowledge his innocence."
(Courtesy of David Troedson/Elvis Australia)

TWELVE

· · · · · · · · · · · · · · ·

Twin Surprises

At the start of 1957, Elvis found himself in a constant grip of anxiety. The Colonel had lined up a plethora of creative and career opportunities for him—a third *Ed Sullivan Show* appearance, and two movies scheduled just for that year alone—but Elvis's personal life lay in shards.

June would barely take his calls, Dottie considered her visit to be a disaster (Elvis was late coming to get her, girls held up banners at the airport that said GO HOME, DOTTIE HARMONY, and the Presleys read this *big gold Bible* every single night), and Barbara was upset about . . . well, maybe a lot of things. She obviously hadn't liked her shaver, but then that's what Dottie got her, going down the list of "female gifts" that Gladys gave them when they went shopping.

Elvis had never meant the gift to be cold. In fact, he had extended himself for her with Hal Kanter on Audubon Drive. Knowing that Barbara had an interest in acting, and building on the conceit that the film was essentially his own story, Elvis had asked the director if Barbara might play his girlfriend. He wanted them to meet, he told Hal, and thought she would be good in the part.

But Kanter thought otherwise, telling Elvis she was lovely to look at but horrible to hear. "He said I had the worst voice he had ever heard," Barbara reports. "I just assumed the Colonel, who was very rude to me, did not want me around, that the thought of me working with his boy every day curdled his blood. But it was very sweet and naïve of Elvis to see if it could be done."

To make it up to her, Elvis would wear Barbara's gold lamé vest with one of Natalie's shirts on *The Ed Sullivan Show* on January 6. He hadn't prepared her for it, so it was a wonderful surprise.

"I said, 'There he is on *Ed Sullivan,* coast-to-coast television, and he's got on my little five-dollar vest.' I just loved it."

At the network's request, Elvis sang a gospel number, "Peace in the Valley," along with a version of "Don't Be Cruel" that was heavily influenced by rhythm-and-blues great Jackie Wilson, whose live show Elvis watched obsessively in Las Vegas. On the latter, the cameras cropped Elvis from the waist up—a brilliant tactical move on the part of the Colonel and Hank Saperstein, Elvis's merchandising king, to capitalize on his image as a sexual terror.

At the end of the program, watched by fifty-four million Americans, the stone-faced Sullivan took time to deliver a character reference: "This is a real decent, fine boy . . . We want to say that we've never had a pleasanter experience with a big name than we've had with you."

Elvis knew he was the luckiest guy in the world. But he couldn't really enjoy most of the good things that were happening, because there was so much weighing on him now. On January 4, he'd taken his preinduction physical to determine his draft status, and four days later, on his twenty-second birthday, the Memphis Draft Board announced his classification—1A.

As the Colonel explained it to him, it meant he'd probably be drafted within the next eight months. What Elvis didn't know was that his imminent service was precisely what the wily manager wanted, in part to morph Elvis's image from dangerous hooligan to all-American boy, hence Ed Sullivan's ringing endorsement.

Elvis spent his birthday at home with his parents. He didn't feel much like celebrating, and he was leaving in two days to start work on the soundtrack for *Loving You.* One afternoon, he dropped by to see Dixie Locke, who'd recently married. Her last name was Emmons now. He and Dixie had so much history together that they could finish each other's sentences. But now that she seemed so settled and happy, he sometimes felt worse after he saw her. Emptiness was a terrible thing, a big blue ball that just swelled up inside you.

He made a joke about his relationships years later. "I did *Love Me Tender,* and *Loving You . . . Loving Her,* loving anybody I could get my hands on at the time." But the trouble with love was that the cards were just so stacked against you. How did married couples stay together for most of their lives? Better to just stick with girls who were so much younger that they didn't really expect anything of you.

* * * * * *

In fall 1956, Vernon went over to the local Oldsmobile dealership where the family often had their cars repaired and serviced. As he was leaving, the owner, a man

named Mowel, asked if his fourteen-year-old daughter, Gloria, could meet Elvis. Vernon said that was fine, and for Gloria to come on over anytime.

On October 11, Gloria showed up on Audubon Drive and nervously rang the doorbell. She was shocked to see Elvis answer the door himself. Gloria was cute, sweet, and personable, and she knew music—she'd identified "Ruby, Baby," a recent hit by the Drifters, who Elvis loved, playing on the phonograph in the den. After her visit, Elvis invited her back another day. Soon, she was taking her friends Heidi Heissen and Frances Forbes, who were also fourteen, and Elvis began asking them over for evening swims at the house, or just to sit around and watch TV.

Frances, a petite dark-haired beauty, had been hanging out by the gate since she was thirteen. "He didn't pay any attention to me then, but when I was fourteen, he noticed me. Fourteen was a magical age with Elvis. It really was."

Fanatical in their devotion, the three girls followed him everywhere he went in Memphis. Elvis had an easy rapport with the trio and felt as if he could ask them what the other kids were saying about him and his music. They were his local contacts with the larger fan base, but it went deeper than that. "He was fascinated with them," in the view of Lamar Fike, who was starting to integrate himself into Elvis's entourage.

In no time, Elvis was inviting the girls to go to the Rainbow Rollerdrome, and by 1957, they became his constant companions, part of the group that went to the Fairgrounds to crash into one another in the dodgem cars and eat endless Pronto Pups. They also participated in other outings around town, all of which seemed designed to make up for the friendships and good times Elvis missed out on in high school. "They were just as nutty as fruitcakes, but they were fun," Lamar remembers. "He got irritated with them sometimes, but very seldom. All three of them were pretty cute girls."

As Elvis's attraction to them grew, they started staying for private pajama parties—just fourteen-year-old Heidi, Gloria, Frances, and their twenty-two-year-old host, holed up in his bedroom. "When you were in that room, you wanted to shut out the whole world for the rest of your life," Gloria says.

In an odd suspension of time and gender, Elvis became not only their age but also a teenage girl. After their swims, he'd wash and dry their hair, and they'd blow his hair dry, too. He'd tease them, say to Gloria, "Frances was jealous tonight because I was throwing you in the pool!" Then they'd all giggle, and he'd show them how to put makeup on their eyes the way he liked it, heavy on the shadow and mascara. It was sexy, he said, and sometimes he'd apply the eyeliner

himself. Then they'd lie on the beds and roughhouse and have pillow fights, Elvis tickling and kissing them until they couldn't take it anymore.

The girls insisted that nothing overtly sexual happened inside Elvis's pink lair, though it came close on occasion, as Gloria remembered.

"We'd tickle, fight, laugh, mess around, but all you'd have to say is, 'Stop!,' and he'd roll over and quit. It would never be mentioned again that night. But next time, it would be the same thing exactly. You'd fight with him, kid around and scuffle. The next thing, he'd get serious and you'd just push him away. I think that if he really pushed, I would have done it."

No matter how Elvis defined his philosophy of rearing young girls, the relationship contained a strong erotic element and was reminiscent of the days when he invited several girls into his room at once on the Hayride. Now Elvis and the girls would sit on the bed yoga style, with Elvis in the middle, and he'd kiss each one. "Gloria is jealous 'cause I kissed Frances," he'd say, and then turn it around: "Frances is jealous 'cause I kissed Heidi." Eventually, they'd tire of it all, and Elvis would turn out the light, lying with an arm around two of them, with the third girl stretched out across his feet.

"Elvis was always kissing," says Frances, "and it was a good kiss, a real good one. He might be doing anything—playing pool, anything—he'd walk up and kiss you, or he might turn his cheek for you to kiss him. He did that in the car a lot. He was especially romantic when it was just you and him. He might talk to you about things that bothered him, and just like teenagers, you'd neck a little bit. Elvis was like a teenager somewhat—the things we did were things that kids do. They really were all very innocent. A lot of people didn't think so, but it was a different day and time."

Heidi, Gloria, and Frances were always the last fans to leave Audubon Drive. At three or four in the morning, Elvis would sit up and kiss each girl and say, "I love you, and I'll see you tomorrow." Lamar would drive them home, and they'd catch a few hours of sleep before getting up and going to junior high. "The amazing thing is that I never had one problem with any of the parents. Not ever. It was something I assumed would not happen, and it didn't."

Elvis didn't want his mother to know they'd stayed so late, and before Gladys got up, they were out and gone. But chances are she was well aware that they were there, and that she probably wouldn't have minded, given her approval of Jackie Rowland. She knew that Elvis, a boy-man, was looking for a child-woman he could mold into his idea of a perfect mate. Fourteen-year-olds were just the right age, as they allowed him to play the role of the older man who

would teach them about life. If he could find one who had his mother's coloring, who shared her values, and who also somehow felt like his twin soul, she would hold him captive.

His friendship with the trio lasted through the early 1960s, about the time he met fourteen-year-old Priscilla Beaulieu.

· · · · · ·

On January 14, 1957, Elvis reported to Paramount Studios in Los Angeles, where makeup supervisor Wally Westmore fulfilled one of the star's lifelong dreams— to have his hair professionally dyed black. (The exact shade was "mink brown," so dark brown as to appear black on camera.) Aside from his stint in the army, when he was forced to revert to his natural hair color, never again would he completely change it back. Though he'd inherited his hair color from his father, now he looked more like Gladys. It bolstered their bond, their oneness.

Finally, Elvis also looked like Tony Curtis, whose work he still studied. He met his early idol one day on the Paramount lot. Curtis still remembers it.

"On lunch hour, I'd go for a walk. One day, I went by this big camper, and the door opened, and there was Elvis. He reached down and took my arm and said, 'Mr. Curtis, won't you please come in for a minute? I've been a fan of yours ever since I was a kid. I want you to meet my buddies.' He introduced me to them one by one, and he said, 'What a joy, what an experience, Mr. Curtis, to finally meet you!' I said, 'Excuse me, please, don't call me Mr. Curtis. Call me Tony.' He said, 'Tony.' And I said, 'And what shall I call you?' He thought for a second, and he said, 'Mr. Elvis Presley.'"

In Elvis's view, the black hair was only one of several cosmetic improvements necessary to transform him to movie star perfection. He'd already had his teeth capped. But he'd always felt the bridge of his nose was too broad—with his darker skin tone, he thought it sometimes made him look Negroid—and he wanted a more refined profile. Some time between *Love Me Tender* and *Loving You,* he went to Hollywood's Dr. Maury Parks, a favorite among the film elite, to stream- line his nose, sand away his acne, and tighten the skin around his jawline.

Elvis would return to Dr. Parks in years to come. But at first he was skittish about any such procedure, and so he took George Klein with him, footing the bill for George's nose bob. Elvis had always liked Barbara Hearn's nose, so he brought along his favorite portrait of her and presented it to Dr. Parks as a model for George's new look. After the procedure, Elvis referred to George's proboscis as "Barbara's nose."

He might as well have used the *Loving You* ingenue, Dolores Hart, as an ideal, for the seventeen-year-old actress was the picture of fresh-faced innocence.

Born in Chicago as Dolores Hicks, she spent her early years in Los Angeles. Her father, Bert, was an actor, doing bit parts in films. And her uncle was the opera legend Mario Lanza, one of Elvis's favorite singers.

Hart's parents divorced when she was small, but to escape their bickering, the child wrote a letter to her grandparents in the Windy City, asking if she might live with them. She arrived on the train, alone, with a ticket pinned to her coat. "From the age of seven, I never wanted to be anything but an actress," she says, in part to assuage her sudden mood swings: "I'm positive I'm somewhat manic-depressive by nature. I don't think there's anyone any happier than I am when I'm happy, or can take a nosedive quicker in the face of tragedy. I made a career of looking like an obvious neutral, rather than parading my feelings of being in the depths or at the heights."

She learned her craft in one of Chicago's elegant movie palaces, where her grandfather worked as a projectionist. The child often went with him to work, awakening him from naps every twelve minutes so he could change the reels.

Loving You, in which Hart plays Elvis's young love interest, was her first film. She won her contract after her remarkable lead performance in a Loyola Marymount University production of *Joan of Lorraine* led to an interview at Paramount. She arrived in her school sweater and bobby socks, with her hair pulled back in a ponytail.

Within two weeks, she was on the set, but as a scholarship student who hit the books hard, she hadn't kept up with popular music and had no idea who Elvis was, really. He was just a "charming, simple young boy with longer sideburns than most." But he had impeccable manners. When they were introduced, "He couldn't have been more gracious. He jumped to his feet and said, 'Good afternoon, Miss Dolores.'"

Elvis found her the quintessential shy virgin—she was such a delicate girl, so untouched by worldly experience as to seem almost unreal. But it was obvious that she lived her religion, and as a devout Catholic, she insisted her favorite childhood memory was of her baptism at age ten. With Elvis, she made it clear right off the bat that she would not entertain the idea of mixing work with romance, because she didn't think it appropriate.

Still, something in her responded to the primal beat of his music, and she found him both magnetic and thrilling. When he performed the musical numbers on the set, "I couldn't take myself away from him. Even if I wasn't in the

scene, I still went to hear him sing, because he was just riveting. You were just dragged away—your soul just took you. He was so dynamic."

When they kissed for the cameras, they both felt a connection. Dolores blushed way back to her neck, and "my ears started getting purple," and even Elvis's ears turned red. Director Kanter called, "Cut," and the makeup crew rushed over. But Elvis and Dolores both laughed it off, knowing it would be a mistake for them to get involved.

In an intriguing bit of casting, veteran actress Lizabeth Scott played something akin to a female version of Colonel Parker, except that as Deke's publicist/manager, her feelings for him bounced from maternal to vaguely erotic. Their brief romantic scenes carried a kind of androgynous magnetism—he too innocent and pretty, she too strong and dominant—even as they also telegraphed something taboo for the late 1950s. Today they remain compulsively watchable.

Scott, born Emma Matzo in Scranton, Pennsylvania, was a pointed-bra blond whose Slovakian features spoke of an underlying cruelty. Like Lauren Bacall before her, she exuded a delicious sensuality that managed to be both icy and fiery hot. Off set, she was as captivated with Elvis as Dolores Hart, but for a different reason. "I've always thought that his eyes had been underplayed, and his pelvis has been overplayed. The shadows around his eyes fascinated me, and I can't tell you why. They were powerful, piercing, playful, and sexy, but I wasn't aroused sexually. I just *saw* all these things in his eyes."

Elvis was fairly certain that he hadn't aroused her, because two years earlier, *Confidential* magazine had outed her as a lesbian with a very busy little black book. The husky-voiced Scott, who never married, sued the publication, but it was an enormous scandal, and the public viewed her as a deviant. Hal Wallis, who had signed her in 1945 at age twenty-two, kept her on the back burner for a while, but after *Loving You,* she disappeared from pictures for fifteen years, resurfacing in 1972 with the quirky British film *Pulp.* Around that time, she spoke of her retirement, saying she'd never thought of it as such. "I simply decided there was more to life than just making films. The most important thing to me is my personal life."

Lizabeth tried to bond with Elvis, believing he was extremely intelligent, with a photographic memory, perhaps. But alas, "You couldn't have an intimate conversation with him because of his entourage." And so she tried a different tack. Seeing that the guys played with water guns on the set, Lizabeth joined in. "If anything, I had fun with him and his boyfriends, because I had a water pistol, too! So we water pistoled each other rather than verbalize."

Yet Elvis was somewhat scared of her, as it was the first time he had knowingly been around such an exotic woman. The notion of her sexuality both titillated and confused him (he pronounced her "unholy"), especially since Junior teased him unmercifully. "Are you gonna take her to bed tonight, Elvis?" Junior taunted, Cliff and Gene joining in raucous glee. "Don't worry," Elvis shot back nervously, trying to hide his discomfort. And he did invite her up to his suite at the Beverly Wilshire. But Lizabeth wanted no part of it. She was a sophisticated, smart lady, and she knew the guys had put him up to it.

"They weren't of the same mettle that he was. He was just an entity unto himself. It was like the halo just went all around him. What can you say? That was Elvis."

Deke's mascaraed eyelashes lent Elvis's character an air of gay desire, but no stories of homosexual dalliance or acting out ever surfaced about Elvis himself. In Hollywood, he invariably worked with actors, stagehands, and dancers who were gay, and when he had to be carried or lifted up overhead, occasionally one of them groped him. He didn't particularly like it, but it didn't spark his temper, either. Mostly, he chuckled.

Still, Byron Raphael, the Colonel's young emissary in 1956 and 1957, remembered that when Elvis first went to Hollywood, he was totally unprepared for his visit with rock-and-roll queen Little Richard, whose songs ("Tutti Frutti") Elvis had performed for several years.

A fellow southerner (born in Macon, Georgia, as Richard Wayne Penniman), Little Richard invited Elvis to his house after hearing that he had referred to him as "a friend of mine . . . [but] I never met him" onstage in the spring of 1956. On the surface, they seemed to be interracial twins—both wearing mile-high pompadours and makeup, and both melding gospel and rhythm and blues into a new art form.

Elvis was in complete awe of Little Richard, and Byron recalled that Elvis beamed when the piano-pumping sensation called the Colonel's office to say he was sending a limousine to bring the star out for a visit. Parker insisted that Byron accompany Elvis, who brought along Cliff and Gene.

When they arrived, two beautifully coiffed women with lavender skin and dazzling jewelry opened the door, and then welcomed them with ceremonial grace. Moments later, Little Richard, wearing what could only be called "a bright gold gown," as Byron put it, literally danced into the room. Elvis had never seen a black entertainer so wildly tricked out, not even in the seamier clubs of Beale

Street, and "his eyes got wide as saucers," Byron said. Their host had powdered his face a ghostly shade of white and accentuated his dress with diamond earrings, gold chains, a ring on every finger, and a wig that snaked six inches toward the heavens.

Elvis and his friends stood there motionless as Little Richard rushed around the room, slapping at them playfully and fawning over Elvis and his talent. Elvis returned the compliment, and his new friend fluttered his false eyelashes. "Oh, shut up!" Little Richard said, giggling, and then turned to Gene and Byron. "And you shut up, too!" With that, the two musicians traded performances at the piano, and then it was over. On the way back, Elvis and Cliff guffawed and rolled their eyes, but Gene's face was fixed in a quizzical gaze, wondering why such gorgeous doorkeepers had such large Adam's apples.

For a time, Elvis tried to integrate himself in the film community, even though Colonel Parker didn't want him mingling much. The Colonel preferred that he stay secluded at the Beverly Wilshire, both to give him an air of mystery, and to keep him away from the influence of others, particularly stars who might suggest other representation.

Elvis's fame was already such that he couldn't take a woman to dinner, but that also worked in his favor, helping ensure he wouldn't sleep alone that night. He simply invited girls to the party he held in his suite each evening.

Such blanket invitations lessened the chance for personal rejection, but they also allowed for a more practical cover, meaning other members of his entourage could take the blame if Elvis got a girl pregnant. Byron believed that may have happened, as the Colonel had several important dinners with the parents of young girls who spent too much time with his client. After that, the Colonel had a directive: "When any girl comes up to Elvis's room, I want to make sure at least two of you guys are around. That way, if any problems come up, you can say, 'Well, we made it with her, too.'" Any woman who came up to see Elvis, then—even a famous actress—would have to sit around with one of the other guys before she went in alone with Elvis.

Elvis defied the Colonel at first, wanting to attend his share of Hollywood parties and see the town. One day he was riding a bicycle on the Paramount lot and stopped to meet Valerie Allen, a young starlet walking his way.

"I want to take your picture, honey, with me on the bicycle," he said, and as Valerie found him "the most handsome young man I think I've ever seen in my life," she invited him to a party at her studio apartment. But as soon as he came in

the door, one of the guests said something derogatory about him, and wounded, he disappeared before Valerie could make her way over to him.

Still, he saw her occasionally for the next year or so—she later became Mrs. Troy Donahue—but there were too many women after him for anything real to develop. Some of them, like B movie queen Jeanne Carmen, weren't shy about one-night stands. Neither was Elvis, who was becoming increasingly hedonistic.

Parker fretted about it, especially with the morals clause in Elvis's contract, and strictly forbade him to be photographed in situations that would give Paramount any reason to cut him loose.

"I was at a party," remembered Carmen, a notorious bombshell. "I had this Indian costume on and not much else, just a little thing going between the legs, and no bra. Elvis walked in and went, 'Uh, hello.' The photographer started shooting us and all of a sudden, his manager came along and pulled him away."

Elvis intended to see the busty blond anyway. She excited him on several levels—she was a former consort of mobster Johnny Roselli, and a pal of both Frank Sinatra and Marilyn Monroe, whom she favored. Though she was five years his senior, he invited her over to the hotel. "The first day I went to meet him, I was sitting in a chair, and he was sitting in another chair opposite me, playing the guitar. All of a sudden he strummed and said, 'Are you wearing any panties?' That was his favorite thing to ask any girl. And, of course, I wasn't."

Jeanne, an Arkansas girl who grew up picking cotton in Paragould, related to Elvis's simple tastes in food, and she had him to her place for dinner on occasion. "I cooked southern-fried chicken for him, just like his mother. He brought me a present one night, and I thought, 'Oh, he's going to give me an outfit.' I opened it up and it turned out to be a little French apron. I put it on with nothing else, and everything was going great until I bent over to look to see if the chicken was done. Obviously, it burned that night."

· · · · · ·

Elvis had his mother very much on his mind during the filming of Loving You, *as at* the end of January 1957, she was admitted to Baptist Hospital for tests. She stayed nearly two weeks, as doctors probed to find the cause of the abnormally dark circles around her eyes. They checked her liver, too, suspecting cirrhosis or hepatitis, since she admitted that she drank and used pills. But if the tests were conclusive, no one talked about them at the time.

Barbara Hearn spent two days with her in the hospital. "She did not look seriously ill, and silly as it seems, we had a very good time. I created some crazy

hairdos for her, and filed and polished her nails, and we had something like a girl party in her room. For some reason I was the only one with her for hours and hours each day."

Her hospitalization delayed the Presleys' trip to Hollywood, but four days after her release, Gladys and Vernon, accompanied by their friends Willy and Carl Nichols (Carl was the contractor working on the house), took a night train for Los Angeles. Elvis gave them a tour of Beverly Hills and drove them past Debra Paget's house as an excuse to try to see her.

When they visited the set, they appeared as extras in the scene in which Elvis sings "Loving You" and "Got a Lot o' Livin' to Do" in front of an audience. Elvis's parents can be plainly seen sitting on the aisle, Gladys, still as full of rhythm as she'd been in her youth, clapping gaily to the beat. After her death, Elvis would never be able to watch the film again.

Lizabeth Scott met the Presleys on the set, and she was struck by Elvis and Gladys's passionate bond. "It was so obvious. You could not just see it, but feel it. Their synergy was nonverbal, but that tenderness went to full bloom when they looked at each other."

Shortly after they returned to Memphis, Gladys and Vernon went searching for a new house, someplace bigger and more secluded. Their Audubon Drive neighbors, many of them society people, old money southerners, considered the family an embarrassment and had worried them to death about the hordes of noisy fans who gathered at all hours and trampled the lawns. Elvis, hoping to make amends, accepted an invitation for cocktails from Frank and Betty Pidgeon, who lived up the street. Frank had underwritten the insurance on the house, and the uncommonly beautiful Betty—a mix of southern belle and femme fatale—was the daughter of E. H. "Boss" Crump, who ran the town from his election as mayor in 1910 until he died in 1954.

At the last minute, Elvis, feeling awkward among the country club set, tried to back out. But Gladys insisted he go, and so he took Cliff with him and asked for Coke instead of bourbon. He was nervous until the Pidgeons' eight-year-old daughter, Pallas, invited them to her bedroom to see her teddy bear collection. Elvis and Cliff went to meet the menagerie, and Elvis, who received hundreds of stuffed animals from his fans almost daily, promised to send the little girl a new teddy bear for her birthday, even though she never actually got it.

However, one afternoon of pleasantry could not make up for the fact that the Presleys did not fit in on Audubon Drive. Soon, the neighbors bonded in a public discussion, offering to buy them out, and Elvis politely offered to buy *them*

out. A nuisance suit was threatened. It was clear that the Presleys would be more comfortable elsewhere, and a chance meeting between Gladys and a young real estate agent named Virginia Grant outside of Lowenstein's department store led to the ideal place.

In early March 1957, Elvis wrapped filming on *Loving You,* and on March 17, the day he was to leave Hollywood by train, Virginia drove Gladys and Vernon to see a large home she thought might be suitable. But when the Presleys said they needed a bigger lot, the agent remembered an estate in the Whitehaven area, just before Highway 51 south eased into Mississippi. Called Graceland, and built in 1939 for Dr. and Mrs. Thomas D. Moore, the property comprised about fourteen acres of towering oaks and farmland, with the undulating grounds buffering the house from unwanted visitors.

To the Presleys, who had never forgotten their sharecropping days in Mississippi, it must have seemed like Tara from *Gone With the Wind.* Vernon and Gladys called their son and excitedly told him about it, and Elvis was so eager to please them that without even seeing it, he told them they would have it. The Presleys gave Virginia a $1,000 deposit, and the deal, with an asking price of $90,000, was as good as done.

On March 18, en route home, Elvis sent a telegram to June Juanico, asking her to meet him in New Orleans during his brief layover there. They had barely kept in touch since Christmas, but in January, he'd recorded Faron Young's "Is It So Strange" just for her. All the craziness of Hollywood had gotten him thinking about what was real and what wasn't, and he wanted to start over with her again, at Graceland.

But June had a surprise for Elvis, too. She'd been dating a man named Fabian Taranto. His cousin, Salvadore, played in the band Elvis replaced at the Slavonian Lodge the first time he played Biloxi. Fabian was a good man, and he needed her—unlike Elvis, she thought—and she'd convinced herself that he was the one. Earlier that month, Fabian had asked her to marry him, and June had said yes. Elvis had a big selection of women. Let him take his showgirls and shove 'em.

Yet when she saw him, she couldn't bring herself to tell him right away. Now Elvis was standing in front of her and smiling so brightly that he almost glowed. He scooped her up and kissed her and then put her down, and he took her to a second train that had been waiting for his arrival. He climbed the steep steps, and then pulled her up into his arms and carried her to his private car. There, he kissed her again.

"He wanted me to come to Memphis with him. He said, 'Mama can't wait to

see you, and I got a surprise for you. You're not gonna believe what I bought for you! Wait until you see what it is!' "

"What is it?"

"I can't tell you. I'll have to show you. You've gotta come home with me."

June stammered and tried to clear the cotton from her throat. "But I didn't bring any clothes with me."

"You don't need any clothes. You don't need anything. I'll buy you all new clothes when we get home."

He was still holding her, but she shook her head and pulled away from him. "I can't go with you, Elvis. I can't."

"Why not?"

"I'm engaged to be married."

His face fell, and he stared at her in disbelief. Then he slumped down on the couch and held his head in his hands, not wanting to believe it was true.

"You're kidding me, June. This is just to get even with me, right?"

"No, Elvis. I'm not kidding. I'm serious."

"Is that why you've been so cool to me on the phone?"

"No, I haven't been cool to you. You've been busy doing your thing, and I've been busy doing my thing. Your thing just gets in the paper. Mine doesn't."

They sat there, both feeling sick, not saying anything. Finally, the conductor yelled, "All aboard!" and the train jerked to signal its departure.

June was crying now, and she stood up and kissed him on the forehead. "I love you, Elvis Presley, and I always will." Then she was gone, running from the car, and jumping down to the platform.

She turned back to watch as the train began to move. She saw him leaning out the door, as if he wanted to hold her gaze before the train picked up steam and carried him out of her life for good.

"I can still see him hanging on to that train and waving good-bye. The train rounded the corner, and all I could see was his hand, still waving."

A few days later the papers announced, "Elvis Buys Graceland," and June realized what her surprise was to be.

She married on June 1, 1957, and two weeks later, Elvis phoned her mother to see if she were home. "No, Elvis, she's not here. Married life seems to be agreeing with her." And so he finally let it go.

But June never did. More than fifty years later, "No one has ever taken Elvis's place in my heart. I've just never been able to stop loving Elvis."

When Hollywood starlet Yvonne Lime visited Elvis in Memphis in April 1957, he took her out to see Graceland, which he'd bought the month before. "To think that we Presleys will live here," he told her. "We've been poor so long, I can't believe it yet." *(Michael Ochs Archives/Getty Images)*

"The Most Miserable Young Man"

At 10 A.M. on Monday, March 19, the day after Elvis arrived home, he drove out to Graceland with his parents, where they met with real estate agent Virginia Grant. Elvis looked around the house and grounds for a few minutes, and then baptized the home by playing some rock and roll at the piano. In high school, as Regis's prom date, all he had dreamed of was becoming successful enough to buy his mother a big brick home with a landscaped yard. Now the twenty-two-year-old had secured so grand a property as to befit a governor. All three Presleys signed the sales contract as purchasers, Vernon first in bold deep blue fountain pen, Elvis next in a different ink, and Gladys below in black ballpoint.

By March 26, the closing date, it was officially theirs, with a final price of $102,500, inflated by additional offers on the property as news of the deal leaked out. Elvis had sold the Audubon Drive house to a realty company for $55,000, paid $10,000 in cash, and taken out a twenty-five-year mortgage for the balance of the six-figure purchase price.

Vernon just prayed that Elvis's career lasted another couple of years. When the family got a new bedroom suite, and Elvis gave the old one to his aunt and uncle, his father furrowed his brow. "Son, I wish you wouldn't be giving all of our things away. We may have to put them on our back and walk out of here with them one day."

Gladys had no idea how to update or furnish the eighteen-room colonial, and so on the recommendation of Sam Phillips, who had just turned his ranch house into a modern "space age" showcase, the Presleys asked interior decorator George Golden to give them a bid. The enterprising Golden advertised his services with flatbed trucks that drove around Memphis showing off miniature

rooms with the decorator's flamboyant touches. He knew that "every decorator in town wanted that job so bad they could taste it."

He arrived to find two female competitors "all over poor Gladys, waving sketches in her face and gabbing away like you wouldn't believe," he said. "It was like a circus out there." Golden introduced himself and then stood back with Vernon. The decorator was married and knew a thing or two about women. He saw that Gladys was a shy, country woman who "had a real fear of being in closed-up spaces." As his competitors continued their locustlike siege, Golden began talking as country folk do, saying "ain't" and talking about "deck-core."

"Finally, Gladys had had enough. She waved her hands in those women's faces and hollered, 'Get away and leave me alone! Mr. Golden's gonna do our work!' "

The family wouldn't move in for another six months, and they gave Golden free rein to decorate however he wanted. He livened Graceland's conservative, run-down state with bright colors and a hodgepodge of styles, from Eisenhower-era suburban ranch to classic elegance. He also added dentil molding to the cornices on the first floor and transformed the dining and living rooms with chandeliers, gold-on-white trim, and swagged draperies. And last, he suggested the Presleys erect a temporary fence and staff the perimeter with guards.

Elvis picked out the famed music gates, which would be installed in April. But he wasn't home much for the renovation—he was busy preparing for a major tour and getting ready to shoot *Jailhouse Rock,* his first picture in a new deal with MGM, the following month.

When he was home, "you knew it," Golden said. "Once he borrowed one of my delivery trucks and pulled a hat down real low over his face so he could drive through the gates without getting mobbed. Then, when he got back out of the truck, he took off the hat, bowed to the girls lined up against the fence and said, 'Thank you, ladies!' Well, they liked to die."

As Golden progressed with the property, Elvis proclaimed it "the most beautiful house I've ever seen!" He was so excited he needed to show it to somebody, so he dropped by to see Barbara Hearn. "He said he was going out to look at Graceland, that he wanted me to be the first one to see it. Whether he said that because it sounded good or whether it was really true, I believed it."

Barbara, who remembered how sparsely the family had lived on Alabama Street, was overwhelmed at how lovely and tasteful it was, but she found Gladys worn out with it all. "Mr. Golden almost drove her crazy telephoning, asking her questions about every little thing. He just wanted to please her, but whenever I

was there, she would have me answer the phone. She'd say, 'If it's Mr. Golden, I'm not home.' She cared, but she just wanted him to get on with it."

By now, Barbara's romance with Elvis was over. They'd gone from friends to sweethearts to friends again. He was hardly ever in town, and when he was, their hours were just so different—he was up all night, and she was working or going to school. At the beginning, there had been only the two of them, and then Red, and then the Colonel. Now there was this entourage, and the guys "would get jealous if anybody got in thick with Elvis. They didn't want anything to ruin their positions."

And so it ended with a whimper. "There wasn't any great breaking-off. But I probably would have ended up walking away, because I value loyalty and trustworthiness." In retrospect, she guesses the relationship hadn't really been a big love affair, or "I would have been brokenhearted when it was over, gnashing my teeth and wanting to slit my throat. And I wasn't. I just went on with life."

Elvis did, too. Some time that year, he stopped in El Paso on a road trip home from Los Angeles. Impulsively, he called Debra Paget and asked her to marry him. She told him it could never happen. "I know it's your mother and father," he said. "And if it takes twenty years, I'll get them to like me."

"I knew it was hopeless," she told biographer Suzanne Finstad years later. "My parents would never relent. It was an impossible situation."

The irony was that in a period of months, the most famous boy in America had lost all of his key romantic relationships.

Gladys's sister Lillian had once noted that Gladys's unhappiness made Elvis melancholy, too, even if they weren't together—so incredible was their communicative bond. But just when Elvis thought his mother should be ecstatic with her new showplace, Gladys complained to Lillian that she was cut off from everybody at Graceland. When Elvis was away, she'd say to Vernon, "I wish you could pray with me." And Vernon would respond, "I wish Elvis would come home."

They were lonely, without much to say to each other, or even to Minnie Mae. And so not long after they moved in, Vernon invited his father, Jessie, and his wife, Vera, to come stay for a while, to drive down from Louisville in the new Ford Fairlane Elvis had bought them.

The visit was awkward for Vera, with Minnie Mae in the house, but they all adjusted. Jessie was "kind of overwhelmed at all of it," remembered Vera's granddaughter, Iris Sermon Leftwich. They weren't used to a king-size bed, and that night, Vera sat on one side and Jessie on the other. He looked around the room and then back at his wife. "How's the weather over there?" he said.

.

On March 27, 1957, Elvis left Memphis for Chicago with his cousin Gene (now El-vis's man Friday), Arthur Hooton, and George Klein, who was making his first trip with the group. Before starting Jailhouse Rock, he would do a brief tour of several U.S. cities with a quick swing into Canada.

In a much publicized event, replete with press conference, Elvis would play the International Amphitheater the following night, debuting a $2,500 gold-leaf tuxedo made for him by Nudie Cohen, the Russian-American tailor. Nudie was famous for elaborate and inventive stage costumes—it was Cohen who designed Hank Williams's famous white cowboy suit with musical notes on the sleeves—though he started out customizing underwear for showgirls and strippers at his first store, Nudie's for the Ladies, in New York City.

Elvis had a particular stripper on his mind during his two days in Chicago, as he'd spotted an advertisement for Tura Satana's show at the Follies Theatre. He was still as fascinated by exotic dancers as he had been in 1955 when he and Tura first met in Biloxi. His interest in them grew stronger during his trips to Las Vegas, and then again when he read the script for *Jailhouse Rock.*

Now in Chicago, Elvis went to see Tura's afternoon performance, going by himself, wearing dark glasses and a hat. He watched her routine and then asked to go backstage. She hadn't expected him, so she hadn't made arrangements, and "the girls from the show were just fawning and climbing all over him." Tura took him into her dressing room, but people wouldn't leave them alone, so they went to a restaurant down the street at State and Van Buren. The owner sat them in a booth in the back where nobody would see them, and they planned to meet again late that night at the theater. "That's when we really started really dating."

Just as he had with seventeen-year-old Kay Wheeler, Elvis asked Tura to show him her dance steps. She explained that a lot of her performance was based on martial arts, particularly the flips and splits, and the knee slides and backbends.

"What do you mean, martial arts?" he asked.

"Well, my dad showed me how to protect myself after the rape. I incorporated a lot of it in my routine by just adding it to music."

"Oh," he said. "You've got to teach me how to do that!"

She took him through it and then showed him how to do the shimmy with one leg, both legs, and then switch over. He laughed. It felt good.

"Can you teach me how to twirl the tassels?"

"Yes, but I can only teach you how to twirl one."

He laughed again, thinking about where she might mean to put it.

"What if I want to learn to twirl two?"

"Sorry, honey. You really don't have enough up there to do that."

"Okay, how do you do the knee slides?"

"Carefully."

He saw what she meant, and then she showed him how to do the slide and the splits at the same time. He'd been dropping to his knees onstage already for about a year, though he wouldn't be able to do it in the gold suit, because the gold was already flaking off. But he wanted something a little more dramatic. The first time he tried the slides, he picked up a splinter, so he didn't do it again. He said, "That one hurt!"

Finally, he told her he wanted to learn the bump and grind—the big pelvic thrusts, and the real hip swivel, not just the teases that he'd been doing since *The Milton Berle Show*. Tura showed him some subtle movements, and he pushed her for more.

"He liked to do the bumps and grinds as I did them, and that was basically what he used in his routine from then on." Indeed, his 1957 concerts in support of the release of *Jailhouse Rock*—particularly his benefit show for the Elvis Presley Youth Center in Tupelo that fall—would be his most sexually blatant.

He'd called her a time or two in 1956, and she claims to have visited him when they were playing the same cities in the South. Now she became a sexual mentor for him as well—he might have been with a lot of girls, but he really had no technique as a lover.

In some ways, their sex was clinical, and she sized him up in much the same way. ("He was not badly built. He wasn't humongous, but he wasn't tiny either. I would say that he was a little bit above average.") He was always a considerate partner, always made sure she was satisfied. But in her experience, he kissed like a high school boy ("I told him most women don't like to get their face that wet"), and he was timid in the art of cunnilingus.

"He loved oral sex for himself. He wasn't very aggressive for the female, but he would try it if I wanted. I always cleaned him before and after, took him in the shower, or I would bring a nice scented washcloth with perfumed soap and wash him off and towel-dry him, because I didn't want anybody else's residue. He once told me that I was one of the cleanest women he had ever been with."

After years of separating sex and love, having good girls at home and "whores," as he said, on the road, Elvis now tried to combine the two. But he knew that Gladys would never really approve of her, and Tura knew he couldn't

be monogamous. ("You are only human and you are a man, and that thing rules everything guys do.") She also believed that he couldn't refuse women, that as a southern gentleman, he literally didn't want to be discourteous to their advances. "He wanted to please, and he didn't know how to be standoffish with women, because that was not how he was raised. He always treated all women like ladies."

But he seldom used protection when they made love, remembering the trauma of the early incident in Shreveport, and relied on early withdrawal as his form of birth control. Tura told him that had to stop.

"I said, 'If you are going to be with other girls, make sure you are well protected, because somebody is going to try to say that she's gotten pregnant by you, and if you are not careful, she'll make you marry her or ruin your career.'" His mother had told him the same thing, he said. He'd be careful.

The relationship, which was slight at best, lasted until he went into the army. But though the romance faded, the friendship remained. Sonny West, Red's cousin, who would later join the entourage, remembers meeting her in the early 1960s. Mostly, Elvis would call Tura for advice with various women. "After we split and I was no longer his girlfriend," she says, "I became his adopted mama."

Yet his fixation on burlesque stars—his female equivalent—continued. In October 1957, he went to Las Vegas for a ten-day vacation, staying at the Sahara Hotel. There he had a one-night stand with legendary exotic dancer Tempest Storm, eight years his senior. She later recounted it in a television interview.

"He called me about three one morning. He wanted to come over. I told him to come in the back door, that I didn't want the doorman seeing who I was entertaining. He crawled across a back fence, and in doing so, ripped his pants."

Storm excused herself to put on one of her sexiest negligees, and to lock her French poodle in another room. The pooch would become a problem.

"All night, as Elvis and I were together, my little poodle barked and scratched at the door."

The last time she saw Elvis was about 1970. The first thing he asked her was, "Do you still have that damned little poodle?"

.

*Elvis appeared to everyone to be on top of the world—thriving record career, mov-*ies, women, and now a mansion for himself and his family. But underneath, the stress was getting to him. That March, in downtown Memphis, he was accused of pulling a gun on a nineteen-year-old marine, who claimed that Elvis had intentionally bumped into his wife. It turned out to be a Hollywood prop gun, and

Elvis insisted he hadn't really meant any harm. Still, he sent the marine, Private Hershel Nixon, a rambling six-page telegram that offered both an apology and a window into his psychological state: "Many times there have been people who came up to me and stick [sic] out their hands to shake hands with me, and they hit me . . . and then take off for no reason at all. . . . So when you called me over the other night . . . I didn't know what you were going to do."

The following month, on April 19, Elvis imported another Hollywood starlet to Memphis, this time for Easter weekend. Her name was Yvonne Lime. A California native, the wholesome blond had an uncredited role in *Loving You,* but a costarring role as Michael Landon's girlfriend in *I Was a Teenage Werewolf.*

Elvis had seen her in *The Rainmaker.* Since he'd read portions of the script for his screen test, he studied the picture intently on its release. When Yvonne came on the *Loving You* set, playing a small part in which she talked to a group of teenagers, he stayed to watch her do her scene. It made her nervous, but not as much as when he came over afterward and asked for her phone number. The next day, he introduced her to his parents, who were still visiting, and to his friend Judy Spreckels. Then after he came home to Memphis, he started calling her, saying, "Honey, I miss you so much. Please leave Hollywood and come."

They stopped first on Audubon Drive (where Yvonne's picture now replaced Kay Wheeler's in his bedroom), and then he gave her a quick tour of town on his motorcycle. At the end, he rode her out to Graceland, which was still being renovated. They posed for a newspaper photographer, Bob Williams, in front of the stately columns, but Yvonne had on a striped outfit that looked more like California lounge pajamas than Tennessee street wear, so the pictures telegraphed publicity, not passion. Then they went home. A couple of Elvis's buddies were there, including Gene, who acted goofy, carrying around a doorknob and a sandwich and a pair of pliers in a briefcase. For dinner, the Presleys' new black maid, Alberta, served them all meat loaf and mashed potatoes, Elvis's favorite comfort food.

After dinner, they sat out on the front walk in lawn chairs, and Elvis took Yvonne's hand. Then he picked up his mother's. "My two best girls," he said. He might as well have declared, "My past, and my future," except that Elvis could never really let go of Gladys. He could share himself with someone, and he *needed* that third person to mend the ancient circle, broken long ago in Tupelo. But he could never let there be just two. It reminded Yvonne of their first date in Hollywood, when they'd gone to see James Dean's last movie, *Giant,* Elvis sitting between Gladys and Yvonne, holding his mother's hand with his right, and Yvonne's with his left.

"Are you going to be my little girl?" he asked once Gladys had gone inside.

"Yes, darling," she answered. But even then she realized it wouldn't happen. "I knew from what Elvis told me that he couldn't think of marriage for a long, long time. And I was just beginning to get the picture breaks I'd worked for since I was a child." Most of all, life in Memphis was just too different from the way she'd grown up in Glendale.

That Saturday, Elvis took her to an all-night party at Sam Phillips's house. She could tell Elvis hadn't been feeling well—he had a skin infection on his shoulder, he told her, that had been bothering him for some time. "Even with all the noise and laugher, I could see Elvis was feeling worse by the minute. He was unusually quiet, and his eyes began to get a sick look." He excused himself to talk with Sam about it.

"Elvis came out with a rash just above his pubic hair," as Sam remembered it. "It was just what we call a nice, big ol' risen. The doctor will call it a carbuncle. He hadn't told anybody, and he ran around with that damn thing festering up for two months. We went into the living room, and he showed me. He said, 'What can I do? You don't think I've got syphilis, do you?'

"It didn't look like it, but he was white as a sheet. I called Dr. Henry Moskowitz, my doctor, and I said, 'Henry, Elvis is over here, and he's got a big ol' risen on his stomach. Could you come and take a look at it?' And he said no, but he called down to Baptist [Memorial Hospital], and he said, 'You all run down there, and they'll take a look at it and let me know what they see.'

"We went down to Baptist about seven o'clock. When we first went in, there were three or four nurses there. I don't know what those sick folks did, because before we left, there were fifty nurses down there from every floor.

"Anyway, this thing was so red that when they lanced it, it shot two feet in the air. And you know how much pain he had to have been in for so long, but he was scared to find out what it really was. He hardly said a word on the way down there, and it was about a ten-mile trip. But on the way back, we couldn't shut him up, he was so happy."

When they got back to the house, Elvis told Yvonne they'd given him some penicillin to help clear the infection, and he was feeling well enough to stay at the party. But by 2 A.M., he'd lapsed into a somber mood, and began singing hymns and spirituals. It was raining by then, and Sam put some wood in the fireplace to cut the chill. It thrilled Yvonne to hear that famous voice in the darkened room, with just the light from the fireplace, and she saw he had more passion for religious music than any other.

By daybreak, everybody was out by the swimming pool, laughing again and eating breakfast. Yvonne cooked Elvis's eggs for him—hard as a rock, the way he liked them.

On Easter night, Elvis, with Yvonne and the entourage, went to services at the First Assembly of God. It was the first time he had been to church in a long time, and he felt both awkward and relieved. He passed a note to one of the ushers for Reverend Hamill, asking if the pastor would see him in his office afterward.

He was sitting, waiting, when Reverend Hamill walked in. Elvis quickly rose. As the clergyman remembered, "He said, 'Pastor, I am the most miserable young man you've ever seen. I'm doing the things you taught me not to, and I'm not doing the things you said I should.' He cried and asked me to pray for him."

For more than an hour, the two prayed together, and Elvis continued to weep, asking the minister to forgive him for his sins. "He didn't say what they were, and I didn't know what they were." But clearly Elvis "was constantly in conflict with what he wanted to do and what he was doing." Reverend Hamill told him to call the next day, and he would give him the address of a pastor friend in Hollywood, M. O. Balliet. Elvis phoned Reverend Hamill's secretary on Tuesday morning, but he never followed through with the contact.

The last time Kay Wheeler saw him, at the press premiere for *Jailhouse Rock,* she, too, could tell that Elvis was not himself. "The change had set him. He seemed lonely and isolated, not the 'Memphis Flash' of the Texas tours of 1956. He walked in the room of probably a hundred reporters, and yelled loudly at me across the room, 'Is that you, Kay?' Everybody turned to look at me, and I answered, 'Yes, Elvis, it's me.' Those were our last spoken words. But he remembered me. I was the one who got away."

.

The plot of Jailhouse Rock, *in which Elvis's character, Vince Everett, goes to prison* for accidentally killing a man in a barroom fight, drew on two aspects of Elvis's life—his father's time at Parchman, and his own fears of violence at the hands of others, as Elvis alluded to so fervently in his telegram to Private Nixon. The story (by Nedrick Young, who won an Academy Award for *The Defiant Ones*) follows Vince as he learns the guitar from a fellow prisoner (Mickey Shaughnessy), and becomes a hot new singing star with the help of record promoter Peggy van Alden, played by Judy Tyler.

Jailhouse Rock, shot in black and white, is memorable as the movie in which Elvis first hints at his abilities as a serous dramatic actor. It also contains two

scenes that would rank among the most unforgettable of his film career—the iconic, cell block production number ("Jailhouse Rock"), which choreographer Alex Romeo created from Elvis's natural stage movements, and his cocky love scene with Judy Tyler, which mirrored his brash behavior in his early days at the Louisiana Hayride. When Vince impulsively grabs the tough but provocative Peggy to kiss her—a serious piece of manhandling—she pushes him away. "How dare you think such cheap tactics work with me," she admonishes. "Them ain't tactics, honey," he drawls. "That's just the beast in me."

"The beast" emerges in another famous image connected with *Jailhouse Rock,* a publicity photograph of Elvis in a nightclub scene with a blond striptease dancer. In it, he sits at a bar in the background, gazing up at the stripper onstage, his image framed between her legs in the foreground.

"They spent almost all day lining up the shot, shooting it, reshooting it, and changing the marks," remembers the dancer, Gloria Pall. "He watched me so intensely every single moment of that scene. He never took his eyes off me. Even when we took a break he kept watching me. I did a whole dance for him with bumps and grinds, and I told him, 'This reminds me of what you do.'"

When Gloria first arrived on the set, Elvis thought she looked familiar. Then it hit him: She was the former showgirl whose fingers he'd sucked backstage in Vegas. He walked over to her for a playful reunion.

"What are you doing here—are you an extra?" Gloria teased.

"I'm the star of the movie," he said.

"You are? You flopped in Vegas and they made you a star?"

He liked her cool banter and invited her up to the Beverly Wilshire for a party later that night. He had Suite 850, the Presidential Suite, he told her. It was four thousand square feet of opulence, one whole wing of the hotel—four bedrooms, a living room with a fireplace, dining room, den, kitchen, library, and a butler's pantry. "I'd love to," she said, "but can I bring my husband?"

It took him aback.

"When did you get married?"

"About a month ago."

"Gee," he said. "I don't mess with married women."

"Well, I'm sorry about that," she told him. "I don't mess around either."

That was the end of that. "But he invited me to lunch, and he held my hand all the way. He was very sweet and boyish."

One night, Byron Raphael, the William Morris agent-in-training, took his new wife, Carolyn, to one of Elvis's parties at the hotel. She was hoping to be-

come an actress, and Byron could tell that Elvis found her attractive. The next day, when Elvis and Byron were sitting in his MGM dressing room, the star said, "Your wife sure is a sweet one, Byron. That's the kind of girl I've been looking for. There must be hundreds of girls outside the gate. Why don't you see if you can find me another Carolyn? In fact, take care of business for me."

From then on, Byron began supplying him with young girls, particularly his ideal type, a five-foot-four brunette with pretty eyes and a round behind. "To him, that was the most sensual part of a woman's body."

As Elvis's pimp, Byron would make one bad choice in two years—on the road, after a concert, he procured a luscious girl who stood five foot ten. He guided her into Elvis's room without warning him that she wasn't his usual cup of tea. Later that night, Elvis came out in his bathrobe and barked, "There were ten thousand girls out there, and you picked the only one on stilts! Don't send any more Amazons in here!"

Though Elvis described his sexual appetites as voracious—he'd say, "I like it hot and heavy, Byron the Siren, hot and heavy"—Byron was surprised to find that Elvis was far more interested in heavy petting than doing the wild thing, especially with young virgins. One evening, he brought three young girls into Elvis's bedroom. Soon they were all naked, but Elvis stayed in his underwear, kissing and fondling them, and eventually falling asleep with them in his arms, his own records playing softly in the background.

"He would never put himself inside one of these girls. Within minutes, he'd be asleep, and often the girl would still be rubbing herself against him. I'd step in and say, 'It's time to go now, honey. Elvis needs to sleep.'"

Girls would come out in tears, crying that Elvis had told them to wait until their wedding night. Or they'd get hysterical and whine that Elvis didn't love them. Byron learned damage control on the job.

"I'd say, 'No, that's not true. He just wants to make sure you don't have a baby. He'll call you again.' Of course, he almost never did. But with some of the younger ones, he'd be like the tooth fairy, slipping hundred-dollar bills in their schoolbooks."

· · · · · ·

In May, Lamar Fike read in the paper that Elvis had aspirated a cap from one of his front teeth while sliding down the pole in the film's big production number, and that he was recuperating from surgery to remove it from his lung. For several months, Fike had been living in Texas and working as a deejay. His career was

short-lived—he couldn't coordinate the turntables, check the Teletype machine, read the barometer, and get the commercials in order at the same time. "One day I just put an LP on, locked the doors, and got in the car. I heard the record going *chick, chick, chick* on my way out of town. That was my way of signing off."

Now Lamar picked up the phone and called Cedars of Lebanon Hospital in Los Angeles. He asked for Elvis's room, and the operator patched him through. Elvis answered the phone himself.

"I told him about my little exit from the radio station, and he laughed and said, 'What are you going to do?' I said I didn't know, and he said, 'Get your ass out here.'" Fueled on uppers, Lamar climbed in his new two-door 1956 Bel-Air Chevy and drove thirty-six hours straight on Route 66 to Los Angeles. From then on, he was an official part of Elvis's entourage, and within a day, Elvis would get him work as an extra, along with Gene, Cliff, Junior, and George.

At the Beverly Wilshire, Lamar was surprised to see Natalie Wood, whom he had met in Memphis on Audubon Drive.

"By now I knew that Natalie was a good person, but she wasn't very sure of herself, and you never knew what she was going to do. One day, she got out on the window ledge at the hotel. She must have liked Elvis better than she did in Memphis, because she said she was going to commit suicide over him.

"I came running in to Elvis, and I said, "She's out on that thing! She's going to jump!' He said, 'She won't jump.' I said, 'I'm telling you, she's going to do it!' She crouched out there about half an hour—promising, swearing—she was going to jump. He finally talked her back in. He said, 'Nat, come and sit down and quit being so dramatic.' She came back in, and I just collapsed in a chair. But Elvis was real nonchalant. He said, 'I told you she wouldn't do it.'"

As filming began, Elvis had a date with Anne Neyland, who had a credited, but minor, role in the picture. But as on his first two films, where he'd set the precedent, he quickly turned his attention to his costar. Judy Tyler was a newlywed, having just married second husband Gregory LaFayette in March. Despite what the singer told Gloria Pall about not fooling around with married women, "she and Elvis had a thing going," according to Lamar.

At twenty-three, Judy Tyler (real name Judith Hess) was a tough cookie and a show business veteran with a pedigree—her father, Julian Hess, was well known as a trumpeter for Benny Goodman and Paul Whiteman, and her mother, Loreleo Kendler, danced with the Ziegfeld Follies. At sixteen, Judy had won a Miss Stardust beauty contest, which led to a job as a singer-chorine at the Copacabana nightclub. In 1951, when she auditioned for—and won—the part of Princess

Summerfall Winterspring on *The Howdy Doody Show* children's program, the irrepressibly sexy seventeen-year-old failed to mention that she was married, to twenty-six-year-old Colin Romoff, the Copa pianist and her vocal coach.

She lasted two years as the grown-up puppet, but by then she had quite a reputation, drinking and stripping on nightclub tabletops. The consensus was that she was drop-dead beautiful, but she had a foul mouth, round heels with some of the cast and crew, and took no guff from anyone.

In his book, *Say Kids! What Time Is It?* Stephen Davis, whose father, Howard Davis, was the show's writer-director, recounts numerous stories of Judy's wild behavior and numerous romantic liaisons. "She loved sex—she slept with everybody," lamented Chief Thunderthud's Bill Lecornec.

Clarabell was especially shocked. "I would go out on weekend appearances with her," said Bob Nicholson, "and while we got along fine, she would just as soon tell a store manager to go fuck himself as she would look at him. She had stars in her eyes and thought she was bigger than he was."

And she was. In 1956, she earned a Tony nomination for her performance in the play *Pipe Dream,* which landed her on the cover of *Life* magazine.

Jailhouse Rock was Judy's second film, and she appeared to be poised for a long career. But over the Fourth of July weekend, with filming just finished in mid-June, she and her husband were killed in a car crash near Billy the Kid, Wyoming. One story said she'd been cut in half.

Elvis was devastated. "It really, really upset him," says Lamar. "He broke down and cried, sitting up in the bathroom at Graceland."

"Nothing has hurt me as bad in my life," Elvis told the newspapers. "I remember the last night I saw them. They were leaving on a trip. . . . All of us boys really loved that girl."

On July 4, Elvis, clearly distraught, showed up at George Klein's house early in the morning. It was so awful about Judy. He'd just saved her from one serious accident, when she'd run into a door, putting her arm through the glass. He'd managed to grab it, keeping her from falling through.

Then, changing the subject, Elvis mentioned he'd been watching this tiny blonde, Anita Wood, the replacement for Susie Bancroft on Wink Martindale's WHBQ *Top 10 Dance Party.* George said he could get him an introduction.

That was Thursday. On Monday night, Elvis had his first date with his next serious girlfriend.

Elvis and Anita Wood embrace as she steps from a plane at Memphis Municipal Airport, September 13, 1957. She had been in Hollywood preparing for her first movie role. Elvis had given the nineteen-year-old a friendship ring the previous week. At some point, she would dye her hair black for him.
(Robert Williams/the Commercial Appeal,
courtesy David Troedson/Elvis Australia)

FOURTEEN

· · · · · · · · · · · · · · · · · ·

Nipper Dreams

Anita Wood was nineteen years old, wore her hair in an appealing blond bob, and *was in all ways a perfect southern sweetheart.* She had grown up in Jackson, Tennessee, where she developed a spunky personality, as well as a soft, lilting accent that rolled the *r*s off the end of her words ("teen-agah"). It sounded cultured, though, so it didn't get in the way of her deejay work. And Anita was not only pretty and pert, with dimples at the ready, but she was also talented and poised. She'd cultivated her singing voice and knew how to perform on camera. She also had a strict code of ethics, which Elvis was soon to learn.

Instead of calling her himself for their first date, he'd asked Lamar to do it that Saturday, after her dance party show. Elvis wanted to see her that night.

"I'm sorry," she said. "I already have a date tonight."

Lamar couldn't believe it. He went, as Anita remembers it, "ballistic." But she'd given her word to Jimmy Omar for that night.

"You mean you won't break a date to go with Elvis Presley? Are you crazy?"

No, she wasn't crazy, but she also really wasn't an Elvis fan, though as a disc jockey she played his records, and she'd grown up with Cliff Gleaves.

"Well, I don't believe Elvis would like that if I did that to him."

Anita thought she'd never hear from Elvis after that, but Lamar called again for Monday night, and this time she said yes.

She wasn't sure what she was getting into, though.

She'd grown up innocent and sheltered with stern parents, and since they wouldn't allow her to date, she'd never had a serious boyfriend. In the big city of Memphis, she rented a room from an older woman, Miss Patty, who clucked over her like a mother hen. When Elvis's sleek black 1957 Cadillac limousine

pulled up at the house, George Klein got out and walked to the door. "I'm here to pick up Anita," he said. But Miss Patty pulled herself up in a self-righteous stance and refused him.

"No, I'm sorry," she said. "If Elvis wants to see Anita, he'll have to come to the door and pick her up."

George went back to the car and explained the situation, and then the two of them came up the walk. Elvis had on his red velvet shirt, black trousers, and a black motorcycle cap, and for a moment, he stole Anita's breath. "He was effervescent . . . absolutely the best-looking man I've ever seen, before or after."

The protective Miss Patty led Anita's gentleman callers into the living room. There, she laid down the law. "Now, you have to have her back at a reasonable hour," she said. Otherwise, Anita couldn't go.

Out in the car, Anita was surprised to find Lamar and Cliff, too, as she thought this was a *date,* the kind of thing where a boy and a girl go out together without other people. And where were they actually going? Elvis just seemed to be driving around. Then they pulled up by the Strand Theater, where Elvis showed her a giant cutout of himself as a display for *Loving You,* which was scheduled to premiere the following night.

They drove around some more, stopping at a Krystal's stand to get three dozen hamburgers. Anita didn't like the little square steamed sandwiches, and she was amazed to watch the guys wolf down every one. After that, Elvis asked if she'd like to see Graceland.

"I said, 'Sure,' you know. 'I'd love to.' I felt really at ease because of the guys in the backseat that I knew."

As soon as they got in the door, Elvis gave her a pink-and-black teddy bear from a large supply in a box in the dining room. His double-sided single "Teddy Bear/Loving You" had just sold 1.25 million copies in a week, and the Colonel had bought a gross of stuffed animals from a wholesale carnival house.

It was a pleasant evening. Elvis introduced her to his parents and grand-mother, and then gave her a tour of the lower floors. Then the group listened to some music, and Elvis played the piano. Finally, he said, "Come up. I want to show you my office."

There wasn't much to see in his office, really, but it was right next to his bed-room, and he gently led her inside. She couldn't believe how dark it was, with navy blue drapes. Then she saw his bed. It was ten by ten feet, and required specially made sheets, he told her. He had mirrors all around the room, too, and light blue mirrors in the bathroom that matched the baby blue carpet.

They were just talking, finishing their tour, when Elvis began to sit her down and kiss her. She knew she was a small-town girl, but she was shocked—people didn't kiss on the first date then. She didn't care who he was. And she didn't like it, especially when "his hands moved just a little bit where I didn't think they should have been."

"I think I need to go home now," she said. He didn't put up a fuss.

A couple of nights later, he invited her with his parents to see a private screening of *Loving You,* and then he came by one day in his old panel truck. He wanted to take her down to Lauderdale Courts to show her where he grew up, and then swing by Chenault's drive-in for hamburgers. After that, he saw her almost every night, even if it was just to go back to Graceland to watch TV.

Five days after that first date, Gladys invited Anita for dinner. She liked this girl, and she told Elvis not to let her get away. Elvis liked her, too. He talked baby talk with her ("I just ate that up. He treated you like you were a doll"), and because she stood only five foot three and weighed 110 pounds, Elvis affectionately called her "Little," or "Li'l Bit." He referred to himself as "The Thing."

Within two months, he was serious about her. He took her home to Miss Patty's one night and lingered on the porch. "Little," he said. "I think I'm falling in love with you." A diamond and sapphire ring quickly followed, and before long, he'd give her a car, a 1957 Ford.

At first Anita wasn't sure if she was in love with him or not, mostly because they'd been alone only a few times, and even then not for very long. It gave her serious reservations about their future. They'd go off together on his motorcycle and sit at the big white piano in the music room and sing together for hours. But some of the guys, like Lamar, lived at Graceland, and Lamar even spent the night in Elvis's room sometimes to keep him from sleepwalking. The cousins were always around, too. Elvis and Gene had that weird little language that only they seemed to be able to decipher (they said "ep skep, skep, skep" a lot), and little Billy was now fourteen, old enough to tag along places.

When they'd go to the Fairgrounds for crazed nights riding the Pippin, the rickety wooden roller coaster, or rent out the Rainbow Rollerdrome or the Memphian Theatre across town on South Cooper Street, he invited everybody who was at his home, and even the strangers standing around at the gate. "He always invited his fans to go. They would all go to the Fairgrounds—friends, family, and fans."

Sometimes the group numbered as many as two hundred. And now Elvis had added another guy to the circle, Alan Fortas, a friend of George's through the local Jewish organizations. Alan, a big, overfed boy, was a year younger than

Elvis, but Elvis already knew who he was—Alan had been an all-Memphis foot-ball star at Central High. Given his own mediocre showing on the field in high school, Elvis liked having Alan around. But most of all, he liked Alan because he was full of the devil. Soon, he'd give him a nickname, "Hog Ears."

Around the same time, Marty Lacker started coming out to Graceland. A New Yorker who'd moved to Memphis at fifteen in 1952, he'd attended both Central and Humes, so he already knew Alan and George and Red, and to some extent, Elvis. The first time he went out to visit, Elvis and Anita were just com-ing out of the barn. He, too, would eventually become a part of the group, as would fifteen-year-old Jerry Schilling, who Elvis first met in 1954 through Red West, playing football in Guthrie Park.

Elvis would brag about Anita to the guys, and everything about her seemed to enchant him. He told his friends he was pretty sure she was a virgin, and he loved it when she showed off her figure. One day it was hot, and Anita suggested they go swimming. Lamar was there, and Elvis turned to Anita in her swimsuit. "Lamar, look at her. Just look at her. That hip is just a little bit bigger than the other hip. But other than that, she's just perfect. Turn around, Little."

Elvis was not alone in appreciating Anita's attributes. That summer, the Memphis *Press-Scimitar* ran a photograph of half a dozen girls who would com-pete on August 22 in the Mid-South finals of the "Hollywood Star Hunt," a beauty-talent contest that the newspaper sponsored with the Strand Theatre. Of the six, Elvis had dated three—Barbara Hearn, Anita, and Barbara Pittman. Both Anita and Barbara Pittman sang, two of the other women danced, and Barbara Hearn did a dramatic interpretation of George Bernard Shaw's *Saint Joan,* the climactic burning at the stake scene.

Anita won and went on to the finals in New Orleans, where she captured the grand prize—a seven-year contract with ABPT, American Broadcasting Para-mount Theatres, which also entailed work with Paramount's movies, television shows, and record label. Elvis told Anita "the things that went on in California were the things that went on in hell." But Elvis was happy for her and pleased to see that Little was still her unaffected self.

One morning about six, they were coming home from the roller rink with Lamar and Alan. It had been a ferocious night—they'd played tag and roller derby and the rough game of "knock down," skating toward each other with all their might with only the winners left standing—and everybody was bruised and battered. Elvis whispered something to Anita in the backseat, but Alan, sitting next to Lamar in the front, couldn't make it out. Suddenly, Anita leaned forward.

"Hey, y'all, my cunt hurts."

What? Alan wasn't sure he'd understood her. Surely she hadn't said what he thought she'd said. Lamar was driving and just sat frozen at the wheel. "God," he thought, "did I hear that? I have never—"

"Did y'all hear me? I said, 'My cunt really *hurts!*'"

Lamar almost ran off the road—he had to stop the car—and Alan doubled over. Elvis fell on the floor, choking now, barely able to catch his breath.

"He had a Pepsi in his hand that just went up in the air all over the seat," Anita says, "and they just died laughing." She didn't know why they were making such a big thing of it. Elvis had told her that now that she was going to Hollywood, she had to know the L.A. word for *behind*. And her rump *was* sore.

"He loved to pull tricks. I was so embarrassed when I found out what I'd said. It's not that I was dumb. My family didn't talk ugly words, and I was just very naïve."

Anita was also ingenuous about Elvis's ability to be faithful. Two weeks before the finals of the "Hollywood Star Hunt," he had brought the British-born starlet Venetia Stevenson to Memphis. She had been divorced from Russ Tamblyn, Elvis's Hollywood acquaintance, only since Valentine's Day.

"He'd always come to me and say, 'But, Little, you know these are just publicity stunts. It doesn't mean anything. You're the only one I care anything about.'" For proof, he wrote her mash notes: "I love you, love you, love you, you Little."

Anita wanted to think it was true, that even though he had his arms around all those starlets and showgirls (the latest was Vegas singer Kitty Dolan) it didn't really mean anything. "And gullible me . . . Elvis could make you believe anything."

She moved into Graceland in 1957 and lived upstairs. "That got to be a hot and heavy affair," in Lamar's viewpoint. The guys weren't sure whether she actually slept with him—there were two other bedrooms on the second floor—but they assumed not. Anita was too proper for sex before marriage, and Gladys wouldn't have liked it going on under her roof.

Either way, says Marty Lacker, Elvis reverted to his usual ways when she was out of the house.

"One time Anita went out shopping, and Elvis brought another girl upstairs. He was fooling around with her in the bedroom, when all of a sudden, one of the guys called up and said, 'Hey, Elvis, Anita's coming through the gate.'

"If you looked out his window, it was a straight drop to the ground. So we put a ladder up to the window. He let the girl climb down first, and he waited about five minutes, and then he went down. Anita came in and went upstairs, and, of course, he wasn't there. He walked around the back of the house to the

front and came upstairs behind her. He said, 'Oh, you're home. Great.' He would do stuff like that all the time."

When she found out about the other women, she was hurt and angry, but she rationalized it as the actions of a man in a unique situation. "They were all available, and it was a great temptation, and he succumbed to it."

And he was also her first love. Now she cared so much for him that when she went out to California for a movie role, she realized she didn't really want a career if it kept them apart.

"He called me on the phone. 'Little, I miss you. I want you to come home.' Well, I just said okay. He met me at the airport." Eventually she would give up her whole career.

It hadn't meant a lot to her anyway. Her parents had always wanted her to be an entertainer, because God had given her a voice, and she did like to act and sing. "But really and truly, I just wanted to get married and have children and be a normal person. Well, with Elvis, you could never be normal. I found that out right away."

The Colonel, for example, insisted that she and Elvis stay at different hotels when she accompanied him to California. His fans would leave him if they thought he was in love, Parker argued, and so Elvis should just say that he and Anita were dating. The manager didn't even want them photographed together, or if they were, he said, Anita should look away from the camera, and from Elvis, too. He certainly didn't want her looking *happy*.

But there she was, right behind him, smiling like a newlywed backstage at the Tupelo Fair in late September. The Colonel chomped hard on his cigar. But nobody seemed to notice. They were talking about those big pelvic thrusts that Elvis did onstage. Wow, where did he learn to do *that*?

.

On October 28, 1957, a who's who of show business celebrities were among the nine thousand in attendance on the first of Elvis's two nights at the Pan Pacific Auditorium in Los Angeles. That evening, Elvis not only gave the most incendiary performance of his career, but he also scandalized himself in a lascivious display that surpassed anything the majority of his audience had ever seen. Harnessing all his power as a sexual revolutionist, he went far beyond his inflammatory appearance on *The Milton Berle Show,* and even his recent act at the Tupelo Fair.

Byron Raphael had the best view of anyone, and in 2005, he wrote about it for *Playboy* magazine:

The Colonel had put me on Nipper Control that night, which meant he positioned me beneath the stage and charged me with the safety of a three-foot-high, plaster of Paris canine—the infamous cocked-ear, Jack Russell mascot of RCA, Elvis's recording label. Elvis was going to use the pup as a prop during "Hound Dog." "Whatever you do, don't let that dog fall off the stage," Parker snapped. "And tell Mr. Presley you're going to hold Nipper up, so he doesn't have to worry, he can just be free."

The Colonel often said, "Elvis has stardust," meaning that it was remarkable how such a shy person could change himself into a creature of infinite magnetism onstage. But the old hustler never dreamed what Elvis was planning to do with man's best friend.

Elvis came out onstage with his now-famous gold-lamé jacket topping a pair of loose-fitting, black dress slacks. During his fifty-minute, eighteen-song set, he "wiggled, bumped, and twisted," according to Jack O'Brian of the *New York Journal-American*, one of many out-of-town papers that covered the event. But it was the finish of "Hound Dog" that prompted another paper's headline, "Elvis Presley Will Have to Clean Up His Show—Or Go to Jail." I don't know exactly what got into him, but as he launched into that song, he was vastly different from the Elvis I knew at the studio—his eyes were dilated, as if he were taking his direction from someplace far, far away. Then he did the unthinkable. Pumped up by either adrenaline or libido, he began to unfasten his pants and slowly pull his zipper down, which prompted wild screaming from an audience that was already frenzied at the sexual surge Elvis sent out through the auditorium.

With his pants now open, but not down, Elvis reached for Nipper, which I still held tight from below the stage. Suddenly, Elvis pressed the dog against his crotch, and I could feel him pushing it back on me as he rode the pooch back and forth in a masturbatory glide. As the crowd noise grew to a furious roar, Elvis continued to dry hump poor Nipper as if he were a teenage girl at a drive-in.

Then all of a sudden, Elvis pulled the dog out of my grip, and then began rolling around on the floor with him in full simulation of bestial bliss. It was one of the most shockingly erotic things I'd ever seen. There's no question that Elvis was truly trying to have sex, because when he finally gave the dog back to me, I could see a huge hard-on through his pants. The next night the L.A. Vice Squad came, armed with warnings, and the police filmed the show. But Elvis toned it down, and Nipper made it through without undue violation.

When the *Playboy* article was published, Elvis aficionados challenged Raphael's account. Gordon Stoker of the Jordanaires, who performed with him that night, insists he saw nothing inappropriate in Elvis's actions. "Elvis did not do anything onstage with Nipper that was suggestive or off-color. We were standing very close to him onstage as we always were. We would have seen him."

Photographs, however, show Elvis draped across the dog, and the *New York Journal-American* reported his performance was "far too indecent to mention in every detail."

"He was on the floor, he put his arm around the dog lying flat next to it, and he had his leg around it," offers Kevin Eggers in explanation. "That's what was happening. Now, in the context of what he was doing, it was outrageously provocative. But it wasn't Jim Morrison." Byron had made it clear that Elvis had not actually exposed himself, as the lead singer of the Doors was arrested for doing in an infamous 1969 incident in Miami. Still, Eggers says, "Elvis Presley would never have pulled down his fly."

But Eggers was not in the audience that night. And the Jordanaires did not have Byron's proximity from beneath the stage. Even if Byron embellished his story, or if his memory was faulty after nearly fifty years, others had the same interpretation of the singer's intent. Albert Goldman's 1981 controversial biography, *Elvis,* refers to adults leaving the theater with the idea that "Elvis had capped an obscene performance by pretending to bugger the dog."

Dick Williams, the entertainment editor of the *Los Angeles Mirror-News,* was clearly outraged at what he saw, calling Elvis a "Sexhibitionist," and going on for a dozen paragraphs: "If any further proof were needed that what Elvis offers is not basically music but a sex show, it was proved last night. . . . The madness reached its peak at the finish with 'Hound Dog.' Elvis writhed in complete abandon, hair hanging over his face. He got down on the floor with a huge replica of the RCA singing dog and made love to it as if it were a girl."

Ricky Nelson, who met Elvis at a party in his hotel suite after the second night, never got over the performance, telling friends for years how Elvis "groupfucked 10,000 people."

Whatever happened on the first night—whether Elvis's eyes were "dilated," as Raphael wrote, because he was taking pills, which might have affected his behavior—Elvis was far less flamboyant the following evening. When the police showed up with a movie camera, he poked fun at it all, just as he had in the Jacksonville incident. Using hand gestures, he repeatedly indicated to the audience that the censorious camera was on him, even holding his arms out and binding

his wrists together, suggesting that he had been handcuffed. At one point, he announced to the crowd, "You should have been here last night!"

But there was plenty to captivate on October 29, too, at least for one young girl, eleven-year-old Cherilyn Sarkisian, who grew up to be a singer herself. Like Elvis, she would be famous for just one name: Cher.

The child had already seen Elvis on *The Ed Sullivan Show,* and it was as if a thunderbolt had hit her: "I was a goner. I loved the way he sang and the way he looked. In some strange way, I felt he expressed who I was."

It was weird for an eleven-year-old girl to feel that way, she thought. She was a tomboy, but a girlie girl, too, though definitely more of a tomboy in a lot of ways. She liked to sing, but she had a really low voice, and she didn't even get into a singing group in her school. Not even a play. She was always in the chorus, but her voice was too high for guys and too low for girls, so she just sang for herself. She didn't seem to neatly fit into any category, and that was part of what she got from watching the gyrating image on TV: Elvis didn't either. "When I saw him, I thought, 'Well, this is kind of who I am.'"

Part of it was his bad-boy vibe, the way he went against the grain and defied authority, because as a younger child, Cher did, too. "I got in trouble a lot. Not really big trouble, but when I was ten or eleven, my friend and I ran away from home—took a horse and went out to San Bernardino and hopped a train—just for the adventure of it. I ran away from home once on my tricycle, too. I was always this strange child that wanted more adventure than there was."

When she saw Elvis on TV, then, "I thought, 'This is perfect. I'm going in the right direction.' He just validated where I was going."

It helped that her mother, Georgia Holt, a backwoods beauty from Sharp County, Arkansas, not all that far from Memphis, was also into early rock and roll. She thought it was good music, and she wasn't threatened by it. When Cherilyn's friends' mothers saw Elvis, they shrank in revulsion and forbade their children from buying his records. But Georgia watched *The Ed Sullivan Show* with her daughter, and then when Elvis came to town, she bought tickets for the two of them. Cherilyn was ecstatic, she said in an interview for this book.

"I was so crazy. I got my hair cut for it, because I hoped he would notice it. I was in such heaven. I almost didn't walk on the ground."

Inside the auditorium, she saw him in the gold suit that Nudie, her mom's friend, made. "He's really shiny," she thought. Then all of a sudden, "All the girls were on their chairs screaming. I didn't understand why exactly—I wasn't completely sure about the sexual part of it—but I was just fascinated with it. I

remember saying, 'Mom, can we stand on our chairs and scream, too?' And so we did. My mom was yelling and laughing, and I projected myself up there. It didn't make much difference what sex he was."

Cherilyn had seen *Dumbo* as a little kid, and sitting in the dark, watching the big screen, she was so transfixed that she'd peed her pants rather than get up and miss anything. The die had been cast for her future that day. But when she saw Elvis, "It was cemented in stone."

· · · · · ·

The Pan Pacific shows, among the greatest Elvis ever played, were meant to be the last of the tour, until promoter Lee Gordon convinced the Colonel to let him book two Hawaiian dates in November, just as *Jailhouse Rock* opened in theaters. Those concerts, in Honolulu and at Schofield Barracks, Pearl Harbor, would be Elvis's last public performances before entering the military.

Every branch of the military service made bids for Elvis to join their ranks, offering perks of one kind or another. Elvis and the Colonel decided on the army, which offered a two-year enlistment with a 120-day deferment so he could complete his new movie, Paramount's *King Creole.* He'd begin shooting it in January with Hungarian director Michael Curtiz, most famous for *Casablanca.*

On December 20, 1957, he went down to the Memphis draft board to pick up the dreaded notice in person. The Colonel told him to do it, saying it made him look more patriotic, and that mothers and fathers all across the nation would respect him for it. It was good publicity. When reporters asked how he liked trading his blue suede shoes for army boots, he bit his tongue and followed the drill. "It's a duty I've got to fill, and I'm going to do it," he said.

In private, it was a different story, according to Barbara Pittman, who Elvis had planned on taking on the road with him. "Elvis cried in my lap because he had to go into the service. Parker had said, 'Look, son, you play the hero. If you start battling it and try to get out of it to support your mother, it's going to make you look bad. Just be the all-American kid type.'"

Milton Bowers, the draft board chairman, had sent him informal word that his induction notice had been drawn up and was waiting for him.

Anita remembers the day. His parents were devastated. "They could not believe that he was going to have to leave them. He didn't mind going and serving, but he really didn't want to leave his family. And his mother was so worried about what would happen to him. She did not see another happy day after they received that notice."

The newspaper came out and took pictures. Elvis held his draft notice up in one while the others captured the splendor of Graceland and the white nylon Christmas tree festooned with red ornaments. Cliff and Elvis then posed with a huge pile of presents, but neither could resist some attitude—Cliff holding a cigarette, and Elvis, wearing gloves indoors, offering a half-sneer.

Otherwise, he pretended everything was fine. Elvis bought his mother a mink coat, his father a diamond ring, and the Colonel a snazzy Isetta sports car. Even Billy and Bobby got hundred-dollar bills.

"That whole Christmas was like a kid's dream," Billy remembers. A couple of Christmases before, the Smith children had gone to the Goodfellows dinner for underprivileged kids. Now Aunt Gladys had "all kinds of good things to eat for the holidays," and the house was decorated with holly and berries. "It was a fun time," Anita confirms, and Gladys made herself get in the spirit for her first Christmas at Graceland. "She would look at Elvis, and grit her teeth and talk this baby talk, and he would do it back to her. They were gritting their teeth at each other."

By the time next Christmas rolled around, Gladys told Elvis, she hoped he and Anita would be married with a blond-headed baby on the way. They talked about it, Anita says. If it were a girl, they'd call her Alisa Marie. But Gladys wanted a boy, Elvis Jr. "She said, 'I can just see him running up and down the driveway in his little bare feet.' She was trying to plan Elvis's future, not having any idea of things that were going down.'"

.

*At twenty-three, the most famous man in the world was in no hurry to marry, espe-*cially since his military service was upon him. The younger Elvis proposed marriage quickly and often, but he was now past such impetuous actions. Lamar understood the changes.

"As kids, we were taught that you grow up, get married, and smoke cigarettes. That's just what you did. But he really didn't want to get married. Because we'd go on the coast, and he'd get loose and chase everything that was moving."

In early 1958, Anita went with Elvis to New Orleans for location shooting on *King Creole,* his fourth and best film. But she stayed back at the hotel on Parker's orders, as she did in Los Angeles: Anita ensconced at the Knickerbocker, and Elvis at the Beverly Wilshire.

On the set, he took a shine to seventeen-year-old June Wilkinson, who had just come over from England at the invitation of Hugh Hefner and *Playboy* magazine. (Hef dubbed her "The Bosom.") The amply endowed cheesecake

model (43-22-37) had been trained as a ballerina, but began her career as a topless dancer at age fifteen, joining London's Windmill Theatre as a fan dancer in 1957. June would later gain fame as a platinum-haired vixen in the mode of Jayne Mansfield. But at the time Elvis met her, she was a stunning brunette and merely a young friend of the choreographer on the picture.

"Elvis came over and started talking to me," June recalls of their meeting, "and he said, 'Would you like to have dinner?' A seventeen-year-old girl, of *course,* I would like to have dinner!"

He sent a car to bring her to his hotel, and then in his usual approach, he offered to show her the luxurious suite. When they got to his bedroom, "He started kissing me, which was okay with me, and then he wanted to make love." But June was a virgin and intended to stay that way.

She thought Elvis would surely cut the evening short when she told him. But instead, "He said, 'Oh, okay,' and sat me on his bed, got out his guitar, and sang to me for a couple of hours. I was so impressed. He knew he wasn't going to get anyplace with me, and it didn't matter."

Even Sophia Loren flipped for him during a chance meeting on the Paramount lot while filming *Desire Under the Elms.* A studio photographer captured the meeting of the two international sex symbols, her arms around his neck, flirty smiles all around.

King Creole, based on Harold Robbins's gritty novel *A Stone for Danny Fisher,* offered Elvis a magnificent role as a young singer navigating the mob-controlled New Orleans club scene. His work reflects his close study of Brando and Dean, and finds him worthy of leading a first-rate cast, including Walter Matthau (as Maxie, the crime boss) and Carolyn Jones (Maxie's jaded mistress, who also has a soft spot for Danny).

Elvis's scenes with the exotic Jones proved powerful and poignant. ("He was always asking a lot of questions," she remembered. "God, he was young! He was always talking about his folks and the house he'd just bought them.") But he took more pleasure in reuniting with Dolores Hart, as the straight-arrow dime-store clerk Nellie.

Again, Elvis showed interest in her (he nicknamed her "Whistle Britches"), and again, Dolores demurred. She played with his pompadour on the set, but she might as well have been his sister.

Elvis didn't push himself on her, because it wasn't right to do so. It was the same with their characters' relationship, too. He understood this so innately that in a rare display of assertiveness, he challenged director Curtiz about a scene in

which Danny tricks Nellie into going to a hotel. Still shots remain in which the two sit together on the bed, with Nellie about to unfasten her dress.

As the actress remembers, the scene wasn't effective. "It was Elvis who finally called a halt to it. He said, 'I just don't see how Nellie would even come this far. She wouldn't have me take her dress down and then say no.' I agreed with him."

After *King Creole* wrapped in March 1958, Dolores never saw Elvis again, though he wrote her postcards from his military service in Germany, asking, "What's doing, hot lips?" It was a private joke, since they'd been forced to do one of their kissing scenes in 104-degree temperature. Elvis was "like a young animal," she told a British reporter. "He doesn't have much refinement, but this is part of his charm."

Still, stories swirled that she left show business and became a nun because she was pregnant with his child. Today, Mother Dolores is, indeed, a Benedictine nun at the Convent of Regina Laudis in Bethlehem, Connecticut. But she didn't enter the order until 1963—five years after making *King Creole*.

Philip Stanic, an entertainer who calls himself Elvis Presley Jr. (born December 24, 1961, in Gary, Indiana), initially said he believed that he was the actors' illegitimate son. Now, however, he claims his birth mother was the late actress Angelique Pettijohn, an extra in Elvis's 1961 film *Blue Hawaii*.

Elvis was always a business associate and not a close friend, Dolores insisted. Yet she spent enough time around him to make some observations. In 1959, a movie magazine quoted her as saying, "Elvis is a young man with an enormous capacity of love . . . but I don't think he has found his happiness. I think he is terribly lonely."

In 2003, she spoke of her most abiding memory of him, which occurred during the making of *Loving You*. They were out in the country, and they'd finished filming for the day.

"There were some horses around . . . and we were just laughing and enjoying being out there. He was standing by a rail, and he had his arms reaching out each side of it. He put his head back . . . he was looking up to the sky, and he was so beautiful and real. And for a moment, he just looked so peaceful."

Elvis had finally found some footing in a world he, himself, had turned upside down. Now the army was about to separate him from everything that mattered: his fame, his career, and most of all, his deathly ill mother.

On leave from the army, Elvis posed for this formal portrait with his parents at Graceland, June 1958. Gladys would die before the summer was out.
(Robin Rosaaen Collection)

Private Presley

On January 1, 1958, Jimmie Rodgers Snow, who had been Elvis's roommate on some of the early tours, arrived at Graceland for an extended visit. Elvis had run into Hank's son backstage at the Grand Ole Opry eleven days earlier, when he'd gone to Nashville to deliver the Colonel's Isetta sports car. Elvis invited him over to take part in his last big hurrah—a man-child marathon of roller-rink bashing, motorcycle riding, and all-night movies—before leaving to make *King Creole* and then going off to the service.

They'd had a long talk one night. Jimmie laughed about opening for Elvis in Texas in 1955, saying how the "Memphis Flash" came out in "a chartreuse jacket and black pants with a white stripe down the side, and the kids were just going wild." And he remembered "how cool he was in my mind. I wanted to sing like him. I wanted to dress like him, and do things that I never cared about till I met him."

Elvis was studying his script for *King Creole,* and tossed it to Jimmie. "Hey, man. Why don't you just go out to California with me? I'll get you a bit part in the picture." But Jimmie declined.

"I told him how much it meant for me to be there, but I said, 'I'm getting married in March, and I'm going into the ministry.' Elvis thought that was great. As a matter of fact, he was probably the only one who commended me for it. Everybody else thought I was crazy."

Two months earlier, Jimmie realized he'd been living a perpetual dark night of the soul. He'd been drinking and doing pills since his days on the road.

"I was just a miserable, unhappy man. But the call of God was on my life. I had sensed it for years, but I didn't know what it was." Just prior to going over to

Graceland, Jimmie had turned his life over to Jesus. "I quit drinking and pills cold turkey. I was changing my life."

Jimmie thanked Elvis for his offer of a part in the movie, but the only way he knew to break with the entertainment business was just to cut all ties.

When Jimmie left Graceland in early 1958, his heart was heavy for two reasons. He feared for Elvis's soul, for the way he was conducting his personal life. And he worried about Gladys. "My memory of his mother is coming downstairs and seeing her sitting in the kitchen drinking beer, always in the same chair. I don't know if she was a lush, but I would see it all the time."

Alan Fortas was also concerned about Gladys. She hardly ever left the house, and Alan didn't know what she did with her time. Elvis talked about what a great cook she was, but since they got Alberta (Elvis called her "VO5"), Alan had never seen Gladys fix a meal. In 1954, when Elvis made his first records, he'd walked into Harry Levitch's jewelry store and bought his mother an electric mixer for Christmas. A few days later, he came back and bought another one, also for Gladys. When Harry asked why, Elvis said he wanted one for each end of the kitchen so she wouldn't have to walk so much. Now, as both Jimmie and Alan noted, she hardly ever got out of the chair.

"I just remember passing through the kitchen on my way out to the pool or into the den, and she'd always be there.

" 'Hello, Miz Presley, how you doin'?'

" 'Fine, Alan.' "

She was a nice, simple woman who never pretended to be more than she was, in Alan's view. "She dipped her snuff, she watched TV in her room, and she worried about her boy."

That was her life.

She sat by the window in the kitchen, daydreaming or looking out in the backyard. Sometimes she sat out front, away from the fans, sequestered from the neighbors who had tormented her on Audubon Drive. Other times, Vernon would take her for a drive in her pink Cadillac, since she'd never learned to drive. That summer, he would carry her down to Tupelo to see Annie Presley.

"We was sittin' there talkin'," Annie remembered, "and she said, 'Annie, I'd give the world if I lived next door where I could just get out and feed my chickens and do things, but Elvis won't let me do nothin'. You know me. I want to *do*.' "

She killed her pain with the multitude of beer bottles she hid in the refrigerator behind the milk and the Pepsis, and she sipped on them all day long from a brown paper sack, washing down diet pills—Dexedrine, or other forms of

amphetamine—that the doctor gave her. She wanted so to lose weight, to shine in the pictures the magazines took of her family. Normally, she wouldn't drink in front of others, Billy Smith says. She'd stay in her room.

"The biggest majority of the time she would go without it, but it seemed like when she got worried, she clung to that real quick."

Elvis had known about her "medication" for a long time, because as Lamar remembers, he pilfered her "speed" to stay awake on the long drives on tour, even though it made him more hyper than usual. But he had been mystified by her wrenching mood swings. She would be bubbly one minute and at the ends of despair the next. She seemed to be weepy all the time, and pale and withdrawn. She almost never came out of her robe anymore, and she walked so slowly. Somebody put it to early menopause, because she'd be hot one minute and cold the next. But the dark circles under her eyes, the color of old blood, were getting so deep they threatened to one day swallow her up. She was almost forty-six years old now, but everything about her seemed so much older.

Why did she look so unnaturally bloated, as if she might burst if pricked with a pin? Elvis asked about it, but Gladys didn't want him to find out how sick she was—said she didn't know just exactly what her tests had shown. Their bond was so strong that when the wheel bearing went out on his Cadillac that time in Arkansas and caught fire, she bolted upright in her sleep and screamed, *"Elvis!"* But he was so busy now, so preoccupied with getting things ready for the army, that he wasn't in tune with her the way he had been. That, too, was a source of grief.

She was losing him. First it was Jessie, and now Elvis. The first weeks of basic training, they wouldn't even let her come see him. And then they were sending him overseas. To Germany, enemy territory. Elvis had already said he'd take his family with him, but she couldn't imagine such a thing. She told Lamar, "I can't see myself away from Sonny Boy that long. But I just can't go with him." How would she cope without her baby? How would she live?

· · · · · ·

The night before his induction, Elvis, Anita, and the gang went to the drive-in movie to see *Sing, Boy, Sing,* starring Colonel Parker's onetime protégé Tommy Sands. The picture was an adaptation of a television drama, "The Singing Idol," loosely based on Elvis's own story. Everybody got a kick out of it, especially since Nick Adams played Elvis's buddy, standing in for the whole inner circle. Afterward, the group went to the roller rink one last time and played Crack the Whip, Elvis handing out "happy pills" he got from the dentist to ease everyone's pain.

That night, Alan pulled sleepwalking duty and stayed in his room. But Elvis was too keyed up for sleep, worrying what the next two years would bring, so they just stayed up all night and talked.

At 6:30 A.M. on March 24, 1958, the twenty-three-year-old recruit, modeling black trousers, pink-and-black socks, and a blue striped shirt under a gray-and-white-checked sport coat, reported to the Memphis Draft Board in the M & M Building at 198 S. Main Street. There, he and twelve others would be inducted into the U.S. Army, and Elvis would be assigned army serial number 53 310 761.

With him were his parents, Anita, Lamar, Alan, and Judy Spreckels, who had taken over some of his national fan club duties. His double first cousin, the teenaged Patsy Presley, showed up, along with a smattering of fans and quasi-romantic interests, including an attractive blonde named Bonnie Mosby Underwood, the wife of songwriter and future Sun Records engineer Charles Underwood, and the girl some people thought secretly owned Elvis's heart. He carried a small leather bag containing exactly what the induction notice said to bring—a razor, a toothbrush, a comb, and enough money to last for two weeks. Among the officers there that day was Walter Alden, whose one-year-old daughter, Ginger, would grow up to have her own unique place in Elvis history.

At Kennedy Veterans Hospital, the most famous man in America was reduced to being just another U.S. male, undergoing processing, enduring the rigors of a physical, and weighing in (185 pounds). Photographers caught him with the rest of the recruits, stripped down to his underwear.

Later that afternoon, he raised his right hand before Major Elbert Turner and swore the words that made him a soldier. "Congratulations!" Major Turner told the group. "You are all privates. That's the way you'll be addressed from now on." Private Presley was put in charge of the unit.

As Colonel Parker worked the room, cheerfully handing out balloons stamped *KING CREOLE*, Elvis hugged and kissed his mother. Her big face was puffy, and her brown eyes swollen with tears. They hung on each other until even Elvis felt self-conscious, and then he kissed Anita. "Little," he said, "I love you, and I will return, and don't forget me." Anita didn't want him to see how upset she was ("My heart was being torn away because he was my first love"), but they were all crying now—his mother, his father, Anita. It was time for him to board the army bus for Fort Chaffee, Arkansas.

He looked at Lamar and the Cadillac limousine that had brought him there that day, and suddenly it was a symbol of everything he had worked so hard to get. Now it was all about to be gone. It was like a dream.

"Good-bye, you long black son of a bitch," he said to the Caddy, and every-body laughed. Then he climbed on the bus to begin life anew as Private Presley. Five hundred screaming girls saw him off.

At Fort Chaffee, the new inductees got their shots, and then predictably had their hair sheared off. Elvis, whose pompadour once swam with "sweat and goose grease," as *Time* magazine noted, listened to the whirring of the electric clippers and blew the flying fuzz off his hand. "Hair today, gone tomorrow," he said in a studied line, and the news media—fifty-five photographers and reporters—dutifully wrote it down. By the end of the day, the army confirmed what he already knew: He would be stationed at Fort Hood, near Killeen, Texas, the largest army post in the United States, and assigned to the Second Armored Division, General Patton's "Hell on Wheels" outfit.

On March 28, en route to Killeen, the army transport bus made a stop for lunch at a diner in Hillsboro, Texas. For a full twenty-five minutes, Elvis blended in with all the other new privates in their fatigues. But a caravan of fans also made the trek to Texas. Suddenly, a young voice squealed, "*There's Elvis!*" and a small riot broke out. After he left, girls wrestled over his chair.

When the bus arrived at Fort Hood about four-thirty in the afternoon, a clutch of thirty newsmen stood waiting in summer clothing, holding notebooks to their eyes to shield them from the Texas sun. Private Presley was the second soldier off the bus. Sure, he'd salute for the cameras, he said, flashing his Holly-wood smile, and then he held a press conference before going off to his first army meal of fish and French fries. A dozen teenage girls hovered outside the mess hall. "Let us see him, and we'll go away!" they cried, but the military police shooed them off. Soon, Elvis's fan mail would number fifteen thousand letters a week, all of it redirected to the Colonel's office in Tennessee.

On March 29, Elvis woke up not to Lamar or Alan at the foot of his bed, but to five dozen other men all around him. Some of them wanted their pound of flesh from the millionaire singer, now earning seventy-eight dollars a month. Fellow soldier Rex Mansfield, who was on the bus with Elvis coming out of Memphis, remembered how they teased him: "Where's your hound dog?" And "Aren't y'all lonesome for your teddy bear?" They were all watching him, waiting for him to screw up.

But Elvis was determined to fit in. Each arriving recruit received twenty dol-lars in cash for toothpaste and other basic necessities, and a sergeant immedi-ately seized his moment.

"Presley, give me that twenty dollars—you don't need it."

"Naw, Sergeant, I'm broke."

The teasing would stop when they saw he didn't want any special privileges, that he did his KP and guard duty and marched with a seventy-five-pound pack in the irrepressible heat, eating the Texas dust like everyone else. Elvis was an okay guy, they decided, and who'd have thought that? And Elvis was even more surprised to find out that he liked the army—the organization, the respect of men, the routine, and predictably with twinless twins, the uniform, the infinite replication. It served a psychological need.

Besides, the fans had no intention of going away. Fort Hood was an open base, meaning soldiers could receive civilian guests when they were off duty, and "the girls seemed to know where he was, as if they were sending secret messages to each other, fired by hormones," wrote one reporter.

It was true. Jane Levy Christie, then a high school junior, thought it was too gauche to scream and carry on over Elvis, but she and her friends went searching for him anyway. ("We found him and took him for a ride to the Dairy Queen, which our boyfriends didn't like very much.") Only once did things get problematic. Dorton Matthews, a sergeant, heard a commotion one night around midnight. There were fifteen or twenty women in the barracks, giggling and looking for Elvis. The army couldn't put up with such sorority pranks. "We had to have guards after that."

But Elvis was not precisely as alone in Killeen as he appeared. Lamar, who had tried to enlist with him, but at 260 pounds flunked the physical ("They tried to get me clearance through the surgeon general"), just drove on down in Elvis's Lincoln Mark II and checked into a motel. Elvis was glad to see him, but the truth was that he wanted Gladys. He fell into a deep malaise.

As his depression worsened, Master Sergeant William Norwood saw the misery on Elvis's face and took him home to place a phone call. After that, Elvis was a frequent visitor to the Norwood residence, where the sergeant became a confidant, offering hot coffee, home-cooked meals, and fatherly advice. "When you come in my house, you can let it all out," Norwood told him in a rural drawl. "But when you walk out of my front door, you are now Elvis Presley. You're an actor. You're a soldier. So, by God, I want you to act! Don't let anybody know how you feel on the inside."

During basic training—reveille before 5 A.M., sharpshooter practice, crawling over barbed wire—Elvis found another soft shoulder in Eddie Fadal, a theater owner who had been a deejay in Dallas in 1956 when the young singer made the rounds at radio stations. Eddie wasn't in the army but lived in Waco, forty-five minutes away, with his wife, LaNelle, daughter, Janice, and son, Dana.

At the base, the Lebanese-American talked his way through security with a picture of himself with the singer. He found Elvis in the dayroom, shining his boots. Would Elvis like to come out to the house at 2807 Lasker Avenue and visit on weekends? The Fadals were a warm and welcoming family, he said, and Elvis could relax and listen to the latest 45s. Elvis said he had to stay on base for two weeks, but then sure, thanks, he'd be there. He showed up not long after, but the first thing he did after meeting Eddie's family was phone his mother.

Eddie remembered the call. "When he got her on the line, all he said was, 'Mama . . .' And apparently, she said, 'Elvis . . .' And from then on, for a whole hour, they were crying and moaning on the telephone. Hardly a word was spoken."

Now Anita started coming down for weekends, though she'd slipped into town before, staying at the Norwood house, Elvis sneaking out of the barracks to be with her. She was surprised at what a regular guy he'd turned into, without his hair dye and the lifts in his shoes. His skin was so beautifully tanned, and for the first time since she'd known him, he was just as normal as anybody else.

"He would come over and then we would go in the backyard and look up at the sky. We'd talk about all the things we were planning on doing, like getting married, all the things in the future."

And he meant it. Being in the army had changed his thinking. One time when they drove to Dallas with Eddie, Anita went to the restroom, and Elvis called Eddie over to the car. "He put his foot on the bumper and said, 'Eddie, when ol' E here gets ready to get married, it's gonna be to that girl, Anita Wood, and no one else. She's the one.'"

He took her to the Fadals' house, where LaNelle cooked a pound of bacon for him—burned crisp, like he liked it—and Eddie got him banana and chocolate cream pies from the Toddle House. In fact, Eddie built a room onto the house just for Elvis, decorating it in pink and black, and outfitting it with a piano and the latest hi-fi equipment. There wasn't anything Eddie wouldn't get for Elvis. And that included prescription drugs, both uppers and downers.

"My father knew all the doctors in town," says Janice. "It was easy to get a prescription filled. He'd say, 'Elvis needs to sleep.'"

If Elvis's relationship with the older man seemed vaguely odd and unhealthy, no one said anything about it at the time. Everybody just concentrated on having fun. In May, Anita celebrated her twentieth birthday, and the Fadals got a cake for her. Elvis, too, made a special effort, slow dancing with Anita in a circle, and softly singing, "Happy, happy, birthday baby . . ."

Eddie turned on the tape recorder, and Elvis and Anita sat for their first

home recordings, Elvis playing piano, and the two of them singing Hank Williams's "I Can't Help It If I'm Still in Love with You." Anita, who had her professional recording debut coming up in June, was nervous about her first record.

"I wish they'd let me pick it," Elvis is heard saying on the tapes. He worried that Anita's producers would try to turn her into Julie London. "They gotta give her somethin' like Connie Francis's songs. Somethin' with some guts to it."

Looking back, "It was the greatest time that I ever spent with him," Anita says. "He was a soldier boy, and I was his girlfriend from back home, and we were in love and we were together with friends. We just had a wonderful time."

.

On May 31, Elvis got a two-week leave before his next phase of training, a concentration in tank warfare. After a week in Memphis, where he had an oddly somber family portrait made with his parents, he drove to Nashville for an all-night recording session at RCA's Studio B. On the surface, nothing seemed right. He was wearing his uniform ("Simple, I'm kinda proud of it"), and it was his first session without Scotty and Bill, who had quit in a money dispute, leaving only D. J. and the Jordanaires from the old lineup. But musically, Elvis was in fine form. By the time they wrapped things up, he had several hits in the can ("I Need Your Love Tonight," "A Big Hunk O' Love") to keep him on the charts while he was away. It would be his last recording session for almost two years.

When Elvis returned to Fort Hood, he applied for permission to live off base with his family. All soldiers who completed basic training could request permission to live with their dependents, though for most soldiers, that meant wife and children. On June 20, he worked a deal with Stylemaster Mobile Homes for use of a three-bedroom trailer in exchange for photographs of himself and his parents and grandmother in the unit. They parked it near Fort Hood, and that weekend, Elvis, Vernon, Gladys, Minnie Mae, and Lamar moved in. And when Anita came down on weekends, flying in from New York where she was doing a summer television series with singer Andy Williams, she'd stay there, too.

At first Gladys was elated, even in a trailer. She was taking care of her son again, and they were together. But then it got so cramped, and the air-conditioning didn't work right, and the toilet stopped up, and Gladys couldn't get any rest, fans knocking on the door night and day. Her mood soured, Anita remembered. Even the scrub trees bothered her. "It was in the hot summertime and in the middle of a field way back in the woods, because that's where you had to be if you wanted any privacy at all. It was a difficult time."

On July 1, Vernon moved them all to a large three-bedroom brick ranch on Killeen's elite Oak Hill Drive, paying the owner, Judge Chester Crawford, an exorbitant $1,400 for two months. Elvis obligingly stood outside in the big yard and signed autographs, and everybody was happy again. They all went to the Fadals for the Fourth of July, where Gladys ate hamburgers and talked with LaNelle, and soon Gene and Junior came down.

Elvis had everything he needed now. Minnie Mae fixed his beloved purple hull peas and sauerkraut and wieners, and he'd hug and kiss on the skinny ol' firecracker of a woman, Minnie slapping the devil out of him when he'd play tricks on her.

On the base, he was doing well in his ten weeks of advanced tank training. He liked the sixty-ton M48 Patton Tanks, liked being in Patton's division, liked being a gunner, liked it all. He was a good soldier, winning sharpshooting medals and placing third in tank gunnery, even as the big shells damaged his hearing. When Sergeant Matthews put Elvis in command of a tank, the other soldiers begged for someone else. "He's working us to death," they griped.

Anita thought he had finally found himself, and Rex Mansfield wondered the same. "He loved the army," said Rex. "It was a way to express himself and find out who he really was."

But the last happy chapter of his life was coming to an end. Suddenly Gladys's health began to spiral. She lost her appetite, and she seemed so listless in the Texas heat, found it hard to breathe. Lamar saw what was happening. "One day I looked at her, and she had a yellow tinge to her eyes. I went to Elvis and I said, 'You need to call a doctor. Something's wrong, and I mean it.' But he didn't want to hear about it."

Her liver was giving out. Gladys was jaundiced, suffering from acute hepatitis.

Within days, her skin took on an ocher hue. Lamar again pleaded with Elvis. They fought about it ("If you don't let her go to the hospital, buddy, she's going to die right here on you"), but Elvis didn't want it to be true, insisting she'd get better. Then Red came down, and the two of them forced Elvis to act. A local doctor came to the house and recommended that Gladys return immediately to her own physician, Dr. Charles Clarke, in Memphis. On Friday, August 8, Elvis drove his parents to Temple, Texas, and put them on the train.

"She didn't want to go," Lamar says. "She knew she was dying."

Vernon and Elvis, Methodist Hospital, Memphis, August 12, 1958. After threatening to go AWOL, Elvis had just received emergency leave to visit his stricken mother. *(Robin Rosaaen Collection)*

SIXTEEN

.

"Wake up, Mama, Wake up"

As Elvis completed his advanced tank training the next day, August 9, 1958, Gladys was being put into an ambulance and taken to Methodist Hospital, where she'd once been a nurse's aide. Her condition was listed as grave.

Vernon called Lamar.

"You need to tell Elvis to get up here as quick as possible—tomorrow if he can!"

"He's out in the field, Vernon," Lamar said. He borrowed a jeep and went out and got him. The next day, Elvis, now frantic with the realization that Gladys could die, tried to get home. But he was set to begin basic unit training, and his captain denied emergency leave. Gladys's doctor called military personnel in Washington and stressed the urgency of the situation, but only when Elvis threatened to go AWOL did the army grant his leave. On August 12, Lamar flew with him from Fort Worth to Memphis, where Elvis got a cab to the house, and then drove up to the hospital on his own.

When he went over again the next morning, August 13, Gladys told Elvis she was feeling better, that the doctors were saying she could go home the next day if she kept improving. He breathed a sigh of relief, kissed his mother, and went home for a few hours before returning in the afternoon.

In the interim, Gladys had another visitor, Dotty Ayers, a fan who had met the family after writing Gladys a letter of support at the height of Elvis's negative press.

"We were in the room talking, and they brought in some flowers and asked Gladys to sign for them. Her hands were swelled. She was swelled all over, and she asked me to sign for her. I signed, 'Mrs. Presley,' and laughed and said, 'I

didn't think I would ever be signing this name.' She said, 'Don't ever give up hope, honey.'

"Gladys looked at me, and she must have had a premonition or something. She said, 'Dotty, I don't think I'll ever see Graceland again.' I said, 'Gladys, you know the doctors said that you're better.' She said, 'I know, but I just got this awful feeling.' She said, 'Will you promise me something? Will you watch after my boy, 'cause there's just so many people that don't care about him.'"

Billy Smith went back with Elvis to the hospital later that day. They stayed until nearly midnight, Elvis patting her, asking if he could do anything for her.

"Mama," he asked. "Do you want me to stay the night?"

"No, son, everything's okay."

"Well, I might go to the movie, and then I'll come back by here."

"No," Gladys said. "Just go on to the movie now, and come back up here tomorrow. If I need anything, Daddy will call you."

He kissed her, and then he left and picked up Frances, Gloria, and Heidi to go to the Crosstown Theatre.

"I don't think Elvis had any idea she would die," Billy says. "He really thought she'd get better."

But Gladys knew the truth. "Son," she said, "when you come back tomorrow, make sure the other patients have these flowers."

When Elvis got home, he asked Lamar to drop off the girls and told him Gladys had asked about him two or three times. But Lamar had been running back and forth, taking Minnie Mae up to the hospital and talking to the doctor. "They drained something like a gallon and a half of fluid off of Gladys two days before she died. But Elvis said, 'Come with me in the morning and we'll go see her, 'cause she's going to be all right.' I said to Billy, 'She's not going to make it through the night.'"

Billy went up to Elvis's room, and they watched TV a little while before drifting off. Suddenly Elvis raised himself on the bed. "Something's wrong," he said. Billy asked what he meant. "I don't know. I got an eerie feeling." Then he laid back down.

It was a little after 3 A.M. on August 14, and Vernon, sleeping in a chair at the hospital, woke up to the sound of Gladys struggling for breath. Her face was a yellow mask of fear. Gladys Love Presley, age forty-six, was in full cardiac arrest and would die within minutes.

Shortly after, the phone rang downstairs at Graceland. Lamar was still out, and at first, Elvis just let it ring.

"It's late, Billy," he finally said. "Maybe you should go down and get it."

When Billy answered, "I heard Vernon say, 'Oh, God—' He was just sobbing. He said, 'Tell Elvis . . .' Then he really broke up. I don't know if the nurse took the phone from him, or if he handed it to her, but she got on, and I could hear him crying in the background."

"Tell Elvis he needs to get up here quick as he can," she said. "His mother has taken a turn for the worse."

Billy ran upstairs. "That was the nurse. She said to tell you that you might ought to get up there, that your mom is starting to slip."

"He said, 'Oh, my God! No, Mama, no!' I think he knew, but he didn't want to believe it." Elvis quickly pulled on his white shoes, a pair of white pants, and a white ruffled shirt. "We ran downstairs, and we jumped into the Lincoln Mark II, and we tore out of there like all hell had broke loose. The whole time we were driving, he said, 'Oh, God, I'm scared! I'm afraid I've lost my mama!'"

When they got to the hospital, Elvis, nearly hysterical, slowed the Lincoln and jumped out, leaving the car in drive and letting it run over the breaker. Billy shoved the gearshift in park, and then he took off, too, leaving the car running, the lights blazing, both doors open. Elvis was way ahead of him now, running, running, running to Gladys.

Upstairs, as Elvis turned the corner, Vernon was just coming out of Gladys's room. His face hung in folds of grief. Vernon reached out his arms, and Elvis rushed toward him. "God, son, she's gone!" he cried.

"All the color just drained out of Elvis's face," Billy remembers. "He was white as a sheet. He started to sob this kind of unearthly sound. It just went through me."

Father and son, so unable to show affection before, held each other and cried unashamedly in the hallway. Then Elvis broke away. "I want to see her," he said.

"No, no, son," Vernon pleaded. "Don't go in there."

But Elvis wouldn't be stopped. "No, I've got to see my mama!"

With Billy by his side, Elvis entered the room where Gladys lay, so very still in a pink nightgown. An oxygen tent was pulled back from her face. She had a restful look about her.

Elvis leaned over and lifted her head, and pressed his cheek to hers. He cried and stroked her head, and then patted her on the stomach the way he had when he was a child, the two of them alone, with nothing but each other, in Tupelo.

"Oh, God, Satnin'," he said. "Not when I can give you everything in the world."

He stood petting her, talking to her in their little language, until Vernon and the nurse pulled him away and took him down the hall to the waiting room.

About 4 A.M., Lamar arrived back at the house in the black Cadillac. The wind was blowing, and the front door open. Minnie Mae came out on the porch and said, "Gladys is dead. We need to go to the hospital."

"We shot over there," he remembers, "and that elevator opened, and I've never heard such crying, and screaming, and hollering in my life. It was unbelievable. This wailing, almost like wolves. It made me shudder. I came around the corner and Elvis was walking toward me, and he said, 'Lamar, Satnin' isn't here.' And I said, 'I know, Elvis. I know.'"

Lamar sat with him for a long time. He wanted his mother to have an old-fashioned southern visitation and service at home, he said, and Lamar offered to help with the arrangements. As they were on their way to the car, leaving through the loading area at the back of the hospital, the attendants brought Gladys's body down to be transported to the funeral home. "He wouldn't let her go for the longest time. He was sobbing, saying, 'She's all I ever lived for! She was my best girl.'"

They sat in the car in the parking lot, both of them crying, and then they went back to Graceland so Elvis could make a few calls. One was to the base, requesting extended leave. Another was to Eddie Fadal.

"Eddie," he said, his voice cracking, "she's gone! I've lost the only person I ever really loved!" Eddie tried to console him, and finally Elvis choked out, "Can you come?" Eddie said yes, of course, and Elvis told him he'd send Junior to the airport to get him.

The Memphis Funeral Home took care of the body, and then they brought Gladys back to Graceland, the house she had lived in barely a year, the mansion that had never felt like home.

Elvis saw them coming up the drive. "Daddy, Mama's comin' home," he called to his father. Elvis asked the attendants to put the copper-and-silver casket between the music room and living room, and they placed her there. Elvis walked over to where she lay in her blue dress, a glass top covering most of the body. He then asked that the lower half of the casket be opened, so that he might see her feet, which were clothed in little slippers. Elvis removed them, and massaged her feet and hands, and then, taking a comb from his pocket, rearranged her hair. Lamar couldn't stand it.

"He got nearly hysterical. Started that wailing again. It made my skin crawl."

Elvis's first cousin Harold Loyd heard about Gladys's death on the radio and

came right up from Mississippi. Now he wondered if Elvis had lost his mind. "He was in pitiful shape. His eyes were all swollen and red. He would walk over to the casket and say, 'Wake up, Mama. Wake up, Mama. Wake up, baby, and talk to Elvis.'"

He kept it up, parading from the couch to the casket, pleading with her, fondling her, lapsing into baby talk. At one point, he went out on the porch and sat on the steps near one of the stone lions that guarded the entrance. Billy went to the door and watched him, saw him put his arm on his knee and bury his face. "He just cried something awful. I followed him out there, but I didn't know what to say or do, so I just let him be." Afterward, he sat up almost all night and stared at her.

When Eddie got there the next day, Elvis and Vernon were standing at the casket. Both of them touched the body "like they wanted to pick her up and kiss her," Eddie thought, so he walked in quietly. Vernon was wailing, and Elvis was chanting and smoothing his mother's forehead, comforting her, comforting himself, almost going back into the womb.

"Mama," he said, "you never would dress up for me, and now here you are dressed up in the most beautiful gown. I never saw you dressed up like this."

Eddie felt as if he had intruded on a private moment, but then Elvis saw him and brought him up to the casket. "Mama, here's Eddie. You know Eddie. You met him in Killeen." Eddie got chills, and then Elvis took her hand.

"Look, Eddie, at those hands," he said, "those beautiful hands. They worked so hard to raise me."

Anita was in New York when Gladys died, and after taping her Andy Williams program that night, she got on a plane. Lamar met her at the airport.

When they pulled up at the house, Elvis and Vernon were sitting on the front porch, weeping.

"Little! Little! Little!" Elvis cried. "I've lost her! I've lost her!"

Anita put her arms around him, and then he pulled away and said, "Come on in. I want you to see her."

She hesitated. She'd never seen a dead person before.

"No, I don't think I want to go in there."

But he insisted. "Yes, Little, she loved you, and I want you to see her."

Anita hung back, but she loved Gladys, too. She was such a sweet lady. Elvis saw her weakening, so he grabbed her and brought her inside.

"We went in there where the coffin was, and he just talked like a baby. He called her Satnin', and he showed me her feet. She was barefooted, and her toes were painted. He talked about her feet, her 'little sooties,' he called them. The

corpse was so swollen, and he made me stand there forever, just looking at her and talking to her. I broke down. It was just really sad. Very hard to get through."

Dixie Locke came, too, and while she was sad for Elvis, "He reacted as I would have expected him to act. He was devastated, of course, and I think he wondered how he would even be able to get along without her, really."

More and more people showed up as the night wore on, Barbara Pittman remembered, but as the mourners tried to console father and son, Colonel Parker burst in and tried to run everybody off.

"Get all of these people out of here!" he barked to no one in particular. "I want them out of here now!"

Elvis, in a rare moment of confrontation, rose from his seat on the couch. "Look, these are my friends. Don't you come in my house and tell me to run my friends out of here!"

But Parker worried he couldn't handle security at Graceland and urged Elvis to move the next day's services to the Memphis Funeral Home. Elvis thought about it for a minute and nodded in agreement.

The attendants came to get Gladys early the next day, and Elvis, who had again stayed up all night, followed the casket all the way out to the hearse, crying, "Please don't take my baby away! Bring her back! She's not dead. She's just sleeping. Oh, God, please don't take her away!" Harold Loyd nearly broke down himself, seeing his cousin suffer so. "He said, 'Everything I have is gone—everything I've ever worked for. I got all this for her and now she's gone. I don't want any of it now.'"

But Vernon was in a more practical frame of mind, according to Elvis's music publisher Freddy Bienstock, who was staying at the house. In Freddy's view, Vernon was not as broken up as he seemed.

"When the funeral director came to Graceland, Vernon was crying and carrying on, and it was pure bunk, because he was cheating all over the place, and everybody knew it. But he was saying, through these not very convincing tears, 'The best of everything! Give her the best of everything!' The fellow marked it all down and left very quickly, and the moment he walked out the door, all the tears and crying stopped. Vernon turned to Colonel Parker and said, 'Don't let them take advantage of me in my hour of grief.'"

.

Three thousand fans ringed the area around the Spanish-styled Memphis Funeral Home on Union Avenue, many of them there to show their support, most of

them hoping for a glance at Elvis. Memphis Police Captain W. W. Woodward, a friend of Elvis who had posed for a photo with Nick Adams the year before, stationed 150 policemen to keep order along the route to Forest Hill Cemetery, where Gladys would be buried.

Reverend Hamill officiated at the funeral, and as Dixie knew he would, Elvis asked the Blackwood Brothers to sing, since the revered gospel quartet was Gladys's favorite group. They arrived early for the three-thirty services to go over the songs and meet with the family.

J. D. Sumner, the Blackwoods' bass singer since 1954, was astonished at Elvis's level of grief. "I've never seen a man that loved his mother as much as Elvis loved Gladys. He laid on that glass over the coffin, and I've never heard a kid scream and holler so much as Elvis did at his mother."

The Blackwoods had planned on singing three or four numbers, including "Take My Hand, Precious Lord," and "Precious Memories." But Elvis kept scribbling down song titles and sending notes up until the quartet, worried about making their concert in South Carolina that night, performed a dozen numbers.

Barbara Hearn had been on vacation in Pensacola, Florida, with her friend Anita Burns and family when her mother called with the news. Anita's father insisted they return immediately so Barbara could attend the funeral. Anita went with her.

They managed to get seats despite the crowd, and Barbara could see Elvis in the family section off to the left. But after a short time the curtain was drawn, blocking him from view. Afterward, a policeman held up the procession so Barbara could join it, and she went to Forest Hill Cemetery as part of the front end of the cortege.

When everyone had left the chapel, Elvis promised James Blackwood he would charter a plane for the group that evening, and thanked him for what he had done. "He put his arms around me and said, 'James, you know what I am going through,'" referring to the airplane crash that had taken James's brother, R. W. Then he leaned over his mother's body and kissed her. "Mama," he said, "I would give every dime I have and even dig ditches just to have you back."

At the cemetery, Elvis got through the brief service without incident. But then as the mourners retreated to their hot summer cars, Elvis lost control again. As they lowered the coffin, he threw a small shovel of dirt on top, and cried out inconsolably.

"Good-bye, darling, good-bye. I love you so much. You know I lived my whole life just for you." Then as everyone watched in horror, Elvis tried to jump

in the ground with his mother. "They were holding him back and he was scream-ing," Barbara Pittman said. "It was horrible. It was really just the worst thing I had ever seen."

.

*Barbara and Anita stayed until the end of the ceremony, and then drove to Grace-*land, where Elvis and Vernon were receiving guests. Barbara was surprised to be denied entry and left her card. Later, someone called and asked her to come back out. Elvis hugged her and apologized for her experience earlier. "Of every-one," he said, "she would have wanted you here."

"He was in a trance. I don't think he himself could describe how he acted. Everyone was so sad. It happened so fast, it was difficult to comprehend."

Reverend Hamill would meet with Elvis one on one in the next days and weeks, but Elvis's grief was so deep that he was almost beyond reaching. Noth-ing, not the 200 floral arrangements, the 100,000 cards and letters, or the 500 telegrams, seemed to help.

Then the Colonel spoke with Mae Axton, who had been like a second mother to Elvis when he was starting out. Mae had just gotten out of the hospital and was unable to travel. Now she wrote Elvis a letter ("I just wrote my heart"), and put it on a plane. Tom Diskin took the missive directly to Elvis, who holed up in his room to read it over and over.

For a little while, then, Elvis seemed calmer. Then he was just as shattered as before. Guests noticed that he couldn't sit still. He ambled from person to per-son, as if pleading with them to bring her back. And he wandered through the house, always stopping outside one door. "I can't go into my mother's room," he said. "I can't bear for anyone to go in there yet."

Arlene Cogan, a tagalong fan who had met him at fourteen at his Chicago press conference in 1957, couldn't believe how hard he took it. "He walked around carrying Gladys's nightgown for days. He wouldn't put it down. It went with him everywhere he went."

"People were screaming, 'Somebody, please help him!'" Barbara Pittman remembered. Finally Vernon called for a doctor, who disappeared with Elvis up-stairs and gave him a shot to settle his nerves. He also left a bottle of pills.

"I saw Elvis come down from his bedroom so stoned out of his mind he didn't know where he was," Barbara said. "He had a line of mirrors that ran along the stairs in the hallway. Elvis came down and said, 'Hey, look at all them

little Elvises! A thousand little Elvises here!' The doctor was giving him tran-quilizers, and he liked 'em."

Anita saw the pills, too, but they seemed warranted at the time. He would rally, as when the Memphis Highway Patrol, trying to cheer him, took him for helicopter rides all over Memphis. Then something would happen, and he'd break down again.

One day Elvis was sitting on the floor talking with some of the fans, telling stories about his army experiences, when Vernon came in the room carrying a stainless steel saucepan. Inside were three baseball-size snowballs.

Back in the winter, sitting at her seat at the breakfast bar, a melancholy Gladys had watched the snow fall and pile up in deep drifts by the back fence. Elvis was out of town, and more and more lately, she'd missed her son as if he were dead.

"How Elvis loves the snow!" she'd said, turning to Vernon. "Do you think he will be home for Christmas?" Without a word, she went to the cupboard and took out a small pan. Then she headed for the back door to make snowballs. "I'm going to put these in the freezer and keep 'em 'til Elvis comes home," she'd explained. Vernon had forgotten all about them.

The discovery set Elvis off again, and he was awash with regret, tormented by how tender she was, how she'd thought of him every minute, and how he'd disappointed her at times.

They'd fought as hard as they'd loved, and their fights were commonplace, Gladys smacking him so hard on the back of the head sometimes ("Mama!") that she nearly knocked him down. One day at Graceland, she'd started on him the minute he got up—about women, about staying out all hours.

He wasn't living according to Jesus' plan, she said, and she was angry, as mad as when she'd ripped a plowshare off in her youth. Elvis took it until lunch, but then his anger bubbled over, and he picked up a plate of tomatoes and threw it hard against the wall, the china shattering and fleshy red specks flying every-where. Gladys set her jaw. "You do that again," she warned, "and your life will be miserable from here on out!"

At the time, he worried about breaking her dishes and ruining her walls. But now he saw she didn't care about that. All she wanted was him, the way they used to be, before he belonged to everyone.

"Funny," he told a reporter four years later, "she never really wanted anything fancy. She just stayed the same, all the way through the whole thing. There's a lot

of things happened since she passed away that I wish she could have been around to see. It would have made her very happy and very proud. But that's life, and I can't have her."

Gladys Love Presley had been an ordinary country woman, but she had brought greatness into this world. She had shaped a man who made a difference, who helped create a musical art form. Through that, he had united disparate people, changed sexual mores, and harnessed a burgeoning youth culture. No one would ever forget him, or her.

On August 24, ten days after his mother's passing, Elvis went back to Fort Hood to rejoin his unit. Just before he left the house, he went to Gladys's door. "I got to go, Mama," he said, and broke down once more. Then he told his father and Alberta that nothing was to be moved in Gladys's room while he was away. He wanted it to remain exactly as she had left it, preserved as if she were still alive, as if he might find her there when he returned from overseas. In a month, he would be in Germany, assigned to the Third Armored Division, and stationed in Friedberg.

But Elvis was not ready to go back to Killeen, let alone go to Europe. It was all too soon for a trauma of such magnitude. Gladys's death had not just been the passing of his mother and his best friend, but psychologically, Elvis had experienced a double death. The forfeiture of his twin and the immediate loss of his mother were inextricable, compressing twenty-three years of shock and emptiness into a single moment. His extraordinary keening had been a manifestation of stuck grief for Jessie, and now new anguish for Gladys that he would never surmount.

"Psychologists call this the premorbid personality, or the underlying structure that, given something apocalyptic, triggers all the pathology and pushes it to the surface," says Dr. Peter O. Whitmer, an expert on the twinless twin phenomenon. "When Gladys died, so, too, did Elvis's ability to bond with a woman. He may have gotten close at times, but he was already taken, as so many twinless twins are."

· · · · · ·

In Killeen, Elvis tried to pick up where he had left off. Eddie Fadal invited him out every weekend, but nothing was really right—Colonel Parker told him to stay away from Eddie, that he was a homosexual with designs on him. LaNelle, too, was tired of all the commotion, weary of having to cook for Elvis and his gang.

Later, Janice Fadal, who would grow up to marry Lamar Fike in a short-lived union, would realize that her mother had resented Elvis.

"Once I saw a bunch of limos pull up and I ran screaming through the house, 'Elvis is here!' Dad was excited, but Mom freaked out. . . . He became my father's focus instead of us—the family."

Still, everybody tried to put on a bright face when they got together and told funny stories about Elvis's early touring days in Texas, when Elvis signed women's breasts in Lubbock, and the girls put Band-Aids over the signatures to protect them in the shower.

At some point that summer, Elvis and Rex and a few of the guys drove to Dallas to girl-watch at the Sheraton and the Quality Inn. Then they learned about the American Airlines Stewardess College in Fort Worth. When they showed up, the house mother, Ronnie Anagnostis, got on the P.A. "Girls, guess what? Elvis Presley is coming through the front door!" The only thing they didn't do was fly over the balcony, she said.

But "things were never quite the same again at Fort Hood," according to Rex Mansfield. "We all suffered with and for Elvis's great loss."

Soon, the whole gang began to visit, because Elvis seemed to need them. Arlene Cogan went down, and Frances Forbes, and fan club presidents from Chicago and elsewhere. They all stayed with Elvis, joining Lamar, Vernon, Minnie Mae, Red, and Elvis's cousins Gene, Junior, and Earl Greenwood. Sometimes there were twelve in all sleeping at the house while outside, a crowd of a hundred kept vigil.

When Anita arrived on the weekends, she was distraught to find so many people in the house, especially women. It was bedlam. "I could not believe it. They were all over the place. Every time I went down, there were different people there. Strangers. I'd never seen those people. Elvis didn't act like himself. He would play the piano and look around. 'Little, where are you?' "

She thought he was too intimate with them, that they were taking advantage of him. "I don't like to sit alone too much and think," he said by way of explanation. But Anita felt uneasy and wondered how it boded for their future.

On September 19, 1958, Elvis packed his things and put on his military attire to leave Fort Hood. At 7 P.M., a troop train would take him and 1,360 other soldiers to the Brooklyn Army Terminal in New York, where they would sail to Germany on the U.S.S. *Randall*.

Before he left the house, he asked Eddie to lead the group in a word of prayer. They all got down on their knees and held hands in a circle, and after Eddie spoke, each one took his turn. "There wasn't a dry eye in the group," Eddie recalled. Afterward, he rode with Elvis and Anita in the Lincoln. "Eddie," Elvis said softly, "I really feel this is the end of my career. Everybody is going to forget about me."

A light rain was falling, and a reporter approached him as he waved goodbye to Anita, Eddie, and the fan club presidents. Everybody had tears in their eyes, including Elvis. How do you feel? the reporter asked. "I just feel sad," Elvis said.

There were people to catch his attention along the way, though—in Memphis, during a refueling stop, Alan and George came to see him, and while Elvis wasn't allowed to get off the train, George introduced him to a pretty Mississippi girl named Janie Wilbanks, who climbed up the steps in her white leather coat as Elvis leaned down for a kiss. And somewhere as the train wound through New England, Elvis became reacquainted with the five-foot-three Charlie Hodge, who hailed from Alabama and played country-gospel with an outfit called the Foggy River Boys. Elvis had once met him briefly backstage at a Red Foley show in Memphis just before they were both drafted.

When the train pulled into Brooklyn at 9 A.M., a band was playing Elvis songs. The RCA execs were there, including Anne Fulchino, the national publicity director who'd taught Elvis how to eat pork chops. Immediately, Private Presley, stunningly handsome in his uniform, and ten pounds lighter than he'd been before basic training, disappeared into a conference with the Colonel and a much-decorated wedge of army officials. He emerged to a firestorm of flashbulbs, then kissed a WAC for the cameras, and sat down to a large bank of microphones and an eager throng of press.

What if rock and roll should die out while he was in the service?

"I'll starve to death," he quipped.

How did he feel about being sent to Europe?

"I'd like to go to Paris. And look up Brigitte Bardot."

What's his idea of the ideal girl?

"Female, sir."

Everybody laughed.

"I suppose I'll know if I ever find someone that I really fall in love with."

He was handling it all so deftly. The men from RCA beamed and nodded approvingly, and Anne Fulchino felt a wave of pride. He had come so far so fast,

and grown from a green amateur to a confident star in two years. It was amazing, really.

Then, carrying a shoe box that Parker had handed him, Elvis waved to the crowd, hoisted a borrowed duffel bag to his shoulders, and climbed the gangplank of the U.S.S. *Randall*.

By now, the band had played "Tutti Frutti" three times. Elvis stopped at the rail of the ship and lifted the lid on the shoe box. The boat began making its metallic creak and then started its slow pull from the harbor. With that, Elvis emptied the box, and thousands of little Elvis images poured down the side of the boat and onto the pier, disappearing into the frantic hands of female admirers.

Elvis signs autographs in a park in Bad Homburg, Germany, October 5, 1958. He will soon begin dating sixteen-year-old stenographer Margit Buergin *(to his right)*. Red West and Vernon stand behind him. *(Robin Rosaaen Collection)*

SEVENTEEN

· · · · · · · · · · · · · · · ·

Fräulein Fallout

When the boat docked at Bremerhaven, shortly before 9 A.M. on October 1, 1958, Elvis, "the rock 'n' roll matador," as the Germans called him, received the same frenzied media attention that had surrounded his send-off in America. But the 1,500 German fans who turned out were greatly subdued in comparison to the screaming throngs in the States, so the media engaged in a bit of manipulation. Photographers from the teen magazine *Bravo* stage-managed pictures to show MPs struggling to hold back an eager crowd, and newsreel cameramen encouraged the bravest youngsters to feats of daring.

Sixteen-year-old Karl Heinz, who didn't even own an Elvis record, was goaded into rushing up the gangplank to get Elvis's first autograph in Europe. But as Elvis shifted his sixty-five-pound duffel bag to scrawl his name, he nearly lost his balance. Finally, he shook his head, "Sorry," and moved on down to board the troop train, which would take him two hundred miles to Friedberg, population 18,000.

Elvis's permanent army post was the Friedberg Kaserne, better known as Ray Barracks, home to the Thirty-second ("Hell on Wheels") Battalion of the Third Armored Division. The long, bleak rows of brick buildings had formerly housed Hitler's SS troops and made an unwelcome sight as the train pulled in about seven-thirty that evening, delivering Elvis and his battalion directly to the base. There, Elvis found high fences, well-guarded gates, and another barrage of media. "I'm just a plain soldier like anyone else," he said.

Initially assigned as a jeep driver to Company D, Elvis would soon be transferred to Company C, a scout platoon often sent out on maneuvers. His primary duty would be to drive a jeep for Reconnaissance Platoon Sergeant Ira Jones, the

military hoping the assignment would keep him out of the public eye. Three days after his press conference on October 2 ("Classical music is just great to go to sleep by"), the army closed the base to the media.

Just as Elvis was settling into the spartan Ray Barracks, with its steel-framed beds and cold linoleum floors, Lamar, Red, Vernon, and Minnie Mae (following through on a promise she made to Gladys on her deathbed) arrived in Germany.

For a few days after Elvis left Fort Hood, it looked as though there might be a delay in getting the family matriarch overseas. Vernon had relied upon his attorney to verify Minnie Mae's date of birth, which was necessary for her to secure her passport. But no record of her birth was readily available.

It took seventy-five cents' worth of gasoline to drive through the backwoods of Arkansas to find a cousin who could supply the information, recalled Frank Glankler, a senior partner in the Memphis firm that represented the Presleys. "When we finally found the house, there was a goat on the front porch. The cousin didn't want to sign the affidavit because he couldn't read. He was afraid he might be signing away the deed to his house. In the end, he gave us his *X*."

Now, on October 4, after an eighteen-hour flight from New York to Frankfurt, the Presley party drove to Bad Homburg and checked into the Ritters Park Hotel, a resort spa that offered thermal baths as palliative care for patients with bad hearts and respiratory ailments. Elvis joined his family for dinner at the hotel as a crowd collected outside.

Within days, Elvis got permission to live off base with his dependents, i.e., Vernon and Minnie Mae, and moved the entire group to the Hilberts Park Hotel in Bad Nauheim, an Old World, cobblestoned spa town of fourteen thousand people. There, they occupied four rooms on the third floor.

On weekends, Charlie Hodge came up from his post ten miles away. The two were close now, having bonded during the crossing. Charlie had been a regular on the *Ozark Jubilee* TV show, so he and Elvis knew the same country stars (Elvis asked a lot about Wanda Jackson), the same gospel stars, and the same songs.

They'd put on a talent show on the ship, Elvis playing piano but not singing. And after he was assigned to sergeant's quarters—his fellow G.I.s wouldn't leave him alone—he requested that Charlie be allowed to bunk with him. It helped stave off his loneliness and the pain of losing his mother. Despite his father, grandmother, and Anita, he felt totally alone in the world. Just before he left, another G.I. had given him a little book, an anthology, *Poems That Touch the Heart.* He read the pieces about motherhood and death over and over until he finally drifted off to sleep.

"I could hear Elvis dreaming sometimes at night, and I'd get out of my bunk and sit down and start talking to him, maybe joke with him a little bit, get him in a little better mood. He said years later, 'Charlie, if it hadn't been for you,' he said, 'You kept me sane all the way across the ocean.'"

Each morning, Elvis left early for the base, traveling by taxi or hitching a ride from Sergeant Jones. He was back by 6 P.M., except on Fridays, when he helped clean the barracks (his was number 3707, on the ground floor) and latrines for Saturday's inspection.

But three weeks later, the group moved again. Someone more famous than Elvis now occupied the hotel, oil sheik Ibn Saud, the king of Saudi Arabia, who arrived with his harem of wives, a dozen children, and an assorted entourage, all in Bedouin gear. The king handed out gold watches instead of autographs, and Elvis felt upstaged, as Lamar saw it. "He didn't like it that the king attracted all that attention."

And so the Presley camp rented the top floor of Bad Nauheim's elegant and luxurious Hotel Grunewald, a small three-story family establishment festooned with ornamental spires, located at Terrassenstrasse 10. Everyone but Red and Lamar, who shared a room, had his own quarters, decorated with antique furniture and crystal chandeliers. The wealthy clientele was elderly—Red said they all "looked like they had one foot in the grave and the other one on a roller skate"—but Elvis was happy there. "We put in a kitchen," Lamar recalls, "and Elvis rented a separate room just for the bags of mail." Soon, he would receive between five thousand and ten thousand letters a week.

Among them would be almost daily missives from Colonel Parker. He typed them himself, using the hunt-and-peck method, apprising Elvis and Vernon of all his hard work and bragging about his efforts. Before Elvis sailed for Europe, Parker promised him he would be a bigger star when he came home than he had been when he left. Already, the manager had negotiated new contracts with Twentieth Century-Fox and Paramount for huge increases in fees—$150,000 more than what Elvis would have gotten under the original contract at Paramount, he crowed.

The Colonel couldn't travel to Europe because as an illegal alien, he had no passport. But even from afar, he ruled with an iron hand. When Elvis told him Anita Wood was planning to come for an extended visit, Parker insisted she stay home. The press would have them engaged or getting married, and Elvis didn't need that kind of publicity, especially not now.

On October 28, 1958, Elvis wrote Anita a three-page letter on Hotel Grunewald

stationery. He called her often ("weird hours . . . very late, because the time change was so different"), but this was his first letter to her from Europe, and his first ever "in a hundred years," he said. But there were so many things he wanted to tell her and couldn't say over the phone, he wrote, his handwriting making big loops of his *t*s and *y*s.

His words were intensely romantic, Elvis lapsing into predictable lovers' language about how much he missed her, and saying he kept her picture by his bed. But then, after insisting, "I haven't dated a single girl since I have been here," he took on a serious tone.

I want to explain something to you, and you have got to trust me and believe me, because I am very sincere when I say it. I will tell you this much. I have never and never will again love anyone like I love you, sweetheart. Also, I guarantee that when I marry, it will be Miss Little Presley Wood. There is a lot you have to understand, though. Only God knows when the time will be right. So you have to consider this and love me, trust me and keep yourself clean and wholesome, because that is the big thing that can determine our lives and happiness together.

No matter what I'm doing, whether it be the army, making movies, traveling or singing, I will be thinking of the time when we have our first "little Elvis Presley." So keep this in mind and don't get discouraged and lonely. Just remember this is a guy that loves you with all his heart and wants to marry you.

Such demonstrative words must have been a comfort to Anita. Except what Elvis didn't mention was that on October 5, while showing his family around a park in Bad Homburg, twenty-three-year-old Elvis had met sixteen-year-old Margit Buergin, a pretty blond stenographer for an electrical company in Frankfurt. It had happened as soon as they left the Ritters Park Hotel that evening, when a group of shutterbugs from the German tabloids "descended on us like a horde of locusts," in Lamar's words. Robert Lebeck, well known for his photographs of politicians and show business personalities, had asked the petite beauty to come with him, thinking a pose of the most famous American G.I. with an attractive German girl would make a salable picture. Lebeck asked Elvis to kiss her, and Elvis obliged, and then wanted more. He began seeing her immediately.

Elvis was so smitten with her that he mentioned her in his one letter to Alan Fortas, which he wrote from maneuvers in Grafenwöhr, Bavaria, on November

14. "I have been dating this little German 'Chuckaloid' by the name of Margit. She looks a lot like B.B. [Brigitte Bardot]. It's Grind City [a steamy affair]."

The German papers made a big splash of the couple, and soon she was the most-talked-about woman in the country, receiving dozens of letters a day. "She's blond and has blue eyes," Elvis told an Armed Forces Network reporter. "I've seen her about five times already, which is more than any other girl 'round here." He bought her a wristwatch, and she showed it off in the press. Elvis called her "Little Puppy."

Back in Memphis, the other "Little" blinked at what she read. She could believe that reporters made up quotes sometimes, as Elvis always told her. But Anita's face flushed when she saw the pictures of him with his arms around another blonde, holding her close and looking deeply into her eyes. She fired off three letters to him about her disappointment.

"Well, I can't blame you," Elvis quickly answered, "especially since that mess was written about 'Little Puppy,' and all that horseshit." He then explained how they met, that she was a photographer's model, and a newsman had brought her over the first week he was in Germany.

"I have seen her one time since then," he lied, his letter postmarked on the same day he told Alan about his affair. "I have not been dating her, and . . . I have not tried to keep anything from you. . . . Every night, I lay in my bunk, I see your little eyes and your little nose, and it's almost like you are here, like you are pressed up close to me. I can feel your little hair on the side of my face and sometimes I get so excited and want you so bad I start sweating. WOW!"

In closing, he told her their song from now on was "[Please] Love Me Forever," by Tommy Edwards. "Every night I play it just for you," Elvis wrote.

But he was also playing the record for Margit. He was seeing her several times a week now, either in Bad Nauheim or at the home she shared with her mother in Frankfurt-Eschersheim. He drove the thirty miles alone in his white BMW 507, parking his car in the American Forces Network lot, with the staff instructed not to bother him. As the relationship wore on, he sent a taxi driver, Josef Wehrheim, to Frankfurt for her twice a month.

Elvis and Margit went to the movies, to the Frankfurt Zoo, talked in back corners of nightclubs where they could hold hands undisturbed (he particularly liked La Parisienne), and cuddled at the parties Elvis held at the hotel. They were known to spend the night together on several occasions in both cities. But the romance was hampered by the fact that Margit spoke only minimal English, and so they communicated in other ways.

"He is shy and rarely speaks about himself," the teenager told reporter Mike Tomkies about her boyfriend. "He's not at all conceited. He doesn't like to go out often. We spend evenings listening to pop records, or he would play the piano and sing folk songs. . . . He plays the guitar, and says as little as possible about his success as a singer."

But if Elvis was modest, Margit was eager for attention and posed for cheesecake shots published in *Overseas Weekly,* the American G.I. magazine. *Look* magazine, too, would feature them together, Margit saying, "He's so different from what I thought he'd be." Elvis was embarrassed—it put him in more of a jam with Anita—and he felt exploited.

"She went and got herself pinup pictures made," Red said at the time, "and spread them all over the front pages as Elvis Presley's German fräulein. Elvis doesn't like that. It made him mad. He certainly liked her a lot, but after that he never saw her again."

Lamar remembers it differently. "Elvis dated her on and off the whole time he was in Germany, but the heavy stuff lasted about two months. Then he got tired of her and went to somebody else."

When Memphis disc jockey Keith Sherriff asked him about her in a phone interview in early 1959, Elvis replied, "Don't get me wrong, she's a cute little girl and all of that, but it's mostly a lot of publicity."

Margit did not take it well. "I feel mad and humiliated," she complained. "All the girls who envied me so are now busy making jokes about Presley's exgirlfriend."

Years after their relationship, Margit would suggest that it was she who broke things off, because Elvis insisted that he belonged to his fans, and therefore could not consider marriage.

"I'm a corporation, not a man," he told her. "Sure, I want to get married and have kids. But for me it's impossible."

· · · · · ·

Late in the fall, when Elvis was still involved with Margit, he received a call from Devada "Dee" Elliott Stanley, the wife of Bill Stanley, a much-decorated American master sergeant stationed in Frankfurt. Dee, the mother of three young boys, Billy, Ricky, and David, was unhappy in her marriage. Her husband, who had been one of General George S. Patton's drivers, was a mean drunk, and Dee found Elvis a delicious diversion. She invited him to dinner with her family, but Elvis had a

good excuse—he was about to go to Grafenwöhr, on the Czech border, for six weeks of reconnaissance maneuvers. He'd be up to his elbows in snow.

However, Vernon, who was growing a Boston Blackie mustache, offered himself as a stand-in for a coffee date. Dee, a bottle blonde given to showy clothing, had a come-hither tone in her voice that let him know she would make it worth his while. The fact that she was married didn't faze him, since he'd been carrying on his own escapades for years, and had begun fooling around with at least two women in Killeen in the days after Gladys's death. For her part, Dee wanted anyone who was close to Elvis. "Boy," says Lamar, "she stalked him like prize game."

Like Elvis, Vernon, who started hanging out in the little bars around Bad Nauheim, drinking vodka or bourbon and Coke and buying rounds for women at Elvis's expense, could compartmentalize sex and love. Before coming overseas, he and his son had gone to the Memphis Memorial Studio and ordered an enormous monument for Gladys's grave, replete with Italian statuary—a towering cross with a beckoning Jesus and attendant angels. In November, they were proud to learn that the accompanying marker had been completed. The inscription: "She was the sunshine of our home."

.

On November 20, 1958, Elvis and Rex Mansfield went to the movies at the post theater in Grafenwöhr, which was often their habit. Rex, from the little town of Dresden, Tennessee, 120 miles north of Memphis, remained Elvis's closest army buddy. They'd been inducted together, gone through basic together, and traveled on the same train to New York and ship to Germany. Elvis called him "Rexadus." There wasn't much they hadn't shared.

Waiting at the theater that night was a nineteen-year-old German girl, Elisabeth Stefaniak, the modest and well-groomed stepdaughter of an American sergeant. Elisabeth was infatuated with everything about Elvis—his looks, his music, his voice, his movies, and his celebrity status. She'd read in *Stars and Stripes* that Elvis went to the theater every night in Grafenwöhr, entering after the lights went down, and leaving shortly before the movie was over. She saw it as her chance to get an autograph.

When she got there, "All the G.I.s were coming in, and in their crew cuts they all looked the same. So I asked the manager and he told me approximately where they were sitting.

"I saw one soldier who was sitting in that area get up, and he came back to

get some popcorn. I was waiting in the lobby in the dark, and I asked him, 'Are you sitting anywhere near Elvis?' and he said, 'Yes, in fact, I'm sitting right next to him.' I said, 'Would you please just get me an autograph?' And he said, 'Sure,' and went back inside." Moments later, Rex appeared and told her that Elvis would like her to come down and sit with him.

Elvis took a shine to the dark-haired girl, finding her body, as he would later tell Joe Esposito, "voluptuous." He walked her home that evening and surprised her with a good-night kiss. For the next six nights, she met him at the theater, and then he dropped in at her apartment unexpectedly for Thanksgiving and met her parents.

"Everything was 'Yes, ma'am' and 'No, ma'am,' " Elisabeth remembers. "They were very impressed." He talked about his mother, of course, but surprisingly, the only time Elisabeth saw tears in his eyes was when he talked about his father. "He was hurt that his mother had just passed away and his father was already dating."

After that first visit to her apartment, he came every day, often at odd times, sometimes for meals or talks with the family, and sometimes to take Elisabeth to the movies. Her family felt comfortable with him, and he liked the close, homey atmosphere. When his maneuvers were over, and he was about to return to Bad Nauheim, he gave her parents a 365-day gold clock. Elvis and Elisabeth's step-father, Raymond "Mac" McCormick, spent hours putting it together.

It was a calculated gift, of course: He told Elisabeth's parents he had about fifty duffel bags of fan mail, and he needed a secretary who could read and write both German and English. Elisabeth was perfect for the job, since she had lived in the States for a time and was fluent in both languages. She could stay in her own private room at the Hotel Grunewald, he told them. "I assure you that she will be in good hands with me and my father and grandmother, and we will take full responsibility for her."

"You think about it," he said to Elisabeth as he left. "You don't have to give me an answer now, darlin'. I'll call you in a couple of days."

But she didn't have to think about it, and neither did her parents. Elvis had said her duties would start at the first of the year, but three days later he called and asked how soon she could come. "I can be there in one week," she told him, and arrived on the train the first part of December. Bad Nauheim was 351 kilometers from Grafenwöhr, or 218 miles, and she'd never been away from her parents for any real length of time, or even taken a train ride that far by herself. It was all a great adventure.

Vernon, Lamar, and Red picked her up at the station and drove her to the Hotel Grunewald, and on the way, Vernon explained that she would be working for him, not Elvis, at a salary of thirty-five dollars a week, paid on Fridays. Minnie Mae would be her foremost companion. The old woman, who perpetually parked a toothpick in the side of her mouth for dipping snuff, was looking forward to some female companionship, and she insisted that the teen call her Grandma. Elisabeth thought she had a grand sense of humor.

"We hit it off that night, and I knew we would be great friends. She accepted me right away like one of the family."

But Elisabeth wasn't precisely sure what her relationship was with Elvis, since they'd only kissed in Grafenwöhr. That first evening, he made it clear. He came downstairs to her room and said he would be spending the night with her. Elvis saw a look of worry cross her face and told her not to be concerned, that he didn't have full intercourse with girls "he was going to see on a regular basis," because he didn't want to run the risk of getting her pregnant. "Such a risk would damage his reputation and image," Elisabeth remembers him saying. "That first night we sort of played around. Over the course of the next weeks and months, I went to bed with him almost every night."

He called her "Foghorn," because her voice was so low in the mornings, and she took it as a term of endearment. She worked hard on answering the mail, practicing his signature for a week (though eventually reverting to a rubber stamp), but she also wondered how long she would be on the job, or even if he would continue to be her lover. As she soon learned, "No woman could hold Elvis Presley's attention for very long." Only days after her arrival, he took another girl to bed, and after he dispatched Lamar to drive her home, he knocked three times on the wall between their bedrooms, signaling Elisabeth to come to him.

At first she had her reservations about seeing him at all. He was still involved with Margit, and often Elisabeth had to be the translator between them, which hurt her heart. "He was the man I adored, and the last thing I was interested in was helping their relationship blossom."

She would hear him with other girls through the walls, too, and even if she thought he was not doing any more with them than he was with her, it made her feel empty inside.

"There would be at least a couple of girls each week, more on weekends. . . . These were often very beautiful girls [but] although I resented them, I knew they were not staying . . . I did not let him see me cry [and] all the time I was telling myself how lucky I was."

Elvis never apologized or tried to explain his actions. "I guess he never felt he owed me an explanation. I do remember the pain of getting into bed with him maybe ten or twenty minutes after another girl had left. Many times we never made love. He would sometimes just give me a good-night kiss and go to sleep. It was like a comfort thing for him."

Elisabeth could see that the combination of events—his mother's death, his father's fling with a married woman, his being away from home, friends, and family back in the States, and the potential loss of his career—served to make a private, much darker Elvis emerge during his time in Germany. His hot-flash temper seemed nearer the surface, "mostly when he would say harsh things to you. I never saw him throw things at me, but he could say some hurtful things."

The worst of it came one day on a shopping trip. There were things he needed for himself, and he wanted to buy Elisabeth some clothes. While they were out, he picked a waste can he wanted for his bathroom. "I said, 'Elvis, you already have a basket in your bathroom.' Well, that was the wrong thing to say. He turned to me and said, 'Don't you ever tell me what to buy or not to buy! If I want to buy a *thousand* trash cans . . .'"

It was an awkward moment, a terrible moment, and when they walked out of the store, he was still angry. "I was going to buy you some clothes, but you ticked me off," he told her. "Then for two days he didn't speak to me very much."

She never got the wardrobe, but Rex put such behavior down to his friend's natural complexity, now exacerbated by his pressures, including the expectation of being the perfect soldier, one who could never grumble or gripe like any other G.I. He had no real way to blow off steam when he was tired, discouraged, upset, lonesome, or bored. The press would have a field day with it, and Colonel Parker would have threatened to leave him—the last thing Elvis wanted when he was so insecure about his future.

He bought a Grundig tape recorder to make some home recordings ("Danny Boy," "Mona Lisa"), thinking music would be his outlet. But Rex thought it was more than just situational circumstances, that Elvis was in a serious psychological slide. "Elvis," Rex says, "had two definite and distinct personalities."

He was promoted to private first class during the holidays, the army saying he was a soldier of "above normal capability." But since it was his first Christmas without his mother, he was not in much of a mood to celebrate. It was "dismal," as Lamar remembers. They set up a tree, and everybody went through the motions of giving presents. But it didn't seem like Christmas, not even when Elvis sang an affecting rendition of "Silent Night" for the other soldiers. The guys

bought some fireworks to cheer him, and Elvis, caught up in the moment, blasted German civilians from the balcony of the Hotel Grunewald, which got him in trouble with the owner, Herr Otto Schmidt.

They were already on thin ice. Red had accidentally shot Herr Schmidt with a spring-loaded stopper gun, leaving a wooden stick dangling from a suction cup on his forehead. And Elvis had been reprimanded for other crazy stunts—water gun duels, wrestling matches, and noisy pillow fights in the hallways. Then Lamar bought a cane to torment an old lady who beat her own cane on the ceiling to tell them to pipe down. "It like to drove her crazy. She'd pound on that ceiling like there was no tomorrow, and I'd beat back on the floor like there was no tonight."

But the worst of it was when they nearly set fire to the hotel. In the middle of a shaving cream fight, Elvis locked himself in his room, and Red put a paper soaked with lighter fluid under the door and lit it. It coaxed Elvis out, all right, but smoke billowed out into the hallway, alarming the ultraconservative guests. That prompted an eviction notice, as well as a cautionary letter from Colonel Parker.

It was time for Elvis to find his own house.

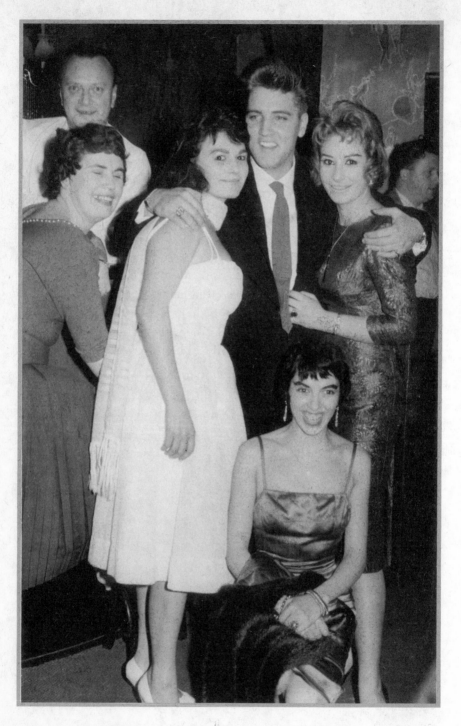

Elvis and the fräuleins of the Moulin Rouge, Munich, 1959. Dancer Angie Zehetbauer, with whom Elvis was involved, stands at right. She would later commit suicide. *(Courtesy of Andreas Roth)*

EIGHTEEN

.

House Full of Trouble

In February 1959, Vernon found a white three-story, five-bedroom stucco house for rent at 14 Goethestrasse in Bad Nauheim. By American standards, the home was not well appointed or extraordinary, but it suited Elvis's needs, mostly because it was roomy enough to accommodate his family and friends—two bathrooms, a large living room, a glassed-in porch off the kitchen, and a basement for storage. The house also offered a retreat from the restrictions of hotel life and separated him from the image of elitism associated with the Grunewald. Now he could maintain his posture as a regular G.I., living off base with his dependents.

The downside was that he paid an exorbitant rent, roughly $800 a month, at least five times the going rate. However, the landlady, the obstinate and rotund Frau Pieper ("a bitch and a half," in Lamar's view), knew that she could command it and made hay of her opportunity. Moreover, as part of the deal, she insisted on staying there as the housekeeper, mostly to keep an eye on her tenants and her property. Fans kept a constant vigil, some camping out in tents a hundred yards from the house, others covering the wooden fence with lipstick confessions of torrid desire. When he sings, one girl said, "gold comes out of his hot throat."

Even a house as large as Frau Pieper's could not always accommodate two female heads, however, and Frau Pieper and Minnie Mae, who shopped together, cooked together, and drank together in local cafés, often butted heads. They made quite a pair—one tall and skinny and cursing in English, the other short and fat and cursing in German—chasing each other around the house with a broom. Then they'd make up and swap recipes, Minnie Mae learning to fix Wiener schnitzel, and Frau Pieper serving up a plate of southern "cat head" biscuits.

Lamar found it hilarious. "Frau Pieper mouthed off to her one day, and

Grandma threw a skillet at her. She missed her that time, but later on she decked her." Elvis offered to rent her an apartment, but she refused. Then Lamar threw a firecracker under her bed. But Frau Pieper was not moving: She now had romantic designs on Vernon and couldn't keep her hands off Elvis, either. When she'd catch him in a bear hug, he'd smile and hurl insults at her ("Get away from me, you fat slob!"), knowing she hadn't a clue what he'd said. When Frau Pieper asked Elisabeth to translate, she covered for him: "He said you look nice today!"

Elvis left the house at five-thirty each morning to report for duty, which meant he was up by four-thirty for breakfast at five. But since he was hosting parties or playing music with Charlie and Red until late into the night—he had rented a piano and was trying to expand his vocal range—he found it hard to stay awake.

A sergeant in Grafenwöhr gave him amphetamines on maneuvers, but he was out of them now, and he went in search of a pharmacy mate who could get Dexedrine, his mother's drug of choice, in quart-size bottles. It was amazing what money and fame could do, and almost no one said no to Elvis. He seemed to do everything to excess these days, from buying uniforms (as many as a hundred) to bedding girls. Pills were no exception.

If Elvis got up at dawn, everyone had to get up at dawn, so all the guys took Dexedrine to match his schedule and energy level. He assured Rex the pills wouldn't hurt him.

"Truck drivers back in the States use these all the time to stay awake on long trips," he told him. The only side effects were good ones—Dexedrine was an appetite suppressant, and doctors prescribed it to overweight people every day. Plus, uppers increased your sex drive, gave you pocket rockets. He washed his down with hot coffee for an extra caffeine jolt, he said, and recommended Rex do the same.

"After taking my first pill," Rex later wrote in his memoir, *Sergeant Presley: Our Untold Story of Elvis' Missing Years,* "I actually felt the hair on my head standing up and a surge of energy bolting through my body. Elvis was completely right about one thing—that white pill provided me with an abundance of strength and energy I didn't know I had. I could take them and stay awake an entire weekend. I was astonished that after taking only one pill, I could easily go 24 hours without food or sleep. And they were harmless!"

Any time Rex ran out, Elvis handed him a hundred.

Vernon knew about the amphetamines and on occasion took them himself.

Elisabeth, too, was aware of them, as Elvis gave her some on the nights they went to the shows and clubs in Frankfurt. He particularly liked the Holiday on Ice extravaganza, as he'd become enamored of several of the skaters, who numbered among the women who came home with him. "Beautiful girls were constantly coming and going," Elisabeth found. "I had to painfully accept this, and just grin and bear it."

With Gladys's death, says Lamar, "he just let loose sexually. He was after everything he could get. I watched it change. But he had no compunction about that kind of stuff. To him, it was just banging. He had absolutely no guilt and no trouble balancing his behavior with his religious beliefs."

Hit-and-run sex, then, was a way for Elvis to shut out his grief, forfeit his past, and quell his inhibitions. He was the most famous man on the planet, a millionaire several times over, with the world at his feet. But he had lost the only thing in life he truly loved. It was as if the devil himself had set a price for him to pay. But the excitement and arousal of a young girl made a lot of things go away—the Assembly of God church, Judge Marion Gooding, and his regret over Dixie and June. In the dark, skin on skin, everything felt good and right. It made him feel alive. It made him feel that Satnin' was still alive, and he could pat on her and call her baby. That's all he knew, and that's all he wanted to know for the moment.

Several of the guys, especially Rex, felt sorry for Elisabeth and wondered about the cruelty and callousness with which Elvis paraded girls in front of her. "Sometimes she looked like she was about to cry," Rex later wrote. She was completely in love with Elvis. And it was deflating and degrading for her to spend all day answering his love letters, and then hear his muffled moans with others through the walls.

Near the end of 1958, he had told her that a girl named Janie Wilbanks was coming to visit, and he wanted Elisabeth to make her feel at home, even share her office-bedroom. Janie had been the girl George Klein introduced him to at the train refueling in Memphis. George had only just met her himself that day, when she walked up to him at the station. Even George was taken with her ("I don't know if she went to Ole Miss at the time, but she was a typical Ole Miss beautiful girl"), and he figured Elvis would like her, too. She had coal black eyes.

A photographer had captured their kiss and put it on the newswire. But more important, Elvis had called George two weeks later, saying, "Who in the hell was that girl? Man, she was good-looking! Tell her to send me some pictures and write to me." That December, she came to Germany to see her uncle, an army

captain, and stayed with Elvis for a week. Elisabeth was "instantly jealous" but ended up making friends with the pretty eighteen-year-old, as they both realized they were just two of the thousands of girls vying for his affections.

.

The next glint in his eye was an eighteen-year-old actress, the delicate, green-eyed Vera Tschechowa, whom he'd met in January 1959 while doing publicity pictures for *Confidential* magazine, building on a session he'd done in late 1958 for the March of Dimes. In this latest calculation of the Colonel to keep Elvis in the public eye, Elvis posed with a young polio victim, Robert Stephen Marquette, the son of Master Sergeant John Marquette, stationed in Friedberg. Robert wore leg braces and was confined to a wheelchair. In the first session, Elvis was photographed bending down next to the chair, his hand on Robert's, his hat on the boy's head. In another picture from that same session, the two plaintively held a sign that said GIVE.

But a third photo, taken in January, involved Vera, who had just made a film in America and who conveniently spoke English. Now only thirteen years after the end of World War II, it seemed a perfect moment of German–American alliance. Vera and Elvis stood on either side of Robert, Vera holding one of the boy's hands, and Elvis the other. But the way Elvis looked at the comely brunette, Robert might as well have not even been in the room.

Vera was far more worldly than Margit Buergin. Her grandfather was the nephew of Anton Chekhov, the famous Russian playwright, and her grandmother Olga one of the most popular stars of the silent film era. A favorite of Adolf Hitler (she always called him "The Führer"), Olga was reputedly a Russian agent in Nazi Germany. ("They had handwritten notes from Hitler on their walls in Munich," says Lamar.) Vera's mother, Ada, was likewise an actress in films, and Vera was following in their footsteps. She had just been voted Germany's number one pinup girl, with some sixty-five fan clubs, and the German papers were keen to turn her slight involvement with Elvis into a romance, whether it really blossomed into one or not.

When interviewed about Elvis in the 1970s, Vera seemed to find the entire subject distasteful, beginning with the notion of posing with Elvis and a disabled boy. Her involvement with the photographs came about because "somehow they were missing a woman to be used like parsley or trimming."

"We took these horrible pictures," she said. "What terrible trash. The child bound to a wheelchair, and Elvis standing with the child. I was somewhere with

the nervous parents. I talked a little bit with him. Not much, just a couple of sentences."

"Vera was a strange girl," in Lamar's view. "The longer you were around her, the crazier she got." He warned Elvis to stay away from her, he says, but Elvis, who called her "Kitty Cat" for the shape and color of her eyes, was intent on pursuing her. "Once Elvis had her in his crosshairs, there was no turning him back."

In early March, he got a three-day pass and went to Munich to see her, planning also to take in the nightclubs with Red and Lamar. The driver, Josef Wehrheim, motored them over in Elvis's new 300 Mercedes four-door sedan, and they accepted an invitation to stay with the Tschechowas in Obermenzing. A photographer from *Bild Zeitung,* Germany's answer to the *National Enquirer,* accompanied Elvis and Vera on their dates. According to Lamar, the magazine had already photographed the two in Bad Nauheim at the Hotel Grunewald. And Rex remembers that she invited the whole group to a local movie theater to see one of her films, Elisabeth translating the dialogue.

Now Vera was performing in a minor play, *The Seducer,* in Munich's Theatre unter den Arkaden, a small boulevard venue in the Maximilianstrasse. Elvis told Vera's mother, Ada, that he wanted to see it.

"You won't understand a word of it," she said.

"That doesn't matter," he replied, and then rented out the entire theater for himself and Red and Lamar. It was more of a grand romantic gesture than a practical act for a star who might be mobbed. And when Elvis sat in the first row, beaming up at her, Vera found it embarrassing and "miserable" to perform with only three people in front of the stage. Afterward, he took her mother and her theatrical friends to an expensive dinner at the Kanne restaurant, Red and Lamar tagging along.

"Red and I felt funny around Vera," Lamar remembers. "It was like she was already looking down her nose at us." Vera and Ada, however, found it odd that Elvis's bodyguards, as they called them, stood around him like walls and went with him everywhere, even to the toilet. Elvis, Vera thought, "was incredibly shy, a typical American middle-class boy, well bred with a crease. No hooligan at all." But after the three spent the night at the Tschechowas' home, Vera was less complimentary about Red and Lamar, whom she considered uncouth.

"They were very ordinary, with belching and farting and everything that belongs with it." And her mother objected to their foul language, their refrigerator raids, and their penchant for putting their feet on the table. Elvis suggested

his friends check into the nearby Hotel Edelweiss, where they got caught and were evicted for bringing women in through the window. Elvis, meanwhile, remained the Tschechowas' houseguest.

In the next two days, Elvis and Vera watched a Viking movie in production at the Bavaria Film Studios in Geiselgasteig, and took a boat ride on Lake Starnberg, a popular recreational area. "Elvis was after her, all right," Lamar remembers, but in the photographs, neither looks especially happy to be there.

Elvis's trip to Munich would be far more memorable for his three visits to the Moulin Rouge, a strip club, where he was photographed in suggestive poses with a number of scantily clad dancers, B-girls, and hookers. In several shots, he is shown aggressively kissing twin showgirls, the Orkowskis, first pushing one back along a stair rail, and then mashing the other against the opposite wall. He was also photographed in similar situations at another location, the Eve Bar, on his first night there.

In contrast to the playful and sexy tone of Al Wertheimer's famous photograph, *The Kiss,* shot in Richmond, Virginia, only three years earlier, the German pictures, most of them taken by Rudolf Paulini, the house photographer of the Moulin Rouge, have a seedy, depraved, and somewhat pornographic feel about them. Elvis seems dazed, almost in a trance, and the women, predatory and reptilian, have a nightmarish look, as if sprung from a vampire's dream. The photographs run totally at odds with Elvis's wholesome, all-American image and are, in fact, so sensational and shocking that they might have ruined him had they been published at the time. They look, says rock critic Dave Marsh, like "the answer to a question no one thought to ask."

Vera found her Moulin Rouge evening unpleasant for another reason. While Red and Lamar always understood that part of their role was to protect Elvis in all ways, Vera resented how they cautioned him to reel in his behavior. They tossed a comb across the table at him and told him to straighten his hair, she said, and when he got up to sing with the band, Red reminded him that the Colonel had prohibited public performances. Even a glass of champagne was off limits, Lamar insisted, and embarrassed him, Vera thought, by suggesting he drink tomato juice instead. Yet ironically, Elvis enjoyed more freedom in Germany than he did at any other time in his life.

There are conflicting stories about how Elvis and Vera felt about each other, and why they never saw each other after March. Thomas Beyl, a family friend, reported that Ada Tschechowa found Elvis and Vera together upstairs in Vera's bedroom and kicked him out. And Elvis was quoted in the press as saying,

"Sure, I've got a new girlfriend . . . I've been to visit her family in Munich . . . but it's just good fun."

Yet Vera steadfastly denied that anything romantic occurred between them ("I've got tired of all the fantastic stuff they write about Elvis and me—it seems hard to get through with the truth"), and suggested that she was interested only in the publicity value of being photographed with an American rock star. She insisted that her mother asked him to leave because he had "bothered our animals, canaries, dogs, and cats long enough."

Besides, he was more interested in one of the Moulin Rouge striptease girls than he was in her, Vera said. And, indeed, according to Andreas Roth, author of *The Ultimate Elvis in Munich Book,* Elvis had an affair with a Moulin Rouge dancer named Angie Zehetbauer, and took the blonde to a hotel, though probably on a subsequent visit. On their one night together at the Moulin Rouge, Vera apparently left early with Walter Brandin, the songwriter, who acted as her chaperone. Elvis, she said, turned up for breakfast the next morning with "bits of tinsel everywhere, in his hair and his eyebrows." She asked him where he had been, and he said only, "I stayed there." He would go back the next night, too.

· · · · · ·

When Elvis returned from Munich, he made a number of lengthy phone calls to Anita Wood. But it was clear to Red and Lamar that he was outgrowing her. He also seemed less considerate of Elisabeth Stefaniak, who did everything she could to please him, even improving on his favorite snack—mashed-banana-and-peanut-butter sandwiches—by frying them in a skillet like a grilled cheese.

In late March, Vernon and Elisabeth were hurt in a car crash on the autobahn, returning from a shopping trip at the PX in Frankfurt. Vernon, driving the big Mercedes, attempted to pass another car, when a vehicle pulled out in front of them. He slammed on the brakes, but the Mercedes fishtailed and spun out of control, rolling several times before slamming into a tree and landing on its roof. The car was a total loss. Elisabeth suffered head wounds from broken glass, and at first she couldn't move, fearing her back was broken. She arrived home on a stretcher.

It was a terrifying ordeal, and both Elisabeth and Vernon might have been killed. But Elvis's reaction shook her up almost as much as the wreck. He raced out to the accident scene in his BMW, but later he took her aside. "Foghorn," he said. "Be straight with me. Were you and my daddy messing around with each other while he was driving the car?"

Vernon had no romantic interest in Elisabeth, but his relationship with Dee Stanley had escalated from a fling to a full-fledged affair. At first Elvis and Vernon fought about it, and then Elvis realized that his father was lonely and needed company. "Bring her over to the house," he said.

But when Vernon did arrive with Dee, they almost always disappeared into his bedroom, right off the living room. Elvis confessed to Anita Wood that he had once peeped through the keyhole. "I have hated Dee ever since then," he told Anita. Not only did the affair come too soon after Gladys's death, Elvis thought, but his father also embarrassed him with their antics.

When Dee was in the throes of sexual pleasure, Lamar reports, she was not a quiet woman. "When they started banging, Dee would start screaming. God, Almighty, she'd scream so loud you could hear her all over the house. Elvis would turn sixteen shades of red. We'd be in the living room, and he would look at me and say, 'I can't stand this. It's driving me crazy!' Sometimes he'd just go upstairs. Or Vernon would come out of the room about twenty minutes later, and he'd be real cocky, and he'd sit there.

"One time Elvis said, 'Daddy, you need to take her in a car or take her out somewhere. Don't do it in here. Everybody in the house is hearing this.' But it got worse and worse. One time, they spent over an hour in there, and Elvis had about fifteen people in the house. When Dee started to holler, Elvis got up and started playing the piano so damn loud it made Liberace sound like a paraplegic. He beat that piano to death, man."

But the son had learned from the father. When Freddy Bienstock arrived in Bad Nauheim a few months later to help Elvis pick songs for his first postarmy movie, *G.I. Blues,* he found himself in the middle of a southern gothic novel—he could hear *both* Elvis and his father having sex in the house.

In June, after Dee had gone home to Virginia with her three sons, leaving her husband in Germany, Vernon followed her to persuade her to seek a divorce. The relationship had grown so serious that on this same trip, he drove her to Louisville to meet his father, Jessie. Then he returned to Germany and told Elvis they'd decided to marry.

Red, too, left the country, going home about the same time for good. He had come to Germany with Elvis fresh out of the marines, where he'd spent two years in Spain, and he was tired of military life. But he also complained that Elvis treated him like a "Chinese coolie." Vernon, with whom Red was constantly at loggerheads over his temper and his habit of getting in fights at Beck's Bar, gave Red and Lamar only a pittance in spending money—a couple of marks

at best, barely enough for a beer—and Elvis refused to do anything about it. Around the time of his departure, Elvis was hospitalized with what was reported to be tonsillitis, though the inside story had it that he suffered carbon monoxide poisoning from a jerry-rigged heater in his jeep.

In Red's absence, Elvis got antsy for another of his pals from home, and instructed Lamar to "call Cliff and tell him to get the hell over here."

Cliff, being Cliff, accepted Elvis's plane ticket but took his time getting to Bad Nauheim, flying first to Paris to visit friends and then going on to Munich and staying several weeks. "Where *is* the son of a bitch?" Elvis asked. Cliff finally showed up in Bad Nauheim and then took off in Elvis's Volkswagen. He was gone for a month. Eventually he came back and announced, "I'm not going to stay around and shine some fuckin' shoes." He took Elvis's Mercedes 220 and moved in with Currie Grant, a clerk for Air Force Intelligence at Schierstein, near Wiesbaden, for three months.

Soon Currie and Cliff would be regular fixtures at the parties at the house, along with a smart Chicago street kid named Joe Esposito, part of the Twenty-seventh Artillery. Joe, whose parents had immigrated to America from Calabria, Italy, was friends with the family of Tony Accardo, Chicago's last great mob boss. He was also a decent touch football player in Elvis's weekend games, and the man to see for a bit of loan sharking.

That June, Elvis took off on a fifteen-day furlough that mixed a bit of business and sightseeing with a large sampling of sex. He first returned to Munich, where he checked into the Hotel Bayerischer Hof, and spent his nights at the Moulin Rouge, making time with his favorite dancers, including one named Marianne, who demonstrated a strip routine wearing nothing but an Elvis record. Then along with Rex, Lamar, and Charlie, he took the train from Frankfurt to Paris. There, Freddy Bienstock and his cousin, Jean Aberbach, another of Elvis's music publishers in Hill & Range, met them at the station. Bienstock and Aberbach, Austrian émigrés, knew Paris well, and gave Elvis and his friends a tour of the Eiffel Tower and the Louvre. After that, they settled down to discussions of music for his upcoming films—Elvis, now influenced by European songs, wanted a larger, more operatic sound—and Elvis gave a press conference in the lounge of the Hotel Prince de Galles. A room service waiter told the press that during Elvis's stay in a top-floor suite overlooking the Champs-Elysées, young women were seen "going in and out of Monsieur Presley's suite, in and out, like a door revolving."

In the day, Elvis was mobbed on the streets, which boosted his ego and eased

his fears about being forgotten. At night, he enjoyed himself at the famous Parisian burlesque houses and nightclubs—Le Bantu, the Folies-Bergère, Carousel, the original Moulin Rouge, Le Café de Paris, and the Lido, with its famous seminude revue featuring the high-kicking, London-based Bluebell Girls, who performed the cancan in "glittering clouds of sequins, ostrich feathers, voluminous headgear, and not a great deal else," as the *New York Times* once noted.

When Elvis took the guys backstage after the first show, Rex was astonished to see girls roaming around naked "without batting an eyelash. I just about fainted at the sight," he said. Later he learned that Elvis and Lamar had put the girls up to having a little fun with him.

The Bluebell Girls, considered the most glamorous chorus line in Paris, inspired Elvis to indulge his friends in a smorgasbord of sex.

"We went through the whole Lido chorus line," says Lamar. "Same thing at the 4 O'Clock Club. We'd have as many as thirty or thirty-five girls there. You'd get up in the morning and just step over bodies. There were wall-to-wall women everywhere."

One late afternoon the stage manager of the Lido called the hotel three times. Lamar answered, half-asleep.

"We're ready to begin the first show," the stage manager said.

"Go ahead and start," Lamar told him, and then hung up.

Shortly after, the phone rang again.

"We need to start the show!"

Lamar hung up.

A third call, frantic now: "The show is starting!"

"Well, start the damned show!" Lamar said.

"But you don't understand, monsieur! You have all our Bluebell Girls!"

Lamar looked around and realized he was right. Not only were all the Bluebell Girls in the suite, but they were also still asleep. Now, like a determined den mother, Lamar rounded up the guests and called downstairs for four limousines. Suddenly the girls were a whirlwind of high heels and ostrich feathers, hopping down the hallway with one shoe on and trying to zip up their costumes.

While in Paris, Elvis became especially enamored of dancer Jane Clarke, a Brit, and Nancy Parker, a red-haired American ice skater at the Lido whom he would later see in Las Vegas. But his one disappointment was never meeting Brigitte Bardot. According to Rex Mansfield, he managed to get her phone number and left several messages. But she never called back—she was out of the country making a movie. "Nevertheless, Elvis felt snubbed, as though she should

have been there for him," Rex wrote in his memoir. " 'To hell with that bitch!' he said in frustration."

.

The sheer volume of women with whom Elvis had some kind of relationship, whether sexual or emotional, now bordered on the pathological.

Waiting for him at home in Bad Nauheim, for example, was twenty-three-year-old Ingrid Sauer, a blond telephone operator who came to his parties and brought her friends. She also posed for tabloid photographers in only a towel and gave interviews as Elvis's girlfriend. ("His hobby is to see how many times he can get a pellet from an air pistol through the center hole of a gramophone record at five or ten yards," she reported.)

But though Ingrid was only a year younger than the twenty-four-year-old Elvis, she was too old for his tastes at the time. "In Germany, Elvis was fascinated with the idea of real young teenage girls, which scared the crap out of all of us," Lamar says. One was fifteen-year-old Heli Priemel, a dancer Elvis nicknamed "Legs."

And perhaps another was fifteen-year-old Siegrid Schutz, an English-speaking German fan who spent practically every day of her three-week summer vacation outside Elvis's house. Though he had hung a sign out front that read AUTOGRAPHS 7:30–8 P.M., she frequently rang the doorbell and asked to see him.

Some of the gate watchers, including USO hostess Sue Anderson, got invited in for more than an autograph. Siegrid, however, sometimes got a scolding, since she and a friend would sit waiting in one of Elvis's cars. Eventually he took the zealous fan and her girlfriend to a party at the house of soldier Rex Harrison.

After that, Siegrid saw Elvis often. She went with him and the gang to play football and was photographed with him more than any other German girl, both that summer and again in January 1960. She has been described as one of Elvis's secret loves, perhaps because she kept her dozens of photographs private for more than thirty years.

However, none of the pictures was taken inside the house, which suggests she was not as intimate with him as some people think. And in the pictures of them together, Elvis looks mostly put upon, as if she has worried him to death.

Elvis showed considerably more interest in another teenage girl he would meet that September.

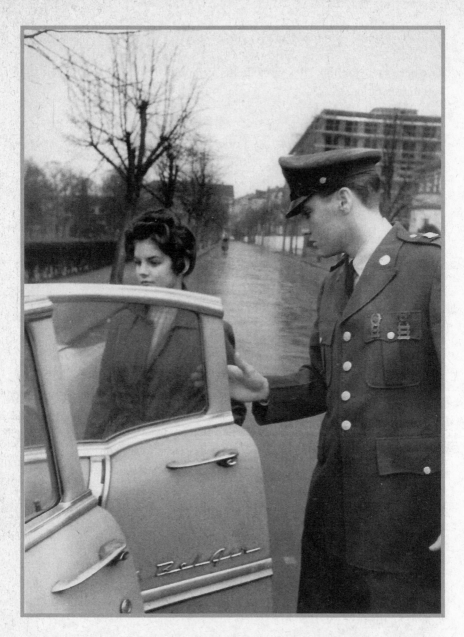

Sergeant Presley helps fourteen-year-old Priscilla Beaulieu into Currie Grant's car, March 2, 1960, as he leaves his rented home for the air base to return to the States. *Life* magazine would write about their involvement, calling her "The Girl He Left Behind." Of her childhood, Priscilla has said, "I always knew something extraordinary was going to happen to me." *(Robin Rosaaen Collection)*

NINETEEN

· · · · · · · · · · · · · · · · ·

Priscilla

On August 15, 1959, fourteen-year-old Priscilla Beaulieu arrived in Wiesbaden, Germany, where her stepfather, Air Force Captain Joseph Paul Beaulieu, was about to begin the next phase of his military career with the 1405 Support Squadron. A veteran of World War II, in which he'd served with the marines in Okinawa, Captain Beaulieu had seen much of the world and nearly all of the United States. The family's last posting was Bergstrom Air Force Base in Austin, Texas, where Priscilla and her younger brother, Don, welcomed another two siblings, first Michelle and then Jeff. (Twins Tim and Tom would be born later.)

An especially beautiful young child, with china doll features and a turned-up nose, the blue-eyed brunette had been quite the popular girl in her junior high in Del Valle, Texas. A cheerleader, she knew all the latest dance crazes and was crowned queen of the whole school. More important, she had made real friends for the first time in the family's frequent moves. By the time she was ten, she had gone to six schools, from Connecticut to New Mexico, Texas to Maine, and back. "I knew this would be difficult for her," Captain Beaulieu said of the transfer, "but we had no choice."

"I was crushed," Priscilla confirmed. "The last thing I wanted was to leave my friends and go off to some frozen foreign country."

When Priscilla's stepfather brought home Elvis's first LP in March 1956, she liked the music, she said. She *loved* "Blue Suede Shoes," but as she would later say, she "didn't want to be part of the Elvis mania. In fact, I refused to join the Elvis fan club—admission twenty-five cents—when I learned that one member had asked Elvis to autograph her breast. In my preteen mind, that was too risqué. On the other hand, I liked Elvis enough to want to watch him on *The Ed Sullivan Show*."

Just before she left Texas, one of her schoolmates said, "Elvis is in the army over there. Maybe you'll run into him."

"Oh, sure," Priscilla replied.

As she predicted, she was miserable in Germany and missed Austin terribly. She had no one to spend time with, she didn't really know the language, and her mother was occupied with a new baby. But two blocks away, at Paulinenstrasse 7, she found an oasis at the Eagles Club, a pre–World War II mansion converted to an air force community hangout. There she wiled away the hours, listening to the jukebox and writing long letters to her friends back home.

And then something extraordinary happened, she would later say.

"One afternoon I was there with my little sister and brother when a serviceman happened to strike up a conversation with me. He was an especially nice guy who sensed that I was homesick.

"'Would you like to meet Elvis Presley?' he asked. 'Who wouldn't like to meet Elvis,' I answered. I thought he was kidding, but he wasn't. His name was Currie Grant, and he said he and his wife often visited Elvis, who lived forty-five minutes away in the town of Bad Nauheim."

The meeting and courtship of twenty-four-year-old Elvis Aaron Presley and fourteen-year-old Priscilla Ann Beaulieu is a beloved part of American cultural mythology: the handsome rock king, grieving for his mother in a faraway land, the beautiful young princess, wise beyond her years, waving forlornly at his departure, only to become the virgin bride, conceiving on her honeymoon and bearing the great man's only child, a daughter, who at her father's untimely demise, inherits the kingdom of Graceland.

Such is the fairy-tale romance of Elvis and Priscilla, as related by the woman so often mistaken for his widow. But as with the Camelot years of Jackie and John Kennedy, another couple who defines a generation, the truth has been rewritten and altered so many times that even many of the participants are not precisely sure what happened, or when. Especially Priscilla.

In her own book, *Elvis and Me,* Priscilla writes that when she saw Elvis on Jimmy and Tommy Dorsey's *Stage Show,* before even *The Ed Sullivan Show,* she was sexually attracted to him. She also says that when her friend, Angela, looked at a map and found that Bad Nauheim was close to Weisbaden, Priscilla declared, "I'm going over there to meet Elvis."

She was a girl on a mission, then. Photographs show that she had taken it to such extremes, in fact, that after she read that Elvis was smitten with Debra

Paget, who everybody said she favored, she began wearing her hair in the exact style of Paget's in *Love Me Tender,* replete with long ringlet.

It wasn't that Priscilla *happened* into a situation whereby she was invited to meet Elvis, then, but according to Currie, an Airman First Class assigned to the 497th Reconnaissance Technical Squadron, she approached *him* at the Eagles Club. As he related in Suzanne Finstad's biography, *Child Bride: The Untold Story of Priscilla Beaulieu Presley,* it was about five o'clock, and he'd gotten a hamburger at the snack bar and taken it to the last table in the farthest corner so no one would bother him. Then he saw the door open and Priscilla enter. He'd barely gotten a bite down when she began walking toward him.

"Hi," she said, "I understand you know Elvis." Currie was deflated. A married man who valued his wife and family more than anything, LaVern Currie Grant was also a sex addict, a fellow, as Finstad quoted him, "just in overdrive when it came to sex . . . I craved it all the time." He had no compunction about fooling around on his wife, and he had already seen Priscilla at the club and wanted her. He had hoped she wanted him, too.

But he played along, wondering how he could work it to his advantage.

"Sure do," he said.

"Well, I sure would like to meet him."

"So would a lot of other girls, but sit down and we'll talk about it."

Currie, a part-time manager of the Eagles Club, ran a weekly variety show called "Hit Parade" for the Air Force. He'd gotten to know Elvis through Cliff Gleaves, who Elvis had just brought over to Germany. Cliff, a sometime rockabilly singer, harbored dreams of becoming a stand-up comedian and promised Currie an introduction to Elvis in exchange for work.

Once Cliff moved in with Currie and his wife, Carol, he and Currie often frequented a swimming pool, where Currie, a photographer, liked to take pictures of beautiful women. And *there*, says Lamar Fike, is where Currie and Cliff both met Priscilla, after she had been in Germany for about a week and a half.

"Currie was taking pictures of her," Lamar says. "Cliff described her to Elvis, and Elvis told Cliff to have Currie bring her over."

No matter precisely how Priscilla and Currie first began talking about Elvis, everyone agrees on how she looked the night Currie and Carol picked her up for the drive from Wiesbaden to Bad Nauheim. She had on a blue-and-white sailor outfit—a middy blouse with a wide skirt over a crinoline—and white socks. It was Sunday, September 13, 1959.

Captain Beaulieu, who had met Currie and knew his commanding officer,

had given his approval as long as Priscilla would be chaperoned. He reminded the Grants that she had classes the next day at the H. H. Arnold American Military High School, sponsored by the U.S. military, and that Priscilla should be home by midnight.

She was nervous on the drive, but when they arrived at the house in Bad Nauheim, Priscilla drew on all her experience as Queen of Del Valle Junior High and transformed herself into a model of sophistication and mystery.

The Grants passed by the predictable group of fans gathered at the gate and brought Priscilla into the house through the front door. Vernon was there, of course, as was Minnie Mae, and Lamar, and Elisabeth. They ran into Rex in the hall and introduced him to Priscilla.

Elvis was in the living room, wearing a red sweater and tan slacks, sitting leisurely in an armchair, a cigarillo dangling from his lips. Priscilla, who had waited for this moment since she was ten, stood tentatively behind Currie until he reached behind and took her hand. Then he pulled her up beside him. "Elvis," Currie said, "this is Priscilla—"

Currie had started to say more, but before he got it out, Elvis was on his feet. "If you could have seen his face!" Currie remembered in *Child Bride.* "He jumped out of that chair like he was sitting on a hot plate. I had *never* seen him react to any girl like that—and I'd seen him meet at least fifteen beautiful girls. He started bouncing off the walls!"

He asked her name, but out of nervousness—he already knew it. Currie had told him then, and Cliff had told him, and Lamar had even gone to check her out before Currie brought her to the house. "I told Elvis, 'She's as cute as she can be. But God Almighty, she's fourteen years old! We'll end up in prison for life!' I watched that from the very beginning with abject fear."

Gladys had always told Elvis to beware of a blue-eyed girl. But now that he had seen her, there was no turning back. Petite, demure, dark haired, with deep-set eyes, she so matched his ideal fantasy, as Finstad wrote, that it was as if he had designed her himself. Not only did she resemble Debra Paget, his unrequited love, but as with Debra, there was something about her face that matched his childhood memory of his mother when she was slim and vibrant. And, of course, at fourteen, she was almost certainly a virgin, another of Elvis's aphrodisiacs. "She's young enough that I can train her any way I want," he later told Rex, practically bubbling over with enthusiasm.

According to her memoir, Priscilla's account of that evening differs greatly from Currie's recollection. After Currie introduced them, the airman stepped

away, leaving them alone, and she and Elvis sat down to get acquainted. He asked her if she went to school, and when she said yes, he said, "What are you, about a junior or senior in high school?" She blushed, she wrote, and said nothing, not wanting to reveal how young she really was.

"Well?" he persisted.

"Ninth."

Elvis looked baffled. "Ninth what?"

"Grade," she whispered.

"Ninth *grade,*" he said and started laughing. "Why, you're just a baby."

She was miffed, and he could see it. "Well," he said, "seems the little girl has spunk." Then he gave her "that charming smile of his," she wrote, "and all my resentment just melted away."

They made small talk a little longer, and then he walked to the piano, playing "Rags to Riches," "Are You Lonesome Tonight," and "End of the Rainbow," before launching into a hard-pounding Jerry Lee Lewis impersonation.

She didn't applaud, she wrote, because she had noticed a life-size poster of a half-nude Brigitte Bardot on the wall, and "she was the last person I wanted to see, with her fulsome body, pouting lips, and wild mane of tousled hair." It made her feel young and out of place.

But quickly, she noticed that Elvis vied for her attention, that the more disinterested she appeared, the harder he tried to impress her. He soon took her into the kitchen, where Grandma was frying up a pound of bacon, and Elvis devoured five bacon sandwiches, all slathered with mustard.

As he ate—Priscilla was too on edge to think about food—he pumped her for information about who the kids were listening to back home. "You," she said, because she could see "he was nervous about losing his popularity." They talked about Fabian and Ricky Nelson for a while, and then he asked her about herself.

"What kind of music do you like listening to?" he asked.

"I love Mario Lanza."

"You're kidding!" he said, both because he loved opera, and because Lanza was the uncle of Dolores Hart. "How do you know about Mario Lanza?"

Priscilla told him she adored his album *The Student Prince.*

"That's my favorite," Elvis told her, and they just seemed to click.

"He thought I had the taste of someone older than fourteen," she says.

She could tell he missed his mother, missed Memphis, and was looking for a tie back to his fans in the States. And he seemed younger in his G.I. haircut.

"I found him extremely vulnerable and sweet. He had beautiful manners and an open heart. There was nothing false about him."

All too soon, Currie came in and pointed to his watch. Couldn't she stay a little while longer? Elvis asked. Priscilla didn't take it as a sexual come-on, she said later, but rather a "request of someone eager for companionship." But Currie said no, that he had made a promise to Captain Beaulieu.

"I felt like Cinderella, knowing that when my curfew came, all this magic would end," she wrote. Then Elvis casually mentioned that maybe she could come back another night. "Though I wanted to more than anything in the world," she said, "I didn't really believe it would happen."

When Currie finally got her home, her parents were up waiting. Fog had delayed them another two hours, she said. But she assured her folks that Elvis was a total gentleman.

The events of so long ago are often blurry in memory. While Priscilla was still there that first night, he walked into the kitchen alone to get a cold drink, Elisabeth would recall, and she could see he was enchanted. He had a glazed-over look, and he had everyone peek through the door at his guest, as if she were some exotic creature. "She looks just like a beautiful little angel, doesn't she?" he said to the room. Elisabeth agreed. "She reminded me of a painting, because she was flawless."

From there, the story turns into a wildly diverging narrative, Currie Grant offering a far more candid and realistic rendering of the events than the sketchy details Priscilla recounts in her memoir. As reported in *Child Bride*, Elvis went back out into the living room, and when Currie and Carol walked out to join them ten minutes later, "He had Priscilla backed up against the wall, kissing her." By eight-thirty, they were upstairs in his bedroom, according to several people in the house. Priscilla would confirm it many years later to Mike Edwards, a post-Elvis boyfriend, though her own book never mentions such activity on the first night.

"He just took her by the hand, went up the stairs, and said, 'We'll be down later,'" Currie remembered in *Child Bride*. "And she just went right with him."

That's when Currie began to worry. He'd seen Elvis take many girls upstairs and then lose all track of time. It wasn't until 1:00 or 1:30 A.M., that they emerged, Elvis holding Priscilla's hand until she got to the steps. "Bring her back, Currie," Elvis said, and Currie, hurrying to get her into the car with Carol, called back, "I'll try." Then the nervous airman sped off to face Captain Beaulieu.

When Priscilla left, Elvis continued to rave about her, telling Rex he had "been looking for someone like that all of his life."

Charlie Hodge and Joe Esposito, who both insisted they were there that night, though others dispute it, reported similar statements from Elvis.

"He looked at me and he said, 'Charlie, did you see the structure of her face? It's like everything I've ever looked for in a woman.' He was just enraptured, looking at her."

And to Joe, who agreed that "she was so beautiful, you could not take your eyes off her," Elvis said, "She's just unbelievable." Joe already understood his deeper meaning. Naturally, says Joe, "He was attracted to women who reminded him of his mother, as Priscilla [did] with the dark hair and the beautiful eyes like his mother had when she was young."

That night, Elvis would transfer *all* of his symbolic feelings for his mother, his twin, and for Debra Paget onto Priscilla. Later he would tell her he knew at that moment that she was his "twin soul," his destiny.

"It's amazing to me the timing of Elvis meeting Priscilla," says Peter O. Whitmer. "Boom! Gladys dies. Elvis goes to Germany and puts Gladys's death as far behind him as he can. And then what happens? Bam! He runs into Currie Grant and Priscilla. And the dynamic has everything to do with Gladys's death."

In a loose analogy, Whitmer explains, Elvis became Gladys to Priscilla's Elvis, in an attempt to replicate and work through his trauma. Subconsciously, Elvis would perform a lot of the functions for Priscilla that Gladys had performed for him, allowing him to fall back into a more relaxed state of mind. "He found himself a little Elvis-like sylph, and he became the owner of it, the control of it, the mother, the father, the Holy Ghost. Everything."

But if it were a cosmic moment for Elvis, strangely it was not the same for Priscilla. She did find him even more handsome in person than he appeared in his photographs and in the movies. However, she did not share Elvis's feelings of love at first sight, or that their meeting was the answer to a prayer. "No," she admitted later to Suzanne Finstad. "There was definitely a *pull* there—the energy was very electric—but not in the sense that this is *it.*"

Many years later, she would see that their attraction was based on fantasy, each looking to the other to replace someone they had lost. It wasn't really Priscilla he was in love with, but an idealized manifestation of his yearning. And Priscilla may have only been fourteen, but she, too, had a giant void to fill. Only

one year earlier, she had made a shattering discovery, as Finstad wrote in *Child Bride*, that threw her into an identity crisis she hardly knew how to handle.

· · · · · ·

Born in Brooklyn, New York, on May 24, 1945, Priscilla arrived in the world as a cross between Brooke Shields and JonBenet Ramsey, an arresting and exquisitely beautiful child who seemed older than her years. Pampered by her mother, who entered her in baby contests and children's beauty pageants, she was soon an ultrafeminine, prissy child, "the sort of little girl who would be in ruffles and lace, and would lift the corner of her skirt to curtsy" says Suzanne Finstad, who interviewed her subject at length for her biography *Child Bride,* first published in 1997. "Priscilla was the perfect name for her."

She was also a born coquette, Finstad wrote, projecting a sexual quality by six or seven that was disturbing for one so young and beyond her ability to even understand what she conveyed. Her mother, Ann, a former photographer's model, fostered and reinforced her behavior, buying her showy cowgirl outfits and fancy dresses with coordinated purses, shoes, and hats. In the family's home movies, she waved to the camera and, tilting her head like a movie star, looked akin to a modern Shirley Temple.

From the beginning, she was a relentless flirt with boys several grades ahead of her, but by twelve and a half, she was also attracting grown men, especially soldiers on the base. She worked at getting their attention, too. "She was kinda like a little honeypot," said her Texas neighbor, Mary Clements, in *Child Bride*. She obsessed on her looks—opening her compact more than her schoolbooks—and manipulated situations with boys and men. She'd sit out on the lawn, for example, watching the older boys playing football—and watch them watching her.

However, Priscilla's loveliness, and the way she used it to create an effect on others, was only the first of four interrelated molders of her personality. The second was the air force itself. In dictating that families were always on the move, military life created a lack of emotional security for children, who felt no sense of roots or permanence other than their ties to their parents and siblings. It was as if they were in the foxhole together.

Growing up in a military family, Priscilla learned early to close ranks, to never get too close to outsiders. Since the military is always on the move—either her family would be moving, or her friends' families—it would just be easier not to make attachments outside of the clan. Young Priscilla understood not to trust

anyone outside of the service, either, as the military runs on secrets. The family's unwritten rule dictated that it was better to suppress emotions, then, especially since the military despises weakness and prizes control, and giving in to emotional displays and feelings could lead to a loss of that control.

Priscilla had the very model of control right in her own home in the form of her authoritarian military stepfather, Paul Beaulieu. The third integral influence on Priscilla's personality, Captain Beaulieu maintained a brutal, Draconian presence in the household (a family member describes him as "one tough dude"), ruling the house with an iron fist and inspiring occasional terror in both his wife and his children.

"My father was very strict," Priscilla told an Amsterdam television interviewer in 1992. "I'm hoping today we have a better [way of] bringing up our children. He was doing the best he could. He was very military. A disciplinarian. We were to be seen and not heard. We were to do as he said. It was kind of the old way, I think."

Colonel Eugene Desaulniers, who served with Captain Beaulieu when he returned to the States in the 1960s, presents a different picture. In fact, the captain seems almost a different person in the eyes of his fellow officers. Known as Joe in the military and Paul at home, he was "a great guy, a fun guy," says his friend. "He was a very hard worker, and committed to doing his job. But he was also very sociable and had a good personality. We used to have a lot of laughs at work."

Captain Beaulieu, who would eventually retire as a Lieutenant Colonel, was a typical family man, according to Colonel Desaulniers. "I think he was a little strict with his kids, but I wouldn't call him rigid. When you have children in the military and you are constantly moving them, it becomes even more important that you set some path for them to follow. Career military people work hard to keep their families together. It isn't like you live in the same neighborhood for thirty years, so you make your home life much more cohesive. I don't think he was a heavy disciplinarian, but he made his kids tow the line. We all did."

Priscilla grew up always wanting to please him, both to earn his praise and to mute her own fear, for Paul Beaulieu was said to be a heavy drinker, a fact he struggled to conceal from the world. Colonel Desaulniers questions that, too, saying his friend was "a very good social drinker, but I wouldn't ever characterize him as a hard drinker. In those days, we were all classified as hard drinkers." But when he did drink, the captain's attention sometimes made Priscilla uncomfortable, she told Elvis. "He said Priscilla said her father gave her the creeps staring at her," Marty Lacker remembers.

That would be enough of a psychological trauma for any young girl, but at age thirteen, Priscilla stumbled upon a family secret, which she discussed with Finstad in *Child Bride*. She was babysitting one night for her siblings while her parents were at a party. Once the children were asleep, she got bored and began snooping around, rummaging through things. In the back of her parents' closet, she found an old trunk and felt compelled to explore it.

As she opened it, Priscilla told Finstad, "I had this unbelievable feeling." The first thing she saw was an American flag, folded in the shape to present to widows of servicemen. It was a sacred thing, almost, not to be disturbed, like a grave, and Priscilla kept thinking, "I shouldn't be doing this." She knew the trunk was private, that she shouldn't go any farther. But she did, of course, and under the flag she found a cache of yellowed love letters. She quickly flipped through them, fearing her parents would burst through the door any minute and catch her, and saw that they were between Rooney, her mother's nickname in her youth, and a boy named Jimmy.

Her pulse raced, and as she dug inside the trunk for more, she found a stash of photographs of herself as an infant. She'd never seen them before. In some, she was alone. In others, she was with her mother. But in the most puzzling ones of all, her mother, holding baby Priscilla in her arms, stood next to a handsome, dark-haired stranger. Who was this man? The teenager turned the photo over, and there she read the words that nearly stopped her heart: "Mommy, Daddy, Priscilla."

Suddenly, as Finstad wrote, her whole life, a *different* life, one she had not known about, lay before her in the trunk: a birth certificate, baptism records, all with the last name of Wagner. It weighed on her so much that she called her mother at the party, and Ann Beaulieu rushed home to find her daughter hysterical, angry, and confused.

Yes, she told her. She had been married to a navy pilot named James Wagner. He was handsome and kind and loved Priscilla like nothing in this world, but he was killed in a crash when Priscilla was six months old. Several years later, Ann met and married Paul Beaulieu, and now *he* was Priscilla's father, having adopted her.

Her mother hadn't told her before, she continued to Finstad, because Paul didn't want anyone to think Priscilla wasn't his natural daughter. He, himself, had almost come to believe that she was, so the lie had to be perpetuated. In fact, Finstad learned, the Beaulieus had cut Priscilla's paternal grandparents out of their life. It was as if Jimmy Wagner had never existed.

Priscilla would remember it as a terrible moment, a life-changing moment, asserts Finstad, that completely unsettled Priscilla in every way. Her only anchors—the things she took for granted as her sense of constancy and identity—were suddenly demolished. She wasn't who she thought she was. "That's an incredible kind of displacement," says biographer Finstad.

Psychologists say that concealing information about a child's biological parents is one of the most damaging family secrets, rating just below incest. Priscilla, predictably, was highly upset to learn that her mother, the person she trusted most in the world to protect her, had lied to her. And now she was being asked to be a coconspirator in that lie, protecting her stepfather and shutting herself off from a set of loving, grieving grandparents who wanted nothing so much as to know the child who so resembled their son.

At first she told no one about the secret, but it was too much of a responsibility for a girl of her age, no matter how mature. Her only way to deal with it at the time, coming only months before the family's move to Europe, was to shut down emotionally, even as she was filled with rage and the need for attention.

However, that did not mean that Priscilla did not act out. Her friends told Finstad they noticed a personality shift, mainly in her attraction to older boys, especially the hoody kids, the tough promiscuous crowd, boys who already had cars and drank beer and spit in the face of authority. By eighth grade, she had a reputation for hanging with the wrong crowd.

Once she got to Germany, she repeated her pattern, flirting with the black-leather-jacket boys and making poor grades. But more than before, as Finstad relates, Priscilla demonstrated two personalities, the good Priscilla and the naughty Priscilla; the latter was confident and assertive, especially where sex and seduction were concerned.

In Currie's telling in *Child Bride*, when Priscilla approached him and told him she wanted to meet Elvis, she agreed to a Faustian pact. Currie had once taken another girl to Elvis's house, and she wanted nothing else to do with him once Elvis invited her to his bedroom. Currie was not about to have that happen again. And so the twenty-seven-year-old married man wanted to make sure he was alone with Priscilla before he would take her to meet Elvis.

According to Currie, at first, it was just kissing. He took her up into the hills around Weisbaden—she concocted a story about going to the movies—and it was obvious she didn't want to do it. "It was like kissing a table," Currie said in the Finstad book, and all she wanted to do was talk about Elvis. But eventually he wore her down and she got into it a bit, and then he took her home.

By their second visit to the hills that late August or early September 1959, she was more eager with him, though they held their activities to kissing and a little touching. On the third trip, she was more effusive. But on the fourth rendezvous, Priscilla succumbed to the married airman.

"It actually started getting better on the third," he said in *Child Bride*, "but she did everything humanly possible to please me on that fourth time." It was then that Currie agreed to take her to meet Elvis, and by that time, he contends, "she became a little aggressive herself." On the way back to her parents' house, Currie wanted her again and pulled his car over to a dark area near the Wiesbaden Museum. Her skirt was up and her blouse was open when a German police car pulled in behind them. Currie told Finstad he feared he'd go to prison—she was a minor, and her father was an officer in the air force. But the German cop let him off with an admonishment: "You'd better be careful, and take her on home when you get ready." Priscilla denies Currie's account, in a classic case of he said, she said.

Currie would say later that Priscilla had not bled when he penetrated her, leading him to believe that she had already had intercourse, perhaps with one of the older "bad boys" she ran around with in eighth grade. Later he decided that probably wasn't right—she seemed so inexperienced at lovemaking.

The bottom line, if Currie's account is to be believed, and from what Priscilla's schoolmate Tom Stewart told her biographer, Suzanne Finstad, about his own sexual relationship with Priscilla in 1959, is that in 1967, when Elvis and Priscilla married, she was not the virgin bride that Elvis always said he wanted. She was not even a virgin on the night he first met her.

When writing her biography of Priscilla, Finstad interviewed both Currie and Priscilla and found their versions of the story at great variance. Hoping to reconcile their accounts, Finstad arranged to interview the two of them together. Presented with Currie's story, Priscilla became hysterical. "May God strike me dead if that ever happened to me," Finstad quotes her as saying. "I am telling you on the life of my son and my daughter, that never happened. That man is a liar!"

But by Priscilla's later account to her then-boyfriend, Mike Edwards, related in *Child Bride*, she *did* have some kind of episode with Currie in the German hills that led to her meeting Elvis.

In 1998, Priscilla sued Currie for defamation, arguing in her legal action that his statements were fabrications. She and her attorney sought $10 million in damages. In August of that year, Los Angeles Superior Court Judge Daniel Curry entered a default judgment against Currie for libel and ordered him to pay

$75,000, far less than the $10 million Priscilla sought. Neither Finstad nor her publisher, Harmony Books/Crown, were ever sued.

Priscilla used the default judgment to make it appear that the information that Currie provided was tainted. While there is a default judgment against Currie on file, there is also a confidential settlement agreement, a secret arrangement dated August 11, 1998, between Currie and Priscilla that underlies and supercedes the default judgment.

In the private side letter agreement, apparently prepared by Priscilla's attorneys, Currie is *not* required to pay Priscilla a dime as long as he does not repeat his accusations or disclose the existence of the secret settlement. According to the settlement, he and Priscilla agree not to discuss each other in public, other than a statement from Priscilla in which she says she "feels vindicated." In exchange, Priscilla does not enforce the default judgment against Currie and pays *him* $15,000 for pictures he took of her in Germany.

The confidential side letter states:

The parties stipulate and agree that the parties can state to the Media that a judgment for defamation has been entered in favor of Presley against Grant. No mention will be made by Presley or her attorneys to the Media of the dollar amount of the judgment. Presley can state to the Media that she feels vindicated by this result. Grant will make no comment to the Media other than the fact that Grant is glad to move on.

Furthermore,

The parties stipulate and agree that Grant will no longer state to the Media or any other individual that he had sex with Presley and Presley will no longer state to the Media that Grant attempted to rape her.

Per the side letter, Currie must pay a minimum of $75,000 if he engages in any "prohibited communications" regarding Priscilla. Clearly Priscilla has taken extraordinary measures to silence Currie, presumably to protect the myth of how she met Elvis and whether she was a virgin at the time.

· · · · · ·

When Currie brought Priscilla back to Elvis's house a second time, he knew that Elvis would waste no time in taking her upstairs. A few days after Priscilla's first

visit, Currie voyeuristically pressed her for details of what had happened that first night. Elvis was sweet and tender with her, she told Currie. They lay on the bed and he kissed her gently, and then things got a little hotter. "He just played with her," Currie told Finstad. "He was doing the hand thing: He was feeling her up, so to speak. He went under with his hand, very slowly, rubbing the skin, rubbing across her chest, stuff like that, and telling her to relax, that he wasn't going to hurt her, talking to her like she was a kid—which of course she was."

Priscilla was only too eager to please Elvis, and she complied. At first she just listened while he talked. To a background of sad music on the radio, Elvis shared his heart, telling her of his insecurities about keeping his fan base, talking again of his grief over losing his mother, and confessing how disappointed he was that his father was involved with another woman so soon after his mother's death. He seemed not only to trust Priscilla, but also to speak to her as if she were his age.

That night, they forged an integral psychological bond. If Priscilla became a projection of everything Elvis wanted and couldn't have, as Finstad wrote in her biography, he would become a stand-in for the lost and romanticized Jimmy Wagner. Elvis also offered her an escape from her complicated relationship with her stepfather, even as Elvis would quickly replicate the captain's control. Eventually she would tell Elvis the family secret.

"I felt more comfortable with him and had more trust in him," she would say about that second night. "I felt that he was a trustworthy person that I could depend on."

And perhaps that was part of the reason why Elvis was able to get as far as he did on Priscilla's second visit to his bedroom. Priscilla didn't want to tell Currie about it when he asked for a running report of their activities. But he controlled her fate with Elvis—she was dependent on him to take her back to the house. Plus, she needed someone to talk with about her situation—she was fourteen years old and playing adult games with an international film and music star. According to Currie, Finstad wrote, when he demanded the details ("Don't play coy with me!"), she told him everything—how Elvis had her blouse and bra off, how his hands were going everywhere, and how he started to get under her dress.

As her nights with Elvis continued, Currie would insist on hearing about the intimacies on the very night they occurred. But Priscilla would want to know what *he* knew, too, particularly about the other girls. Not only would Elisabeth Stefaniak crawl into Elvis's bed after Priscilla left ("not necessarily for sex," Joe

Esposito offers), but sometimes fifteen-year-old Heli Priemel would be leaving Elvis's bedroom when Priscilla arrived. And one night, she had sneaked a peek at Anita Wood's letters and knew that Elvis was heavily invested at home. Her competition was keen, and she needed Currie to both quell her anxiety and help her level the playing field.

However on one of their drives back to Weisbaden, Currie told Finstad he became excited at Priscilla's recounting and pulled off the autobahn for a quick assignation. He tried to kiss her, and she resisted, and then he fondled her breast, and she wriggled away. Finally, he quit. It was the old syndrome—she'd been up in the bedroom with Elvis, and so she didn't need him.

Priscilla would describe the event to Finstad as more of an attempted rape. "I was terrified. I did everything in my power to keep him off me. There was a house there . . . [and] I was going for that. I kicked doors open and blew horns." When the lights came on in the house, it scared Currie, she said, and he stopped. She told no one, "because I thought I wouldn't see Elvis anymore."

And she had to see Elvis again. But she later said to Finstad that when Currie tried to rape her a second time, taking her by the Rhine River, she told her parents and Elvis what had happened.

Her parents had become concerned about her friendship with Elvis, they said, when Elvis started calling her. Priscilla talked about him every minute at home, too, and suddenly the captain needed some answers.

"I don't think he was prepared to know what was going to happen, because I only went for a visit," Priscilla has said. "But I just kept visiting and visiting. And then we started to fall in love. I visited a lot, but it was always with other people. And there were parties. In [my father's] mind, there were always a lot of people, and I wasn't the only one Elvis was seeing. When you are a parent, you never really see the full picture. And when you are a child, you don't really give the full picture."

Captain Beaulieu insisted that Elvis come to the house before Priscilla would be allowed to see him again. Elvis agreed, and when he arrived, he wasn't alone. "I'm Elvis Presley," he said. "And this is my father, Vernon."

"I enjoyed speaking with Elvis and was impressed with his manners," the captain said in 2005. "Anyone would be. He seemed impressed by my military service and asked a number of intelligent questions about my work. All this was fine. But at a certain point I had to ask him, 'Why my daughter? With millions of women throwing themselves at you, why Cilla?' His answer was straightforward. 'I feel comfortable talking to her,' he said. 'She's more mature than her

age. And don't worry. I'll take good care of her.' I concluded that he was genuine, and now I am absolutely certain that I came to the right decision."

Ann Beaulieu felt the same.

"When we met Elvis that first time, our entire outlook changed," she said in a documentary DVD. "I'd never met such a polite young man. He addressed my husband as 'sir' or 'captain.' He addressed me as 'ma'am.' He was soft-spoken and sincere. You couldn't help but like him. He treated us with complete respect."

As Joe Esposito observed, "Elvis could talk anyone, particularly female, into anything."

But there were other reasons, perhaps, why Priscilla's mother was so willing for her to attach herself to Elvis, as Finstad wrote in *Child Bride*. Ann had been only fifteen when she snuck out to see another handsome dark-haired serviceman, Jimmy Wagner, at the USO. And there was another factor: Ann loved it that her daughter was seeing a celebrity, as if some of his stardust would rub off on Priscilla and on her, as well. Ann had always dreamed of a career in show business, perhaps as a dancer, if not an actress. In fact, Ann had become infatuated with Elvis while watching *The Ed Sullivan Show.*

The surprise, then, was that she didn't just *let* Priscilla go to see Elvis—she *encouraged* it, in part to live vicariously through her daughter. When Currie first spoke with the Beaulieus about getting permission to take her to the house, he told Finstad, "It was not a question of if Ann would let Priscilla go," he said. "It was rather a question of when I would take her."

The Beaulieus had to have known what eventually would happen with a twenty-four-year-old man and a fourteen-year-old girl who kept such close company. But Elvis assured them they were just playing music.

Priscilla wrote in her autobiography that she begged Elvis "to consummate our love" before he left Germany, and that he refused to do it. But in this case, "consummation" becomes a matter of semantics. Elvis's young visitor was apparently not sexually shy in the slightest. Joe Esposito remembers Elvis telling him, "She's a beautiful girl. I wouldn't lay a hand on her. But to have her sit on your face!"

On the third or fourth nights, the temptation got to be too much, and after the tickling, and the teasing, and the kissing, Elvis and Priscilla had intercourse, she told Currie. And not just once. But Elvis didn't consider it going all the way, because he would pull out before he felt that they had consummated the relationship. That way, in his mind, she was still untouched. But in time, Elvis

would tell members of his entourage that, indeed, he and Priscilla had had sex in Germany. And Priscilla would later confirm it to Billy Smith's wife, Jo.

Once that behavior began, Priscilla returned to Goethestrasse three or four nights a week, becoming a part of the group that regularly congregated at the house. With such hours, it took everything she had to keep from falling asleep in class, and Elvis began slipping her pills to keep her awake. She swore she didn't take them, though, only keeping them in a box with her other Elvis souvenirs. "I was leading two lives," she says, "ninth grader by day, Elvis's girl by night."

After each visit, Currie, or Lamar, or Joe would drive Priscilla home. In dreadful weather, the forty-five-minute drive would take far longer, and they would sometimes get her home at two or three in the morning, far after her curfew. Instead of a dressing-down, however, they received only pleasantries from her parents. Priscilla could hardly get up for school the next morning, but all her mother would say, Currie told Finstad, was, "What time do you want her ready the next time?"

· · · · · ·

Priscilla was right to worry about Anita Wood. Late that fall, while out on winter maneuvers in Bavaria's Wildflecken, where he spent thirty days sleeping out on the ground, often in snow, Elvis wrote Anita a four-page letter. Postmarked November 6, 1959, it was the last of three letters Elvis wrote her during his military service, and it was by far the most revealing, as he rolled out in frank terms his homesickness, mother need, and hormonal desire.

He addressed her as "My Dearest Darling 'Little,' " and began by saying how miserable he was out in the field. He was down with a fever and tonsillitis again, he wrote, and listening to the radio. His only consolation was that his tour of duty was almost over, and he would soon come home to his career, friends, and "most of all you, my darling."

His reason for writing, he told her in well-thought-out paragraphs, was that he was worried about how she might react when he did return home. He didn't know how she felt about him now, he said, "because after all, two years is a long time in a young girl's life."

It was a curious choice of words, considering that Anita would turn twenty-one in May, and was nearly a woman, while fourteen-year-old Priscilla was clearly a child. His words suggest that he was melding them emotionally in his mind. But on the surface, he seems concerned that Anita may have gotten older and wiser, and that she might have moved on.

Whether Elvis wrote the letter as much to make up his own mind between his two loves, he spent the majority of it declaring his love for Anita and apologizing for things she might have read or heard. He also said that he had the feeling she had cooled on him, not only because she hadn't written to him, but also because of the sound of her voice on the phone. "The warmth and love seems to have dimmed," he said.

I want you to know that in spite of our being apart, I have developed a love for you that cannot be equaled or surpassed by anyone. My every thought is you, my darling. Every song I hear, every sunset reminds me of the happy and wonderful times we've spent together. I tell you this because I want you to know my feelings toward you have not changed, but instead has [sic] grown stronger than I ever thought it [sic] could.

I have hurt you sometimes because I was mad at some of the things you did, or I thought you did, but every time these things happened, I thought that maybe you only liked me for what I am, and didn't really love me for myself. . . . The fact remains, if it's really love, Anita, if we really love each other, it will last . . . although things will come up in the future that will hurt us both. They are to be expected.

Please believe me when I tell you it's you and only you, my darling. But I think that you will keep our word, and tell me if you had grown to care for someone else and vice versa . . . Darling, I pray that you haven't let your loneliness, passions, and desires make you do something that would hurt me. If you have, it is better you tell me now. I can't believe you have or would.

So darling, if you still feel the same and if you love me and me alone, we will have a great life together, even though you hear things and read things. Just think as you said, everyone knows how I feel about you. I can't explain to you how I crave you and desire your lips and your body under me, darling. I can feel it now. The things we did and the desire we had for each other's body!!! Remember, darling, "True love holds its laurels through the ages no matter how loud the clamor of denial." That which deserves to live—lives.

Yours alone,
EP

In challenging Anita to "keep our word" about growing to care for someone else, Elvis breaks *his* word in not being truthful with her about Priscilla.

Anita had read about her in the papers, and "he assured me that this was a child, a fourteen-year-old child." While she considered this letter from Elvis to be "a little cruel," she says, "I had been a little cruel to him."

If he really thought that Anita might leave him, it would have been a grave concern, particularly now that he was returning to Graceland for the first time since his mother's death. His letter suggests that his real intention in writing was to secure Anita as a backup—that he was making certain he had, literally, a warm body awaiting his return from frozen, frosty Deutschland.

Elvis's psychological set would have mandated a backup, in case he had trouble with Captain Beaulieu, for his relationship with Priscilla had to feel tenuous, given her age and the fact that she would remain in Germany when he went home. If Priscilla were the new obsession, "Anita was a known entity, comfort food for the mind, a distant, parsed-off reality that in Elvis's mind smelled, felt, reeked of home, Gladys, Memphis, and stardom," says psychologist Whitmer. "Whatever carnality the two of them had enjoyed, that, too, would be exponentially magnified."

Elvis's reference to two years being "a long time in a young girl's life" may also have been his subconscious—and accurate—assessment of the time it would take to get Priscilla to Memphis. Yet given the malleable mind of a fourteen-year-old, Elvis must have sensed that he was in the catbird seat in being able to mold her during those years, even from afar.

That Christmas, he arranged for a French poodle to be delivered to Anita, while at a party at Goethestrasse for his family and friends, he had Priscilla sit next to him at the piano as he sang "I'll Be Home for Christmas." She was furious with him—when he started to switch to guitar, he nonchalantly asked two English girls where his pick was. One of them told him its precise location: "It's upstairs on the table right beside your bed," she answered, smiling. "I'll get it."

Priscilla, who'd given Elvis a pair of bongo drums for Christmas, knew he had betrayed her once more. But he denied it, explaining that he'd mentioned how unkempt his bedroom was, and the girl had merely offered to clean it for him. Priscilla didn't believe him, but now, at the piano, "when he leaned over and gently kissed me, when he told me I was the one, the only one, when I saw tears in his eyes, nothing in the world mattered but our love. Nothing mattered but him."

· · · · · ·

When Elvis returned from winter maneuvers, he contacted a South African doctor named Laurenz Johannes Griessel Landau, who advertised herbal skin treatments

to reduce acne scars and enlarged pores. Elvis, who "had pores big enough to hide a tank in," as Lamar put it, fretted about how he looked in his close-ups on screen, and began weekly treatments with the doctor. But their association came to an end when the dermatologist—who turned out not to have a medical degree at all—made inappropriate advances to Elvis during a procedure. "He eased his hand down between Elvis's legs and gave him a good squeeze," Lamar remembers. "And, boy, Elvis jumped thirty feet up in the air."

Elvis told him to get out, that his work was finished. But Landau was not so easily dismissed. He had tape recordings and pictures of Elvis and "a young, young girl" in intimate situations, he said, and he threatened to expose them. Panicked, Elvis gave Landau enough money to relocate to London. Then he called the Colonel, who recommended that he go to the army's Provost Marshal Division, which referred the case to the FBI.

It never occurred to Elvis to end his inappropriate relationship with Priscilla, however, nor to curtail his activities with the dancers and strippers at the clubs. In early January 1960, just after his twenty-fifth birthday, he returned to Paris for six days with Cliff, Lamar, and Joe, acting as his new friend's tour guide in the romantic city. Joe, at Vernon's request, would keep tabs on the expenditures, a job he would do well, impressing not only Vernon and Elvis, but also their accountant back in Memphis.

"We just played all night and slept during the day," Joe remembers. ("Well, I'll tell you, it's a gay town . . . if you like nightlife and everything," Elvis would soon remark to Armed Forces Radio.) They stayed in the penthouse at the George V Hotel and hit all of Elvis's usual nightspots, taking in the drag show at Le Bantu. Elvis had enjoyed an encounter with a female contortionist in Frankfurt one night ("He stayed in that dressing room five or six hours—came out of there wringing wet," Lamar says), but he kept his distance from the impersonators. Lamar and Cliff had already gotten burned, and he didn't want to be next.

Elvis had a more legitimate reason for going to Paris—to further his new study of karate. ("It gave him permission to be a badass," says Lamar.) For the last month, he had been taking lessons twice a week from Jurgen Seydel, the father of German karate. Elvis had been fascinated by martial arts since 1957, when Tura Satana mentioned their influence on her strip act and showed him some of the moves. Only recently, he had read a magazine article about Hank Slamansky, the ex-marine who introduced the sport into the armed services.

Seydel saw how serious Elvis was about it and recommended that he take classes from the Japanese instructor Tetsuji Murakami in Paris.

Within days of returning to Germany, he was promoted to acting sergeant, and after another round of maneuvers, he threw a party to celebrate his forthcoming transfer. His army experience was finally coming to an end. On March 3, 1960, he would be on his way home, flying into Fort Dix, New Jersey. "They thought I couldn't take it, and I was determined to go to any limits to prove otherwise," he told Armed Forces Radio.

Now he began making real plans to resume his old life in the States. Joe Esposito would go to work for him when they got home, and Elisabeth had agreed to come to Graceland to be his secretary, with occasional trips to Hollywood. Elvis hoped Rex Mansfield would also join the group as his road manager, and he would talk with him about it on the train heading home to Memphis. They had walked every step of their army hitch together, from the first day to the last.

Looking back on it all, he defined his time in the service as a blessing in disguise. "It was a time of grief for me. . . . It came at a time when I sorely needed a change. God's hand at work. The army took me away from myself and gave me something different."

On March 1, the day before his departure, the military held a press conference for its celebrity sergeant. More than one hundred reporters and photographers attended, capturing Elvis's every word and gesture as his commanding officer presented him with a certificate of merit for "cheerfulness and drive and continually outstanding leadership ability."

Nobody but Joe Esposito knew that at that very moment, Elvis had 1,200 pills packed in his luggage, "a box of twelve bottles with a hundred pills in each one." In Paris, "We'd be out partying all night, then get up and take one of those little pills, and it was great. Elvis was the type who thought you never take just one, because two is even better."

Before he left the press conference that day, Elvis ran into an old friend, someone he hadn't seen since her enlistment in 1957. He hadn't even known she was in Germany. It was Marion Keisker, his mentor from Sun Records, who still insisted that she, and not Sam Phillips, had really discovered him. She was assistant manager of Armed Forces Television there, a captain under her married name, MacInness.

She caught him just as he was coming in the door, flanked by M.P.s. It was "like they were taking him to the gallows," she thought. "He stepped through

and I said, 'Hi, hon,' and he turned around and his jaw fell. He said, 'Marion, you're in Germany and an officer!' I knew he didn't know. He said, 'Do I kiss you or salute you?' I said, 'In that order.' There I was in my uniform and he was in his uniform, and I just flung myself on him."

But the only girl he was really thinking of was Priscilla. The countdown to his departure had been hell for both of them, and they clung to each other on that final day, first at the house, and then on the ride to the air base.

The night before, he told her for the first time that he loved her. "We swore undying fidelity," she says. But underneath, she was a mass of insecurity. "What was I to think? What was I to believe? He was going back to America where he was [the] biggest star. He was going back to making music and making movies. He was going to appear on the Frank Sinatra [special]. Where did all this leave me?"

She tried not to worry too much. Hadn't he given her his combat jacket and his sergeant's stripes? "Little One," he said softly, "these prove you belong to me." Then he got out of the car, waved cheerfully to the crowd, and boarded the plane.

"He was in love with Priscilla, no two ways about it," says Joe.

And it showed. The photographers figured out who she was and snapped her picture as he waved directly to her. Priscilla offered a lonely wave in return, and even in her sorrow, with a scarf wrapped around her head to keep the March wind at bay, her face rivaled that of a Hollywood starlet. She didn't smile, but she didn't cry, either. She kept her famous family reserve. And then he was gone.

But there was a postscript to the story, and it involved Currie Grant and how Suzanne Finstad knew that he was telling the truth in the he said/she said account.

After Currie had attacked her in the car the second time, Priscilla told Finstad, her parents banned Currie from ever coming anywhere near her. Elvis, too, declared he was no longer part of the group, according to Priscilla. But Currie argued that Priscilla was wrong, that he was still very much a part of the inner circle. Finstad arranged to interview them together, face-to-face, and to record the conversation with their permission, Currie said he brought Priscilla to the air base the day that Elvis flew back to the States. He and Carol had picked her up at her house.

"You think my father would *let* you pick me up at the house?" Priscilla countered angrily, as Finstad reported in *Child Bride*.

"He was glad to let me pick you up that day," Currie mocked. "A *Life* cameraman took all the pictures around my car. I'm standing outside, holding the

door. Priscilla, you don't remember that, huh? You've got something up there that's really blocking your memory."

Priscilla soon left, insisting Currie was "in a dream world."

Finstad had a scientist, Ray Gunther, put the tape of their conversation through a personality stress evaluator, or PSE, a computerized voice stress test considered more accurate than a polygraph, and used by police departments all over the Unites States. In evaluating twenty-eight points in Currie and Priscilla's dispute, Gunther concluded that Currie was telling the truth 100 percent of the time, and that Priscilla was deceptive in all but one of her statements, an innocuous one about how Currie originally introduced himself.

Finstad also discovered that Currie had an almost photographic memory for details. He had even remembered the make, model, and license plate number of the car that he was driving at the time.

In the course of her research, Finstad found a German magazine, *Film Journal,* from 1960. The publication chronicled Elvis's last day in the country in a minute-by-minute account, replete with a little clock in each photograph. There in the magazine was a picture of Currie, opening the door of his 1955 Chevrolet Bel Air for Elvis and Priscilla. Not only did the license plate number match what Currie had told her, but so did the hour.

"It was literally the smoking gun," says Finstad. "I didn't care which one was telling the truth. I simply wanted to know what really happened."

In her opinion, Currie's story doesn't in any way tarnish Priscilla, she adds. It just makes her more human. She was like every other teenage girl in the world, desperate to make Elvis Presley her own.

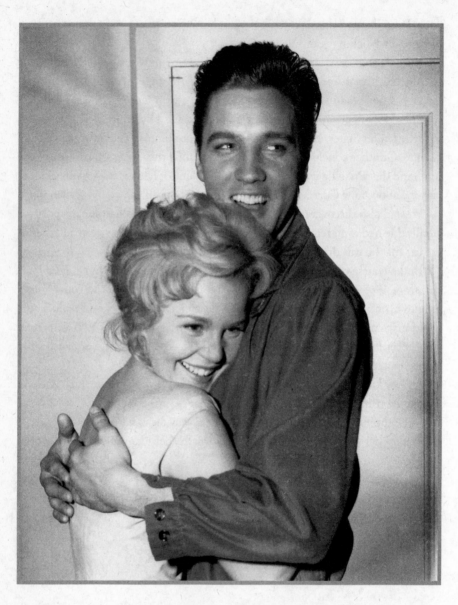

On *Wild in the Country*, filmed in late 1960 and early 1961, Elvis met actress Tuesday Weld. She called him "dynamite—real dynamite." Their relationship was often tempestuous. *(Robin Rosaaen Collection)*

TWENTY

· · · · · · · · · · · · · · · · · · ·

"Crazy"

He arrived at McGuire Air Force Base near Fort Dix, New Jersey, at 7:42 A.M., in the midst of a snowstorm, full of barbiturates to stave off his nervousness about flying. It was still dark that early March morning, and standing in the snow in his dress blues and hat, smiling, waving, and illuminated by hundreds of flashbulbs, Elvis was beyond handsome. He was lean, at 170 pounds, and positively glowing. No actor in Hollywood could have approached his magnificence.

The army held a full-scale press conference, and on hand to welcome him were the usual parties—the RCA executives, his music publisher Jean Aberbach, as well as Nancy Sinatra, who presented him with two formal, lace-fronted shirts, a gift from her father, Frank.

The publicity stunt was to billboard his upcoming television special, "Frank Sinatra's Welcome Home Party for Elvis Presley," in which a new, cleaned-up, adult Elvis would be presented to the public with an imprimatur from the chairman of the board. It was a slick piece of behind-the-scenes machination by the Colonel, and came together through connections as simple and obvious as the William Morris Agency and as complicated and opaque as Las Vegas mobsters.

As far as the Colonel was concerned, rock and roll was dead, just like Buddy Holly, the Big Bopper, Ritchie Valens, and the careers of Jerry Lee Lewis (who had married his underage cousin) and Little Richard (who had gone into the seminary). It was time for Elvis to move on to the next phase of his life as an all-American hero. That's what the military years had all been about.

The reporters had their predictable questions, and Elvis had answers:

"Have two years of sobering army life changed your mind about rock-and-roll?"

Sobering army life? No, it hasn't changed my mind, because I was in tanks for a long time, and they rock and roll quite a bit.

"Are you apprehensive about what must be a comeback?"

Yes, I am. I mean, I have my doubts. The only thing I can say is that I'll be in there fighting.

"There's a rumor floating around, Elvis, that you plan to get married soon. Is that true?"

No, sir. I don't expect to be a bachelor, sir. I just haven't found anyone yet that I wanna marry.

Two years earlier, at a similar press conference in Brooklyn, as he was waiting to board the U.S.S. *Randall,* a reporter had asked, "Are you leaving any special girl behind to go overseas?"

Naw sir, not any special one. There's quite a few of 'em, though. (Laugh)

And there would continue to be quite a few, starting with three. As Elvis boarded a train two days later that would eventually wind its way home to Memphis, he had Anita and Elisabeth waiting for him in Tennessee, and Priscilla pining away in Germany.

Priscilla's stepfather didn't quite know what to make of it. "It was a very difficult parting," she said years later. "He saw how I responded to it. I really went into deep depression. I locked myself in my room. I wanted to be in dark places. I didn't want to go to school. I skipped school. He started realizing there was something wrong with me. I was fourteen at the time, but this was more than a teenager's crush."

Elvis instructed her to write to him on pink stationery, so Joe Esposito could pick her letters out of the endless sacks of mail.

The media asked about her at Elvis's Memphis press conference, held March 7, 1960, in Vernon's office just behind Graceland. Some fifty reporters crammed into the small room, where Elvis, dressed with a new European flair in all dark clothes, his hair still a muted blond (he would dye it Cadillac black four days later), sat at his father's desk and swiveled nervously in the chair. He had been awake all night on the train, getting in just before 8 A.M., in the middle of another snowstorm. He looked weary, but boyish.

"Now, gentlemen," he announced in mock seriousness, "I have called you here to discuss a very important matter." Everybody laughed. He swiveled some more, looked down, dealt with his emotions.

"I just can't get it in my mind that I'm here," he said, looking almost dazed. And then the questions flew: about the music, about the movies (he had three to do that year, and would soon start *G.I. Blues*), even about his tonsillitis. And then they got down to business.

"How about any romance . . . did you leave any hearts, shall we say, in Germany?"

Elvis, clearly uncomfortable, grinned, glanced away, and looked altogether like a man who'd just been caught doing something he shouldn't. Then he laughed and broke out in nervous titters as he attempted to answer the question. "Not any special one, no. There was one little girl that I was seeing quite often over there. Her father was in the air force. Actually, they only got over there [a few] months before I left. I was seeing her and she was at the airport when I left. And there were some pictures made of her [laughs]. But it was no big . . . it was no big romance. I mean the stories came out, 'The Girl He Left Behind' [laughs], and all that. It wasn't like that, I mean [laughs]. I have to be careful when I answer a question like that [laughs]."

Soon, it was over. "You'll never know how happy I am to be here," he said, his voice full of feeling. "Somebody asked me this morning, 'what did I miss about Memphis?' And I said, 'Everything.'"

That evening, he saw Anita, who he'd asked to wait at his cousin Patsy's house, so they could have a private reunion, apart from his family. "There'll be no one else in the room but just us," he'd told her. But he couldn't stand not seeing her and had her come on out with everyone there anyway.

"He was standing right there in the doorway of the music room where the piano was. He said, 'Little . . .' And I just ran over there to him. I was glad to see him. [And] I guess he was glad to see me. We just embraced for a while. Quite a while. It was a really good time, happy time."

In a month, she would dye her hair black to match his, using his new color, Miss Clairol 51 D, "Black Velvet." And he would buy her a diamond necklace. But still, he could not be entirely faithful. He was already seeing nineteen-year-old Bonnie Bunkley, who had come to the house with her voice teacher, collecting money for a benefit for Whitehaven High School.

It seemed to be a compulsion for him, and Elisabeth Stefaniak could not stand it a minute longer. He had bought a yellow Lincoln for her to use, and even gave her driving lessons himself. He had taken her for motorcycle rides and ensconced her in Graceland to help with the incessant flow of mail. But he had also visited the Holiday on Ice show to see the female skaters he had met in Germany,

and then invited the whole cast home. And she had covered for him with Anita about his behavior in Germany. However, she could not be his occasional girl-friend, not when there would always be so many others. She was still in love with him, but she needed someone who wanted only her.

On March 15, barely two weeks after her arrival, Elisabeth left Graceland, saying she was going to Florida to see her family. Instead, she went to meet Rex's parents. Secretly, she and Rex had decided to marry. It had been Rex who had introduced Elisabeth to Elvis, and now it was Rex who was taking her away.

The suggestion had come largely from Minnie Mae, back in Germany. Rex knew better than to hit on one of Elvis's girls, but Grandma had said, "I want you to do it." It showed her love for both of them and her disdain for how her grandson treated the girl.

The night before Rex and Elisabeth ran off, Rex went to Elvis and told him he'd thought about what it would be like to work for him, but he was going to go back to his old job. Elvis said he understood and wished him luck.

He had rented out the Memphian that night, and Rex was helping him get ready. "Elvis was looking into the big walled mirror at himself," Rex wrote in his memoir. "I was directly behind him, helping him with his tuxedo suspenders."

"Elvis," he said, "would you mind if I took Elisabeth out on a date tonight?"

For a minute, Elvis said nothing. Rex held his breath. "Clearly a nerve had been struck," Rex wrote.

"Rexadus, you know Elisabeth will never love anybody but me," Elvis said, his voice steely. Then he switched gears. "Heck, I'm glad you're taking her out. I know I can count on you to treat her like a lady."

That summer, they sent him an invitation to their wedding. But he didn't come, and they never saw him again.

It was a confusing time for Elvis. He was home, but home wasn't really home anymore. His mother was gone. He had driven out to see the marker and the big stone angels on her grave the day after he got back to Memphis, and he placed a standing order with Burke's Florist to deliver fresh flowers there once a week. But he found it hard to return to the cemetery himself. It was just too painful. "He didn't seem like Elvis ever again," his Aunt Lillian observed. "He was de-pressed. He'd say, 'I can't go to the cemetery, Aunt Lillian. I can't hardly pass there.'"

To make things worse, Vernon was converting the three-car garage into an apartment for himself and Dee and her boys. Elvis and Anita were out by the

swimming pool the day Vernon moved Dee in. "Daddy," Anita remembers Elvis saying, "are you sure you want to do this? Why do you want to do this?"

Anita felt for Elvis. It was hard to watch him struggle with the idea of another woman occupying the house he had bought for Gladys. "Eventually, the two of them moved into Mr. and Mrs. Presley's old bedroom. That wasn't very good, either. Elvis didn't like that a bit."

When Vernon and Dee married in Alabama that July, Elvis was noticeably absent. "She seems pretty nice," Elvis told the Memphis *Press-Scimitar.* "I only had one mother and that's it. There'll never be another. As long as she understands that, we won't have any trouble."

· · · · · ·

In April, Elvis and his entourage, which now included new members Joe Esposito, Charlie Hodge, and Red West's younger cousin, Sonny, headed for California to make *G.I. Blues* for Paramount. Producer Hal Wallis had visited his star in Germany to soak up the ambience for Elvis's first musical comedy, in which he would play a romanticized version of himself. As Tulsa McLean, a singing army specialist stationed in West Germany, Elvis accepts a bet that he can romance a chilly cabaret dancer, Lili, played by the well-cast Juliet Prowse.

Unlike his prearmy films, which were based on previously published novels or stories, *G.I. Blues* was written for the screen and follows a predictable and formulaic storyline. Elvis makes the best of the tepid script, in which he babysits an infant and sings at a children's puppet show. But the film telegraphs only ominous things about his future screen persona. Gone are the swiveling hips, the sideburns, the songs of sexual undertow, and Elvis the rebel. In his place is a clean-cut, harmless, and conservative Elvis, designed to appeal to middle America. *G.I. Blues* would serve as the prototype for all the Presley musicals to come. From here on out, the public Elvis would become much more what people thought he should be.

Offscreen, he was not nearly so neutered, as he pursued three actresses on the film, Juliet Prowse, Leticia Roman, and a bit player, Judy Rawlins. He had more success with Juliet and Judy, the Italian-born Leticia, nineteen, telling the press, "He kept asking me to go out with him, but I tell him, 'No. I don't think it would be a good idea. It would seem too much like a publicity date.' Besides, I don't think my parents would approve."

Juliet was not his usual physical type—the South African dancer-actress was just under six feet tall, and she originally snubbed him on the set. ("Man, I'll tell

you, that is one cold chick," Elvis remarked to Sonny West.) But part of her appeal lay in the fact that she was the girlfriend of Frank Sinatra, who had just devoted his Timex special to spotlighting Elvis's return from the army, the two trading songs (Elvis sang "Witchcraft," Frank sang "Love Me Tender") in a generational détente.

Just like his character in the film, Elvis was determined to win Juliet over, and carried their love scenes far beyond director Norman Taurog's cries of "cut." After a while, Taurog called him over. "You don't have to put your heart and soul into it," he said. "How can you help but put your heart and soul into this?" Elvis answered, defrosting the ice queen. "A few days being around him, she just wore right down," says Sonny. "She started cutting up with us."

Soon he and Juliet began spending time in his portable dressing room. Red and Sonny teased him, repeatedly knocking on the trailer door and saying, "Frank's coming, Elvis!"

"Elvis would open that door and say, 'Where is he?', and we would just run off laughing," says Sonny. Then one day Sinatra showed up for real. Red went over to that door and whispered, "Elvis, Elvis, here comes Frank, man! I promise you."

"Get away from that door, Red."

"I mean it. I can't talk too loud or he will hear, man. I can't say any more."

"Frank came up and introduced himself, very nice," Sonny remembers. "He said, 'Hi. Is Elvis in?' And we said, 'Yes, sir, he's going over his dialogue.' Frank knocked on the door, and thankfully Elvis had heard his voice, so when he opened it, Juliet was sitting there prim and proper with her script, and Elvis had his script in his hand like they were going over lines. He said, 'Well, hey Frank!' And Juliet said, 'Hi, darling!' Everything was fine, and she left and went to lunch with him. Afterward, Elvis said, 'You sons of guns, you almost cost me there!'"

Their lovemaking was fierce and intense. "He said Juliet liked to grab her ankles and spread her legs real wide," reports Lamar. And Juliet would sit on the floor at friends' houses and just hug herself, she was so smitten with him. ("He's really one of the most sincere people in the most insincere town on earth," she said.) But Elvis dropped her after a few dressing room encounters—not because she was Frank's girl, but because he saw her as smarter and more sophisticated than he, which made him uncomfortable.

Their friendship, however, remained, and she played it cool in interviews: "He had a wonderful sense of humor . . . I remember thinking at the time it

must be very hard to be him. . . . He had a suite up at the Beverly Wilshire and he couldn't leave because the place would be surrounded by girls."

According to Byron Raphael, around this same time, Elvis had a momentary brush with a far more intimidating Hollywood star, Marilyn Monroe. Lamar, of all people, had already chatted up the screen goddess at a party. But Elvis had never seen her. Then in the early summer of 1960, the two most explosive and legendary sex symbols of their era sized each other up in the street in front of a soundstage at Twentieth Century-Fox and came away unnerved, if not befuddled.

Marilyn, who was reeling both from her fractious marriage to celebrated playwright Arthur Miller and from her affair with actor-singer Yves Montand, was costarring with the latter in *Let's Make Love,* then in production at Fox. Elvis was due to start principal photography on the period western *Flaming Star* there in August, and two months earlier, reported to the studio for wardrobe.

Byron said he was with Elvis, Cliff, and Gene (who now hoped to pursue a movie career under the name "El Gino Stone") when the guys began goading him. They were sitting in Elvis's dressing room on the lot. "Man, you gotta meet Marilyn Monroe," Gene started. "Elvis, you've got to ask Marilyn out!"

"No," he said, seeing Marilyn in a league of her own. "She won't talk to me." Cliff, who would soon be fired over a minor dispute, pushed him harder: "Elvis, man, you're a star! You've gotta take the bull by the horns. It's Marilyn Monroe! You've gotta be forceful!"

Finally the guys talked Elvis into taking his chances, Byron recalled, "and somehow we found out Marilyn's soundstage. Then the four of us made our way over on bicycles."

They almost missed her: Marilyn, dressed in a bathrobe and looking distraught, her hair all askew, was suddenly in front of them, coming out of stage twenty-three. Elvis approached her in his usual self-deprecating way, his soft baritone edged in southern charm. "Hello, my name is Elvis Presley. How are you, Miss Monroe?"

"Marilyn smiled in a way that said she liked the way Elvis filled out his Oxxford trousers," Byron wrote in *Playboy.* "But then her face fell as she took in his companions: Gene, the most pathetic yokel who ever hit Hollywood, and the always embarrassing Cliff, a smooth operator who was so oily he practically left stains when he walked.

"Monroe, forever insecure, had been searching for class in her choices of husband Miller and lover Montand, and the sight of Elvis's barely civilized

friends launched an unmistakable look of fear and disgust. Marilyn's famous suitor, oblivious to her reaction, began his roundabout way of asking for a date, mentioning a party at the Beverly Wilshire and inviting her to come.

" 'Oh, I'm sorry, I can't,' " she declined in a breathy rush. She wasn't feeling well, she said—a headache from some kind of allergy—and promptly pulled a bottle of pills from her purse."

Elvis was relieved. But he took something from the encounter after all, Byron said. "As a studio aide offered Marilyn a cup of water, I spotted the physician's name—Dr. Hyman Engelberg—on the prescription label. Elvis did, too. A few weeks later, he had his own scrip from the good doctor in his dressing room."

.

During the making of G.I. Blues, *Elvis was much more comfortable in the company of a younger female, and if things had turned out differently, Priscilla Beaulieu might never have seen Elvis Presley again.*

He spent his evenings at a restaurant-nightclub in Panorama City called the Crossbow, where Red knew a white rhythm-and-blues singer from Louisiana named Lance LeGault. The club was popular with celebrities, since they could sit unnoticed in the balcony and watch the dancing below. One night, Elvis, then twenty-five, was talking with the owner, Tony Ferra, and noticed a picture of Tony's fourteen-year-old daughter, Sandy, in his office. Elvis said he'd like to meet her, and Tony called and got his sable-haired child on the line. Sandy would remember it was nine-thirty, while her mother, Mary Lou, fixed the time at more like 2 A.M.

Elvis and Sandy chatted for a few minutes, and then he asked the teenager if she could come to the club.

"No," Sandy said. "I've got to go to sleep." The girl had school the next day, and her mother refused to drive her up.

Mary Lou took the phone. "I said, 'Elvis, she's only fourteen.' But then he kept buggin'.' He called again and again. He kept coming to the club until the night I said, 'I will bring her up.' "

The evening Mary Lou made good on her promise, Elvis was there with a date, Kathy Kersch, who was just breaking into show business and would be crowned Miss Rheingold beer queen of 1962. Sandy remembers Kathy was "gorgeous," but to her surprise, it was Sandy's hand Elvis held all night. Mary Lou was perplexed. "He was paying all of the attention to my daughter. And I'm thinking, 'Gee, she's only fourteen. What's his problem?' "

Soon they were dancing and making out, nothing more, Sandy says, though even that turned into a problem. "In school the next day I'd be embarrassed, because my face would be so raw. But when he would hold me in his arms, it was like, 'If I died now, it would be okay.'"

Mary Lou accompanied them on their first date and then insisted on tagging along for the next two, according to Sandy. "He loved my mom." But Elvis continued to puzzle the older woman. One night at the Beverly Wilshire, Elvis and Mary Lou sat in the kitchen, Elvis telling her about Gladys and talking about cooking, among other subjects, while Sandy watched TV.

"I want to ask you something and maybe you will do it," he said. "I would like for you and your daughter to move to Graceland."

"You're kidding! Why?"

"Well, you said you want to be with her. I'd like to have her at Graceland."

"She's too young right now, Elvis."

"That's all right. I'm not going to do anything. I just want to raise her. I want her to be there as my wife."

Mary Lou went home and told her husband. "Oh boy, he raised the roof! He went crazy! He started cursing and yellin'. I said, 'That's all right. I'm against it, too.'"

Sandy would end up dancing in a number of Elvis's films (*Viva Las Vegas*; *Easy Come, Easy Go*; *Double Trouble,* and *The Trouble with Girls*), and go on dance auditions just so she could see him. She won the part in *Viva Las Vegas* on her own, with no help from him. "Elvis was quite surprised when he saw me on the set. During one of the scenes, he kept bumping my butt with his. He really got off on that.

"I was making $100, $150 a day. We would have lunch together." A lot of days, she would get paid just for sitting there and eating with him. "What a great life for a young girl!"

Their romance lasted six years, up until the time he became engaged, she says. Mostly, they went to the movies or sat around and ate pizzas, since Elvis had early wake-up calls on the set. "We would kiss for hours, and dance for hours, and watch television, and sit at the piano and sing. We had an awful lot of fun." But all through it, "There were no expectations on either of our parts."

Still, Elvis had his rules. He sent her home for wearing a pants suit one night. ("Don't ever wear pants again!") And she was expected not to date anyone else, though he was free to do as he pleased. That caused a bit of friction. Once Sandy got a little older, she had a date with Wayne Newton, and Elvis saw it in the paper.

"He pulled this article out and said, 'Who's this Fig Newton person?' He was really upset about that." Later the two singers met, and one of them mentioned they were dating the same girl. "They came up with the idea to both stop dating me at the same time. It was going to be a joke, but neither one of them did. I continued to date both of them for a very long time."

In 1975, Sandy married Wink Martindale, who Elvis had known for more than twenty years. Says Sandy, "I tell my husband he's the best husband, but Elvis was the best kisser."

· · · · · ·

While Elvis was getting to know Sandy, another fourteen-year-old was thinking of moving on. Elvis and Priscilla were talking on the phone, sometimes all night long, but he had taken three weeks to call her. Her mother had said, "Forget him, honey. It was a lovely chapter in your life, but it's over."

Priscilla apparently thought that way, too. She had already found someone in Weisbaden close to her own age who excited her. Elvis was not the bad boy renegade Priscilla thought he was from his music and movie roles, and that disappointed her. But as Suzanne Finstad wrote in *Child Bride,* sixteen-year-old Tommy Stewart, a sophomore at H. H. Arnold American Military High School, was the actual embodiment of that and reminded her of the boys she'd been involved with back at Del Valle. He had the look—the black leather jacket, the dark, slicked-back hair—and the intimidation factor. He smoked, he drank, he was a Golden Gloves champion, and "he was not afraid to let people know that he was a sort of dangerous guy," his friend Tom Muldoon told Finstad.

Most of all, Tom Stewart was sexually active, and not just with girls at school. He was known to hang out in the rough part of town, on Meinzerstrasse, where prostitution was legal. And he was also known to disappear after school with Priscilla before she even met Elvis. After Elvis returned to the States, she began wearing Tom's ring on a chain around her neck.

"She and Tom Stewart had a very physical affair," says Finstad. "I found Tom after my book came out, and he confirmed all that I had been told. He also said that Priscilla's mother was so concerned about the depth and the nature of their relationship, that at a certain point, she put Priscilla in a chastity belt before her dates with him."

All the time Elvis was phoning Priscilla to discuss his insecurities about his film and music career, his father's new bride, and all his other extremely adult concerns, "this child," says Finstad, "and she was a child, really wanted to be out

on a motorcycle with Tom. She was having normal and very intense relationships with boys her age, and she was infatuated with them."

Her parents objected to the relationships—not just because some of the boys were negative influences on their young daughter, but also because the Beaulieus were now *reserving* her for Elvis. The boys who came to call told Finstad they got the distinct impression that Priscilla's family didn't want them there. Al Corey, who she saw during a brief breakup with Tom, remembered that when he turned up at the Beaulieus, "The parents would say, 'Our daughter is with Elvis Presley; you need to find someone else.'"

Priscilla, then, was getting pressed from both sides. When Elvis would phone, he used language that was similar to what he had written to Anita. He repeated to her what he had told her on their last day in Germany—he was expecting her to remain "untouched." If she didn't, he told her, the next time he saw her, he would know.

Often after he hung up with Priscilla, Elvis would turn around and call Anita at Graceland ("I stayed with Grandma a lot when he was gone"), where he would spend time with her between movies. Often, too, he would bring her out to Hollywood to keep him company after a long day of shooting. But when that happened, she tended to cramp his style. Better to leave Anita home most of the time. He was running wild, parsing out his heart, being true to nothing and no one.

Lamar Fike sees it a little differently—that few women complained or left him over his promiscuity. "There was a lot to go around. He wanted to keep everybody happy. It was the lure."

On August 1, 1960, Elvis began preproduction work on *Flaming Star*. Directed by Don Siegel for Twentieth Century-Fox, the film, based on Clair Huffaker's novel, *The Brothers of Broken Lance,* appealed to him. After *G.I. Blues,* he was back to a serious dramatic role, playing Pacer Burton, a half-breed caught between the feuding worlds of his Kiowa Indian mother and white father. But Elvis was disappointed in the decision to place four songs in the film, and director Siegel backed him.

To Colonel Parker's chagrin, only two songs remained in the final cut. The title number appeared over the opening credits, and Barbara Eden, who played the ingénue, remembers the other song, "A Cane and a High Starched Collar," as little more than "Elvis playing guitar and me hopping around the table."

Eden was aghast at the Colonel, who set up a desk just inside the soundstage to sell Elvis records and memorabilia to the cast and crew. ("I watched and I did a double take. I couldn't believe it.") But she was impressed with Elvis, who wore dark makeup for the role.

"God, what a talent he was!" Not only was Elvis "a natural on a horse, but like a lot of country entertainers, he had a path to emotional truth. He immediately became that character. He believed what he was doing, and he cared so much about doing a good job. He wanted to please. He had his friends and cousins from Memphis around him on the lot, and his father was there. They sat around in chairs and on boxes and sang a little of this and a little of that. It was very pleasant. Everything was easy with him."

They also discussed personal things, beginning with their weight. "We were both watching what we ate. I said, 'Well, you don't have a problem. You're very lean.' And he said, 'No, no, my mama was heavy, and I take after her. It shows in my face, so I have to be really careful.'"

But what Elvis wanted to know was how Barbara and her actor husband, Michael Ansara [*Broken Arrow*], were able to blend marriage and their careers. "I said, 'It's not tough at all. It's our job. We just go our ways and do it.' He said, 'I'm really thinking about getting married, but I'm a little worried.' I said, 'Oh, have you met someone?' He said, 'Yeah, I met this girl. She's awful young, though. I don't know.'"

Director Siegel would say that Elvis gave a beautiful performance, but *Flaming Star,* in which he dies at the end as in *Love Me Tender,* was not a commercial hit, and a hastily created EP of the two songs, coupled with 1960s smash hits "It's Now or Never" and "Are You Lonesome Tonight," peaked at only number fourteen. Coming after *G.I. Blues,* with its number one soundtrack, it was a disappointment, especially since the Colonel was in negotiations for all of Elvis's film and recordings contracts. The Mirisch Brothers and United Artists were about to pay him $500,000 plus 50 percent of the profits on each film of a two-picture deal (*Follow That Dream, Kid Galahad*). This was no time to be screwing things up.

· · · · · ·

In May 1960, Elvis took the entourage to Las Vegas so he could introduce the newer members to his favorite getaway. Lately, he'd taken to dressing them all in black mohair suits and sunglasses—an early "Blues Brothers" look, and most certainly his answer to Frank Sinatra's Rat Pack. The press picked up on it and started calling them the Memphis Mafia. The name stuck.

By now, most of the guys shared Elvis's fondness for pills—speed, or amphetamines, in the day, and sleeping pills at night. As in Germany, "It didn't matter if you needed to sleep," Joe Esposito says. "If he was awake, you had to be awake. That's just the way it was." They'd get up in the morning and take uppers

and stay up all night, and then finally crash on sleeping pills. "That," says Joe, "became a vicious routine."

One side effect of the pills was that Elvis's camp became more noisy and disruptive at the Beverly Wilshire. Elvis was always breaking boards in his karate practice, and they were staging three-hour pie fights and pouring buckets of water on each other now, not just having squirt gun battles. "One time we came in and water was dripping from the ceiling," Charlie remembered.

In a repeat of the Hotel Grunewald incident, it provoked complaints from management and residents alike, especially after Elvis threw an old cheap guitar down the hall, Charlie said, "and a lady looked out and ducked back in, because it went right by her head and broke in all pieces when it hit down there."

And so Elvis went searching for a house to rent. In October, he found one at 525 Perugia Way, in the Bel Air section of Beverly Hills, overlooking the Bel Air Country Club. "It was a round house, more or less," as Charlie put it. "You could walk all the way around the garden inside it. It was unique." The home was part of the estate of Prince Aly Khan, Pakistan's representative to the United Nations, who had also been actress Rita Hayworth's third husband. Rent was $1,400 a month.

In November, Elvis started production at Twentieth Century-Fox on *Wild in the Country,* his last shot at challenging movie material. In Clifford Odets's intelligent script (adapted from the J. R. Salamanca novel *The Lost Country),* Elvis is a troubled college kid (Glenn Tyler) whose bad temper gets in the way of his gift for writing. As with *King Creole,* his character teeters between the good girl (Millie Perkins) and the bad (Tuesday Weld), Hope Lange playing the psychiatrist who helps him find his way. With three leading ladies, Elvis was allowed to show his acting range: he was courtly and sweet with Perkins, wild and mischievous with Weld, and wary, then reverential with Lange.

Millie Perkins, who would go on to play Gladys Presley in the 1990 television series *Elvis,* was fresh from the title role in *The Diary of Anne Frank.* She found the offscreen Elvis "very sensitive about who a person was and what they needed. I was very shy and he treated me . . . with such care, like a hothouse flower."

Hope Lange, who costarred with Marilyn Monroe in *Bus Stop* in 1956, and garnered an Oscar nomination for *Peyton Place* the following year, was a replacement on the project for Simone Signoret, who had become ill. Casting Lange instead of Signoret, director Philip Dunne would say, gave the characters a discrepancy of class more than a discrepancy of age, which worked well with their forbidden sexual pull.

Lange had never seen Elvis before, except on television, where "I wasn't that impressed. I thought he was kind of a greaseball. [But] I was surprised. We had a wonderful time. We were always cracking up."

Hope was a classy, Connecticut-born lady, but if Elvis feared she'd be too stuffy, she squelched that notion immediately, and he invited her to the house several times for pizza. While her marriage to actor Don Murray was failing— their divorce would be final the following year—Elvis made no moves on her, treating her only with respect. She, in turn, found him charming. According to Alan Fortas, she teased him about having no liquor in the house, which made him stock the bar on Perugia Way and on location in Napa Valley, California. She also got him drinking screwdrivers. When Elvis developed a boil on his rear end ("It hurt so much he couldn't sit down—he had to just kind of lean on his hip, or lay in a chair," Alan recalled), the studio sent a doctor to the motel to lance it.

"What's the problem?" Hope asked, coming to the room where Elvis was in bed.

"I got a boil on my ass," he said, trying to mask his embarrassment.

"Let me see," she teased and yanked back the sheets. Alan, Gene, and Joe exploded with laughter, and Elvis turned as red as his boil. His posterior healed, but Elvis's pride remained wounded. Every few days, Hope would saunter over to him and whisper, "How's your ass?"

On location, Elvis secluded himself with blond wardrobe girl Nancy Sharp, whom he'd met on *Flaming Star,* but the Ivy Leaguer was a little too proper for him. He was more interested in Tuesday Weld, who looked a bit like a blond Priscilla. Although known for precocious, sex kitten roles, Tuesday was as brilliant as she was volatile. At her father's early death, she became a child model and the family breadwinner, but it proved to be too much. At nine, she had a nervous breakdown, and she began drinking heavily at ten. Two years later, she tried to commit suicide after falling in love with a homosexual. She was seventeen at the time she filmed *Wild in the Country.*

Alan Fortas, who had a crush on her, remembered her as being "sweet" to everyone in Elvis's camp. But Joe Esposito recalls her salty language and reck-lessness. Before Elvis moved from the Beverly Wilshire, "She decided to chuck a quart of milk out the window of our top-floor suite" just to see it splatter, and got in a shouting match with hotel security when they failed to recognize her. Tues-day also liked to throw things at people from Elvis's moving car.

Their romance was apparently hot—Tuesday called him "dynamite, real dynamite"—but harried. "She thought Elvis was very emotionally immature,"

says Kevin Eggers, a friend from the early days in Hollywood. "He lost his temper and physically came at her one day, and she just looked back at him and said, 'You make the mistake of touching me and I'll put you in the hospital.' She had a great, funny line about him. She said, 'You know, Elvis looked better with his clothes on.' But the simple fact was that one was a bright, talented young woman, and one was a bright, highly talented boy–man. He was never comfortable with a woman. He didn't have lovers. He had playmates. Once Elvis realized the girl had a mind of her own, it was over. Tuesday had the nerve to talk back."

That was part of Elvis's problem with Christina Crawford—the adopted daughter of screen legend Joan Crawford—who had a small part in the picture. Joe brought her to the house one night, and when he sprung from his seat to light Elvis's cigar, she knocked it out of his mouth.

"He shouldn't have to light your cigar," Christina huffed.

"I don't mind," Joe said.

But Elvis, living on amphetamines and pain pills, was incensed and "pulled her by the hair across the coffee table, and ordered her to leave," Joe wrote.

Wild in the Country, with four songs, most of them inserted in odd places, fell short of box office expectations. Director Dunne praised Elvis as "an excellent dramatic actor, a natural actor," but lambasted the Colonel for ruining the film with musical numbers. "I shot them so they could be dropped out, and I wish they would drop them out of the prints now. People would see a good movie." In preview, the audience, caught up in the story, laughed whenever Elvis started to sing. Author Salamanca called it "a terrible film."

Elvis was terrifically depressed and deflated, even during shooting, and knew deep down that the picture would seal the coffin on his hopes to become a serious actor. His resentment toward Parker and the studio heads fueled his drug use and brought dark and brooding changes to his personality. He pulled a four-shot Derringer on a group of kids who mouthed off at him in traffic in San Francisco on a weekend trip, and soon he would display other aberrant behavior. Joe and Lamar started calling him by a new nickname, "Crazy."

Later that year, Barbara Hearn got a call from someone in Elvis's inner circle, asking if she would come out to Graceland. Barbara hadn't seen Elvis since Gladys's death, and when she arrived, he was sitting around downstairs with his new pack of friends. She was saddened at their interaction: "Whatever he would say, everybody would agree with him."

They were talking about his next picture, *Blue Hawaii,* which would be choreographed by Charles O'Curran, the husband of singer Patti Page.

As Barbara remembers it, "Elvis said, 'Patti Page is the best female singer,' and everybody said yes, she was the best female singer. Then he looked at me and grinned, and I said, 'No.' And he laughed and he said, 'Well, you can count on Barbara to disagree with everybody. Who do you think is the greatest female singer?' I said, 'I like Peggy Lee better than anybody else.' I thought she was a much better musician. She wrote great songs, and I just liked her style. So we had a big discussion about Peggy Lee versus Patti Page. But in a few minutes, it was back to the same old thing, so I went upstairs and called Mother and asked if she would come get me."

Elvis followed her up as she was hanging up the phone.

"Why are you leaving?"

"Well, honestly, I'm just not having a good time."

His face fell, and then he said, "Neither am I."

But it was his house, she told him. "You can do something about it."

"We talked until Mother came, and she was very touched because he just hugged and hugged her, and kissed her on the cheek. Later, she said, 'I think he knew that was the last time we would ever see each other.' And I said, 'I think he did, too.'"

It would be another sixteen years before Barbara would see him, and then only onstage. When she left Graceland that day, she cordoned off a part of her life.

If Elvis had just lost a vital female connection, he made another through a chance encounter. In the fall of 1960, the man who had been out of the housing projects only seven years bought a black Rolls-Royce Silver Cloud II. He was driving down Santa Monica Boulevard one night and caught the eye of seventeen-year-old Patti Parry, who was on her way to a fraternity party with a girlfriend. That one minute in time changed her life.

"Let's go see who's in that Rolls-Royce," she said to her friend and pulled her old clunker of a Buick next to him at a red light. Patti, who was going to beauty school, had been born in the Stamford Hill section of London, England, but she'd been in the States since she was ten, and she knew the drill in L.A. "It's Elvis Presley," she said. "Pretend we don't know who he is."

He rolled down the window.

"Hey, girls. Hi!"

Patti played it cool.

"You look familiar," she deadpanned. "Do I know you from somewhere?"

Elvis laughed and said, "Pull over!"

He knew she knew who he was, and he liked being noticed—liked the looks on people's faces when they saw him out in public.

They chatted for a few minutes—he was on his way to Radio Recorders to do the title track for *Flaming Star*—and he invited her up to the Perugia Way house later on. He liked her sass and wit. But after the tour of the bedroom, when she told him, "I'm a nice little Jewish girl," Elvis thought of her only as a little sister. "I got on well with all the guys, so they just adopted me, and from that time on that was it! I was around until he died. Amazing, isn't it?"

Patti (Elvis called her "Patricia") would become the only female member of the Memphis Mafia. "He didn't have a mom or a sister, and I told him the truth. He needed someone to commiserate with him. I became his Jewish mother." He talked baby talk to her, and she nurtured him, did his hair, cut his toenails, rubbed his back, gave him a shoulder to cry on. She never went on the payroll, because she had her hairdressing work four days a week in Beverly Hills, "and I couldn't give up my complete life to work for him."

But she ended up traveling with him part of the week, and "practically lived at his L.A. homes," going over every day after work and having dinner with the gang, and staying until about 1 A.M. When she'd announce she had to go home, Elvis would say, "Don't go home, don't go home." Then he'd send someone to follow her, make sure she got in okay. "He was a good, good man."

Later she accompanied him to Memphis, where he took her to Humes High, and Sun Records, and Lauderdale Courts, and to Gladys's grave, "which was the greatest honor he could give me. He teased me. He said, 'You're standing on my mother.' He had a very, very funny sense of humor."

Despite her Jewish background, she ate his deep-dish southern food—red-eye gravy and grits—and even sang gospel songs with him. She loved that music, loved being around him, loved having all those "brothers" to take care of her.

Her parents weren't crazy about the idea. She wasn't dating anyone and just wanted to hang out with Elvis. But they eventually came around to it, seeing that he loved her platonically, and that he wasn't a threat. Any other girl who came to the house had to accept her, too, even as some tried to muscle her out: "On Perugia, girls would come up to the house, and I'd sit next to Elvis on the couch. And as soon as I'd get up to go to the bathroom, some other girl would run over to sit next to him." But there was no displacing her. She was a lifer.

"Elvis was like my family. We grew up together. He brought me up, and he liked bringing up his women. He adopted me and protected me and wouldn't let

anybody hit on me. Even when I was in my thirties, Elvis used to say, 'Patti is family. She doesn't fool around.' I'd say, 'Hey, I can fool around.'"

But living with Elvis was "really difficult. You had to be mother, sister, and confidante." Patti was a lucky girl, she says. "But you know what? He was really lucky to have me, too."

* * * * * *

All around him now, there were new beginnings and sudden endings, and they wasted no time as 1961 rolled in.

On February 4, Junior Smith, Elvis's frequently frightening cousin, died. ("The way he would look at you. God! It would make your bladder weak," says Lamar.) Elvis kept him going by adding him to the entourage, like his brother Gene. But then when Elvis went away to the army, Junior just stayed drunk, trying to wash away his flashbacks of shooting civilians in Korea with a Browning automatic rifle. He'd get that stare. "Oh, oh," everybody would say, "he's remembering stuff again." Then he started mixing alcohol and drugs, popping sleeping pills and amphetamines that Elvis gave him. The combo did him in.

The night he died, he went on a bender with his uncle Travis Smith. Travis went on to his bedroom and passed out, and Junior went to Billy's room and lay down on the bed.

When Billy came home around eleven-thirty, he realized Junior was there and started to crawl over him when he saw something on the bed. "Well, he's done thrown up," Billy thought and went into the living room to sleep on the couch. The next morning, Billy awoke with a start. It was eerie, the way he felt. He just knew something was wrong. He went in and looked at Junior, "and my heart liked to stop. He had thrown up, but the stuff on the bed had some blood mixed with it, and it seemed like it had come out of his nose."

Billy went over and touched him.

"God, Almighty! He's dead!"

Now Billy ran in to his parents.

"I said, 'Daddy! I think Junior's dead!' He said, 'No, he's all right.' Then he went in and I heard him say, 'Oh, my God, he is!'" Junior had choked on his own vomit.

Travis called Elvis, who hurried over with Anita. "We were the first there," she says. "A terrible sight, but that was just the first tragedy that happened in that family."

Within the next few years, there would be more, some macabre. Billy's brother,

Bobby, who had gotten a Section 8 in the National Guard for swallowing safety pins and puncturing his intestines, would be unable to handle Elvis's fame, and take rat poison and die. And Junior and Gene's brother, Robert, who worked for a chrome-plating company, fell up to his waist in a vat of hot liquid chrome. It cooked him.

Billy would remember that Elvis was "extremely hurt" by Junior's death. It was too soon to be having another funeral in the family, and Elvis thought he should have done more for him. Still, he was glad Junior was finally out of his private hell. At the house, Eddie Fadal remembered, "He just kept saying, 'It's all over, Junior. It's all over.'"

"It affected Elvis," says Joe. "He started to stay away from booze." Pills were one thing, because the doctor approved them. But drinking had killed his mother and now Junior, and other relatives on the Smith side.

Junior's death had a ripple effect with Elvis: a fascination with cadavers, and a thirst for knowledge about death. When Junior was still at the Memphis Funeral Home, being embalmed, Elvis and Billy made a nocturnal visit.

"We went up about 3 or 4 A.M. The door was locked, but a guy let us in the back way. We viewed the body, and then Elvis said, 'Let's ease on back and see how they do this.'"

They went on down a dim hallway, passing through a casket display room, and followed a noise through the dark. Billy became frightened, but Elvis led him on, and finally they happened on two morticians. One was working—he had rock-and-roll music playing—and the other was lying in a casket, snoring.

"May I help you?" asked the one.

"I'm Elvis Presley. You've got my cousin up there, and I was just fascinated by all this."

"You're not supposed to be here," he said. But because it was Elvis, he and Billy got a tour and a brief education on the fine points of embalming.

After that, Elvis would sometimes take new girlfriends to the funeral home in the middle of the night. It was a test, of sorts. He'd whip back the sheets covering the corpses, and if they could handle that, they could handle anything.

Joe puts it down to Elvis's interest in the unknown, part of his exploration of God and heaven and the afterworld. But, he also admits, "He would do things to shock people, anything out of the ordinary." Bottom line, says Joe, "Elvis was not a normal human being. He was just bizarre."

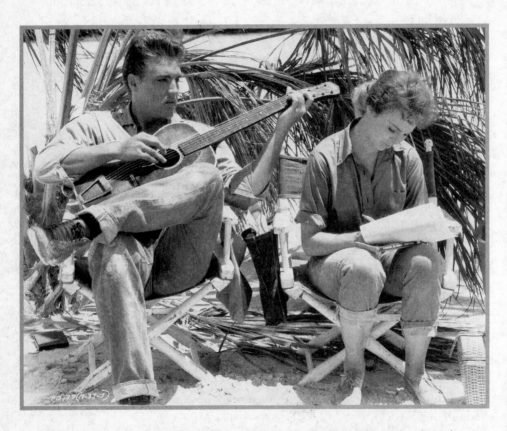

Elvis's romance with Anne Helm on *Follow That Dream*, shot in Florida in the summer of 1961, wouldn't survive once they returned to California. But she remained impressed with how he treated his fans, calling his kindness "One more thing to love Elvis for." *(Robin Rosaaen Collection)*

TWENTY-ONE

.

Going Under

While Elvis was busy with his twin obsessions—music and movies, pills and women—the Colonel worked feverishly to polish his client's image as a patriot. When Elvis was first discharged from the army, Parker had wrangled Tennessee Senator Estes Kefauver into reading a tribute to the new sergeant into the congressional record. "To his great credit this young American became just another G.I. Joe," the senator said in puffed-up prose. "I for one would like to say to him yours was a job well done, soldier."

Tennessee Governor Buford Ellington and Memphis mayor Henry Loeb now joined forces to declare February 25, 1961, "Elvis Presley Day." It was historic in more ways than one: At a special luncheon at the Hotel Claridge, RCA presented the singer with a diamond watch to honor record sales of more than seventy-five million. And later on, at Ellis Auditorium, he played two Memphis charity shows, his first live performances in three years.

The hometown paper raved that Elvis successfully blended "Negro cotton field harmony, camp meeting fervor, Hollywood showmanship, beatnik nonchalance, and some of the manipulations of mass psychology." Of the $51,612 raised, $47,823 would go to thirty-eight foundations and funds in the Bluff City, the remaining money to the Elvis Presley Youth Center in Tupelo. The contribution built on Elvis's yearly donation to a long list of Memphis-area charities, with input from the governor.

Fewer than two weeks later, Elvis stood before the Tennessee State Legislature in Nashville. His appearance, staged by the Memphis delegation, was designed to thank him for his financial contributions, and to raise the city's profile

around the world. Governor Ellington, born in Mississippi and reared on gospel music like Elvis, also hoped the event would draw attention to tourism throughout the state.

The governor's teenage daughter, Ann, attended college thirty miles away, at Middle Tennessee State University. She skipped classes that day to go to the capitol building, where her father would first meet Elvis in the governor's suite of offices. The event had been well publicized, and all of capitol hill was jammed with cars and people standing outside. Everybody hoped to get a glimpse of Elvis.

As Ann remembered, the governor's staff had been waiting quite a while, seated around the conference table, when all of a sudden the door opened and, "Here this entity was standing in the doorway [with] this black suit on, and every hair immaculately combed. There was absolutely dead silence in the room. It was just like somebody had sucked all of the air out of it."

Elvis shook hands with Governor Ellington and sat down at the end of the table and talked a minute. Then when the sergeant at arms announced it was time to go, Elvis hit on the governor's daughter.

"You're going, aren't you?" he asked.

The pretty blonde said no, she wasn't scheduled to be part of it.

"I need for you to go," he said.

Ann blushed and broke into a smile.

"I don't think I am supposed to go. There's not a seat up there for me." She knew that seats were at a premium.

But Elvis didn't care about any of that. "Yeah," he said. "You've got to go."

He grabbed her hand, and when Ann looked at her father, the governor nodded his approval. Then out they went, through the crowd, down the hallway, up the steps, and down into the opening of the legislature. After the governor and the speaker of the house made their remarks, Elvis went up to the podium. "Of course, the people just went bananas—you could hardly hear him because of the screaming," Ann says. Before he left that day, Elvis became a Tennessee colonel, and he thanked the legislature for "the finest honor [I've] ever received." After that, Elvis went to the state penitentiary to see Johnny Bragg of the Prisonaires, whose long-ago newspaper profile had led him to Sam Phillips.

Ann went with him, and then Elvis, with Joe and Alan in attendance, took her to the governor's residence, where they sat awhile and talked. It was "kind of awkward" for both of them, Ann thought, and before long, Elvis turned and said good-bye and headed off to Memphis.

The next weekend, he was back to record at RCA's Studio B. He called ahead and asked if she were going to be in town, and she invited him back out to the residence, where a uniformed highway patrolman greeted him at the door. "Elvis thought that was so neat."

They talked for the better part of the evening, just the two of them in a small living room downstairs. He reminisced about Mississippi and talked about the movies he had done and hoped to do, telling her each one was a stepping-stone, "and that he wanted to get scripts that would show the talent that he knew he had."

The hour grew late, and Ann's parents were upstairs. "About two o'clock, there was a knock on the door, and the sergeant who was on duty at that time, said, 'Miss Ann, the governor's just called down and says he thinks it's time for the gentleman to go.'

"Elvis rose then, saying, 'Well, I'll see you tomorrow evening,'" which was an invitation for her to go to the recording studio with him.

"After he left, the two patrolmen were absolutely rolling on the floor laughing, and I couldn't figure out why. And then the sergeant told me, 'Well, that wasn't exactly what your father said. What he said was, 'It was time for the Hound Dog to go.'"

Over the next two days, Elvis recorded the mellow *Something for Everybody* album, Scotty Moore and D.J. Fontana from the old days sitting in with the Nashville "A-Team," which included Hank Garland (guitar), Bob Moore (bass), Buddy Harman (drums), Floyd Cramer (piano), and Boots Randolph (sax).

Soprano Millie Kirkham, who often worked with the "A-Team," came in for backing vocals, and Elvis was glad to see her again. He had loved her distinctive high harmony since they recorded "Blue Christmas" together in 1957, and he was always respectful in her presence. On their first session together, she was six months pregnant, and he asked for a chair for her. When one of the players used foul words, Elvis brought it to his attention, saying, "Please watch your language. There's a lady present."

Now he was equally protective of Ann, camouflaging her to bring her into the studio, where she sat off to the side or the back. He would invite her there more than once, and, as if for inspiration, "He always wanted me where he could see me, or at least acknowledge that I was standing behind him." That first night, he played her "Can't Help Falling in Love," which he was about to record in California for the soundtrack of *Blue Hawaii.*

In time, he would try to shield their relationship from the press. "When it got time for us to leave the governor's residence, I always had a highway patrolman with me, who drove me over to the motel where Elvis was staying. And then we switched cars, and I would go to the studio with him. Then when everything in the parking lot was quiet and nobody was there, we would run in. We would be there till early in the morning, and then go get some breakfast, or come back to the residence. Then he'd turn around and head back for Memphis."

Rumors flew that Elvis was secretly courting Ann and that the two were a heavy item. "I think any female who had an opportunity to sit down and meet him, even for five minutes, would find a love for him that words cannot describe," she says. But she didn't want an affair, or a fling, or any kind of romantic situation, really. "It wasn't that I was trying to create a spot in his life for me. We enjoyed our friendship."

Aside from their physical attraction, Elvis took a parental interest in her and apparently saw her as a twin substitute as well. When he told her, "I need for you to go" into the legislature, he meant it. As he had done with Priscilla, he formed a bond with her based on mutual loss and displacement.

"He came into my life at a time that was very crucial for me," Ann says. Her father's political career had taken "a thirteen-year-old girl from a farm life and put me in a place that I was not accustomed to, was not prepared for. Elvis had the same kind of situation, just in a different world. He helped me adjust more than anybody else . . . I could tell him things that I'd never told anybody."

In turn, he gave her advice on how to deal with situations, like "how not to let hurts get to you so bad that you couldn't deal with them. He had already experienced so much of that, and I was just beginning it."

But while they came from similar backgrounds, they both "pretty well knew where life was going to take us," and that Ann was not meant to be the wife of an itinerant entertainer. And so the romance faltered, even as they continued to care about each other. "I always knew that if I ever needed him at any point in time, all I had to do was pick up the phone and call and he would be there."

· · · · · ·

A week after the Nashville studio sessions, Elvis was on the Paramount lot in Los Angeles to begin work on *Blue Hawaii,* which would costar thirty-five-year-old Angela Lansbury as his mother. After the flat response to Elvis's last two dramas at Twentieth Century-Fox, Hal Wallis had brought in two proven entities for the return to the musical format—Hal Kanter, the writer-director of *Lov-*

ing You, who would pen the story, and director Norman Taurog, who had been at the helm of *G.I. Blues* and would go on to direct seven more Presley pictures.

Once again, Kanter drew on a piece of Elvis's autobiography to shape the framework. As Chad Gates, Elvis is fresh out of the army, but instead of returning to the Mississippi Delta, he goes home to the fiftieth state. Hawaii had been admitted to the union only two years before, and the milieu was wondrous to most moviegoers. It was also a place dear to Colonel Parker's heart, since Parker had spent his first hitch in the service at Fort Shafter.

As the plot unfolds, Chad rejects the notion of going into the family business—his father supervised a pineapple company—preferring to work as a tourist guide, along with his Hawaiian girlfriend Maile (Joan Blackman). Romantic diversion comes in the form of Abigail (Nancy Walters), there with her underage charges. "Mr. Gates, do you think you can satisfy a school teacher and four teenage girls?" she asks. "Oh, I'll sure try, ma'am," Chad answers.

On March 25, 1961, the cast and crew flew to Honolulu for location shooting. But the Colonel had also booked Elvis to perform a benefit show that evening to raise money for a memorial to the U.S.S. *Arizona,* the battleship in which 1,177 seamen were entombed after the surprise attack at Pearl Harbor. President Dwight D. Eisenhower had approved the creation of the memorial in 1958, while Elvis was in the army, and Parker had worked feverishly behind the scenes to attach himself and his client to the cause.

The show, in Honolulu's Bloch Arena, where the audience never stopped shrieking, "not for one minute," according to Joan Blackman, raised more than $62,000. Elvis, wearing the jacket to his gold lamé suit, was both energized and uninhibited. At twenty-six, he was also at his physical peak, looking lean, hard, and well tanned, after producer Wallis issued strict orders through Colonel Parker that his star get in shape, watch his weight, and use a sun lamp.

Colonel Parker had booked country comic Minnie Pearl as an opening act for the show, but until they landed at the Honolulu International Airport, she hadn't realized "how encapsulated Elvis was in his fame." As three thousand screaming females rushed to surround the plane, "I began to get these chilling feelings that maybe I didn't want to be all that close to Elvis—the fans were all along the route he was taking to the [Hawaiian Village] hotel, and my husband was afraid that we'd be trampled trying to get inside. I felt myself being lifted completely off my feet by all these people."

On the afternoon following the show, Minnie, aka Sarah Cannon, joined some of the musicians down on Waikiki Beach, "cavorting and kidding and

having a big time. We got to talking about how we wished Elvis could come down and be with us, and we turned and looked up at his penthouse, which was facing the ocean. He was standing on the balcony, looking down at us, this solitary figure, lonely-looking, watching us have such a good time. He was literally a prisoner because of the fans. We sat there on the beach and talked about how it would be—what a price you pay for that sort of fame."

Elvis had a different experience from the balcony when nineteen-year-old cast member Darlene Tompkins visited his penthouse. "His buddies had gone out onto the wide patio which overlooked the beach, and they started yelling to him, 'Elvis, come out here, some of the girls on the beach want to see you!'

"I realized he was ignoring them, and I finally said, 'Elvis, those are your fans. You really should go out there and let them see you.' He hesitated and then said, 'I probably shouldn't.' Whereupon I asked, 'Well, why not?' He kind of sighed for a second and then said, 'Okay, come on out here with me, and I'll show you what always happens.'

"The two of us walked out onto the patio, and an immediate cheer went up from the crowd of people, mostly beautiful young women. No sooner had we gotten to the railing before a number of the young females began taking their bikini bathing suit tops off and waving them around in the air, while the ones wearing one-piece suits pulled their tops down, trying to catch his attention. Elvis immediately yelled, 'Come on now, girls, don't do that,' which was quickly met by a resounding, 'Keep doing it! Keep doing it!' from Elvis's guy friends. Elvis looked sheepishly at me and in an embarrassed tone, said, 'That's what the girls always do.' "

Darlene, who played one of the teenagers, had first run into him in the hallway of the hotel, where he said, "Hi, how are you?" in "a very soft, friendly voice." She doesn't remember what either of them said after that because, "I was so nervous and my legs were so wobbly I was afraid I was going to fall to the floor right there in front of him. I just remember thinking as we stood there chatting, 'I can't believe how beautiful he is, more so than in any picture I've ever seen of him.' It was an experience I'll never forget."

Later, they expanded their friendship to kissing, though Elvis also became interested in Pamela Austin (then billed as Pamela Kirk), who played another of the students on tour with their teacher, and who would also appear in a later Elvis movie, *Kissin' Cousins.*

His more intense love interest was his scripted girlfriend, Joan Blackman, who bore a slight resemblance to both his mother and to Priscilla, Joe Esposito

thought. Joan understood the attraction: "He was always looking for someone with black hair and blue eyes, and I had that naturally." She was cast in *Blue Hawaii* only eleven days before shooting, replacing Juliet Prowse, who made too many demands for Hal Wallis's liking. The day she walked on the set, Joan says, Elvis approached her and said, "Man, you're beautiful." Joe counts their romance as one of Elvis's "real relationships," though it was brief.

"We had rooms next to each other in the hotel, and for weeks we just about lived together," she has said. But she was serious about her work. "If it came to a toss-up between meeting Elvis for dinner or getting my sleep because of having to be on the set the next day, my work always won." She also objected to the entourage: "It's hard to talk with eight people at a time and really relate."

Joan, who had competed in beauty contests as a young child and began singing and dancing professionally at age eleven, claims to have met Elvis at Paramount in 1957 and dated him for a year before he went into the army.

"There was something between us . . . he had really liked me [when I knew him before], and some of that rekindled on the set. Had I not been dating someone else at the time we filmed, things could have gotten serious between us."

Blue Hawaii, for all its lush tropical settings and sentimental romance, was not a particularly fun movie to shoot, Joan says, as Hal Wallis "was not the kind of person that you had a good time with. Our sets were very serious. . . . In certain dialogue scenes Elvis was very nervous. He used to hold my hand until I thought he'd never let me go."

To break up the tension, whenever something went wrong on the set, particularly if one of the guys accidentally ruined a take, Elvis would cup his hands around his mouth and mimic a loudspeaker: "Flight 247, now leaving from Honolulu to Memphis, with Charlie Hodge on board."

"He needed to do stuff like that because he was not at ease in front of the camera," in Joan's estimation.

On the other hand, Joan thought that Elvis was too passive. He rarely asked to change dialogue that he found difficult. And unlike in his prearmy films, he usually accepted direction he didn't agree with rather than question it.

"It takes a lot of courage to take a chance and fight for it, to say, 'I want this.' I don't think he could handle that. He didn't want to make waves."

Joe Esposito blames it on Elvis's military experience and his renewed respect for authority.

"The army calmed him down, but it hurt him more than it helped him, because it tamed him too much. When he came out, he became more oriented to

do what he was told. And because of his upbringing, he could never stand up to a person who was older than he was. He could scream and yell and chew us out, but he was taught to always respect his elders. That hurt him in his career. He should have said, 'This is what I want to do. Let's try it, and if it doesn't work, I'll understand.' That's why he made so many mediocre movies."

He particularly put too much trust in director Taurog, Joan thought, as well as other directors down the line. Had he gone along with some of his own instincts, "He might have done some different kind[s] of films."

Blue Hawaii, Elvis's first bikini picture, followed the musical format of *G.I. Blues*—fourteen songs in all, three more than even its model. But it easily surpassed it at the box office, and quickly recouped its $2 million budget. In placing Elvis in an exotic locale, and wedding a plethora of romance to nonstop music—the film's biggest hit, "Can't Help Falling in Love," fell just short of number one, and the soundtrack topped the charts, selling two million copies in the first year alone—Wallis had perfected his winning Presley formula. The popularity of *Blue Hawaii* doomed Elvis's chances of ever returning to serious dramatic fare, and only rarely did he even attempt to venture beyond the film's stifling structure.

Nearly all the Elvis movies produced after the release of *Blue Hawaii* would be assembled around his personality—or Hollywood's conception of it—just as films had once been fashioned around such female stars as Mae West and Shirley Temple. The Wallis productions were the last Hollywood vehicles guaranteed to pull a reliable gross solely because of their star. This led the producer himself to remark, "A Presley picture is the only sure thing in show business."

· · · · · ·

Elvis's next film, Follow That Dream, *for United Artists, also sent him to a sunny* clime, this time to Crystal River, Florida. Based on Richard Powell's novel *Pioneer, Go Home,* and produced by David Weisbart (*Love Me Tender*), the film attempted to meld comedy and social satire. But in failing to capture the humor of rural southerners, director Gordon Douglas ended up with something akin to a "Li'l Abner" cartoon, an embarrassing mishmash of a movie about a blended family, welfare, and homesteading.

Still, there were highlights. "Elvis was really good in that film," in the estimation of his costar, Anne Helm. "I thought he was a wonderful actor. He had a scene where we were in a courtroom, and they had hired all the townspeople to be extras. . . . He turned to them and gave a very emotional speech about why

the children should not be taken away from us. He was so believable that he had the townspeople in tears. It was interesting to see, because I had never thought about him as an actor."

When Elvis learned that he would be spending nearly three weeks in Florida, he sent word to Jackie Rowland, his Jacksonville sweetheart, asking her to come to him. She was nineteen now, but her mother still frowned on her friendship with Elvis and had refused Gladys's invitation to visit Graceland. Now Marguerite waffled on whether she would let her daughter go to Crystal River. ("You will go when I will take you.") By the time they finally arrived, says Jackie, "Elvis had gone, and left a message that he couldn't wait for me any longer. I knew at that point that it was a hopeless cause for the two of us." Never again would she receive an invitation from him, though he would have RCA send her albums into the 1970s.

Elvis had his hands full of women in Crystal River as it was. He was romancing both of his costars, the voluptuous, Toronto-born Helm and the southern beauty Joanna Moore.

Of the two, he had an easier time with the down-to-earth Helm, whom he allowed to "become one of the guys" and join his poker games with the Memphis Mafia. "I lost money. One time I had to write a check to Elvis to cover my loss. He didn't cash that check for a long time."

In many ways, her character mirrored Elvis's fantasies about Sandy Ferra and Priscilla Beaulieu. As Holly Jones, Anne played a live-in orphan who grows up under Elvis's protective eye, maturing from a scrawny teen to a young woman. "You know anything about sex, Holly?" his character asks.

"I really fell for Elvis, I mean, who wouldn't? We did have a romance, and it was quite wonderful." She wrote poetry about him during the day, and at night, they went for drives in his Cadillac, flying through silhouetted palms and scrub oak along State Road 40, Elvis fiddling with the radio dial.

"It was so strange when 'Hound Dog' would come on, and there I was, sitting next to him." The evenings usually ended up with more than a romantic drive, though. "He really liked sex. A lot of nights I didn't go back to my own bungalow. I felt a little ashamed about it the next morning, because I knew that the people on the set realized what was going on." At the same time, "I had fun. And it was special."

Though she had been a showgirl at New York's Copacabana nightclub, she hadn't realized the extent of Elvis's fame until she accompanied him to Weeki Wachee Springs, Florida, on July 30, 1961, for a special ceremony honoring his

achievements. There, the Colonel, reliving his Florida carnival days, arranged for a mermaid show of what the ol' hustler dubbed the Elvis Presley Underwater Fan Club.

Thousands of people showed up, "and they were behind a wire fence to keep them away from him, because they were crazed," Helm remembers. "I was really overwhelmed by it, because I'd never seen such madness for someone." She was equally surprised that Elvis stayed and signed autographs for several hours. "I was so touched by that. He really revered his fans. He was lovely with them." They brought out all "the sweetness and cream in him," she thought, watching him walk along the fence, talking with people.

She continued to see him when they returned to California, but she found it more difficult to date him there, where he no longer knocked on her door and brought her flowers, and where his parties consisted of carpet-to-carpet women, mostly young girls. One night at the piano, he said something to her that angered her, and she pulled the piano lid down on his hands. It hurt his finger, and "He was really mad, for the first time, at me." She apologized, but it didn't seem to help, and the next day, she went out and bought a gag gift, a big rubber thumb, and sent it to him with a note. Still, "I never heard from him again."

She knew to give up and to cherish what now seemed like a shipboard romance in Florida. In California, "He had many lives, he had many women around him. It wasn't like Crystal River, where I had him all to myself every night."

But that was only because Elvis had become frightened of Joanna Moore. According to Joe Esposito, her reputation for promiscuity preceded her on the *Follow That Dream* set, and "sure enough, they went off together." The affair was short-lived, however, because Elvis found her strange and emotionally fragile. She spoke in a voice that was both high-pitched and tense, and she was far too effusive with both the guys and with Elvis, declaring her love for him almost immediately. When she became clingy, he quickly moved on to Anne.

However, when filming resumed in California, Joanna was not to be ignored. She showed up at Elvis's door late one night, looking terrible, "as if she'd just climbed out of bed," Joe remembered. Slurring her words, she demanded to see Elvis. When Joe told her Elvis was asleep, she began crying and tried to force her way into the house. She passed out in Joe's and Charlie's arms, and after Charlie got a wet cloth and revived her, Joe asked her what could be so important that couldn't wait until morning.

"Elvis got me pregnant," she moaned. "And I took a bunch of sleeping pills. I have to talk to him!"

Charlie and Joe took her to the UCLA Emergency Room, where doctors pumped her stomach. The next morning, the guys told Elvis what had happened.

"Make sure you call and find out how she's doing today," he said. "I knew that girl had problems. That's why I stopped seeing her."

As for the pregnancy, Joe says, the doctors saw no evidence of it.

On his next picture, *Kid Galahad,* a remake of the 1937 boxer film of the same title, Elvis was once more romantically paired with Joan Blackman. He had requested her on the film, but by the time it went into production, he was also involved with twenty-three-year-old Connie Stevens, who he'd seen in the *Hawaiian Eye* television series. As soon as he asked her out, "I knew," she says, "this was a fellow who could break your heart." Still, she couldn't resist him: "He was just so beautiful. He had mischievous eyes that darted around the room."

She saw him on and off for two years. "I really cared about him. I cared what happened to his life." And so she worked on him to find a way to live a more normal existence, to not be so isolated and such a prisoner of fame. He no longer walked around with a wallet. ("Elvis never carried a dime in his pocket, no matter where he went," says Joe.) And when it came to women, it was as if he had forgotten how to date. As for being mobbed, once he got past the gate girls, who waited all day and night for him to come out, surely he could just go to dinner and a movie in the film star capital of the world, couldn't he?

"He finally listened to me long enough, and we went to Grauman's Chinese [Theatre], and I thought, 'I'll never put this guy through this again.' I remember Joe put money in his pocket, and he was nervous as hell. And we went out in the car, and he wore his favorite cap, and we ran out of gas. He was just panic-stricken. 'Don't worry, we'll push this car.'"

They managed to get the car into a gas station, but as he had done in Germany, he missed the beginning of the picture, because he was afraid too many people would recognize him going in, and he missed the end of the picture, so they could get out without being bothered.

"Sure enough, we got out into the car and we were going home, laughing about the whole night, and he went to reach for his favorite cap, and it was gone. That was so typical, people wanting a piece of him all of the time."

Connie wanted something too, of course: She wanted a part of Elvis's heart. "But one of the things I knew instinctively was that he probably couldn't be captured, and shouldn't be captured, because he was so special that he needed to be in the world. He was a very dear, precious person."

Of all the men she dated—she would later marry Eddie Fisher—Elvis was her

father's favorite. "He was one of the loves of my life," she admits. "I could have spent a lifetime with him. And I knew it was never to be." Not only were the other women a problem, she says, but to be with him, "you had to follow the crowd." Like Joan Blackman, "I got tired of going out with eleven guys for dinner."

By spring 1962 the entourage included Joe, Gene, Lamar, Alan, Billy, and Ray "Chief" Sitton. Sonny, Red, and Charlie were still part of the Mafia, though they all sought independent work, Sonny and Red in Hollywood, and Charlie with country singer Jimmy Wakely. Cliff would continue to be hired and fired with regularity, and Lamar would soon be gone, though only temporarily, after a blowup with Elvis.

Patti still worked her hairdressing job, but she went wherever Elvis was three days a week and remained a fixture at the house whenever he was in California. And Marty Lacker, who had first started coming up to Graceland in 1957 but had just now officially joined the group, would weave in and out in the early 1960s. Marty would quickly develop a fondness for pills, mostly downers to round off the high ends of his intensity.

Elvis now began traveling cross-country in a 1962 Dodge motor home, replete with double bed, two bunks, a kitchen, and air-conditioning. He paid in excess of $10,000 for it and planned to have George Barris, "Customizer to the Stars," who'd transformed Elvis's 1960 Cadillac limousine into a "solid gold," Vegas-ready extravaganza, add the finishing touches.

And there were other changes. At the end of 1961, Elvis decided he'd outgrown the Perugia Way house—neighbors complained that the girls out front made the place look like a male bordello—and moved to another rental property, an elegant Italian villa just around the corner at 10539 Bellagio Road. The mansion was "very grand," says Joe, and came with a butler.

They had been there only a few days, according to Alan Fortas, when Elvis mourned the fact that he hadn't brought along the source of much of his fun on Perugia Way—a two-way mirror, which he used to spy on the guys and their dates in the den. It was small, maybe three feet by two feet, but it fed Elvis's growing interest in voyeurism, and the guys loved it, too, even if the women didn't. Tuesday Weld came over one time and looked through it and called them all a bunch of adolescents.

On Bellagio Road, Sonny got the idea to install a new mirror in the cabana, where female guests changed from their street clothes into their bathing suits. It was huge—the size of a picture window, five by five—but it worked only at the back of the cabana, which meant the guys had to crawl under the house to see

anything. The first time girls came over for a swim, Alan was surprised to see Elvis with dirt on his cheeks and a big smear across his forehead.

"I can't believe you crawled under there. Hell, Elvis, they'll *let* you look!"

Elvis thought about it for a second. "Yeah," he said, "but it's a lot more fun this way."

The Bellagio Road home was the scene of many memorable parties, particularly as Elvis had recently acquired a forty-pound chimpanzee named Scatter, the retired star of a children's TV show in Memphis. He was a perfect party animal, since he naturally gravitated toward women, sticking his head up girls' skirts, unbuttoning their blouses, and hiding behind the bathroom door to scare the wits out of them.

The first time Patti Parry came over after Elvis brought Scatter out to California, he came in the room screeching, with his hands up, every hair standing on end, and Patti thought he was going to attack her. Scatter only wanted to look up her skirt, but when she told him to stop and he didn't, she said, "You do that one more time, and I'm going to knock the hell out of you."

"Naturally, he did it again," Billy Smith says, and Patti hit him under the chin, and he did a back flip and landed on the couch, dazed. "He looked at her like he couldn't believe it," in Billy's description. "Scatter had a head like a bowling ball, but she put a dent in it."

Alan and Sonny found his antics hilarious. Sometimes they sent him into a bedroom where a couple was making love, and Scatter would get excited and jump on the guy's back. Elvis thought it was funny, though he was embarrassed when the chimp would masturbate in front of his female guests. ("Believe it or not, we did not teach him to do that," says Marty Lacker.) But it fascinated Elvis, who was becoming more and more interested in all things sexual. Soon he would ask Alan to have soft porn films made for him, often of two girls wrestling in white cotton panties. It was a flashback, of sorts, to his childhood turn-on—seeing his two aunts dancing together and waving their skirts up in the air.

Patti says it's important to remember the context of such things. "Listen, you gotta realize," she says. "Nineteen-year-old truck driver overnight becomes superstar and super stud, which he wasn't."

Scatter's days were numbered, especially when he became destructive. He tore up the drapes in hotel rooms, punched a hole in Elvis's 35 mm projection screen, and bit the hired help. One evening, he got out and ruined a neighbor's fancy cocktail party, the guests jumping up on the tables and the backs of couches as he roared through the house screaming "Whoo-whoo-whoo!"

Alan usually took care of him, but because he had no one specific master, Scatter simply couldn't be controlled. He eventually brought out the worst in the guys—Lamar hated him, and poked him with a cattle prod, and Elvis whacked him with a pool cue.

Eventually, they took him back to Memphis, where he lived in a cage behind Graceland. Even there, he was a little terror, tearing the wig off a maid named Daisy when she went to feed him. He died not long after, hanging on to the side of the cage, hard as a brickbat, with his long arms out and his legs bowed. Elvis always wondered if Daisy had poisoned him.

· · · · · ·

Elvis's own treatment of Scatter was indicative of how his behavior continued to change in the wake of his frustration over his film career and his escalating dependency on drugs. In 1962, also on Bellagio Road, his temper began to show more and more with the women who attended his parties. He got so mad at an actress that he picked up a watermelon and hurled it at her like a missile and hit her in the rear. But the more famous incident came with a girl named Judy who Elvis thought failed to mind her manners.

She had tried to get his attention, and when he went downstairs to play pool, she followed him and continued her pursuit. Finally, he had to say, "Look, I'm shooting pool, and I'm going to finish this game before I do anything else." With that, she took the cue ball off the table, and he flushed with anger.

"If you do that again, they'll have to surgically remove it," he heatedly told her.

She stared him down. "You're a smart-ass son of a bitch, aren't you?"

No one called Elvis a son of a bitch—to him it was a slur against Gladys, and he launched the cue stick before he even knew what he had done, hitting the girl in the chest near the collarbone and almost harpooning her. "She fell right over," Joe remembers. Elvis rushed to see about her, though he didn't apologize, and he had one of the guys take her to the doctor. "That was the first time I saw him really, really mad, just unbelievably mad," says Joe. Later, he cried.

In Lamar's view, "Elvis had no parameters. He moved the lines of behavior wherever he wanted them, and if he went too far, he moved them out farther. His discipline was nonexistent. And the more insulated he got, the stranger he got."

In March 1962, Elvis began preproduction on *Girls, Girls, Girls,* his first picture for Hal Wallis after *Blue Hawaii.* Wallis sent him back to Hawaii for location shooting, and again assigned sixty-three-year-old Norman Taurog to direct.

The producer was now certain that Elvis was best showcased as an enter-

tainer specializing in light musical comedies, and not as an actor. To that end, Elvis would begin a long series of movies in which he would play the carefree bachelor with an offbeat occupation. The plot almost always turned on some feeble predicament over which he would triumph, winning the girl in the process.

For *Girls, Girls, Girls* he was cast as a charter boat pilot who moonlights as a lounge singer to buy a sailboat that once belonged to his father. The musical numbers were slighter than those in *Blue Hawaii,* and Elvis was humiliated by having to sing to a crustacean ("Song of the Shrimp") and warble about the joys of ocean fishing ("We're Coming in Loaded"). He channeled his discontent through karate, breaking as many as forty boards a day in his hotel suite until Wallis stopped him, fearing the star would injure his hand.

For Elvis, the film's saving grace was the obvious hit, "Return to Sender," which soared to number two and stayed on the charts for fourteen weeks, following on the heels of several other huge records, "Can't Help Falling in Love," "Good Luck Charm," and "(Marie's the Name) His Latest Flame."

Yet one more song, "The Walls Have Ears," a dance number with costar Laurel Goodwin, became a private joke with Elvis and the guys. "He dressed in the black trousers made for the scene," Joe wrote in his autobiography, "without putting on underwear. Elvis rarely used underwear."

"Hey, Joe, these pants don't feel right," he told him. "They're rubbing me the wrong way."

"The dance scene was complicated," Joe continued. "The apartment was rigged for special effects, including a coffee table that bounced around the floor and a ceiling that crashed down a few seconds after Elvis and Laurel jumped backward, out of the way and onto a floor model record console. At some point during all the wiggling and jumping, 'Little Elvis,' as he called it, became erect."

Director Taurog didn't notice, and when Elvis came off the set, he walked straight to the nearest chair and sat down.

"Did you see that?" he whispered to Joe. "I couldn't stop the feeling. Geez, I hope they don't have to reshoot this. The ceiling might get me this time."

Of course, Joe told all the guys, who teased Elvis mercilessly.

When he went to the dailies, Elvis nearly leapt from his seat. "Hot damn!" he said, "Will you look at that?" There was no mistaking the woody, which was not only obvious, but prominent. Joe tried to quell his fears, saying the studio would probably cut it out in the editing.

"Man, I hope they don't see it and decide to cut it off before we get out of here," Elvis cracked.

But when the film was released, there was "Little Elvis," rising to attention and aimed directly at Laurel Goodwin.

On the whole, says Goodwin, whose character vied against Stella Stevens's for his affection, "Elvis did not like this film. . . . Once he commented to me, 'One thing about working with Wallis is that he spends a lot of money on the production, the accommodations, the catering, because he has me so cheap. With the money he makes on my movies, he then can afford to go off and do *Becket*.'"

Elvis got along well with Laurel, who was Wallis's second choice, replacing Dolores Hart, who had decided to enter the convent. Laurel, who was nineteen years old and making her film debut, found Elvis surprisingly sweet and attentive. He told her that he had lost Gladys four years before, and "truly believed he would one day rejoin his beloved mother." The teen actress spent a lot of time with Elvis and the guys, who "all treated me like protective big brothers."

However, Elvis seemed to clash with Stella Stevens. On the surface, they should have gotten along, as Stella, a year younger than Elvis, was born in Mississippi, grew up in Memphis, went to Memphis State, and had once worked as a model in the tearoom of Goldsmith's department store. But according to Goodwin, she "had to be ordered by Hal Wallis, to whom she was under contract, to do the film."

Stella concurs that she wasn't keen on making an Elvis Presley picture ("I was looking to work with great actors"), and when she read the script, she threw it across the room, calling it "dreck." She was miffed to be cast as the girl Elvis dumps, and as a singer herself, ticked that Marni Nixon dubbed her voice in the nightclub scenes. She never saw the film, she asserts, and never will.

"I was thought of as the bad girl, while Elvis was crazy about little girls in white cotton panties," Stella has said. They never dated, because when Red West called her to see if she wanted to "hang out," she thought Elvis should have called her himself. "They were just a group of boys having fun, but I was a grown woman by then, or life had made me one," says the actress, who married at fifteen, had a child at sixteen, and divorced at seventeen. "I had nothing against Elvis. I thought he was greatly talented."

But the two clashed on his professional standards. "I said, 'Why do you do pictures like this instead of seeking out the best directors in the business?' He said, 'Why knock success?' I wasn't knocking it. I was saying, 'There are no limits to the work you could do, rather than these singin' and a'lovin' and a'fightin' films.'" The longer she talked, though, "the more he disliked me."

In recent years, when a fan approached her for an autograph and asked what it was like working with Elvis, Stevens reportedly said she couldn't stand him,

and that when they were alone together, he forced himself on her, and she had to fight him off.

Whether that was true, more and more, the angry Elvis used physical force with women, including Anita.

In early 1962 she was out in California at the Bellagio Road house when Elvis was making *Girls, Girls, Girls.* She stayed home from the studio one day and went into the library outside Elvis's bedroom and picked out a book. There, pressed inside, she found a letter. "I saw it was from Priscilla."

She stood reading it, just as Priscilla had read Anita's letters in Germany.

"I remember it said something to the effect of, 'Please call my daddy,' and, 'If you call my daddy, I know he'll let me come over there. I want to come over there soooo bad,' like young girls talk."

It took her breath away. "Elvis had said, 'She's a friend. She means nothing. She's a *fan.*'"

She faced him with it as soon as he got home. "I said, 'What is this letter? Who is this, this Priscilla? You said she was just a *child*!' I was just furious, and he was furious, too, because I had found it. Oh, he was so upset! He grabbed me and threw me up against the closet. I said, 'You're telling stories, and everything you said was a *lie*!' I packed my bags and came back home that night to Graceland, to Grandma."

When she walked in the house, the phone was ringing. She didn't want to talk to him, but he kept calling.

"I remember when he got me on the phone, he said, 'Little, please don't tell anybody about this. This girl, again, she's just a child. She's just a fourteen-year-old *child*. It means absolutely nothing. She just wants to visit. And if you told anybody, I'd get in a lot of trouble, she's so young.' He just begged me, 'Little, Little, Little.'

"I just couldn't imagine. Coming over to the United States . . . it didn't sound right to me. But I said, 'I won't tell anybody,' and I never did. I never did tell anybody."

By late 1963, on *Kissin' Cousins*, Elvis had a myriad of women on his mind, including costars Yvonne Craig *(left)*, who dispensed maternal advice, and Pamela Austin. Craig also appeared in *It Happened at the World's Fair*. *(Robin Rosaaen Collection)*

TWENTY-TWO

.

"A Little Happiness"

*By the time Priscilla arrived for a two-week visit on June 17, 1962, she was no lon-*ger a fourteen-year-old girl. Elvis may have still thought of her that way, and even preferred for her to remain fourteen, which could be why he referenced her as that age in his argument with Anita. But in truth, Priscilla had celebrated her seventeenth birthday three weeks earlier. And she was a far more experienced girl than the one who had stood at the air base in Germany and waved good-bye to her soldier boyfriend.

But she was also more insecure about her place in his life. When she saw him on the big screen kissing such glamorous movie stars as Juliet Prowse, Tuesday Weld, and Joan Blackman, she wondered how she could ever measure up to such women. She was a schoolgirl in Germany.

For "two torturous years," as she would put it, Elvis maintained only sporadic contact. Every day she waited for the mail, and every night she listened for the phone. He wasn't much of a letter writer, but he sent her records with clues in the song titles: "I'll Take Care of You," "Soldier Boy," "It's Now or Never," "Fever."

"When I didn't hear from him, I was heartbroken," she has written. "When I did, I was ecstatic." On the telephone, he assured her he still loved her, and no, he wasn't going with Nancy Sinatra or any of those actresses she had read about in *Photoplay* magazine. He hadn't called for the past month because he was making a movie. It didn't mean anything.

But her fear—or possibly her mother's fear—that he had lost interest in her spurred Priscilla to write the letter begging Elvis to bring her to the States. She didn't know what was going on or what to do. And neither did her parents, who

must have weighed the predicament of whether it was better to have Priscilla consorting with reckless boys in Germany or with an international playboy ten years her senior.

Finally Elvis said he would work out the arrangements with her stepfather and send her a first-class round-trip ticket to Los Angeles. "When Elvis wanted something with utter passion," Priscilla says, "he could convince anyone of anything."

Now he went to work on both of Priscilla's parents, speaking with them at length. He wired Captain Beaulieu a detailed itinerary of where Priscilla would be every minute of her two-week trip. He also promised she would have round-the-clock chaperones—either Vernon and Dee, or George and Shirley Barris, who would open their Griffith Park home to her. The captain, so rigid and harsh at home that even his own family was afraid of him, said yes.

The reason, offers Joe Esposito, is not because Priscilla's parents promoted this relationship more than Priscilla, as some suggest, but because "they knew that the two of them were in love. And Elvis loved the military. He was a very patriotic guy, and he had a lot of respect for the captain, and the captain could tell that. So that made him feel good, too."

When the arrangements were in place, Elvis spoke with Patti and the other girls who regularly partied at the house. "I want you to know something," he said, sounding serious. "I met this girl in Germany and we've been talking on the phone a lot. I'm bringing her here." But during Priscilla's visit, the house would be family-oriented: the guys who were married, including Joe, would bring their wives over each night, and the parties would temporarily stop.

Still, there was the problem of Anita. Elvis always spent the Fourth of July in Memphis, but the holiday fell during Priscilla's trip to the States. So Joanie Esposito, Joe's wife, who was pregnant with their daughter, Debbie, was assigned the task of keeping Anita occupied. If Joanie went to Memphis, Elvis figured, Anita would think he and the guys weren't far behind. He could deal with the fallout later.

When Joe picked Priscilla up at LAX that summer day, he found a nervous teenager who had no idea what to expect. He gave her a short tour of Los Angeles, taking her by the film studios where Elvis made his movies, and then speeding along Sunset Strip to the wrought-iron gates of Bel Air and on to the mansion on Bellagio Road. In Joe's memory, "She pretty well didn't say too much. Whatever Elvis said was right, and she did it. Remember, Priscilla was young, naïve, and shy, didn't know too much about the world, and was in awe of Elvis and of the life he was leading."

Indeed, even the airport seemed beautiful to her after the drabness of Ger-

many, and when Elvis's butler, Jimmy, met her at the door ("Mr. P is in the den"), Priscilla could hardly believe such opulence. Joe led her downstairs, where she heard loud music and people laughing, and then she saw him, leaning over the pool table, ready to make a shot. His face lit up, and in dark trousers, a white shirt, a dark captain's hat on his newly black hair, he looked thinner and even more breathtaking than ever.

"There she is!" he shouted, and threw down the pool stick. "There's Priscilla!"

He picked her up and kissed her and then gave her a wide smile. "Let me look at you," he said. "You're all grown up!"

She was embarrassed that everyone was watching—Patti Parry saw fear in her eyes—and she hoped when Elvis looked her up and down that he hadn't noticed the five pounds she'd gained, or that he didn't think her ponytail made her seem too much like a little girl. But he did seem overjoyed to see her, even if he went right back to his pool game.

He was different, though, than he'd been in Germany—mischievous and cocky, with a quick temper. When a girl warned him to look out for a glass tee-tering near the edge of the pool table, he shot her a nasty look, as if to say she should have taken care of it herself. And a few days later, when he played Pris-cilla some of his new songs and asked her what she thought, he "flipped out" when she told him she loved his voice, but she preferred the raw rock and roll to his new brand of polished pop.

"I didn't ask you what style I should be singing," he charged. "I just asked about these songs." Then he called her an "amateur" and stormed out of the room, slamming the door. His moods would continue to be erratic, but she knew his true nature was kind, generous, and romantic.

That night, he sent her alone to his bedroom. "Up the stairs, the first door to your right," he whispered to her. "The lights are on. I'll be right up." They would go separately, so it wouldn't seem so obvious.

Upstairs, she gazed at the luxurious carpets and furnishings and then at his king-size bed. "I immediately thought of how many women might have slept there . . . whose bodies he had embraced and fondled . . . and even worse, whose lips had passionately pressed his and driven him to ecstasy," she wrote in her autobiography. "I couldn't think about it anymore."

She took a quick bath and dusted with powder she found in the medicine cabinet, and soon they were lying next to each other. He told her he hadn't been able to get her out of his mind since Germany—that she had been the one thing that kept him going.

Their kissing was passionate and intense, and as they began to explore each other, he "discovered that I was still as untouched as he'd left me two years before." But her sex drive was even more powerful.

"I was ready," she has said.

He wasn't. "He was glad I had saved myself, but was still committed to my purity. What could I say? What could I do? I wanted him, I know he wanted me, but according to him, the time wasn't right.

"We'll know when," he said and had Joe drive her to the Barrises' home, where she "reluctantly" spent the night. However, that was the only night she spent with George and Shirley. After that, she slept in Elvis's bed.

And so, as President Bill Clinton would do nearly thirty-five years later, Elvis and Priscilla parsed the meaning of what constitutes sex, and then lied about it for years, Elvis insisting to the guys, as Priscilla did, that she was a virgin until their wedding night. ("I believe that with all my heart," Charlie Hodge said.) If they did not have full-out sex, it was because Elvis was content with the foreplay he preferred to intercourse. But Elvis would tell one of his last girlfriends, Mindi Miller, that he and Priscilla had, indeed, been sexually involved long before they married, just as Priscilla confided the same to Billy's wife, Jo Smith. Publicly, meanwhile, she continued to perpetuate the myth.

The day after Priscilla arrived in Los Angeles, Patti Parry did her hair "in that big boom-bah," as Patti puts it. "She had light hair, too, and we dyed it black." It was Priscilla's idea, Patti says, but the seventeen-year-old already knew what Elvis liked, or thought she did. At first, he was critical of it and made her cry. But everything got smoothed over: They were leaving the following day for Las Vegas, taking the motor home and staying at the Sahara Hotel, run by the Colonel's mob friend, Milton Prell.

"She's a nice girl," Alan Fortas told Elvis. "A little *young* maybe." Alan didn't want to come right out and say he thought theirs was an inappropriate relationship. That wouldn't have been his style. Instead he said there were a lot of pretty girls who were legal age. But Elvis insisted that seventeen-year-old girls were a lot more advanced than seventeen-year-old boys. "Yeah," Alan said, "but they're still jailbait."

In Las Vegas, Elvis took the first steps in grooming Priscilla to be his perfect wife. He bought her half a dozen gowns and matching shoes—in part to make her look older, so she could accompany him to adult clubs—and then took her to the famous Suzy Creamcheese boutique for wilder clothes. Finally,

to complete her new look, he asked Armand, a hotel hairdresser, to come to the suite. The cosmetologist then spent two hours teasing and twisting up her hair with one long curl falling at her left shoulder. Then he went to work on her makeup, applying the kohl, mascara, and eyeliner so heavily that no one could have been able to tell "if my eyes were black, blue, or black and blue." When he finished, Priscilla had the classic, exaggerated cat-eye makeup that defined the extreme 1960s Vegas style, replete with two pairs of false eyelashes.

"That was what Elvis wanted," she wrote. "When I put on my brand-new brocade gown, my transformation to a sophisticated siren was complete. I looked like one of the lead dancers in the Folies-Bergère."

More specifically, she looked exactly like Elvis's stripper friend, Tura Satana.

"Goddamn, what happened to Little Cilla," said Elvis, who had darkened his own eyelashes. "You look beautiful."

"Sure doesn't look like the same girl we met in Germany wearing a sailor dress," Joe said.

She had changed in other ways, too. In Germany, Priscilla had only saved the pills Elvis offered her to stay awake during school. But now she took amphetamines and sleeping pills right along with him, to keep up with his hours. She liked the feeling. The pills melted away her inhibitions and put her more in sync with Elvis in every way. But she was moving in a world she didn't know and couldn't handle without the drugs. And deep down she was scared and confused, loaded with lurking anxiety.

The night before she went back home to Germany, Elvis told her he would see about bringing her to Graceland for Christmas, and their lovemaking reached new heights, even if Priscilla was coy in describing it. "Elvis wasn't going to let me go home without my taking a little of him with me," she wrote. "He didn't enter me; he didn't have to. He fulfilled my every desire."

When she stepped off the plane in Germany, Priscilla's parents could hardly believe their eyes. She had left two weeks earlier in a white cotton suit and nothing more than a touch of mascara. But she came home in a tight black dress, with her hair in an architectural monstrosity. Her mother remembers that she "obviously had been crying. Her eyeliner was running, her eyes were red. She looked lost and terribly sad."

Captain Beaulieu was more blunt: "Her eyes looked like two piss holes in the snow." When Priscilla asked to go to the ladies' room to wipe her face, her father yanked her up. "You're going straight home," he barked. "If you left it on this

long, you might as well keep it on another hour." He barely said another word to her until they got home. For a girl whose self-worth had been tied to her physical appearance since she was a child competing in beauty contests, it was devastating.

Now Elvis, too, was in deep, and he faced his toughest Christmas since the year he brought Dottie Harmony to town. If he convinced Captain Beaulieu to let Priscilla return for the holidays, he was going to have to break things off with Anita. There was no way he would not be at Graceland for Christmas. And if he were in Memphis with Priscilla, there was no way that Anita wouldn't know. Anita would expect to spend Christmas with him herself.

"It was a tough choice," in Joe Esposito's estimation. "Anita is a great lady." But Priscilla looked like Gladys, and Anita didn't. In fact, every time he looked at Anita, he was reminded of how he'd disappointed Gladys in not marrying her. Anita was also older and might resume her career at any time. If Elvis were to marry, he wanted a traditional wife who stayed home and cared for the house and family. "He pretty well raised Priscilla to be that way," says Joe. "He fell out of love with Anita because he started dating Priscilla."

On July 10, 1962, Elvis returned to Memphis and resumed his usual activities, playing touch football, renting out the Memphian, and three or four nights a week, watching the night turn to dawn on the rides at the Fairgrounds. As before, Anita was his date, but he knew not to mention Priscilla to her. She'd found out that Priscilla had visited him in L.A., and she knew the teenager was in his life. But Anita convinced herself that Priscilla's youth ruled her out as serious competition and clung to the notion that there were certain kinds of girls that Elvis spent time with, but others he reserved for marriage. Besides, they'd been together five years. It was a real relationship, not some little infatuation.

Then one evening, Anita was coming down the back stairs at Graceland when she heard Elvis, Alan, and Lamar talking in the kitchen, sitting around the breakfast bar.

As she neared the door, "I heard Elvis say something like, 'Well, I'm just having a really hard time making up my mind between the two.' And, of course, I stopped. I knew exactly what he was talking about. Back then, girls had pride, and I was very prideful. So I just marched my little self down the stairs."

They went into the dining room to have their evening meal—breakfast for Elvis—and sat down at the table with Vernon.

"I heard what you just said," she announced, her voice shaky with anger, "and I'm going to make it real easy for you. You're not going to have to make that choice, because I'm going to leave."

She had hot tears in her eyes, and she got up and called her brother, Andy, to come get her. Elvis followed her and put his hands on her shoulders and said, "I hope to God I'm doing the right thing in letting you go." Anita shook him off. She was too hurt for a conversation like that, even though it had been the most difficult decision she'd ever made. "You can't keep me from going!" she snapped. "I'm going!" Then she calmed down and simply said, "It doesn't matter. It doesn't make any difference."

They walked back into the dining room, and "Elvis became very upset, and Mr. Presley began to cry, too." Nobody could eat a bite, and then Vernon said, "Well, if you must leave, Anita, maybe you'll meet again. There are people who sometimes separate and get back together. You'll get back together again." Anita shook her head. "I don't know. I'm not planning on it." Then she left to go upstairs and pack her things.

When she came down, Elvis thought about how she had stopped working to be with him, and then shoved some money down in her purse. But even that angered her. "No," she yelled, "I don't want any money!" She took it out. And then she left.

"It was very hard, but I never went back again as his girlfriend."

She moved home to Jackson, Tennessee, for a while, and later began working for the Memphis city commissioner. Then one day Elvis showed up at her office. "He caught me in the hall up there, and I could never get away from him. He had me cornered talking to me. My goodness, my knees got weak, because I still cared. But I'd made up my mind that it was over."

· · · · · ·

At the end of August 1962, Elvis began work on It Happened at the World's Fair, his twelfth film, and his first in a four-picture deal with MGM. Norman Taurog would again direct. The light musical comedy costarred Joan O'Brien as Elvis's love interest and was set in Seattle against the real-time backdrop of the 1962 exposition. Elvis plays a crop duster in money straits: his partner (Gary Lockwood) gambled away their money, and the sheriff has attached a lien to their plane.

It Happened at the World's Fair is memorable for both the number eleven hit, "One Broken Heart for Sale," and Elvis's sartorial splendor. Hollywood tailor Sy Devore dressed him in conservative suits and ties to make him look "like a smart, well-dressed young businessman," according to producer Ted Richmond. Thus Elvis's metamorphosis from rebellious rock and roller to handsome lead-

ing man was complete. *It Happened at the World's Fair* is also the only picture on which Elvis had the Memphis Mafia dress in actual uniforms—black short-sleeve tunics over white shirts with black pants. It gave them all a slight garage mechanic look, but for Elvis, it was just like being back in the army—each of his troops had his name festooned across his breast pocket, JOE, ALAN, BILLY. The only difference was that now Elvis was the general, in total power and in complete control of his black-suited brigade.

Research on twinless twins such as Elvis has shown an odd, yet consistent and inherent fascination with "uniformity." They commonly talk of being powerfully drawn to groups of individuals dressed alike. The semblance of everyone appearing, if not being, the same—identical, twinned—is at the base of their motivation and intrigue. It gives them a sense of solace and reinforces the notion that they are not alone—a feeling Elvis wrestled with to the extreme once his mother passed away.

While seldom publicly reported, says psychologist Whitmer, "The need for uniformity underscores the difficulty any twinless twin has in communicating to others with a different personal history the strange world in which he finds himself trapped."

The cast of *It Happened at the World's Fair* included two young actors who would go on to distinguish themselves: Kurt Russell, playing a bit part as a bratty child who kicks Elvis in the shin (and would later portray Elvis in a television film), and TV's future "Batgirl," Yvonne Craig, who had a secondary role.

"It was not a good film. I had a small part, and it was a dance number, although I didn't dance. My sister and I went to the drive-in movie to see it, and I didn't want to stay for the rest of it. I just wanted to see how I looked with short hair. After [my scene] was over, I would like to have left, but I thought, 'God, that's really egocentric,' so I sat there bored witless, and my sister did, too. Finally, she said, 'Would you mind terribly if we went?' I said, 'No, no, I'd love it!' I was sitting there dying."

Elvis romanced three of the actresses on the film, including the blond O'Brien, a former country singer who had made the jump to acting and was just finalizing her divorce, and brunette Sandra Giles, whose name appeared near the end of the credits. She was amused when she met Elvis on the set: "He said to one of his men, 'Would you get up and give Miss Giles your chair?' But usually the man gets up and gives you *his* chair." They went out to a steak restaurant in a place where "you had to know the owner to get in," and just sat and talked.

"We had a few dates and he was very nice. He wasn't pushy. He didn't even try to make out."

Elvis was equally genteel with Yvonne Craig, who was impressed at how he interacted with the women on the film. Just as he knew what his female fans expected, he also knew that all of the women in the cast needed his attention.

"It wasn't predatory at all, or it didn't seem so to me. It was more of a southern gentleman thing. He would spend five minutes with each of the girls on the set, one at a time. It was really sweet to see. And it was like having fourteen brothers with the guys. They were all around, lighting your cigarette and asking if you would like another Pepsi."

Yvonne wondered if Elvis was going to ask her out—she could feel a sort of latent heat between them—and finally, he made his move. During shooting, Joe called and made his smooth approach: "Elvis wanted me to ask if you would be free for dinner." Yvonne was dating someone else at the time, but not exclusively, and so she accepted. In an unusual move, Elvis accompanied Gene Smith and Richard Davis, a new member of the group, to pick her up, mostly because he wanted to show off his gold-dusted Cadillac. George Barris had recently customized it, repainting the black exterior in white Murano pearl, and finishing the interior with "solid gold," as Barris liked to say, meaning everything was gold-plated and stamped with a golden guitar insignia. The effect was something between a rock-and-roll chariot and a pimpmobile.

Richard knocked at Yvonne's door and told her that Elvis was waiting in the car.

"I lived in an apartment that was like a cell block or some other kind of lockup—it was all square and you could look down in the patio and see who was coming and going. And when I saw this car, I said, 'Oh, my!' It was the weirdest thing I had ever seen. Elvis said very apologetically, 'I brought this because I thought it might be fun. It's not like I travel like this all the time.'

"It had deep, deep, deep carpeting, so that when you got in, your feet sort of sank in and disappeared. And then he pushed all the buttons for me. It had two telephones, one with a direct line to Memphis. It had a complete entertainment center. It had an electric shoeshine machine, and a bar filled with Pepsi. He offered me one, which I thought was funny. Oh, it was a crazy-looking thing."

When they arrived on Bellagio Road, Jimmy, the butler, served the two of them what should have been a romantic dinner. But the house was so baronial, and the table so long and expansive—it probably sat thirty people, by Yvonne's

estimation—that everything just seemed awkward. "I'm thinking, 'Oh my God, if he sits at the end, I'm so nearsighted I'll never see him.' So I sat at the head of the table and he sat next to me. But because he was shy and I was, too, there wasn't a lot of conversation. All you could hear was the sound of chewing and forks going."

The scene proved livelier when they joined the guys and their dates afterward to watch television. Scatter, the chimp, made an appearance, all dressed up like a person in a little suit and hat. But Yvonne wasn't wearing her glasses ("There was this thing that came into the room and someone was holding on to him"), and at first, she thought he was one of the boys being silly. She quickly caught on when Scatter started jumping around and misbehaving.

"He was really obstreperous, this animal. He would pry your mouth open, looking for gum! And he would belly up to the bar and bang his glass, and they would give him hard liquor and he would drink it. Then when he would get tired of it, he would pour it on the floor. Today, that couldn't happen. Somebody would turn them in for animal abuse, because they shouldn't have been getting this chimp drunk. It's a wonder they didn't kill him. But nobody did anything about it, and this was somebody's rented house with this chimp loose in it."

In a little while, Elvis invited Yvonne to his bedroom on the pretense of getting away from Scatter. Soon, "there was kissing and hugging and stuff like that," but it wasn't particularly passionate, and "there was no sexual relationship at all." At twenty-five, Yvonne was two years younger than Elvis, yet she felt protective of him, and already the brunette sensed he liked her because she reminded him of Gladys. And so she launched into what she calls her "Mother Craig" lecture.

"I said, 'You know, Elvis, it's fine that you brought me here, but this is a dangerous move for you. You're just lucky I'm the way I am, because you have no idea. You should be very careful who you bring here, because you're in Hollywood now, and it's a terrible trap. If you take a girl alone back here in your quarters she can say anything happened—cry rape, scream, carry on—and the courts will say you did it. There will be horrible publicity, and you'll be in a lot of trouble. Do you do this often? I'm worried about you.'

"And I'm telling you, he sat there saying, 'Yes, ma'am, yes, ma'am.'"

On the way home, she suddenly became overwhelmed with embarrassment. After all, he'd been in the business for years and knew all the pitfalls. But "it did occur to me that he needed talking to. He had such innocence that I thought, 'Oh, my God, I don't want anything bad to happen to him,' and he did encourage this sort of motherly interest in him." Besides, "I had seen some of the women the

henchmen had in the house, and I thought, 'I know where they picked up those girls, and I know what they have on their minds, too.' "

However, before she left that night, Yvonne and Elvis found common ground. She mentioned that when she was a teenager, before ballet dancing led to acting, she thought about going to medical school. She'd had her *Gray's Anatomy* and *Cecil-Loeb* since she was sixteen, she said, and to her surprise, "He dragged out medical books and started showing me."

Scooting close to her, Elvis paged through his *Physicians' Desk Reference.*

"Do you have any pills in your house that you can't identify?"

"I don't think so," she said.

"Well, if you do, this book will tell you what every one of them is."

"I thought he was interested in medicine, but now I think he was interested in what you can take to keep yourself skinny, and what you can take that won't be contraindicated with another drug and kill you."

Elvis was, indeed, studying to see what kinds of pills he could take and in what quantity to keep thin, stay up all night, and then rest enough to be bright-eyed on the set. Even so, he made some near-fatal errors.

According to Alan Fortas's memoir, *Elvis: From Memphis to Hollywood,* one occurred that November 1962 on the drive home in the motor home. Elvis and the guys had gone to Las Vegas when filming wrapped on *It Happened at the World's Fair,* staying up day and night to catch the shows, including Johnnie Ray at the Hacienda.

"Gene was wired from all the pills he was taking, plus all the extra that Elvis had given him. In fact, he'd been so wired for three days and two nights on speed that he couldn't sleep.

"We were in Arizona, and it was freezing outside. Elvis was driving the bus, and he gave Gene 500 milligrams of Demerol, a synthetic opiate. Gene took the little white pill and waited to fall asleep. But forty-five minutes later, when he was still stoked to the skies, Elvis gave him another hit. An hour went by, and Gene was still bouncing off the clouds—trying to fix stuff on the bus, working on things under Elvis's feet—trying to do everything, he was so out of it.

"Finally, Elvis told him, 'Look, Gene, go back in my bedroom, man, and get some sleep. Those pills will kick in before long.' So Gene went back in the bedroom, and after a while, Elvis told Billy to go check on him. In the meantime, Gene had opened the window, and a terrible draft had blown in on him. So when Billy tried to wake Gene up and couldn't—the stuff had finally hit him—he felt Gene's face, and it was just ice-cold. Gene's heartbeat had probably slowed

down, and his breathing, too. But mostly he was cold from all that air coming in on him.

"Well, Billy just freaked out. It hadn't been that long since he'd found Junior dead in his bed, and he thought it had happened again. Billy came running back up to the front of the bus, yelling, 'Elvis! Elvis! I think Gene's dead! I shouted in his ear and he didn't move a muscle, and he's cold to the touch!' Elvis pulled over to the side of the road real quick, and he had his seat belt on, and he jumped up so fast the seat belt almost cut his damn legs off.

"Of course, we all ran back there, but Gene wasn't dead. He was just cold from the window being open. He wasn't coming around, though, that was true, so we got him out and dragged him along the side of the highway. He was okay. He'd just been up for three days, and he had two big hits of Demerol in him. It scared the shit out of Elvis, though. He said, 'Goddamn, Gene, I ought to kill your ass!'"

* * * * * *

Two months earlier, while on the film set, Elvis gave an interview to Lloyd Shearer of *Parade* magazine, in which he mentioned that he often read medical texts and would have liked to become a doctor. He also talked about how males seemed to dislike him when he started out, but that his stint in the army changed that, along with "the fact that there's never anything about my thinking that I'm a lover or a ladies' man. I've never looked at, or thought of myself, as being a lady-killer or anything like that. And I've never shown it, that I know of." Finally, he talked about friends, saying, it was "important to surround yourself with people who can give you a little happiness."

Elvis thought he'd found more than that with Priscilla, who was coming for Christmas after all, even though the Beaulieus had never been apart for the holidays.

"At first, I said no," Ann Beaulieu remembers. "But when I saw how much it meant to her, I finally convinced my husband. It wasn't easy."

Vernon and Dee, who now had a home of their own near Graceland, flew to New York's Idlewild Airport to meet the passenger flying under the name of "Priscilla Fisher." They accompanied her to Memphis, and then Elvis asked her to wait at his father's house on Hermitage Road.

"I want to drive her through the gates," he said. "I want to see her face when she sees Graceland for the first time."

He had decorated the grounds with a life-size nativity scene and Santa's

prancing reindeer, edging the walkways in blue lights for his song "Blue Christ-mas."

"When we drove through those gates and I saw the Christmas lights and glittering decorations on those long white columns," Priscilla later said, "I thought I was living inside a dream. Except the dream had come true. I had come home with Elvis."

Elvis and Ann-Margret's love affair on *Viva Las Vegas,* in the summer of 1963, carried over into real life. "It was a very strong relationship, very intense," she has said. He gave her a round bed. *(Robin Rosaaen Collection)*

TWENTY-THREE

.

Nungin, Thumper, and Bug

"*The first time I saw Priscilla,*" remembered Elvis's cousin Patsy Presley, "*she* looked like a little doll. She was exquisite. She was standing in the stairwell and Elvis came out of my grandmother's room. He was so proud of Priscilla. His eyes were filled with love."

He had just told Vernon's mother she was there.

"Come on," Elvis said to Priscilla, taking her hand. "Someone's waiting to see you." Then he led her in to Minnie Mae, who sat in a chair, a yellow crocheted throw on her lap. She wore dark glasses to keep out the light.

Priscilla hadn't seen her since Germany, and the old lady hugged her and asked her to sit down and chat. She had a lot to talk about, especially Elvis's dislike of Dee Presley. The more she talked, the more she dipped her snuff, and pretty soon, she was telling Priscilla to call her "Dodger," as Elvis did. "I feel like I can confide in you," Priscilla said. "You can, young'un," Grandma soothed. "You're family now."

The teenager had brought along little gifts for everyone that Christmas, especially Elvis, to whom she gave an ornate three-tiered wooden box for his cigarillos. In return, Elvis gave her a diamond ring and a puppy, which she named Honey. But he also gave her something else: two 500-milligram Placidyls, since she was jet-lagged from her trip across the ocean, and hadn't slept, trying to keep up with Elvis. "These pills will relax you," he told her.

Two days later, she was still out. "It scared the hell out of Vernon and Grandma," remembered Billy Smith, who thought Elvis would have learned his lesson from Gene's episode in the motor home. "They wanted to get a doctor in

there, but Elvis said no, he'd just walk her around. But that didn't do any good, either. She finally woke up on her own."

Priscilla opened her eyes to see Grandma standing over her, her craggy features bent into a frown. Then Minnie Mae breathed a sigh of relief and chastised her grandson for overmedicating his guest.

"How long have I been asleep?" Priscilla asked.

Elvis told her.

"Two days! I've missed Christmas!"

"Naw," he said, "you haven't missed anything. The fun's just starting!"

"More and more," Priscilla says, "I was getting used to Elvis's notion of fun." On New Year's Eve, he watched her drink four double screwdrivers through a straw and never cautioned her that she would be sick in the ladies' room afterward.

Most nights, he merely scared her silly, taking her on all his usual thrill-seeking activities, including the killer roller derby parties, which Priscilla found unnerving. Back at Lauderdale Courts, he had climbed the tall sign outside Billie Wardlaw's window to get her attention, and now he showed off for Priscilla at the Fairgrounds. He played a trick on her on the roller coaster, getting out at the top when it teetered for a minute, making her think he'd fallen to his death. He just wanted to see her face when the car returned without him. Then he broke into a big laugh and grabbed her and held her.

Patsy could tell right off that Elvis acted differently with Priscilla than he did with his other girlfriends. He was less intense and more relaxed. "You got the idea she was his one true love."

Other of his relatives also saw it. Billy Smith remembers Elvis would say, "Here she comes. Isn't she beautiful?" And Ricky Stanley, Elvis's stepbrother, saw how excited Elvis was that she was coming to visit, that he was "like a fifteen-year-old kid with his first crush. It was like prom night."

Marty Lacker, who had temporarily left the group to work for WHBQ Radio, got another impression when he stopped by the house soon after Priscilla's arrival. Elvis was sitting out on the front steps, which was unusual for him, and he was up early, which was also out of character.

"We sat and talked for about an hour, and then I said, 'Well, I'll see you later. I've got to go.' And Elvis said, 'No, no, wait a minute. I want to show you something.' We talked on a while, and then the front door opened, and out came this girl, all primped up. She had her hair dyed black and in a beehive, and she was made up like a painted doll, with all this mascara and bright eye shadow.

"Elvis said, 'This is Priscilla, from Germany.' I looked at him and smiled,

and gave him a nod, like, 'Yeah, she's really pretty.' He showed her off like he was showing off a new car. She was his trophy, his new toy."

Barbara Little, George Klein's girlfriend, remembers how nervous Priscilla looked that Christmas, sitting in the kitchen in bobbie socks, a kick-pleat skirt, and cardigan sweater. She was filing her nails and trying to mix with a group of adults she didn't know.

And, in fact, Priscilla wasn't sure where she fit into Elvis's life. She only knew she was hurt that he flirted with other girls in front of her on their nightly outings. But in a pattern that would continue through their relationship, he always turned it around on her: "He'd accuse *me*; he'd say that I was just jealous; I was inventing things; I was confusing friendliness with flirting. His accusations were made with such skill that I'd wind up apologizing to him."

She was ambivalent about his lifestyle, too. All these *people* were always around, and except for the time they spent in the bedroom, it seemed like Elvis preferred the company of the guys to her. On her last trip over, she'd gotten so bored watching him play touch football that she took off in his limousine and drove around the field just to amuse herself.

In truth, the relationship was mind-boggling for both of them, and Elvis wrestled with all kinds of conflicting emotions. Deep down, he yearned for lasting love and respected the institution of marriage, but at the same time, he didn't want to be tied down to one girl. There was also the matter of one of the biggest stars in Hollywood approaching his twenty-eighth birthday with an underage girl in his bed. He knew, consciously or not, that he was emotionally still a child, and so the fact that he was involved with a minor didn't feel wrong at all. In fact, it felt right. But then that got confusing, too. In his schizophrenic choice of gifts that Christmas, as Suzanne Finstad noted in *Child Bride,* he defined the relationship as both older lover–Lolita (the diamond ring), and father–daughter (the puppy).

All he knew for sure was how right Priscilla looked at Graceland, and how his mother would have claimed her as her own, the way Dodger did. In fact, he thought of his mother all the time he was around Priscilla. He patted her all the time, called her Nungin (young'un in baby talk), and sometimes also Satnin'.

After she'd been there a few days, Elvis thought he had to have her there all the time. In early January 1963, on the morning she was supposed to go home, he told her he loved her, that he didn't want to let her go. They were sitting in his upstairs office.

"You'll finish your senior year in Memphis," he said.

"My parents will never agree to that."

"I'll talk them into it."

"You can't."

And he couldn't. At least not yet.

So Priscilla flew on back to Frankfurt. The two moaned together on the phone, and he redoubled his efforts to persuade the Beaulieus to let her move to Memphis.

Priscilla, too, worked on her parents, especially on her stepfather. On January 5, she wrote to Elvis to say, "I've been talking with my dad and a decision hasn't yet been made. But still, he hasn't said no, so at least I know there's a chance. Like you said, his main concern is [my] living in a strange place and where I will stay."

In mid-January, before he left for Hollywood to start his next film, *Fun in Acapulco,* Elvis phoned the captain for an extended talk. He understood Priscilla's grades hadn't been that good—she had failed algebra and German, and barely passed English and history, altering her report card to make a D minus look like a B minus—when Elvis was stationed in Germany. Now she was failing English, too. But if she came to live in Memphis, he would see to it that she got a first-class education at an all-girls Catholic institution, Immaculate Conception High School, where she would wear a uniform like everyone else. And she would live with his father and his new wife at their house, not at Graceland, so she would be properly chaperoned.

"I was enormously resistant to the idea of Cilla going to live in Memphis," Paul Beaulieu has gone on the record to say. "As far as I was concerned, it just was not going to happen."

But once more, Priscilla's mother was the key. "You hear about people with magnetic personalities," Ann Beaulieu has said. "No matter how strongly you might oppose his position, he would charm you over to his side. He did it by being persistent, and also, to a large degree, by being sweet."

And so little by little, Paul Beaulieu began to think seriously about Elvis's offer. "Elvis pledged to care for her with absolute devotion. The intimation was that one day they'd marry."

In March, Captain Beaulieu and Priscilla flew to Los Angeles, where Elvis was still working on *Fun in Acapulco.* They stayed at the Bel Air Sands motel, and Elvis picked them up every day in his Rolls-Royce or the far more ostentatious "solid gold" Cadillac and took them sightseeing, driving from one end of Los Angeles to another—the Hollywood Hills, Sunset Boulevard, and the Pacific Coast Highway. Captain Beaulieu was impressed, and in between the touring

and the studio visits, the two men continued to discuss Priscilla's education and living quarters if she were to move to Memphis.

Paul Beaulieu was a military man, but he was also a businessman—he had earned a degree in business administration in Texas—and he had pointed questions about precisely how Elvis saw the financial arrangements. But Elvis had all the answers, and before the captain got on a plane back to Germany, he took Priscilla to Memphis, where he delivered her over to Vernon's care.

"I kissed my father good-bye and thanked him for trusting me and Elvis," Priscilla wrote. "It was now out of my hands. My new life had begun."

At the time—only five years after Jerry Lee Lewis had created a scandal by marrying his thirteen-year-old cousin—the arrangement was so unorthodox and threatening to Elvis's career that he would lie about it to the local press. That spring, he told a reporter from the *Commercial Appeal* who spotted Elvis and Priscilla together in Chenault's parking lot that she was the daughter of a military officer who "sent her ahead because she wanted to graduate on time." He also implied that her family was not far behind.

Yet Priscilla's stepfather seemed completely nonchalant about discussing the arrangement with others. Phillip Barber, who had gotten to know Elvis on Audubon Drive in 1956 during Natalie Wood's visit, was in the air force by 1965 and had a staff officer's job in Operations Plans at Travis Air Force Base near Sacramento, California. One day, he was in casual conversation with a newly minted major named Joseph Paul Beaulieu ("My boss called him Joe"), whom he saw and talked with almost daily. Major Beaulieu reviewed war plans for active duty units engaged in flying missions in and out of Southeast Asia, as well as contingency plans posed by the intelligence community.

The major noted Phillip's southern accent. "Where are you from?" he asked.

"Well, I came into the air force from Memphis, Tennessee."

"Oh," Major Beaulieu said. "My daughter lives there."

"Really, what does she do there?"

"She just got out of school."

"Memphis State?" Phillip asked.

"No, Immaculate Conception."

Phillip recognized the Catholic girls school.

"Do you have relatives there?"

"No, she lives with Elvis Presley."

At first Phillip didn't know what to say. "Oh!" he finally managed. "She lived with him in high school?"

"Yes, um hum."

"Well, are they going to get married?"

"Oh, yes, that's been arranged for several years now."

But was a perceived promise of marriage really all that it took to get Priscilla to Memphis? Many people think no, that in essence, Elvis "bought" Priscilla, or that her parents "sold" her into marriage.

Whatever the arrangement, once Priscilla's parents and Elvis came to some understanding, it was as if Priscilla herself had no say in it. She was infatuated with him, yes, but just before she came to Graceland to live with him, she had major misgivings about the move.

"My feelings were mixed—grateful and glad that Elvis had pulled off this coup, hopeful and determined that our relationship would last," she has written. But her friends back in Germany have a different view. When it came right down to it, they say, she didn't want to go. She preferred staying in Germany with her boyfriend Jamie Lindberg, with whom she was intimately involved. In fact, her mother was afraid Priscilla would throw Elvis over for Jamie, and his own impression, he told Suzanne Finstad for *Child Bride,* supports that: "Her mom more or less said, 'You are going.'"

"It was a terribly difficult position for her to be in," sympathizes biographer Finstad. "She was conflicted because she had her own relationships that were deceptive to Elvis, so she was just in a quagmire."

But throughout her childhood, Priscilla had always been compliant and dutiful in terms of her parents' requests of her. And since she was extremely tied to her mother, the only thing for her to do was to go through with it. If it didn't work out, she could always come home.

When her friends in Germany found out, they were aghast—not only that her parents permitted it, but also that she had simply disappeared that March without telling anybody good-bye. The timing of it had been odd, too. Captain Beaulieu had to get special military leave to come to the States, and Elvis was making a movie that March and couldn't go home to Memphis. Why hadn't Priscilla just finished out her school year and moved after turning eighteen that May?

Colonel Eugene Desaulniers, Paul Beaulieu's friend, neighbor, and fellow officer at Travis Air Force Base, explains the story as he heard it. "In that era, it was a very strange thing that somebody would allow that. But it was a situation where she was going to hightail it out of there one way or the other. And from a family point of view, he wanted to make it [look like], 'All right, if that's really what you want to do, then we will support you. I'll take you there.' So he went and made

the deal with the Presleys to finish her education, and he and Priscilla made their own deal between them, and away they went. If they had announced that she was leaving, the whole place would have been in an uproar with all the publicity. He just snuck her out and took her, and it was all done before anybody really knew."

.

In Los Angeles, meanwhile, Elvis resumed his old way of life. He had moved back into the house on Perugia Way—the Bellagio Road house was a little too fancy for him, said Alan Fortas—and his nightly parties went on as before. He intended to give up nothing to keep Priscilla. She was merely an add-on.

One of his frequent guests on Perugia Way was singer-songwriter Jackie De-Shannon. The pretty blonde was then still a teenager but already teetering on the edge of fame as both an artist and a writer ("Put a Little Love in Your Heart," "Needles and Pins") and soon she would become an important figure in the evolution of folk-rock. She often came to Perugia Way with her friend Sharon Sheeley, her sometime collaborator, who had been showing up at Elvis's parties with her sister, Mary Jo, since the Knickerbocker days.

They sat with Elvis and listened to records, sometimes jamming with their guitars and singing. Jackie and Elvis became good friends—he loved her soulful singing and her laid-back southern personality (she was born in Kentucky), and he appreciated her talent and saw that she was going places. Sometimes he offered her career advice, and in some ways, he considered himself a mentor to her.

Before she first went up to the house, Elvis told her he was going to send one of the guys to pick her up. She was living at home then, and she realized that wasn't going to work. "I come from a background where no matter who you are, you come to the door and you say, 'Is Jackie home?'"

But Elvis persisted.

"He would call and track me down and say, 'Come on up. We're going to sing tonight.' And I would say, 'Elvis, I can't come. My mother will not have it.' This went on for several months, and so finally, I came home from ballet class one night, and there was Elvis talking to my mother with a huge pink dog— bigger than I was. From then on, my mother didn't care how I got there."

Actress Teri Garr, who danced in nine of Elvis's movies, was also a familiar face around the Perugia Way house starting at age sixteen. She remembers going to a party there with her friend, Carrie. ("No chips, no dips, just Elvis, his boys, and a couple of girls sitting around.") Soon, Elvis and Carrie began flirting, and eventually they disappeared into Elvis's bedroom. "I was usually such a Girl

Scout," Teri wrote in her autobiography, *Speedbumps: Flooring It Through Holly-wood.* "Just so you know, she swore they didn't 'do it.' Knowing Carrie, it's the truth."

One woman Elvis was not about to romance was Ursula Andress, his leading lady on *Fun in Acapulco.* One, she was married (to actor-producer-director John Derek), and two, the Swiss-born sex goddess intimidated him. He was uncomfortable in their romantic scenes, believing that her shoulders were broader than his and made him look weak. "I was embarrassed to take my damn shirt off next to her," he told Alan, laughing. Later, he elaborated to Mindi Miller. "He didn't think she was pretty. She had this big, broad back."

He masked it well, though. "The only way I knew Elvis was from television," Ursula later said. "Here was this new idol, this hip-swinging lover with the guitar. I said, 'Oh, my God!' And the first day I went to work, here comes over this humble man, full of charm, love in his eyes, and kind, and considerate, and warm. I was so surprised." She liked him well enough to drop by on another picture later in the year—and according to Sonny West, to pester him, always asking for Alan as a way to get around Priscilla. "She went after him. She wanted him bad. And Elvis told us never to leave him alone with her."

Fun in Acapulco, another tame Hal Wallis musical, marked a new low in Elvis's career. He sometimes referred to his films as "travelogues," but this time, he didn't even get to travel, since the Colonel refused to let him go on location. In 1958 a rumor had circulated that Elvis found Mexican women unattractive, and Parker was afraid that someone might try to harm him.

"We had to do all kinds of trick shots," says screenwriter Allan Weiss. "A lot of it is background projection. We all knew that making money was the basic thing, but at the same time, we wanted to preserve a little bit of his dignity."

All background settings were shot without him, including the breathtaking 136-foot dive off the cliffs at La Quebrada. For that, Elvis modeled his swim trunks, mounted two stairs to a platform on the set, and with his arms rigidly fixed in a diver's pose, stared resolutely down at the floor.

It might as well have been an abyss of self-loathing. *Fun in Acapulco* was, as journalist Chet Flippo has noted, another of the "worthless movies that obviously began to drain his self-confidence."

RCA publicist Anne Fulchino, concerned about Elvis's spirits and the quality of the music of the soundtracks ("Bossa Nova Baby" would be the film's only notable song), visited him on the set. "That kid was not only unhappy, he was ashamed for me to see him prostituting himself with those crummy pictures,"

she recalled. She took him aside and advised him to take better control of his career, citing Colonel Parker's "nonguidance," and "practically drawing him a diagram on how you build a star."

Elvis promised Fulchino he would speak with the Colonel about finding both better scripts and songs. "He knew Parker was not the right manager for him—the way the Colonel wanted him to go was not the way Elvis wanted to go." But Elvis seemed paralyzed to make the kinds of changes Fulchino told him were necessary to revitalize his standing in the music world.

· · · · · ·

When Elvis received his release from the picture in late March, he hurried home to Priscilla, who felt isolated, lost, and awkward, making no real friends at school, and knowing only Grandma, Vernon, Dee, and Patsy in the entire town. Though Vernon was tight in doling out spending money (thirty-five dollars every two weeks), sometimes she went shopping at nearby Southland Mall, where her frightening vampire look drew stares. Jacque Carter, who lived in Whitehaven, remembers seeing her there. "She had jet-black hair that was all backcombed, heavy eye makeup, and white lipstick. She was very quiet and shy."

Over the next few weeks, Elvis bought Priscilla a red Corvair as an early graduation present so she could drive herself to school—she was embarrassed at Vernon's chauffeuring her every day—and $1,400 worth of clothing at Laclede's on Union Avenue. He encouraged her shopping habit: It gave her something to do while he was off making movies.

"Elvis expected her to be totally loyal," says Billy Smith. "He thought, 'I'm in California, and I can fool around and it won't mean anything, because it's going to be over and done with. But when I get back home, I know I'll have somebody there.' He had that old southern belief—'A woman's place is in the home.'"

Several years ago, Siouxzan Perry, manager of Tura Satana, Kitten Natividad, and other stars of Russ Meyer's sex-and-violence porn films, sat around a table with author Pamela Des Barres, who was writing a book about rock stars and groupies. A number of the Russ Meyer girls were there, and predictably, they played the "Who Have You Slept With?" game. The names came fast and furiously. "Somebody said, 'Jim Morrison,'" Siouxzan remembers. "And somebody else said, 'Elvis.' And practically everybody at the table went, 'Oh, *I* slept with *Elvis.*' It was just the funniest thing ever."

"He did not want me in Hollywood," Priscilla admits. But, of course, she wanted to be with him wherever he was, and as their separations grew longer

and more frequent, their relationship grew strained. She felt as if she were living a double life, not unlike the way she lived after she met him in Bad Nauheim. "I was a prim-and-proper schoolgirl by day, and Elvis's girlfriend by night." That meant she stayed up until 5 A.M. to attend all the outings, and then had to be at school by 8:30 A.M. "I would average maybe one and a half hours of sleep to make all the good grades for my father. That was the difficult part."

But it was obvious that Elvis, too, compartmentalized his life. "Hollywood was there and Graceland was here, and never the two should meet," as Priscilla has put it. For Elvis, "The two worlds represented a balance, or perhaps a perpetual imbalance, between his professional life and his home life." When a movie wrapped, he couldn't wait to get home. But then he felt trapped there and got anxious for his freedom and the companionship of other women. Then there was the matter of explaining just what he was doing with a teenager. And so Priscilla was kept back.

When he was home, though, "the place lit up. I lit up. And I was willing—even eager—to cater to his every whim. We all were." And so she forgave him for not attending her graduation ceremony, knowing it would cause too much commotion. She also overlooked his constant criticism: If she slumped, he straightened her back. If she had a chip in her nail polish, he pointed it out. He asked her not to eat tuna fish, her favorite food, because he hated the smell. But she despised the way he repeatedly rapped her on the forehead to remind her not to frown or wrinkle her brow. "Pow! I still feel his hand there," she says. "If I looked up, it had to be with my eyes only, so the skin would stay smooth."

"I was someone he created. I was just a kid, and I was consumed by him. I could never speak my mind. All I desired was not to disappoint him."

He stayed in Memphis for several months that spring, and Priscilla insists she still hoped each night would end with Elvis "finally making love to me. I was drunk with ecstasy. I wanted him. I became bolder, reaching out to him, totally open and honest in my need." Again, he stalled her, she wrote, and they fought about it. Elvis's compromise was to play sex games, dressing her up in tarty disguises and capturing their fantasies on Polaroid film. She became what she calls "his femme fatale."

Almost every night she made quick trips to the drugstore to buy more packs of film. She was certain that the clerk knew what they were up to, and Priscilla would blush as she approached the counter, paid, and then hurried back to Graceland. There Elvis would direct her as he might any starlet. She'd wear her schoolgirl uniform to seduce him, or pretend to be a teacher coming on to a student, or a secretary pleasuring herself. Eventually, they worked up to include

another girl, a hairdresser Elvis knew, for simulated lesbian sex. And in time, they moved up to videotape.

Watching two women together isn't an unusual fantasy for men—there's a purity to it, since nobody but a woman knows what a woman wants. But involving a teenage girl is more than just imposing artifice. It's a bent use of power and control, something akin to slavery, or human bondage. It's also a bit sadistic.

But Priscilla says she didn't mind doing it—it brought them closer, she thought. "I was ready to indulge him any way I could." And that included carrying a small, pearl-handled derringer in her bra, or in a holster around her waist, since Elvis had taken to always carrying a gun under his coat. Before she graduated, she'd sit in class and daydream about how surreal it all was. "While my classmates were deciding which colleges to apply to, I was deciding which gun to wear with what sequined dress. I was tempted to say to Sister Adrian, 'Oh, by the way, Sister, does gunmetal gray go with royal blue sequins?' "

Almost every night, Elvis gathered a group to go screen movies at the Memphian, renting three or four and watching them until daybreak. As was his habit, he also let in a few fans who waited outside the doors. One evening, he was surprised to see an old love there. June Juanico was in town for the WIBC, the women's national bowling tournament. Her friends goaded her into stopping by Graceland, the "surprise" Elvis so wanted to show her six years before. The gate guard, most likely one of his uncles, recognized her name and told her she could find him at the theater that night.

Her heart raced as she peered through the glass doors at the Memphian, and she pounded hard on the thick metal in hope someone would let her in. A man came, and she was flabbergasted when he said, "You're June, aren't you? I've seen pictures of you at the house. I'll tell Elvis you're here." June grabbed his arm. "No," she pleaded. "If you don't mind, let me just go surprise him."

Elvis was one of the most famous men in the world now, and he lived in a different universe than the one they'd shared in the 1950s. With his streamlined features, tailored clothes, and razor-cut hair, he hardly looked like the same person. It took all the nerve she could muster, but she made her way down the aisle.

"I went in the row behind him and I tapped him on the back, and as he turned around and looked at me, our eyes just locked. He got up and put me in a death grip. Joe Esposito ran over because he thought someone was hurting him. But Elvis was holding on to *me*. Priscilla was sitting next to him, and she just kept her eyes glued to the screen. She was very gracious. But when I got back

to my girlfriends, I said, 'If y'all want to buy some makeup in Memphis, Tennessee, you ain't gonna find any, because Priscilla's got it all on her face.'"

• • • • • •

Just after the Fourth of July holiday in 1963, Elvis returned to Hollywood to make Viva Las Vegas, his best MGM picture since *Jailhouse Rock.* The plot revolved around Elvis as Lucky Jackson, a guitar-playing race-car driver whose life is upended after meeting Rusty Martin, a swimming instructor with show business aspirations.

With the casting of the delicious and dynamic Ann-Margret, Elvis found the first costar who could match him in looks, musicality, and screen appeal. Together, they were nothing short of electrifying—*Viva Las Vegas,* directed by George Sidney, would plug two live wires together and make a formula musical sizzle.

Yet Elvis would find an even higher voltage connection with the twenty-two-year-old actress offscreen. Ann-Margret Olsson, born in Sweden and reared in suburban Chicago, had just made a splash in her third film, *Bye Bye Birdie,* a satire about the Elvis phenomenon and the teen mourning that accompanied his entering the armed services. Three months after its premiere, Sidney, who had directed her in *Bye Bye Birdie,* introduced her to Elvis on the set of *Viva Las Vegas.* He believed the meeting would be so momentous that he arranged for a studio photographer to be on hand.

"Elvis Presley, I'd like you to meet a wonderful young lady, Ann-Margret," the director said. "Ann-Margret, this is Elvis Presley."

Simultaneously, the two stars started to say, "I've heard a lot about you," then stopped in midsentence, and broke into nervous laughter. They were both dressed like young professionals, she in a white knit, double-breasted jacket and A-line skirt, and he in a suit and tie. Their conservative appearance hid the fact that they both shared a devil within, she would later write.

"We were quiet, polite, and careful," Ann-Margret remembered in her autobiography, *My Story.* "But I knew what was going to happen once we got to know each other. Elvis did, too. We both felt a current that went straight through us. It would become a force we couldn't control."

Ann-Margret was the female Elvis, all beauty, sex, and talent. She spoke in a breathy, morning-after voice that managed to sound real, and projected a paradox of midwestern reserve and raw sensuality. Men would have died for her.

On day one, they both realized the relationship would be serious, but whether Elvis knew it immediately, Ann-Margret was the woman he had waited for all his

life. He had been deluded into thinking so many girls were his twin soul, but now he was face-to-face with the one woman who fulfilled that destiny.

She felt it, too, writing, "It was like discovering a long-lost relative, a soul mate . . . shy on the outside, but unbridled within. . . . In many ways, both of us, despite fame and whatever else we'd achieved so quickly, had remained very childlike, and emotionally dependent. We wanted to find that same nonjudgmental, unqualified love that our parents gave us. . . . He had touched something deep within my psyche."

Just as they said the same exact words when they were introduced, when they began to rehearse their dance routines, they looked at each other and saw virtual mirror images: "When Elvis thrust his pelvis, mine slammed forward, too. When his shoulder dropped, I was down there with him. When he whirled, I was already on my heel."

"It's uncanny," she said. Elvis grinned.

"The minute they looked into each other's eyes, they clicked," says Joe Esposito. "There's no two ways about it. You could just feel the energy."

Now Elvis asked Joe to find out if Ann-Margret was single. Learning she was, he bypassed his usual approach to courting and picked up the phone himself.

"Rusty," he said, using her character's name in the film, "how about going out with me and the guys to see a show?" It was a group date, innocent and friendly, and they were never alone for a second. But the next time he asked her out, he brought her home to Perugia Way, and he told the guys he wanted the house to himself when he got back. Their late-night talks revealed a shared love of motorcycles, music, and performing, along with strong family and religious ties.

At first Ann-Margret told no one but her parents. But soon, says Joe, the secret was out: "Everybody on the movie set will tell you that when they were together, it was obvious they loved each other."

Soon they were wheeling through L.A. on their Harleys, and pedaling around Bel Air "on a bicycle built for double takes."

"People honked, we waved," she wrote.

It was the worst possible time for Elvis to be falling in love—only four months earlier, he had made promises to a military captain and installed a teenager in his home and in his bed. But neither he nor the kittenish redhead could deny what was happening.

"Ann-Margret really was the love of his life," says Patti Parry. "She was just the best girl. And they were like little kids together, laughing and having fun."

They spent a lot of time together, and as Lamar remembers, "it blew our

minds" that he went with her alone so much. "We would give him a bunch of money, and he'd jump in that Rolls-Royce and stay gone. Nobody knew where he was, except that he was with her." Part of the time, he was over visiting her parents at their apartment, an indication of how serious he was about the girl he called "Rusty Ammo," and "Thumper," the code name she would later use when she phoned for him at Graceland. As for what she called him, "When I like someone," she told a magazine, "I say scoobie. Elvis is scoobie."

The Memphis Mafia, half in love with her themselves, could hardly stand the thoughts of the two of them together. When the film went on location in Las Vegas, Elvis stayed in Milton Prell's suite at the Sahara, and he and Ann-Margret secluded themselves there for the weekend. The guys "aggravated the shit out of them," as Marty Lacker recounts, Red and Lamar stuffing newspaper under the door and lighting it. "They even shined butter knives 'til they looked like mirrors. And then they slipped 'em under the door to see if they could see Ann-Margret without her clothes on. They tried everything. But Elvis and Ann-Margret would not come out of that suite."

"It was a very strong relationship, very intense," she has said. Elvis was so entranced by their lovemaking that he later had a round bed made for her in pink, but when word leaked out about it, Elvis made sure not to be seen with her at industry events. He invited Yvonne Craig to go with him to the screening of the film, and when she pried him for information, "he was very circumspect about the whole thing."

Viva Las Vegas was an immediate hit, topping *Blue Hawaii* as Elvis's highest grossing film ever—by 1969, revenues would reach $5.5 million, up from Elvis's usual movie gross of $3 million.

Colonel Parker might have been expected to see that spending money for bigger costars, bankable directors, and an involving script would ensure longevity for his client. But during production, he constantly harped that *Viva Las Vegas* was over budget, which could mean a loss of profit participation, a given in each of Elvis's movie contracts.

However, on several levels, Parker was also greatly worried about Ann-Margret. The artful manager was nervous about what she might have told Elvis about the way other managers worked—that they took far less than the 50 percent that Parker commanded on some of his deals. And the Colonel was unhappy that director Sidney seemed intent on awarding Ann-Margret as much screen time as Elvis. He grumbled that the director gave her more close-ups and flattering camera angles, and complained that it was difficult to tell just whose film it

was. He also nixed special billing for her in the advertisements that MGM hoped would help draw audiences beyond Elvis's core fans. "If someone else should ride on our back," Parker huffed, "then we should get a better saddle."

Parker may have been looking after his client, but he was particularly short-sighted in insisting that the director cut the couple's duets down from three to one. The news didn't go over well with RCA, either, remembered Joan Deary, who was then Steve Sholes's secretary.

"There was no cut of Ann-Margret on the *Viva Las Vegas* product, because the Colonel did not believe that anyone should cash in on Elvis's popularity." Though several of the Ann-Margret songs have appeared since Elvis's death, "There was never *any* female singer on any of Elvis's albums with the exception of Nancy Sinatra ["Your Groovy Self," from *Speedway*], and that was because of the Colonel's friendship with Frank. We had no influence on what [songs] went into the movies, and no choice of what the selections were going to be in that [soundtrack] album. The movie years were the worst years for Elvis's music that we ever had. There were a few exceptions, but most of the songs were ridiculous."

Viva Las Vegas was, indeed, an exception, with the title song becoming one of the most recognizable and popular songs in the Presley canon. Elvis also sang the rest of the soundtrack with new enthusiasm. But Parker still seemed oblivious as to how the movie resuscitated his client's spirits and musical dynamism.

None of that was lost on Priscilla, however, because by the time the cast and crew returned to Los Angeles, the press had picked up on Elvis's relationship with Ann-Margret, the inspiration for his creative renewal.

"They hold hands. They disappear into his dressing room between shots. They lunch together in seclusion," Bob Thomas wrote in an Associated Press story that summer.

And they talked marriage, she admits. But Elvis had stalling to do both in Hollywood and in Memphis. Earlier, he had described Ann-Margret to Priscilla, now eighteen, as merely "a typical Hollywood starlet." Then one afternoon she picked up the Memphis *Press-Scimitar* and read a story headlined, "It Looks Like Romance for Elvis and Ann-Margret." That evening, she grilled him on the phone. "Is there anything to it?" she demanded.

"Hell, no," he lied and then repeated his mantra that reporters blew everything out of proportion. "She comes around here mostly on weekends on her motorcycle. She hangs out and jokes with the guys. That's it."

But Priscilla's intuition told her otherwise. She knew he had little affairs all the time, but the fact that everybody called Ann-Margret "the female Elvis," and

that she had the same effect on men that Elvis had on women scared her. How could he resist that, his equal?

"That one affected her tremendously," Joe confirms. "She was very, very upset. She couldn't believe it, and she was very concerned that he was not going to marry her. I can't even think what was going through her mind. That had to be very tough for her."

Billy Smith says that Elvis and Priscilla had many arguments about Ann-Margret, usually upstairs in his room at Graceland. Then Priscilla came up with a new strategy. She watched Ann-Margret's movies and learned some of her dance moves, then began dressing like her and doing her hair like hers, too. Billy's wife, Jo Smith, tried to help her, and told Billy "she'd stand in front of a full-length mirror just cussing Ann-Margret, all the time trying to be as much like her as possible. It was pitiful." Soon she enrolled in the Patricia Stevens Finishing School in Memphis.

But she also began emulating some of Elvis's behavior, pursuing seventeen-year-old Mylon LeFevre, of the gospel group The Singing LeFevres. The first time she met the wild-haired teen backstage at Ellis Auditorum, Marty Lacker's wife, Patsy, went with her and was stunned to see Priscilla openly flirt with him. After that, Patsy refused to go with her, as did Jo Smith. "She went down to the auditorium every time Mylon came to town," says Marty. Once Mylon found out Priscilla was Elvis Presley's girlfriend, he made himself unavailable.

When Elvis began his next picture, *Kissin' Cousins,* in October, Priscilla insisted on accompanying him. She loved Los Angeles, and she'd grown tired of the stultifying pace of Memphis when Elvis wasn't home. But most of all, she was there to size up the competition, knowing full well that Ann-Margret was still in Elvis's life, even though *Viva Las Vegas* had wrapped six weeks before. She made sure to wear her five-star diamond on her ring finger.

But two days after Priscilla's arrival, Ann-Margret stunned the entertainment world with a syndicated UPI interview from London, where she was attending the royal premiere of *Bye Bye Birdie.* She was in love with Elvis, she announced, but she didn't know if they would marry.

Priscilla was hurt, humiliated, and livid. And when Elvis told her the Colonel thought she should return to Memphis until the publicity died down ("Honey, I'm gonna have to ask you to leave"), she finally broke.

"What's going on here?" she wrote in her memoir. "I'm tired of these secrets. Telephone calls. Notes. Newspapers!" She picked up a vase of flowers and threw it, watching it shatter against the wall.

"I hate her!" she yelled. "Why doesn't she keep her ass in Sweden where she belongs?"

Elvis went on the offensive.

"Look, goddamn it! I didn't know this was going to get out of hand. I want a woman who's going to understand that things like this might just happen." He looked at her hard. "Are you going to be her—or not?"

"I stared back at him, furious and defiant," she wrote, "hating him for what he was putting me through." But in the end, she went home, wanting to please him, wanting not to disappoint her parents. When President John F. Kennedy was assassinated later that month, Elvis watched the awful aftermath with Ann-Margret, not Priscilla.

· · · · · ·

Kissin' Cousins, *in which Elvis plays dual roles as a dark-haired, upright military* man (Josh) and a blond hillbilly Lothario (Jodie), was in some ways a new take on his own story. Producer Sam Katzman, known in Hollywood as "King of the Quickies" for his low-budget pictures and tight shooting schedules, filmed it in seventeen days.

Parker had asked for him after the experience on *Viva Las Vegas.* He didn't much care what Katzman's product was like, as long as most of the money ended up on the Colonel's side of the equation. While the film was in production, Parker negotiated a $750,000 contract with Allied Artists for *Tickle Me.* Another slight picture, it would sacrifice quality production values, known actors, and even new music (the soundtrack would be made up of previously recorded songs) to pay half the budget in salary to the star. Like *Tickle Me, Kissin' Cousins,* with a budget of $800,000 compared to $4 million for *Blue Hawaii,* would be an embarrassment to Elvis, especially as the finale prominently showed his stand-in, Lance LeGault. ("It's too expensive to shoot it over—no one will even notice," said Katzman.) Many regard it as Elvis's worst picture ever.

The film required Elvis to wear a light hairpiece for his twin, the character of Jodie, and according to Cynthia Pepper, who played the role of Corporal Midge Riley, "He hated that blond wig. He didn't want to come out of the dressing room."

He found it emasculating, and it took him back to the Elvis of old, before he reinvented himself as the suave and dark-haired leading man. But in some ways, Elvis should have felt comfortable on the set. For a few days, at least, he enjoyed a triumvirate of women who re-created the psychological set-up he enjoyed with his mother and, by extension, Jessie Garon.

Yvonne Craig, cast in the role of Azalea, Josh's girlfriend, had already proven herself a Gladys substitute. In blond Cynthia Pepper, whom he dated and requested after seeing her in the TV series *Margie,* he found a replica and a peer. And when Priscilla was on set, he had his "child" to rear and shelter.

As Cynthia noted, "Everybody had a different relationship with him. When we did the scene where he sings to me, we were out in Big Bear Lake, and we had a pause. It was sprinkling a little bit, and we were talking, and he said, 'I don't know what I'm doing here.' I said, 'What do you mean?' He said, 'I mean making all these movies. I should be back home driving a truck.' "

He watched over Cynthia, who was twenty-three but young and naïve, by her account. When producer Katzman repeatedly made innuendos about the two of them having spent the night together ("He said, 'Why didn't you wake me up when the alarm went off?', and I would just die with embarrassment, because it wasn't true"), Elvis put the funny man in his place: "Hey, that's enough. Leave her alone."

Elvis was not above pulling his own prank on her, though. The script calls for Cynthia's character to flip him over her shoulder, and they rehearsed the scene over and over. "One time I flipped him, and no one was around, and he didn't get up. He had his eyes shut, and it was like he'd hit his head and he was out. The only thing I could think of was, 'Oh, my God, I killed Elvis!' He let it go for a minute or two, which seemed like forever, and then he said, 'Gotcha!' "

If he hated making the film, which Cynthia later heard, she didn't see it at the time. He was always professional, knowing everybody's lines, and showing up for the over-the-shoulder shots that most stars would leave for the stand-ins. Yvonne, too, was impressed with him, seeing he was such a natural actor that he didn't appear to be working at all.

"I've only seen that with one other person, and that was Spencer Tracy. You'd think, 'He's just putting in his time and not doing anything.' Then you'd go to the dailies, and he'd be so riveting that you couldn't look at anybody else."

As on *It Happened at the World's Fair,* Elvis invited Yvonne over to the house for dinner, teasing her about her big sunglasses and calling her "Bug." Again, they ended upstairs in his playpen of a bedroom ("back where he shouldn't be taking women"), this time to watch a Katharine Hepburn movie. Yvonne continued to give him all kinds of unsolicited advice: that perhaps he should dye his hair dark brown, because his was so shiny black that it ate the light. ("He said he would think about it.") And that he ought to take on some meaty roles again, since all his movies had him bursting into song, like an operetta.

She saw how he could sit on a set and know what everyone was doing and

why. "If you are that observant," she told him, "and you understand everybody's motivation, it just makes for a whole depth that you could bring to almost every character." But he was tired of hearing it, tired of fighting. "I don't make any of those decisions," he said, and the next time she looked over at him, he had drifted off to sleep.

"I figured I needed to get out of there, so I went around and like a good fairy, shut off the TV and all the lights, and quietly tiptoed out of his room. As I was walking down the hall, Joe Esposito was coming to see if I would like to go home. I said to him, 'Listen, Elvis fell asleep. I shut out all of the lights, but he needs to get undressed.' And Joe said, 'You shut out *all* of the lights?' I said, 'Yeah.' He said, 'Well, Elvis likes to sleep with a light on.' And I said, 'How would I know that? I'm not his mother.' We laughed, and he said, 'I'll fix it,' and then we went on downstairs."

But when they opened the door, there were five Bel Air patrol cars in the drive, and at least that many officers pointing guns right at their hearts.

Joe looked at Yvonne.

"Did you touch a button up by the top of the bed?"

"I touched all of the buttons until the lights went out," she said meekly, not realizing she had inadvertently pushed a panic button that summoned the cops.

"The next day on the set, I was sitting in my chair and Elvis sheepishly came up and said, 'I hear you called the police because I went to sleep in your face.'"

They never worked together again, but Yvonne would see Elvis around Hollywood now and then. Sometimes they would pass each other in Beverly Hills, and he would lean out the window and yell, "Hey, Bug!" She loved it.

During Priscilla's brief time on the *Kissin' Cousins* set, she impressed the cast and crew in various ways. One of the actresses found her chilly ("Not a bit of warmth there—Elvis had it all"). But Yvonne thought just the opposite. "She was very poised, and you know, she was just a *baby*. She said to me, 'I was so jealous of you during *It Happened at the World's Fair*. But I'm not now.' She said, 'I thought you were a threat.' And I went, 'Wow! It takes a lot of guts to say that to somebody, especially at her age.'"

But Priscilla, who had spent so much of her life concealing her true emotions, did a fine job of masking her insecurity. "I always felt worn out because there were such emotional highs and lows," she would say nearly thirty years later. "There was never really any time that I let my guard down."

Actress Mary Ann Mobley made Elvis *Girl Happy* in June 1964, but off the set, their friendship was based more on respect and shared background. Though she adored him, "It was like I was working with my brother." *(Courtesy of Mary Ann Mobley)*

TWENTY-FOUR

.

Satyrs and Spirits

In January 1964, not long after celebrating his twenty-ninth birthday, Elvis took the entourage—including foreman Joe Esposito, Alan Fortas, Richard Davis, Billy Smith, Jimmy Kingsley, and the newly returned Marty Lacker, to Las Vegas for an extended vacation. Priscilla was at home. They stayed at the Sahara, and each night they attended shows around town by such disparate acts as Fats Domino, Don Rickles, Tony Martin, Della Reese, and the Clara Ward Singers. At the Desert Inn, they also took in a performance by the McGuire Sisters, Christine, Dorothy, and Phyllis, best known for their songs "Sincerely" and "Sugartime."

If Elvis defined the liberal and progressive culture of the 1950s, the McGuire Sisters embodied the conservative and staid white majority. Yet immediately Phyllis, a pretty blonde, caught Elvis's eye. He thought of Anita Wood, who was then engaged to the Cleveland Browns' tight end Johnny Brewer, and would marry the NFL star later that year. It hurt Elvis to think of Anita with someone else, but it was too late to go back now, and he tried not to think about it. Still, at times, he did.

"Man," he told Marty Lacker, now staring at Phyllis, "she's as pretty as Anita." He repeated it several times, his eyes fixed on her. When the show was over, he said, "I've got to meet her," and they all went backstage. After that, Elvis returned to the Desert Inn every night—not to see the show, but to visit Phyllis in her dressing room, often staying more than two hours.

One of the braver guys finally said it might not be such a good idea for Elvis to keep seeing Phyllis, since it was well known that she was the girlfriend of mob boss Sam Giancana. Elvis paid no attention to it, and one evening he told Marty to get him up by noon the next day and to make sure the Rolls-Royce was ready.

Elvis seemed anxious when Marty knocked on his door that afternoon, and he insisted on driving the Rolls himself. They ended up at the Desert Inn.

"We went upstairs, and Elvis knew exactly which room to go to. He knocked on the door, and Phyllis cracked it open a little, because she had the chain on it. Her hair was in rollers. Elvis started talking to her, but she didn't really want to let him in. So he said to me, 'Why don't you just go wait in the car?'"

An hour and a half later, Elvis came down. They were driving back to the Sahara, and all of a sudden, he started laughing.

"What's so funny?" Marty asked.

"I was up there with her," Elvis said, "and I noticed there was a gun sticking out of her purse. I asked her what she was doing with it, and she said Giancana had given it to her for protection. And I said, 'Well, tell him I carry two of 'em.'"

Marty felt a chill and then cautioned his boss that that might have been a foolish thing to say. "What if she goes back and says that to the guy in a way he doesn't like?" But Elvis just smiled.

"We were rather attracted to each other," Phyllis admits. "We had a few dates. It was nice. The nights in Las Vegas are quite beautiful, and I was so impressed with his car, because I had never ridden in a Rolls-Royce. I remember that he opened the glove compartment, and there was this beautiful, beautiful gun."

They drove out to the desert, and Elvis shot the gun for her, showed her he wasn't afraid of a firearm, or much else. "He always did everything to the fullest. I giggled and laughed, and I thought it was the greatest thing. So we bonded in more ways than one."

At the end of February he started work on *Roustabout,* a carnival picture with Barbara Stanwyck and Joan Freeman. *Roustabout* is memorable only for the black leather figure Elvis cuts on a motorcycle, and for the musical highlight, "Little Egypt." But what he would remember most was how the notoriously iron-willed Stanwyck belittled him in conversation. She referred to a Greek goddess, and Elvis told her he was unfamiliar with the name. "You don't know who Athena is?" she chided, her voice full of scorn. Elvis turned scarlet and made his exit, but the next day he hunkered down with a stack of books on Greek mythology in his dressing room.

Sonny West saw that "there was a little situation there at first. She was very cool toward Elvis. But once again, his charm. He never backed off. It was a challenge to him. Later she told him why she didn't want to get close to him at first. She took him aside and said, 'It's because you remind me so much of Robert.' She was referring to Robert Taylor, the love of her life. . . . They had the same

look: dark hair, smoldering features. 'He was gorgeous, and you're gorgeous,' she said to Elvis."

The *Roustabout* soundtrack logged the top spot on the charts, but it would be the last of his to do so, both because the music became weaker on subsequent films, and because Beatlemania and the British invasion were just about to dominate the American music scene. When the Beatles appeared on *The Ed Sullivan Show* that February, Parker sent a congratulatory telegram "from Elvis and the Colonel" for the old impresario to read on the air. It was a clever way to attach Elvis to his competitors, and to attempt to convince viewers that he was still on top.

"Elvis always said there's room for everybody," Red West would recount. "He was never threatened."

But privately Elvis told women just the opposite, that he was very worried about the Beatles' ascension, especially as their 1964 film, *A Hard Day's Night,* was an inventive piece of moviemaking. Elvis's films, still churned out at three a year and timed for release during school vacations, had become passé, and he knew it. "They never go to bed in a Presley picture," an MGM spokesman would be quoted as saying in the *Saturday Evening Post.* "Otherwise, mamas wouldn't let their kids come."

"When he made movies," his late record producer, Felton Jarvis said, "he'd have to sing to a cow, or a dog, or a kid, because they were situation songs—they fit into the script. I remember him talking about the soundtrack to *Roustabout.* They were cutting the title song, and he told the Jordanaires, 'Fellas, sing along with me on the chorus.' And the director [John Rich] ran out [in the studio] and said, 'Elvis, I don't think you understand where this song's going to be in the picture. You're riding down the highway on a motorcycle, singing. If the Jordanaires are singing, too, where are they supposed to be?' And Elvis said, 'The same damn place the band is.'"

In *Roustabout,* Sue Ane Langdon plays the fortune-teller, Madame Mijanou, and recalls that she almost passed on the film, "because doing an Elvis movie at that time was not such a sensational thing to do." She acquiesced mainly because she'd always wanted to work with Stanwyck. Nonetheless, she enjoyed her kissing scenes with Elvis ("his lips were very, very soft") and recalls he giggled through most of them. Around the set, he called her "Madame," for her character. "He thought that was so funny."

The opening scenes of *Roustabout* introduce Elvis as a short-tempered singer (Charlie Rogers) who loses his job at a roadhouse for brawling. Making her

uncredited film debut as a college girl in the audience was twenty-three-year-old Raquel Welch.

Like so many adolescents of the 1950s, Raquel had been "completely gaga over Elvis." She saw him live in San Diego in 1956 at her first rock-and-roll concert, and she was struck by how he was able to synthesize the sensuality and the sexuality of black music for the mainstream. She was also smitten with him. "That was the first time I ever conjured up what a sexy guy could be. It was just so cool to see a guy dance like that. And then he had this wonderful, full, rich voice. But he also had the attitude down, and that sexy little sneer."

She hadn't kept up with him, though, and when she saw him on the set of *Roustabout* eight years later, "It was a little shocking to me, because they took all the sex out of him! He was a whitewashed, cleaned-up Elvis. His clothes were not the same, his hair was obviously dyed, and it was all sprayed into place—no cool tendrils flopping over on his forehead. He didn't even move the same way. I thought, 'Why have they made this fabulous guy all antiseptic?' He was like a cardboard figure."

Raquel had hoped to find a moment to speak to him, but "there were all those guys to go through. There was no such thing as walking up to Elvis on a set." And all the official work time was orchestrated and appointed, so "there was never any chance for him to sit and schmooze." Then one day, all the actresses were called to shoot publicity stills with him, and Raquel was included.

"They lined us all up, and Elvis came in for something like fifty-seven seconds, and he was so charming. He had a smile for everybody—'Oh, this isn't too hard to do, all these good-looking girls'—and he kidded around with the guys and the photographer a little bit. Then they said, 'We got it, Elvis,' and that was it."

But later, one of the entourage approached her and invited her to a party at the house. She felt funny about it—she wasn't sure if it was an invitation from Elvis or from the guys, using Elvis. "I'd had a very strict upbringing, and there was a way that things were supposed to be done. And what would happen if there was someone else there that he was more interested in? I didn't like the setup, so I didn't go. I figured if he thought I was that attractive or wanted to see me again, it would have been different."

She never did get a word with him ("I know people think that I'm very formidable, but I'm really quite shy"), but she watched his every move from the sidelines—how he did his takes, how many takes, what he did in between. "I was just fascinated. And I was so green. I wanted to see how everything worked, and how a real star behaved. He was just so polite, and very jokey in between the

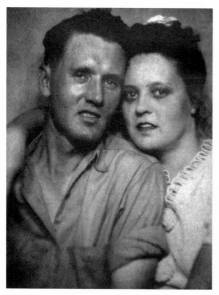

Vernon and Gladys Presley, around the time of their marriage, 1933. *(Courtesy of David Troedson/Elvis Australia)*

Young Gladys, probably late 1940s–early 1950s. *(Robin Rosaaen Collection)*

Rfd #2

Tupelo, Miss.

Nov. 25, 1938

Dear Sir:

My Husband was ~~arrested~~ Convicted and sent to prison at Parchman Miss. He was Convicted along with two others for forgery. Will you please turn him loose? Give him a parole or pardon either. I am begging you to please turn him loose. I am sure god will bless you if you will. We feel like you are a just man. I am asking you from the bottom of my heart to turn him loose for I feel and know that his punishment is enough for the little crime he did. My health is bad and I am not able to do the work. I have no mother or daddy and no one to look to for a living. I have a little boy 3 years old. Please send him home to his wife and baby. His mother is grieved about it and would rejoice if you would set him free. Trusting that you will heed my plea. With Gods blessing upon you.

Mrs Vernon Presley

Tupelo, Miss.

When Vernon was incarcerated at Parchman Penitentiary for forgery, Gladys began a letter-writing campaign seeking parole or pardon. In this letter dated November 25, 1938, she pleads, "I have a little boy three years old. Please send [my husband] home to his wife and baby." *(Parchman Penitentiary Archives/Courtesy Roy Turner)*

Elvis and Regis Wilson, Humes High senior prom, 1953. *(Courtesy of Regis Wilson Vaughn)*

Carolyn Bradshaw during her stint on *Hometown Jamboree,* late 1954, just before returning to the Louisiana Hayride and meeting Elvis. *(Courtesy of Carolyn Bradshaw Shanahan)*

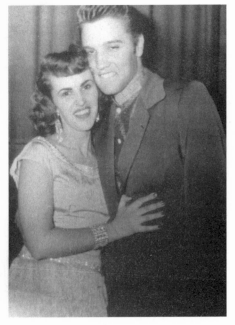

Wanda Jackson and the Memphis Flash, first meeting, Cape Girardeau, Missouri, 1955. *(Courtesy of Wanda Jackson and Wendell Goodman)*

Elvis poses with the architects of his Sun career, Sam Phillips and Marion Keisker, in this undated photograph, probably from 1956. *(Courtesy of Connie Lauridsen Burk)*

During his Las Vegas debut in April 1956, Elvis befriended thirteen-year-old Nancy Hebenstreit (now Kozikowski) and posed for a spooky photo booth picture for her at the Last Frontier Village penny arcade. *(Courtesy of Nancy Kozikowski)*

Maid of Cotton Patricia Cowden *(left)* and Memphis Cotton Carnival Queen Clare Mallory gave Elvis the royal treatment just before his performance at Ellis Auditorium, May 15, 1956. *(Robert Williams/the* Commercial Appeal*)*

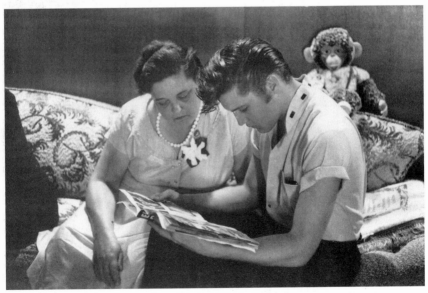

Gladys kept scrapbooks of Elvis's early press coverage. Here, mother and son peruse a magazine in the living room of their new home on Audubon Drive, probably spring 1956. *(Robin Rosaaen Collection)*

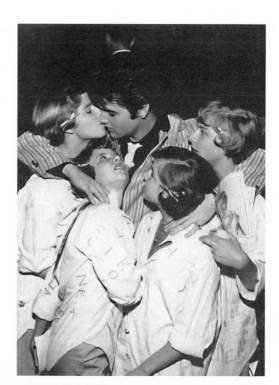

Elvis's relationship with his young fans crossed brotherly affection with erotic desire. *(Paul Lichter's Elvis Photo Archives/elvisunique.com)*

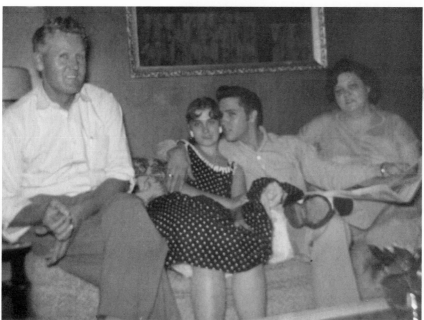

When fourteen-year-old Jackie Rowland and her mother, Marguerite, visited the Presleys on Audubon Drive, July 4, 1956, Elvis treated her more like a girlfriend than an adoring fan. *(Copyright Jackie Rowland 1978. All rights reserved)*

Elvis and the guys aboard the *Aunt Jennie* with June Juanico, her mother, May, and May's boyfriend, Eddie Bellman, July 1956. *(Robin Rosaaen Collection)*

Elvis, Natalie Wood, and Nick Adams became "almost a threesome, having a lot of fun together," as she put it. They clowned for a Hollywood photographer in September 1956, while taking in a movie. *(Robin Rosaaen Collection)*

In mid-December 1956, on his way to the Louisiana Hayride with film director Hal Kanter, Elvis stopped at the Trio Club in Pine Bluff, Arkansas, to visit with the Browns *(from left)*, Jim Ed, Maxine, and Bonnie, an early sweetheart. *(Courtesy of Maxine Brown)*

When Las Vegas showgirl Dottie Harmony came to Memphis for Christmas 1956, it shattered Elvis's relationships with June Juanico and Barbara Hearn. Gladys and Vernon share in the gift giving. *(Paul Lichter's Elvis Photo Archives/elvisunique.com)*

Elvis took time on the set of *Jailhouse Rock* for a coffee break with costars Anne Neyland *(left)*, whom he dated, and Judy Tyler, May–June, 1957. *(Robin Rosaaen Collection)*

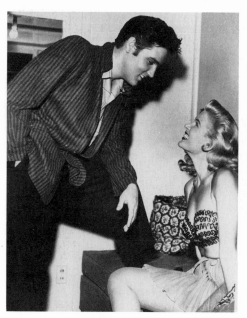

On the set of *Jailhouse Rock,* Elvis became reacquainted with "stripper" Gloria Pall, who had called him a "corny, horny little hick" in Las Vegas the year before. *(Robin Rosaaen Collection)*

At Sy Devore's Beverly Hills Halloween party, October 31, 1957, Elvis met actress Jeanne Carmen *(right)*, who would later share steamy tales of their romance. He was rarely photographed with alcohol, but here holds a beer. *(Earl Leaf, Michael Ochs Archives/Getty Images)*

Gladys wipes away a tear as Elvis departs for Fort Chaffee to begin his army life, March 1958. Anita Wood *(left)* comforts her, as Vernon looks on. There to see Elvis off was Judy Spreckels *(with headscarf)*, his double cousin Patsy Presley *(middle)*, and his aunt, Mrs. Vester Presley. Alan Fortas can be seen at rear left. *(Don Cravens, Time & Life Pictures/Getty Images)*

While Elvis was in Germany, Anita Wood, shown here Christmas shopping in 1958, pursued a television career. The two exchanged a series of emotional letters during his tour of duty overseas. *(From the author's collection)*

Fourteen-year-old Priscilla Beaulieu helps Elvis's grandmother, Minnie Mae Presley, to the car in front of his house in West Germany, March 1960. They would see Elvis off at the plane for his return to the United States. *(James Whitmore, Time & Life Pictures/Getty Images)*

G.I. Blues, Elvis's first post-army film, paired him with actress-dancer Juliet Prowse in May 1960. Elvis found her "one cold chick," but soon warmed her up. *(Robin Rosaaen Collection)*

When Elvis addressed the Tennessee state legislature in March 1961, he became smitten with Ann Ellington, daughter of Governor Buford Ellington. They enjoyed a long friendship. *(Courtesy of David Troedson/Elvis Australia)*

Joan Blackman, on location with Elvis in the fiftieth state, April 1961. She helped make *Blue Hawaii,* his first bikini picture, his most popular film. *(Robin Rosaaen Collection)*

Priscilla as the well-dressed young lady, Memphis, early 1960s. *(Michael Ochs Archives/ Getty Images)*

The film *Roustabout* was conceived as a nod to Colonel Parker (shown here with Elvis and Barbara Stanwyck, spring 1964) and his carnival past. *(From the author's collection)*

But Elvis got a number one soundtrack out of *Roustabout*—and a chance to pose with real live Kewpie dolls. *(Robin Rosaaen Collection)*

Elvis and Priscilla tie the knot, May 1, 1967, at the Aladdin Hotel in Las Vegas. All of the entourage (with the exception of Red West) attended the reception afterward. From left: Richard Davis, Jerry Schilling, George Klein, Joe Esposito, Priscilla, Elvis, Charlie Hodge, and Marty Lacker. Joe and Marty served as co-best men. *(Robin Rosaaen Collection)*

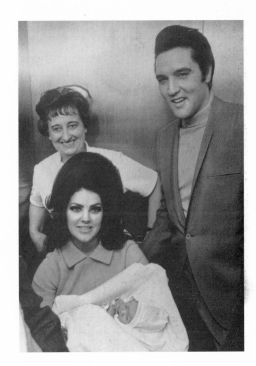

Baby Lisa Marie was delivered at Baptist Hospital in Memphis, February 1, 1968, nine months to the day after her parents wed. Elvis later called her "the love of my life." *(Keystone/Staff, Hulton Archive/ Getty Images)*

On *Live a Little, Love a Little,* filmed in spring 1968, Elvis made an important friend in actress Susan Henning. *(Courtesy of Susan Henning and Rodney Woliver)*

He also became close on *Live a Little, Love a Little* with Celeste Yarnall, who says, "He made me feel like I was the only woman in the world." *(Courtesy of Celeste Yarnall)*

With his 1972 separation from Priscilla, Elvis's health began to fail. That June, hardly resembling himself, he rode his motorcycle around Memphis with twenty-year-old dancer Mary Kathleen Selph. She was killed in an auto accident the following month. *(Dave Darnell/the* Commercial Appeal*)*

In 1974, a year before their three-month romance, JoCathy Brownlee met a seemingly dazed Elvis at the Memphian Theater. *(Courtesy of JoCathy Brownlee Elkington)*

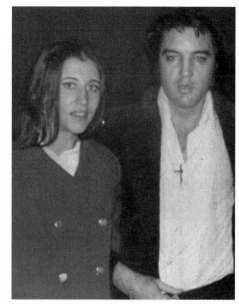

Late in life, Elvis still looked for young girls to mentor. One of the last was fourteen-year-old Reeca Smith, who hoped to become a model. "I think she is a wonderful girl, and I have great intentions," Elvis told her father in late 1974. *(Courtesy of Reeca Smith Gossan)*

The night Elvis met model-actress Mindi Miller in 1975, he persuaded her to give up her life in Rome to be his girlfriend. He'd had a premonition she would know him. *(Courtesy of Mindi Miller)*

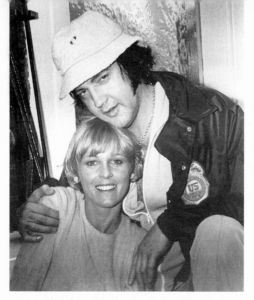

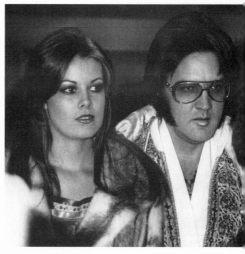

Elvis hugs Shirley Dieu, Joe Esposito's girlfriend, on vacation in Hawaii, March 1977. "He always told me he wanted someone who would love him like I loved Joe," she says. *(Courtesy of Shirley Dieu)*

Elvis's relationship with twenty-year-old Ginger Alden was the source of much of his frustration in his last year. *(Robin Rosaaen Collection)*

After Elvis's passing, Linda Thompson (shown here in October 1977 on the set of *Hee Haw*), went on to enjoy her own show business career, particularly as a songwriter with composer and record producer David Foster. *(Alanna Nash)*

takes. You can't help but think that was the real Elvis, the nice, well-spoken, well-mannered southern guy who was just so hot."

One reason Elvis may not have tried very hard with Raquel was because since October 1963 he had been seeing Gail Ganley, a dancer from *Kissin' Cousins*. One day the brunette was in the middle of rehearsing a dance number when suddenly there was a hand on her shoulder. For a moment, it stunned her—not because of who it was, but because he looked remarkably like her former boyfriend.

"He had a blond wig on, playing the part of the twin, and he said, 'Hello, there,' in this beautiful low voice, 'I'm Elvis Presley. What's your name?' By the second week of shooting, he made it known that he was very interested and he wanted me to go out with him."

Gail, much like Barbara Hearn before her, bore a great resemblance to Elizabeth Taylor. Whether she reminded Elvis of his younger days in Memphis, he was like a teenager in his pursuit: Gail had been knitting a sweater on the set, and she returned to her chair one day to find it unraveled. Then after she filmed a scene in which she had to be barefoot, Elvis came up and said, "I couldn't stand it anymore. I have to tell you that I hid your shoes."

As usual, he had one of the guys invite her to the house, but it scared her, and like Raquel, she turned him down, making up an excuse of having to attend a bridal shower. The next day, she thought better of it and brought a box of See's candy to the set, giving it to one of the entourage to take to him. Elvis invited her to his trailer.

"Did you think about me last night?" he teased. After that, she gave in.

The first time she came to the house, they just watched television, and he kissed her good night like a gentleman. Gail was relieved. She'd had only the one boyfriend. But she had a history of a different kind—she was the last of the Howard Hughes starlets, and she'd just sued the mysterious billionaire over her unfulfilled contract. When Hollywood columnist Harrison Carroll showed up on the *Kissin' Cousins* set to interview her, Elvis was enthralled. In fact, it made her more attractive to him, as in a roundabout way, it linked her to Debra Paget, in whom Hughes took a personal interest. But it also made Elvis nervous—was she going to talk about him next? Soon, however, he got over it.

Their first night in the bedroom, he made no attempt to undress her. Instead, they talked and cried all night about their lost loves—her boyfriend, his mother— and he was "careful with his hands," she remembers. "Elvis made me feel like I was a queen, like a very, very special person."

She immediately fell in love with him, and she was surprised that it took her such a short time to forget the guy who jilted her. The relationship lasted fifteen months, through three film productions.

"At one point, I had to ask Elvis about other ladies in his life. He said, 'Well, I don't want to talk about that. There's somewhat of a commitment down the road, [but] I don't know if I can keep it. Right now, *we're* dating each other and there's nobody in my life.' "

Counting Ann-Margret, Yvonne Craig, Cynthia Pepper, and Priscilla, who went with him to California on the film, Gail Ganley was at least the fifth woman Elvis courted during the seventeen-day shoot of *Kissin' Cousins.*

Psychologist and Presley biographer Peter O. Whitmer says that Elvis's behavior fits the description of satyriasis, an uncontrollable and abnormal sexual desire in men, the equivalent of nymphomania in women. And yet, "Of all aspects of male sexuality, the concept of satyriasis is as time-honored a behavior as it is difficult to define." The ancient Greeks sculpted statues of the desire-reveling man-child, epitomizing the charming carelessness of youth. The ancients also held to the sacred customs of "satyr dances," or religiously observed and licentiously performed moratoriums on morals, staged to glorify fertility and the central act of sex.

In the 1970s, sex researcher Judith Singer Kaplan, emphasizing the psychological origins of what she termed the "Sexual Desire Disorder," divided this behavior into six levels, the top being "Hyper Active," where individuals are simply unable to regulate their desires, and they engage in frequent, compulsive sex, many experiencing several orgasms a day.

"For Elvis," says Whitmer, "it seems essential that his psychological baggage as a twinless twin be seen as creating his hypersexual desire. Childhood trauma is generally accepted as the basic cause for such disorders. In his case, the trauma of being a surviving twin was infused into his psyche before birth, and resulted in an exaggerated need for human contact. This was perpetuated by his relationship with Gladys."

As Elvis reached puberty, especially, Whitmer posits, "Human contact, sexual or otherwise, replicated his first memories of touching another human and provided him with a lodestone to his most meaningful sense of identity—having been 'whole,' one of a pair of twins. It was a 'desire' that controlled him, not vice versa."

In interviews with twinless twins, the psychologist reports, these two themes—the insatiable, yet impossible need for human contact, and their lack of control over it—appear nearly universal. Studies show that twinless twins expe-

rience divorce and sexual dysfunctions at rates far higher than normal. A commonly heard and emblematic quote: *"How can I become—or stay—married, when someone else was there at the very beginning?"*

· · · · · ·

On April 30, 1964, during the making of Roustabout, *Elvis met Larry Geller, who* would change his life in profound ways. Larry, who had lived in Los Angeles since the age of eight and gone to beauty school with Patti Parry, was a hairdresser in the salon of Jay Sebring, whose celebrity clients included Warren Beatty and Steve McQueen. Elvis's usual hairdresser, Sal Orifice, was unavailable, and Elvis was looking for someone who did good work and didn't mind traveling once in awhile.

"I was styling Johnny Rivers's hair one afternoon, and the phone rang and it was Alan Fortas. I picked it up and I heard this southern drawl, and Alan said, 'Elvis heard about you and he wants you to come up to the house to fix his hair.'"

Larry showed up at Perugia Way around 4 P.M. that day, and as they talked, Elvis found him both personable and engaging, especially when Larry launched into a discussion about the subject closest to his heart—esoteric studies and the metaphysical.

Elvis nearly bolted up in his chair.

"What you're talking about," Elvis told him, eager for a connection, "is what I secretly think about *all the time.*" Suddenly it was as if Larry had opened a vital passageway that Elvis couldn't wait to enter. He began to talk intently about what his mother had told him, that he was living for two, and that he had been destined for something great. He admitted that he thought of himself as "chosen," but he didn't know why or what his real purpose was in life. "Why was I plucked out of all of the millions and millions of lives to be Elvis Presley? Why did this happen to me?"

As they talked on, Larry could see that the basic stream that ran through Elvis's life was not so much a desire to get closer to God, but rather a quest for happiness and for an understanding of his place in the grand scheme of things. Larry, who had grown up in the Jewish faith before exploring Eastern philosophies, explained the concept of "the divine I" and told Elvis he would bring him some books to read that might lead him on a path to spiritual discovery.

The following morning, as Elvis reported to Paramount for publicity stills, Larry turned up at the studio with several classics, including Joseph S. Benner's

tiny spiritual volume, *The Impersonal Life,* first published in 1917. That book in particular would become one of Elvis's favorites. He would read and reread it studiously through the years, giving out annotated copies to friends, especially women, saying, "You *have* to read this."

For the next month, Elvis dedicated himself to learning more about Eastern religion and spiritual disciplines. Larry, Elvis decided, would be his tutor. He coaxed the hairdresser into quitting his job with Jay Sebring and going to work for him both as his hairstylist and as his spiritual adviser. Soon they were spending far more time one on one than Elvis had ever spent with anyone else in the group. Larry would take him down to the Bodhi Tree, the spiritual bookstore on Melrose Avenue, where they'd keep the store open after hours just for Elvis. Then the two of them would hole up together in the bathroom at the house, talking for at least an hour or two each evening and reading passages from *Autobiography of a Yogi, Cheiro's Book of Numbers,* and Kahlil Gibran's *The Prophet,* which Elvis had once received as a gift from June Juanico.

Elvis liked the fact that Larry was Jewish and told him that, technically, he was, too, since Gladys's maternal grandmother, Martha Tackett, was of Hebrew descent. Elvis would soon start to wear a small chai around his neck, "to hedge my bets," he would say. And that December, he would add a Jewish star to Gladys's grave marker.

One of the topics Elvis wanted to probe with Larry was how sex and spirituality could coexist in a pure state of mind. Larry told him that sex was the most important energy in life, that "we got here through sex, but we have to be able to understand our sexual nature. If you dissipate that energy and use it in the wrong way," he warned Elvis, "it will come back and destroy you—make you physically ill and lead you down some very strange paths with the wrong people. But if you learn how to harness that energy and be with one person, your mate, then it can uplift you.

"That's what God wants," Larry said. "That's the original design for creation."

The subject of sex and love was much on Elvis's mind, Larry saw, because "he was living different lives within that body, and he was always in a battle. He fought with himself. He was raised in this ethical stream of church, and to do the right thing and never betray. And yet he became somebody else. He became Elvis, and he attempted to show everyone that he was superman."

That June 1964, during the filming of *Girl Happy,* Larry was talking with Elvis on the MGM back lot about 1 A.M. when Ann-Margret came on the set. "It was the first time I ever saw her, and she was really beautiful. This girl glowed."

Elvis asked the two of them to come into his dressing room trailer so Larry could do his hair. "He was like a little boy around her. You could just see he was enamored. He really, truly cared for her."

Not long after, Elvis confided to Larry about his dilemma. "I have to make a decision," he said. "It's between Ann-Margret and Priscilla. I really love them both, but I'm choosing Priscilla because I want a wife who isn't in show business, somebody who will devote herself to a family. Besides, I think our egos would clash."

Elvis was also mindful of his promise to Priscilla's stepfather. But that was problematic, too, Marty Lacker notes: "Elvis's infatuation with Priscilla started wearing off early, right after she first came. But he put up with her because he didn't want to hurt her, and because she was convenient." Elvis was rearing Priscilla, but the dynamic was changing. "I'll give you Elvis's relationship with Priscilla in a nutshell," says Lamar Fike. "You create a statue. And then you get tired of looking at it."

When Priscilla came on the set of *Girl Happy,* a bathing-suit-and-babes romp set in Fort Lauderdale during spring break, she struck actress Chris Noel precisely the same way. "She sat in one of those director's chairs, her hair piled up real high, and she was like a statue. She never moved. She just sat there staring."

There was no communication, remembers Chris, who played a bikini-clad coed, and Elvis didn't introduce her to anyone. "She gave off an untouchable vibe. Like, 'I'm here because I have to be, but don't anyone dare speak to me.' So nobody said anything to her." The actress thought Priscilla was stuck-up, but she also felt sorry for her. "It was like she didn't have any friends, like she wasn't even *allowed* to have a friend."

Priscilla probably suspected that Elvis was distracted on the set when she wasn't around. And, in fact, he was.

"He came on to me in a very strange way," Chris says. "I was sitting in a chair one day, engrossed in watching people move things around on the set, when all of a sudden, there was this tongue in my ear. I was pretty defensive. I didn't know who it was, and my reaction was to snap, 'Lay off.' And I turned around and it was Elvis. He said, 'W-w-w-whud you say?' Oh, my gosh, I almost died! How could I tell Elvis to lay off? But I did. I said, 'You heard what I said.' So he said, 'Okay, if that's how you feel.' He knew that wasn't a cool thing to do."

She thought he would never speak to her again. But right after that, they were walking toward each other on the lot and, "Just over and over, he started singing 'Leon,' 'Leon,' 'Leon,' which is 'Noel' backward. He had quite a sense of humor."

If Chris was Elvis's love interest on the picture, his relationships with the other women on the set went a long way toward completing a familiar triad. Here, Shelley Fabares, on her first of three Elvis pictures, stood in for Jessie Garon. He constantly cut up with her the same way he had with Betty Amos on the Louisiana Hayride, teasing her all the time and elbowing her in the ribs. When Elvis sang "Puppet on a String," Charlie Hodge remembered, "He'd say the *P* in the song, and her hair would go. . . . And they'd get to laughing. [The director] just sent them home. He said, 'We'll shoot around you.' And they came back the next day and finally got it shot. He loved doing things with Shelley. . . . I think [she] was probably his favorite star."

"Talk about brother and sister," says Chris. "He totally adored her, because she wasn't coming on to him like a bombshell."

Neither was Mary Ann Mobley, Miss America of 1959, who was making her first film after five years of musicals and guest shots in episodic television.

"We never had any kind of romantic association," Mary Ann explains, "because you were either one of the girls, or you were a lady. ('Where is Mary Ann's chair?,' he asked the guys.) I was never invited to the house. He used to say, 'Mary Ann, one day I'm going to have a party I can invite you to.' He was very conscious of that. And I took that as a compliment."

They enjoyed a true platonic friendship, she says, even though she found him completely arresting. ("The attraction was there. I don't think I've ever met anyone who had such a dynamic presence as Elvis.") But if he took comfort that Mary Ann was a dark-haired Mississippi girl like his mother ("He said, 'If you ever need us, just call,' and gave me his number"), for Mary Ann, "It was like I was working with my brother. He didn't have to put on airs with me, and I wasn't after anything. He thought I understood him, and I think I did."

As an example, Elvis took time to share with her what was on his mind. He told her about his brother and said he was reading a lot of books about the metaphysical, and he asked if she ever wondered about the things that happened in her life.

"I said, 'All the time.' And he said, 'I do, too, especially about why I lived and Jessie Garon didn't.' I think he was looking for answers. He knew there should be answers, but he wasn't sure how to find them."

Their conversation got back to Colonel Parker, who wasn't pleased to hear about it, fearing Elvis's constant talk about spiritual searching might make him seem unstable in the view of the studio heads. Parker, Priscilla, and most of the entourage also took a dim view of Elvis's new course of thought. And though

Elvis was the one who had reached out to Larry Geller and invited him into the group, they viewed Elvis's new guru with jealousy and suspicion, if not derision. (Lamar called him "the swami.")

From one chance meeting, they thought, Larry had upended almost everything about Elvis's life. The nightly parties continued, but now Elvis was spouting philosophy and religion, not playing pool. Instead of seeing Larry as a positive force who brought depth and challenge to a man desperately in need of change, nearly everyone in the group regarded Larry as a disruptive interloper who threatened the status quo.

"Elvis was very much into all this unknown stuff, and Larry came along at the right time," offers Joe Esposito. "I wasn't into it that much, so whenever those conversations started taking place, I would disappear. I just didn't trust Larry too much. I thought Larry was out for Larry and that was it."

Larry was acutely aware of what they thought. One day the Colonel said, "You missed your calling, Larry." It was a sly remark, a put-down from the old carny. "I knew that he was speaking metaphorically, that he thought I was a magician, that I had power and that I was hypnotizing Elvis. And yes, it was true on one level. But it had nothing to do with putting someone in a trance or playing with his subconscious mind. My whole motive with Elvis was to be as truthful as I knew how. All I wanted was for Elvis to be his own man. What does that mean? That means opening your eyes. It means waking up—not being hypnotized by influences and suggestions."

At first several of the guys considered Elvis's metaphysical studies his latest obsession, a mood regulator like his interest in slot cars that would come along at the end of 1965. But in short order the group accused Larry of "messing up Elvis's head with all that nonsense," as one of them puts it. Joe realized that it didn't just fill a void in his life: "He got so wrapped up in it that he started forgetting about his work and his music. All he talked about was this religious stuff."

The Colonel, who was negotiating with MGM for the benchmark figure of $1,000,000 for Elvis's next picture, *Harum Scarum,* had a heated discussion with Elvis about it at the studio that August, accusing him of going on a "religious kick." Elvis was furious. "That motherfucker, man," he told Larry. "My life is not a 'religious kick.' I'll show that fat bastard what a kick is.'"

Elvis fumed for days and made plans to fly Larry and his wife, Stevie, and their children to Graceland later that month. On the way home, during a stopover in Amarillo, Texas, Elvis was still so testy that he blew up with Joe over a minor matter and fired him. Marty would now be the foreman of the Memphis Mafia.

He stayed home until October, lying around much of the time, depressed, listless, not feeling well. Late in the fall, he took the caravan back to Hollywood for Allied Artists' *Tickle Me,* with Norman Taurog again in the director's chair. It was another embarrassing plot—Elvis plays a singing rodeo cowboy who moonlights as a handyman at a beauty spa—and served mostly to get half-naked girls on the screen.

As usual, he flirted with women on the set, beginning with the tall brunette Francine York. They had a scene together in which he pretends to teach her how to shoot a bow and arrow. "There was something wrong with the lights or the camera angle, and so we had to shoot the scene several times. Norman asked Elvis if he'd mind shooting it again, and he said he wouldn't mind doing it all day. Then he pulled me closer and whispered, 'And all night.'"

She took it as just a friendly comment but, "Elvis and the guys enjoyed themselves with all the beautiful women in the movie. Elvis had a girlfriend then, too, and I remember him getting angry when she drove onto the set. He had a few words to say to her, and it seemed as though he was upset that she had come to the studio." Francine didn't remember her name. But "this definitely wasn't Priscilla. She had a huge car, a Cadillac or something."

It was his last trip to California for the year, and with him on the way out were two new members of the entourage, Mike Keaton, and twenty-two-year-old Jerry Schilling, whose brother, Billy Ray, was a friend of Red West. Jerry, who'd grown up poor and scrapping, and without a mother, had been planning to return to Arkansas State University for his senior year when Elvis made him the offer. He had been part of Elvis's touch football games from the age of twelve, and Elvis treated him almost like a younger brother. But when he found out that Jerry lost his virginity with an actress Elvis had romanced on his last picture, they had a tense exchange. Jerry had no idea that Elvis and the girl had any history, and Elvis let it blow over. But Jerry learned a cardinal rule in the inner circle: None of the guys were permitted to date a girl Elvis had known.

Jerry did know that part of his gig was protecting Elvis, and he was also well aware that Elvis had his share of crazy fans who would do almost anything to get near him. His heart started pounding on his first night in the Perugia Way house, then, when about 2 A.M., he heard a key turn in the front door lock, and watched a shadowy female figure cross the room in the dark. Jerry had been too buzzed from Dexedrine to sleep, and now he called out sharply: "Miss—

"The woman spun around and let loose a bloodcurdling scream," he wrote in his memoir, *Me and a Guy Named Elvis.* "And at that very moment, the wall

behind her opened up to reveal Elvis. He flicked on the lights in the room. There was a huge smile on his face. The girl being there didn't seem to bother him at all. In fact, he seemed to know her.

"My eyes adjusted to the light. Now I recognized the girl, too. It was Ann-Margret. Elvis put an arm around her and grinned in my direction. 'It's okay, Jerry. It's just Ammo. She's not gonna hurt anybody.' "

.

Elvis went home around Thanksgiving and spent the holidays in Memphis, renting out the Memphian for New Year's Eve. But it was getting harder to watch quality films now when his own fell so short of the mark. No one was allowed to sit in front of him, and there in the darkened theater, when he'd get caught up in the emotion of a dramatic scene, he'd cry and slyly wipe away tears, or pretend that something had gotten in his eye. Sometimes he wasn't sure if he was weeping because of the situation on the screen, or because he knew he'd never get a role like that again.

Then January 8, 1965, brought a milestone birthday—his thirtieth. The morning newspaper, the *Commercial Appeal,* called about an interview. Reporter James Kingsley wanted Elvis's ruminations on growing older.

"I can never forget the longing to be someone," he said in the article. "I know what it is to scratch and fight for what you want." Kingsley asked him about his relationship with his fans, who always hung around the gates and made it difficult for him to go to his old haunts without being bothered. "I certainly haven't lost my respect for my fans," he said. "I withdraw not from my fans, but from myself."

He demonstrated that at the end of February, when he went to Nashville for a hastily set-up session for the soundtrack to MGM's *Harum Scarum,* his million-dollar movie. The picture, another Sam Katzman quickie, cast him as a Rudolph Valentino–style matinee idol, kidnapped by a gang of assassins on a personal appearance in the Middle East. Elvis hadn't been in a recording studio for eight months, but he was so dispirited at the material, much of it laced with flute and oboe for a Persian flair, that he stopped the first session after only four hours—thirty-eight takes into the disaffecting "Shake That Tambourine."

A number of people around Elvis had started to worry about him, one telling the *Saturday Evening Post* reporter C. Robert Jennings that the heavy schedule of three pictures a year was beginning to take its toll.

"The money is so big," said the anonymous source, "that he's always doing what everybody else wants him to do. He's a lonely guy in many ways."

But Joan Blackman, who was also concerned about him, later laid much of the blame at his own feet: "Elvis could have demanded changes, had he wanted to. He could have said, 'Until we do what I want to do, I am not doing any more [of these cookie-cutter movies].' Had he stuck by that, things could have been different."

Word filtered back to Colonel Parker that Elvis was lethargic, that he seemed to have no interest in coming to Los Angeles for *Harum Scarum,* and that it was going to take some effort to get him there. At the end of February, the Colonel arranged for Elvis to be able to take his cast insurance medical examination in Memphis to give him a bit more time at home. Then he wrote anxious letters to foreman Marty Lacker, cautioning him to get the convoy on the road in plenty of time, and to watch out for inclement weather. In a rare, unguarded moment, the Colonel let his frustration show, telling the *Saturday Evening Post* that "sooner or later someone else is going to have to take the reins."

They finally got started in early March, but on the way out, Elvis insisted on checking into a motel in Amarillo, Texas. He'd been thinking about the way he used to be, the way he lived, the things he'd said, and how he was trying to change. He contemplated what Larry and the books had taught him.

"He was so strong in so many ways," observed Jo Smith, Billy's wife. "If you were with him, you felt safe. But in other ways, he was like a little kid. He was such a contradiction. As selfless as he was in religion, he always had to be number one in everything else. One time, everybody wanted to go bowling. So Elvis rented Bowl Haven Lanes, right down the street from Graceland. I don't guess he'd ever been bowling. Billy had been on a team, and several of the other guys had gone bowling in California, so they were pretty good. And Elvis wasn't good at all. He guttered, and he tried to throw the ball too hard. So that's the last time we ever went bowling. If he couldn't be the best at whatever we did, we didn't do it anymore."

Back in Germany, he used to play a game with Rex Mansfield. Rex called it "God playing," and Elvis would initiate it. "We'd be sitting around the house, the whole group," as Rex recalled, "and if anybody would compliment something, or say, 'Boy, it's a beautiful day,' he'd say, 'Thank you.' Or if someone would say, 'That's a beautiful dress,' he'd say, 'Thank you,' like everything anyone owned, it belonged to him. We all got into that game, and it became a matter of who could say 'thank you' first."

Elvis was ashamed of all that now. Having to be the best. "God playing." How could he have done it, even in jest? In that Texas hotel room, he confided to

Larry that after all his months of study and meditation, he was disheartened, that something was missing. "I read all of these wonderful books," he said. "But they all talk about these great, profound spiritual experiences, and I never had one."

Larry explained to him that it had nothing to do with an intellectual perception, but that it happened in the heart and was more of an emotion, a surrendering of the ego to God. They talked for thirty or forty minutes, and then they all got back into the vehicles, Larry and Elvis riding alone in the Dodge motor home.

They drove the rest of the night and all the next day, traveling through the panhandle of Texas, through New Mexico and eastern Arizona. As they approached the famous San Francisco Peaks, the home of the sacred Hopi Indians at Flagstaff, Larry suddenly realized they had gotten separated from the rest of the caravan.

"Uh, I think we're lost," Larry said. But Elvis was unfazed: "This is really good, because I needed to be away from everyone. I'm into something very, very important within myself."

It was getting on in the day now, and the sky was electric blue, deep and unfathomable. Suddenly, Elvis called out. "Look, man! Do you see what I see?"

He pointed to a cloud, and Larry immediately knew what he meant.

"What the hell is Joseph Stalin doing in that cloud?" Elvis said, amazement in his voice.

Larry laughed. "I don't know. That is really far-out." He watched as the cloud dissolved back into a nebulous shape, and then he saw a change come over his friend.

"I looked at Elvis, and all of a sudden, his jaw dropped, and he gasped for breath. He said, 'Ahhh,' and his eyes were wide open, and he had a look on his face that was just full of revelation. He pulled the motor home over, and he jumped out into the desert and yelled, 'Watch! Just follow me, man!' He ran about thirty feet away, and he turned around and looked at me, and there were tears rolling down his cheeks. He grabbed me and he hugged me and he said, 'I love you! I know now! It happened. It *happened*.'"

Larry stood back. "I saw Stalin in the cloud. But what happened, man?"

Elvis struggled to regain his composure. "Larry," he finally said, "I remember you said, 'It's not a thing in your head. It has to do with your heart.' And I said, 'God, I surrender my ego. I surrender my whole life to you.' And it *happened*. That face turned into the face of *Christ*. It was like a lightning bolt went right through me! I know the truth now, and I don't *believe* in God anymore. I *know* that God is a living reality! He's within us!"

He was laughing and crying at the same time now, shaking with emotion, and wiping away tears. "You can't understand it unless you get the experience," he said. "Otherwise people will just think you are nuts, man!" Suddenly he was aware of cars passing on the highway.

"Man," he said, "can you imagine what the fans would think if they saw me now and knew what I was going through?"

"Elvis, they would probably love you all the more, you know?"

Just then, the caravan caught up with them, and Red West stuck his head out the door.

"Hey, boss," he yelled. "You all right?"

"Yeah," Elvis yelled back, "don't worry about it. I'll be right there."

Whatever he went through, "It was very, very meaningful to him," in Larry's estimation. "It was a classic rebirth, a confluence of religious feelings and perceptions of his earlier life in the church, and it impacted him deeply."

When they got back in the motor home, Elvis was still so discombobulated he couldn't drive, and he called for Red to take the wheel.

"Come on, man," he said to Larry. "Let's go in the back." He laid on the bed and kept repeating, "Wow, wow," softly, like a mantra. Soon Elvis would start talking about giving up his career and entering a monastery. And he would spend a lot of time with a woman named Faye Wright, better known as Sri Daya Mata, at the Self-Realization Fellowship's Lake Shrine retreat in Pacific Palisades.

· · · · · ·

Mary Ann Mobley was Elvis's costar on Harum Scarum, *and she dropped by Colo*nel Parker's office one day to sign her contract. *Time* magazine called while she was there. "They said they wanted to put Elvis on the cover, and Colonel Tom said, 'Good, that'll be $25,000,' or some outrageous price. And *Time* said, 'You don't understand, it's an honor to be on the cover of *Time.*' And Colonel Tom said, 'No, *you* don't understand. We don't need you.' "

Parker, still gloating that Elvis was the first actor ever to be paid $1 million for a single movie, might have been smart to let *Time* promote *Harum Scarum,* for despite Elvis's astonishing fee, the picture rivaled *Kissin' Cousins* as his absolute worst. Shot in eighteen days, it recycled the 1925 set of Cecil B. De Mille's silent feature *King of Kings,* as well as costumes from the 1944 production of *Kismet.* The plot was paper-thin, the music unlistenable, and the sight of Elvis in a turban ludicrous. Even the Colonel, who would eventually suggest adding a

talking camel as a narrator so the absurdity might seem intentional, admitted it would take "a fifty-fifth cousin to P. T. Barnum" to sell it.

The only way they got through it, remembered Mary Ann, who played Princess Shalimar, was by joking. "Elvis said, 'This isn't going to change history, is it?' I said, 'No, but it's gonna make people laugh.' "

The whole thing seemed a comedy of errors.

"For part of it, I was dressed as a beggar woman, because I was supposedly this princess in disguise. And then the rest of the time I had on seventeen thousand yards of orange chiffon, and all these veils and so much hair I could barely keep my head up. And Elvis came out in this Arab sheik outfit, and if he wasn't a good sport to be seen in *that* getup! But he never complained about it. He never said, 'You want me to wear *this*?' He wasn't one of these prima donnas."

Still, she was concerned about him. "He was into the metaphysical then, 'willing' things to move. That was unique to me. I hadn't seen that before. I was worried about it, but it was not for me to judge. I thought, 'If that works for him . . .' But it didn't cause problems. He was never late and never caused a discussion. It was just so easy working with him."

The picture also reunited Elvis with Barbara Eden, whose husband, Michael Ansara, was cast as a prince. Barbara sat with him for a while on the set and found him more outgoing and sure of himself than he had been five years earlier on *Flaming Star*. "He'd laugh out loud, for example. But he was still the same basic, good, sweet, malleable guy. Such a gentleman. He said he was a huge fan of my husband, who was in the series *Broken Arrow*. I said, 'When do you ever have time to watch television?' And he looked at me and said, 'Barbara, that's all I do. I can't go out. I have to stay in.' I got the impression it was like a jail."

He got his opportunities, of course, but as Patti Parry knew, sometimes they were unorthodox. "When he was doing *Harum Scarum,* we found out that Rudolph Valentino was buried in the Hollywood Forever Cemetery. So we drove over there at eleven o'clock at night and poked around a little bit, and we found Valentino's grave. Elvis just wanted to see it."

They walked around cemeteries a couple of times, she says. "That's the only place nobody bothered us."

Elvis found a willing spiritual acolyte in costar Deborah Walley during the filming of *Spinout* in early 1966. "I was never the same after Elvis," she said. Their friendship lasted until his death, and afterward, she often felt him around her. *(Robin Rosaaen Collection)*

"You Don't Really Love Me!"

In March 1965, the Colonel convinced Elvis that Joe Esposito should come back into the camp. Parker had never liked Marty Lacker, who refused to kowtow to him and share secrets of the internal workings of the group, and the Colonel was determined to find a way to exercise more control over his loose canon of a client. Citing Joe's excellent organization skills, Parker encouraged Elvis to mend fences with him. For a time, then, Joe and Marty became co-foremen of the Memphis Mafia. But Marty's time was written on the wall, for Joe was also a favorite of Priscilla, going back to their shared time in Germany. With his return, she began playing a bigger role in Elvis's life.

"I am a child-woman," Priscilla said in 1991. "When people meet me, they don't know what to say to me. They really don't know how to approach me. I'm always trying to find that place to fit in. I am a misfit."

But as one of her business associates knows, "Priscilla has a remarkable interior gyroscope which keeps her on course. She's uncanny."

In 1965, her interior gyroscope was already at work, and the "child-woman" began working hard to drop the prefix on her self-image. Lamar saw that while Elvis controlled the guys, starting in 1965, Priscilla started lording it over the wives. She expected them to cater to her, Billy thought, and took advantage of her position, borrowing the wives' clothes and not returning them, and asking to use their credit cards.

As she asserted herself, the group began to splinter into separate camps—Jerry Schilling gravitated to Joe and Priscilla—and a caste system took hold among the couples, Joe and his wife, Joanie, leading the pack behind Elvis and

Priscilla. Marty thought Priscilla paid attention only to Jerry and Joe, and that Joanie became her shadow.

"It became like the First and Second Family," Lamar says. "It just galled Billy and Marty, and I wouldn't put up with it. I told them all to go fuck themselves."

Suddenly, there were rules. Only Joe and Priscilla were allowed to take pictures of Elvis, according to Billy, "and then after they took them, you couldn't even get a copy of them. Same with home movies."

In general, Elvis did not want the wives to come out to California or accompany their husbands on trips. "He was going to play around, and he didn't want anybody carrying tales," as Lamar puts it. "Being with Elvis put a hell of a strain on a marriage. And on being a family. I was home so infrequently that my kids would see an extra place at the table and wonder who was coming."

Billy's wife, Jo, was especially hurt over the way Elvis excluded the wives, as many of the guys now had families, and he didn't always seem to respect those ties. She also thought she was in a vulnerable position because of Elvis's closeness to Billy. Though the two men were first cousins, Elvis regarded him as a brother, someone he had reared and guided from the days when they first came to Memphis and lived in the slums. "I saved you," Elvis told him over and over.

"Elvis couldn't live without Billy," says Jo. Part of it was the connection to Elvis's past, especially to Gladys, since Billy had been close to her. Part of it also was that Elvis's father and Billy's father had been in prison together, so there was nothing that Elvis had to be ashamed of with him. Consequently, Elvis wanted Billy with him all the time, and he resented it when Billy got married.

"Sometimes Elvis was like the Devil to me," Jo admits. "I pitied him, but I also feared him. I knew the power he had over everybody who worked for him, including my husband. When he took him on trips, it was like he was taking him *from* me, because I lived by myself in Memphis while Billy lived in California. When our first child was born, Elvis wouldn't let Billy come home. And I didn't understand that. I lived in fear that Elvis would win and take Billy away forever. Patsy Lacker, Marty's wife, was my best friend then. Patsy used to say Elvis made her a hateful person, even to herself. We threw rocks at the bus and wished them all dead."

Jo Fortas, Alan's wife, was also at her wit's end. Alan had developed a frightening dependency on pills, usually downers—hypnotics—though he'd take uppers when driving cross-country, and Jo didn't know how to handle him. She'd call Red or Marty when things got really out of hand, and one of them would have to go over to their apartment on Beverly Glen Boulevard and search for the pills and flush them down the toilet. Usually it was Marty. "We had to haul Alan

over to UCLA Medical Center in '65. He had thirty-five yellow jackets in him. Tried to kill himself over this tug-of-war between Elvis and his wife. Alan had six, seven, maybe eight real good scares."

To alleviate some of the tension, Elvis would invite Jo Smith to live in the house in L.A. in the mid-1960s. Lamar thought it made her seem like one of the guys. But Jo thought Elvis was jealous of how close she and Billy were. He wanted a similar closeness with just one woman, she could see. "But he wanted the closeness to be just on the wife's part."

That May, Elvis began work on *Frankie and Johnny* at MGM, where he became the first star in studio history to have two dressing rooms—one for himself, and one for the guys. The irony was not lost upon him that Tony Curtis's dressing room had been prepared for him.

Directed by Freddy De Cordova, whose credits included *Bedtime for Bonzo* and *The Tonight Show Starring Johnny Carson, Frankie and Johnny* was a comedic turn on the old folk song by the same name, recast as Victorian period froth. Donna Douglas (Frankie) and Elvis (Johnny) appear as riverboat performers whose lives change when dancer Nellie Bly joins the troupe.

During production, Elvis and Donna ("Elly May" from *The Beverly Hillbillies*) squirreled away to discuss all things metaphysical. But Lamar saw that "he didn't try to date her. She was a smart cookie, and she knew about as much as he did, so they just talked books and religion."

On Perugia Way, Elvis was reading Timothy Leary's *Psychedelic Experience* and Aldous Huxley's *The Doors of Perception,* and encouraging Red, Sonny, and Alan to drop LSD while he watched. He tried smoking pot, though it burned his throat. But when he and Priscilla innocently got into a batch of Lamar's marijuana brownies, they didn't come out of the bedroom for days. "They just stayed ripped the whole time." Shaking, Lamar went in and confessed what had happened, expecting to be fired. Instead, "Elvis held out the tray and he said, 'Lamar, put another ounce in there.'"

Sue Ane Langdon, in her second picture with Elvis, remembered that he was "never really taxed" to do much on the film. "He was quite natural as himself . . . and I think Elvis played Elvis the best that anybody could ever have played him."

Elvis seemed to just be sailing through both his life and his film roles in the mid-1960s. But by late July, when his next picture, *Paradise, Hawaiian Style,* was scheduled to go into production, he was in trouble.

Like Alan and others of his group, Elvis was experimenting with barbiturates,

particularly Seconal and Tuinal. Uppers had helped him keep his body trim, but downers slowed his metabolism while he continued to eat such typical lunches as a bowl of mashed potatoes, a side boat of gravy, nine slices of bacon, a quart of milk, a lettuce salad with dressing, tomato juice, and six slices of bread. For breakfast, he often upped his bacon intake to an entire pound.

He showed up at Paramount for preproduction on August 2, a week late, citing illness. His appearance was shocking. He looked jowly and puffy in the face, soft around the waist, and he perspired so heavily that he frequently changed his shirts. Director Mickey Moore, who had worked as assistant director to Norman Taurog on a number of Presley pictures, was appalled. Elvis was to play a helicopter pilot with a tourist-related charter business, which required him to look lean, handsome, and rugged. Instead, in costume, he was so pudgy, with visible pooches of fat, that he split his pants.

Producer Hal Wallis was livid. He had been steadily complaining about Elvis's weight to the Colonel since before *Roustabout.* The two were friendly adversaries, and he had warned Parker in late 1963 that he needed to have a stern talk with his client, and that if Elvis didn't shape up, "It could have a very detrimental effect on his entire career." On one occasion, Wallis sent his sister, Mina, to the Samuel Goldwyn Studios to check up on him. She greeted Elvis warmly and then stood with her arm around him in conversation. When she left, Elvis went berserk. "That goddamn old fucking bitch!" he spewed to Marty. "She was feeling to see how much fat I had around my waist!"

Paradise, Hawaiian Style was the last picture in Elvis's revised 1961 contract with Wallis, and during filming, the Colonel would enter into arduous negotiations with him on a new deal—$500,000 per picture, plus 20 percent of the profits. He also wanted one nonsinging role for his client. The producer would stall him until the following year.

On August 5, Elvis, Priscilla, Vernon, and Dee flew to Hawaii for location shooting. Jerry Schilling, Larry Geller, Red and Sonny West, Charlie Hodge, Mike Keaton, Richard Davis, Marty Lacker, and Billy Smith went with them.

Jo Smith was pregnant with their second child, and she stayed in California with Patsy Lacker and her three children. "Patsy and I depended on each other." Like Elvis and Gladys, "We even had our own little lingo that only we understood." It was Jo's first time on the West Coast ("I'd never been anywhere before"), and the Watts riots broke out while the guys were gone. Thirty-four people were killed, more than a thousand injured, and nearly four thousand arrested. Jo was terrified, wondering what in the world she'd gotten herself into.

In Hawaii, the movie set was also fraught with little wars and dramas, as Elvis juggled friendships of one kind or another with three starlets—Suzanna Leigh, Julie Parrish, and Marianna Hill—and a child actress, Donna Butterworth.

Priscilla rarely visited the set, which might have boded well for Elvis's flirtation with twenty-four-year-old Marianna, whose exotic looks and long, dark hair set her apart from the more conventional Julie and Suzanna. The problem was that she didn't find him impressive either personally or professionally and considered him little more than "a show business phenomenon." Marianna, whose real surname was Schwarzkopf (her cousin H. Norman Schwarzkopf, would become commander of the Coalition Forces in the Gulf War of 1991), had a sexy dance number with Elvis, "Scratch My Back (Then I'll Scratch Yours)." That led reporters to ask if the two might schedule some private time off the set. "No," she answered, indicating that she found his ubiquitous entourage too strange for that sort of thing.

Elvis didn't end up dating any of the film's actresses, though he might have easily made time with either Suzanna or Julie, both of whom had been fans since their teen years. Suzanna, a Brit born in Redding, England, was the goddaughter of actress Vivian Leigh, from whom she took her stage name. She had grown up dreaming of winning a Paramount Studios contract, or more specifically, of making a film with Elvis. *Paradise, Hawaiian Style* was her second American movie. She played Elvis's girlfriend, Judy, who ran the office in his helicopter charter service.

Suzanna began appearing in British productions at eleven, but now at nineteen, the show business veteran was still nervous about meeting her childhood idol. She planned to tell him that they had a good friend in common, actress-turned-nun Dolores Hart, but she never got a chance to deliver her prepared speech. She was on the set the first day, studying her lines, when suddenly a hand holding a cup of tea appeared before her face.

"I believe everyone from England drinks tea," said a male voice.

Suzanna began speaking before she looked up. "No," she said, "I don't, actually . . ." But then she saw him. "Oh, yes, I do! Yes, yes, I love tea!"

They found an easy rapport, as Suzanna was a strong believer in spiritualism and held a deep faith. "We talked a lot about religion. I had a rough childhood. I found my father dead when I was six. I had a religious experience in a convent when I was small, so Elvis was fascinated by that. He said that he had been searching for someone who could give him facts that Jesus did exist."

During their heart-to-hearts, Suzanna suggested that Elvis expand his repertoire and come to England, "because there were a lot of great movies being done there." Colonel Parker, who had entered the country illegally from Holland and

had no passport to travel, felt threatened by her and, according to Suzanna, fabricated a magazine article in which it seemed that she had "sold Elvis out. There was one thing that Elvis would not let you do, and that was speak to the press about him. If you did, he would drop you like a hot potato."

When Parker had someone slip a copy of the article beneath her dressing room door, "I was in a terrible state over it." She figured Elvis would never speak to her again. But instead, when he walked on the set, "He came up and flicked my bra strap and said for me to go with him."

When he got her alone, she was nearly in tears. "I never said those things!"

"Don't worry," Elvis said. "I know where it came from."

He saved her a second time on the Paramount lot when Steve McQueen wouldn't leave her alone. Grabbing her by the hand, he led her to his photo session, where suddenly he took her in his arms and kissed her for the camera.

"This won't do your career any harm, baby!"

Elvis also had a swoon-inducing effect on Julie Parrish, who had joined a fan club for him at thirteen. When she first met him on the set, "My heart was beating so fast I was afraid he could hear it. . . . He did not seem that comfortable with me at first, but then I was not all that comfortable with him, either, to say the least."

They warmed up to each other, though, and Julie was only too eager to listen to Elvis carry on about metaphysical studies. Then one day she became unwell, following a rough patch with Hal Wallis.

Despite being married, the "old letch," as she called Wallis, kept putting the moves on her. Shortly before the film went into production, "He called me into his office, locked the door behind us, led me over to the sofa, and briefly kissed me on the mouth. He said, 'Little, girl, we're going to have a long talk about your future.' I looked at my watch and apologized, saying I'd like to stay and talk, but that I really had an audition I had to get to."

He continued to pursue her on location, "constantly calling and asking me out. . . . On his last call . . . he said, 'You'd better think again.' I think the stress of all this nonsense contributed to my becoming ill during that film."

When she and Elvis rehearsed the musical number "Stop Where You Are," they stood for hours on end, doing the scene repeatedly. Julie felt a sharp pain in her leg, and soon it crept up the right side of her body. The actress had just gotten out of the hospital, so the experience scared her.

"I complained of it and had to sit down." When she said she couldn't go on, "Elvis came over, picked me up in his arms, carried me to his dressing room and

laid me down on his sofa. He then tried to do a healing. He held his hands about a foot above my body for a while, but I was so nervous, worrying about what everyone on the set must be thinking, that I couldn't enjoy it." Being in his arms, she confessed, "was almost scary to me."

When she got back to the mainland, she went into the hospital for tests and was told she might have suffered a slight stroke. She had another idea: "My intuition told me that it had to do with taking [the sedative] Librium, diet pills, and drinking alcohol. . . . I had also been taking tranquilizers since the age of fourteen."

Elvis could identify with both of Julie's problems. His own difficulties with Wallis were apparent to everyone, even ten-year-old Donna Butterworth. She and Elvis were rehearsing the song "Queenie Wahini's Papaya" when the producer appeared on the set. Suddenly, Elvis's demeanor changed, and as Donna remembers, "he did not dig it that [Wallis] was there. He got miffed and wouldn't continue until he left." She never knew the reason behind it, but Elvis stormed off and went to his trailer, all the guys following behind him. When Wallis left, they resumed their rehearsal as if nothing had happened.

Elvis always made time for the pint-size performer, particularly after she got upset with him one day. She had already met Priscilla and found her "classy and quiet, but a lovely person." But watching Elvis kiss all the girls confused her, since he'd told her that he and Priscilla would eventually marry.

"How can Elvis kiss and be nice to the other girls on the set when he is supposed to be with Priscilla?" she wondered.

One day he invited Donna to lunch in his dressing room, making sure he had the Mexican food she enjoyed from Del Taco.

"Little sister, I can see something's bothering you. What's going on?"

She told him. Elvis took her question seriously.

"Well, you know, sweetheart, the Lord wants you to love everybody as your brothers and sisters. But really, we are *in love* with one person, and for me that is Priscilla."

Looking back, she says, "The King of Rock and Roll explained the whole love thing to me over tacos and cheeseburgers in his dressing room for an hour. If that's not something to remember, I don't know what is."

· · · · · ·

On one of his days off, Elvis went with the Colonel to see the recently completed memorial to the U.S.S. *Arizona,* which Elvis had helped fund with his 1961 benefit concert. Parker had designed an enormous bell-shaped wreath for the occasion,

with one carnation for each of the 1,177 men who died there, and an admiral gave Elvis and his party a special tour on his private boat. Jerry Schilling remembers standing next to Elvis at the rail as they looked down through the water at the sunken ship. They were both surprised to see oil from the engines still bubbling up to the surface. Elvis was visibly moved. "Those guys are still down there," he said, speaking very softly.

He couldn't get it out of his head and talked about it when he got back to L.A. But when Suzanna Leigh returned home, all she talked about was Elvis. One woman in particular hung on every detail. Suzanna was among a group of film stars, including Deborah Kerr, to be presented to Queen Elizabeth. Nervous, Suzanna walked up to Her Royal Highness and curtsied, but before anything else could happen, the queen gushed forth: "Do tell me all about Elvis Presley. . . . What we all want to know is whether he is going to come over here."

Queen Elizabeth was not the only British subject eager to meet Elvis. On August 27, under heavy secrecy and security, the Beatles made a visit to Perugia Way. In a sense, their visit was anticlimactic—at first, the Fab Four seemed too awestruck to speak. Elvis, clad in a red shirt and gray slacks, was sitting on the couch, his leg constantly twitching, while the Beatles nervously came and sat cross-legged in a semicircle on the floor. "There was a silence, and they were looking up at him, no they were *gaping* at him," remembers Larry Geller. "He out-eclipsed everyone, and they knew it." Finally Elvis stood up and said, "If you guys are just going to stare at me all night, I'm going to bed."

That broke the ice, and then Elvis, John, and Paul picked up guitars in the den and played three songs, "Memphis, Tennessee," "Johnny B. Goode," and "See, See Rider," with Elvis on bass. Elsewhere in the house, Ringo, Marty, and Billy shot a bit of pool, while the Colonel, Beatles' manager Brian Epstein, Alan, and Joe spent the evening playing roulette and shooting craps. Larry, hoping to talk with George about metaphysics, followed him outside, where the quiet Beatle smoked a joint by himself under a tree. The next day John, who had famously remarked that "Before Elvis, there was nothing," told Marty it was the best night of his life. Paul would later call it "odd."

Just before they left, Elvis took the Beatles in the back of the house to show them a gift from the Colonel, a large wooden sauna, stationed outside his bedroom. Larry went along. "We all walked through this long hallway up to the sauna, which had a little glass window. Paul looked in, and he turned to Elvis, and he said, 'Who's that?' We opened the door, and there was a fourteen-year-old girl, huddled down in a fetal position. She jumped up, and screamed, and lunged

at Elvis, and someone pulled her away. Elvis said, 'Don't hurt her! Don't hurt her! She's only a fan.' He was so protective. It was really beautiful. But no one ever figured out how this girl got into the house. It was impossible, with the security."

As the quartet went to get in their cars, a fan took a picture of the swirl of activity in the driveway. Several of the wives were there—Patsy Lacker, Jo Fortas, Joanie Esposito, and Jo Smith, pregnant and in maternity clothes. Later, it turned up in a magazine with the headline, "The Night Elvis Shared His Women with the Beatles!"

"Jo laughed like crazy," says Billy Smith. "She saved that for a long time."

After they were gone, Elvis turned to Larry. "Man, I really liked those guys," he remarked, though at thirty, he wondered if his time had come and gone. Out at the gate, the thousand or so fans shouted their allegiance, chanting, "Elvis, we love you!" or "The Beatles! The Beatles!" Elvis couldn't quit thinking about it. "That was quite a battle out there with the fans." And then a pause. "I guess it was a tie, huh?" Larry knew he felt self-conscious. "I think you won, Elvis," he said. Elvis brightened. "Do you really think so?"

He burned to be back onstage again, and he envied that about the Beatles even more than their chart dominance. The year before, the quartet had paid homage to him by putting the Bill Black Combo on their U.S. tour, where Elvis's friend Jackie DeShannon was also an opening act. Now Bill, Elvis's first bass player and one of the architects of his original Sun sound, lay dying of a brain tumor, and would succumb that October at age thirty-nine.

Despite the Beatles' prominence in the music world—and the fact that Elvis's record sales were down 40 percent from 1960—that fall, the Colonel renegotiated his RCA contract on considerably improved terms. The new agreement guaranteed $300,000 against a 5 percent royalty, with 75 percent going to Elvis, and 25 percent to the Colonel.

Even RCA was amazed at his longevity, according to Joan Deary, the label's first female executive, and an employee for more than forty years. "In the very beginning, they thought he'd have a tremendous rise, because he did go up like a rocket. But most artists who go up like a rocket come down the same way. I don't think in a million years they expected that he would go on forever the way he did."

To keep up musically, he continued to expand his knowledge of current acts, listening to folk music, primarily Peter, Paul, and Mary, Ian and Sylvia, Odetta, and interpretations of the songs of Bob Dylan, whose voice proved too shrill for him. But mostly he spent his free time plunging deeper into the escape of mysticism. In October construction began on the Meditation Garden just beyond the

swimming pool at Graceland. Marty Lacker's sister and brother-in-law, Ann and Bernie Grenedier, designed it after the Self-Realization Park, with stained-glass panels, Italian marble statues, and a fountain with underwater light formations.

According to Larry, during the Christmas holidays, Elvis took a bigger step on his path to enlightenment, finally dropping acid under Sonny's controlled supervision.

It was a group trip, of sorts, and began with everybody sitting around the conference table. Elvis split up some tabs—Lamar got his own 750 milligrams—and soon, when Jerry looked at Elvis, he had morphed into a child, first a plump, happy boy, and then a big, chubby baby. Everybody started laughing, and the next thing Jerry knew, he was sitting on the floor in Elvis's closet, eating dates hand over fist.

Priscilla, who had never shown much interest in Elvis's cosmology, joined in. But suddenly in the middle of a mellow trip, Larry wrote in his memoir, *If I Can Dream,* "Priscilla began sobbing. She fell to her knees in front of Elvis and cried, 'You don't really love me! You just say you do!' Elvis . . . tried to convince her she was wrong, but nothing he said worked. Next thing we knew, she was saying to Jerry and me, 'You don't like me.' When she started telling us that she was 'ugly,' I worried she might be having a bad trip."

She snapped out of it, though, and later Larry, Priscilla, Jerry, and Lamar walked around outside, talking openly and unashamedly about how much they cared about one another. They were all exhausted then, and called it a night, but not before Lamar tried to dive into the hood of the 1964 Cadillac limousine, thinking it was a swimming pool. ("The black was so deep.")

On his trips to California, Elvis continued to visit Sri Daya Mata, who tried to help him attain self-control and work toward the highest spiritual existence through meditation. He read her book, *Only Love,* and kept it close around him, as Billy Smith remembers. "He called her 'Ma,' which I guess was short for 'Mata.' But Priscilla used to say she looked like Gladys. So maybe that was part of it, too."

Elvis found another little sister in Deborah Walley on his next picture, MGM's *Spinout,* which went into preproduction in February 1966. The lightweight musical comedy again spotlights Elvis as a race car driver, this time fronting a band in his spare time. Deborah, best known for her iconic teen movies (*Gidget Goes Hawaiian, Beach Blanket Bingo*), plays his androgynous drummer who vies with Shelley Fabares and Diane McBain for his attention.

The bouncy redhead had not particularly wanted to work with him, being a Beatles fan, not an Elvis fan. (The camps rarely overlapped.) But when she first

met him on the set, he was so captivating ("like getting hit with a tidal wave of charisma") that she immediately changed her mind. By the time the film was over, Elvis had become one of the most influential people in her life.

"We had a very close relationship, a spiritual relationship," the late actress said. "I really have to say he changed my life."

He had been studying new books of late, going down to Gilbert's Book Shop at Hollywood and Vine and buying *The Changing Conditions of Your World* by J. W. of Jupiter, and *Billy Graham Presents Man in the 5th Dimension*.

His thirst for spiritual knowledge was almost unquenchable now, and he was eager to talk about it with anyone who would listen. It was all new to Deborah, who had grown up in the Catholic church. Her earlier experience "was a turn-off . . . I was not on good terms with God. It was a void of not feeling one way or the other."

She had lunch with Elvis in his trailer every day, and he took her for motorcycle rides on the back of his Harley. Just as Larry Geller mentored Elvis, "In a kind of odd way, Elvis was a guru to me, and I was a very eager pupil." The guys made light of it ("Whew! He spun her head around like Linda Blair in *The Exorcist*," Lamar said), but Deborah was profoundly grateful.

"I think Elvis found in me an empty vessel into which he could pour all the knowledge that he had acquired. We talked about Buddhism, Hinduism, and all types of religion. He taught me how to meditate. He took me to the Self-Realization Center and introduced me to [the teachings of Paramahansa] Yogananda. We talked a lot at either my house or his house . . . eating big bowls full of ice cream."

One day when she was at the house, he showed her Priscilla's picture. He told her that they were going to get married, but "he didn't talk much about her," and she couldn't say that he sounded like a man in love.

When the picture wrapped in mid-April 1966, Elvis got behind the wheel of his new customized Greyhound bus, and the usual caravan of cars followed him for the drive home. They traveled by night and slept by day. When they checked into the Western Skies Motel in Albuquerque, New Mexico, he asked the guys to carry in his heavy Sony Betamax video machine, one of the early models.

"Every time we'd stop, Elvis would have the video recorder taken off the bus," Marty remembers. "He'd sit up there and watch sex tapes." Some were the ones Alan had commissioned for him in L.A. Others were of Priscilla wrestling in bed with another girl, both clad only in bra and panties. And still others were of girls he went out with once or twice.

They'd barely checked into the motel when Elvis called Marty's room.

"Have someone go out to the airport and meet this girl coming in from L.A."

"What's she doing here?"

"I called her before I left and told her to meet me here."

Marty let out a groan. "We had to stay four damn days while they played around with the video in the room. We were all pissed off, because we wanted to get home to our families."

Elvis had been in a foul mood since they left L.A., with two pieces of news weighing on his mind. The first was professional: Hal Wallis had opted not to renew Elvis's contract past their next picture, *Easy Come, Easy Go,* scheduled for the following year: "It's not so much that Elvis is changing, but that the times are changing. There's just not the market for the no-plot musicals that there once was."

In a way, Elvis was relieved. But Wallis was the producer who brought him to Hollywood. He remembered how excited he had been when Wallis first came calling. He was still a kid then, bursting with ambition, eager to learn, and even more passionate to show what he could do. Back then, when he lay on the pillow at night, he dared to dream of winning an Oscar some day.

The Colonel certainly wasn't one to soothe over hurt feelings, but he pointed out that Elvis's new MGM contract, while backing off from the $1 million hallmark, called for four films at $850,000 each, with the profit participation raised to 50 percent. Elvis didn't talk with Priscilla about it, other than to say that Wallis had bailed. In her view, "He insulated himself from his own feelings. Whenever he was scared, or doubtful, or guilty, he'd say, 'I can't feel that way.'"

However, his second disappointment was harder to dismiss, for the larger ache was the news that Ann-Margret had become engaged to actor Roger Smith. He knew they saw each other, but he had refused to believe it was serious. He'd told Marty, "Roger calls her, and she goes out to dinner with him, but there ain't nothing there."

They had parted some time before, as pressure mounted from Priscilla, her father, Colonel Parker, and even Vernon to follow through on Elvis's implied promise of marriage. It was building again, especially as Priscilla was about to turn twenty-one. There was also the fact that "Elvis never would have had a superstar as a wife," Joe says. But Elvis couldn't quite shut down his feelings or even tell Ann-Margret to her face, and so he did nothing.

It confused her. She thought about the time when her parents were living with her in her one-bedroom apartment on Cañon Drive. Her landlords were a

Danish sea captain and his wife by the name of Jorgensen. Elvis had met them, and after Mr. Jorgensen passed away, Elvis suggested they go see Mrs. Jorgensen on her birthday, to try to cheer her up. "He was just so sensitive and considerate, and he knew about honor, and manners, and respecting your elders, and being civilized," she would say. So where was he now?

Marty and Joe ran into her on Sunset Boulevard one day when she was out riding her motorcycle. Marty blew the horn, and she pulled over.

"What the hell is wrong with your boss? One minute we're in love, and the next minute I don't hear from him again. He won't even take my calls."

But as time passed, she was able to rationalize it: She was independent and wouldn't take orders from anyone, and Elvis required slavelike devotion. For so many reasons, then, as Ann-Margret puts it, "Both of us knew that no matter how much we loved each other, we weren't going to last."

Lamar believes the truth is that Ann-Margret shut Elvis down because of his commitment to Priscilla, and that she never intended to marry him. On the other hand, Larry thinks that when she couldn't get a commitment from Elvis, she began dating Roger with an eye toward a reliable future, even though she and Elvis still occasionally saw each other. Either way, says Lamar, when Elvis learned she was engaged, "He got real upset about it."

More than forty years later, Ann-Margret refuses to talk about the relationship in depth, other than to say that she and Elvis found something deep and primal in each other that she still feels compelled to protect. Whether she is also shielding the feelings of her husband and Priscilla, who she never mentions by name in her autobiography, she seems to grieve for Elvis like a recent widow. When she went to make Tennessee Williams's *The Loss of a Teardrop Diamond* in 2007, the cast and crew were told that no one was to make a reference to Elvis while she was on the set. And in 1994, when television interviewer Charlie Rose pressed her for details, she teared up: "Our relationship was extremely special. It was very strong, and very serious, and very real. We went together for one year. And he trusted me, and I do not want to betray his trust even in death."

· · · · · ·

He was home for several weeks in May 1966, but the bad mood hung on. When soul star James Brown, in town for a performance, repeatedly tried to reach him by phone, he was told each time that Elvis was asleep. Elvis sent his guys on alone to the show and screened movies at the Crosstown Theatre.

At the end of the month, he traveled to Nashville for his first nonsoundtrack recording in more than two years. He had a new producer now, a thirty-year-old Georgian named Felton Jarvis, who'd made a name for himself with rhythm and blues.

"I'd just come to work for RCA. Elvis came in to record, and Chet Atkins said, 'I'm going to carry you over to Elvis's sessions. Elvis likes to record all night long, and I don't like staying up like that. Y'all are about the same age. Maybe you and him'll hit it off and become friends.' And that's exactly what happened."

They spoke the same musical language, and Elvis seemed rejuvenated, eager to get into his contractual task of delivering two singles, a Christmas song, and a religious album during the four-day sessions. The religious recordings, highlighted by the presence of the gospel group the Imperials, would win him his first Grammy and count among Elvis's proudest achievements.

Jerry Schilling was surprised at the depth of intensity Elvis poured into his performance. On the title hymn, "How Great Thou Art," he sang as if he were standing before his savior, his voice trembling with emotion. When he finished, he was hunched over, nearly to his knees, shaken. A hush filled the room.

"I've never seen a performer undergo the kind of physical transition he did during that recording," Jerry wrote in his memoir. "He got to the end of the take and he was as white as a ghost, thoroughly exhausted, and in a kind of trance." As Jerry continued to watch, "He happened to look up, he saw me looking back at him, and a beautiful smile spread across his face. He knew I'd seen something special."

But in the next days, Elvis's spirits started to sag, and Felton booked a second session starting June 10. By then, though, Elvis had a cold, and for two days, he refused to go to the studio, holing up at the Albert Pick Motel, then a near fleabag that the Colonel recommended to save money. Red made demo recordings, trying to approximate Elvis's voice and tone, and brought them back for him to hear. Finally, on the third day, Elvis made an appearance at the studio but rushed through three songs in thirty minutes.

Two weeks later, he was back in L.A. for *Double Trouble,* costarring the eighteen-year-old British actress Annette Day. Elvis took a shine to her, and when he heard she didn't own a car, he surprised her with a '64 Mustang. The problem was that it was Jerry Schilling's car, and Jerry had paid for it himself. But Elvis gave him a Cadillac convertible to make up for it.

Double Trouble, set in the English discotheque scene, might have taken him across the pond for location shooting. But instead, as on *Fun in Acapulco,* he

stayed home. In some ways, the film mirrored his private life: His pop-singer character romances two women but throws over an exotic temptress (Yvonne Romain) for Annette, cast as a seventeen-year-old heiress. The script included the line "Seventeen will get me thirty," words similar to those he uttered in earnest during his wild Louisiana Hayride period.

Charlie Hodge could see that Elvis was bitterly frustrated not to be going to England: "Everyone else was shooting their pictures outside this country in different locations. He was the only one that wasn't leaving town." It was especially galling, in Charlie's view, since in the early 1960s, Elvis "honest to God, kept Hollywood alive." But the Colonel wouldn't hear of it. Recently, in fact, he had turned down an engagement in Japan, saying the star was booked through 1969.

Then came more bad news. The day after he reported to MGM, his uncle Tracy, Gladys's retarded brother, passed away. Elvis always had a soft spot for him—Tracy's oft-repeated saying was "I got my nerves in the dirt"—and his sudden death was only one in a series of sad family events.

Early in 1966 Elvis changed California houses again, moving to 10550 Rocca Place in Bel Air. As with the Bellagio Road house, his landlord was Mrs. Reginald Owen, the wife of the esteemed British character actor. The modern ranch-style home allowed more privacy for Elvis and Priscilla, though Marty and Charlie, who was no longer working with Jimmy Wakely, would live there, along with Jerry Schilling and his fiancée, Sandy Kawelo. By now, a number of the guys, including Joe, Red, and Alan, had their own residences in Los Angeles.

Even with the new house, Elvis now wanted to spend his weekends in Palm Springs or Las Vegas, primarily for bacchanals. He didn't seem to care what toll his extremes might take on his relationship with Priscilla, who was often left at home.

"He was way too out of control," says Joe, "whether he was making movies or later, being on the road and touring. The most important things to him were one, his onstage singing, which he loved more than anything in the world, and two, women. He just loved to be around women."

One time, Joe remembers, they went to Las Vegas to hang out for a few days, and ended up staying six weeks. "Every night we were out chasing showgirls, partying with them all night, going to all the different lounges, seeing all these great acts, and finally going to sleep in the morning. Then we'd wake up in the afternoon and start all over again.

"We did this for such a long period of time that Elvis started getting nosebleeds. The doctor said, 'You're just not resting enough. Your body is telling you to slow down.' So we rested for a couple days and started over again. Twice, we

left Vegas and we were a hundred miles out, and he said, 'What are we going home for? There ain't nothing to go back to L.A. for. Shit, turn around and go right back.' That's just the way he was. He was very compulsive about that."

In Palm Springs, the guys found their female companions by trolling the streets, using Elvis as bait, and always coming back to the house with carloads of women. "We talked, smoked grass, drank, went for late swims, and even had orgies," Joe wrote in his memoir. One night, everyone was out at the pool. Charlie, Red, Sonny, and Joe were splashing around with several girls they'd met earlier that night, and Elvis laid on the lounge chair with one of his guests. After awhile, they quietly slipped off to his room.

As things got livelier around the pool, Red came out of his swimming trunks, and in no time, bathing suits were flying around everywhere, guys chasing girls, and girls chasing guys. Elvis heard the commotion and came out to investigate, wearing only a towel around his waist.

"Come on in!" they yelled.

"You guys are having too much fun," Elvis answered, laughing.

Then he noticed that the girls were nude, and while he took it all in, Joe wrote, Red sneaked around in back of him and pulled off his towel. Elvis, though oversexed, had always been surprisingly modest—even prudish—about showing himself to women, and he stood there in shock for a second, and then, embarrassed, jumped in the pool. When he finally got out, he wrapped a towel tightly around his midsection and went back to his room for the rest of the night.

More and more, Elvis seemed pulled between the quests of hedonism and heaven. In Palm Springs, where the girls revolved with more frequency than the women in L.A., he was freer to indulge his new habit of preaching to party guests. Joe saw it as just another game he liked to play. This one was "master instructing the multitudes."

One late night in Palm Springs, almost everyone had been smoking marijuana, including Elvis. He asked Joe to turn off the television, and he launched into his discourse, emphasizing each key point with a cane he used as a staff.

This was a pattern that had quickly worn thin with the guys, especially as Elvis would open the Bible and say, "You gotta hear this!" As Elvis began to pace and read, the guys would groan good-naturedly, knowing what was coming. "Verily I say unto you, except ye be converted and become as little children," he started. Then he interrupted himself.

"Jesus!" Elvis exclaimed. "This is unbelievable. Listen! 'But whoso shall offend one of these little ones which believe in me, it were better for him that a

millstone were hanged around his neck, and that he were drowned in the depth of the sea!' "

Suddenly, as if called to deliver the sermon on the mount, Elvis jumped up on the coffee table, pointed his cane at the heavens, and still holding the Bible, began spouting words he never heard at the Assembly of God church: "And Jesus said, 'Woe ye motherfuckers!' "

"With that," Joe recounted, "we all fell out laughing, including Elvis, once he'd realized what he'd said. Everyone was rolling on the floor. Someone lit up another joint, and that was the end of Bible class for that night."

The Colonel, who had wangled a free home in Palm Springs out of the William Morris Agency, encouraged his client to spend his weekends there, so that he might keep a closer watch on him. In September, Elvis signed a one-year lease on a modern home at 1350 Ladera Circle. It made the Colonel happy, but they spent almost no real time together, and Elvis carried on the same as if Parker were a thousand miles away. He'd started to hate the old codger, whose bad back and massive weight—he tipped the scales at around three hundred pounds now—necessitated that he walk with a cane. When Elvis was particularly displeased with Parker, he'd do dead-on impersonations of him to the guys, and then hang his cane over his erect penis in a not-so-subtle message.

The two had words in September over a letter Hal Wallis sent the Colonel saying he was concerned about Elvis's appearance. Wallis cited feedback from film exhibitors who watched *Paradise, Hawaiian Style* and reported that something must be "radically wrong" with Elvis, as his hair was too black and fluffed up and resembled a wig, and he just didn't seem like himself. He certainly didn't fit the profile of a navy frogman, his forthcoming role in *Easy Come, Easy Go,* which was to begin filming at the Long Beach Naval Station on October 3.

Elvis didn't much care, and while he slimmed down for the part, he was short-tempered on the set and fought with director John Rich, whom he hadn't liked when they worked together on *Roustabout.*

One day Elvis and Red got a case of the giggles during a scene, and Rich, angry at what he interpreted as unprofessional behavior, threw the entire entourage off the set. Elvis was livid, as he already believed that the picture, which featured a yoga class and the song "Yoga Is As Yoga Does," mocked his interest in Eastern philosophy. His paranoia over the Colonel was such that he believed—incorrectly, according to screenwriter Allan Weiss—that Parker had planted it in the script. In later years, he told Larry Geller he regretted doing the scene and should have stood up for himself. Instead, he blew up at Rich and Wallis about the entourage.

"Now, just a minute," he told the Paramount brass. "We're doing these movies because they're supposed to be fun, nothing more. When they cease to be fun, then we'll cease to do them." But he should have said it years earlier. *Easy Come, Easy Go* was his last picture for Wallis, and none of his seven remaining films for other studios would live up to his expectations.

Wallis refused to give him his release from the picture until just before Thanksgiving, which Elvis uncharacteristically spent with the Colonel in Palm Springs before heading home to Memphis on his retooled Greyhound.

Just outside of Little Rock, Arkansas, around Forrest City, Elvis heard his buddy George Klein spin Tom Jones's new "Green, Green Grass of Home" on his WHBQ radio show. The country weeper, which Elvis turned down when Red brought it to him the year before, now struck a nerve, especially the line "And there to meet me is my mama and papa." Elvis stopped the bus at a pay phone and had Marty ask George to play it again. "Soon, he was stopping at every pay phone. George played that thing three or four times in a row, which he wasn't supposed to do."

When they got to Graceland, the guys unloaded the bus, and as Marty started to leave, he went in the hallway to see if Elvis needed anything. He was near the front door, next to his parents' bedroom, kneeling on one knee, his head in his hands, sobbing. Larry was standing over him, trying to console him.

"Elvis, what's wrong?" Marty said.

"Marty, I saw my mama."

"What do you mean?"

"I walked in the door, and I saw her standing here. I saw her, man."

Elvis went upstairs to his bedroom, which had recently been redecorated in a black-and-red Spanish motif, with two television sets embedded in the green Naugahyde ceiling. The effect of the room was oddly womblike, with an amniotic calm. More and more, Elvis demonstrated a need for just such an atmosphere. Whether his "vision" of Gladys was simply triggered by hearing the song or by what psychiatrists call hallucinations of bereavement, where individuals believe they have actually seen someone who has died, Elvis required time for himself. He stayed upstairs for days, refusing to come down.

In early December, he had recovered enough to gather the gang at the Memphian nearly every other night, screening *Who's Afraid of Virginia Woolf,* with Richard Burton and Elizabeth Taylor, *After the Fox,* with Peter Sellers, *Fantastic Voyage,* and *Dead Heat on a Merry-Go-Round.* Then to torture himself, he slipped in Ann-Margret's remake of the John Ford classic *Stagecoach.*

He'd actually been thinking of all things western lately, including horseback riding, as he had two films coming up—*Stay Away, Joe,* and *Charro!*—in which he would probably be required to ride. Just before Christmas, it turned into his latest obsession, and he went on a shopping spree for riding accoutrements and, finally, horses. He would be a gentleman farmer, he thought. By the end of the year, he would have an entire stable of horses and start clearing the area behind Graceland for a riding ring and a barn.

"My happiest memories of Elvis are the times—there were few of them—when he dropped that wall, when he became the person he might have been without all the pressures," Priscilla says.

One such time was the day he bought horses for everyone at Graceland. "I can still see him out there in the dirt, in his jeans and heavy coat and cowboy hat, going around, writing everybody's name on the stalls ('Daddy's,' 'Priscilla's,' 'Mine') with a red marking pen—watering the horses, blanketing them. He looked so satisfied, so . . . simple."

Two of the horses were bays, and soon he would buy a black quarter horse named Domino as a Christmas present for Priscilla. But on Christmas Eve, he had another gift for her. He walked into her ornate bathroom-dressing room while she was brushing her hair and bent down on one knee and presented her with a small black velvet box. Inside, from Harry Levitch's jewelry store, was a ring of twenty-one diamonds, one for each year of Priscilla's young life.

"Satnin'," he said, "we're going to be married."

It wasn't the most romantic place for a proposal, but then it was more of a directive than anything else.

"I told you I'd know when the time was right. Well, the time's right."

He didn't really want to marry her at all, according to Sonny. "There was still love there, but the intensity was gone. But he'd given his word to Priscilla's father, and when it came to her being twenty-one, he asked Elvis to fulfill his obligations. Elvis resisted for a while, and then [Major] Beaulieu spoke to the Colonel. The Colonel went to Elvis and said, 'You can do one of two things: Marry her or break it off. You can't continue to live with her, because things will get out.'"

That New Year's Eve, Elvis held his annual party at the Manhattan Club. But when he got there, he couldn't find a parking place, and after circling around a few times, he gave up and drove home. While his guests enjoyed a catered dinner to the music of Willie Mitchell and his band, Elvis sat at Graceland, restless and dissatisfied, his foot going a mile a minute.

Shelley Fabares was paired with Elvis for the third time on *Clambake,* shot in spring 1967. "I loved doing those pictures," she said. "They weren't great, but they were great fun." Elvis pursued her without success, yet their deep affection transcended the years. (*Robin Rosaaen Collection*)

TWENTY-SIX

.

Hitched!

By early 1967, Elvis owned at least a dozen horses, which meant that he could now play cowboy for real. In 1953, he and Gene Smith had gone to the Mid-South Fair and posed in western hats and holsters for an iconic image of the era, and he'd never gotten over the way it made him feel—tough, brooding, ready to take on the world, even as he felt apart from it.

Every day he went out in his chaps, boots, Stetson, and rancher coat to check on his growing herd. Lamar called it dressing the part. On the rare occasions when he traveled by air, "he'd put a scarf around his neck and fly the plane. At Graceland, I'd say, 'Alan, where's Elvis?' He'd say, 'He's upstairs. He's in the middle of the bed with his helmet and shoulder pads on, watching *Monday Night Football.*' "

In late 1966 he went on a horse-buying expedition to find a Tennessee Walker for Vernon. On the drive, he happened upon Twinkletown Farm, a 160-acre cattle ranch near Walls, Mississippi, about ten miles south of Whitehaven. It was daybreak, and before him, a white, sixty-five-foot lighted cross stood in the middle of rolling green hills near a rippling lake. Nearby was a small farmhouse.

At first glance, Elvis felt as though he'd had the breath knocked out of him: It was a vision nearly as powerful as seeing Christ in the cloud in the desert. Alan was driving Elvis's double-cab pickup truck, and he had him pull over. The property was for sale, and Elvis took it as a sign that he was meant to have it. He sent Alan to investigate, and almost immediately, Elvis made a $5,000 down payment toward the $437,000 purchase price, which included prize Santa Gertrudis cattle. He would rename the farm the Circle G Ranch, for Graceland, and appoint Alan as foreman to nominally oversee the maintenance and livestock.

The ranch became Elvis's new obsession, and at first, he was like a man re-born. He dove in, making extensive renovations and improvements, putting up a fence, building a barn, grading roads, and installing a gas tank. Then he went shopping for farm equipment, breaking out of his self-seclusion long enough to load up the car with the guys and drive to the Sears store at the Southland Mall. He gathered up hammers and nails and hinges for the pasture gates, and even the display model of a twelve-horsepower lawn tractor, taking everybody for a ride when he got home.

Ray Walker, the tall bass singer of the Jordanaires, couldn't believe the differ-ence in him. Instead of the apathetic and lethargic Elvis he'd last seen, he now saw a man with a renewed energy for life: "The happiest we ever saw him was when he had that ranch. I think those were the only peaceful, relaxed moments he had in the last ten years of his life. He walked in one day, and we just stood there and stared at him. Finally, he broke into a smile and said, 'Shall we dance?' "

To Elvis, the Circle G Ranch was not just a place to relax but also a breeding ground for communal dreams. He was thirty-two years old now, and he thought the ranch would allow him the chance to replicate a family, to feel complete in a way he never had with the death of his sibling, and then the loss of Gladys. When he was on maneuvers in Germany, he wrote a letter to Patsy Presley and her parents in which he reminisced about the last Christmas Gladys was alive, when they were all together at Graceland. "You couldn't read the letter without crying," Patsy Presley later said. "For Elvis, family was everything."

That was one reason he had just allowed his forty-three-year-old aunt, Delta Mae Biggs, to move into Graceland on the death of her husband, Pat, a riverboat gambler and nightclub owner. Pat had instilled the desire in Elvis to make some-thing of himself, and to own a nice house and car, even though Pat himself could never hold on to money. "Family talk was that Pat and Delta had lived the wild life all across the country in casinos and bars," according to Patsy. "There was a mystique about them, a mysterious past that no one could detail."

Delta, a diabetic alcoholic, had a nasty disposition and hated everybody—she flipped the bird to fans and once set fire to her wig because someone liked it and asked her for it. But she was kin, and Pat had left her flat broke, and she had nowhere else to go. Elvis despised her drinking, but he found her antics amus-ing, and Minnie Mae also liked the idea of having her daughter live with her. That made Elvis happy, too.

At the Circle G Ranch, Elvis's initial plan was to build a new home for him-self and Priscilla near the cross and the big lake. Then he would give each of the

guys an acre of land and the down payment to build his own house, since no one in the group except Marty and Lamar had a home of his own. They would all live there together with their wives and families.

The guys were ecstatic about the idea, and Joe and Joanie made plans to move from California. But Vernon, punching numbers on his calculator and holding his head, nixed the idea right off. Instead of standing up to his father and saying he was the one who made the money and would do with it what he liked, Elvis honored Vernon's position as his business manager.

"How are you going to break it to the guys?" Marty asked. "I'm not," Elvis said. "You are."

He felt bad about it, but then he got another idea: If he couldn't give them houses, he'd give them house trailers. He bought the first one for Billy, and then found a three-bedroom model for himself and Priscilla. Pretty soon, there were trailers everywhere, twelve in all, to the tune of $140,000. But everybody needed a truck, too. He bought twenty-two in one day—and three more another day—giving them to anyone he could, even the carpenters and electricians working on the place. He couldn't spend money fast enough.

He loved to see people's faces when he did something like that and found gratification in giving people big-ticket items they couldn't afford themselves. If he had a good feeling or experience from something, he also just wanted to share it. But part of his motivation was swing guilt, a phenomenon of the twinless twin, says psychologist Whitmer, meaning Elvis felt compelled to earn applause to affirm his oneness, his uniqueness. But then he swung back in the opposite direction out of guilt for being the individual who received all the recognition, instead of his twin.

Elvis had always been a generous person, beginning in childhood, when he gave away his toys to other children. And long before he bought the ranch, he was already in the habit of buying cars for friends, family, employees, and even strangers. But once he began walking the spiritual path, says Larry Geller, "He started to get very philanthropic, and he really did give away a lot of money and significant gifts. Buying the ranch was a very large manifestation. It freaked Vernon out."

More than that, it almost literally gave Elvis's father a heart attack. Vernon despised it when he gave away money—he frowned on Elvis's annual Christmas donations—and was preoccupied with the idea of people taking advantage of his son's generosity. After the truck-buying frenzy, he reminded Elvis that the ranch wasn't a working farm, so all the money was going out and none was coming in. "Get a ninety-day note and cover it," Elvis said, nonchalantly.

"He had a couple of months before he had to go do his next picture, which was *Clambake,*" Marty recalls, "and he spent almost every day down at the ranch. It was winter. We had a little office by the stable, and one morning about two o'clock we were standing outside there.

"It was snowing, and Elvis was on a small tractor, pushing the snow and mud out of the way. Vernon walked out of the office and came up to me with an adding machine tape in one hand and a flashlight in the other. He was, like, whining. He said, 'Marty, look at this! He's spent $98,000 on trucks and given them away!' I said, 'What do you want me to do about it? He's your son.'"

With his charm and charisma, Elvis had the ability to lead others on a natural high. But he was often on a different kind of high at the Circle G, as he was using barbiturates again to calm himself and tune out his father's rants. He was also getting heavier into Demerol, the synthetic narcotic normally prescribed for severe pain.

Now Elvis wanted it more and more, in late 1966 flying Marty out to see L.A. dentist Max Shapiro, who gave him two prescriptions for Demerol, as well as other pills. Elvis also got pills from the studios, and when he'd run low, there wasn't much he wouldn't do to replenish his supply.

One Sunday when his local Walgreens was closed, he halfheartedly suggested that Marty and Richard break in, and then had another thought: "Does anybody know where the pharmacist lives? He's like a doctor. He's probably got all kinds of stuff at his house."

The man opened his door to find Elvis Presley standing there in a sheepskin coat and a cowboy hat. Stunned, he invited him in. Elvis chatted him up for a few minutes, explained his dilemma, and then followed the pharmacist into his bathroom to look in his medicine chest. By the time he left, Elvis was carrying a bag full of pills and promising to get prescriptions to cover them all.

What he needed, he thought, was a local Dr. Feelgood like Max Shapiro, but he hadn't found him yet. And so he just went on self-prescribing, getting pills wherever he could, sometimes consulting the *PDR* for dosage and interaction, but more often, throwing caution to the wind.

Many times, he'd take two or three sleeping pills on top of his amphetamines, then get up after two hours of sleep and climb on his horse, a gorgeous Palomino he named Rising Sun. At times, Billy remembers, he comically rode around the ranch looking like Lee Marvin in *Cat Ballou,* leaning over so far that the guys feared he'd fall off and hurt himself.

The pills gave him strange food cravings, and his latest kick was hamburger and hot dog buns, which he ate straight from the plastic bag, tied onto his saddle horn. The constant diet of white bread threw his insulin levels off and made him store fat around the middle. And though he had the movie to do at the beginning of March—*Clambake* would be his twenty-fifth—Elvis ate whatever he wanted, from cheeseburgers, to mashed potatoes, to sweets. He seemed to have something in his hand all the time, the guys noticed.

Normally, in Jerry Schilling's view, "He ate out of depression. The movies were boring to him, and when he didn't have a challenge, he always got depressed." But now the reason was twofold: The ranch felt like perpetual vacation, offering a quasi–dream state for a boy-man in need of escape. Predictably, the weight piled on.

He was due in Los Angeles on February 21 for the start of the film, but instead, as a stalling technique, he arranged to go to Nashville to record the soundtrack at RCA's Studio B. Though the distance was an easy four-hour drive, he arrived in a rented Learjet—shades of megalomania—and wore his cowboy clothes, replete with chaps, into the recording session. He demonstrated little interest in the movie songs and instead did twenty-one takes of an Eddy Arnold ballad, "You Don't Know Me," putting off recording most of the soundtrack until he got to Hollywood. However, when his second departure date arrived, he balked again, complaining of saddle sores.

Elvis was prone to minor skin infections, as he rarely bathed, taking mostly sponge baths, washing up with a rag and soap and rinsing off. Barbara Little, George Klein's girlfriend, worked for a Memphis physicians' practice called the Medical Group, and she recommended that Dr. George C. Nichopoulos come out to the ranch and examine him.

The forty-year-old Dr. Nick, as everyone called him, was a Pennsylvanian by birth, though he grew up in Anniston, Alabama, where his father, a Greek immigrant, ran a restaurant, Gus' Sanitary Cafe. He'd received his medical degree from Vanderbilt University, but not without an interruption for academic probation. He came to Memphis from Nashville's St. Thomas Hospital and was well liked by the Medical Group employees and patients, Barbara said. "He went above and beyond normal expectations when it came to the doctor-patient relationship."

Dr. Nick's ears perked up the first time he heard that Barbara knew Elvis, and he had asked her several times for an introduction. She and George had

invited him along to Elvis's last New Year's Eve party at the Manhattan Club, but Elvis hadn't shown up. Now Dr. Nick was only too glad to drive down to Walls, Mississippi, to see about Elvis's behind.

In time, Dr. Nick would come to love Elvis like a brother, Barbara says. Elvis, who had genuine respect for physicians (he never called Dr. Nick by his first name), would also take a liking to the easygoing, white-haired Greek.

But most of all, Elvis liked what the physician might be able to do for him, since almost no one ever said no to Elvis about anything. Overall, pronounces Dr. Nick, "He was healthy then," though the physician agreed to call Colonel Parker to explain just how painful Elvis's ailment was, even as he recognized that a second postponement on the film stemmed more from patient preference than from medical necessity. The Colonel saw right through it, of course, and would forever regard Dr. Nick as an adversary.

In the following days, when Parker couldn't get Elvis on the phone, he'd label Marty Lacker the same, issuing a stern warning to him to keep the lines of communication open. Otherwise, he wrote, "We will have some proper assignment, whether it be you or someone else, where we have a definite immediate contact at all times." Elvis was to appear at United Artists Studios on March 6, or else.

In the interest of time—and because so many in the entourage were now too dependent on pills to safely drive cross-country—Elvis boarded a plane for Los Angeles on March 5. With him were Red, Marty, Billy, Charlie, Larry, Ray Sitton, and Gee Gee Gambill, the husband of Patsy Presley, who Elvis nicknamed "Muffin." Joe was already in place in California.

On March 6, when Elvis met with director Arthur Nadel and producers Arnold Laven, Arthur Gardner, and Jules Levy, everyone at the studio was shocked to discover that Elvis weighed 200 pounds, up 30 from his usual 170. Parker immediately demanded a conversation with his client, instructing Elvis to do everything he could during rehearsals to get his weight down before principal photography began.

Elvis tried burning the weight off with Dexedrine, but on top of the sleeping tablets, the Demerol, his usual arsenal of mood-altering drugs, and restricted food intake, the medications made him dizzy.

Sometime late on the night of March 9, Elvis got up to use the toilet on Rocca Place, tripped over the television cord in the bathroom, and hit his head on the sunken tub. He was woozy the next morning, and the guys could tell something was wrong by the way he staggered to his chair and plopped down. "Oh, man," he said, and held the back of his head.

"What's wrong, boss?" Joe asked.

He told them what had happened.

"Feel this," he said, and each of them went over. He had a lump the size of a golf ball.

"Man, I'd better get back into bed. I'm in bad shape here."

"I'm calling the Colonel," Joe announced.

Elvis braced himself for the fat man's tirade, but no one foresaw how the incident would become such a firing pin in detonating Colonel Parker, or how it would lead to an inevitable powder keg of events.

The Colonel arrived at the house and phoned a doctor, who came out with several white-uniformed nurses. He examined the patient and said he would return the following day with portable X-ray equipment. Elvis could barely hold his head up, but the diagnosis would be only a mild concussion, not a fracture. Still, principal photography would have to be delayed by nearly two weeks, and Larry remembers that "a couple of men in suits came from the studio" to take a look.

Parker, fed up with Elvis's undisciplined behavior, seized the moment to tighten control, starting with the entourage: "I want to see all of you out in the hall."

He first approached Larry, whom he saw as his main target. "Mr. Geller," he bellowed, hammering his words home with his cane, "get those books out of here right now! Do you understand me? *Right now!*"

Then he turned to the others. He was purple with rage, his voice thundering. "Goddamn you guys! Why do you let him get this way? He's going to mess up everything! They'll tear up the contract! I want one of you with Elvis twenty-four hours a day, sitting by his bed in his room. If he has to go to the bathroom, one of you walk with him. Do not let him walk on his own."

He turned on his heel and thudded back in to his client. "Here's the way it is," he told him. "From now on, you're going to listen to everything I say. I'm going to set down these guidelines, and you'd better follow them. Otherwise, I'm going to leave you, and that will ruin your career, and you'll lose Graceland, and you'll lose your fans. And because I'm going to do all this extra work for you, I'm taking 50 percent of your contract."

It was Parker's most outrageous attachment of Elvis's earnings. Officially, his commission had been 25 percent, although the Colonel had long been taking 50 percent of many of Elvis's business deals, and usually more from side agreements, double-dipping, and perks under the table.

Now he prepared a new agreement and backdated it to January 1, 1967. In setting down terms for what he called a joint venture, Parker would continue to

collect 25 percent of Elvis's standard movie salaries and record company advances. However, his company, All Star Shows, would now receive 50 percent of profits or royalties beyond basic payments from both the film and record contracts, including "special," or side deals. The commission would be deducted before any division of royalties and profits.

Three days later, when Elvis was feeling better, the Colonel called a meeting at Rocca Place. Priscilla and Vernon had flown out from Memphis, and sat in the living room with Elvis and the guys, already knowing what was about to happen.

Elvis spoke first. "Fellas," he said. "The Colonel has some things to say. And he's speaking for both of us. What he's going to tell you is coming straight from me."

Parker struggled to his feet and then delivered his power play: Number one, from now on, Joe was to be the lone foreman. Number two, there would be no more discussions about religion. "Some of you," the Colonel mocked, looking around the room, "think maybe Elvis is Jesus Christ who should wear robes and walk down the street helping people. But that's not who he is." The guys should not allow Larry to be alone with Elvis, he directed. And number three, due to larger-than-normal expenses, everyone's salary would be cut back. Furthermore, several people had better start looking for jobs.

Everyone looked at Elvis in disbelief. Most of the guys made only $200 a week. How could they keep their apartments on less than that? But Elvis offered no answers, simply staring at the floor. No one had ever seen him so passive and defeated, and they wondered why he let Parker get away with it.

In the end, no one was actually fired. But every relationship Elvis had was strained—with the Colonel, with his father, with Priscilla, with the guys. Jerry Schilling, who got married that same week, would soon leave to take an apprenticeship as a film editor. And the following month, on April 30, Larry would also leave voluntarily. "It was like taking my arm off, it was so painful." But he did it rather than cause Elvis more strife with Colonel Parker.

Early in May, Priscilla persuaded Elvis to gather the religious books that the Colonel had banned and dump them in an abandoned well at Graceland. Then he poured gasoline over them and lit a match.

However, five years later, Elvis would intimate to Larry that he had tricked her. They built a bonfire, yes, but "I threw in maybe two or three books . . . there is no way I would have burned all of those. That's what the Nazis did." Larry found out it was true: "He didn't burn the books, because I saw them. All the books that I gave him . . . I'm talking many, many books . . . were still there."

Though nearly everyone would drift in and out of the entourage through the years, Elvis's intimate circle was shrinking. It was the beginning of the end of the group, and it made him feel vulnerable and adrift. He had never quite accepted his stepbrothers, who were still adolescents. Dr. Nick remembers that in conversations with Elvis, "There were many times that he wished that he had a brother or a sister. He wanted to be part of something. Wanted to have a family."

But he did not want to be told when to have it, or with whom.

He had always felt close to Shelley Fabares, who costarred with him for the third time in *Clambake.* They had a mutual respect and an easy understanding that went beyond words: "He was a private person who had no privacy. My experiences working with him were wonderful. I really loved him, and thought he was terrific. We had a fabulous time doing each film, even though some of them were mind-numbingly stupid. Sometimes we'd hear each other say lines, and look at each other and say, 'Is there any possible way to make these sound real?' We laughed from beginning to end."

Their friendship might have become something more, as she had the petite physical build that he liked, and she was also an occasional recording star: Her single "Johnny Angel" topped the charts in 1962, only to be ousted by Elvis's "Good Luck Charm." But whenever Elvis played up to her, according to Sonny, Shelley always stalled him.

"He went after her from the first picture. He thought she was adorable. But she said to him, 'I'm dating someone,' and she said it was serious, so he backed off. But that chemistry was still there. So the next picture he went after her again. He said, 'Are you still goin' with that same guy?' She said, 'No, I'm not.' Elvis said, 'Great!' Then she said, 'I'm engaged to him now.' So the final picture: 'Are you still engaged to that guy?' She said, 'No, I married him.' After a while he said, 'You were weakening, weren't you? And you had to get married to stop it, right?'"

· · · · · · ·

In April, rumors swirled about Elvis's own imminent marriage, and while gossip columnist Rona Barrett thought they were true, few others paid any attention. Sonny, working in the film industry at the time, dismissed the rumors out of hand, since no one in the group had mentioned a wedding to him. And Larry did the same. Whenever Elvis and Priscilla decided to marry, he was to share best man duties with Joe and Marty. Surely Elvis would have mentioned it if he were planning a ceremony, Larry thought, even though he had left the group.

What they didn't know was that Parker, Vernon, and Priscilla had formed a triumvirate, threatening to ruin Elvis if he didn't shape up. That included getting on with the marriage.

Vernon figured if his son settled down, he'd stop the incessant spending at the ranch, and he wouldn't need so many of the guys, whom he considered leeches.

Priscilla thought if Elvis had a ring on his finger, the philandering might stop. She was so starved for his attention that she had faked suicide on Perugia Way with an overdose of Placidyl, the same drug that put her in a coma-like state her first Christmas at Graceland. The dangled promise of marriage was the only reason she stayed, and Elvis had already postponed the nuptials twice.

And Parker, always seeking control, wanted to keep his client an employable commodity. At thirty-two, Elvis was too old to live in such a crazy, free-spirited manner, and eventually the studios would hear about it. Parker would always disavow personal knowledge of Elvis's drug use, but he did know that Elvis's recklessness had to stop.

Furthermore, if Elvis were to marry, it would reinforce his Hollywood image as a pure purveyor of family entertainment. ("He's a clean-cut, clean-living man," director Sam Katzman had described him.) In spring 1967 the nation was undergoing a radical social shift, divided over the Vietnam War and awash in all things counterculture, hippie (the Summer of Love was right around the corner), and psychedelic. Parker was intent on offering Elvis as a noncontroversial alternative to the fray and insisted that his placid persona remain intact.

And so the three of them—Colonel, Vernon, and Priscilla—went to work, sharing their secret only with immediate family.

At 9:41 on the morning of May 1, 1967, Elvis and Priscilla said "I do" before Nevada Supreme Court Judge David Zenoff in Milton Prell's private suite at the new Aladdin Hotel in Las Vegas. The justice would remember that Priscilla "was absolutely petrified, and Elvis was so nervous he was almost bawling."

Afterward, the newlyweds held a press conference in the Aladdin Room, where Priscilla's stepfather told the press, "Our little girl is going to be a good wife," and Elvis turned to his father for answers to questions he didn't like. "Hey, Daddy, help me!" he said good-naturedly. But Vernon only smiled. "I can't reach you, son," he said. "You just slipped through my fingers." Owner Prell laid out a $10,000 champagne breakfast with suckling pig and poached salmon, and then the couple flew to Palm Springs on Frank Sinatra's Learjet to begin their honeymoon.

The Colonel arranged every detail, from the room to the rings, calling on his

high-powered friends and connections. Elvis and Priscilla went along with it for the sake of expediency and secrecy, though later Priscilla would write "as we raced through the day, we both thought that if we had it to do over again, we would have given ourselves more time . . . I wish I'd had the strength then to say, 'Wait a minute, this is *our* wedding, fans or no fans, press or no press. Let us invite whomever we want.'"

But Priscilla and Elvis had also allowed the Colonel to pick the attendants and the guests, who numbered fewer than twenty. The suite couldn't accommodate any more, they said. So while there was room for George Klein, who flew in from Memphis, there was not enough space for Red, or Jerry, or Alan, or Richard. Charlie knew about it—he drove the Colonel from Palm Springs—but there wasn't room for him, either. Some of the guys were invited to the breakfast, but others had to save their congratulations for a second reception to be held at the end of the month at Graceland, where Elvis and Priscilla would wear their wedding finery once again.

Larry learned about it when he picked up the afternoon paper. Sonny was similarly informed. "I was making a motorcycle movie, and I was on location. I came back to my room, turned the TV on, and the guy said, 'Elvis Presley got married today . . .' And I went, *'What?!'* I thought, 'Dad gum, that was fast.'"

Hurt feelings ran rampant, and Red, who would remain estranged from Elvis for two years over the exclusion, had a hellacious fight with the Colonel. Charlie later defended the way Parker handled things, saying he was "just doing what he always tried to do with Elvis, and that was keeping something like that from becoming a circus." But in retrospect, says Joe, "We should have used another arena so that everybody could have been there."

The Memphis paper ran the headline "Wedding is Typically Elvis—Quick, Quiet, and in Style," and fan reaction was mixed. There was no national hue and cry as there would be with Paul McCartney's marriage two years later, as the new youth of America considered Elvis rather hokey, a has-been. And fans of Kay Wheeler's ilk had largely moved on, Kay herself saying, "Well, somebody finally caught him. I guess Elvis's career is so down already that it doesn't matter anymore." In Europe, the girls seemed to take it harder.

On May 4 the married couple flew home from Palm Springs, arriving in Memphis around 6 A.M. After a quick stop at Graceland, they went on to the Circle G to continue their honeymoon. It was there, in one of the trailers, that Priscilla conceived a child, a girl, to be named Lisa Marie, so near the name Elvis and Anita had picked out years before. The baby would be born February

1, exactly nine months after the wedding. It was at the Circle G that Priscilla and Elvis had sex for the first time, they would say. Marrying at a place called the Aladdin was not the only fairy-tale element of the Elvis and Priscilla saga.

· · · · · ·

Just because Elvis now wore a wedding band did not mean that either his feelings or his behavior would change. On May 8, one week after he and Priscilla tied the knot, Ann-Margret married Roger Smith, also in Las Vegas. When she opened an engagement there on June 7, Elvis sent flowers in the shape of a guitar. He would do so for each of her Vegas bookings until his death.

Already Elvis knew his marriage had been a mistake—that he and Priscilla had never truly been compatible, and that they had tragically outgrown their dreams. He had fallen for a fourteen-year-old girl, and she, as an eleven-year-old, for the flickering image of a bad boy, dancing suggestively on TV. Neither of them was the same person now. They had married ghosts.

On July 1, two months after his wedding, Elvis went to see Ann-Margret's show, bringing along his father and several of the guys. They visited her in her dressing room afterward. At one point, Ann-Margret slipped off to the inner-most room of her dressing area. Elvis followed and shut the door.

"Our eyes met and suddenly the old connection burned as brightly and strong as it had years before," she wrote. He complimented her on her show and then turned wistful, thanking her for all the happiness she had given him, and re-counting the good times they had shared.

"Elvis then stepped forward and dropped to one knee. He took my hands in his. I felt the heat in both of our bodies. In a soft, gentle voice weighted by seri-ousness, he told me exactly how he still felt about me, which I intuitively knew, but was very touched to hear."

But as usual, Elvis had not one but three women on his mind. He was making a movie, *Speedway,* with Nancy Sinatra at MGM, and Priscilla had just learned that she was pregnant. Elvis was thrilled and announced it on the set on July 12. "This is the greatest thing that has ever happened to me," he gushed to reporters.

And at home, he affectionately called Priscilla "Belly."

"Look who's talking!" she wanted to say, though Elvis had dieted himself thin again. Still, Priscilla was stung by it, especially as she never even needed a maternity dress.

"Elvis was always talking about women who let themselves go when they were expecting, who used it as an excuse to gain weight. So I actually *lost* eight

pounds when I was carrying. I ate only eggs and apples. I never drank milk." She never saw a doctor, either. She never saw anybody new, because Elvis wanted only his same friends around. It was life in a bubble. "We were in a cocoon."

At Elvis's nudging, Nancy offered to throw a baby shower for the new mother. But behind the scenes, she was busy fighting off Elvis's advances. She had fantasized about him for years, even before she met him on the day he returned from Germany in 1960. Now that she was divorced from Tommy Sands, it was easier to think about being involved with him. But she refused to have sex with a married man, even as she indulged his adolescent games, so reminiscent of the rough-housing he did with his slumber party teens on Audubon Drive.

At lunchtime, they'd go back to her dressing room trailer. Elvis would mess up her hair and her clothes, teasing her, and when he got especially frisky, he'd pin her to the floor and dry hump her. They'd laugh and giggle and toss back and forth in the mock throes of ecstasy. "Did you come yet?" he'd ask, a big smile on his face. But there was no mistaking that Elvis was truly turned on. "Do you feel Little Elvis?" he'd whisper in her ear. And, of course, she did.

When they walked out of the trailer for the afternoon's shoot, people stared at them and whispered behind their backs. Priscilla was well aware of it—she had worried that something was between them as far back as 1960—and somehow they took a bit of perverse pleasure from it. Nancy asked her one day how she kept her figure with the baby and learned that Priscilla ate only one meal. "Good for you," Nancy praised, but what she was really thinking was, "She's got her hands full trying to hold on to this man."

The flirting, then, had to stop. Near the end of the picture, Nancy was in her trailer alone. Wearing only jeans and a brassiere, she went to her closet to pick out a shirt. She had just removed her bra when Elvis popped out of the closet. It was an awkward moment—she tried to cover herself, and then she laughed. Elvis pulled her to him.

"He just got very quiet. He just held me . . . and he lifted up my face and he kissed me, and I started to melt. I really thought I was going to die. Then he pulled away and looked at me and said, 'I'm sorry . . . I'm sorry.' And he went out."

Elvis would appear the supreme cad in pursuing a costar only months after marrying and impregnating his live-in Lolita. But now that Priscilla was going to be a mother, his sexual interest in her had all but disappeared.

At first he blamed it on the fact that she constantly slathered her stomach with cocoa butter to stave off stretch marks. He couldn't stand the smell and would have to leave the room. They fought about it—she was so sensitive with

her hormones in flux—and one night she threw the whole container at him. He threw nothing back, he later told girlfriend Mindi Miller, because "first of all, she's a girl and she's pregnant, and she's my wife. You don't do that as a southern gentleman."

The larger problem was that Elvis now further equated Priscilla with Gladys. It was a huge psychological and emotional quagmire, Priscilla would say, that neither one of them fully understood. Elvis only knew that any woman who'd had a child was a turnoff for him, and he wanted nothing to do with her sexually.

"He just didn't feel comfortable doing that," says Joe. "Sometimes if I met somebody I was going to introduce him to, I'd tell her, 'Don't say you have a kid.' There were a couple of other girls he dated who were mothers, but he never knew it. In other words, they weren't big affairs, just small little events."

"I guess he had a Madonna complex," Priscilla sums up. While she has written that having Lisa Marie was the end of intimacy, she now says, "No, no, of course we were having sex! I mean, he was Elvis, after all, and I must say he was very creative, very playful.'"

Just after the wedding, when Elvis and Priscilla returned to the ranch, it was a "magical time," says Jerry. Elvis was calm and happy, Priscilla was glad to be out of Graceland and the big L.A. houses, and everyone got along. They really did feel like one big family, Jerry thought. "Somehow, after a false start, Elvis's dream of a cowboy commune seemed to be working perfectly."

But by August, Elvis had lost interest in the ranch, and Vernon began to sell off the trucks, the trailers, and the cattle, and soon he would look for buyers for the land, too. Dr. Nick had already observed that this was a pattern with Elvis: "He never seemed to be attached to anything for very long. He would pick up a sport or some new thing, and it would last just a few weeks or a few months."

When Elvis did spend time at the ranch, he wasn't so interested in horses as he was in target practice. That was his new fixation now, and he started buying rifles, clay targets, and ear protectors with all the zeal he poured into his earlier hobbies. That October, he got whatever western fix he needed on his last picture of the year, *Stay Away, Joe,* where he again played a Native American, this time as a rodeo rider.

By fall, he already had another residence in mind. Graceland would always symbolize his hopes for a happy life, but he wanted a new home that would nurture a more intimate family atmosphere. Around the same time that Vernon auctioned off equipment at the Circle G Ranch, Elvis and Priscilla bought their first Beverly Hills home, a smaller, four-bedroom house at 1174 Hillcrest Road

in Trousdale Estates. Only Charlie Hodge and Patsy and Gee Gee Gambill would live with them there. They finalized the sale in November. Elvis said he liked it because it gave them so much privacy.

Then in December, the seventh month of Priscilla's pregnancy, he dropped a bomb on her in asking for a trial separation. She was floored. She'd been determined to keep up with him, never once shying away from a snowball fight or a hayride or whatever physical activity he fancied. They'd had their fights, but nothing that severe, she thought. He gave her no explanation, but she wondered if he were afraid of his public image as a husband and father.

"I said fine, and stormed out of the room. But he never left, nor asked me to leave, and never mentioned it again. I was relieved, but things were never quite the same after that."

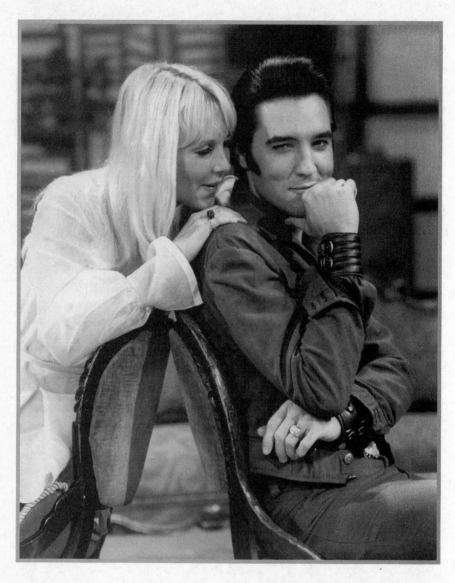

Susan Henning played the symbolic "Virgin" to Elvis's itinerant "Guitar Man" in his 1968 Comeback Special. Off the set, she helped him get over his Madonna complex. *(Robin Rosaaen Collection)*

TWENTY-SEVEN

.

A Baby, a Babe, and Black Leather

On the morning of February 1, 1968, Priscilla's water broke. She and Elvis were at Graceland, and he was still asleep. Priscilla managed to rouse him, and she hurried with her hair and makeup while Elvis rallied Jerry and his wife, Sandy, in the annex. Jerry would drive Elvis and Priscilla to the hospital while Charlie rode shotgun.

"Hey, don't get yourself all excited," Elvis said over the intercom. "But meet me in the kitchen. Priscilla's ready to go to the hospital."

By the time the Schillings came inside, Charlie and Minnie Mae were up, and everyone nervously buzzed around. Everyone except Elvis.

"Where's that box of cigars I bought?" Elvis calmly asked. No one seemed to know, but he wasn't leaving without the Roi-Tans.

"Who cares about the cigars?" Priscilla asked.

"I do. I need to pass out cigars at the hospital."

Priscilla would remember that her husband seemed to be moving in slow motion—finally finding the cigars, and then stopping in the kitchen to fix a bite to eat. Meanwhile, Priscilla was crossing her legs.

Jerry knew that it was just a front, that Elvis was more nervous than he had been at any other time in his life. But his way of dealing with it was to slow himself down and act as if absolutely nothing was the matter.

Now Elvis and Jerry went over the plan again. They'd rehearsed it repeatedly. They'd even made several trial runs to Methodist Hospital, timing the trip, and checking out alternative routes in case there was a problem.

"Elvis—HURRY UP!" Priscilla yelled.

She was out in the front drive trying to get in the Lincoln. Elvis could tell she

was panicked now. The color went out of his face as he and Jerry and Charlie rushed out the door and got Priscilla comfortable in the backseat. Then they took off down the winding drive.

When they drove through the Graceland gates, the press gave chase. Elvis was amused. But Priscilla looked puzzled.

"Are we headed in the direction of Baptist Hospital? If not, I'm having the baby in this car."

Charlie spoke up.

"It's the wrong hospital."

Jerry ignored him. He knew the plan.

Then Elvis meekly said, "It's the wrong hospital, Jerry. I forgot to tell you—we switched it over to Baptist."

"Oh, no," Priscilla said softly, her voice tense and strained. "Hurry!"

Jerry was perspiring as he changed course, praying the backseat wouldn't soon become a delivery room.

When they got there, the nurses took Priscilla down the hall, and Elvis, Charlie, and Jerry went to a special waiting room the hospital had reserved for them. Soon, Vernon and Minnie Mae arrived, and then as the day wore on, some of the other guys showed up, including Joe, who flew in from California.

By early afternoon, Elvis, "hot-wired with nervous energy," as Jerry remembered, could no longer contain himself. He bounced around the little room until Minnie Mae couldn't take it anymore.

"Calm down!" the old lady told him. "You're not having the baby. She is!"

Finally, at 5:01 P.M., Elvis became a father. He left to go see his child, and when he came back, his face was one big smile. He led everyone to the nursery to proudly point out the newest Presley, Lisa Marie.

"I've never seen Elvis that ecstatic," Patsy later said. "He was in heaven. He became an extremely conscientious and protective dad. Maybe even overprotective. He adored that child."

A few days later, Jerry brought Elvis, Priscilla, and Lisa Marie home from the hospital. The Beaulieus were there, standing with Vernon and Minnie Mae to greet them as they came in the door. As Jerry watched Elvis hold his daughter, "I got the feeling that whatever he'd been searching for in his spiritual explorations, he had finally found a piece of, right there in his arms."

Elvis had been seeking a replication all his life, and Lisa Marie looked as if he had just spit her out. She had his own hooded eyes and a full head of Gladys's dark black hair. "He was thrilled to no end when he had a daughter," Joe says. "He

loved kids. He talked baby talk and played with my daughters, and he was just happy to be a father, because his mother raised him to be family oriented. It fulfilled a dream."

On Valentine's Day, Elvis and Priscilla took the baby to visit Gladys's grave. They left a wreath of flowers with a card from "Elvis—Priscilla—Lisa Marie," and instructions for the card to be burned with the flowers when they wilted.

He was thirty-three years old, in the prime of his life, at the start of what would prove to be a monumental year. Lisa Marie's birth had him thinking more intently about the circle of life and death, and about the spirit, so indomitable and mysterious. Five days after Lisa Marie entered the world, Elvis's old friend Nick Adams left it—a suicide, over a woman. When they found him, he was braced against the wall with his eyes wide open, staring at the face of death. The last time Elvis saw him, Nick had visited him on the set of *Girl Happy*.

· · · · · ·

For more than a year, Colonel Parker had been thinking of ways to redraw his great plan. Elvis's films now grossed a fraction of the big dollars of the early 1960s, and it was clear that his client was unhappy and despondent about his career. Parker had tried, and failed, to find projects to jolt him from his artistic apathy. With *Easy Come, Easy Go*, Parker asked Hal Wallis to frame Elvis in a nonmusical role, and the producer had refused. And as late as March 1967, the Colonel sent a memo to MGM, nudging the studio to come up with something inspired for the remainder of Elvis's contract. Whatever it was, it should not include bikinis or nightclub scenes, "which have been in the last fifteen pictures. . . . I sincerely hope that you are looking in some crystal ball with your people to come up with some good, strong, rugged stories."

Now the Colonel returned to an old idea. In 1965 he had begun talks with Tom Sarnoff, vice president of NBC's West Coast division. Parker offered Elvis for a motion picture for television, and Sarnoff liked the idea, but the Colonel wanted world rights to release the movie theatrically after only one airing. The negotiations were long and exasperating, Sarnoff felt, and finally sputtered and stalled.

In October 1967 Sarnoff met with the Colonel again. This time they began negotiating a package deal to include Elvis's first TV appearance since the Frank Sinatra "Welcome Home, Elvis" special of 1960. On January 12, 1968, they came to terms: $250,000 for a music special, and $850,000 for a feature film (*Change of Habit*), plus 50 percent of the profits, bettering Parker's million-dollar marker.

Sarnoff had a vision for the music special, one that would let Elvis stretch out in his first full-length performance since the U.S.S. *Arizona* concert of 1961. However, the Colonel had his own idea about what the special should be. For now, the two men just agreed that it would tape in June 1968 and air in December, sometime around Christmas.

First Elvis would make *Live a Little, Love a Little* for MGM that March. The studio brass had paid heed to the Colonel's memo. The film was not precisely the "good, strong, rugged" story Parker requested, but it freshened Elvis's image. He played Greg Nolan, a photographer who shoots for both a girlie magazine and a classy advertising agency. Screenwriters Michael A. Hoey and Dan Greenburg adapted Greenburg's comic novel, *Kiss My Firm But Pliant Lips.*

In the era of free love, the writers offered Elvis a more realistic approach to sex, but only to a point. Greg and his kooky model girlfriend (Michelle Carey) share a playful shower scene, and they're even shown in bed together. But the audience knows it's all innocent fun—she's on the other side of the shower door, and a bed divider keeps them apart.

Live a Little, Love a Little, which features a cameo from Vernon as a rich hotel guest, was billed as a comedy, not a musical comedy. As such, Elvis sings only four songs, including a well-received psychedelic production number, "The Edge of Reality." And in a second bit of rehabbing, he performs a fresh, modern rhythm number, "A Little Less Conversation," written by a young Texan, Mac Davis, who had seen Elvis perform in his hometown of Lubbock on Elvis's Louisiana Hayride tours.

Davis had written the song for Aretha Franklin, but it fit a scene in the movie, and he was thrilled to be associated with Elvis in any way. He was deflated, however, when he showed up at the recording session: "You couldn't carry on a conversation with him. There were at least four or five guys sitting around staring at you as if to say, 'You'd better not mess up.' I felt terribly uncomfortable."

The songwriter was twenty-six years old, seven years Elvis's junior, and Elvis had been his hero since he'd first heard "That's All Right (Mama)" on the radio at fourteen. "It turned me on, and I've been hooked on music from that moment on." But in person, Elvis was "just like a big old kid, you know? It was like he never got past nineteen in a lot of ways."

"A Little Less Conversation" would become one of Elvis's biggest postdeath hits, when in 2002 an irresistible dance remix by Dutch musician Junkie XL soared to number one in more than twenty countries. The revamped track—vibrant, dynamic, and techno heavy—introduced a timeless Elvis to a whole new

generation of fans. To many who remembered the original rendition, which sold just over 100,000 copies, it was a revelation.

"I told him it would be a number one hit," boasts Celeste Yarnall, the actress Elvis romanced with it in the film. "It just took a few years."

The scene in which it appears pairs him with the pretty blonde "swaying my hips" at a poolside party. It's one of his smoothest on-screen pickups: In the scope of a single song, he chats her up, lays the lyric on her, grabs her coat, and sings her out the door and into his convertible before the last note rings.

.

Celeste was so entranced with "A Little Less Conversation" that when they wrapped the scene, Elvis took her over to the soundman. "The little lady loves the song," he said. "I'd like to give her the disc." The soundman frowned. "This is the property of MGM. I could lose my job." Elvis told him not to worry. "I'll take care of it."

The film picks up with Elvis taking Celeste's character back to his house. "He's hoping to get lucky," as she puts it. "But he's thwarted by Michelle Carey's character and her famous vacuum cleaner, chasing me around with Albert the Great Dane by her side. It's a very cute scene."

Celeste and Elvis had an equally droll first meeting in real life. Five years earlier, when she was a brunette and about to be crowned Miss Rheingold 1964, they were both shopping for luggage at the Broadway Department Store in Hollywood. "I turned around and there was Elvis and his entourage. He gave me this beautiful smile, and then every time I went around a corner, there he was again, with this little look. I won't say we were playing peekaboo, but we were definitely making eye contact."

When Celeste showed up for a wardrobe check her first day on the set, producer Doug Lawrence told her Elvis wanted to meet her.

"I turned around and there he was. I wasn't expecting to see him, and I just about fell over. He was exquisitely beautiful. You had to see this man in person—the skin, the nose, the profile. And he had the most gorgeous sapphire blue eyes. One could never forget the color of his eyes."

They became "instantaneous friends," she says, and almost pushed the relationship to a different level with one of their first scenes together, which called for them to kiss. They rehearsed it far more than they needed and drove the makeup people crazy—his dark makeup rubbed off on her, and her lipstick ended up on him, and his heavy beard made her face a mess.

"One of the kissing sequences was covered from the crane. It was a long, long kiss, and Norman Taurog finally called out, 'Cut, print, okay, lunch. One hour for the cast, half hour for the crew. Elvis, you can stop kissing Celeste. The girl's gotta eat.' The arc lights went *ka-boom, ka-boom,* and I could hear the crew starting to break up a little bit, but Elvis would not stop. He was kissing, and kissing, and kissing, and the set was getting dark. I started to laugh, so my mouth began to pucker, and he went, 'What's wrong, baby? What's wrong?' I said, 'It's lunchtime, Elvis.' And he said, 'Oh, okay. Come on, we're going to feed you right now.' He was adorable. He loved to play."

She knew he'd done that with lots of costars, but she says they soon had a deep connection and labels their chemistry "profound." Beyond that, she won't elaborate. "I am very private about our relationship and I want to keep it that way. But we just had a lot of love for each other, and it was a very special time."

Celeste was surprised that Elvis was more interested in hearing about her than in talking about himself. Still, she drew him out. He confided he was nervous about how fans would receive the film and his more progressive character. And he told her he was scared sick about the TV special, for which he was dieting on "cremated hamburger patties and shriveled-up peas with sliced tomatoes." She loved it that he "could show his very highly developed feminine side" and thought he could only really be himself with the opposite sex.

They were in the middle of filming in April when Martin Luther King Jr., was assassinated, and they watched the funeral together in his dressing room trailer during lunch. Elvis took it hard. Not only was the "I Have a Dream" speech one of his favorite recitations, but Dr. King was shot in Memphis, practically a stone's throw from Graceland. Elvis told Celeste the backstory of his own struggle—that he felt a tremendous brotherhood with the black community because he rose up from the poor and knew the hardships that poverty creates. He was also proud that blacks had embraced him as one of their own.

"He sobbed in my arms like a baby. He was just devastated and desperately would have liked to attend the funeral. We choked down our lunch and sang a little a capella tribute of 'Amazing Grace.'"

Their relationship was hard to define, strung between the poles of pure friendship and romantic yearning. But they were both married, though Celeste and her husband would soon separate. "I was a good girl. I wasn't a player. I wasn't a party girl. Elvis had tremendous respect for me and he knew that I wasn't anybody's weekend girlfriend." All the same, "He made me feel like I was the only woman in the world."

Elvis had that effect on many women, but in truth, he was seeing another girl on the same film. Despite the birth of his daughter and his new family unit, he continued to lead a triple life and to maintain the emotional triangle that had shaped him since childhood.

Twenty-one-year-old Susan Henning, born in North Hollywood and reared in Palos Verdes, California, had been in the business since the age of six (*Wagon Train, Father Knows Best*). Her mother, the Swedish-born Golden Henning, was an actress, as was her older sister, Bunny. At fourteen, with her back to the camera, she appeared as Hayley Mills's twin in the Disney movie *The Parent Trap.*

Like Celeste and so many of Elvis's girls starting with Carolyn Bradshaw, Susan was a beauty queen. In 1965 she won the Miss Teen U.S.A. title, which launched her successful modeling career. By 1968, with her blue-green eyes and Rapunzel-like blond hair, she was the quintessential all-American girl. More than that, in a bikini, showing off her long legs and bronzed tan in commercials for Pepsi and Sea & Ski, she seemed the embodiment of the California dream, a Beach Boys song come to life. Her perfect smile projected healthy sex appeal and promised fun in the sun, moonlight dances, and true-hearted entanglements.

In *Live a Little, Love a Little,* the tall actress had a small part as Sally, the Mermaid Model, for which she wore an orange-and-yellow fish tail. In a waist-length blond wig attached to pasties, she also appeared to be topless. Elvis's character photographs her sitting on a diving board at Marineland of the Pacific.

They met just before shooting their scene, when, unable to walk on her fish tail, she was brought up for her introduction in a wheelchair. ("It was very awkward to be sitting in a wheelchair with a fish tail naked, but that was our moment.") Still, they mostly waved from a distance, and didn't do much talking on the set—the more dramatic moment came when a whale jumped out of the tank and ate her jelly doughnut.

She went back to her dressing room afterward, and Joe knocked on her door and said that Elvis would like to see her, and the three of them took a ride up Marineland's tall tower. She thought it was odd that Joe should accompany them, but romance bloomed anyway, and Elvis asked for her phone number as they spun around the top. She couldn't believe how long and dark his eyelashes were—not knowing he dyed them—and when he pulled her close and slipped his hand over hers, she knew he would call. "It happened pretty quick. It was just a fun, happy, easy time."

Their physical chemistry was obvious. They were both extraordinary-looking, and together—she so fair, and he so dark—they seemed the ideal complement,

shadow and light, yin and yang. As they began spending time together, they talked about their biggest disappointments and fears, and what they both hoped to find in life. He was more articulate than she would have guessed, and she was surprised to learn he was a deep thinker. He told her about his restlessness, his search for inner peace, and they both acknowledged their frustrations over their careers, Susan confessing "there were times when I would cry that nobody loved me for anything but my body." They also bonded over faith. They talked about scripture, and about how "people abused religion," and they recited the Lord's Prayer together, soulfully, feeling each word.

Mostly they tried to shut out the world. Sometime between finishing the film and beginning the NBC special, he sent a Learjet for her and took her for a getaway in Arizona, where he had shot *Stay Away, Joe* on location. Later there would be a trip to Las Vegas.

Because he was married, and because he was Elvis, they largely stayed in the room, especially in Arizona. They were playful together, almost innocent. He called her his "Teen Queen," which made her smile.

To amuse him, she began transforming his lubricious raft of hair into a variety of impossible dos—the surfer style, combed over to the side, and Elvis's favorite, the butler style, parted down the middle. "He laughed so hard. He just thought that was the funniest thing to see the hairstyles that I would come up with. I would show him the mirror and he would make a silly face and chuckle."

Aside from their obvious interests, they had family things in common—they both worshipped their mothers, and they were both the parent of a young daughter. Susan's child, Courtney, was just over a year old, and Lisa Marie two months. "He was very proud of her, and at the time I wasn't married, and my daughter was the apple of my eye." They showed each other pictures of their babies but did not dwell on what anchored them at home, because "it would have brought a different reality into it, and take away what we had."

She didn't get the feeling that he was running from anything ("I think he was enough of his own person that he did what he wanted"), and he told her that he and Priscilla weren't together. It was true, in a way—they were married in name only, and Priscilla spent most of her time at the Hillcrest Road house. Susan thought maybe he was only telling her what she wanted to hear, but either way, they simply concentrated on the moment.

Through the years, Susan has been tasteful in describing the relationship, using words such as *sensuality,* and *passion,* and saying only, "you can use your own imagination about two people who are in love."

But now, for the first time, she forthrightly states, "It was definitely a physical relationship" and offers such information only to clear up a falsehood that has permeated Presley lore since the 1970s: that Elvis would never have sex with any woman who had borne a child. He was usually squeamish about intimacy with anyone who had given birth, but the more complicated truth was that Elvis did not desire sex with any woman who had borne *his* child, which effectively killed any chance he might have had for a happy marriage of many issue with *anyone,* not just Priscilla. He couldn't really explain it, but he knew it had something to do with Gladys and Jessie, and beyond that, he didn't want to talk about it.

In any case, Susan did not need to worry. Her fair coloring would have separated her from both Gladys and Priscilla in Elvis's mind. And on at least a subconscious level, it was a plus: Her Scandinavian heritage would have reminded him of one Ann-Margret Olsson.

.

Elvis's ability to build walls and compartmentalize his relationships—husband, father, philandering sex star—was never stronger than during the time surrounding what is now commonly referred to as "the Comeback Special," in part because he was so frightened and in need of emotional succor.

He spent Easter with Priscilla at their new rental house on Camino del Norte in Palm Springs, and then two weeks later, the couple celebrated their first wedding anniversary at home in L.A. with a catered party from the Deli Restaurant. Elvis sent Priscilla a bouquet from Sada's Flowers in Culver City, but his card—"Love, Elvis"—was anything but effusive.

Elvis wanted a family, but he was conflicted about Priscilla's role in it. It was as if in birthing Lisa Marie, she had served her function. And Priscilla knew it. She had already started becoming her own person and building a new life—taking dance lessons, using the pseudonym "C. P. Persimmons," and softening her look, letting down the beehive and throwing out the hideous black eyeliner. She needed to get away from everything that symbolized the suffocating lifestyle she had led as Elvis's overly made-up concubine.

That same day as the Presleys' anniversary, May 1, Colonel Parker took a meeting at his office at MGM with executives from NBC and the Singer Sewing Machine Company, which would be the show's sole sponsor. "Would TV serve to refurbish that old magic, the sort of thing that gave old ladies the vapors and caused young girls to collect the dust from Elvis's car for their memory books?" *TV Guide* would ask.

That was the question on everybody's mind that day, though no one spoke of it in precisely those terms. Parker told fifty-year-old Bob Finkel, one of four executive producers under exclusive contract to NBC, that he wanted the special to follow a Christmas theme, in effect, casting Elvis as Bing Crosby or Andy Williams. The producer said he'd like to explore other options but broached the subject gently. Parker said Finkel could push the creative margins, as long as Elvis sang a Christmas song to close the program, and that they controlled the music publishing throughout. Later, he would have more specific ideas.

The Colonel suggested that Finkel stop by and meet his client, and the executive producer made his way over to the star's trailer on the lot. He was stunned at what he saw. Elvis was in a declining period, yes, but "most stars had trailers that were a half a block long. Elvis's was like a little Andy Gump. It didn't seem to bother him, either. We shook hands and talked, and I said I was happy about the show. He looked at me very carefully and I guess made a judgment, and the next thing I knew we were in business."

Having appointed himself Parker's keeper and chief distracter, Finkel knew there was no way he could produce and direct the show, too. Thinking he should bring in someone who was closer to Elvis's age, and to whom the singer could relate, Finkel placed a call to Binder-Howe Productions.

Twenty-nine-year-old Steve Binder was a TV wunderkind, but he'd grown up with blue-collar roots, working in his father's Los Angeles gas station. He had a rock-and-roll heart, having directed NBC's prime-time musical-variety series *Hullabaloo,* a quality, big-budget showcase for the top pop acts of the day, and *The T.A.M.I. Show,* a 1964 concert film with James Brown, Marvin Gaye, and the Rolling Stones.

Only weeks before getting the call from Finkel, he'd produced and directed a Petula Clark special that sparked a national controversy. While singing a duet of "On the Path of Glory" with Harry Belafonte, Petula touched Harry's arm. In an era when racial mixing could still raise eyebrows, the show's sponsor, Plymouth, requested that "the touch" be edited out, fearing it might offend southern viewers. Binder and Clark not only held their ground but also destroyed all other takes of the song, insisting the show be broadcast uncensored. It aired on April 8, 1968, to high ratings and critical acclaim, and made history as the first time a man and a woman of different races had physical contact on American variety TV.

The Elvis special would also be unique, but for different reasons. At the time, it was the first prime-time network show devoted to one star. Today it is also recognized as the first "unplugged," or acoustic concert given by a rock-and-

roll artist who usually performed with electric instruments. More important to Elvis's artistic growth, the show marked the first time he would buck the Colonel. But neither Finkel nor Binder saw it coming.

"We didn't know we were doing anything historic," says Binder. "This was just another special with somebody we never listened to, because his records were not our thing. We'd only been exposed to him by Steve Allen, Ed Sullivan, and Milton Berle, though we'd been amused by his publicity and the stories about Colonel Parker."

But Binder's business partner, Dayton Burr "Bones" Howe, who had been the music supervisor on Binder's TV shows, had some history with Elvis. He was currently producing records for such sunshine pop groups as the Fifth Dimension and the Association. But after college at Georgia Tech, he moved to Hollywood for a career as an audio engineer and found work at Radio Recorders. There, he worked on Elvis's early RCA records as the assistant to engineer Thorne Nogar.

Howe recalled how Elvis had really been his own producer, that while he rarely recast a song from the style of the demo, he had remarkable ears for the mix, asking that a guitar lick be brought up here, or a bass thump toned down there, and he never wanted his own voice to stand apart from the instruments.

He also remembered how much fun Elvis had been in the early days, how he'd flirt with girls in cars at the stoplights, rolling down the glass just as the light turned green and taking off his dark glasses ("It's him, it's him!"), or talking them up the fire escape at the Knickerbocker Hotel. Sometimes he'd invite teenagers from nearby Hollywood High right into his recording sessions ("Hi, what's your name? I'm Elvis").

"He was really involved with what was going on in a healthy way," Howe recalled. So when Finkel told him that the Colonel insisted that the NBC show be a twenty-song Christmas special and that Elvis was not to say anything other than, "Good evening, ladies and gentlemen," and "Merry Christmas, good night," he scowled.

Binder and Howe realized the best way to present Elvis was in a relaxed atmosphere—some kind of showcase where people could see how warm and funny he was, instead of the canned personality from the movies. They tossed around the idea of a live segment where Elvis could talk about his musical roots, and then maybe play a little informally. Binder talked to Finkel and said he would only come on board if he could draw the curtain back on what he saw as a once-in-a-lifetime personality.

On May 14, Finkel again met with Elvis, who listened to his ideas and agreed

with his direction. Afterward Finkel wrote a memo reporting that Elvis would like the "show to depart completely from the pattern of his motion pictures and from everything else he has done. . . . [He] wants everyone to know what he really can do."

Next Binder and Howe met with the Colonel, who lived up to his eccentric reputation, showing them the scrapbooks he kept as the dogcatcher in Tampa, diverting their attention while he sized them up. Binder, watching Parker in action with his staff, saw that the Colonel prided himself on his ability to terrorize grown men all around him. Politely, but firmly, Binder insisted he needed a one-on-one meeting with Elvis before he committed to the special.

Secretly, Binder was thinking that at thirty-three, Elvis was no longer the rebellious Hillbilly Cat whose fluid hips and good-natured sneer had captivated a nation. The world was a different place than it had been in 1956, and the movies had rendered Elvis an anachronism. Musically, he had been eclipsed by a long list of British and American musicians, from the Beatles to the Doors to the Jefferson Airplane. He would always be remembered as a pioneering rock-and-roll icon, but to a generation that listened to FM rock radio and elongated album cuts, he was a relic, a man who hadn't placed a record at the top of the charts in six years.

The producer-director suspected that "with that exterior of self-confidence and bravado, Elvis was actually a scared little boy," even as the singer had to know that the special, if done correctly, could rejuvenate his career and liberate him from the artistic brimstone of grinding out three B movies a year. And indeed, years later, Priscilla would tell Binder she had never seen Elvis so excited about anything, that he was so eager to get started he could barely sleep.

They met in Binder's office, in what was known as the glass elevator building on Sunset Boulevard. At first Binder was taken aback by the enormity of Elvis's presence, which he hadn't expected. ("You certainly knew that this was a special person . . . his looks were just phenomenally sculpted, without any weak points.") The two men liked each other, and both were comfortable enough to speak candidly.

"I felt very, very strongly that the special was Elvis's moment of truth," says Binder, "and that the number one requirement was honesty." They joked around a bit, and Elvis told Binder he had never felt at ease doing television, going back to Steve Allen, the tuxedo, and the basset hound. Binder told him he understood, but that this would be different, because this time it would be about music: "You make a record, and I'll put pictures to it, and you won't have to worry about television."

They talked about the Colonel, and Binder said they would probably move in directions that Parker wouldn't like. Then as tactfully as possible, Binder told Elvis that Parker had neither kept up with the times nor his client's need to grow. Parker had certainly been a promotional genius, though "once he had the stranglehold, he forgot that what he was marketing was built around talent, and manipulated the whole thing with smoke and mirrors." The Colonel had pulled off a great con in getting MGM to pay Elvis a million dollars for *Harum Scarum,* but if Parker had been really smart, he would have turned around and given that money to a great director to put Elvis in the right kind of movie.

"He laughed at that, and said, 'You're right.' " He then told Binder he had been burning up inside for years to communicate.

But Binder still wasn't sure what that meant. How was Elvis's musical gut these days? If songwriter Jimmy Webb had brought him the melodically complex, lyrically poetic "MacArthur Park," for example, would he have recorded it, even at seven minutes?

"Definitely," Elvis said, his voice firm and eager. Now Binder felt certain that Elvis was thinking more about the future than the past. They had a deal.

Elvis said he was going to Hawaii to get a tan and relax for a few weeks, and Binder told him they'd have a project he could believe in when he returned.

On May 18, Elvis, Priscilla, and the baby flew to Honolulu, and while they had talked about the trip as being a second honeymoon, they also brought along Joe and Joanie Esposito, Patsy and Gee Gee Gambill, and Charlie Hodge. Elvis, determined to be in the best shape of his life, went on a crash diet and slacked off on his barbiturates so as not to impede his weight loss.

Still, he indulged his interests. A week after they arrived, the group attended Ed Parker's championship karate tournament at the Honolulu International Center. Elvis had known Parker since 1961, but he had never met Mike Stone, the former international light-contact champion.

When the couple was introduced to the cocky young champ, Priscilla's eyes lit up. She now looked at other men the way Elvis looked at women, and Stone was precisely her type. The twenty-four-year-old half-Hawaiian was the recognized bad boy of karate, a dangerous rebel who considered competition a blood sport. Moreover, he was dark-skinned and swarthy, which she found a turn-on. ("There is a certain strength I feel with dark men. They're very virile.")

Less than a year after their marriage, Elvis had heard that Priscilla was having an affair with her dance instructor, Steve Peck, a tall, dark, tough-talking Sicilian. And only recently, word had gotten back to him that she had danced

and flirted with Little Anthony of the Imperials at a disco on a recent trip to New York. In fact, they'd had a terrible row about it.

Priscilla was just so tired of the lying, sick of the games, and especially angry that she and Elvis had not had full intercourse for ten months, while she knew he was getting sex elsewhere. As Joe remembers, "Often Elvis would say, 'I've got to go away, honey, to get away from all the pressure.' She'd say, 'What pressure? You're at home with your wife and daughter.' And he'd go, 'I've just got to get away,' which meant he wanted to go out and fool around."

What was good for the goose was now good for the gander. Priscilla's flirtations with Steve Peck and Little Anthony wouldn't amount to anything, but Mike Stone would be big trouble down the road. Elvis either didn't see it coming, or didn't care.

"This guy's great," he told her. "You should take karate lessons from him." Priscilla would later tell Mike that she decided the day of the tournament that she would do exactly that. She also vowed that he would be her lover. There was something catlike about Mike Stone that she found irresistible. And the fact that Elvis admired him, that he couldn't *touch* him in the sport they both loved and shared, made Mike an especially delicious conquest.

· · · · · ·

While Elvis was in Hawaii, Binder brought in writers Allan Blye and Chris Beard, who structured the special around Maurice Maeterlinck's 1908 theater staple, *The Blue Bird,* in which a young girl and her brother leave home to pursue their cherished lost pet, quite literally the blue bird of happiness.

To tailor the theme for Elvis, Blye and Beard wove a medley of songs that told a story about an innocent, small-town boy who loves to play the guitar. Soon, he sets out to explore the world, traveling what he hopes will be the road to success. His journey leads him to a carnival boardwalk, a house of prostitution, a seedy dance bar, an upscale nightclub, and a stadium arena.

So that viewers would realize it was Elvis's story, too, the team incorporated snippets of his own music, as well as a gospel segment that symbolized salvation. They'd use very little actual dialogue but rely on his song "Guitar Man" as an autobiographical cord to tie it all together.

It was a clever, if natural, concept, but a more inspired moment came from costume designer Bill Belew, who conceived Elvis's now-famous black leather suit, a brilliant update of the classic '50s motorcycle jacket, and an inside homage to James Dean and Marlon Brando, Elvis's idols.

When he first saw the singer in the initial production meeting, Belew, a graduate of the Parsons School of Design, perked up: "This is somebody who is going to be fabulous to dress. This is one gorgeous man!" He chose Cordoba leather, the kind usually reserved for ladies' gloves, so that the heat and perspiration would mold the suit to Elvis's body, despite a lining of black Chinese silk. Belew knew the suit would be hot under the lights, but he felt certain Elvis would like it.

On June 3, Elvis arrived at the Binder-Howe offices for the start of two weeks of rehearsals. He was fourteen pounds lighter from his diet, and his skin was bronzed from the Hawaiian sun. "He looked amazing," Binder remembers. Elvis got excited about the script, and then Howe said he'd like to bring in some of L.A.'s best session players, like guitarists Mike Deasy and Tommy Tedesco, and drummer Hal Blaine. Elvis nodded in agreement. In fact, he said, "I like it all."

However, the team's buoyant mood vanished three days later, when on a visit to Los Angeles, Robert Kennedy was shot and killed at the Ambassador Hotel. His death, coming so close on the heels of the Martin Luther King Jr., assassination, spiraled Elvis into a well of despair. Binder, seeing Elvis's deep reaction and listening to him talk about the lost Kennedy brothers—and in a roundabout way, civil rights—asked songwriter Earl Brown to compose an emotional finale that captured some of Elvis's idealistic and spiritual outlook on life.

Brown stayed up all night to write a climactic ballad called "If I Can Dream," the title hinting at the slain leaders' impassioned words.

In mid-June, to Elvis's surprise, Binder dismissed Billy Strange, the musical director who, with Mac Davis, had written "Memories," one of the special's keynote ballads. Strange, who also worked as a writer-scorer for Nancy Sinatra, was the only person Elvis had asked to be on the project, stemming from his work on *Live a Little, Love a Little*. In his place, Binder brought in Billy Goldenberg, a cohort from a number of Binder's previous specials.

At first, both men were uneasy. Goldenberg thought, "I'm a Jewish kid from New York who grew up on Broadway. What am I doing playing 'Hound Dog'?"

Their first big test came on the day the team went to Elvis's dressing room and played "If I Can Dream." Howe said he was sure it was a hit song, but the way Goldenberg played it, Elvis thought it sounded a little too theatrical. Howe knew it was right for him: "You can do it with a real bluesy feel."

"Let me hear it again," Elvis said.

Goldenberg played it seven or eight times, Elvis bowing his head, getting inside the song. Finally, he looked up. "Okay, I'll do it."

For his entire life, Elvis had fronted nothing bigger than a small rhythm section onstage. Now, in backing him with a thirty-nine-piece orchestra, Goldenberg would bring about the biggest change in Elvis's music since his move from Sun to RCA.

Ultimately, the musical director would create a new, sophisticated sound that would set Elvis up for the next phase of his career. But Elvis had never allowed anyone to tamper with the direction of his music. The angriest he'd ever gotten with Colonel Parker was in January, when Parker had ordered RCA to remaster "Guitar Man" and bring Elvis's voice farther out front. And when he walked into the session at Western Recorders and saw the horns and string section, he nervously called the producer-director aside. Binder told him they'd send everybody home if he didn't like it.

"When Elvis heard the first note, he loved it," Binder says. "He had his sunglasses on and was standing next to Billy on the podium, and he looked into the control booth at me and gave me the high sign, like, 'We're going to be okay.' He just fell out, and he never once questioned anything that we did musically. That was the one moment when he knew it would all come together."

Elvis had now literally moved into the NBC studios, the staff having converted the dressing rooms on the stage into sleeping quarters. Each evening, Elvis jammed and cut up with Charlie, Joe, Alan, and Lamar, and Binder was enthralled, realizing that was the kind of intimacy, informality, and playfulness he'd hoped to get onscreen. He could use a new little handheld video camera to capture it and give the audience a glimpse of an Elvis that no one outside his friends and family had ever seen.

"Absolutely not," Parker vetoed, but he gave Binder permission to re-create it. That inspired the "improv" segment, in which Elvis sits on a small stage with Charlie, Scotty, D. J., and Alan, jamming and telling stories of the early days. A highlight came when he poked fun at the Judge Gooding incident in Jacksonville, as well as his own famous sneer:

"There's something wrong with my lip, man. No, wait a minute, wait a minute. There's something wrong with my lip. Hey, you remember that, doncha? I got news for you, baby. I did twenty-nine pictures like that."

· · · · · ·

At the last minute, Binder and Howe informed Colonel Parker that "If I Can Dream" would close the show. After a battle of wills ("Over my dead body will

Elvis sing an original song at the end of the show! We had a deal for a Christmas song!"), Binder added "Blue Christmas" to the improv.

Binder had bested the Colonel, something few men had ever done. But Finkel gives some of the credit to Parker's client. "We got Elvis to take a stand. It was a miracle."

On June 23, Elvis recorded "If I Can Dream" in several passionate takes. To Binder and Howe, his performance was so staggering as to seem almost a religious experience. Out on the floor with a hand mike, standing in front of the string section, Elvis fell to his knees. For a moment, he was back at Ellis Auditorium, at the gospel sings of his youth, or maybe down in Tupelo at the Assembly of God church. Howe, having worked with him before, might have anticipated such an immersion. Not everyone was prepared: "The string players sat there with their mouths open. They had never seen anything like this."

But the more astonishing performance came when the producers sent everybody home and Elvis rerecorded the vocal in the dark. Binder sat motionless, afraid to move as Elvis lost himself in the song. Once again, he fell to his knees. But this time, in a fervent act that was equal parts artistry and emotional regression, he assumed a fetal position, writhing on the cement floor. Then, after four takes, he got up and walked into the control room, and Binder played the recording back for him. Elvis sat in rapt attention and asked to hear it again until Binder had played it some fifteen times. Only then was he satisfied.

At the start of the project, Parker had told Binder he'd never interfere if things were going well. "On the outside, the Colonel was very unhappy with what was happening. But being a good businessman, there's no doubt that he saw we were on to something special and he shouldn't rock the boat."

Parker was, in fact, a step ahead of everyone. The show would garner high ratings and sell albums, yes. But the Colonel had long foreseen the event as a catalyst for the next stage of Elvis's career. Elvis had three movies to make to fulfill his contracts, but then the Colonel was taking him to Las Vegas, where Elvis would be the biggest act in the desert, and the highest paid performer in Vegas history.

Two months earlier, in April, Elvis, Priscilla, and the Colonel had gone to see Tom Jones in concert at the Flamingo Hotel. On the surface, it looked like nothing more than a star, his wife, and manager out for a night on the town, especially since Elvis and Jones were friends, and the Colonel could never pass up a blackjack table.

But they were there for a much bigger purpose. That night, Parker met with Flamingo president Alex Shoofey, whom he'd known during Shoofey's twenty-year tenure at the Sahara. Over dinner, they roughed out an agreement by which Elvis would appear at the International Hotel, which Shoofey would build with Kirk Kerkorian the following year.

It was time to start reshaping Elvis's profile. Lamar figured it out: "The only way he could set it up was to show how Elvis would perform with a group behind him. That's why the Colonel envisioned the special."

At six-fifteen on the evening of June 25, Parker presented his rehabbed attraction to fifty TV-radio editors at a press conference on NBC's Rehearsal Stage 3. The Colonel cracked a few jokes to warm the crowd, and then Elvis bounded into the room in an electric blue shirt, black pants, leather wristbands, and a diamond ring one reporter described as the size of a Ping-Pong ball.

"Come on, Steve," Elvis said to Binder. "These are always fun."

Binder and Finkel sat on either side of him as he smoked his favorite stogie. Bones and Lamar anchored the end of the table, and Joe, Charlie, and Alan stood behind them. Almost everyone had on a yellow scarf—Parker had handed them out as gifts from Elvis.

The reporters were eager for answers.

"Elvis, why are you doing this show?"

"We figured it was about time. Besides, I thought I'd better do it before I get too old."

"Do you think your audience has changed?"

Elvis smiled: "Well, they don't move as fast as they used to."

They were just starting to enjoy the exchange when the Colonel ended it abruptly, springing his client in full pitchman's style. "Right over here, folks, get your picture taken with Elvis."

"I have no proof to back this up," says Binder, "but I felt the Colonel had the magic power. And I believe that before Elvis did anything, the Colonel would take him quietly into a room and use his hypnotism on him. Elvis was very insecure. But fifteen minutes later, he would come out oozing confidence, convinced that he was the greatest performer who ever walked on the stage."

• • • • • •

Somewhere around June 26, choreographer Jaime Rogers began rehearsing the "Let Yourself Go" dance sequence. Like everyone who worked with Elvis on the

show, he was impressed: "People would be shocked to know how hard Elvis worked on this special."

Dick Loeb, an NBC executive, would later nickname the production number "Bordello," as it frames Elvis wandering into a house of ill repute. There, the Guitar Man is surrounded by a bevy of older, hardened prostitutes who paw and grab at him seductively. He has fun with them, and just as he is about to pick one for the evening, he spots a virginal innocent, a young girl with long blond hair who has yet to meet her first client. They eye each other from across the room, but as the Guitar Man makes his way toward her, the vice squad arrives, and he jumps out the window, continuing on his journey.

In the days leading up to the segment rehearsals, "Elvis ushered young girls into his dressing room like they were on a conveyor belt," Alan remembered. And then the dancer playing the "Virgin" showed up: It was Susan Henning, Elvis's mermaid from *Live a Little, Love a Little.* He had no idea she would be there, and Binder wasn't aware Elvis even knew Susan when he hired her: "With her blue eyes, long blond hair, and angelic face, she just looked like the ideal person to cast."

Susan thought she'd have a little fun with it.

"When I walked into the room where we were to rehearse the dance, he had his back to me. He had his little macho pose, and I think I had on a pair of short shorts. . . . I remember walking up and sticking my leg between his legs, and kind of doing a little can-can. He looked down [and said] his favorite expression, 'My boy, my boy!' "

Susan spent her nights in Elvis's studio dressing room, and then she would have to get up and rush to her parents' home to pick up her daughter. "Mom would say, 'You still taping?' And I'd say, 'Yeah, Mom, sometimes they need you late.' I remember it was a teensy bed, and one night, one of my eyelashes came off on his pillow." At first, it scared him—he mistook it for a spider, he later told the guys. "He thought that was so funny."

Though Binder didn't realize that Elvis and Susan were spending time together ("I was and still am very naïve about these kind of things"), it was obvious to everyone else that they were dating. Priscilla was always home with the baby, and Elvis and Susan flirted openly. Says Binder, "I understand that was the real reason Elvis didn't want Priscilla around. A few years later, she told me Elvis said for her to stay home because there were too many good-looking men on the set."

It made Elvis feel good to have Susan nearby. They were always joking and joshing and teasing with everybody, and to her, "he seemed very comfortable. He was happy to be back working."

Elvis never let her know about his anxiety, but still, she saw herself as his support, since he asked her to stay for much of the taping. "I almost feel I was there to be his strength during that time. I would just be off on the side, and when he's singing, you can often see him looking over that way."

They saw each other for a year and a half. "And certainly we talked about the future." But in the end, she didn't think they had enough in common. She was ready to phase out of show business, and he was going in deeper. And while they shared a love of horses, his was an occasional interest, and hers was a passion— she would become one of the top horse breeders in America.

"The sparks and chemistry lasted with us. But I wasn't prepared to follow anybody around the country. I still had a lot that I wanted to accomplish." And, of course, there was another problem: "He had a multitude of women."

The Bordello sequence would be cut from the original broadcast, as the sponsor was afraid it "might offend the little ol' ladies in the Singer Sewing Centers across the country," as Binder puts it. However, the segment was reinserted in the airings that followed.

· · · · · ·

On June 27 Elvis rehearsed the gospel medley, taped the carnival segment, and then went to his dressing room to rest before his two, one-hour sets before a live audience that evening. But shortly before the six o'clock taping, he panicked, reporting "sheer terror" that he might lock up once he got onstage. Binder had seen him agitated only once, when Finkel suggested they might need to lighten his hair ("Do you think my hair's too *black*?"). But now Howe recognized a crisis: "He sat in that makeup chair and literally trembled, just really sweated. He said, 'What am I going to do if they don't like me?'" Binder reasoned with him and then asked Elvis to do it as a personal favor: "If you get out there and you have nothing to say and you can't remember a song, then say, 'Thank you,' and come back. But you've got to go out there."

It was his first serious musical performance in seven years. Although he was so nervous that his hand shook, he performed as an artist who was evergreen and timeless, and he revalidated his achievements and rendered himself fresh at the same time. When he lit into the rockabilly and blues that fueled the engine of his life, his energy blazed raw and palpable, his voice boasting a tough exu-

berance, his looks telegraphing sensuality, submission, cruelty. By the time he
taped the arena segment two days later, he'd summoned such assurance that he
was not so much a man, but a panther, feral in his black leather skin, growling,
prowling, strutting across the stage.

For the production team, part of the thrill was seeing the metamorphosis take
place. But Elvis may have had some help. After the first taping, when they had to
peel the suit off him, Bill Belew went to Binder. "We have a problem," he whis-
pered. The suit would have to be cleaned: Elvis had experienced a sexual emis-
sion onstage. "That," declares Binder, "is when I really believed that Parker had
planted the seed through hypnotism that Elvis was the greatest sex symbol who
ever existed. I don't think he could have built himself up to have an orgasm unless
there was a stimulus there to drive him to do that. I just felt it was not a normal act."

The "stimulus" may have been Susan Henning, sitting offstage, but where
Elvis could see her, as he requested. Either way, it was a remarkable reaction.

In a conversation with the late Dr. William Masters, who pioneered research
into human sexual response with his wife, Virginia Johnson, psychologist Peter
O. Whitmer asked about Elvis's onstage climax, which was well known in show
business circles. "Bill Masters said yes, it happens, but it's very unusual. It shows
the real depth of the drive of an individual to prove his abilities."

When the special, titled _Singer Presents ELVIS,_ aired on December 3,
1968, critics hailed the return of an authentic American original. The program
garnered 42 percent of the viewing audience and gave NBC its biggest ratings
bump of the year. The soundtrack also soared to number eight on _Billboard_'s
pop album chart. Today the music, which has been repackaged several times,
most recently as _The Complete '68 Comeback Special,_ still inspires wonder.

"What impresses," says music reviewer John Bush, "is how much it prefigures
the rest of Elvis' career. . . . During the '70s [Elvis] was the apotheosis of rock
music, a righteous blend of rock and soul, gospel and pop, blues and country."

"The greatest thrill I got out of it was seeing a man in a small window of time
rediscover himself," Binder reflects. "That's the legacy of the '68 special."

Before they parted that summer, Binder screened an hour's edit for everyone
on the project. Elvis didn't react, which made Binder terribly nervous. Then El-
vis asked if he could see it again, just with Binder. "He watched it three more
times, and laughed and applauded, and he said, 'Steve, I will never sing a song
that I don't believe in, and I will never make a movie that I don't believe in. I
want to do really great things from now on.' "

But first he had to go to Arizona to make _Charro!,_ an offbeat film that aspired

to Sergio Leone's spaghetti westerns. Elvis, heavily bearded for his Clint Eastwood–like role of Jess Wade, a reformed badman, had high hopes that *Charro!* would be a serious film, as the director-screenwriter, Charles Marquis Warren, had produced the legendary TV westerns *Gunsmoke, Rawhide,* and *The Virginian.* But the studio, National General, was in flux, and when Elvis arrived at the Apacheland Movie Ranch, nothing seemed to gel.

He was disheartened over the poor production values, and European star Ina Balin, who played the dance hall queen with whom Jess was involved, seemed ill cast. The script painted Jess as a cynical antihero, and one day at the studio, Charlie remembered, "They had the house sitting there . . . Elvis was standing over at the end of the porch, and he looked down and said, 'Charlie, I'm beginning to feel like this character.' "

The film nonetheless would give him a margin of crowing rights, and he was eager to promote it: "*Charro!* is the first movie I ever made without singing a song," he told reporters. "I play a gunfighter, and I just couldn't see a singing gunfighter." However, in the end, he relented and crooned the title tune. "I'm sure they had to pretty much hog-tie him to get him to cut it," says Mac Davis, who wrote it.

By the time he reported to the set of *The Trouble with Girls* in October, he was in high spirits again, hearing nothing but great things from the Colonel about NBC's reaction to the special and the anticipation over its airing in December. He was also happy to be at the end of his MGM contract. In this movie, with Broadway musical star Marlyn Mason as his assistant, he plays the manager of a traveling Chautauqua in the 1920s.

The Trouble with Girls is an odd entry to the Presley filmography, as he's on-screen for only about one-third of the picture. Yet Marlyn would remember the movie, a mix of music, comedy, and melodrama, as "ten weeks of hilarious bliss . . . all party, every day. I still smile."

Marlyn hadn't been an Elvis fan and wasn't prepared to like him, but "I felt very close to him. I know that he liked me very much, and I liked him very much. It was a sweet relationship. We hit it off immediately. I think if you are in tune with somebody, you sense things. I could be sitting fifty feet from him, and I would just get a feeling, and I would turn, and he would be looking at me."

He called her "Cap," for a hat she wore to work. She was single at the time, and everything between them just clicked. She didn't mind the practical jokes— not even the loud firecrackers under her chair—and found they shared a sexy sense of humor, both appreciating a line of dialogue in which Elvis tells her they should continue a conversation in bed.

"You could ad-lib with him. We would do a lot of that. If the director [Peter Tewksbury] was doing a close-up on Elvis and he wanted a certain reaction, he would come to me and say, 'I don't care what you do, but this is the reaction I need from him.'"

The next time Tewksbury said that, Marlyn "started slowly unbuttoning [Elvis's] shirt and taking his belt off, very quietly. He was just giving me these looks. . . . He didn't stop and say, 'What is she doing?' He would just roll with the punches."

Elvis held his upbeat mood throughout filming, but in his quiet moments with Marlyn, he told her how he'd come to Hollywood full of dreams. "The saddest thing E ever said to me was that he'd like to make one good film, because he knew the town laughed at him. It broke my heart."

For all their rapport, theirs was strictly a working relationship, she says, and she never saw him after the picture wrapped.

It had been an extraordinary year, one that witnessed a birth, Lisa Marie, and a rebirth, Elvis himself. But just as it was a period of grand beginnings, it was also one of hard endings.

Johnny Smith, the uncle who taught Elvis guitar, died that year at forty-six, as did Bobby Smith, Billy's brother, at twenty-seven. Dewey Phillips, who had spun Elvis's first record on the radio, also passed on. For years, Dewey had suffered terribly from osteomyelitis in his leg, which left him with a limp, an incessantly open wound, and an addiction to painkillers. But a heart attack took him out. He was forty-two, just like Bobby Kennedy. They were all too young to die: Nicks Adams at thirty-six, Martin Luther King, Jr., at thirty-nine.

"Mrs. Dorothy," Elvis said to the deejay's widow, "Dewey was my friend."

Steve Binder was his friend, too. But though Elvis had scribbled down his phone number and asked him to stay in touch, Binder's messages were always ignored, his calls never returned. Or maybe they had just been intercepted.

Yet Binder could console himself with the knowledge that together, he and Elvis had created one of the most important and defining moments in the history of rock. And maybe the producer-director had done more than that.

In March 2008 Priscilla Presley sat at the William S. Paley Television Festival in Los Angeles, watching a screening of a forty-year-old TV special in which a man in a black leather suit recaptured his lost glory. Eighteen minutes into it, she leaned over to the person next to her. "You saved his career," she told Binder. "You saved his life."

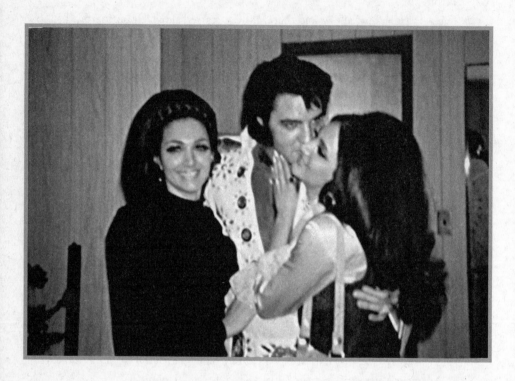

Joyce Bova *(right)* and her twin sister, Janice, greet Elvis backstage at the Baltimore Civic Center, November 9, 1971. Their twinship intrigued and comforted him. "I understood," he told Joyce, "that until your twin gave her blessing to us [that] you wouldn't be able to give yourself to me." *(Courtesy of Joyce Bova)*

TWENTY-EIGHT

.

Sin City

*Barely two weeks after "Singer Presents ELVIS" aired in December 1968, the Colo-*nel accepted the deal to take Elvis into the $60 million yet-to-be-built International Hotel, Kirk Kerkorian's oasis of refinement in the Vegas desert. The showroom, with two thousand seats, would be the largest in town.

Alex Shoofey, nicknamed "the Cleaver" for his attention to the bottom line during his years at the Sahara and the Flamingo, was a good match for the Colonel. When the two sat down at the negotiating table, Shoofey, now married to Joan Adams, the girl who had pushed Elvis off the couch in her trailer years before, told Parker the hotel would be very pleased to have Elvis, but they had to face facts. After so many years in Hollywood, he was unproven as a stage act. He hadn't even appeared in Vegas in twelve years, and in 1956 he hadn't exactly set the town on fire, you know?

The Colonel, intent on outmaneuvering the long-faced Canadian, fixed his antediluvian eyes on him and told him that was all in the past, before the movies, before the TV special. Elvis had his old fans, and his new fans. The International would offer 1,500 rooms—two and a half times the size of Caesars Palace—but they'd have no trouble filling them when his client was in town. Vegas had never seen the kind of business Elvis would generate, and the Colonel would see to it personally.

"You're going to find out what an opening is like when Elvis comes in," Parker boasted, closing his deal with a jab of his cane, and then waving it across an invisible map. "They'll come from all over the world." Shoofey raised a thick eyebrow, pondered the thought, and then shook his head yes.

In late July 1969 Elvis would kick off a four-week engagement of two shows

a night, seven nights a week. No other entertainer had ever committed to such a grueling schedule, usually taking Monday or Tuesday off. As compensation, Parker demanded $100,000 a week, out of which Elvis and the Colonel would pay the musicians and backup vocalists. "Mark my words," Parker declared, "Elvis will be the first star in Las Vegas to make money for the showroom, apart from whatever his fans drop out in the casino. You'll never have an empty seat. I can promise you that."

Elvis, meanwhile, concerned himself more with what he'd promised Steve Binder—to maintain his artistic credibility. On January 6, two days before his thirty-fourth birthday, Elvis took a meeting with Felton Jarvis, who drove over to Graceland from Nashville to discuss Elvis's next record. Marty Lacker was there, and for a while, he just listened to what the two men had to say.

Marty was now running a small record label and working closely with Chips Moman at his American Studio there in Memphis. He had already reminded Elvis that Chips was one of the founders of Stax Records, and that 164 hit records had come out of his little run-down studio at 827 Thomas Street in just the last eighteen months. Red had recorded his own stuff there recently, too, and though he and Elvis still weren't speaking, George Klein also prompted Elvis to think about cutting his next record at American. Maybe there was something magical in those North Memphis walls.

Elvis hadn't recorded in his hometown since the Sun years, and it might put some of that deep-dish soul back in his music, Marty told him some months earlier. It would be his most logical album setting in years. But Elvis had only said he'd think about it. Jerry Leiber, who wrote so many of Elvis's hits with his partner Mike Stoller, knew that Elvis's music was "really white music with black undertones," but that there was no getting around "that Memphis place, where a lot of different things came together at the right time, at the point it was ready to happen."

Maybe it was time for that to happen again, Marty said, speaking now to both Elvis and Felton. Nothing against Nashville, of course, but a lot of the records that came out of there sounded like something turned out of a factory. Felton knew what Marty meant. He knew, too, that Moman had a group of players there—particularly Reggie Young on lead guitar, Bobby Emmons and Bobby Wood on keyboards, Gene Chrisman on drums, and Tommy Cogbill and Mike Leech on bass—who'd mastered a hand-in-glove synthesis of pop and rhythm-and-blues.

After the television special Marty "saw that it could go either way. And

Chips kept saying, 'When are you going to tell Elvis to let me produce a record?'"

It took a bit of arm-twisting, but before Marty and Felton left that day, Elvis had agreed. And during the first two months of 1969, he would record some of his most enduring music, including "Suspicious Minds," "Kentucky Rain," "In the Ghetto," and "Long Black Limousine."

"It would have taken a complete fool not to hit with Elvis Presley, if you had the songs," Moman says. But in getting the *right* songs to him, the project would be fraught with tension, as both RCA and the Colonel threw up obstacles and hurdles about studio policy and publishing rights. That put Lamar, now working for Elvis's publishers, Hill & Range, and Marty, who was Chips's friend and also moonlighted as a song plugger, in the middle.

A confrontation quickly ensued over the publishing rights to "Suspicious Minds," which Moman controlled, as well as Mac Davis's "In the Ghetto," which Moman thought was a perfect statement for a man whose music sprang in part from black culture. Davis, like so many songwriters before him, including the great Otis Blackwell ("All Shook Up"), relented, and gave up part of his publishing for Elvis to record the song. But Moman held firm.

"Their deal was that they weren't going to record any song that they didn't have the publishing on. I was ready to erase the tapes and just let it go. I ended the session and sent the musicians home and asked all of Elvis's people to leave my studio."

Parker told his lieutenant, Tom Diskin, that if Moman didn't play ball, they'd figure a way around him or simply scrap the sessions. But RCA's Harry Jenkins knew that "Suspicious Minds" could be a huge career record for Elvis, and at the next day's session, he mediated for the greater good: Elvis would cut it, and Chips would keep his publishing.

Lost in the battle was the fact that without a Steve Binder there to fuse his backbone, Elvis made no attempt to persuade the Colonel that the material was right for him, or to rise up and say he was going to have the song, publishing rights be damned.

That summer, "Suspicious Minds" became Elvis's first number one single in seven years, and though he would never see another, the sides from the American Studio sessions rank among the finest work of his career. Eventually they covered two albums. *From Elvis in Memphis*, the first to be released, earned a lead review in *Rolling Stone* magazine.

Looking at it again as a reissue in 2001, the magazine still found it remarkable,

James Hunter calling it "new as polyester yet old as leather, religiously involved yet flashy as neon, refined like pop yet savage like rock & roll." The Elvis Presley of 1969 "was a more mannered and complex adult version of the Fifties kid with the nerve to combine the gnawing friction of the blues, the flourishes of gospel quartets, the zinging concision of pop and the melodic leisure of country."

Elvis was on such a fiercely creative roll that it could only have been stultifying to have to return to Hollywood in March. There he honored the second half of his commitment with NBC, teaming with Mary Tyler Moore for Universal Pictures' *Change of Habit.* Though he would make two concert films for MGM in the 1970s, this was his last narrative motion picture.

Change of Habit was measurably better fare than the likes of *Stay Away, Joe* or *Clambake,* in that it offered a dramatic role and only a handful of songs. But it presented little in the way of challenge. As Dr. John Carpenter, the head of a free ghetto clinic, Elvis finds himself with the unexpected help of three young women—nuns in street clothes—who never reveal their true vocations. Dr. Carpenter falls for Sister Michelle Gallagher (Moore), but the film forgoes a happy ending, framing Sister Gallagher in church, struggling with her vows.

Moore, whose range of characters spans the perpetually buoyant Mary Richards (*The Mary Tyler Moore Show*) to the bitter, raging mother of *Ordinary People,* seems somewhat embarrassed by *Change of Habit,* joking that "Elvis has said on the record, 'I slept with all my leading ladies except one.' Well, I don't mean to bust anyone's cover, but I know who the one is. And what was I thinking?"

It wasn't strictly true, of course—he hadn't slept with *all* his leading ladies. But putting the words *Elvis* and *nun* in the same sentence always seems to make people smile. That includes one of his earliest acquaintances in Tupelo, Barbara Spencer, for decades a member of the Sisters of Charity of Nazareth: "Gladys and my mother were friends, and my mother loved to tell that I slept with Elvis. However, it was when we were infants. They even put us in the same crib sometimes."

Change of Habit was yet another different direction for Elvis—it marked the first time he played a professional man, and he didn't exactly get the girl. But the film seemed more like an after-school special for the preteen set than a movie of the week. Elvis never quite commanded the bearing of a doctor, and his scenes with Moore were so preposterously wrongheaded as to render the two the least likely couple in the universe.

It was a dreary, if emblematic, end for an actor whose talent was misused, misunderstood, and all but choked off by the big screen. "He came to Holly-

wood a greasy golden boy, dripping with sexuality," observed entertainment journalist Steve Pond. "He left an entertaining, safe icon."

.

As Elvis finished his film obligations, Parker was busy mounting a colossal promo- tion and advertising campaign, drawing on his background as an advance man for the carnivals to build Elvis into the biggest act in Vegas. "He just loaded this hotel," remembered Shoofey. "He had every billboard in the entire city, not only in Vegas, but leading all the way to California. There was so much excitement it was unbelievable. We got calls from all over the world. We couldn't accept all the reservations."

Parker had insisted that Elvis be the second star in the new showroom, not the first, so that the hotel could work out any of the bugs with the lights or sound before Elvis went in. Barbra Streisand was the International's opening draw, then, but by 5 A.M. after the close of her engagement, anticipation for Elvis was so great that fans were already standing three blocks deep to get into the hotel, and the lobby was jam-packed. Parker, meanwhile, stayed up all night plastering Elvis posters, banners, and flags all over the elegant walls and installing Elvis stand-ups in the lobby. Management bit their tongues and went along with it: Hotel employees donned straw hats with Elvis plaques on the front, while crou- piers added red, white, and blue "Elvis" armbands. "They looked like riverboat gamblers," says Imperials member Joe Moscheo. "Honestly, it was a very strange atmosphere."

.

In May, Elvis took Priscilla and Lisa Marie back to Hawaii on vacation for two weeks. He needed time to think, to formulate the show. And he wanted the kind of deep Hawaiian tan that would be seen from the last row of the showroom. Since he never flew commercially under his own name, he booked the family as "the Carpenters," using the name of his *Change of Habit* character.

As always, he brought along a retinue, adding the Fikes to the previous year's party of the Espositos, the Gambills, and Charlie Hodge. They spent their week- days at the Ilikai Hotel in Honolulu, and moved to the more intimate Coco Palms on Kauai for the weekend.

Priscilla, her overinflated hairstyle a laughable memory, was now much more comfortable in asserting herself and stepping out of her role as Elvis's wife. She was still refining the changes in her appearance—growing her hair long and

straight to her waist and lightening it to a honey brown, for example, and choosing her own style of dress. Now more serious about her dance lessons, she had also taken up photography and delighted in decorating the new house.

She would still say that her biggest ambition was "to be a complete person," but she had recognized that the marriage was never going to work, that she had entered into a pure fantasy and an impossible, unworkable dynamic with a man who was by turns a father figure and a boy. "I need an equal," she would say. "I need a relationship with a man I can grow with."

Then she would be beguiled by him again and lapse into the old patterns: "Elvis brought out this mothering quality. I cut his meat up for him. I tasted it before he ever had it. I would fix his deviled eggs, cut off the top, put his butter in, prepare all his food as a mother would for a child. I would test it to see if it was too hot. Even making his coffee . . . I loved doing it for him. We'd all baby him. Then you'd see him onstage and he looked so strong and virile, it was like, 'Oh, my God!' But there was this child that was still in there."

By the time they landed in Hawaii, Priscilla was tired of all of it—of the guys who surrounded them to the point of suffocation, of the upside-down hours, of living someone else's life. "It was never about me," she would say. "It was really about him on every level."

She reached her threshold on the weekend they checked into the Coco Palms Hotel and rented the king and queen huts, the individual cottages among the coconut trees in the rear of the property. It was there that they had their biggest fight about their sex life, Joe remembers.

"We had one suite, and they had the other, and the headboards of the beds were back to back. My wife and I were asleep, but we could hear them right through the wall."

The tropical setting had put Priscilla in an amorous mood, especially since so much of *Blue Hawaii* had been shot on the grounds. But again, Elvis put her off. In Joe's recollection, Elvis thought it was "like making love to his mother. He just had a hang-up about it. And Priscilla kept yelling at him, 'You never make love to me anymore!'

"It had a lot to do with their relationship, naturally. I'm sure they [had sex] a little bit after the baby, but he wasn't thrilled with it. That night, he didn't say why. He just screamed and yelled back at her. But that's one of the reasons the marriage fell apart."

Elvis spent the rest of May, June, and July working up material with Charlie,

or "Cholly," as he pronounced the little man's name. He wanted only the best musicians and songs, and as a fan of Mario Lanza, Jan Peerce, and Roy Orbison, Elvis was eager for songs that would let him show off the voice he'd kept hidden so long, one that could now handle sustained high notes and operatic endings. His artistry had never been so well developed, Charlie saw. "He would be Billy Eckstine, he would be Bill Kenny of the Ink Spots, he would be Hank Snow—all these people became Elvis Presley. He had all these people inside him."

In choosing the musicians, Elvis spoke to nearly every good player he'd known, including Billy Goldenberg, whom he wanted as his arranger–musical director, but who declined, citing previous commitments. For now then, he'd go with Bobby Morris, who led the thirty-piece International orchestra.

To lead his own band and help audition the players, he settled on famed Louisiana guitarist James Burton, who had come out of Ricky Nelson's late 1950s group and gone on to become a top L.A. session musician. And for backing voices, he chose not one, but two groups: The gospel-based Imperials, a white male act, and the Sweet Inspirations, a black female quartet that had backed Aretha Franklin. It was a "helluva big stage to fill," he told Charlie.

What he hoped for, he remarked to James, pulling on what he learned in the television special, was a sound that would bring together all of the diverse American traditions—black and white, sacred and secular—that had influenced him.

"Our music was from the same school," explains Burton, who, like Elvis, got his start on the Louisiana Hayride. "He needed to have that strong background, that drive, and he liked to have a lot of voices back there singing and really pushing. He had a natural feel for the way the tempos should be, and how the background should surround his vocal. . . . He knew the feeling he wanted."

Now he was trying to think of everything, including the way he'd interact with the fans. So he could get in the habit of being in public again, dealing with the crowds, he made concerted efforts to go down and sign autographs at the gates. He wasn't sleeping well, though, worrying if he could sustain his voice over such a long engagement, with two full-hour sets a night. And he was short-tempered, partly out of nerves, and because he was working hard at staying skinny, hovering around 168 pounds. He wanted his cheekbones to show in the photographs.

Most of all, he wanted to be able to fit into his new Bill Belew–designed outfits. Belew, who had never worked in Vegas before, originally made his stage costumes in a variety of colors, including red and blue, Elvis's favorite. Then he

discovered that white worked best, to accommodate the changing colors of the lights.

"The first thing I said was, 'I will not dress him like Liberace.' Elvis, for me, was a very macho man. I did not feel that all the furs and feathers and sequins were right for Elvis. So the jumpsuits and macramé belts I did for him in the beginning were very subdued."

Some of them, however, like the white Cossack-style suit, accented with a dangling macramé belt, played up Elvis's androgynous beauty and made him contemporary with many of rock's leading figures, who favored a flowing, feminized style of dress. He wore the outfit for at least two of his three run-throughs of the performance with full orchestra accompaniment on July 31, only hours before the show opened at 8:15 P.M.

For days he suffered the kind of debilitating panic attacks that crippled him just before the Singer special. If he seemed at thirty-four to be the King of the Oldy-Moldy-Goldys, or simply fought off technical problems, it would be reported in the press both domestically and overseas, where he had such a stronghold of fans. That would affect business and future touring, which he hoped to resume in 1970.

He would also have to face the invitation-only audience, studded with such celebrities as Cary Grant, Paul Anka, Carol Channing, Fats Domino, Wayne Newton, Ann-Margret and Roger Smith, and most important, Sam Phillips, who had started it all. He was so jittery, in fact, that he asked Joe to tell Marty Lacker and George Klein not to come until the second night. He would start his two-shows-a-night schedule then, and he was afraid the showroom would be half-empty.

But when he finally hit the stage at 10:15, following warm-up sets from the Sweet Inspirations and comedian Sammy Shore, he buried his nervousness in the bravado of the rock-and-roll beat, walking out onto stage left unannounced, and winking to the Imperials as he passed.

Just as he shuffled onstage at his high school variety show, he hesitated for a moment, as if summoning his courage. Then he churned through a repertoire that burned the fires of nostalgia ("Blue Suede Shoes"), and thrilled with the soulful tenderness of the Memphis sessions. He was as much athlete as aesthete, falling to his knees, sliding across the stage, even turning a somersault. The crowd leapt to its feet and stayed there.

Both the establishment and the counterculture press, including the *New York Times,* the *Village Voice,* and *The New Yorker,* rushed to praise, and even

the seen-it-all pit bosses said they couldn't remember such excitement on an opening night.

There to share it was June Juanico, who seemed to speak for most of the women in the audience. "Oh, my God, he was still the most gorgeous creature I have ever laid eyes on. I could hardly control my heart. It was just jumping out of my chest. He knew I was in the audience, and I had to pretend I wasn't in love with him, because I was with relatives, you know? That was not an easy thing."

When the Colonel greeted Elvis backstage, he was visibly moved and pulled out of a quick embrace to contain his emotion. Then he made his way to the hotel coffee shop to join Alex Shoofey, the International's president. There, in blue ballpoint ink, they turned a badly stained tablecloth into a contract. Figuring Elvis's engagement would break all Vegas records (grossing $1,522,635, with an attendance of 101,500), the hotel boosted his salary to $125,000 a week and extended its option for two engagements a year for five years, through 1974. The Colonel, who always bled a deal for the extra drop, gouged Shoofey for a trip to Hawaii for Elvis and eight companions. The short man smiled, the fat man grinned, and the two shook hands.

Secretly, Shoofey knew he'd just made the best deal in Vegas history, and he'd done it standing on the back of Elvis Presley. Parker had hit the million-dollar mark again and crowed that he had negotiated the most money ever for eight weeks of work in Vegas. But he hadn't demanded a sliding scale, and instead had signed Elvis to five years for the same amount of money, without an increase.

Why? To protect his own interests with the hotel, for Parker was the most pathological of gamblers. He couldn't lose money fast enough.

"[The] Colonel was one of the best customers we had," Alex Shoofey later reported. "He was good for a million dollars a year." But others later questioned that figure, saying it was too conservative: The truth was that Parker routinely lost between $50,000 and $100,000 a night during Elvis's engagements, the hotel treating him like royalty, roping off tables for his private play twelve or fourteen hours at a stretch.

While Parker was figuring Elvis's future in numbers on a coffee-marked table covering, Steve Binder was discovering that the Colonel had barred him from going backstage. It would be thirty years before he found out Elvis had been expecting him, eager to get his feedback.

"I was convinced at the time he left the '68 special that he had a whole different mind-set of what he wanted to do with his life. And quickly, that window of

opportunity was shut tight, and he ended up being a saloon singer in Vegas just to indulge the Colonel's gambling habits."

As Elvis's guests and friends filtered back to congratulate him, he told them what he repeated the next day to reporters—that he'd been "a little nervous for the first three songs, but then I thought, 'What the heck, get with it, man, or you might be out of a job tomorrow.'"

Patti Parry was there, as much for support as to see the show, and sat near him to help quell his butterflies. As celebrities filed through his dressing room, Elvis looked around nervously for Ann-Margret and Roger Smith, and invited them up to the suite later on. Then, hoping to impress Roger, he leaned over to Patti and whispered in her ear: "Go put on every piece of jewelry I ever gave you."

At his press conference the next afternoon, wearing a black suit with a standing collar and an accent scarf of bloody orange at his neck, he resembled not so much a Vegas performer as a European prince, at once modern and timeless. The questions were predictable, his answers sometimes not.

"Did you enjoy performing live again?" came a voice.

"Yes! This has been one of the most exciting nights of my life."

"How does your wife feel about you being a sex symbol again?"

"I don't know . . . you would have to ask her."

"Why have you led such a secluded life?"

"It's not secluded, honey, I'm just sneaky."

Elvis had gone into the engagement without a serious girlfriend. He had called Celeste Yarnall and made it clear he wanted her to come be with him, be his lady, but she turned him down. She had a brand-new Collie puppy, she said, which was true. But the larger issue was that "I was married still, even though I was separated, and I just knew it would be the wrong decision for me to enter into that lifestyle. I didn't go to the Hollywood parties, never drank or smoked, went to bed early. Maybe if I had said 'yes,' I would have been the Linda Thompson in his life. Who knows?"

· · · · · ·

On August 16, 1969, twenty-four-year-old Joyce Bova, a junior member of the Armed Services Committee of the Unites States House of Representatives in Washington, D.C., came to Las Vegas on vacation. With her was a girlfriend, AnnMarie Wade, a huge Elvis fan. AnnMarie couldn't believe it when Joyce lucked into a pair of comps to his show on their third night, but they were a gift

from Paul Anka, who had inadvertently embarrassed her with an offhand comment during his own performance.

Joyce and AnnMarie were waiting in line for their passes on August 19 when suddenly a greeter from the International plucked them from the line and asked if they'd like to meet Elvis, right then before the second show. It seemed a most peculiar series of events, but Joyce and AnnMarie went with the flow and soon found themselves being led down a maze of hallways and into a room with Vernon Presley and the members of the Memphis Mafia. Everyone was waiting for Elvis.

Joyce worked with famous people every day, but when he finally walked through the door, "I wasn't prepared for how beautiful he was. Beautiful. That was the word for it." Elvis inspired not so much desire in her, she would write in her memoir, *Don't Ask Forever: My Love Affair with Elvis Presley,* but "a mixture of curiosity and awe."

Elvis responded to her in kind, for Joyce—striking, so petite as to be tiny, with long dark hair and the olive skin of her Sicilian heritage—had the exotic looks that always caught his attention. Joe could see why: "Pretty girl. Black hair, beautiful eyes, and a dancer. Attracted him tremendously. And they just hit it off."

He laid his usual flirtatious prattle on her, arranged for her and AnnMarie to sit in his booth, and invited her back after the show.

Joyce felt almost lightheaded watching him perform, and just then it occurred to her, seeing him with all the shrieking women, that he might be expecting more from her than she was prepared to give. She promised herself she wouldn't let it get out of hand, but once she was back in his private dressing room, she could feel an intensity from him—the way he gripped her hand, the way he moved too fast. Suddenly, a woman came up and mistook her for Priscilla, an easy thing to do, and she could feel her face flush.

Things might have ended there, especially as AnnMarie had promised Paul Anka that they would come see *him* backstage. But then Charlie was standing there with something for her to drink, and Elvis was babbling on about how "unique" she was, because he could just tell. And it was then that Joyce uttered the words that would capture Elvis's attention forever.

"Actually, there are two of me," said the spunky brunette. "I have an identical twin sister."

Elvis stared at her with a look of "surprise and shock, but like he was trying to digest it," Joyce remembered in a rare interview for this book. And then his whole demeanor changed. Gone was the superstar pose and the man on the make. Suddenly Elvis was just someone who'd lost a vital part of himself.

"My little brother, Jessie Garon, died when I was born," he told her. "You know, they say the twin who survives lives on carrying the qualities of both, of the one who died."

She thought she'd upset him, but as he talked on, she saw that the look was really one of discovery and recognition, that he had met someone who knew what it was like to be a twin. It turned out that Joyce was also the second born, like Elvis, and in an odd way, this was his own personal reunion. Meeting her almost gave him the ability to look and see what might have been, if not for fate. Now he wanted to hear more about her sister.

Joyce and Janice had been nearly inseparable since birth, she told him. They did everything together, even though Janice had recently married.

"Do you miss her a lot?" he asked. "I mean, when you're away from her, like tonight?"

Joyce told him she'd wished all night that Janice were there to share each amazing moment of her visit. "But, of course, I know she knows how happy I am."

Elvis asked her what she meant.

"Well, it's hard to explain, but Janice and I have always had this capacity to feel the other's emotions, no matter how many miles separate us from each other."

Now he looked at her for what seemed like a long time, and she got the feeling that "he had many questions he wanted answered."

"Joyce," he said, "would you come up to the suite later and have dinner with me?"

Oh, wow. Now she was stunned. Her hands turned to jelly. She didn't know about this. Suddenly she felt as vulnerable as if she were naked. She was afraid. She'd had a strict Catholic upbringing in Baltimore, and her father was a sergeant on the vice squad. Her mother had been a dancer, and because of her own history with show people, she had imposed a "relentlessly repressive regime" on the twins their whole lives. And so Joyce turned Elvis down, saying she and Ann-Marie had promised to meet some people.

He pressed her. "Is this some guy? Y'know, I can tell . . . some guy you maybe just met?"

She finally told him what was really on her mind, that she figured he picked a different girl each night, and tonight it was she, and that wasn't what she wanted. "I adore you," she said, "but no thank you."

All he wanted was to get to know her better, he said. "Besides, you ought to realize that it's not physically possible for me to be with a different girl every night and still do what I do up on that stage."

"Well," she said, though she felt a little sheepish, "there's also the fact that you're married."

Now he was indignant. "What does 'married' have to do with this? I just want to be with someone I can talk to. You should realize that with you I would have to be a perfect gentleman. And that's a promise."

And so she caved, she wrote, "like a freshman congressman confronted by Tip O'Neill."

Joyce was too nervous to actually enjoy her cheeseburger dinner with Elvis and the guys in his suite on the twenty-ninth floor of the International, but Elvis was intrigued with her—the fact that she was a twin, that she worked on Capitol Hill, and that her father was a cop. And so he asked her questions almost the entire time until she left at 5 A.M., when he had Gee Gee Gambill take her down and put her in a cab for her room at the Dunes.

When she returned for a second dinner a few days later, she asked him point-blank, "Why me?" His answer: "Trouble is . . . it's been a long time since I've felt so comfortable with a woman."

It made her dizzy. But that couldn't be true, could it? Elvis Presley? She didn't know what to think, especially when he asked her to stay in Vegas a few more days.

"Believe me, I would love to, but the Congress of the United States doesn't recess for me." Before she left, he kissed her for the first time and asked for her home phone number. She scribbled it out quickly and put it in his palm, and he replaced it with a small diamond ring, a perfect stone set in finely wrought gold. "So you won't forget me," he said.

A week later, he called her at 2 A.M. He wanted her to come back to see him. Right then. And when he heard her sister was at the door, he seemed delighted. "Put her on," he said. "I want to meet her."

On their first night together, Elvis gave Barbara Leigh a gold medallion of Jesus, shown here on a chain around her neck. Their faith made up part of the bedrock of their relationship. *(Courtesy of Barbara Leigh)*

TWENTY-NINE

· · · · · · · · · · · · · · · ·

Girls, Guns, and the President

In October 1970, Elvis and Priscilla were back in Hawaii again, the Colonel having held Alex Shoofey's toes to the fire for the perk. Vernon and Dee, the Espositos, the Schillings, and the Gambills all came along at their invitation. Elvis had nothing scheduled until his return to the International stage in January, and while he'd once told Jerry that one of the most important lessons in life was being able to cope without anything to do, he was looking forward to the time off.

Although there was always much to interest Elvis in Hawaii for either work or play, after his huge fight with Priscilla there, the locale no longer seemed the paradise it once had. He never seemed to go anywhere else on vacation, one of the guys pointed out, and someone suggested that they all just continue their holiday in Europe. The Colonel always had some excuse why Elvis couldn't perform there, so if he were going to see any more of the Continent than Germany and France, he needed to do it on his free time.

They made a plan to return to the mainland, where they could pull some strings and expedite passports. But when the Colonel caught wind of the idea, he squelched it immediately, arguing that Elvis's rabid European fans would be insulted if he visited as a tourist before ever appearing in concert.

As usual, Elvis relented and accepted Parker's suggestion to go to the Bahamas for two weeks instead. The Colonel had contacts there, he said, and they'd love the gambling and the deep-sea fishing. But the sea was too choppy for the latter, and the trip was largely a bust: Rain and hurricane winds kept them virtually trapped at the Paradise Island Hotel, where Elvis sat in with an Irish band, the Witnesses, and resumed fighting with Priscilla. The group returned home earlier than expected.

On October 30 gossip columnist Rona Barrett ran into Elvis at the blackjack tables, a girl on each arm. Her November 6 column carried a most candid item: "Everybody is commenting on how good Elvis Presley looks these days while he's having fun at the International. . . . Elvis's answer in response to such compliments: 'That's what a bad marriage does for you!' "

In the middle of December, he started calling Joyce Bova again, asking her to come to California. She couldn't, she told him. Her committee was investigating the My Lai incident. She was putting in twelve-hour days. They went round about it again, and finally he just informed her he was making arrangements for her to come the following day.

"I can't . . . Elvis you know I can't," she pleaded. "I don't see why you can't come *here*." He started in, saying maybe she wasn't interested after all, and she snapped at him, blurting, "Anyway, what about your *wife*?" They exchanged a few tense words, and then she heard a click.

When he went back to Vegas for four weeks on January 26, 1970, he was again the talk of the town and drew almost universal acclaim, the Los Angeles *Herald Examiner* writing, "The new decade will belong to him." This time, Bill Belew dressed him in one-piece jumpsuits made of stretch gabardine ("I got the idea from a karate suit," Elvis would say), which gave him freedom of movement. Most were either all black or all white, including a stunning white suit cut to the sternum with a "necklace" of rope at the neck.

The reviewer for *Life* magazine, a Columbia University professor named Albert Goldman—later a controversial Presley biographer—took particular note of the costume and the "male cheesecake" who wore it. Though he savaged the outfit as effeminate and indicative of the star's "immaculate narcissism," Goldman admitted that "not since Marlene Dietrich stunned the ringsiders with the sight of those legs encased from hip to ankle in a transparent gown has any performer so electrified this jaded town with a personal appearance."

He also derided the fan reaction. "Watching the women in the audience lunge toward the stage like salmon up a falls becomes the show's real comic relief," he wrote. But Elvis managed "very well with his constituency by occasionally grabbing a blue-haired lady at ringside and kissing her firmly on the mouth."

Not all the ladies were blue-haired, by a long shot, and when Elvis returned in August, he would begin the ritual of handing out scarves to the women brave enough to make their way downstage. Charlie would stand behind him like a king's courtier, feeding what seemed to be an endless supply. Then Elvis would wipe his brow with one, and as the women screamed, shrieked, and elbowed one

another for standing room, Elvis would religiously place one in their outstretched hands. It was rock-and-roll communion, Vegas style.

Everything was coming together now, the return to the stage, the resurgence of fame, and the industry respect. Now it was time to test the waters for touring, to see if the faithful only came to Vegas, or if they were still out there, tucked away in the small towns and walking the streets of the bigger cities.

At the end of February, he flew to Houston on Kirk Kerkorian's private jet. There, in his first performances outside Las Vegas since 1961, he played four concerts over two days at the Houston Livestock Show, breaking attendance records by some 10,000. Robert Hilburn, reviewing for the *Los Angeles Times,* called the first evening performance "masterful."

The appearances warranted a press conference, and Elvis said that while the size of the Astrodome was daunting ("It scares the . . . it's a big place, man"), in a way it felt like a homecoming, because he played so many early dates in the Lone Star state during his Louisiana Hayride days.

Yet at one point, the shows looked as if they might not happen after all, remembers the Sweet Inspirations' Myrna Smith. "The promoters didn't want us to go, because it was in Texas, and at that time, they weren't as liberal as they are today. They told Elvis not to bring 'those black girls.' Elvis replied, 'Okay, but I'm not coming, either.'" Then he went a step further by making a promoter's daughter drive the Sweets around in a limousine.

For the second day's show, Priscilla flew in, just as the Houston papers reported rumors of the breakup of the marriage. Yet she was not the only woman he had seen in Texas lately. Elvis had been flying to Dallas routinely since October 1969, registering in hotels as Jon Burrows, and spending time with a stewardess, and perhaps more than one. Lamar reports that Elvis was making trips to the American Airlines Stewardess College in Fort Worth and trolling for women, just as in his army days.

If, indeed, one of the world's most desired men flew around the country looking for girls, it speaks not only to his insatiable need for female companionship—and particularly the companionship of women who all dressed alike, as in twinship—but also to his desire to be the aggressor in relationships, since women had been literally fainting at his feet for decades. Soon he would start sending out for hookers in Vegas, but mostly for the guys, Joe says.

"We were so jaded by this point that it had become too much trouble to go out and look for women." They'd switch girls as the night wore on, but according to Joe, only on occasion would Elvis disappear in his room with one, saying

he'd rather watch. His preference was almost always two women together. "Elvis romanticized sex. Paying by the hour grounded it all too well."

In Houston, reporters asked him if he still planned on making films. "I hope to," he said, and then laughed. "I'd like to make better films than I made before." But as far as he knew, there was nothing planned. He then deferred to the Colonel. "Is there anything in the workings?"

"I can't commit myself," the crafty manager dodged. But in exactly one month, Parker closed a half-million-dollar deal with Kerkorian, the new owner of MGM Studios, for *Elvis: That's the Way It Is,* a documentary to chronicle his 1970 summer engagement at the International. The Colonel had sought twice that much, as the film would have a theatrical release. But with Oscar-winning director Denis Sanders on board, it was still a prestige project.

"He loved it," says Jerry. "He must have seen it ten times." Elvis was particularly proud because the staging worked. He'd gotten so much opposition from the Colonel about having so many musicians and singers right around him, instead of hiding the band and sticking the singers way off to the side. He wanted it all out front, cocooning him, the way he liked to work in the studio. It was comforting. It was human touch, almost, what he always desired the most.

When Elvis finished his superstar engagement in Houston, he was off to California to play family man again, spending extended time with Priscilla. Despite the shakiness of the marriage, they went house hunting in Palm Springs, and in early April, they found one to their liking at 845 Chino Canyon, making a $13,000 down payment and signing a mortgage for $85,000.

Priscilla's husband seemed to be trying, she thought, but even though he threw her a surprise twenty-fifth birthday party in May, she still felt "I was always a little girl to him." When it came to selecting furniture for the Palm Springs house, they moved some of what they had in storage. But then Elvis chose the rest, and it was big and masculine and not her style at all.

At the end of the year, as part of creating her own life, she would pick a new home in Los Angeles as well, spending $339,000 for a more private residence at 144 Monovale Drive, in the Holmby Hills section of Beverly Hills. She decorated it herself with a more feminine touch, while keeping the big couches and modern furniture that pleased her husband. Now that they had Lisa, she felt they had outgrown the Hillcrest house, and on Monovale, there were five bedrooms, with two more bedrooms in the guesthouse—room to stretch out or accommodate the entourage and their spouses.

She looked back at her former self and could hardly believe how she had lived. "If he said, 'That's a terrible color on you,' I'd change my clothes immediately. For years, I was self-conscious that my neck was too long because Elvis always told me to wear my shirt collars up. Now I realize . . . You know all those pictures where *he* had *his* collar up? *He* was the one who was self-conscious about his neck."

That hadn't really dawned on her when he started with Bill Belew's Napoleonic collars, but now there was no denying it. As she continued to simplify her look and uncover her natural beauty, Elvis piled on his own plumage and wrapped himself in ever-increasing flamboyance and fantasy costumes. One white outfit was so fringy and bat-winged that when he raised his arms, he appeared to take flight, and he was already thinking jewel-encrusted capes for next year. When the first one arrived, Bill saw, he "was like a child who had gotten a new toy and couldn't wait to play with it. He would prance and dance around the floor, twirling the cape, and ask the guys, 'What do you think? How do you like this?' " In a way, Elvis was becoming his own skewed vision of the Priscilla he had dolled up and created, taking her from schoolgirl to Dracula's party queen overnight.

"It's true," Priscilla says. "It was a flamboyance that he didn't have to do. It was a *cry,* I think. . . . From that point on, he began to self-destruct."

The self-destruction manifested itself in several ways, including a return to binge spending that rivaled his out-of-control habits at the ranch.

Four days after signing the mortgage on the Palm Springs house, he bought a six-door 1969 Mercedes limo. He continued to indulge his taste in showy automobiles when he bought a 1971 Stutz Blackhawk—the first of its kind in Los Angeles—and gilded the lily in delivering it to George Barris for customizing. He'd buy more cars as the year wore on—another Mercedes for himself, and one for Jerry, and while he was writing checks, a house for Joe, too.

Then there were the gun sprees. In three nights, he dropped $20,000 on firearms at Kerr's Sporting Goods in L.A., four salesmen falling over themselves to keep up with him. He bought guns for anyone he could think of—girlfriends, the guys, even people off the street. And he became more obsessed with badges, with all the guys being deputized and armed at all times.

It wasn't just about power and control, or even for protection when death or kidnap threats came, as several did in Las Vegas, beginning that summer of 1970. Deep down, it was part of his paradox, his lifelong obsession with authority,

going back to Vernon's incarceration, his boyhood visits to the prison, and the shame that made his child's face flame scarlet.

.

*The latter half of the year also saw more expenses as Elvis began adding to his pay-*roll. First he brought RCA producer Felton Jarvis on the team, inducing him to quit his job and work directly for him. That June they holed up in the record la-bel's recently refurbished Studio B in Nashville and, as with the television spe-cial, blended players old and new. Scotty, D. J., and Floyd Cramer, among other stalwarts, joined newbies Norbert Putnam on bass and Jerry Carrigan on drums. James Burton, the guitarist from Elvis's show band, held it all together as session leader.

The first night, they captured eight songs in ten hours, running every style and tempo, and by the end of five nights, Felton had thirty-five masters in the can. Nothing rivaled the American Studio masterworks, but Elvis would never have such a productive recording streak again, and the quality rode high—a gospel-flavored cover of Simon & Garfunkel's "Bridge over Troubled Water," an impassioned rendition of Dusty Springfield's ballad "You Don't Have to Say You Love Me," and the modern pop of "I've Lost You," Elvis's next single. The song seemed to speak to his domestic situation, even as outward appearances indicated otherwise.

Norbert Putnam was surprised to see that while the food was catered, and the players were told to order anything they liked, Elvis "was so sheltered that he never learned anything about cuisine," and always ate the same thing—a cheese-burger, fries, and a Coke. One night, Norbert told him that he learned to find the notes on the bass by listening to Elvis's first records.

"At the end of the conversation, he looked at me and took a deep breath and said, 'Well, I guess it's time to go be Elvis.' And I got chill bumps, because he went from being this regular guy to having this voice come out. . . . He could go from this real deep baritone to a scream that Paul McCartney would love to be able to do, every night, and I don't think he even thought twice about it. It was all natural to Elvis. It was subconscious."

That August Elvis made changes to his Vegas lineup. Joe Guercio came in as the hotel's new musical director, and now there was a new girl onstage, too. Mil-lie Kirkham, the venerable session soprano, had been subbing for Sweet Inspira-tion Cissy Houston, who took off for a solo career. But Millie needed to get back

to Nashville. So Kathy Westmoreland signed on for what was supposed to be three weeks. She would end up staying seven years.

At barely twenty-five, Kathy was classically trained and immensely talented—her high notes would summon angels—but though she was a top L.A. session singer, she was also idealistic and naïve, believing in storybook love.

She'd been with Elvis's band about two weeks when he invited her up to the suite. "I thought it would be a party, but he said he just wanted to get to know me. When I walked in that room, there were all these knock-out beautiful women waiting to meet Elvis. He came into the room and walked directly over and sat next to me."

He asked about her family life, and he was intrigued that her father had sung in such MGM films as *The Great Caruso* and *The Student Prince,* which spoke to his Mario Lanza fixation. He also liked it that she was petite, only five foot one, and that she'd been runner-up in the Miss Teenage America contest in 1962.

They connected right off: He told her about his marriage situation ("I was a little uncomfortable with that"), and stated flatly and unemotionally that he didn't have that much longer to live, that his family had died young. "He told me that he knew exactly how much time he had, that he was going to die at the age of forty-two, close to the age of his mother." Kathy was taken aback but found herself attracted to his mind, his humor, everything about him. "He reminded me a lot of my own family."

When she gave him her virginity, she thought they might actually make a go of it: They carried around the same metaphysical books ("We were both on this search for the truth"), and he told her Priscilla had no interest in the spiritual dimension. Though he insisted he had an open marriage, "He kept on saying, 'I wish she would divorce me so I wouldn't have to divorce her.'" Kathy knew he had other girlfriends and that she would be sandwiched in between. But when he said, "I love you" and then moved on, she was dazed and hurt, even as she had called a halt to the affair at one point, finding no valid excuse for adultery. The friendship, at least, would remain, along with the professional association. On-stage he called her "the little girl with the beautiful high voice." Offstage, she was "Minnie Mouse."

· · · · · ·

That same August he began seeing Kathy, he could no longer keep the strain of his life secret. On August 14, 1970, he told the Vegas audience that he'd been hit

with a paternity suit. A Los Angeles waitress named Patricia Ann Parker claimed she had become pregnant with his child during his engagement earlier that year. Pacing the stage, Elvis angrily detailed why it couldn't be true, using a vitriolic tone that shocked the majority of his audience.

Twelve days later came a major kidnap-assassination threat, which sent Elvis and the guys into overdrive. The Colonel called in the FBI and private detective John O'Grady, a former head of the LAPD Hollywood Narcotics Detail, who was already at work investigating the Patricia Parker case. For the next several nights, the entourage stood ready to move in, while Elvis performed with a pistol in each boot. An ambulance stood at the ready. Even Red, now back in the fold, was frightened.

"The lights were up in the audience more, and the curtains were closed," Red remembers. "That was one of the strangest feelings I've ever had, because when he did his last song, he went down into a very low karate stance to make [himself] a small target, and Sonny and I came rushing out and stood in front of him, waiting for whatever was coming."

But nothing did happen, except that Elvis became more on edge, and crowed that he'd been more willing to take a bullet than let some son of a bitch bully him off the stage.

It was about that time when Joyce Bova returned to Las Vegas, feeling odd about the way things had ended between them before they ever really began. On August 29, she surprised him, showing up in town with her friend Karen for support. She dialed Joe, who put Elvis on the phone. "You must be psychic, honey, I was just about to call you," Elvis drawled, and he invited them to be his guests for the show.

Afterward, in his private dressing room, he greeted Joyce warmly. "You're even more beautiful than the last time I saw you," he said as they hugged. "You've don't know what it means to me, baby, having you here. But it sure took you long enough."

Elvis had made it clear that Joyce would be going up to the suite later on, and so she left him alone as he milled about with his other guests, including Ricky Nelson's wife, Kris, and James Aubrey, president of MGM Studios.

Aubrey, a powerful Hollywood player known as "the Smiling Cobra," and the inspiration for Jacqueline Susann's 1969 best-selling book *The Love Machine,* was there that night on business, since he had green-lighted the documentary *Elvis: That's the Way It Is.*

Elvis had already spotted Aubrey's date, Barbara Leigh, an exquisite twenty-

three-year-old model and starlet, sitting in the front center booth. She felt as though Elvis were making eye contact with her, but she wondered, "Why would he be looking at me? He could have any girl in this place. Then I'd be damned if he wouldn't be smiling at me again." As soon as she stepped into his dressing room that night, "he couldn't take his eyes off her," Joe remembers. "Man," Elvis said to Sonny, "that's Venus sitting down over there."

Barbara and James picked a table in the center of the room, and when James got up, Barbara barely had time to look around before "Elvis swooped in and sat down next to me. He looked into my eyes and that was it! We were both in lust, or love, or whatever you want to call it. It was like a thunderbolt. He snuck a tiny pencil and piece of paper under the table for my number, and I had *no* problems writing it down. What girl wouldn't have given him her number? He was the sexiest entertainer on the planet, and a beautiful soul. That was just too much to resist."

Later that night, James wanted to make love, but Barbara's heart wasn't in it. She was back in that dressing room, reliving her conversation with Elvis. It seemed unreal. As a kid, she'd seen him on *The Ed Sullivan Show*. He was so free and alive, but her family was appalled at such shaking and swiveling, and when she got up and tried to move like he did, she was quickly sent to her room. It was too much to dream that she would meet him one day, let alone that he would want to be with her.

Meanwhile he was up in his new Imperial Suite, a blue-and-yellow penthouse that encompassed the entire thirtieth floor. When Joyce and Karen arrived, they found wall-to-wall guests, far more crowded than Joyce expected, though that was the norm according to Red. "There always were a lot of people up there . . . he wanted an audience of just people to talk, to unwind." And, of course, on a typical night, "There was hundreds of girls."

Sometimes he'd have other performers like Tom Jones or Andy Williams over, or just his own backup groups, the Imperials and the Sweet Inspirations, and they'd sing with him. One night, he put on a stack of 45s and asked Myrna Smith to dance. Elvis never flirted with black girls—he made up an excuse when he thought Diana Ross came on to him from the rolled-down window of her limousine—and this was just a friendly spin around the floor. Yet he was still just as uneasy at the idea of dancing as he had been at his parties back at Lauderdale Courts.

Myrna thought at first "that it was me shaking, but he was the one who was shaking! We finished the whole song. It was just a warm and comfortable feeling. He was so shy. It was great. Wonderful."

But on this particular night, he was not in such a fine mood. Elvis sat around telling stories, going through the kidnapping threat in detail, laughing, boasting, and then in an abrupt mood change, he got surly with Joyce in front of everyone when she mentioned going to see Engelbert Humperdinck. To make up for it, he came over and picked up her hand and led her to one of the seating areas in the living room. She noticed his leg quivering.

"Happens sometimes, baby. When I'm winding down after a show, you know? It's a back and forth thing. Part of the highs and lows . . . the cycles of having to get myself up to do the show, then coming back down again after."

But the tremor became more obvious, and then she noticed he was speaking much faster. He got up quickly and signaled the guys to start clearing the suite.

Suddenly she felt his arms around her, and his mouth was at her ear. "I need you to be with me tonight, honey. Please go to my room. I promise I'll be right there."

Joyce felt a hot, shaky rush of emotion—she wasn't sure she wanted to do this—and then rose and led Karen into the bedroom to tell her privately that she wouldn't be going back to the hotel with her. But before they finished, Elvis jerked open the door. "Well, did you tell her?" His voice was harsh, and he bored a hole right through her. Karen hastily made her exit.

When he got inside, he was even more brusque: "You staying or what?" Joyce felt as if she'd been slapped in the face.

"What?"

"You're standing there like you got one foot out the door."

His eyes were cold now, and she could hardly believe he was the same person. He had changed so rapidly, it scared her.

"What've we got here, darling, a failure to communicate?" He shook his head at her. "I'm just using plain, simple English."

It went back and forth, not getting any better, and then he pulled open a dresser drawer and barked, "If you're gonna stay, then stay! And get this on and get into that bed!" Then he stormed into the bathroom.

Joyce stood there stunned, the black silk pajama top he had flung at her still hanging from her shoulder. She could barely think straight. But then as she looked around at the suite, overblown and gaudy, she knew there was really only one thing to do. She brushed the flimsy top off and stepped on it on her way to the front door, slamming it so hard that the security guard jumped up and reached for his holster.

So much for reconciliation! She hoped Elvis would come racing after her

and apologize, but he didn't. The Muzak mocked her as she rode the elevator down, but as she walked out to the street, at least she had one consolation: She had walked out on Elvis Presley.

.

Joyce hadn't even gotten on the plane to Washington when Elvis searched for the scrap of paper with Barbara Leigh's phone number. He couldn't get her out of his mind. Tall, with dark hazel eyes and high, Indian cheekbones, she not only had the smoldering brunette sensuality that Elvis loved, but she was also a southerner who had come up hard.

Born Barbara Kish in Ringgold, Georgia, she spent her early years in a children's home before marrying, moving to Chattanooga, Tennessee, and having her son, Gerry. When the marriage collapsed, she fought her way to Los Angeles, where she didn't know a soul. Elvis felt at home with southern women, and he had talked with her long enough that first night to see that wounded streak in her. That appealed to him, too, and Barbara could tell that it had.

"I do believe he liked my vulnerability, as my image might have been something more sexy and alluring. In reality I was just a country girl struggling to survive and accept what life brought me, both good and bad."

The next evening, as she was walking into her apartment in Hancock Park, the phone was ringing. She and James had driven from the airport to a beach party in Malibu, and she was late getting home. She knew it was Elvis.

"I've been calling you for days, darlin'," she heard in the familiar voice. "Where you been?"

"Oh, Elvis," she laughed. "I've only been gone for a day."

"Yeah, well, it feels like you've been gone for days!" His voice was teasing, sexy. Then he turned serious. "I'd like to see you again. When can you come back?"

She was in the middle of shooting a film, *Pretty Maids All in a Row,* with Rock Hudson. She couldn't get away for a week. Still, he persisted. What about the weekend? She had plans with James, but she didn't want to tell him that. Finally they settled on Thursday, but she'd have to be back Friday.

When Joe picked her up at the airport, he informed her that she couldn't attend the first show: Jim Aubrey was there with actress Jo Ann Pflug. Barbara had no right to be angry—she was doing the same thing he was—but she was still fuming when Joe took her to the suite Elvis kept specifically for his ladies-in-waiting, which had a round pink bed atop deep, pink carpeting. She assumed it

was a dais of seduction, but Elvis would make love to her in his own suite, "where all his stuff was. He needed to be around his medications and his books and the boys."

Until then, she cooled her heels, watched TV, called her answering service, thought about what she was doing there, and tried to shore up her flagging spirits. Finally Charlie Hodge arrived and escorted her upstairs to the penthouse. Elvis took her hands and kissed her softly, yet quickly.

"I melted."

She was surprised to find that the entourage never disappeared, and that the suite was filled with gorgeous women, all competing for Elvis's affections. Since Elvis had invited her there, Barbara didn't think she should have to do the same, but he had distinct expectations.

"Elvis wanted a woman's undivided attention. He wanted his woman to wait on him and take care of him, and be right there next to him. One had to ask permission to go to the bathroom, because he wanted to know where his woman was at all times."

She leveled with him that she didn't appreciate all the other girls around, that it was exhausting and a little demeaning. He said he understood, but she also knew that she had to either accept it or leave, and it was a difficult toss of the coin.

At 3 A.M., he took her to his bedroom, and this time the pajamas were red, not black, and offered instead of thrown. They carried the vague scent of what Barbara thought was Old Spice. He showed her the guest bathroom, and then retired to his, and when she came out, he was waiting for her. She sat at the foot of the mammoth bed, and then Elvis held out a surprise for her.

"I'd like you to have this," he said, producing a gold medallion of Jesus.

A Jesus charm might have been a mood killer for a dazzling actress who had come to Las Vegas to spend the night with rock's reigning sex god. But Barbara had relied on faith to get her through the worst of her childhood, and now Elvis was sharing a part of his. God, Jesus, the Bible became the basis for their relationship. In time, they would get down on their knees and pray together, and the most vulnerable she ever saw him was when he was on his bed reading scripture and talking about what God meant to him. But in just that moment, a tear came to her eye, and she leaned over and kissed him.

That first night, the kissing was the foreplay. "His mouth was round, full, and soft." But during lovemaking, he reminded her a bit of his character from *Jailhouse Rock*. He kissed her over and over, eventually finding his way to the back

of her neck. It sent chills through her. Then he kissed his way downward, touching and kissing her breasts, and working his way down her arm to the back of her hand. There, he briefly stopped, and they both broke out in laughter.

He grabbed her again, and then they kissed harder, more passionately, almost frantically. "He was spontaneous, hungry, and made love with the enthusiasm of a teenager. It was a dream to be with him, to kiss him, to smell him, to taste him, and finally to feel him inside of me."

An hour later, they made love again. And then he started asking her about numerology. Did she know what it was? She didn't have a clue, she told him. "Good," Elvis said smiling. "When the pupil is ready, the teacher is willing." Eventually they read all kinds of spiritual texts together, including Ram Dass's 1971 book, *Be Here Now.* "He was an old soul," she says. "I loved spending private time with him, because that is when you saw the real Elvis."

Yet in many ways, she held herself back with him. "I loved him with all my heart and soul, but didn't fall 'in love' with him because I really wanted to be with Jim Aubrey. But Elvis was a gift, something good that happened to me."

From the beginning, he knew about her son, Gerry, who was six years old. He knew, too, that Barbara had given birth to him, that she was a mother. Yet "it never stopped him from wanting to make love with me or be with me. If one doesn't talk about something then one forgets it exists, and in my case we didn't talk about my son." Nor did he mention Lisa Marie, because "I understood what he wanted, and a part of that was fantasy. Having children brings reality into any given situation."

The only time Barbara was aware of Priscilla was when she saw her things in the bathroom at the Trousdale home. But he did talk of Ann-Margret, mostly in the sense of how jealous he was of Roger Smith. Even though he had chosen Priscilla over the sensuous redhead, "It took him a long time to forget Ann-Margret . . . as Ann had moved on. When he spoke of her, I could tell it hurt his feelings."

Elvis and Barbara would see each other off and on for two years and keep their affair secret from almost everyone. Elvis bought her a brown 250C Mercedes, gave her guns so she could keep herself safe, and adorned her with beautiful clothes and jewelry. "I loved my little brown Mercedes. But Elvis was the most excited, because he truly loved to give. He loved surprising you when you least expected it."

Unlike Joyce Bova, she knew Elvis "had a girl for most every night and every occasion. But why not? He was the King. I can't blame him. It kept his stories fresh. And he loved all women really. He appreciated us all."

Their relationship was unique for both of them. Soon she would be juggling

not just Elvis and James, but also Steve McQueen, with whom she would make the 1972 film *Junior Bonner*. Elvis never asked her to stop seeing other men, and Barbara was the only woman from whom Elvis tolerated such behavior, otherwise insisting on complete faithfulness. He took pride in stealing James Aubrey's girlfriend, but he couldn't stand the idea of Barbara being with McQueen, whom he otherwise admired, as he did Aubrey. Elvis called McQueen "that motorcycle hick," the tough-guy actor returning the barb with "that guitar hick."

"What's ironic," she says, "is that all three of us were hicks, and I mean that in the most affectionate way."

· · · · · ·

On September 9, 1970, Elvis began a pilot tour of six cities—Phoenix, St. Louis, Detroit, Miami Beach, Tampa, and Mobile—to resume his live concerts. With all tickets selling out within hours of going on sale—netting Elvis nearly $175,000 for six nights of work—he knew his rock-and-roll caravan would be on the move for some time. He was healthy, trim, and sexy, though his sideburns had grown into such huge mutton chops that they threatened to envelop his face.

The Colonel advanced the dates, going into each city the day before, and the old gang came back to do their jobs—Joe in overall command, Charlie stage-managing with scarves and water at hand, Lamar running lights, Richard handling wardrobe, and Sonny heading up security. Dr. Nick was now on the payroll as tour physician.

On the first night, Elvis met an attractive, long-haired brunette named Sherry Williams, who turned eighteen in his hotel room after the show. She lived in L.A., but she had a friend who had met Elvis before and wanted someone to make the trip to Arizona with her. Sherry was actually more of a Beatles girl, but she knew Elvis was interested in her, because "he would be talking to someone and glancing at me out of the corner of his eye. I could tell then that there was some kind of connection."

Before the evening was over, Jerry slipped her a card with Elvis's contact number on it. But she never called it—Elvis was thirty-six and nearly twice her age, and it just didn't feel right. Then a month later, Charlie called her friend and invited her to Palm Springs, asking her to bring along the girl from the Phoenix show. Sherry spent a few days there, sleeping on the couch, and then went back later in the fall and winter.

As a teenager, she was confused about it all and felt overwhelmed on her visits. Charlie and Joe were nice to her, but the rest of the guys intimidated her.

She'd had no male role models in her life and didn't really know how to act around men that age. Then she tried talking to Ricky Stanley, because he was more of a peer, but she later learned that Elvis didn't like any of the entourage—not even his stepbrother—talking with his girlfriends. It wasn't allowed. He wanted all her attention.

"It was a very complex relationship . . . he was a lot of things to me: a friend, a brother, a father. He wasn't a lover yet, [but] he filled a lot of shoes. He and·I talked about that a lot."

· · · · · ·

*Late in the fall of 1970, perhaps spurred by the threats in Las Vegas, Elvis's obses-*sion with law enforcement took a pathological turn. In Denver that November, he spent more time talking with the off-duty policemen assigned to protect him than he did with his entourage and band. He made lifelong friends of detectives Ron Pietrafeso and Jerry Kennedy, who at his request, got him his own blue policeman's uniform.

Like many collectors, he wasn't content with just simply reaching a certain level, and each time he obtained a long-desired badge, he was already in pursuit of the next one. He talked his pals on the Denver police force out of an honorary shield, and then a real one, just as he had Shelby County Sheriff Roy Nixon back in Memphis. He was especially intent on acquiring Sheriff Nixon's official deputy badge, as it permitted him to lawfully carry a pistol.

But after seeing a Federal Bureau of Narcotics and Dangerous Drugs (BNDD) badge that belonged to John O'Grady's friend, Paul Frees, no other badge would do. Sooner or later, he would have one.

Offstage, his dress was beginning to reflect his compulsion. Not only did he actually wear the Denver police uniform on occasion, but when Regis Wilson's brother, Jim, joined Elvis's crowd at the Memphian one night, he was shocked to see that Elvis "had on a jumpsuit with guns in a holster, like a cowboy would wear."

And that December, as best man at Sonny and Judy West's wedding, he festooned his black velvet bell-bottomed suit with a large belt with gold eagles and chains. Then he strapped on an additional belt with a large gold buckle and a sheriff's star, as well as his own official deputy badge that Sheriff Nixon had just given him. To that, he added two guns in a regulation police shoulder holster. Finally, he stuck a pair of pearl-handled pistols in his waistband, and a derringer in his boot.

To complete his look, he carried a fifteen-inch Kel-Lite flashlight. Before they went into the church, Marty practically had to wrestle it from his hands. It was daylight—he didn't need a flashlight to see—but the black metal Kel was official police issue. "Goddamn," he cursed. "I hate to give this up."

Even without it, says Marty, he was a strange sight—his hair long and curled up in the back, his black suit set off by a white tie, his eyes covered with amber glasses: "I'll bet he was the only best man in the history of Memphis to go to the altar with five guns on him, just to stand up for a groom."

Each badge seemed to spawn another gun-buying spree, and his desire for firearms and all their accoutrements—he had customized gold handles made for his Colt and Berretta pistols—seemed to know no end. Marty called it his "super-spy period."

The customizing of things also became another obsession, though he had always liked seeing his initials on things, starting with the rifle he got as a boy. It was an aggrandizement that spoke to his vanity, just as he could never pass a mirror without stopping to check himself out. ("He just had to make sure he was still the King," says Barbara Leigh.)

Around this same time he started incorporating *EP* into 14-karat gold, goggle-shaped eyeglasses designed by Dennis Roberts and made up to his prescription at Roberts' Optique Boutique on Sunset Boulevard. But that wasn't enough. He wanted something uniquely Elvis, not just for himself, but also for the guys—something that showed they were a group, his group, exclusive and powerful.

He was on a flight with Priscilla one day when together they began sketching out the design for a 14-karat gold charm with the letters *TCB* laid atop a zigzag lightning bolt: "Taking Care of Business—in a flash." He took the design to Schwartz and Ableser jewelers in Beverly Hills, to be made into pendants, and that fall, he picked up the first two dozen on gold chains. In time, he would add *TLC,* or "Tender Loving Care," pendants for the ladies. Patti Parry would treasure hers like nothing else: "My *TLC* has never been off my neck since he gave it to me. I clean it, and I had it reinforced, but it's going with me, you know?" Soon, the *TCB* symbol would appear on his eyeglasses, too.

· · · · · ·

On December 19, 1970, Vernon sat out in his office at Graceland, tallying up his son's recent expenses, and then walked in the house to take Elvis to task. On top of all the guns and jewelry and the ten Mercedes he had bought as gifts, includ-

ing one for Vernon himself, Elvis had offered to pay for Sonny's wedding. Vernon told him it had to stop. They had a terrific fight, Priscilla joining in to support her father-in-law's point of view.

Elvis didn't feel well—he was taking penicillin for an eye infection—and now outraged that the very people who lived large off his money would try to dictate how he spent it, he stormed out of the house and sped off, ending up at the airport. There he did something he had never done before in his life: He boarded a commercial airliner by himself and left the city without anyone knowing where he was or where he was going.

Though he hadn't seen Joyce Bova since August, when she slammed the door on the penthouse suite in Vegas, Elvis decided he had to see her and her twin, Janice. He wasn't sure why, exactly, but unconsciously he seemed to feel Joyce was the only one who could sympathize with his plight and offer relief.

"There are two reasons for Elvis to hunger for that sort of connectivity with the twinned twins," says Peter O. Whitmer. "First, there are psychological phenomenon so odd to a singleton that only another twin would understand with unconditional regard and agreement. Second, it undoubtedly transported him back to an emotional state that was far more static than the one he was actually in."

An easy analogy conjures three survivors reunited after a terrible accident. If two were still a pair, and the third had lost his "other" in the tragedy, no one could understand that phenomenon better.

For Elvis, going to see Joyce "was a temporary fix, a Band-Aid, that must have soothed him from the inside out," in Whitmer's view. To even envision any kind of "reunion" with them might have been the most healing phenomenon ever for him. Yet as *they* were the "united" ones, he was still somewhat an outsider to them, ever to remain so.

When his plane landed in the nation's capital, Elvis arranged for Liberty Limousine Service to take him to the Hotel Washington, where he registered as Jon Burrows, using his own address in Memphis. However, he had thrown away Joyce's telephone number after their altercation at the International that night, and now he didn't know how to find her, either at home or at work through government listings. Realizing he had no way to locate her alone ("He couldn't take care of himself, so I don't know how he got here on an airplane," Joyce says), he checked out of the hotel, and went back to the airport.

There he booked a flight to Dallas, where his stewardess was based. But in arranging for his ticket, he got into a hassle with the agent, who noticed his gun

and followed him on the plane and demanded he hand it over. Elvis refused to give up his weapon. Embarrassed, he got up and left, only to have the pilot come apologize and invite him back on the plane.

In Dallas, he discovered that his girlfriend was apparently out on a flight. Now flummoxed and hungry, but uncomfortable going into a restaurant by himself, he dialed Jerry about midnight in Los Angeles. Jerry was working at Paramount as a film editor, and Elvis woke him up.

"Jerry," Elvis said. "I'm coming into Los Angeles."

His friend was half asleep and didn't know who it was, partly because it was that unusual to hear his voice on the phone, since "there were always people to do those things for him."

"Jerry," he said again. "It's me. I'm going to be in Los Angeles at 2 A.M. Get a car. Call Gerald and meet me at the airport." Still groggy, Jerry said, "Fine," and wrote down the TWA flight number. Before they hung up, Elvis cautioned Jerry to tell no one where he was. He wanted Vernon and Priscilla to sweat a little.

Gerald Peters, Elvis's new limo driver, swung by Jerry's apartment and on the way arranged permission to drive out to the plane. When Elvis walked off, Jerry could see "he was really prepared. He came down the steps with a little cardboard box. I said, 'What is that?' He said, 'Well, I had to get some stuff for traveling.' He had toothpaste, a toothbrush, a bar of soap, and a little washrag."

Once they got in the light, Jerry noticed that Elvis's face was "all swollen up, and he was in really bad shape." He had a rash on his face and neck, worsened by the chocolate he ate on the flight.

"Elvis, what happened?"

"I got a real bad reaction to penicillin," he answered. "Let's call a doctor right away."

While Jerry was on the phone arranging for a physician's house call at 2:30 A.M., Elvis started chatting up a flight attendant, and then said they had a stop to make.

"Jerry, we got to take her by her place."

"Okay," Jerry said, shaking his head. "But I got a doctor up there on Hillcrest for you."

Suddenly the stewardess was more important than Elvis's ailment. It was "one of those real cold, misty nights," as Jerry remembers, but even after they got the girl home, they sat in the car for an hour so Elvis could talk to his date.

The doctor stayed all night, monitoring his patient, so Jerry stayed up, too. The next morning, Elvis was much improved and announced they were going to

Washington. "He didn't tell me why he wanted to go, and I didn't ask him." But Elvis needed Jerry to help him find Joyce. He also wanted to see about getting a narcotics agent badge, like Paul Frees's.

Gerald drove them to the Beverly Hills Hotel, where Elvis cashed a check for $500. Then they boarded a nonstop flight from LAX to Washington National that would get them in about 6 A.M.

The airline boarded them first, and then the rest came on—"heavy Christmas crowd, guys in uniform from Vietnam on the way home for the holiday," as Jerry remembers. One soldier stopped and shook hands with Elvis, and then the two started up a conversation. Suddenly Jerry felt Elvis nudging him in the side.

"Where's that money?"

"I got it. It's safe."

"Give it to me."

"Elvis, this is our expense money."

"Jerry, he's going home for Christmas."

"Yes, but we won't have any money for tips."

Elvis looked deflated. "The guy just got back from Vietnam."

So Jerry reached in his pocket, and Elvis handed the soldier the money and wished him a Merry Christmas.

Later in the flight, Elvis told Jerry he intended to see Deputy Director John Finlator, who was John O'Grady's contact at the Bureau of Narcotics and Dangerous Drugs. He wanted that badge, and he wanted it bad. And then, flying through the clouds, Elvis had another idea: He would write a letter to President Richard Nixon.

Woozy eyed and shaky, using the pull-down tray as a desk, he told the president that he was writing in his capacity as a concerned American, and that he had met Vice President Spiro Agnew in Palm Springs only several weeks before and expressed his fears for the country. As he wrote the president, he was especially concerned about such subversive elements as the hippies, the drug culture, the Black Panthers, and the Students for a Democratic Society.

However, such groups "do not consider me as their enemy, or as they call it, The Establishment," he wrote. He knew so because he had done "an in-depth study of drug abuse and Communist brainwashing techniques, and I am right in the middle of the whole thing where I can and will do the most good." All he needed, he said, was for the president to make him a Federal Agent-at-Large. And he would stay in Washington as long as it took.

The irony, Jerry says, is that Elvis "felt a certain amount of responsibility" for the way drugs were taking over the music business, "and he wanted to do something positive. He never said he wanted to be a narc." His thinking was that if he were "talking with someone in the entertainment field and he knew it was a bad drug situation, he wanted to scare them out of that type of environment without busting them. He liked to have credentials, and he wanted to be able to show them a badge."

"I would love to meet you just to say hello if you're not too busy," Elvis told the president at the close of his letter. Then as soon as they landed, penniless in Washington, Elvis insisted on dropping off his missive at the White House gates. It was 6:30 A.M. Elvis then had the limousine service take them to the Hotel Washington to await Nixon's call.

Later that day, Joyce Bova was sitting at her desk looking over the Naval Court of Inquiry on the *Pueblo* incident. Her phone buzzed.

"My name is Jerry Schilling," said the voice on the other end. "I'm a friend of Elvis Presley."

She was too astonished to say anything.

"It's because of Elvis that I'm calling. In fact, he's here in Washington, and he wants to see you."

"Put him . . . put Elvis on the phone."

He was contrite now and told her he hadn't been himself that night she walked out on him. He came to Washington, he said, to ask her to forgive him.

She wasn't even sure what to say.

"How did you find me here, anyway? I never gave you this number."

"It wasn't easy! I had Schilling here calling all over Congress looking for you."

Then he went through the whole thing, how he'd been there a few days before, then went on to California. But he'd tell her about all that later. Right now, all he wanted to do was find out where to send the car.

"And honey? Bring your sister."

From then on, "Elvis always wanted my sister to come see him, too. He was acutely aware of our closeness and understood that 'thing' between twins and wanted it so badly himself. He always made her feel welcome anytime, anywhere, which was one of the qualities that was so precious about him and very important to me."

By the time Joyce and Janice saw Elvis at the hotel that night, Sonny West had joined him, and Elvis had another story to tell: Outrageously dressed in his

best "Vegas does D.C." outfit—a velvet coat topping a black suede suit, a massive gold belt given to him by the International, glittering chains circling his neck, tinted sunglasses, and a cane—he got his meeting with the president in the Oval Office. He also came away with a promise of his cherished badge. John Finlator turned him down, but the president, who later said how much he had liked his visitor, wanted him to have it.

In a bizarre way, Elvis and Nixon hit it off. When the White House photographer was setting up his equipment, Nixon looked at Elvis and gave him a poke. "You dress kind of strange, don't you?"

"Well, Mr. President," Elvis said with a smile, "you got your show, and I got mine."

Later that evening, Elvis and Sonny drove Joyce home in the limo. She gathered her things and returned with him to the hotel. It was December 21, 1970, the first time she spent the night with Elvis Presley.

"You're a beautiful woman, and you're a pure little girl, too, aren't you?" he said sweetly.

They were sitting on the edge of the bed, and she was wearing a flimsy nightgown. She put her fingers to his lips.

"Joyce, I know this is new for you, but it's right, believe me."

Her stomach was in knots. He'd had a very big day. He'd met the president. And soon he would have a really cool new badge. It was no time to disillusion him with confessions.

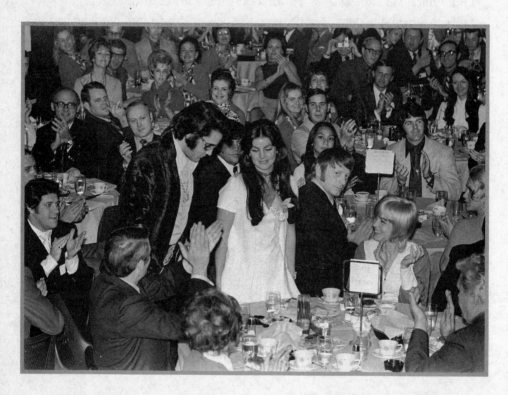

Elvis and Priscilla at the Junior Chamber of Commerce luncheon, January 16, 1971. Surrounding them are Charlie Hodge *(left, clapping)*, Sonny West *(between)*, Red West *(right)*, and Jerry Schilling *(far right, middle)*. *(Dave Darnell/ the* Commercial Appeal*)*

THIRTY

.

"A Prince from Another Planet"

For his thirty-sixth birthday, Elvis tricked out his new light blue Mercedes with all manner of law enforcement gear—a police radio, a revolving blue light, chemical weapons, and handcuffs. Then he spent the next few days buying $3,500 worth of additional guns and police equipment. If he couldn't be an officer, at least he could play cop.

In D.C. he'd had the limo driver pull over at the scene of a terrible accident one night on the rain-slicked Baltimore–Washington Parkway. Someone had hit a car and driven it across two lanes, and it ended up a tangled wreck. Inside, an injured woman lay across the front seat. Elvis approached a policeman standing in a rain cape, water pouring down the visor of his cap.

"Officer, can I help with anything? I'm Elvis Presley."

Joyce was standing behind him and saw the policeman's stunned expression in the glare of his flashlight, his mouth agape, his eyes fixed in a wide-open stare. Before he could finally find the words, Elvis moved on. Now he was kneeling down beside the woman.

"Hi, ya. How you doin'?" He tried to sound friendly and calm.

The woman was dazed, but whether it was from the accident or who she saw crouched in front of her, Joyce wasn't sure. She saw her mouth moving a bit.

"She's trying to say something," Joyce pointed out.

"Just relax, ma'am," Elvis said, "and tell me what you need."

"Are you . . . really Elvis Presley?" Joyce worried the poor woman thought she had died and gone to heaven.

The ambulance was coming now. They could hear the siren and see another policeman waving traffic around.

"You're going to be all right," Elvis told her, and then he went on his way.

Now he never left Graceland without his blue police light, his long flashlight, a billy club, and at least two guns. "He'd put on his uniform and go out and stop traffic—pull a guy over, tell him he was driving too fast, and give him a safety lecture," Billy Smith remembers. Elvis may have been impersonating an officer, but he couldn't write anyone a ticket, so he carried a pad to scribble out an autograph, and handed it through the car window as if it were a citation.

More and more, he saw himself as a patriot and humanitarian, a person put in an extraordinary position to make a difference, especially after the Junior Chamber of Commerce of America honored him as one of the nation's Ten Outstanding Young Men of the Year on January 16, 1971. It put him in the company of past winners Leonard Bernstein, Orson Welles, and the Reverend Jesse Jackson.

That night at the awards ceremony at Ellis Auditorium, he would make his famous acceptance speech. ("When I was a child, ladies and gentlemen, I was a dreamer. . . .") But at the press conference at the prayer breakfast that morning, he took the chance to say what was really on his mind: "I don't go along with music advocating drugs and desecration of the flag. I think an entertainer is for entertaining and to make people happy."

Priscilla was by his side that day, and she would come for the opening and close of his Vegas engagement in January and February. But Joyce was there in between. It was the first time they had made love during a time when he was "Elvis Presley." She found that "his private nature was to be soft and tender, playful and cuddly rather than boldly erotic," but that when she went to bed with the "performer," something of the orgiastic frenzy of the crowd came with him.

Still there was some of that sweetness. He was glad to have met Janice the month before, he told Joyce. "I understood that until your twin gave her blessing to us, you . . . well . . . you wouldn't be able to give yourself to me."

But now Elvis had turned Joyce into the Priscilla of old, with the same bouffant hair and the eye makeup, and she was mistaken for her and beseeched for autographs more than ever. As with Priscilla, he also gave her pills to sleep, getting Joyce hooked on Placidyls. She was worried about herself, but she was more worried about him, about what all those books were doing to him.

"I have a serious message for the world," he told her. "I have powers, Joyce, that I don't go bragging about. I could announce them to the world."

"Why don't you?" she asked.

"People aren't ready for me to announce that yet."

When Elvis started messianic talk like that around Dr. Nick, the physician

thought it was more of a game, "a conversation piece, something he would do to entertain himself and others." A couple of the guys thought Elvis really believed he could heal people. But Dr. Nick was sometimes there when he'd do the laying on of hands: "He'd wink at you, like, 'I really don't believe in all of this, but I'm going through the motions and saying these things.'"

Whether or not he had "powers," he was a master planner at covering his tracks. That January, in Vegas, he was particularly adept, bringing Sherry Williams in as soon as Joyce flew out. She spent most of the month of February with him there, where he gave her a *TLC* pendant. He also shared the A & D ointment he used to keep his lips soft, because "we'd kiss so passionately that I'd get the worst razor burn on my cheeks. It hurt so much, but I loved it." He never forced any drugs on her and paid off her car when she refused to let him buy her a new one. "He was a huge impact on my life, all positive and fun. Nothing he ever said or did was negative toward me in any way."

When still other girls came in, Sherry stayed in his suite on the twenty-ninth floor. "I had very mixed feelings about it . . . for a sheltered, eighteen-year-old girl. If it wasn't me, it was going to be someone else, so I rationalized it." At first, she didn't know about the other girls he had there at the same time. She was always told it was Priscilla. "I was very naïve. But I don't begrudge him for that. If anybody could get away with it, it was Elvis!"

She would go back in August and then again when he returned to Vegas the following year. All together, she saw more than fifty of his shows. One time he sang "Just Pretend" and pointed over to her booth. Another time, he sang one of their special songs for her, Buffy Sainte-Marie's "Until It's Time for You to Go," a lover's ballad about an affair that can never grow into a real relationship.

• • • • • •

He was still thinking about Ann-Margret, who was wrestling with her own demons now. Suffering from depression, she was hurtful to her husband and her mother, and her social drinking had slipped into alcoholism. Seeing Elvis at her shows, sitting in the back booth, or coming onstage, doing a knee slide and stopping just at her feet, didn't help.

That February 1971 she came into Vegas a few days early for her engagement, and Elvis invited her and Roger to a party at his suite, where he told her to stand perfectly still, and then demonstrated karate chops all around her face to show off his prowess. She knew that "a mistake of a mere millimeter could kill me, injure me severely, at the least. But I trusted him implicitly." Then she felt a

breeze as he reeled off several punches. When he finished, he shook his head.

"You know, you're crazy," he told her, his voice full of so many emotions.

She smiled. "So are you."

Before long, he'd accidentally break another guest's ankle with a karate kick and, in the recording studio, send a gun flying out of Red's hand and straight through Chip Young's handmade guitar.

• • • • • •

In the middle of March Priscilla flew to California to supervise the continuing redeco-ration of the Monovale house, while Elvis went to Nashville to meet Felton Jarvis at RCA's Studio B. Felton needed a lot from him this time—a pop album, a holiday LP, a gospel record, and some singles—and hoped they would have a marathon session like last time. But it wasn't to be. He had folk songs on his mind, especially Ewan MacColl's "The First Time Ever I Saw Your Face." And at 1:30 A.M., normally a productive time for him, he called off the session. He was having increasing pain in his eye, he said, probably just a flare-up of that infection from December.

When it worsened the next day, he called Dr. Nick, who flew in with Dr. David Meyer, an ophthalmologist. Dr. Meyer first treated Elvis at his hotel and then admitted him to Nashville's Baptist Memorial Hospital. His diagnosis: iri-tis, probably a constancy from the dye he used to color his eyelashes, Dr. Nick thought, and secondary glaucoma.

Barbara Leigh came to visit him, flying in from California and staying in the doctors' quarters when she wasn't lying right in the hospital bed with him. "I held his hand while they shot him in the eyeball, but I looked the other way. He was brave and didn't make a peep." The very word *glaucoma* made him think he was going blind, so Barbara understood when he flew in girlfriends one at a time to stay with him. Later that spring, he invited her to Graceland.

She loved sharing that world with him, seeing all his old Memphis hangouts, and walking the Graceland grounds, though he scared her playing chicken on the go-karts with the guys. Like Minnie Mae, who swore she heard noises com-ing from Gladys's ghost, and Priscilla, who had sensed Gladys's spirit when she found racks of her clothing in the attic, Barbara perceived Gladys around her, first in the dining room, but even more so upstairs in Elvis's rooms where her picture stood on a table.

"I felt her. Her presence was always there. Elvis spoke mostly of her when we were alone in his bedroom." It was there, under the Naugahyde ceiling with the TVs built in above his bed that he shared most everything with his girlfriends, in

his private time away from the boys. "He said Gladys had told him he would marry a brown-eyed girl, and that he knew she would have liked me."

He handed out Placydils to her for sleep, but she didn't want them and hid some of them in the sofa. One time when they were together, he'd given her a gray pill for a headache, and it made her intensely ill.

Joyce, too, visited Graceland that spring. The same day that Barbara went back to California after Elvis's glaucoma scare in Nashville, Joyce came from the opposite end of the country and then flew with him to Memphis. With all the medical equipment now set up in Lisa Marie's room, it was Joyce who held his hand and flinched while Dr. Meyer put the needle in his eye.

He was incoherent nearly her whole visit, but the only part that really scared her was the oxygen tank in the room. "I couldn't understand why there was an oxygen tank for an eye problem. The doctor showed it to me and I thought, 'Oh, my God, I hope I don't have to use this thing.'"

Elvis wore a black patch for a while, smoking marijuana to alleviate the pressure in his eye, and canceled his immediate touring plans. Joyce came back to Tennessee to see him on May 21, flying again into Nashville, where he was completing a weeklong recording session. But he awakened in pain the next day in their hotel room, complaining of stomach cramps, and insisted on flying home to Memphis. They drove straight to Dr. Nick's office from the airport, and suddenly, to Joyce, "He was like brand-new."

At the time, Elvis seemed to be suffering only from irritable bowel syndrome, an uncomfortable intestinal dysfunction that can largely be managed through diet, exercise, and supplements. But it was just the first presentation of a far more serious problem: He had a premorbid condition, a congenital megacolon, or an abnormal enlargement that would soon be revealed as "tremendous in size," in Dr. Nick's words, three to four times normal in diameter. Eventually, the organ would lose much of its nerve enervation and ability to function.

He had been an outpatient in Palm Springs earlier that month for his fourth wedding anniversary, and more and more, Palm Springs would become a place where Elvis threw all caution to the wind. At some point that year, probably that summer, the guys held one of their typical weekend orgies, and one of the female guests later sent a letter to the house addressed to "Lizard Tongue." Priscilla found it, "went ballistic," Sonny says, and called Joe in Vegas, insisting on talking with Elvis. Joe told her he was asleep, and when Elvis called her back, he turned the tables on her, chewing *her* out, and saying the letter had really been

for Sonny, not him. Priscilla apologized and telephoned Sonny's new bride to tell her that her husband was fooling around.

During big arguments such as that, Joe saw that "he played the tough part: 'Hey, you don't like it? Here's the door.' A couple of times, he got in fights with her and some of the later girls and said, 'You can take your clothes and leave.' Elvis was very good about being on the defensive whenever he got in trouble, and he was great when it came to screaming and yelling. It frightened them to the point that they wouldn't say any more. He had a real bad temper."

Priscilla's way of dealing with it all was just to continue building her own life in California with Lisa Marie. She had a new set of friends, and she was taking karate now from Ed Parker. When she was in Memphis, she'd keep up her technique with Kang Rhee at his studio on Poplar Avenue, where Elvis studied tae kwon do. Priscilla also continued her dance sessions while in Memphis, frequently at Sally O'Brien's studio behind the Davis YMCA in Whitehaven. Pat West, Red's wife, went with her, Priscilla driving and taking Lisa Marie to play with Sally's daughter, Paige, who was Lisa's same age.

Sally considered Priscilla to be "a lovely dancer, and missed few classes. . . . I found her to be a very warm and kind person. I think she just needed to have some normal time and conversation away from the spotlight."

It was normalcy that Priscilla craved the most. Some of her favorite moments with Elvis were the "nights when he'd come into Lisa's bedroom—he always called her 'Yeesa'—and read her nursery rhymes on the bed."

But those times grew fewer and fewer. One night in California, Elvis looked across the living room and realized Priscilla could do quite well without him.

"My," he said. "You've grown."

And that, Priscilla says, "is the moment we both knew the marriage was over."

For a while, she remained the token wife, tucked away at home while Elvis indulged himself with a plethora of girlfriends. Finally she did what she felt she had to do. "I took a lover. It was my way out." He was, of course, Mike Stone, the karate champ she and Elvis had seen in Hawaii.

The guys knew about her affair before Elvis did. Henrietta, the maid at the Holmby Hills house, told Red that Mike was spending a lot of time there. Then three-year-old Lisa Marie inadvertently ratted them out. Mike had taken them camping, she told new entourage member James Caughley, and "I saw Mommy and Mike wrestling in their sleeping bag on the beach. They wrestled all night." Finally, Sonny caught them in the shower together on Monovale.

Nobody really blamed her, especially not Joe. "She wanted some real love

that she wasn't getting from her husband. She was at home going out with the girls, and then started to take karate with Mike, and boom, it all changed."

But Priscilla would wait for the right time to tell her husband that she had chosen another man over him.

<div align="center">· · · · · · ·</div>

He was already acting like a man who knew, but even if he didn't, he began moving farther out on the edge, taking bigger chances and demonstrating increasingly reckless regard for his own life. But there were still glimmers that he held out hope. In May he renewed contact with Daya Mata at the Self-Realization Center, and soon he would invite Larry Geller back into the fold. For a short period, he looked into Scientology, the religion founded by L. Ron Hubbard.

While he ultimately dismissed Scientology as cultish and money grubbing ("He stayed away from Scientology like it was a cobra," says Lamar), it ultimately brought about his curiosity regarding actress Peggy Lipton. He'd heard she was spiritually curious, and he thought he might connect with her on several levels. He'd loved her cool reserve on *The Mod Squad,* even as it scared him.

Two of Peggy's actress friends, Janet and Shelly, were seeing him at the same time and suggested she meet him, even as they warned her that he was damaged and fragile. Something about him fascinated her—she had idolized him growing up and called him "the sacred monster of rock and roll."

Joe placed the call, and in July 1971 Elvis got on the phone and invited her to his first engagement at Del Webb's Sahara Tahoe at Lake Tahoe, Nevada.

"He kissed like a god," Lipton wrote in her 2005 memoir, *Breathing Out,* "but that was about it. He didn't feel like a man next to me—more like a boy who'd never matured."

Elvis came for her in a private plane, a Bach 111 twin-engine jet he'd chartered with a full-time pilot to get over his fear of flying. From the moment she stepped aboard, she knew it was a mistake: "Sitting in the cabin in full white regalia complete with sunglasses, rings, and rows of gold chains . . . Elvis looked like an action figure of himself."

He immediately offered her jewelry from a myriad of blue cases, which put her off, as it seemed too practiced. But she accepted a square ring with little diamonds, rubies, and sapphires "that you could move around to form any letter." The one he gave her had a *P* on it, and she didn't know if he meant it for "Presley" or "Peggy." But he *was* funny and charming, and she was surprised to find him "smart and considerably savvy, despite his hillbilly ways." All the

same, he was just too otherworldly and theatrical. What in hell was she doing there?

She'd brought along cocaine to get through it, and after they rolled around on the bed in heavy petting, they made love. "Or tried to," she wrote. "Elvis knew he was sexy; he just wasn't up to sex. Not that he wasn't built, but with me, at least, he was virtually impotent. . . . When he couldn't consummate it, he became embarrassed and went into the bathroom. I knew he felt badly, because he left me a poem scrawled on a torn-off scrap of paper on my pillow."

After his show, they tried again, but then they gave up. He had too many drugs in him to perform, and then each morning, a doctor came and gave him a shot to help him sleep. He wanted her to have one, too. But it scared her. "Had I taken the shot, I'm sure I would have either died or passed out for days. These were heavy chemical cocktails, and Elvis was seriously into them."

It was then she realized that the prerequisite for being with him was to get as stoned as he was. And all she wanted to do was run. One terrifying night, loaded up on his pharmaceutical escort to slumber, Elvis fell into a heavy stupor and woke up violently gagging and choking. Peggy pulled him into a sitting position, but he continued to struggle.

"Oh, my God, I thought, he's going to choke to death," Lipton wrote. "I punched him firmly on the back and he made a final heave. I frantically turned on the light. He was white as a sheet but still breathing. In his lap, all over his silk pajamas, was vomit filled with . . . maybe fifty or seventy-five capsules and pills of every description . . . along with the contents of last night's meal." At the apex of the crisis, "He called for his mother. He sat there like a baby, wailing for her. I cleaned him up and held him until he fell back to sleep . . . while the sun tried desperately to enter the curtained and darkened bedroom."

After that, she quit taking his calls. The way he lived was just too frightening, and besides, she had enough problems trying to curtail her own cocaine use. "I wasn't going to be able to save him—nobody was."

There were other close calls about the same time. During the Tahoe engagement, he picked up a teenage girl named Page Peterson who sat in the second row with her mother. She wore no makeup and was precisely the sort of non-drinking, nonsmoking innocent that Elvis couldn't resist. Sonny brought her backstage, and inexplicably, her mother let her stay with Elvis for much of the engagement. He gave her pills to keep up his hours.

One night after the show, he took her to Palm Springs. He was drinking large doses of Hycodan, a narcotic, analgesic cough syrup, and serving it to Page in

champagne glasses. She had a headache, and Elvis gave her pills to ease the throb in her temples. That night, they both nearly died. When Sonny found them the next day, the room was freezing, and Elvis's breathing was erratic. The Hycodan bottle was almost empty.

"Boss! Boss, snap out of it!" Sonny yelled and shook him by the shoulders. "Wake up, Elvis!" He made a moaning sound, so Sonny moved on to Page. She let out a short rasp, but when Sonny shook her, she didn't come to, nor when he slapped her face hard. Charlie called for Dr. George Kaplan, one of Elvis's regular suppliers, who arrived within minutes.

A shot of Ritalin brought Elvis around, but Dr. Kaplan made no promises about Page. At the hospital, she was placed in intensive care.

"I told her not to drink that much," Elvis said. His voice sounded guilty, Sonny thought, and he paced the floor and sent a Bible verse to the hospital. The guys called John O'Grady and a contact with the Palm Springs police to keep the cops at bay. They came up with a plan that if she died, Charlie would take the rap. "He'd say she was his date, and he'd given her the stuff," Marty reports.

Colonel Parker went into damage control, getting everybody out of Palm Springs and arranging to pay $10,000 to the ambulance crew for their silence. Elvis picked up Page's medical bills, but though he talked to her on the phone several times, he didn't want to see her again. Still, she and her mother came to Vegas. "I'm sorry to say that Page wasn't the same person," Sonny wrote in his memoir, *Elvis: Still Taking Care of Business.* "Her personality wasn't as radiant as before." After Elvis's death, the episode would be reported in the addendum papers to the Drug Enforcement Agency's investigation of his addiction.

· · · · · ·

When Joyce attended his Vegas engagement in August—the International Hotel was now the Las Vegas Hilton—she was ticked off not to have been invited to Tahoe. She thought that Elvis was punishing her. She'd overslept on Placydils when she was at Graceland and raced out for her plane, leaving him alone in bed. But all was forgiven. He had the flu, or at least Vegas Throat, and although he'd seen Dr. Sidney Boyer for it, he wanted to be babied. That led to a natural subject, and Joyce inquired about Lisa Marie, and about Priscilla, too. And then Elvis uttered the words that stopped her heart: "She's a mama. She does the mothering. A mother is different. Once a woman is a mama, she changes."

"I'm not sure I know what you mean."

"Well," he said, "when a woman has a child, it's a gift from God. It's God's

way of telling her she's not a little girl anymore. She's grown up, you know? Now it's time to be respected and all."

Joyce wasn't following it. He didn't respect his wife until she had a *baby*?

No, no, he didn't mean it that way. He just didn't think a mother should try to be sexy and attract men. "It's just not exciting and it's not supposed to be," he said frankly. "Trust me on this, Joyce. I know I'm right."

He didn't say he had no trouble with Susan Henning, and he didn't say that he was currently involved with Barbara Leigh, both of whom had a child at home.

But six days after Elvis made his declaration, Joyce sat in her doctor's office arranging to abort his child. On September 3, 1971, laying on a gurney, she was wheeled down a hospital corridor and into a bright white operating room. Everything was sterile, including the faces of the team that attended her. She felt the chemicals flow through the tubes, and then counted back, "A hundred, ninety-nine, ninety-eight, . . ." She never told Elvis a thing.

"I was so all-consumed with him I was afraid he would leave me. And I didn't want to jeopardize my relationship with him, no matter what."

Within seven months she would change her mind. By the time she joined him in Las Vegas in February 1972, much had happened. She had gone on tour with him in November 1971, where she discovered that his drug use escalated to new heights on the road and made him another man.

They were in the presidential suite of Philadelphia's Bellevue Stratford Hotel the night of November 8 when he called her into the bathroom to show her how he kept his voice in shape, cupping running water in his hands and inhaling it through his nose, then violently arcing a geyser out of his mouth into the sink.

He laughed when she gave him a hard time about it and left the bathroom. But then he called her back, and when she walked to the door he was standing before her completely naked, which "blew my mind," since it was so out of character for him to show himself that way. He once told the guys, "I don't want these girls to know that I have this hillbilly pecker," referring to the fact that he was uncircumcised, and he was so modest he always slept in pajamas.

"Look at this," he said, and took hold of himself with his left hand.

"I've seen it before," she said wryly. "Are you feeling all right, Elvis?"

"I want you to watch this."

Now he pulled his foreskin back and washed himself with soap and water.

"Elvis!" she said. She couldn't believe he wanted her to witness that and turned on her heel. "I'm going back into the bedroom."

"You're not embarrassed are you, baby? I just want you to know I'm clean."

It wasn't that she was embarrassed so much as she was astonished. She knew it was the drugs talking, and she was beginning to get scared. Not *of* him, really, but *for* him.

Seconds later, there was a loud knock at the door, which further surprised her, since no one had the nerve to disturb Elvis in his bedroom. But Elvis moved to answer it, as if he expected someone, and in walked a total stranger.

"Come on in, Doc," Elvis said to the man in the gray suit. He was carrying a black bag, and eyed Joyce suspiciously.

She asked why Elvis needed a doctor, and he told her it was okay. Then the doctor pulled out a rubber tube and a hypodermic needle. Elvis rolled up the sleeve of his pajama top, and the doctor tied the tube around his arm.

"Elvis, what is that? What are you taking?" Joyce was nervous. She'd never seen him do anything like that before.

"Just wait," he said. "It's okay." Then the doctor slipped the needle into his vein and slowly pushed the plunger. Joyce turned away, but Elvis said, "And give her one, too."

She jerked around just as the physician pulled out the spent syringe.

"No! No!" she cried. She jumped back a half step. "I don't want a shot of anything!"

Elvis pleaded with her. She'd feel better. It would help her sleep. They got into it then as the doctor took his leave. He wasn't going to hurt her, he said. She should know that. But what *was* it? she asked. Did he even know?

"All you need to know," he told her, "is that *I* say it's something you need."

As the argument wound down he asked a favor of her: Would she take the used needle back home and throw it away? He didn't want anyone to find it.

When she awoke the next morning, the air conditioner was going full blast, and Elvis was as cold and clammy as the icy winter dawn, his breathing so shallow "that the incredibly handsome face seemed almost like a death mask." Joyce saw then that his innocent shots and pills could kill both of them. Certainly, he was killing himself.

He could be the most charismatic man in the world, like the time he, Joyce, Janice, and Sonny took the limo to Amy Joy's Donut Shop, an all-night drive-in in a tough part of the District where the local ghetto youth hung out. It was past 9 P.M., and Elvis didn't really eat doughnuts the way legend has it. But when he saw the sign, it just felt like a familiar thing to do, the way he used to ride around Memphis at night and stop for sacks of Krystal burgers.

The limo had barely stopped rolling when at least twenty young black men hurried over, eager to see who could be inside such a vehicle.

The situation could have flashed out of control in an instant, with Elvis, decked out in ostentatious gold chains and eye-popping rings, trapped in a limo. They were all at their mercy, and the kids could have shaken them all down, even a man as powerfully built as Sonny. The crowd swelled by the second to yells of, "HEY . . . IT'S ELVIS! C'MON MAN, THAT'S NOT . . . HEY, IT'S REALLY . . . ELVIS!"

But Elvis, who had spent his youth surrounded by girls rocking the sides of his Cadillac, took command, climbing from the car and stepping right into the throng. Sonny stood at his side, trying not to let his nervousness show.

"Whatcha doin' *here,* man," one of the youths asked.

"Just tryin' to get a few doughnuts," Elvis said calmly. Then he leaned down to Ben, the limo driver. "How 'bout goin' in and gettin' us three dozen?"

He straightened back up and faced his audience. Joyce and Janice were frozen in their seats, but Elvis knew what to do. "Okay, guys, keep cool . . . and pay attention now."

Slowly he pulled back his coat to reveal his massive gold belt, gleaming as it caught the reflection from a streetlight.

"This here," he told the kids, "was a gift from the International Hotel in Las Vegas for breaking their all-time attendance record."

A chorus of "oohs" and "aahs" went up from the wide-eyed crowd, some of them moving in to get a closer look. They were pushing against one another now, more excited than before.

"This belt says I'm the best . . . ," he declared. Then he grabbed the pistol out of his shoulder holster with lightning speed.

"And *this,*" he said, turning the gun in his hand, "says I get to keep it."

The rough ghetto kids let out a loud laugh. "Sure, man," somebody said. "It's yours. Okay, take it easy."

It was a masterly performance, and to close it, Elvis shot a curled-lip grin.

"That's it, fellas," he said, and now with Ben back in the car and the doughnuts on the seat, they sped away.

It was Joyce's favorite memory of him. But she didn't know this new Elvis. And he kept asking her to move into Graceland, where she spent his thirty-seventh birthday with him January 8, 1972, Priscilla having told him at Christmas that she was leaving. Now Elvis was finally free to be with Joyce, to really *be* with her. But the idea of living with him scared her.

"He was so out of control. And I needed my independence. He really

wanted to take over my life, but of course, I had no control over his, and I knew there was something wrong with that thinking." She was also disappointed that while he had been "very sexual, though intermittently, it didn't last."

In February, in Vegas, she realized it was impossible to make a life with him. They came from two different worlds, and she didn't want to belong to his anymore. In the ladies' room at the hotel, two hookers who told her they counted Elvis as a customer had just mistaken her for one of their own. Now she just had to get away from it all—the clothes and hair that weren't really her, the dependence on Placidyls, and being around the man who said that pills helped him get close to the "silence," to the "resting place of the soul."

From the passages that he underlined and noted in the margins of his books, she knew he was trying to find his purpose in life. ("El," he said, was another name for God.) But when he read them aloud to her, "It drove me crazy. They didn't make any sense to me." But she did understand that "he truly ached for his brother, and he really wanted his brother to guide him from these books."

On one of her last nights with him, he was just about to slip away, the pills taking him under, when he mumbled something about not having much time left to get his message out. He was terrified of growing older, worried that "it won't be long until I'm forty, and that could be too late."

It was already too late for Joyce. One afternoon when she awoke, he was still sleeping. The room was cold, the way he liked it, and she shivered from the chill. She dressed, packed, and finally, pulled off the gold ring with the little diamond he had given her when they first met, and laid it on the nightstand. Then she kissed his cool cheek and closed his door for the last time.

· · · · · ·

Things were slipping away from him in triplicate now, not just in singles or in pairs. The Colonel had rewritten his management contract to give himself a bigger cut of Elvis's live performances, even as he would soon renegotiate his client's Vegas contract for more money: $130,000 a week for the next two engagements, and $150,000 a week for the following three. And Priscilla, in town for the close of his run that February 23, 1972, had something she wanted to formalize with him, too: In between shows, she told him she was involved with Mike Stone.

He already knew for certain now, knew it when he sent Red down to the hotel's Italian restaurant to bring her up to the suite. But hearing it from her own lips outraged him. He told her she was crazy, that she had everything a woman could want. But she didn't back down. In fact, she wanted a divorce.

Elvis had Sherry Williams in town for consolation. But he'd had two women walk out of his life within a matter of hours, and now he did the unimaginable: He raped his wife.

Priscilla never termed it "rape," but she told Red's wife, Pat, that Elvis forced her to have sex. As she wrote in her memoir, *Elvis and Me,* "He grabbed me and forcefully made love to me. It was uncomfortable and unlike any other time he'd ever made love to me before, and he explained, 'This is how a real man makes love to his woman.'"

After the second show, he called all the guys in and said, "Another man has taken my wife." He was seething, but a river of sadness ran through him, too. When somebody said, "I thought you wanted to get rid of her," his voice was shaky. "Not that way, man."

"It wasn't so much that she was having an affair," Sonny says. "It was that she was going to actually leave him for Mike. If Elvis hadn't known Stone, it wouldn't have been as bad for him."

"Elvis was very upset about the divorce," seconds Joe. "Here he is, the sex symbol of the world, and he's losing his wife to another man. It was really an ego killer for him. He wouldn't admit that to us, but we all knew it was hurting him, and he was affected tremendously by it."

He found solace with Barbara Leigh, who listened as "he cursed Priscilla and Mike on a daily basis, since no one leaves the King. But that was good—it helped him process the hurt and the embarrassment of being left."

When Marty went out to California on business in March, Elvis was still coming to grips with it. He said he had a "problem," that Priscilla was leaving him. He'd just been to the Monovale house and found she had moved out.

"I'm sorry, man," Marty said.

"What am I going to do?"

"Let me ask you a question. Are you going to change?"

"Hell, no. I ain't doing that for nobody."

· · · · · ·

For his next recording session, later in March, he chose songs of heartbreak and re-gret: "Separate Ways," *and* "Always on My Mind." *He poured himself into his work, including a second documentary film,* Elvis on Tour.

After a period in the early 1970s in which he lost his discipline in some of the Vegas shows, "lying down on stage and talking into the mike and laugh-ing," Joe Moscheo remembers, Elvis revitalized himself for the fifteen-city

tour and filming. A young Martin Scorsese supervised the montage editing.

While *Elvis on Tour* would share a Golden Globe award with *Walls of Fire* as the best feature documentary, some critics believed it lifted no veils on Elvis's private life. But a posthumous theatrical release, *This Is Elvis,* contained footage which was originally shot for the earlier documentary. When Elvis is asked in the limousine if he saw the Apollo 16 rocket launch, he implies he was too busy to see it: "I was buried in a beaver." And in a later scene from Greensboro, North Carolina, Elvis references another sexual episode to Jerry.

"You know that girl I was with last night?"

"The dog?"

"Oh, man," Elvis says. "She gave great head, boy . . . Hey, Joe, that chick last night gave the greatest head I ever had in my life." The last line was later overdubbed for a TV and home video version, euphemistically becoming "could raise the dead."

Bragging about cunnilingus and fellatio may have simply been a cover-up for what was really going on with him. "He loved cuddling and petting more than he did the actual sex anyway," one woman noted. "But when the drugs entered the picture, they took over his body and his sex drive took a nosedive, too. I saw the changes starting to happen to him in 1972. It was showing as early as that."

Despite the early stages of his physical deterioration, Elvis could still summon the full strength of his artistry when the Colonel offered him a challenge.

In June 1972 Elvis became the first performer to sell out four consecutive shows at Madison Square Garden, grossing $730,000 over three days. He had never played New York City before, as the Colonel always believed Elvis appealed more to a rural and small-town fan base than urban sophisticates. Now Elvis was apprehensive, though he tried not to let it show. When his new opening act, comic Jackie Kahane, was essentially booed off the stage opening night, Elvis went to him in his dressing room. "Mr. Kahane, they're animals out there. Don't let them bother you. You go out there tomorrow and you kick ass."

When Elvis emerged to the billowing strains of *Also Sprach Zarathustra,* Joe Guercio remembers, a great roar echoed through the fabled building, and "so many flashbulbs went off that the Garden was almost lit for a second."

The *New York Times,* in a rave, recognized it as a legendary performance. Chris Chase's review headlined ". . . A Prince from Another Planet." The writer saw Elvis as a one-of-a-kind talent, "a special champion [like] a Joe Louis . . . a Joe DiMaggio, someone in whose hands the way a thing is done becomes more important than the thing itself. . . . He stood there at the end, his arms stretched out, the great gold cloak giving him wings . . . the only one in his class."

During their four-and-a-half-year love affair, Linda Thompson was as much Elvis's nurse and mother substitute as girlfriend. The Memphis Mafia believes he would have died three years earlier had she not been there. *(Robin Rosaaen Collection)*

THIRTY-ONE

.

Buntin'

The success of the Madison Square Garden engagement buoyed Elvis for a time, but he was still shaken by the divorce. On July 26, 1972, Elvis and Priscilla legally separated, and the world at large learned about Mike Stone. Elvis's lawyer, E. Gregory Hookstratten, drew up the papers and worked out the terms of the settlement, which Priscilla readily accepted: a lump sum of $100,000, plus $1,000 per month for her own expenses and $500 child support. Even though she would reopen the divorce in 1973, seeking more money, they would still walk out of divorce court arm in arm and remain close, in part for Lisa's sake.

"It was like we were never divorced. Elvis and I still hugged each other, still had love. We would say, 'Mommy said this,' and 'Daddy said that.' That helped Lisa to feel stable. There was never any arguing or bitterness."

Elvis recklessly roared around town on his motorcycle, looking terrible, his face unnaturally round and seeming distorted. Twenty-year-old Mary Kathleen "Kathy" Selph, an exotic dancer and singer at the Whirlaway Club and another Priscilla look-alike, was often seen on the back of his Harley-Davidson, her hands around his waist. On June 30, the *Commercial Appeal* photographed them at the corner of South Parkway and Highway 51 South, which had been re-named Elvis Presley Boulevard a year earlier. Her mother saw the picture, and reprimanded her daughter for dating a married man, later learning that Elvis and Priscilla were separated.

But in less than a month, it was all over. Just before three o'clock on the morning of July 18, 1972, Kathy, whose father, E.B. Selph, was the deputy fire chief, was killed in a single-car accident, when her vehicle struck a cement pillar on eastbound I-240 near Elvis Presley Boulevard. She was alone in the car. *The*

Press-Scimitar assumed she was driving home from work, but perhaps she was en route elsewhere.

"There was a real nice spray of flowers at her funeral from the Presley family," her mother, Peggy Selph Cannon told the paper in 2000. "And there was a huge orchid at the funeral. I always felt it came from Elvis."

Earlier that month, Elvis had begun seeing twenty-two-year-old Linda Thompson. She would become not only the most important of his postdivorce girlfriends, but he would also build a stronger and deeper bond with her than he'd ever had with Priscilla. She was his best hope yet for a long-lasting and meaningful relationship with a woman.

Predictably, Linda was the winner of a beauty queen title—Miss Tennessee Universe, representing the state in the Miss Universe pageant—but she did not precisely fall in line with his ideal type, despite her brown eyes. At five foot nine, she was tall, not petite, and refused to darken her long, blondish mane to make Elvis happy. Like Joyce Bova and June Juanico before her, she was an independent thinker. Furthermore, she was educated, having attended Memphis State. But she was a virgin.

Most of all, she would nurture him, seeing that "Elvis needed more love and care than anybody I ever met, probably more than anyone in this world, because of who he was and what he had done." She found him "intensely lonely at heart."

One day Linda was having lunch at a Memphis restaurant with Jeanne LeMay, a former Miss Rhode Island USA who had shared a hotel room with Linda at the Miss USA pageant in Puerto Rico. They had become instant friends, and after the pageant, Jeanne moved to Memphis to live with Linda, the two thinking they might become flight attendants together. That day at lunch, Linda ran into an acquaintance, Bill Browder, who worked in record promotion and would later become a country singer known as T. G. Sheppard. He invited the two of them to Elvis's movie marathon at the Memphian that night, July 6.

"I thought Elvis was still married," Linda remembers, "so I didn't have any kind of designs on him. But I found out he wasn't when I got to the theater."

It was George Klein who actually introduced the two. Elvis appreciated her southern girl beauty and personality, as well as her sense of humor, and asked her to come back the following night.

When Linda then left for three weeks on a family vacation, Elvis turned to another Memphis belle, Cybill Shepherd, the 1966 Miss Teenage Memphis and later the national Model of the Year. Cybill had just made a terrific splash as Jacy Farrow, the small-town Texas temptress in Peter Bogdanovich's *The Last Picture*

Show. Elvis didn't know the classically beautiful twenty-three-year-old was involved with the older director and that she had broken up his marriage. But her provocative scenes in the film reminded him of his sexual awakening with real-life Texas beauties on the Hayride.

He had George call her when she was home from New York, and they followed the usual M.O.: Would Cybill like to come to the Memphian?

"I said, 'Well, I'll come and meet him, but I want to bring my best friend, and my brother, and his best friend.' "

When they arrived, Elvis wasn't there yet, and she tried to concentrate on the movie until he made his grand entrance, everybody to the right of her getting up and moving one seat down. "He was still looking fabulous. And he smelled great." They dated a month, and "if he had smelled bad, it probably would have ended sooner." Things got rolling when he invited her to Graceland for chicken-fried steak, a meal after Jacy's heart.

Just as Elvis and Priscilla had fallen in love with myths, he and Cybill were attracted to each other for all the wrong reasons. He was entranced with a celluloid image that reminded him of his youth, and she had grown up in Memphis hoping to catch sight of the hometown boy who became a god.

If Cybill had been interested enough in Elvis, Linda Thompson might never have been anything but a two-night date. But Cybill, though fourteen years Elvis's junior, ran in far more sophisticated circles, and as with Peggy Lipton, it doomed them from the start. Still, they gave it a try. But like so many women before her, Cybill found his lifestyle stultifying.

In her autobiography, *Cybill Disobedience,* she described a weekend in Palm Springs:

"The house was luxurious in a rental sort of way, sprawling and devoid of personal taste. Everything had a metallic glow. All the King's men . . . spent the afternoon competing to see who could make the biggest splash into a murky swimming pool. The guys raced dune buggies three or four abreast while shouting into walkie-talkies, or sat around a long table with a thick top of beveled glass, eating their favorite deep-fried sandwiches."

Today, she sees that she and Elvis actually had a lot in common, that fame and beauty "can cause you to be emotionally underdeveloped. People do things for you. There were a lot of times . . . where I just didn't get a chance to grow and learn."

But in 1972, she simply couldn't get over the control. Elvis wanted to take her shopping—he didn't like her jeans and tie-dyed mirrored vest—and he demanded

she ditch Bogdanovich, who continued to pursue her. She chose to be with Peter, and when Elvis showed up on an unexpected late-night visit, "I don't think it had sunk in that I had already ended it."

What finished them was the drugs. In a replay of Joyce Bova's experience, Elvis insisted that Cybill join him in his nightly ritual of sleeping medication. "He said, 'Here, take these,' and he had pills in his hands. I said, 'Aren't you going to take some of them?' And he said, 'Well, I've already had mine.' He was almost already asleep, and I went and flushed them down the toilet, returned his emerald-and-diamond ring, and just said, 'Thank you, but I can't.' "

Though brief, their sex life ran the gamut. In an interview with E! television, she labeled him "a wonderful lover, very sexy," but later spoke of his bumbling technique. "Let's put it this way: I think before I met him he was [sexually] conservative, trapped in a stupid macho thing." Her much-quoted declaration that it was she who taught him oral sex brought hoots of derision from other of his lovers, who knew that by the time Cybill arrived "it was just a shuttle—one came in the door as another was flown back to Vegas."

That's precisely what happened when Elvis opened there on July 31, 1972. During his three days of rehearsals, he flew Linda to Los Angeles and then brought her to the Hilton for most of his engagement. As soon as she left, Cybill came in. "The Elvis that I got to know in Memphis was very different than the Elvis that I got to know in Las Vegas. He was unavailable in a way. And then years later, I would find out he had two other women there at the same time."

.

Elvis followed Raquel Welch into the Las Vegas Hilton showroom that summer, and she had someone call the Colonel to ask if she could come see the show. He arranged for her to sit in Elvis's booth, and she sat there agog at what she terms his third transformation. Despite costumer Bill Belew's best intentions, Raquel thought "Elvis looked almost like Liberace or one of those apparitions, dressed all in white, with rings on every finger."

Reviewers noted that he seemed more subdued during his engagement and spent less time interacting with the audience between songs. When Raquel went to his dressing room after the show, "he was very sweet, very nice, and he showed me all his jewelry." But he didn't seem to be really happy, and she couldn't get the show out of her mind. "He had a whole basket of blue scarves, and he must have thrown fifty of them into the audience. It was so carnival. He was almost like a windup toy."

His most devoted fans, including Robin Rosaaen of San Jose, California, saw

him otherwise. "Once he was onstage, it was like somebody flipped a switch. Just pure sex energy filled that showroom." Robin had been attending all of Elvis's Vegas engagements since 1970, and in 1972, he gave her the first of eight kisses and thirteen scarves she would receive over seventy-two shows in six and a half years. "Elvis was like a drug," she says. "Once you saw him, you had to see him again."

She earned that first kiss by holding up an I WANT YOUR BODY bumper sticker, a promotional item from the health spa where she worked. It caught his attention and lured him over to where she sat at the edge of the stage.

"He said, 'You got it, baby,' and I pulled the scarf off from around his neck, and it was hot and sweaty, and he smelled wonderful. I had my ring hand up through his hair, and he was looking in my eyes, and he kissed me with those lips that were like big, soft, warm, puffy pillows. I thought, 'Oh, my God, I wonder what this would be like for more than just a split second?' "

He winked at her then and went on to the next song. "That's when I realized a couple of his hairs were stuck in my ring. I wrapped them in a tissue and stuck them in my bra, and when I got home, I put them in a Gerber's baby food jar, where they've been ever since."

In time, he came to recognize her face, and one year, he pointed her out to the crowd and officially dubbed her "Rockin' Robin." She felt they knew each other then, and so she grew bolder. One night she tried to walk her fingers up his jumpsuit, hoping to tweak a hair off of his leg. "He just looked at me like, 'What are you *doing*?' "

Uh-oh, she thought. Busted.

As a contributor to the book *All the Kings Things,* she became an internationally recognized expert on Presley collectibles and formed a family with other serious fans. Some of them ran to the extreme: "I've known women who went to so many Elvis concerts that they got divorced over it. Their husbands said, 'It's either me or Elvis,' and the women said, 'I'll take Elvis.' "

Sex and love was a topic Elvis and Larry Geller discussed many times, particularly with Larry's return to the camp in August 1972. During one engagement, they stepped outside on the balcony of the Hilton about five one morning as the sun rose over the desert. They were talking about his struggles, and indirectly, his loneliness, and the difference between personal and impersonal love.

"Elvis looked at me and said, 'I want you to put yourself in my shoes. Do you realize I can never know if a woman loves me or Elvis Presley?' And trying to be my philosophical self, I said, 'Elvis, as far as I am concerned, you have had only one real true lasting love in your whole life.' He looked at me and he said,

'Who?' I said, 'The world. Your fans.' He said, 'You're right, man. That's the truth. And that's a heavy price to pay.' "

· · · · · ·

On September 4, 1972, Colonel Parker and RCA President Rocco Laginestra held a press conference in Las Vegas to announce Elvis's next big record-shattering event, "Aloha From Hawaii," a live concert to be delivered worldwide in January 1973 by satellite technology. The show, staged in Honolulu with some of the proceeds going to the Kui Lee Cancer Fund, would reach 1.4 billion viewers. But the "live" label was largely ballyhoo, as both Europe and America would receive a delayed signal.

"It's very hard to comprehend," Elvis said, repeating himself over and over, crumpled in a chair at the press briefing. For many who witnessed it, the more perplexing thought was why Elvis's speech was slurred, and why he perspired so heavily, wiping his upper lip. His eyes, visible through tinted glasses, seemed dull and dazed.

On some days, Elvis appeared clear, lucid, and largely unaffected. But other times, particularly after the divorce action was entered on August 18, his use of sedatives, or downers, was obvious to all. One night, a boy came up to Jackie Kahane after a show. "Mr. Katane," he asked, mispronouncing the comic's name, "Elvis wasn't drunk, was he?"

At the time, Lamar Fike reports, Elvis's usual pattern was to take a Valium, a Placidyl, a Valmid, some Butabarb, and codeine simultaneously. But now, after a sprained ankle took him to Baptist Memorial Hospital in Memphis that July, he began adding Percodan and liquid Demerol to round out his potent and potentially lethal cocktail.

Dr. Nick later learned that "he began getting acupuncture three times a week with Demerol and Novocain in California. He felt so good afterward that he just went more and more."

Considering the severity of his client's drug use, the Colonel might have been expected to speak with Dr. Nick about how to handle it. But he never did.

"He would ask a direct question at a particular moment when something was happening, but we never sat down and talked about any of Elvis's health problems or what needed to be done. It seemed like his main concern was how many shows we could get in that year."

One reason Elvis was excited about the satellite show was what it would say about his "potency," particularly to Priscilla, whose approval he still sought and needed. Dr. Nick remembers that he always had tremendous performance anxi-

ety before any of the shows, that he was "a basket case . . . he'd worry whether he was going to be 100 percent, and want something for his nerves, some Ritalin or amphetamines." If he could perform to most of the *planet* on his own, without any kind of artifice, it would free him. He could boast he didn't need Priscilla, he didn't need drugs, he didn't need anything. He'd even take off his heavy, jeweled cape and throw it in the audience, a symbolic rebirth.

Elvis also hoped the "Aloha" special would impress his new girlfriend. Already he could tell Linda was different from the rest. She was almost always by his side, adored him beyond description, and didn't try to change him, other than to try to temper the drugs. When she went to Dr. Nick and asked him how she could get Elvis off pills, he advised her to simply leave. Instead, she chose to stay.

From the outset, she realized he was a paradoxical man, and that theirs would be a complex relationship that would both exceed and fall short of normal expectations. She wanted to give him plenty of room to explore it and make it whatever he wanted.

"I think it's wonderful if you can be all things to each other, and he and I were. He called me 'Mommy,' and I was like his mother at times, and he was like my father at times, and we were like children, like brother and sister. And we were like lovers at times. That's a full rich relationship when you can do that."

But her most constant roles were caregiver, nurse, and hand holder. The first time he took her to Vegas, Elvis passed out with food in his mouth and started to choke. Linda cleared it out of his throat and turned him on his side to get him breathing again. "I felt a responsibility to his mother to take care of him, and actually to the world, too, because so many people loved him."

She had always felt maternal, and "he was like my little boy." Her nickname for him was "Buntin'," short for baby bunting, after the popular nursery rhyme and lullaby. Elvis called her "Ariadne," for three-year-old Ariadne Pennington, a character in his 1962 film *Follow That Dream*.

"We both just naturally talked baby talk. That was a big part of our relationship." She was the only girlfriend who truly understood the secret language and used it. A Mailgram she sent him when he was away in California demonstrates her prowess:

Baby gullion, you are just a little fella. Little fellas need lots of butch, ducklin', and iddytream . . . Grit. Chock. Chock. Shake. Rattle. Roll. Hmmmmm . . . Hit. Hit. Pinch. Bite. Hurt. Grit. Whew. My baby don't care for rings . . . Pablum lullion (in or out of the hospital). P.S. Foxhugh [the poodle] will

bite sooties if you say iddytream again. Grit. Grit. [Signed] Ariadne Pennington

The two rarely fought. Linda even tolerated Elvis seeing other women when she wasn't around, though for the first year and a half, he was largely faithful. When he did fool around, "it hurt her," Marty Lacker saw. "But her attitude was, 'What am I going to do about it? Say, "Hey, Elvis, you can't do that or I'm going to leave?" He would have said, 'Adios.'"

For Christmas that first year, Elvis gave her what all grown-up girls want, a fur coat. And all year round, she gave him what he wanted, too—she allowed him to regress to an infantile state, to start the full journey back to Gladys.

The irony was that the more childlike Elvis became, the more he treated Lisa Marie as an adult, showering her with the same gifts he gave his girlfriends. The four-year-old spent Christmas at Graceland that year, and she got a fur coat, just as Linda did. Elvis loved to buy Lisa things, including a big, round bed. It was tacky—fake fur, with a round mirror on top and a built-in radio—but he often slept in it when she was with her mother.

He'd been thinking a lot about the first girl to whom he gave a round bed, as that September, Ann-Margret tragically fell twenty-two feet from a platform in Lake Tahoe, breaking her jawbone, and shattering her face, arm, and knee. She required extensive reconstructive surgery, but was back performing in Vegas in late November, and Elvis, who had already sent her flowers, went to talk with her.

One night, as she and Roger entertained friends in the suite, he dropped by unexpectedly. "It was so easy for us to lapse into the closeness we'd always shared," she wrote, and they monopolized each other until it became awkward with the other guests.

Late that night, the phone rang in her bedroom while Roger was in the living room next door. She knew who it was before she answered. Elvis started out saying how wonderful she looked, and that his prayers for her health and healing had been answered. Then his tone shifted. He was lonely, he said, and wondered if she would see him.

"You know I can't," she told him.

"I know. But I just want you to know that I still feel the same."

· · · · · ·

As the "Aloha" concert neared in January 1973, Elvis "was so pumped up he could have hit the ceiling," Marty says. He worked hard to get in shape, losing twenty-

five pounds on a crash diet consisting of six hundred calories a day and what Marty remembers as "injections of urine of a pregnant woman." He worked closely with Bill Belew on the design of what would become his favorite jump-suit, featuring the American eagle, and exercised enormous discipline in staying off his drug protocol.

"Aloha from Hawaii" would be his last great triumph—the album would stay on the *Billboard* charts for thirty-five weeks, and become his first number one chart-topping LP in nine years—and many of his old friends came to Hono-lulu to share the excitement. Felton Jarvis was there, though still weak from an Elvis-financed kidney transplant. And Patti Parry caught a plane at the very last minute ("Get over here, now!") after Elvis looked at a tape of the rehearsal and decided he needed his hair styled.

It was a remarkable performance and earned the highest ratings ever in Japan, where it was broadcast live. The feedback, all glowing, boosted Elvis's spirits. The night after the show, he bought diamond-and-emerald rings for all the wives and gave each of the guys a thousand dollars.

He'd stayed straight for two weeks now, and everyone prayed that Elvis had turned a corner. But just before he went on, he'd asked for a shot of vitamin B-12 mixed with amphetamines.

The next morning, they were all supposed to go to the U.S.S. *Arizona* Memo-rial. Marty banged on his door at the Hawaiian Village Hotel, and nobody an-swered. "Finally, Linda came, and she just made a face and shook her head. Elvis was sitting on the balcony, on the top floor of the hotel, stoned out of his gourd. He was sweating profusely, with a towel around his neck, and he could hardly talk. He'd gone right back into it."

When the special was broadcast in America on April 4, 1973, 57 percent of the television audience watched it, including Joyce Bova. It stirred her emotions, and she called Charlie, just wanting to share the experience with someone close to him. When Elvis himself called back on the "hotline," the private phone he'd had installed in her home, her palms began perspiring. But it was a sweet call. "I miss you," he said. "I want you to come to California. Call me in a couple of weeks." She said yes, and for a second she meant it. Before they hung up, he asked for a copy of a photo of himself with both Joyce and Janice taken in Vegas. She sent it, but she didn't call. "I couldn't have gone back to that. I didn't want to. It wasn't good for me."

Elvis watched the show with Linda and Jerry, sitting at home in the Mon-ovale house in Los Angeles. But over the next few weeks, Jerry felt as if Elvis

were distancing himself from him. The younger man had become infatuated with a girl who was often part of the Palm Springs weekends, and he knew his marriage to Sandy was coming apart. He and Elvis hadn't discussed it. Then on another trip to Palm Springs, Elvis said, "Jerry, there's something I've got to tell you."

Jerry braced himself for a lecture but instead, he got a confession: Elvis had slept with Jerry's girlfriend. It had only been a one-time thing, he said, one night when Jerry had fallen asleep early. Jerry knew he was in no position to be self-righteous, but it stung. Elvis had broken the cardinal rule of the brotherhood.

Soon Jerry's marriage to Sandy collapsed, and he would eventually marry Myrna Smith of the Sweet Inspirations. But that, too, would unravel.

Hanging with Elvis was rough on a marriage. Joe and Joanie would be divorced by the end of the year, but Joe soon meet a smart and energetic blonde named Shirley Dieu, an Oklahoma transplant who had grown up in San Diego.

Joe and Shirley were a strong couple, and Elvis told her on numerous occasions how much he admired their relationship. However, one time when she visited him in the hospital, he was half-dressed and got close in her face, and she got the impression that he was coming on to her. She dismissed it and acted as if it hadn't happened. But he was clearer on another occasion in the Imperial Suite in Las Vegas, when they both got up from sleep and ended up in the kitchen at the same time.

"He put both of his arms up and tried to kiss me, and I just kind of slithered out from underneath him. I said, 'I've got to go. Joe's in the room.' It was awkward, but I never thought of him in that way, and I never, ever, accepted any of his advances. I guess if you are really in love with somebody, you don't."

That didn't stop Angie Stanley, the eighteen-year-old wife of Elvis's stepbrother Billy. She went after Elvis "like he was the last piece of cake on the platter," according to Billy Smith. Elvis's response was to set Billy Stanley up with another girl so he could be with his wife. Billy wrote about it in his book *Elvis: My Brother,* saying the two had a month-long affair in 1972, and that Elvis felt bad about it.

Elvis told Billy Smith that he had intentions, but that he never went through with them. He and Angie simply talked, he said, and he ended up preaching to her a little. But Marty Lacker got a different idea one day when he and Elvis walked down the steps into the den from the kitchen, and Billy Stanley happened to pass them.

"I was thinking about Elvis and Angie, and somehow Elvis knew that. He

kind of glanced over at Billy, and then he looked at me, and he said, 'Well, it ain't like he's my brother.' "

· · · · · ·

Three weeks after the "Aloha" concert, Elvis opened his eighth Vegas engagement. He was tired now. All the Vegas nights of the past seemed to run together, the great shows when he was heralded as the white knight of rock, the bad shows when he'd change songs so spontaneously the band could barely keep up. He thought he'd wanted this life so badly, but what had it brought him in the end? Right now, he only knew what it had cost.

Sometimes he thought about the night Anita Wood came to see him. She was in Las Vegas with her husband, Johnny Brewer, and ran into Joe and Charlie in the hotel lobby. They invited her to the show, saying they knew that Elvis would want to see her, and they gave her his booth right in front. She took a girlfriend with her, "and man, he looked so fine. He talked to me, *sang* to me. I was just . . . ooh, my goodness." She hadn't counted on feeling like that.

She went backstage like they'd told her to, and she and Elvis embraced, held on hard and long. "Come on in this room," Elvis said. "Let's go in and talk." It was a little private area, with just a bed and chair, and he closed the door to shut out the sound of his father and all the important people he didn't want to see.

They talked for about an hour, and the years melted away. Then he looked at her, his face all clouded up and somber. "Little," he said softly, "I wonder if we made a mistake?"

It was a shattering moment, and Anita fought to hold back tears. But she collected herself. "No," she told him. "It's for the best. We wouldn't have our wonderful *children,* Elvis." But they would always love each other, they both knew that, and there were things between them no one could ever take away.

He wished she would come back again. He'd sat with Cliff Gleaves once, playing records, spinning "Funny How Time Slips Always" over and over. "You know why I'm playin' it, Cliff," he said. "My heart still burns for Anita."

On this night in 1973, he didn't care about the present. He only cared about the past.

The *Hollywood Reporter,* in its opening night review, noted his "lack of energy and interest" and attributed it to illness. The guys knew it ran deeper than the flu. He canceled several of his midnight shows, and even Alex Shoofey sympathized with the situation.

"He didn't have breathing room, you know? It was a continuous thing. I even

said to the Colonel one time, 'Give him a breather, Colonel, gosh! You know, he needs a little rest.' He said, 'Oh, he's young. Don't worry. He loves every moment of it.' I think he could have let up a little, given him a little more time off."

But when four South American men jumped up onstage near the end of his show on February 18, it pushed him over the edge. The men had just been overexuberant fans, and probably drunk, and the guys had quickly wrestled them off. In a dramatic display, Elvis knocked one back into the audience, and then told the stunned crowd, "I'm sorry, ladies and gentlemen. I'm sorry I didn't break his goddamned neck is what I'm sorry about."

He was paranoid now, delusional, his behavior drug-induced. In the early hours of the morning, high on pills, he convinced himself that Mike Stone had sent the dark-skinned men to kill him. Climbing the walls, waving guns around, and ranting ("Mike Stone has to die!"), Elvis ordered Red to arrange a hit on the karate champion.

"He really felt that way," Joe says. "He was the man, the masculine guy who was hurt by his wife, and 'I'm gonna *kill* that son of a bitch!' He kept harping on getting it done until finally we said, 'Okay, we have someone who'll kill him for you.' And he said, 'Well, we'll talk about it later,' and dropped the subject."

Things were closing in on him. Priscilla wanted more money for the divorce, and he didn't readily have it. He was overextended now as it was. But RCA wondered if Elvis would be interested in selling his master recordings, or back catalogue, for $3 million.

At first Parker rejected the offer—accepting meant the label would never again have to pay royalties on records released before March 1, 1973, and Elvis would have no control over how the songs would be used. Yet Vernon argued otherwise, insisting it was a quick cure for many of Elvis's financial ills. And so the Colonel sat down with RCA's Mel Ilberman and when he'd finished negotiating, the label paid Elvis $5.4 million for all rights to every one of his songs.

It would have been a paltry sum under any circumstances. But then Parker delivered Elvis a second blow, sliding a new management contract before him. All income from Elvis's recordings would now be divided fifty-fifty from the first dollar, making Elvis and the Colonel pure and equal partners. The RCA monies would be subjected to that agreement, of course, and the Colonel would receive extra monies for his side deals. RCA paid the pair $10.5 million total, and of that, $6 million went to the Colonel, and $4.5 to Elvis. After taxes, Elvis would see $2 million for the most valuable recordings in the history of popular music.

Much of it would go to Priscilla. When the divorce decree was finalized in

October 1973, she received a cash payment of $725,000, plus spousal and child support, as well as part of Elvis's new publishing companies, and half the sale of the Hillcrest house.

• • • • • •

By the time Elvis played the Sahara Tahoe in May 1973, the strain was obvious. He was thirty pounds overweight and lethargic, and canceled a number of shows, going to a local hospital for chest X-rays. Word spread throughout the industry.

Barbara Eden followed Elvis into several venues when she was singing, and one of them was Tahoe.

"The man who hired the talent up there sent me to a doctor one time in the mid-1970s, because I had a terrible cold and sore throat. He said, 'Use him for this one job, but don't use him for anything else.' I asked why. He said, 'He's very proud that he took care of Elvis, but I was there when he treated him. Elvis's rear end was like leather, it had been poked so many times with needles to keep him going.'"

It was so very sad, she said. "Elvis was like a racehorse that you work too hard and then lose."

When Elvis returned to Memphis, the Colonel, furious about the canceled dates, called Vernon about the open dialogue between Elvis's friends and family concerning his abuse of prescription medications. His rant fell on deaf ears.

Dr. Nick saw that Vernon's relationship with Elvis wasn't good enough for him to hold any sway. And Vernon, who had a girlfriend and would separate from Dee the following year, didn't truly realize what was going on. Vernon "was wrapped up in his little world. And he didn't really want to accept that his son needed any help. That was one big problem."

But even Lisa Marie, who often saw her father guzzling pills, knew that something was wrong: "One night when I was about five or six, we were watching TV. I looked up at him and said, 'Daddy, Daddy, I don't want you to die.' And he just looked down at me and said, 'Okay, I won't. Don't worry about it.' I said that to him several times when we were alone together . . . I guess I was picking something up."

Finally the Colonel convinced Vernon to let Ed Hookstratten, Elvis's lawyer, open an investigation with John O'Grady to uncover Elvis's source. But Elvis had doctors all over the country—George Nichopoulos in Memphis, Thomas "Flash" Newman and Elias Ghanem in Las Vegas, George Kaplan in Palm Springs, and Max Shapiro, the dentist, in Los Angeles. And without his cooperation, nothing could be done.

He was into heavy narcotics now, Dilaudid, or synthetic heroin, not just Demerol, and sticking Q-tips soaked in liquid cocaine up his nostrils. He'd get whatever he needed wherever he could, even if it meant self-mutilation: Digging a hole in his foot under the guise of an ingrown toenail, or picking at a spot on his hand until "you could have parked a truck in it . . . really you could see the bones," according to Lamar. "The last five years were just horrendous."

He failed to show at a recording session that July 1973 at the legendary Stax studio on McLemore Avenue, only a few doors down from where he and Dixie Locke had attended the old Assembly of God church. The next night, he arrived late, decked out in outrageous "Superfly" clothes, a white suit, black cape, and Borsalino slouch hat, with Linda and Lisa Marie in tow. The musicians were shocked at his weight ("It was the first time I ever saw him fat," says drummer Jerry Carrigan), and most had never heard him so slurry.

Erratic and moody, he recorded little of use over several nights of sessions. At one point, Felton couldn't find him and went looking outside. Elvis was there in the dark. "Why are you sitting out here?" Felton asked. The response was soft and slow: "I'm just so tired of playing Elvis Presley."

.

He was back in Vegas in early August, adding only one new song, a cover of actor Richard Harris's divorce weeper, "My Boy," and receiving devastating reviews of his opening night. The *Hollywood Reporter* called it "one of the most ill-prepared, unsteady, and most disheartening performances . . . it is a tragedy . . . and absolutely depressing to see Elvis in such diminishing stature."

Pop singer Petula Clark was in the audience that night. She had seen him once before, at a preopening show some years earlier, going with her friend Karen Carpenter. He had been "great, absolutely fantastic. He was really on form, and very handsome and exciting."

She and Karen had gone backstage, where he was his usual charming self. Then, quite suddenly, "The dressing room was empty except for Elvis, Karen, and myself, as the entourage had left rather strategically. He was very seductive and very heavily flirted with us. Karen was younger than me, and I felt a little bit responsible for her, and after about half an hour, I thought, 'Wait a minute.' I said to Elvis, 'We have to go,' and I took Karen's hand and we left.

"We had a laugh about it, because I think that Elvis was rather looking forward to having a threesome with us, and I didn't think that was a good idea, even though there was a bit of a spark there."

Now, in 1973, Petula had been looking forward to another terrific show, but she saw a very different Elvis that night. "He obviously wasn't the same man. He was fooling around onstage, and he was sloppy in his work, not singing everything all the way through."

Again, she went backstage, but when Elvis came into the dressing room, Petula was chagrined to see "he was out of it, and there were people hanging around telling him what a fantastic show it was, and it wasn't. I stayed about ten minutes, and it was a very, very sad ten minutes. The Elvis that we all knew just wasn't there."

Mary Ann Mobley and her husband, actor Gary Collins, also went to see him around this time. He took them back and showed them some of his new wardrobe, but as they talked, Mary Ann realized he was clinically depressed.

"He could see no change in his life. It was just going to Vegas, going back to the house, maybe renting out the movie theater, and that's it. No new interests. That's what keeps you going. No one said to him, 'Look, we're going to get out of this rut. We're going to charter a plane and fly to Capri or Nice, and we'll have plenty of security, and you'll see new places.' What good is it to make all that money and to have the following he had and not be excited to get up every day?"

In October, two days after the divorce decree was finalized in Santa Monica, Elvis had trouble breathing. He and Linda flew home to Memphis on a chartered jet, but on the plane, a worried Linda watched as his breathing grew even more labored, despite a constant administration of oxygen. Dr. Nick came out to the house and was shocked to find Elvis swollen almost beyond recognition. The physician left his office nurse, Tish Henley, more or less on permanent duty at Graceland, but when Elvis worsened in the next few days, the physician put him in Baptist Memorial Hospital, where he underwent extensive testing for all of his health concerns.

He was having occasional problems controlling his bladder and bowels, he said, conditions that would sometimes leave him incontinent. Dr. Nick asked every question in the world, and that's when he learned that the "acupuncture" Elvis received in California had been administered with syringes filled with Demerol. Elvis remained in the hospital for two weeks to detox.

Linda stayed by his side, both because she loved him, and to keep him from charming the nurses into bringing him all the drugs he wanted.

Sheila Ryan was initially shocked by Elvis's emotional regressions, but felt she had to stay. "I knew that I had been sent there for the downfall."
(Courtesy of Sheila Ryan Caan)

THIRTY-TWO

.

"Where Does Love Go?"

One morning in 1974, Elvis woke from a deep Placidyl sleep and groggily struggled to focus on the face of the woman beside him. Linda was exhausted, having survived one of the most frightening nights of her life. It started out like any other. Elvis was eating some chicken soup for dinner, and Linda went into the bathroom to get ready for bed. She took her time cleansing her face and changing into her nightclothes, and when she came out, she saw a terrifying scene: Elvis was facedown in the hot soup, suffocating in the bowl.

She yanked him out and tried to revive him, and when that failed, she frantically called Dr. Nick, who raced in and gave Elvis a shot of Ritalin.

Now, after sleep, it took him an unbearably long time to get out what he wanted to say.

"Mommy?" he said.

"Yes, honey."

"I-I-I-I had a dream last night," he muttered.

"What did you dream?" Linda asked.

"I dreamed that you were my twin, and I came out first and you smothered." His voice was weighty, gluelike, his pauses interminable. "You let me be born. But in the process, you died saving me."

A chill ran over her. She tried to tell him that he'd had a problem breathing, and she'd had Dr. Nick come in and give him a shot. But no, no, he didn't want to talk about that. She was his *twin*. She'd saved his life.

"Well, it was just a dream, honey," she said. And then he fell back asleep.

.

Dr. Nick says he had not realized that Elvis was a hard addict until the Demerol incident. He got on the phone to the doctor in California who administered it and angrily told him Elvis was a very sick man, that he was filled with fluid and that his condition was grave. His patient had an extreme reaction to the Demerol, Dr. Nick said, and asked if the California practitioner was also giving him steroids, as Elvis was now cushingoid. Well, yes, crackled the voice from the West Coast, he'd mixed some cortisone with the Novocain to help with the healing. That might have aggravated Elvis's glaucoma, Dr. Nick thought.

Now the physician consulted with Drs. David Knott and Robert Fink, addiction specialists who worked with alcohol and drug rehab patients. They recommended Dr. Nick immediately put Elvis on phenobarbital to help with withdrawal symptoms, and then after dropping by the hospital to evaluate Elvis themselves, they suggested Dr. Nick start him on methadone, a treatment normally associated with heroin addiction.

The next step was to call in Dr. Larry Wruble, a gastroenterologist, who ordered X-rays and found that Elvis had a bowel ileus, or enlargement of the intestine, and that it was packed full of fecal material, a common side effect of long-term opiate abuse. "He would be so distended," says Dr. Nick, "that a lot of his potbelly was just his enlarged colon and his inability to get it to function."

Elvis also had degenerative arthritis in his neck and lower back, so Dr. Nick asked him to cut certain songs and gyrations out of his show. A larger problem was what his liver biopsy showed. Testing found damage consistent with toxicity, and the organ contained a great many fatty cells, a condition likely brought on by both his eating habits and medication abuse. He had a diabetic tendency, but his diabetes was not so advanced that he needed to be treated with insulin.

Linda slept on a cot beside him for the first few nights, and Elvis would lower his bed so they could be as close as possible. Then the staff brought in a hospital bed just for her. Since Elvis had to wear a gown, he wanted Linda to wear one, too, so they'd look like patients together.

They watched a lot of television, especially game shows, and at night, after the Memphis television stations signed off, Linda remembers, "We used to just sit and watch the little Indian head, you know, 'Bzzzzzzz,' just because there was a picture on television." And they'd listen to "High Flight," the pilot's creed that came on about 1 A.M. and served as another end-of-programming signal. Then they found they could see the closed-circuit images from the nursery, and look at babies all night long. They came to recognize a few of them as time went on—one baby seemed to be waving at them, and Linda later sent him shoes—and the

nurses would tape signs that said, HI, ELVIS! to the cribs and incubators, or come up to the cameras and smile. They got excited when they saw a newborn.

"Elvis just loved babies and children, and he would become very tender and like a little baby himself and regress back into that infantile state, and I'd have to baby him a little. Sometimes we were like two little babies together. Occasionally, he'd be the baby, and I'd want to be the baby, too, so it would be like, 'Wait a minute. *I* want to be the baby, and I want *you* to be the adult. We can't both be babies right now!' We'd get into a silly thing. But it worked for us. It was fine."

They fantasized about having a child together, and Elvis wanted a son. They talked about everything from the way he would look to what his name would be—Elvis had always liked John Baron Presley—"and even our pet names for him. And then we would pretend that he was out somewhere, and we were looking for him. We just had funny games going."

But Elvis would also talk to Linda about his hang-up, telling her "the whole notion of a baby passing through there just made it an unsavory place to be." She found it "very odd. It didn't make me anxious to have his child."

When Elvis got out of the hospital, Drs. Knott and Fink went to Graceland a couple of times, where Dr. Nick and Joe had already been to search Elvis's bedroom and to throw out large bottles of pills, including Dexedrine and Seconal. But Elvis refused to get into anything deep with the physicians, who had hoped to persuade him to enter Dr. Knott's drug treatment program. As soon as they started talking about "iatrogenic and volitional polypharmacy," and he found out precisely what kind of doctors they were, he turned them away. Says Dr. Nick: "He didn't want anybody getting into his brain."

Even after Elvis stabilized, his recovery was slow. But little by little, he felt better. Dr. Nick dropped by every night after work, and they felt like a team— Elvis, Dr. Nick, and Linda—working to restore him to health. One problem at home was getting him to bathe on a regular basis. Left on his own, he would just eat the dark green Nullo tablets that Linda used to keep down menstrual odor. Though recommended for problems with bowel control and colostomy, "Elvis thought they'd kill any type of body odor, from bad breath to butt, even underarm," remembers Billy Smith. "He ordered bottles of 'em." As time went on, "That was his bath."

When he went to Vegas on January 26, 1974, the *Las Vegas Sun* reported that he was back "at the top of his form, in good humor . . . extremely generous timewise, and a jam-packed Hilton main showroom responded warmly."

But at Dr. Nick's suggestion, the engagement was cut from four weeks to

two, with one show on the weeknights, and two on the weekends, "because the more shows he did, the more medications he needed. And I tried to get Dr. Ghanem out of it, because the medications that were giving Elvis the most trouble were the ones he was prescribing him."

The Colonel didn't like the idea—fewer shows meant less money—and he particularly didn't like Dr. Nick telling anybody what to do. Parker was much more comfortable around Dr. Ghanem, with whom he shared a lot of friends: Ghanem was deeply connected to the Mob. Dr. Nick would later lose his license for overprescribing to a number of patients over a period of years, but Dr. Ghanem was just as loose with a prescription pad, and the general feeling among the guys was that he never really tried to help Elvis. Kathy Westmoreland saw it, too.

"When Dr. Ghanem was there, Elvis was worse. When Nick was there, everything was in more control." Besides, Kathy thought, there was something unsettling about Dr. Ghanem. "I think he had an Elvis complex. He thought he *was* Elvis in a way. He dressed like him a couple of times, put on his jumpsuits and had his dark hair. He'd come into the dressing room like that, and Elvis didn't really laugh that much. I don't think he thought it was that amusing."

But Elvis was not acting like a man who had kicked a drug habit. He was becoming more peculiar, erratic, and dangerous, and he was not as patient with the fans as he had been at previous engagements. When one girl tried to yank off his necklace as a souvenir, he snarled his worst epithet at her: "You son of a bitch!" At another show, he kicked at a fan who got too close.

He had a new bass player now, thirty-year-old Duke Bardwell, who replaced Emory Gordy Jr. at the last minute. Duke, a Louisiana native who grew up loving Elvis, was "nervous as a chicken in a yard full of roosters" about the idea of playing with his hero. But on the day Elvis auditioned him, at the RCA Studios in Los Angeles early in January 1974, Duke had another reason to be uneasy.

They'd run through the songs for about an hour or so, and then during the break, Duke found himself standing next to Elvis. He'd noticed the big, nickel-plated pistol that Elvis pulled out of his belt and handed to one of the guys.

"I know you have a lot of martial arts training," Duke ventured, trying to break the ice, "so I was wondering why you carry a gun."

Elvis put his top lip up a little and answered, "That's to handle anything from six feet out. Six feet in, I got it covered."

Duke was thinking about that as Elvis turned to walk away. Then suddenly he spun around and threw a punch that stopped with one of his big rings resting on the end of Duke's nose. "I never saw it coming, but it left me with a red face

and a racing heart. He could have missed by a half inch and driven my nose bone through my brain."

Elvis's behavior grew even more unpredictable once he got to Vegas. One night he shot out a chandelier in the suite, and another night, he fired randomly when he couldn't find Dr. Ghanem. Already, he had narrowly missed hitting Linda while trying to pick off a porcelain owl with a .22-caliber Savage revolver. She had been in the bathroom, and remarkably, though shaken, kept her wits about her as the bullet tore through the wall, nicked the toilet paper holder, and shattered a hanging mirror: "It was crazy, but he didn't take it as casually as some people said he did. He was just having a little target practice, but he was really upset."

The Colonel had invited Bob Finkel, the executive producer of the '68 special, to attend Elvis's show one night, and afterward, Joe took Bob and his wife, Jane, up the private elevator to the penthouse and left them alone to go in by themselves.

When Bob opened the door, he was startled to find that "the suite was pitch-black, except for the light from the television set. There was a western on, and Elvis was sitting there. After all we went through together, all he said was, 'Hi, Bob,' and then he fired at the television with a pistol. He was killing the bad guys, I guess, but it scared the shit out of me. Jane and I got right back in the elevator and went down."

The shooting of televisions started one afternoon at Graceland, when Elvis was eating breakfast and the polished face of actor-singer Robert Goulet suddenly filled the TV screen. It took him back to the memory of Anita Wood's going on tour with Goulet when Elvis was away in Germany. She was writing him a letter one day, when Goulet stopped and scribbled a postscript, something to the effect of, "Hey, Elvis! Don't worry! I'm taking pretty good care of Anita!"

It was just a joke, but it always gnawed at him, and he had been thinking more about Anita lately. In what would be their last conversation, she called him in Vegas to tell him her father had died, and to say that for the first time she understood how sad it was for him when his mother passed away. Now, seeing Goulet just brought it all back, and Elvis flashed in anger, pulled out his .22, and blew a hole through the set. Then, as Marty Lacker tells it, "he calmly picked up his utensils and said, 'That'll be enough of that shit.'"

Elvis's reliance on pills tended to be worse in Vegas than anywhere else, because the playground of his twenties had become the trap of his thirties ("Vegas is a terrible place"), and he chose to get wasted rather than have to deal with it. "It's better to be unconscious than miserable," he'd offer with a tinge of black humor.

"If we were at home," Linda says, "he could just sleep for days and it didn't

matter." But in Vegas he had to get up again for the shows, so it was a continuous cycle of uppers and downers. "They shot him to go to sleep, then they'd have to shoot him to wake him up," Jackie Kahane said. "I saw him wiped out. *Wiped out.* I mean crawling on the bloody floor! It was very sad. Very, very sad."

"There were a good five or six times that he got so fucked up that he almost died," Lamar remembers. Usually it was from the sleeping pills. Then he had the opposite problem at a Howard Johnson Motel somewhere on the road. "He was so wired that Nick had to go in through his neck and shoot him to knock him out."

In Lamar's view, if it hadn't been for Linda and the group, Elvis would have died three years earlier. He constantly had to be rescued from choking on his food—drugs numb the nerves in the throat that control the swallowing reflex— and one time Linda rushed to call Joe when Elvis turned blue with a peach pit stuck in his throat. Being with him was "like being in a firehouse," Lamar says. "You never knew when the alarm was going to go off."

· · · · · ·

During that Vegas engagement, Elvis became better acquainted with twenty-three-year-old Ann Pennington, a model-actress and future *Playboy* Playmate who lived in L.A. Her older sister, Janice, was one of the girls on *The Price Is Right,* a game show that Elvis often watched with Linda in the hospital. He'd met both of the Penningtons earlier that fall at the Hillcrest house. They shared the same Beverly Hills dentist, Max Shapiro, who telephoned Ann and said Elvis was going through a rough patch after his divorce and needed to meet some nice girls. Would they see him? Ann was more of a Beatles fan, and begged off, but Janice had always liked his music, and though engaged, went to the house one evening. The next day she called her sister and said Ann had to meet him, that Elvis was "the most amazing, kind, sweet southern gentleman."

When Ann finally went over, Joe opened the door and she saw Elvis sitting directly in front of her on the couch in a green leisure suit. "He looked, and he got up, and all of a sudden, I went, 'Oh, Geez. Wow!' He was just charming and lovely, and we had a great time."

The beautiful blonde had a three-year-old daughter, Jessica, but Elvis was already interested in her by the time he found out she was a mother. When he did, "He was like, 'Oh, my God!,' and he told me about his block." The first time he heard her call her daughter "Jessie," he said, "That's my twin's name." Soon he was comfortable enough with the situation that they bathed Jessie and Lisa

together in the tub, and he played with Ann's daughter and spoiled her with candy just the way he did his own child. Then when they finally got around to intimacy, and he saw that "Annie Pie," as he affectionately nicknamed her, still excited him, he was able to push his phobia from his mind.

From the beginning he found the soulful Ann, with her big, expressive eyes, easy to be around, and he could level with her. "I'm so lonely, Annie," he would say, and sit on the bed and play "Blue Spanish Eyes" for her on his guitar. She knew about loneliness. She'd recently moved to L.A. from San Diego and didn't know many people other than her sister. And so she was eager to listen to all his old escapades, brag on his karate technique, and appreciate the Charles Boyer album he was currently obsessed with, particularly the Frenchman's heavily accented recitation of "Where Does Love Go (When It Leaves the Heart)."

It was a question he asked himself over and over. When Anita called to let him know about her father's death, he talked so "slow and draggy and not like his effervescent self, the way I remembered him." But he said, "Little, get a pen and paper. I want you to write this poem down. Verbatim. Take a deep breath." She did what he said, right down to the inhale. "Now read it back to me, Little," he said. "Don't ever forget it."

There, with Ann, he did virtually the same thing. "Listen to this, Annie Pie," he'd say to her. "Aren't these just the most romantic words you've ever heard?"

"There was an awful lot of feeling there," she says of the relationship. "My experience with him was nothing but fun and sweetness." They read his books, and she introduced him to one he loved called *Lessons in Truth* that her mother had given her when she was a teenager. They just had such great *conversations*, and while she saw "the drug thing" on a couple of occasions, it didn't dominate their time together.

One night in Vegas, when they were sitting around on bar stools with all the guys, Elvis brought out a joint. It was Ann's first time to smoke grass, "and we got laughing, laughing, laughing, laughing," and he said something and he grabbed her, and they fell off the chairs and laughed some more.

But another night, he'd had a couple of drinks, which Ann realized was a rarity for him, and she woke up in the middle of the night freezing in her negligee. Suddenly, she realized she was soaked, but she just moved over to the edge of the bed and stayed there.

"When he got up, he was mortified. He said, 'Oh, my God, Annie Pie, Annie Pie, oh, my God, I'm so sorry. Why didn't you wake me?' Then we were sitting out with the guys, and he said, 'I peed all over the bed. Do you believe it? Poor

thing! She was huddled in a little corner there. She didn't say a word.'" He didn't seem embarrassed to talk about it, but after the maids came up and carried the mattress out of the suite, nobody said anything else about it.

When Linda found out about Ann, she didn't think that he was really *with* her, but still, "I felt it was a violation of our relationship, and certainly something he wouldn't have tolerated." She'd had an inkling he was with other people now and then: Sherry Williams, for example, came along to Palm Springs with the group, and then when Linda was away with a girlfriend, Sherry spent a week at Graceland. "I wondered, 'What's this all about?' I didn't realize that Elvis was seeing other women when he was with Linda." But mostly Elvis just wanted company. "We did a lot of things, theater, karate, shopping. . . . Basically, I think he wanted someone to stay with him while she was gone. However, it was one of the more intimate times I had with him."

Then there was a dalliance with Nanette Kuklish, a broadcast newswoman who went to Vegas "on a mission to meet Elvis Presley, and I wasn't going to give up." He came on to her twice, the second time in Linda's presence: "She was sitting right next to him. His head was turned in my direction as we were talking, flirting, and laughing . . . we saw each other a week later at his home in Holmby Hills."

"Elvis wanted to be happy," Marty saw. "He just didn't know how to do it. He felt it was too late for him to find happiness. He could have found it with Linda. But instead of concentrating on that, he looked back at Priscilla and thought, 'Maybe I'm not cut out to be married.'"

For Linda, it was past disillusioning, as the two had been together "literally twenty-four hours a day for the first year that we were together," and within two weeks of meeting her, Elvis told her he was in love and wanted to spend the rest of his life with her. But as she grew and matured, she also became more aware of her own needs, and what Elvis could and could not give her.

"I think the timing was bad," Linda assesses. "Not to take away from the magnitude of it, but I was young and he was just coming out of a marriage. It was a transitional kind of relationship, even though it lasted well beyond the transitional years. We planned to be married, and then the time just kind of passed us."

Jo Smith remembers how crazy Elvis had been about Linda: "She had a peach-colored outfit, and when she wore it, he would bite at her. He would be talking, and as she passed by, he'd go, 'And so and so . . . gnaw-gnaw-gnaw-hhhhnnnnhhhhh.' Like a shark or something."

But what started out as marathon lovemaking sessions in Las Vegas dwindled down to "once a year" sex and lifesaving heroics.

It wasn't so much that he was truly impotent, though there were times when the drugs rendered him so. "We discussed sexual things," Dr. Nick reports, "and I think more than anything else he got preoccupied with having more of a mother figure around him to take care of him. I don't think it was because he couldn't perform. I just think that's what he was interested in."

And so he continued to hit on other girls right in front of Linda, including twenty-one-year-old Sheila Ryan, who arrived in Vegas at roughly the same time as Ann Pennington. Joe, who thought Sheila was gorgeous and had tried to date her himself as his marriage was ending, brought her backstage in early 1974. Elvis saw her across the room and, trying to figure out an excuse to approach her, threw a grape at her so he could come over and apologize without Linda being suspicious. He hit her right between the eyes, smack in the forehead.

"I had grape juice running down my face. He flung it from about fifteen feet away, and I mean, it was an *amazing shot*! I thought it had to be a mistake, because nobody would do that. But Joe was laughing, and Elvis was laughing, kneeling down and saying, 'Oh, I'm sorry' over and over, and Linda was so nervous in her yellow jersey dress that it turned a different color from under her arm down to her waist."

When Elvis looked up at her, Sheila finally realized that Elvis had actually thrown the grape on purpose, so she wasn't surprised when Joe was on the phone, having dialed her every few minutes for two days while she was changing apartments: "Where in the heck have you been? My boss likes you and wants to see you."

She was so angelic-looking, she could have passed for a fourteen-year-old. And though she'd been on the cover of *Playboy* magazine just that previous October, she was a virgin, a Catholic girl from the burbs of Chicago, Franklin Park. For some reason she couldn't quite figure out—she had self-esteem issues, as well as what would later be diagnosed as Asperger syndrome—men flocked at her feet. She'd left home fleeing from a crazy boyfriend, intending to go to L.A. But she got only as far as Las Vegas in her worn-out Volvo and wasn't sure what was next.

Sheila was thinking about all that as she rode up the elevator to Elvis's suite between shows. He gave her a hug, and "he was dripping wet with sweat, and he had a white towel, and the towel was dripping wet, and he had no qualms about just sweating all over me."

Immediately, he made a little dig about the fact that she was wearing slacks, but they were the best things she owned. To Sheila, who would be Elvis's only hippie girlfriend, slacks meant dressing up—normally she wore jeans with holes

in them—and now she felt sheepish. "They're Sir For Her," she said defensively, meaning they were a good brand.

"Why do you dress like a man?" he continued. She looked at his stage outfit, which reminded her of a Dalmatian, and then she gave it right back to him.

"Does Cruella know you have her cape tonight?"

He let out a hearty laugh. He liked it that she was capable of such quick and funny repartee, and he admired her spunk. But she could see he was even more nervous than she was, and that a girl in a pair of slacks, with her hair stuck flat to her head, wasn't going to do it for him.

Still, she got in a snit when he ordered her to put on some eyeliner. And when he said, "Your bathroom is over there," she thought, "Oh, it's *my* bathroom, is it?" She was just a little bit miffed, but in a fun sort of way, and as she made her beeline, she flipped him off, but in the front so he couldn't see.

"And don't sass me, either," he called out. Sheila shook her head. How did he *do* that?

In the bathroom, she rummaged around and did the best she could with the little makeup she had in her bag, and when she reappeared, he stunned her. "Do you believe in love at first sight?" he asked.

Sheila was certainly attracted to him, but she didn't know whether it was love, and she wouldn't decide for seven months. She would be his last significant girlfriend. But at that point, all she knew for certain was that Elvis had made it clear how he felt. And that "once you are on the other side of that black velvet curtain, life is never the same."

.

They ate dinner in the bedroom after the second show, and then he moved near the platform bed and sat cross-legged on the floor. People always threw all kinds of odd things on the stage to him, and this night, he brought back a baby's bib, a plastic fireman's hat, and a necklace with a cross on it made of gold twigs, with the initials *EP* and a star set into the bars of the cross.

Since he hated being called "The King," he gave her the necklace. Then he put on the fireman's hat and asked Sheila to tie the bib around his neck. To her astonishment, he began to speak in a tiny voice.

"I'm Elvis! I'm Elvis Presley! I'm a baby! This is my bib! Sit here by me!"

She could tell that he wasn't just goofing around, that he really *wanted* to be a baby, and he wanted his mother.

"I thought, 'Oh, boy. We have problems here.' And I knew I had to make a decision right then and there. She thought for a minute: 'Can I do this?' And the answer was, 'Damn right I can.'"

They spent most of the night together, and while it never got anything close to being sexual, it was romantic. He sang to her on the balcony, and he was very kissy—very, *very* kissy, she thought—and they had a lot of fun just rolling around with their clothes on. Later she was relieved he wasn't the sort of cuddler you have to push off of you all night long.

She let him fall asleep, and then around 5 A.M., she got up and went back to her apartment. Six hours later, Joe was on the phone. "Goddamn it, where are you? The boss is furious!" She realized then that she was expected to stay the night, and when she got back to the hotel, she assumed Elvis would be thrilled to see her. Instead, he was mad. He was sitting at the breakfast table, and his leg was doing a Saint Vitus's dance.

"He said nothing, and I was perplexed. He said, 'Follow me,' and I did, like a little geisha. We went in the next room, and he pulled out a hypodermic needle, filled it with Demerol, flicked it three times so there were no air bubbles in it, and handed it to me." Then he put his thumb into the elastic waistband of his pajamas and pulled it down just far enough.

"Have you ever done this before?"

"Uh-huh." She'd been a nurse's aide, so she wasn't unfamiliar, and she gave him the injection.

"I said, 'How was it?' and he said it was okay, but I knew it had to be better than what he got from whoever else was injecting him, because his whole bottom was bruised with contusions, and hard, with scar tissue. You couldn't really penetrate the skin."

She didn't blame him for wanting it. "Demerol is a great way to start the day when you're around what he was around."

But there, on the continuation of their first date, Sheila had an epiphany: "I knew that I had been sent there for the downfall. I have always been a believer, and I've always known that there is a Higher Power. I knew that Priscilla met him to marry him. And Linda met him for the girls' time, and I met him for the downfall. That's what I felt my job was, and I accepted it. I never thought that I would fall in love with him. I just loved him and wanted to take care of him."

He wanted to take care of her, too, but first he had to put his mark on her. When the shot worked its magic, he had Joe order up a fashion show from Suzy

Creamcheese, who brought over racks and racks of dresses. "When you walk through that showroom," he told Sheila, "I want everybody's eyes on you. I want everybody to know you're mine. I don't want to know that you even existed before this moment. You were born just for me."

When they finally made love, she was afraid. She'd tried it once with her last boyfriend, and she was too dry, and he couldn't enter her. And then there was all that guilt tied in with her religion, so it was emotional and confusing. She'd never heard of a man who preferred pumping to actual sex ("In the Catholic faith, he'd get warts on his hand"), but Elvis was thinking of her benefit. So she wouldn't get pregnant, "he pulled out and finished himself off and put it all over my belly.

"The first thing that crossed my mind was, 'Oh, my God, he's perverted.' Because I was just so naïve. My second thought was that I wasn't enough woman, that my vagina must have been the size of the Grand Canyon, and that he was bouncing off my insides, so he had to hold on to himself. I thought he was so much more sophisticated, so it had to be me."

Eventually, Dr. Nick advised her to go on birth control. Yet sometimes she and Elvis just wrestled on the bed and had pillow fights, or he'd tell her stories, like the time he dry humped a famous British pop star in her panty hose and rubbed himself raw. But when they did become more intimate, it was a familiar ritual.

"He did this little dance. It was the, 'We're going to do it dance,' his little mating call. He was uncomfortable with the beginning of it, so he'd walk on one side of the bed. As soon as he had a certain look on his face, he would turn away, and scratch his head, make sure the lights were right, and then pull off one of his shoes and then one of mine, and talk about the weather for five or six minutes. At the time, I thought it was just adorable, because I knew what was coming, so I would get a little wet."

Despite all the women he'd been with, she was surprised that he was still shy at certain aspects of lovemaking, though he liked giving oral sex.

"He would start at my ankles, and then go up, and once he had his head in my muff, with his hands reaching up to my breasts, all of his shyness went right out the window. He made jokes, and he would come up and look me straight in the eyes."

Because she was inexperienced, at first she wasn't sure if she really had an orgasm. Elvis was a tender lover, but she couldn't relax enough, she thought.

To help her through it, Elvis said an Indian wise man had told him that there was one way to find out for certain if a man had satisfied his woman.

"He said that if the lips on her face were cool, she'd had an orgasm, because all of the blood had rushed to her vagina. Once I was familiar with the story, he would make references to it. And then when I would be making the appropriate noises and sounds of ecstasy, he'd say, 'Okay, I'll see if I took care of my baby.' "

She didn't want to disappoint him, so "a couple times, I was quick to wet my lips and breathe in. I didn't want him to think he hadn't done the job. Then one time I was getting ready to wet my lips, and before I knew it, I was in full-blown orgasm. I was like, 'Oh my God!' And he laughed so hard."

With Sheila, he rarely asked for oral sex in return. Generally, he thought that's what prostitutes were for, not girlfriends, though Sheila thought it had to do with the fact that he wasn't circumcised. "He didn't seem to want it. He was a giver and it didn't stop at giving cars and jewelry—even sexually, he was a giver."

They were good together, at least for a while, and Elvis seemed completely under her spell, bemused by her crooked smile and what he called her "bubble butt."

However, their sexual appetites didn't always match. She understood his rules, that "I was never to be a first-thing-in-the-morning kind of girl," and that "there couldn't be a natural odor to me anywhere." But she hadn't counted on the sleeping pills. One morning, she had douched, showered, powdered, puffed, dressed, and prettied to his expectations, and now it was Sheila who did the mating dance. First, she tickled his nose with a feather, but she watched in frustration as it rose and fell to the breath of slumber. Next, she took all his rings from the bedside table, put them on her own fingers and made tapping sounds, sitting right next to him on the bed.

"I didn't want to get in trouble, but I wanted to play. I wanted to make love, and I really wanted him in me. But he didn't wake up, and I was sitting there, sitting there, and sitting there."

In his conscious moments, Elvis appreciated Sheila most of all because she made him laugh, and he found her naïveté fresh and disarming. He liked to roll her middle name, "Marie," together with her first, so it came out as a mush of sound—"Sheila M'ree"—but he also had several nicknames for her based on her haircut. One was "Dennis," for "Dennis, the Menace," and the second was "Chicken Head." The latter was reminiscent of what he'd said to actress Goldie Hawn when he met her while taping the '68 special: "He walked up to me and he tousled my hair and he said, 'You look like a chicken that's just been hatched.' " Shirley Dieu understood that the concept of an intelligent girl who acted like a ditz was a turn-on for him.

"That's how Sheila was, like Goldie Hawn. She had that same dumb blond personality. Priscilla asked me one time, 'What is it that Elvis sees in Sheila? She's not his type.' But she would just say the stupidest things. For example, if Elvis would walk in the room and everybody would be really quiet, Sheila would be like, 'What? Why is everybody quiet?' And then laugh. She just was oblivious to it all, and she would think out loud when she talked, like, 'Uh, I don't know . . . uh . . .' It was cute, and just really funny. And that's what made her entertaining."

One person who wasn't entertained was Linda Thompson. After Sheila had been alone in Vegas with Elvis for eight days, Linda found out about it, and as Shirley remembers, "Linda was so jealous of her that she had us all convinced that Sheila was a hooker. She told everybody that Joe had picked her up, and after he had paid for her, she wanted to be with Elvis." Shirley actually believed it for a while and then learned better.

Elvis and Linda had a terrific row over Sheila on the phone during Sheila's first stay, and it opened Sheila's eyes to both the volatility and the importance of his relationship with her.

"I heard a tone coming out of him that was so guttural that I thought, 'He must be fighting with Priscilla.' I was in the bathroom and I stayed there, because I didn't even want to believe that there was someone in his life who could make him this angry. She was just letting him have it, and he was explaining to her when he would be home and when she could come see him again, and it was very, very disturbing. He was saying, 'You've always gotta do it, don't you? You've always gotta twist the knife so that my gut can't even breathe.' He just got vehement. And that's when I came to find out that Linda, who he let on was 'just a girl,' was very much a part of his life. That was a rude awakening for me."

What puzzled Linda the most was how paradoxical Elvis was in terms of romance. On the one hand, she knew that he loved her immeasurably and that he was devoted to her emotionally. He took the time to articulate his feelings, saying, "I know that I haven't been completely faithful to you. I know that you don't understand a lot of the things that I do. But you have to know that you could never be with anyone who would love you more."

And so they would remain in each other's lives. But there would continue to be plenty of competition. Not only would Linda and Sheila pass each other on the moving sidewalk in the Las Vegas airport at one point, but when Sheila went on tour with him in March 1974, Elvis had Marty pick up Ann Pennington in Monroe, Louisiana, while someone else took the departing Sheila to the plane. For Ann, "I had a little 'ouch' about it, but it was like, 'That's the way it is.'"

After March, Sheila didn't hear from him for months, understanding that she and Linda were "sort of running a horse race . . . we were neck and neck and then I fell behind." And so she moved to Los Angeles and made no effort to get in touch with him. During the interim, Elvis reconciled with Linda, threw a twenty-third birthday party for her in May, and let her redecorate Graceland in a brilliant red color scheme, replacing the original blue.

Linda was the woman who best met his tricky combination of requirements— sexy, yet motherly, gentle but feisty, and perhaps most important, spiritual. Still, Elvis thought he hadn't found exactly what he was looking for, and one night that spring, he took Larry Geller aside at the Monovale house. "I've got to meet someone, man. You know a lot of women. Fix me up."

To Larry, it was preposterous. Elvis was the biggest sex symbol there was.

"I don't know, Elvis," Larry said.

But then he thought of Michelle Meyers, who booked rock groups for all of the clubs and knew every girl in town. Larry dialed the phone. "Oh, I know this girl, and she'd be great," Michelle told him. That evening, Elvis sent one of the guys to pick her up and bring her to the house for a party. But when she came in the door, Elvis turned sharply to his friend.

"His eyes popped open, and it was like, 'What in the hell did you do to me?' " She was disabled and hobbled in on a cane.

Elvis treated her as he did all the rest of the women there that night ("Honey, would you like some food?"), and she settled in with the group. But when the conversation grew dull, Elvis turned to Larry's younger sister, Judy, a live wire who had come up to the house a number of times. At five foot six and 120 pounds, Judy was tall and thin, with long, dark hair and green eyes, and Elvis had always liked her. He'd also met her twin, Elaine, some years back when Larry brought her on one of the movie sets.

"Elvis was sitting on the couch with beautiful women on each side of him, but they were posed like mannequins—they were afraid to talk to him," Judy remembers. In contrast, and just to breathe some air into the room, she peppered him with questions: "Elvis, how did you get your black belt?"

The night wore on, and about 1:30 A.M., Larry suggested it was time to go. Judy walked over to Elvis, still on the couch and surrounded by women, and kissed him briefly on the lips. "Nice seeing you," she said. She was almost out the door when he yelled out, "Hey, I never kissed you before!" Judy shot him a flirty glance.

"It wasn't so bad," she purred.

"That's all he had to hear. He got up, grabbed my arm, walked me out to the car, took my purse off my hand, and started French kissing me in the car."

"Oh, my God!" Larry thought. "My sister with Elvis!" He hurried away with a quick good-bye.

Now Elvis looked Judy square in the face. "Will you stay?"

"Absolutely not," she said. "You're with another woman."

"Will you come back again tomorrow night? I won't be then."

"I'd love to," she said. But down deep, "I was scared out of my mind. Out of my *mind*! I took a Valium to go to his house."

She was so frightened, in fact, that Larry had to drive her, steering the car up to the gates and through all of the screaming girls who taunted, "You can't get in! You won't get in!"

Inside, Lisa Marie did cartwheels and handstands to entertain her father's guests. After a quick hello all around, Judy sat next to Elvis on the couch, while Larry and a few of the guys filled the rest of the chairs in the den. Larry was even more nervous than his sister, and finally blurted, "I can't take this! I have to go!" Soon, everyone else left, too, and then it was just Judy and Elvis watching television. After a while, Elvis said, "Come on. Let's go upstairs."

His bed, big and round, sat in a curved wall of mirrors, "so that wherever you looked, you'd see Elvis." Judy stared at the ornate chamber of seduction, felt her heart jump, and almost lost her nerve. "I was thinking, 'I can't believe this! It was stunning.'" But it paled in comparison to the sight of Elvis emerging from the bathroom in navy blue pajamas piped in powder blue. "He really was to die for. I couldn't even look at him. I thought, 'I'm with Jesus Christ.' That's how powerful he was, like nothing you have ever seen before. He was so hot it was scary."

The elegant pajamas never came off, but it didn't matter. He and Judy spent the whole night hugging and kissing, doing everything and nothing. The high point came when, "He laid on top of me, held my face in his hands, looked into my eyes, and said, 'I love your mouth.'"

"I can't believe I didn't pass out."

But Elvis soon did. Around 3 A.M., he asked if she minded going downstairs and getting his dinner. The cook had left it in the refrigerator, he said. "You'll know what it is when you see it."

Judy made her way to the kitchen, fixed his plate, gathered the silverware, and brought it all upstairs, only to find him lost to the world. "I said, 'Elvis . . . Elvis?' I thought he was dead. I didn't know. I was scared. I took my finger and

pushed on his eye to see if I could get a reflex. I didn't see him take anything, but whatever he took hit him hard."

She stayed with him, not really knowing what to do, and after a while, he got up, ate a little, and then fell back to sleep, not waking again until 8 A.M.

"Will you spend the night with me?" he asked, meaning the rest of the day. But Judy had had enough. "At that point, I was so freaked out, I said, 'You know what? I think I should go.'" Elvis looked disappointed, but called for one of his stepbrothers. "Open the gates," he said through muzzy speech, "and make sure she gets out okay."

.

His appetites continued to run more to the cosmic than the carnal. In late August 1974, he was back in Vegas, and on September 3, he took in Tom Jones's performance at Caesars Palace, climbing up onstage with the Welsh star who had been his friend since the 1960s and singing "American Trilogy."

Afterward, actress and beauty pageant winner Susan Anton was invited back, where Elvis started showing her his karate technique. Soon he suggested they take the party over to his suite. The two of them sat talking on the couch for a while, and then he said, "Come with me. I have something to show you."

"I thought, 'Uh-oh, here it is. This is the move.' He took me down the hallway to his personal room and motioned for me to sit in a chair. And then he sat on a footstool in front of me and began reading from Kahlil Gibran's *The Prophet.*" Even though Elvis was an icon, Susan could see "he was just a sweet country boy under all that. It was like talking to a big brother."

Whether Susan realized it or not, Sheila was with him that night. By August, when she still hadn't heard from him, she phoned him in Vegas, and he invited her to fly over when Linda, who attended opening night, went home. He'd garnered terrific reviews, the *Hollywood Reporter* calling it "the best show . . . in at least three years. Presley looks great, is singing better than he has in years, and was so comfortable with his show—almost all new songs—the packed Hilton showroom gave him several standing ovations."

But on September 2, his closing night, when Sheila, Priscilla, and Lisa Marie were in attendance, he delivered two long stream-of-consciousness monologues in which he seemed compelled to explain the recent events of his life. He was just coming out of Marty Robbins's song, "You Gave Me a Mountain," and started by saying the song had nothing to do with him or his ex-wife.

"She's right here," he said of Priscilla. "Honey, stand up. [Applause] Come

out, honey. Come out, come on out. Turn around, let them see you. [More applause] Boy, she's . . . she's a beautiful chick. I'll tell you sure, boy. Boy, I knows 'em when I picks 'em. You know? Goddamn.

"And then at the same booth is my girlfriend, Sheila. Stand up, Sheila. [Applause] Turn around, turn around, completely around. Sheila, hold it up. Hold it up. Hold the ring up. Hold up the ring. The ring. Your right hand. Look at that son of a bitch."

Priscilla sank deep into the booth as Elvis began discussing the reasons for the divorce, the $2 million settlement, and Mike Stone, purposely confusing the words *stud* and *Stutz,* referencing the car. "Mike Stone ain't no stud, so forget it," he said. "I wish [Mike] was a stud, you know. He's a . . . *nice guy.*"

He went on to sing "Softly as I Leave You," but then later in the evening, he was at it again, this time trotting out the Patricia Parker paternity rumor, saying, "I had a picture made with that chick, and that's all. And she got pregnant by the camera."

The audience responded nervously, mixing tight laughter with applause, and seemed to fear what might come next. Now Elvis wanted to address another rumor, that he had missed shows because he had been "strung out" on drugs. He had the flu, he insisted, his voice growing angrier and more agitated. "If I find or hear an individual that has said that about me," he ranted, "I'm going to break their goddamn neck, you SON OF A BITCH! [Screams and applause] That is DANGEROUS! I will pull your goddamn tongue out BY THE ROOTS!" And with that, he bizarrely switched gears and calmly segued into "Hawaiian Wedding Song" from *Blue Hawaii.*

"I was in shock," Priscilla said later. "Because [in the past], he would never, ever let on to the audience what his emotions were. . . . This was [so] out of character for someone who had so much pride. Everything that he was against, he was displaying. It was like watching a different person."

Sheila was also perplexed. He'd given her the ring just before the performance, "and I was a little frightened, because I thought maybe he was going to ask me to marry him. It was a crystal ring with diamonds set on the top, and it was huge! I was excited by it, and then disappointed when I realized what it was all about. It was so he could introduce me and have Priscilla turn green with envy. When he said, 'Show them the ring, baby,' I mean, he made that ring big enough for the entire showroom to see from the balcony."

Sheila was confused about all of it, including where she stood in his life.

They went to Palm Springs together for five days afterward, and then Elvis went home to Memphis, to Linda, who wasn't certain about her role, either.

While he was there, he bought Billy and Jo Smith a 1975 Woodcrest double-wide trailer with three bedrooms, and installed it in back of Graceland. The entourage of old hardly existed anymore—the guys were all getting older now, and they had different priorities and families of their own.

Out in California, Elvis had called Patti Parry, who was engaged to be married and living in Malibu with her fiancé. "He said, 'You've got to come up here now.' I said, 'Elvis, I'm moving.' He said, 'No, no, I need a haircut.' I said, 'I just cut your hair.' He said, 'Please.' So I left, and when I got up there, he gave me a mink jacket. I said, 'You're not losing me. You'll never lose me.' He got nervous, because he didn't have that many friends. Not really."

Elvis had added some new guys to help with costumes and security in recent years—Al Strada, karate expert Dave Hebler, and soon he'd bring in Dr. Nick's son, Dean. His stepbrothers, too, had taken on some of the old responsibilities. But Elvis didn't feel the loyalty from them that he had from the old gang. And Red, who Sheila considered to be the only real friend Elvis ever had, knew that the Stanleys numbered among Elvis's drug connections, along with a member of the backing group, Voice. When Red found out the singer was supplying Elvis with hard drugs, his famous temper rushed to the fore. "I kicked the door in, I stomped the guy's foot and broke [it], said, 'You keep bringing them, I'm just gonna work my way up.'" Everybody thought it was a good idea if Billy Smith were just a little closer, to keep an eye on things.

Elvis had now reached a critical level of drug use. On September 27, 1974, before a show at Cole Field House in College Park, Maryland, Tony Brown, Elvis's new keyboard man who joined the show that fall as part of Voice, watched in anguish as Elvis fell to his knees getting out of the limousine. ("I don't even know how we got him on the plane," Red told Sonny.) His performance that night reflected his woozy state, and fans and reviewers alike expressed dismay.

In the audience was Barbara Hearn, Elvis's Memphis girlfriend from 1956. She was living in the Washington, D.C., area with her husband, James Smith, and they attended the show with two other couples.

"Oh, I was so sad! I had planned to go down and to speak to Mr. Presley, and I would have gone back to say hello to Elvis, too, but after sitting through the show, I didn't want to. I had wanted my friends to see how special he was, but he was anything but special."

Elvis and Diana Goodman depart the hotel for his concert at the
Nassau County Veterans Memorial Coliseum, Uniondale, New York, July 19,
1975. Diana, Miss Georgia USA, later enjoyed a short stint on *Hee Haw*,
as Linda Thompson had before her. *(Ron Galella)*

THIRTY-THREE

· · · · · · · · · · · · · · · · · · ·

Flickering White Light

In October, Elias Ghanem became increasingly concerned about Elvis's distended colon and ordered a series of tests. The results were not extraordinary, but Elvis was now traveling with a trunk of Fleet's enemas, which some of the guys groused about carrying, and his bowels were so unpredictable that he would often sleep with a towel wrapped around his midsection.

Lamar saw that "he would be so damn drugged up, he couldn't make it to the bathroom. Or he'd get in there and start back out, and be so groggy he'd fall down on the floor. That's where they'd find him."

Dr. Ghanem had recently added a new wing onto his house for celebrity patients and suggested that Elvis come there for a "sleep diet," for which he would be sedated and take only liquid nourishment. The idea was to force Elvis to rest, and in the process, let him lose fifteen pounds before his next tour. Sheila took the first shift, staying about a week. Linda would return with him for a second stint in December.

Elvis originally told Sheila about it when they were lying in bed on Monovale. She didn't like the sound of it, but "he said, 'Baby, Ghanem's got the sleep diet,' and it was the first time that he and I were making a decision together, and I didn't want to nix it."

There was no way that Elvis could be kept totally asleep without general anesthesia, Sheila learned, and Dr. Ghanem was often not there.

"It was the worst time that I ever endured," she says. Elvis often woke up in the middle of the night and wanted a papaya shake, but it wouldn't be time for it, or he would spill it, and as soon as Sheila changed the sheets, he'd soil them. Then she'd get him up and take him to the bathroom, but "he would have to

crawl. I would stay awake all night. I had my entire face break out from the stress."

.

In September, when Elvis was home in Memphis, he met fourteen-year-old Reeca Smith, a friend of Ricky Stanley. His fortieth birthday loomed in January, and Elvis was doing everything he could to stave off depression. It was the number he had set for himself to deliver his "message" to the world, and he felt defeated, that he still hadn't found his purpose. Reeca, with her long, thick, blond hair, was just the sort of young girl he always delighted in mentoring.

"He was dating Linda at the time, but he mentioned that I reminded him of Lisa, because we both had blond hair. He came over to my house and met my parents, and my dad just loved him, because he was so friendly and such a gentleman. Elvis told him, 'With the age difference, you probably think it's crazy for me to see your daughter. But I think she is a wonderful girl and I have great intentions.'" He called her his "Li'l Lioness" for a jacket she wore with a big fur collar. "He said he loved the way it framed my face."

The relationship lasted only a few months, and mostly they spent time just hanging out and watching television downstairs at Graceland. He needed somebody to keep him company, and he took delight in buying her nice outfits, including a long, ornate suede-and-leather coat that fed her dream of becoming a model. ("When he gave me the clothes, he was just like a kid. He was so excited, seeing me happy.") Elvis also counseled her about the dangers of prescription drugs, saying he didn't ever want to catch her taking them. "In fact, Ricky tried to give me something one time, and Elvis heard about it, and oh, my goodness, he hit the ceiling."

Overall, Reeca considered Elvis to be extremely protective.

"He didn't take advantage of me. He kissed me, but they were just sweet, innocent kisses. There were a few make-out sessions, and we would make out for a long time, but that's all, nothing where he would try to go any further. I remember he would kiss me and say, 'You are just a beautiful little girl.'"

Her father, Ed Smith, let her accept the silver Trans Am Elvis bought her, even though she wasn't old enough to drive, but when Elvis wanted to take her on a plane ride to Nashville, Ed drew the line. Reeca was ready to end it anyway, which she did in February 1975.

"I saw the decline in his health, and it scared me. He had gained a lot of weight over that period, and he just didn't seem as happy. It upset me, just know-

ing his situation. I got to where I would tell my mom I didn't even want to take his calls, because I just felt helpless, and it was sad seeing it happen."

One day when Reeca was there, Elvis called everyone in the house to his room, where he held a meditation—a séance, really—to talk to Gladys. Reeca hated hearing him "slurring . . . just really kind of out of it," since he tried to be alert whenever he was with her. "It broke my heart. He told his mother how much he missed her, and that he loved her, and that he couldn't wait to see her. I got a weird feeling when he was talking to her, because it was like a sadness came over the room. Then he wanted to be alone for a little bit, and everybody left."

In late December, the Colonel canceled Elvis's January 1975 engagement in Vegas, citing health reasons. It was a prophetic call. About 7 A.M. on January 29, Elvis and Linda were sleeping at Graceland when "I woke up and I felt something wasn't right. His breathing was strange, so I shook him and I said, 'Honey, are you okay?' He said, 'I can't get my breath.' So I called for the nurse, and she brought some oxygen over, and we had to rush him to the hospital."

Again Linda stayed with him for two weeks during which time Elvis grew a beard. And while the Colonel issued a statement that Elvis was undergoing tests on his liver, Dr. Nick once more tried to find a way to control Elvis's use of prescription drugs. In the middle of that chaos, Vernon suffered a heart attack and was admitted to Baptist Memorial Hospital, where he recuperated in the room next to his son.

When Elvis was discharged on Valentine's Day, either Dr. Nick or nurse Henley came by each afternoon to dole out a controlled amount of medication. By March, their patient was feeling well enough to record again, flying out to Los Angeles and going into RCA's Sunset Boulevard studios on the tenth. He brought along both Lisa Marie and Sheila, to whom he sang Don McLean's "And I Love You So," begging his girlfriend to "step up, let me sing to you, baby."

On the eighteenth, he began making up his Vegas dates, and ten days into the engagement, he received actress-singer Barbra Streisand and her boyfriend Jon Peters, formerly her hairdresser, in his dressing room. The pair hoped to interest him in their updated remake of *A Star Is Born,* casting Elvis as the aging rock icon in love with the rising young starlet. Elvis was gleeful at the challenge, hungering for a serious role that would make everybody forget his string of celluloid humiliations.

He was poignant in his discussions with Kathy Westmoreland, telling her it was his last opportunity to prove himself on the screen. "People aren't going to remember me, because I've never done anything lasting. I've never made a classic

film to show what I can do." But to the guys, he was more upbeat, excitedly saying, "Can you believe that Barbra Streisand wants me to be with her in that movie?"

Yet after much back and forth, the Colonel denounced it as too cheap a deal, saying Streisand and Peters were only trying to take advantage of him. Once he got over his initial disappointment, Elvis, too, came to that decision, and worried that a loser's role might actually make him *seem* like a loser. "He was really more upset than most people know," Priscilla says. The Colonel, who would never allow his client to accept second billing anyway, helped him save face in the press: "There was never no plan for him to do *A Star Is Born*. He told me to make the contract stiff enough where they would turn it down, 'cause he did not want to do it."

· · · · · ·

That spring Sheila came home with him to Graceland, where he talked to her about moving in. He was finished with Linda, he said. It was not precisely true, even though he bought her a house in Memphis and an apartment in Los Angeles so that she could pursue an acting career. Linda was furious that Sheila was in Memphis, and when she started spending a lot of his money in retaliation—$30,000 on his MasterCard alone—the words *gold digger* floated around the group. ("She was a beauty queen, and she knew how to get what she wanted," Sheila says.) But Linda had her defenders, too, Billy suggesting she'd earned it, and Marty insisting Elvis encouraged her to spend money so she'd be away and he could do as he pleased.

Sheila, meanwhile, found Elvis increasingly difficult to be around and worried that he might be having a breakdown. At the Memphian one night, she asked him a technical question about film, and coming on the heels of the Streisand debacle, it seemed to open a floodgate of anger and resentment about the mismanagement of his Hollywood career. He insisted they immediately leave the theater, and on the way home, he stopped at a drugstore, where they pulled a Bonnie and Clyde, Sheila distracting the druggist with questions about menstrual products while Elvis cleaned out the pharmacy. Later, he mailed the druggist a check.

That same spring, Elvis met twenty-four-year-old model-actress Mindi Miller through Ron Smith, who later became well known for establishing the Celebrity Look-Alikes firm. Ron was another of Elvis's friends who promised to be on the lookout for girls, and ran into Mindi at a Hollywood disco called the Candystore. Elvis had just broken up with Linda Thompson, Ron told her, and invited her to a party at the Holmby Hills house. But when Mindi arrived, she found only Elvis's guys, who proceeded to screen her as their boss's potential new girlfriend.

At five foot eight, Mindi was tall like Linda, and shared a beauty pageant background, but she was also smart, poised, and utterly unimpressed with celebrities, having come from a family of performers. But meeting Elvis was something that intrigued her. She'd seen him driving on Sunset Boulevard sometime before in his Stutz Blackhawk, with his slicked-back hair and *EP* glasses, and she had a premonition she would some day know him. However, that night, when the guys gave Elvis the signal and he strode into the room in a tennis hat, she didn't even recognize him. It was a funny bit of business that broke the ice.

From the beginning, they settled into a natural groove. He looked at her in astonishment when she turned down a ring ("I'm sorry, I wasn't raised to take an expensive gift from a man like that"), and he was more impressed when she said no to a car, though later she did accept a Trans Am.

They spent the first night together without even kissing. Mostly, they laughed and talked, and even sang a little bit, both of them, Elvis launching into his new song "T-R-O-U-B-L-E," just as if he were onstage. ("He just sang his little heart out.") They discussed mystical matters, particularly numerology and "how everything in the Bible is a dividend of seven, the highest spiritual number that there is," and he gave her a set of his favorite little books so they could talk about them on the phone.

Mindi shared his open mind and fascination with such subjects, and she could tell how desperate he was for a real connection. But he was upbeat with her, even when he eventually told her that, "When I die, there will be certain people that I will contact and be in touch with beyond the grave." He also told her he was afraid of the dark, and thanked her for not laughing at him.

At 7 A.M., as she was leaving, he put on a karate demonstration for her with the guys and asked if she'd like to learn the discipline. "I'd love to," she replied. "But I won't be here. I'm moving back to Rome." Elvis was shocked. "What do you mean? You don't live here?"

She explained that most of her work was in Europe, and that it only made sense for her to live there. Elvis turned to the guys and told them they could go, and then he asked Mindi to come back upstairs to the bedroom.

"Listen," he said. "You know I would like to see you again. Do you have to move back to Europe?"

"Well, I don't have to, but I just came back to close up my apartment and sell my car. Everything is packed and ready to go. I'm supposed to leave in three days."

"No," Elvis said, shaking his head. "You can't. I won't let you." Then he called

downstairs to the guys: "Make sure you get her number and address. She's coming on the next tour."

"Look . . . Elvis," she said. "I'll be very straight with you. I have no intention of staying here, but if I did, it would only be to be your girlfriend."

"Fair enough," he countered. "You're my girlfriend." But he had to be honest, too. It wasn't in him to commit to just one woman. He was put on earth to entertain, and he belonged to the world. That might have sounded crazy to a lot of people, but Mindi knew it was true. He kissed her then, and sent her home to get some sleep. But she had hardly gotten home when he was on the phone: "I just wanted to tell you that I'm really looking forward to showing you my life," he said, and the next day, he wrote her a $5,000 check to retrieve her things from Rome and set up her apartment again.

She went with him on tour that April, where she made a lifelong friend of Shirley Dieu. But when she landed in Florida, it was the guys who gave her the real indoctrination to life with Elvis.

"They took me aside and said, 'There are certain rules you need to follow. First, you don't leave Elvis alone. If he gets up in the middle of the night and goes to the bathroom, you get up with him. Then you knock on the door to see if he's okay, and then make sure that he gets back to bed. If for some reason he doesn't answer or something's wrong, here's who to call.'"

Like Linda, Mindi watched him constantly and refused to leave him unattended, laying her head on his chest as he slept to monitor his breathing, and "putting my hand under his nostrils to make sure there was air." But she never saw him O.D. or abuse medication, and balked at giving him shots of anything stronger than vitamin B-12. "I took care of him, so on my watch, nothing ever happened."

The Florida dates consisted of four nights in Jacksonville, Tampa, and Lakeland. In Jacksonville, Jackie Rowland, now all grown up and married with three children, tried frantically to get in touch with Jerry Schilling at the hotel. Ken Floyd, of the coaching staff of Memphis State, had passed along Jerry's name. Ken told her that Elvis could use her help, that he wrestled with serious drug addiction, and that most of his hospital stays were for detoxing. Jerry was one of the few people around Elvis who tried to act in his best interest, he said.

Jackie called Jerry's room from downstairs, but when she got no answer, she asked the desk clerk to ring the room next to it. It was Elvis's room, but Red answered. She told him about her long association with Elvis, Vernon, and Gladys, and that she had pictures to prove it. Red made remarks she found of-

fensive ("I told him I was a lady and that Gladys would be rolling over in her grave for his being so disrespectful"), and after that, he grew angry, saying if she wanted to see Elvis, she should have called earlier.

"You don't need to see him anyway," he barked. "Elvis has changed. I'm busy trying to get him ready for the show, and he's nothing but a problem. I have to give him injections in his feet, because there isn't any place left on him to give them." Then he hung up, leaving Jackie sad and bewildered.

The next morning, Mindi received a reprimand as well, only from Elvis, when she turned up at the breakfast table wearing a robe, her hair up in a towel.

"Uh, honey," he began.

"Yeah?"

"I don't mind the towel or the robe, but next time I want you to put on some eye makeup or somethin'. You're lookin' a little scary."

They both burst out laughing, and then Mindi asked, "Do I have to do it now?"

"No, honey," he told her, "but when you're done with breakfast, get all made up. Look real pretty."

She understood the drill—that Elvis's girlfriend did not smoke or drink in public, and that she looked like a proper lady at all times. But the brunette drew the line on dyeing her hair black, and when he wanted her to have cosmetic dental work ("You need bigger teeth . . . they're tiny"), she said a model couldn't just make drastic changes overnight.

Their relationship was healthy enough that they could openly discuss all kinds of things, including Elvis's weight. He told her he was embarrassed about it, and worried that his fans might not still love him. Mindi assured him that they did, but she also pointed out that he had no conception of nutrition, calories, or portion sizes. When he ate a gargantuan salad and insisted, "It's just a salad, baby. I'm not going to gain weight," she'd say, "Elvis! Yes, you are! It's big enough for five people!"

At another time in his life, they might have made it work. She cared about him, and promised him she would always be there for him whenever he needed her. While she would see other men, she took no serious boyfriend, as he had asked. But then Elvis found out she'd been involved with black actor-football star Fred Williamson, and while it preceded their own relationship, he pulled the plug, just as he had on Joan Blackman when he heard she'd dated a black man, too.

"He wasn't a racist person," Mindi clarifies. "That's just the way he was

raised." And so, she continued to be a part of his support team, if only by phone. The one thing she didn't miss was the touring, which she considered both grueling and boring.

Sheila, who didn't like the road, either, went back on tour with him in June 1975, and found it even more intolerable than before. She knew he was tired of playing the same towns over and over, that he needed the lift of a European engagement or something stimulating to break the routine. But she also suspected that a lot of his moodiness was due to what was in his black bag of pharmaceuticals, which she was in charge of carrying. Elvis was so irritable that the slightest thing set him off. He had a huge tantrum in Mobile on June 2, when he found she didn't have her slippers. Then when she announced she needed to go home for a mammogram, she could feel the heat coming off of him at the breakfast table.

"I never would dare say, 'What's the matter, honey?' But his pajama sleeve caught the creamer and tipped it over, and then he cleared the whole table with his arm, and my scrambled eggs, too, and he said, 'You and your fuckin' tumor!' He didn't want me to go, but I needed the rest. One day with Elvis was like five with anybody else."

Gone were the days when they'd check into some crummy motel on the road and make love in the afternoons. Everybody on tour had known about it, because after Elvis's daily shot of Valium, he'd get so randy that "while all the guys were bringing things in, I had to get in my jammies."

Now Joe was telling her to "get out of this mess," and Ann Pennington, who had become her friend through another girl in L.A., was trying to introduce her to new people. That July after Elvis had recuperated from a cosmetic eye procedure he'd had in mid-June, Sheila was supposed to meet him in Uniondale, New York. But she didn't want to go. In fact, she'd met actor James Caan through Ann, and had already committed to marry him. Nobody wanted to tell Elvis just yet, so they made up a story that she couldn't fly due to an ear infection.

Determined to have Sheila with him, Elvis told her he'd send a low-flying plane for her. But when she begged off again, he angrily said he would call when he got home. After that, he could barely contain his rage, even onstage. In Uniondale, on July 19, he threw a guitar into the crowd and yelled, "Whoever got the guitar can keep the damned thing—I don't need it anyway."

The following night, in Norfolk, Virginia, he was still out of control, repeating crude sexual remarks about Kathy Westmoreland that he had made in other cities. ("She will take affection from anybody, any place, any time. In fact, she gets it from the whole band.") After that, he raised eyebrows saying he smelled

green peppers and onions, and that the Sweet Inspirations "had probably been eating catfish." Finally, a few days later, he accidentally shot Dr. Nick in an Asheville, North Carolina, hotel room, though the bullet, which ricocheted off a chair and hit the physician in the chest, did no real damage.

Taking Sheila's place that tour was Diana Goodman, the reigning Miss Georgia USA, who Elvis picked out of a tour group at the Graceland gates. In some of their photographs, the curvaceous blonde appears dazed, as if the routine of plane, limo, hotel, show—and dealing with a highly unpredictable host—was a nightmare of unimaginable proportions. Their relationship would disintegrate at tour's end.

Elvis's weight had ballooned well over two hundred pounds again, but more disturbing was his bloat. He looked as if he might pop and spiral heavenward. More disturbing, his roundness made him appear as if he were morphing into Gladys. It was as if she had begun to reclaim him.

On the way to play his Vegas dates that August, he again had trouble breathing on the plane. It made a forced landing in Dallas, and after recuperating in a motel for several hours, he continued on.

Joyce Bova slipped into Vegas with Janice, to see if the rumors about his appearance were true. "I thought he must be sick. That show was such a sad sight. He even had trouble trying to straddle a chair."

Joan Blackman had also heard reports, and went to Vegas to see if she could make a connection. "I was just so taken aback. I had changed, too, but when I first saw him, I was stunned. It wasn't just the weight. I saw something that made me very sad. I felt like something had been taken away."

Three days later, the Colonel canceled the rest of the engagement, and Elvis went home to be hospitalized again, this time for multiple ailments: his colon, a fatty liver, a high cholesterol count, general fatigue, and depression. Once again, Linda stayed with him in the hospital. Marian Cocke, the motherly supervisor of nursing services, came by to see him, and when Dr. Nick suggested that Elvis continue his twenty-four-hour home care, Elvis asked for Mrs. Cocke, whom he had previously met during his January stay, to supplement Tish Henley.

However, watching over Elvis, Vernon, and Minnie Mae seemed taxing for even two women, so Marian, who never accepted a salary for it, suggested alternating shifts with yet another nurse from the hospital, Kathy Seamon. The night before Elvis's discharge, he signed a picture of himself "To Mrs. Cocke, the sex symbol of the Babtist [sic]," and when Jerry cracked a joke about "Cocke and Seamon," Marian picked up an entire pitcher of ice water and poured it down

Jerry's shirt. Elvis, who had already surprised the nurse with a white 1976 Pontiac Grand Prix, laughed until he got tears in his eyes, and told Marian she was going to fit in just fine at Graceland.

.

Near the end of that summer, 1975, he was melancholy again and called Sheila at 4 A.M. "I want you to come home," he said. What did he mean? She *was* home. "No, I mean Memphis. I want you at Graceland." There was a great long silence, and then Sheila said she needed some time to think about it. She never really knew if he loved her or if she were just one of the girls, and now she was with Jimmy, and that seemed like the place to stay. She didn't really tell him that, though, just asked about Linda Thompson to shift the focus, and said she was confused. Elvis's voice was so sad she could hardly stand it. She was his last real chance, and he knew it. "Okay, baby," he finally said. They never talked again.

Next he tried nineteen-year-old Melissa Blackwood, who he'd met earlier in August at a World Football League game. She was just about to give up her crown as queen of the Memphis Southmen, now renamed the Grizzlies, but beauty queen or not, she wasn't used to getting calls at dawn at her parents' house. Elvis sent one of the guys to pick her up at 7 A.M., and when she was ushered into his bedroom and found him sitting up in bed in his pajamas, she didn't know what to think. He patted the massive mattress for her to sit down beside him, and he could tell it made her nervous, even though he promised her nothing would happen.

"He kind of held my hand, and we just sat and talked, and he called me 'Brown Eyes.' There was a little piece of hair on my forehead that grew down like a cowlick, and he played with that and said, 'Look at this hair,' just like I was a little child."

Soon, he asked her to change into pajamas, too, which made her think he was out of his mind. But she did it, the big sleeves falling miles off her hands. He talked about his childhood for a while, told her how sick his daddy had been, and how trapped he felt by his fame. Then as they sat out on the front porch, he watched her face as a new Grand Prix snaked its way up the drive. "Why?" she asked him. "What did I do to deserve this?" His voice was small and sad. "You came," he said simply.

But Melissa could not stay, not after she fed him yogurt and hot cereal and he started shaking and "got so sick he could barely hold his head up." She watched as he took his pills, and when he struggled to swallow, it scared her so her heart

fired like a jackhammer in her chest. She asked him not to take any more, saying he didn't need them, that she'd sing him to sleep, do anything to see him feeling better. "All right," he agreed. "Will you just stay and hold my hand?" Every time she thought he was asleep, he'd wake up and grab her arm and say, "Don't go."

She saw him a few more times, but it was all just too unnerving, especially when he asked her to move in. "Elvis, I'm sorry. I care, but I can't just move in here," she said. "I care, too, babe," he answered. "That's the problem." He was nearly in tears when she left the last time, and though she returned to take him a thank-you card, he wasn't there.

At the same time he saw Melissa, he began romancing JoCathy Brownlee, a bubbly, outgoing junior high health and physical education teacher. They met on August 2, 1975, when Elvis attended a Grizzlies game at the Mid-South Coliseum, where JoCathy worked part-time as a hostess in the press box. She spent the evening getting him whatever he wanted—pizza, Coke—and he picked up on her nickname, J. C., frequently calling her over where he sat with Linda, with whom JoCathy had gone to Memphis State.

Her friend Barbara Klein told her that night that Elvis had been watching her reflection in the glass, and in a way it all made sense. Like Mindi, JoCathy had a strong feeling Elvis would be in her life somehow, dating back to when she was a child in Indianola, Mississippi, and her father would drive her past Graceland on their trips to Memphis.

When she first moved to town, she lived in Whitehaven, where a family whose property backed up to Graceland would let her stand on their fence to see him when he was out riding his horse. Then she briefly met him at the Memphian in 1974, and had even dated Charlie for a spell, visiting him in his basement digs at Graceland. In fact, she was so into Elvis that she was taking her mother to see him in Vegas in just a few weeks.

When Elvis got up to leave the game on that summer night, JoCathy was not shy about telling him good-bye. She took a look at the scarf he wore with his blue leisure suit, thought of the signature scarves he draped around the necks of his fans, and joked, "Is that a real Elvis scarf?"

"Well, honey," he said, "not really." And with that, he took it off, put it around her neck, pulled her close, and kissed her. "It was right in front of Linda, and I was just like, 'Oh, my God!' "

That was a Saturday, and on Monday, Sonny called Barbara and asked how to get in touch with her friend—Elvis wanted to give her a hundred dollars for being so nice in the press box. He also wanted a date.

"Believe it or not," she says, "I had this sick, sick, feeling." As it happened, she had a new boyfriend, and it was love at first sight. She did nothing, then, trying to make up her mind, when Dr. Nick tracked her down on Thursday at Barbara's house to tell her Elvis was trying to reach her. By coincidence, JoCathy lived in a duplex owned by Miss Patty, Anita Wood's former landlady. "When I got home, the phone was ringing, and this voice said, 'J. C.? E. P.'"

He wanted her to come to the house and meet Lisa Marie, and then go to the Crosstown that very night. Then when they returned, he changed into his black Munsingwear pajamas with the red piping that Aunt Delta had bought him at Sears. JoCathy already felt as if she knew him—they were both from Mississippi and close to their mothers—so she didn't think, "Oh, oh, he's going to attack me." But she did think it was odd when he made several phone calls while he was showing her a book on numerology, and then sent her downstairs to look up the word "esoteric" in the dictionary.

It was just a ruse, of course—he'd ordered a new Grand Prix for her, just as he had Melissa, and it was pulling up in the driveway. "Elvis walked out in front of me and he turned around and said, 'Honey, I hope this one's okay. It was the best I could do at four o'clock in the morning.'"

She didn't quite know what to say—she'd just made her last payment on her Ford Grand Torino—and though she knew how funny it sounded, she asked if she could give her old car to her mother, unless Elvis needed it for the trade-in.

He had a laugh at that—she could do anything she wanted with her old car—and then told her to hop in. He wanted to drive out to the airport to show her the plane he was in the process of buying, a $900,000 Lockheed JetStar. She was behind the wheel and he was sitting beside her, still in his pajamas, when he asked if she had the lights on. Sure, sure, she told him. Farther down the road, he said, "J. C., are you sure you have your lights on?"

"Oh, yeah, my lights are on."

Finally, he reached across her lap and pulled the knob, and the highway lit up like daylight. That's when she really felt stupid, but then it wasn't every night she got a car from Elvis.

When they got back to the house, they kissed a few times, but he was never too forward with her, and then he laid his heart on the line. "J. C., I can tell that you're committed to somebody, and I have to protect my feelings. But if anything changes in your relationship, let me know because I want to see you again." She told him okay, and then she walked out front and climbed behind the wheel of her new car. The sun was coming up as she crawled down the winding drive,

and the first thing she thought was, "How am I going to explain this to my mother?"

Elvis was not about to give a girl a new car and just let her leave him in it, so two nights later, he showed up at the Grizzlies game and asked if JoCathy could sit with him. Near the end of the evening, he asked her to go to Fort Worth to see his other new plane, *The Lisa Marie*, a $250,000 Convair 880 jet, originally part of the Delta fleet, which was being customized and refurbished at an additional $800,000 as his show plane. From there, they'd probably go on to Las Vegas or Palm Springs, he told her. While it sure sounded good, she said, she couldn't: She had a date.

Only a week had passed since she made the remark about the scarf and he'd kissed her, and she had a lot to process. He then took another girl from the game instead, but when he came back to town, he saw JoCathy every night until he left for his Vegas engagement. There, JoCathy and her mother were his guests in one of the round booths, and when Linda saw her there, "She put two and two together." For the next three months, he would find a way to see JoCathy every time Linda was away.

Soon, they were spotted around town more and more, particularly at the Crosstown Theatre, and at the Colonial or Chickasaw country clubs, where they played racquetball with Billy and Jo Smith, George and Barbara Klein, and Billy and Angie Stanley. Elvis had taken up the sport at Dr. Nick's urging and was building his own court at home. "He was truly trying to get his act together," she says, though his eating habits—six small yogurts at a time from his little refrigerator off the bedroom—were still too poor for him to lose much weight.

One day, one of JoCathy's pupils asked, "Miss Brownlee, are you dating Elvis Presley?" JoCathy told her she didn't discuss her personal life with students, and the child said, "Well, I went home and told my mama that you were dating Elvis Presley, and my mama said, 'There's no way Elvis is dating a P.E. teacher. He only dates beauty queens and movie stars.'"

JoCathy did seem an unusual choice for him, given his history and the fact that they really had little in common. However, they were playful together—at one point he jokingly told her she could use a nose job, and they both laughed when she said he needed to get his entire body retreaded. But when he brought out *The Impersonal Life* and asked her to read it to him, she thought, "This makes no sense. To this day, I have no idea what that book was about." And while he liked her pretty hands and feet, he couldn't really perform sexually if he were medicated, though it was obvious to her that he hadn't lost his desire.

When it came right down to it, she wasn't sure how she would characterize the relationship.

"I cared a lot about him, and I knew he cared about me, but it wasn't going anywhere. He did tell me a few times that he loved me, but it would be right before he dozed off to sleep. I'm not going to say that it was something that it wasn't, but I wouldn't take anything for it."

One of the problems was that JoCathy was exhausted from trying to balance Elvis's schedule with her own. In addition to her teaching and Mid-South Coliseum commitments, she logged two other part-time jobs. He tried to get her to quit working so she could be with him more, but she had better sense than that, even though it irritated him that she was so tired all the time. ("If you yawn one more time, we are out of here," he said at the movies one night.)

She couldn't help it. She left Graceland at 6:30 A.M. to teach school, and by the time she went home and then got back to Whitehaven about 4:30 or 5:00, Elvis would just be getting up. They'd have supper together, read, watch TV, or make the usual outings, and then she'd get only about two hours' sleep before the day started all over again. After a while, she started moving some of her wardrobe there ("my nightgowns, and my teaching clothes, and things that I wore when we would go out") to make things easier. But it wasn't enough for a man who wanted a woman at his beck and call all the time.

Then one Saturday in late October 1975, they got their wires crossed. She arrived at Graceland after one of her part-time jobs, selling tickets at the coliseum, and Elvis "kind of acted like he was surprised to see me. I had gone into the dressing area, and he walked in and he said, 'Uh, J. C., I have plans for tonight. Just grab a few of your things, and I'll call you tomorrow.' Well, I was just worn out, and it rubbed me the wrong way. I thought, 'I am not believing this!' I got a clothesbasket and just started throwing everything in there. Elvis said, 'Look, I just said to grab a few things. You don't have to be such a bitch about it.' And I stormed out of there, and that was the last time I saw him."

A couple of weeks later, JoCathy heard he was dating Dawn Bonner, whose father, Alex, was an Emmy-winning executive at WHBQ.

When nothing came of that, Elvis tested the waters with seventeen-year-old Tanya Tucker during his two-week engagement in Vegas that December. The singer, a child who sounded like a woman, had become a national sensation at thirteen for her grown-up songs of desolate love, including "Delta Dawn" and Would You Lay with Me (In a Field of Stone)." The latter song, especially, had marked her with something of a racy image, but her father-manager, Beau

Tucker, a pipeline worker who fancied himself an eccentric sharpie along the lines of Colonel Parker, hardly ever let her out of his sight.

Beau Tucker had moved his family from Arizona to the Las Vegas area to spur his daughter's career, and Tanya had dreamed of meeting Elvis, with whom she was personally and professionally obsessed, long before she landed a recording contract. ("He would come into town and I wanted to see him so bad, but we couldn't afford the thirty bucks.") She knew he was part of her destiny, though, and their eventual introduction came through Glen D. Hardin, who played piano in both stars' bands. Glen arranged for Elvis to acknowledge Tanya from the stage. But when a security guard came to take her back after the first show, she remembered her father's advice: "Now Tanya, that boy can have anybody he wants. Let him know he can't have you."

"Hey," she told the guard. "Tell Mr. Presley to just wait. I'm signing autographs out here!"

When she finally went back, Elvis gave her the same treatment, stalling her for more than thirty minutes. She sat down next to Lamar, checking her watch while the other guys proffered Cokes and M&Ms. Finally, she turned to her older sister, LaCosta, and announced in a loud voice, "Five more minutes, and we're out of here. I'm not waitin' any longer."

Suddenly, the door opened, and there he was, all in black, a leather coat with a fake fur collar covering a roomy sweat suit, a damp towel setting it off. At that moment, all of Tanya's brashness melted like a Dreamsicle in the Vegas sun.

"It was like the parting of the Red Sea. I was sitting down, of course, and he looked like he was about fourteen or fifteen feet tall. He came right over and said, 'Lamar, get up,' and you've never seen three hundred pounds move so quick. Elvis just plopped right down in front of me and got about two inches from my face and said, 'So how you doin'?' I said, 'I'm just fine. How are you?' I didn't flinch a bit. Inside I was just jumpin', but I didn't want him to know that."

They talked a little bit about music—Glen had told Elvis that Tanya patterned herself after him some—but then things got personal. She'd driven herself crazy picking the perfect gown from the Lillie Rubin shop in Nashville, which catered to women at least twice her age, and when Elvis complimented her footwear ("Man, I love those shoes"), her $250 splurge suddenly seemed worth every penny. Tanya was too nervous to notice, but LaCosta later said, "Oh, God, Tanya, when you turned your head, he was lookin' you up and down. He thought you were sexy." All Tanya knew was that it was a great night.

Soon, someone reminded him that it was time to get ready, and Elvis made his move. "Tanya, you want to come back for the second show?"

"Oh, no, sir," she said, suddenly thirteen again. "I've got to go home and tell my mama and daddy about this." Elvis reached over to kiss her, but his young guest surprised him.

"I just gave him the old side cheek, you know? And he laughed so big and hard when I did that. He thought that was just amazing. Who does that to Elvis Presley?"

He never forgot her, and two years later, as her professional star continued to ascend, he sent her a *TLC* necklace through Tony Brown, who Beau had once fired from Tanya's band. Tanya had continued to go to Elvis's shows and swoon from her seat, but she had too much of her father in her to graciously accept her gift. "Tell Elvis if he wants to be giving me something, he needs to come give it to me himself." Today, the mother of a daughter named Presley, she cringes at the memory. "Oh, my God, how stupid! Just too cocky for my own good."

Getting the brush-off from yet another teenager seemed to drive forty-year-old Elvis back to women of a more appropriate age range, and before the year was out, he took his wildest shot of all. Hearing that Sonny and Cher had just divorced, Elvis placed a call to the ex-Mrs. Bono, then twenty-nine, and invited her for a weekend in Las Vegas. Cher, who had watched his famous 1957 Pan Pacific Auditorium show standing on her chair as a child, was flabbergasted.

"My assistant told me he was on the phone, and at first I thought it was a joke. But I was just too frightened. He'd never stopped being an influence on my life, and sometimes you meet your heroes, and you're really disappointed. I thought it would be much better to just have this fantasy about who he was than to be utterly disappointed."

As his depression deepened, he spent money like it was never going to stop coming in. He had three airplanes now, including a $500,000 Aero Jet Commander, and then he bought fourteen Cadillacs in one day, to the tune of $140,000. Minnie Mae cautioned him that if he didn't stop such craziness, he was going to end up penniless, but he waved her off with a hug and a smile. "It just means I have to do a longer tour," he said. But then every time he did a tour, every woman he knew got expensive jewelry.

"He always gave girls rings," says Shirley Dieu. "That was so common. Oh, my God, we had a ring on every finger. I'll tell you how much jewelry I had. I remember going to Pip's, which was Hefner's private club in L.A., and I was sitting there counting up the jewelry on my hand and all the stuff I wore. I had

over $250,000 worth of jewelry on my person, and that didn't even include the $25,000 watch that Joe gave me. I was twenty-two years old."

Not surprisingly, Elvis found himself with a cash flow problem, and at the end of November 1975, he borrowed $350,000 from the National Bank of Commerce, pledging Graceland as collateral. On Christmas Eve, he told Marian Cocke that he had a dream that all his friends deserted him when he went broke. It threw him into such a fury that he refused to go downstairs, and watched the four monitors on his closed-circuit video surveillance system until everyone who had been waiting for him went home.

The disappointments piled up: The Colonel killed his dream for a karate film, into which he had sunk more than $100,000 over the past year. His beloved orange chow, one-year-old Get Lo, a dog he and Linda raised together, died after three months of treatment near Boston for a congenital kidney ailment. When the end came, Linda remembers, "Elvis was really hurt. We were on tour, and they waited to tell him until we were coming home on his plane. He cried. It was like our little buddy had died."

And a huge show on New Year's Eve at the unfinished Silverdome in Pontiac, Michigan, while grossing the record-breaking $816,000, turned out largely to be a bust—poor sound, frigid weather (one of the musicians plugged in an electric blanket), and Elvis splitting his pants onstage. "I'm scared shitless," he told emcee Jackie Kahane as he mounted the stairs, arriving nearly an hour late. In the end, "he didn't do twenty minutes. I figured they'd kill him. Do you know before we left, they booked him back? That was the magic of Elvis."

Sometime that year when Linda was away, Elvis sneaked Barbara Leigh into the Monovale house. They hadn't seen each other in a long time, and it made her sad to see him so overweight and lost. She could tell how chaotic his life was and that he wanted peace. Lisa Marie played with her doll and sang her daddy's songs, and Elvis mostly quoted the Bible. Then he started choking, falling asleep while eating Mexican wedding cookies.

"I grabbed his head and held it up and slowly made him drink milk. When I told Joe about it, he said, 'Most everyone in Elvis's life has saved him at least once.'" She left around 4 A.M., feeling hopeless.

"He was way past my help or anyone's at that time. It was like his spirit was beaten down. His white light was flickering. I think in many ways he was ready to leave this earthly plane."

Actress Deborah Walley spoke to him in roughly this same period. "He told me that he wasn't going to be around for very long. He was very clear about what

he was saying. He said he wasn't going to live a full life, that he was going to exit early. He was done."

.

In January 1976 he spent his forty-first birthday in Vail, Colorado, with Linda and fifteen others, including his friends on the Denver police force. But what should have been a joyous time turned into one of dissension, with Elvis's moods fluctuating so rapidly that people walked on eggshells, afraid to say anything around him. Jerry even threatened to quit. Then as Elvis's disposition improved, he started buying Cadillacs and Lincolns for everybody, including his police pals and Linda and Shirley. Total cost: $70,000.

At home, work was completed on the racquetball court in back of Graceland, and Jo and Billy Smith would often play with him there. He sequestered himself with the Smiths more and more when he was in Memphis, not wanting to leave the cocoon of home. Even there, he verged on psychosis, his behavior fueled by polypharmacy and professional and personal turmoil. When RCA, needing an album, sent a mobile truck to Graceland in both February and October, Elvis was erratic, showing up the first night in his policeman's uniform, and brandishing a Thompson submachine gun at the latter session. Not much got recorded, especially in February, when he retreated to his bedroom with Red and Sonny to plot a violent bloodbath on all the drug dealers in Memphis.

He toured one-nighters all through the spring and hid from the Colonel, not wanting to talk with anybody, really, except Billy and Jo. When Lisa Marie visited for ten days in June, he saw almost no one else. One night Elvis took three or four sleeping pills and said to the Smiths, "Let's go put Lisa to bed."

They all went in her room, Billy remembers, and Elvis leaned down to kiss her good night. "When he did, his penis fell out of his pajamas. Elvis didn't notice it. He was telling us, 'Oh, ain't she sweet. She's my teddy bear.' And Lisa said, 'Daddy, your goober is hanging out.'"

It embarrassed him.

"'Lisa, you don't say things like that, goddamn it!'"

Then everybody broke up, even Elvis.

One of the things that bothered both Priscilla and Linda was that Elvis wasn't much of a participatory parent and that he never took on any of the real responsibilities of fatherhood. He slept during the day when Lisa Marie was up and playing, for example, and didn't take her to school or pick her up, not even when she was in preschool. Billy could see that the child was starved for her fa-

ther's attention, but Elvis's biggest response was to indulge his daughter's every whim.

He and Priscilla butted heads over their differences in parenting, Elvis giving the eight-year-old a diamond ring, and Priscilla insisting "there's no way I will allow her to wear a diamond ring at the age of eight." The child was pulled one way and then the other, so much so that when she went home to her mother in California, she would throw tantrums, screaming, *"I wanna go back to Grace-land!"*

"She was a terror when I got her back," says Priscilla. "You cannot imagine."

From the age of three, Lisa had listened to records in her room instead of playing with other children. But in Tennessee, she had a whole other life. She could eat anything she wanted, squish frogs, spook the security guards at 4 A.M., sign rude autographs at the gate ("Fuck you, Lisa Marie Presley"), and race around the grounds in her own golf cart, sometimes with playmates Patsy and Peggy Lynn, the twin daughters of country singer Loretta Lynn, who had met Elvis when they were both in the hospital in Memphis.

If Elvis wasn't much of a disciplinarian, JoCathy Brownlee spent enough time around them to know that "he loved it when Lisa was there, and he would get very sad when it was time for her to leave. I can remember him talking to Priscilla on the phone and just begging her to let Lisa stay a couple of more days." And to Mindi Miller he admitted that Lisa had "really softened him and opened him up to being something other than a performer and a man-of-the-world. He said, 'I never thought it, but she has turned out to be the love of my life.'"

It was clear to everyone that Lisa idolized her father, and that even at her young age, she realized his power and position in the world. One night before JoCathy left, the teacher promised Lisa she would ride the golf cart with her when she returned. But the next afternoon, when JoCathy and Elvis were upstairs, "Lisa came running up and said, 'Daddy! The golf cart has a flat tire!' I said, 'Oh, Lisa, I'm so sorry. We can't ride the golf cart today.' And Lisa said, 'J. C., my daddy has millions more golf carts.'"

· · · · · ·

George Klein kept sending girls up to the house, but nobody seemed right, and Elvis asked Jo Smith to check them out. He still liked finger sucking—and toe sucking—and "he'd say, 'You know if I'd like her or not. If her fingernails are dirty, or if her toenails are dirty, she's a definite out.'"

If the girl passed muster, Jo would say, "Step this way." But then a lot of times she or Billy would have to sit upstairs with them and talk. Elvis didn't seem interested in much more than companionship, telling his guests, "I need to have all my bodily fluids to heal myself." Billy thought it was wild, but "we were expected to say, 'Yeah, that's right. He always saves his bodily fluids before a tour.' " Often, Elvis's little cousin wondered, "What the hell does the girl think?" But as Jo remembers, "The girls would just lay there and smile with their little negligees on."

No matter who came around, Elvis couldn't seem to get out of the dumps. In July 1976, Vernon, with Elvis's blessing, fired Red, Sonny, and Dave Hebler over several issues—a lawsuit over the rough handling of a fan, the general friction in the group, and Vernon's ongoing paranoia that Elvis's friends took advantage of him. The three men, especially Red and Sonny, were deeply offended not to hear the word from Elvis himself, and he seemed too paralyzed to pick up the phone.

Then in October 1976 he got word that they were writing a book, one that would expose, among other things, his deep dependence on prescription medication. They were doing it, they insisted, to try to get him to stop, to turn his life around before it was too late. "That was our intention," Sonny says, "whether people believe it or not."

The news devastated him. He cried, ranted, and talked of a plan to kill his friends himself and dispose of their bodies. Then, when he calmed down, he had John O'Grady telephone Sonny and offer the three "overdue severance pay" to cancel the book. O'Grady never named an actual figure, but it didn't matter. "John," Sonny told him, "taking the money would make us just like the doctors who give him the medicine."

While Linda agreed that Elvis had handled the firing "rather unceremoniously," it was "the major turning point, the pivotal current," in his decline. Mindi agrees. "He couldn't sleep at night. He was very depressed about it, an absolute wreck. He was afraid when the book came out that people would view him differently and find fault with him. He talked about that to no end: 'Can you believe Sonny and Red would do this to me? How dare they put me out there! These are lies, the things they're talking about, all these supposed drugs. It's crap!' All I could do was sit and listen. I'd say, 'E, I'm really sorry.' "

Linda, too, tried her best to comfort him. "Let's just go away and live in a little shack on a farm and forget fame and fortune and all of the craziness that goes with it," she pleaded.

"Now, why the hell would I want to do that?" Elvis replied.

"I truly, truly loved him, and I wouldn't have cared if he were John Doe. I loved him as a human soul. He was really a wonderful person," Linda says. But after four and a half years, it was time for her to go. She could only do so much caregiving and putting her life on hold.

"There was a lot of me that wasn't being fulfilled, and I didn't like feeling like I was just an appendage of someone else. I wanted to do some things on my own and be my own person." Still, she acknowledges, "To this day, there's a part of my heart that has 'Elvis' written all over it."

Exactly who did the leaving is a matter of semantics. Linda logged a few days on the next tour, Elvis's eighth of 1976. But she was already emotionally involved with keyboard player David Briggs, who'd offered a strong shoulder. Elvis had his suspicions, and sent Larry Geller to a restaurant, where he found the couple enjoying a candlelight dinner at 3 A.M. "The band was afraid he was going to shoot me," David remembers. "I didn't think he would, because he liked me a lot. I didn't think he would let a woman get between us." But Elvis would soon make his feelings clear, pulling the plug on David's electric keyboard one night toward the end of the tour.

Linda's affair "broke Elvis's heart," says Mindi, "because he had already been betrayed by Priscilla. But he never looked at it that he betrayed anybody else. He just said, 'She's going out with my damn piano player.'"

On November 19, 1976, George Klein, hoping to lift Elvis's spirits, brought Terry Alden, the reigning Miss Tennessee, out to the house. Terry was a pretty girl, slim and self-possessed, but she was engaged, and came only because she thought it would be fun to meet Elvis and see Graceland. That's one reason she brought along her two sisters, Rosemary and Ginger.

Elvis was cordial to Terry and Rosemary, and told them he remembered their father, a public relations officer for the army. But it was twenty-year-old Ginger, with dark eyes, sculpted lips, and long auburn hair, that Elvis liked best. How could he not? The current Miss Mid-South Fair and former Miss Traffic Safety looked like Priscilla, Debra Paget, and Gladys all rolled into one.

In March 1977, Elvis took a party of thirty, including new girlfriend Ginger Alden *(right)* and her sister Terry, to Hawaii. While there, he vowed to make big changes in his life. *(Robin Rosaaen Collection)*

THIRTY-FOUR

.

Breathe!

Ginger.

In rock-and-roll mythology, she is the girl who let him die, knocking the world off its axis. Like his mother, her name sprang from the seventh letter, "G." Gladys and Ginger, bookending his life. One watched too closely, the other not at all.

She was born November 13, 1956, the very year that Elvis rose to national fame. Ginger couldn't remember a time when he didn't loom large in her consciousness. She got her first glimpse of him at perhaps the age of three, when her mother, Jo LaVern Alden, an inveterate Elvis fan, took her down to the fabled Graceland gates and excitedly instructed her to peer through the bars.

Then, at five, she met him. One of his uncles invited the Aldens to join them on an outing at the Fairgrounds, and Ginger had ridden with Elvis on the Pippin, holding tight on the metal bar as the roller coaster made its death-defying dips and turns.

"Elvis was so kind and cordial," Rosemary, then 12, remembers. "He shook hands with each of us and patted Ginger on the head."

Ginger was five foot nine now, far too statuesque for that sort of treatment. But the night the grown-up Ginger met him, Elvis seemed to be in no hurry to see any of the Aldens, and kept them waiting for hours while he practiced karate. Finally, the three sisters were led upstairs to meet him, where he received them in Lisa Marie's bedroom.

"I know this sounds funny," Ginger admits, "but when Elvis entered the room, I thought trumpets would sound."

He entertained them in his usual fashion—taking them on a tour of the

house, singing, and reading aloud from his favorite books. "It turned out to be a truly wonderful evening," Ginger later recalled. By one account, she spent the night, a chaste one.

The next evening, Elvis took her up in his plane for what was supposed to be a quick flight to see the Memphis skyline.

"Have you ever been west?" Elvis asked her.

Ginger shook her youthful head, and suddenly they were on their way to Las Vegas with chaperones Patsy and Gee Gee Gambill. Though she was twenty years old, Ginger seemed incapable of making a single move without her mother's input. She phoned home for permission, and the couples stayed overnight, returning the next afternoon.

Eight days later, Elvis asked her to join his west coast tour, and sent his Jet-Star to bring her to San Francisco, where he would play the Cow Palace. But first, there was a minor matter to resolve. Linda had accompanied Elvis to Reno, Nevada, and Eugene and Portland, Oregon, for the opening dates, along with Larry Geller's new wife, Celeste, and sister, Judy.

While Ginger occupied a room on the floor below the suite, Elvis told Linda she looked as if she weren't feeling well. Maybe she should go back to L.A. to rest, he said. When Linda replied that she felt just fine, Elvis launched into Plan B, and called Larry into his bathroom. He was shaving.

"All right, listen," he said, looking into the mirror at the curve of the razor, and then glancing over at Larry. "Here's what's happening. You've got to tell Celeste and Judy they can come on tour anytime they want, but I'm sending them back to L.A. now with Linda on the JetStar. I've met someone else. She's here now, but don't tell them what's up."

Judy thought it was odd, because the next date was Anaheim. Why didn't Elvis wait until L.A. to send all the women home? It didn't make sense. But she just shrugged her shoulders. "You did what the King asked."

Elvis, meanwhile, told his girlfriend of four-and-a-half years that he was flying out to Vegas right after the Anaheim date, and that they would meet up there. But Larry knew it would never happen, and that the couple was finished: "That was the last time he ever saw Linda."

In Anaheim, Elvis gave one of his better performances, and Larry, seeing him perk up onstage, told Elvis that Ginger inspired him.

She would stay with him the entire two weeks of his Vegas engagement that December 1976, though Ginger's charms could not continue to work miracles. Elvis flagged as the nights wore on, hurting his ankle and seeming tired.

"I hate Las Vegas," he said out of the blue during one late night show, baffling the crowd.

Everything about him signaled that Elvis was in deep trouble, physically, psychologically, and emotionally. Sandy Ferra, Elvis's little Hollywood pal, went backstage with husband Wink Martindale one evening. "When we left, I commented that Elvis didn't look good at all," Wink says.

Priscilla's family, including her parents Paul and Ann Beaulieu, was also in attendance that engagement, and Elvis invited them to his dressing room. He spoke to Michelle, Priscilla's sister, about his hands. "He was self-conscious that they were so bloated. I patted his hands, as if to reassure him."

But Priscilla had noticed them three years earlier on the day they met in the judge's chambers and signed the final divorce decree. As they sat with their fingers entwined, seeming more like an old couple than adversaries who were about to be legally parted, Priscilla grew alarmed at how puffy Elvis was. "I knew something was different; something was wrong. I could see it in his eyes, I could feel it in his hands."

Now in Vegas, Paul sensed that "he didn't want to let us go. He kept thinking of topics that would prolong the conversation . . . he kept asking us what we needed and wanted. We told him that we were just fine. We had everything we needed. But he insisted that we accept something."

Finally, Elvis wrote out a personal check for $10,000 and handed it to Ann. She didn't want to take it, but he seemed to *need* her to accept it. After the divorce, Elvis had called her and said, "Please speak with Cilla," and begged her to try to convince his ex-wife to come back to him.

"It was a very sad conversation. I felt how desperately he wanted to keep his family together." Ann knew that her daughter was determined to move on with her life, but she told Elvis that she would do what she could.

"Please do," he pleaded. "I want you all to be part of my family." It was like a sword through her. "Elvis," she said, "we'll always be part of your family." But when they left after his performance that December, "I had a sinking feeling in the pit of my stomach."

Priscilla, who the fans blamed for Elvis's deterioration and the breakup of the marriage, knew Elvis held out hope that they would reunite.

"I'd take Lisa over to his house and he'd say, 'Cilla, go do what you have to do now. Go see the world. But when you're forty and I'm fifty, we'll be back together. You'll see." But she would later say that in the last year of his life, "We underestimated his emotional pain. And he lacked the means to fully express that pain."

Early in that same Vegas engagement, even as Ginger was by his side, Elvis reached for a pad he kept by his bed and scribbled a note that spoke to the core of his emptiness.

"I feel so alone sometimes. The night is quiet for me. I'd love to be able to sleep. I am glad that everyone is gone now. I'll probably not rest. I have no need for all this. Help me, Lord."

Later, he crumpled it up and threw it in the waste can, where someone—one of the guys, a maid—retrieved it. It was remarkably similar to another desperate note he wrote in the Hilton suite: "I don't know who I can talk to anymore. Or turn to. I only have myself and the Lord. Help me, Lord, to know the right thing."

The pattern of both notes would later fuel rumors that Elvis had contemplated suicide. Though some believe they are forgeries, or fakes, Priscilla included them in her family memoir, *Elvis by the Presleys,* an indication she believes they are authentic.

· · · · · ·

According to Larry, Linda sent letters to Vegas, but Elvis refused to read them or take her calls. If she hadn't immediately been wise to the situation in San Francisco, she soon learned from her brother, Sam, who had quit his job with the Memphis Sheriff's Department earlier that year to work tour security after Red and Sonny's dismissal. As a favor to Linda, Elvis had recently helped Sam and his wife, Louise, buy a house. When the group arrived in Vegas, Elvis took him aside.

"Sam," Elvis said, "I love your sister, but I am not *in* love with her, and I've found someone else. I just want you to know that it's not going to affect your job. I respect what you do, and if you want to work for me, you have a position." Sam elected to stay.

Ginger, meanwhile, was learning what every other woman in Elvis's life already knew, that being on the road and staying cooped up in Vegas was not the heady trip that it appeared. Once the glamour wore off, Ginger was homesick for her mother and her sisters. And, Elvis learned, she missed a young man she had been seeing in Memphis.

Shirley and Joe were in their bedroom in the Imperial Suite one day when Elvis and Ginger appeared at the door. Shirley could see that Elvis was upset, that he seemed frustrated and adrift. She rarely saw him like that, and asked what was the matter.

"Elvis found out that Ginger had a boyfriend, so he told her to call him and tell him that it was over, and she wouldn't do it. She kept saying no."

He and Ginger exchanged heated words, and then in anger, Elvis picked up a glass of orange juice and threw it across the room. Shirley had just taken the plastic off her dry cleaning, and now it was covered with sticky pulp.

"Oh, I was so mad! But he felt bad about it, I could tell. It was sad. Linda had taken off with David Briggs, and he wanted to show her that he could get someone who was prettier and younger."

Shirley thought Elvis seemed all too desperate to make the romance bloom, while others in the group accused him of keeping Ginger a virtual hostage. On December 10, because she had complained she needed to go home to see her family, Elvis flew Ginger's parents, sisters, and her brother and his wife to Vegas. That same day, the Memphis *Commercial Appeal* quoted Jo Alden as saying that Elvis had given Ginger a Lincoln Continental, though "she doesn't think it was an engagement gift."

The strain of the relationship only added to Elvis's lackluster performance and ill health. Two days later, Bill E. Burk of the Memphis *Press-Scimitar* boldly wrote, "One walks away wondering how much longer it can be before the end comes." That night, Elvis met with evangelist Rex Humbard in his dressing room, and in telling the preacher he felt his life lacked all meaning, Elvis wept.

After a two-week rest, however, he was more like himself, and gave a well-received ninety-minute concert on New Year's Eve in Pittsburgh. He seemed to be in high spirits, in part because he had both his girls there, Ginger and Lisa. Ginger sat in a chair near the stage and held up the squirmy eight-year-old so she could have a better view of the performance.

Clearly Ginger's family encouraged the relationship. When her parents' often-troubled marriage appeared to be over, Elvis met with them to see if they could reconcile, but then offered to pay for their divorce and buy Jo a new house.

More and more, there seemed to be nothing Elvis wouldn't do to win Ginger's affections. He went to her grandfather's funeral in Arkansas on January 3, 1977, flying her family to Harrison, Arkansas, and then accompanying Ginger on the twenty-mile drive to Jasper for services in a tiny rural church. Afterward, he, Ginger, and Rosemary flew to Palm Springs for Elvis's forty-second birthday on January 8.

He was more impetuous in all matters of love now. On January 9, he spurred his dentist, Max Shapiro to marry his young fiancée, Suzanne, in Palm Springs

that very day, waking Larry in the middle of the night to come perform the ceremony. Larry, who was licensed to marry couples in the state of California but had never actually done it, nervously grabbed a couple of candles, some incense, and his Bible, and ran for the flight. Elvis bought the rings, and Ginger stood in as maid of honor.

.

"When Elvis met Ginger," Larry observed, *"something came over this guy. Part of it* was beautiful, because he just so desperately wanted a real relationship. The next morning, he said to me, 'Man, I can't believe this girl! I look at that woman's eyes, and it's my mother's eyes.' So for the first month, he was really just nuts over Ginger. But to me, it was unrealistic."

It was an improbable pairing to others, too. Ginger was a sweet person, but her personality was monochromatic. Like Debra Paget and Priscilla before her, she hardly ever said a word, which intrigued Elvis all the more. Whether she was petrified or a blank slate, as Shirley believes, the girl was a mystery.

Not only that, but aside from the fact that she already had a boyfriend, she didn't seem to really *care* for Elvis. Ginger would later say that wasn't true, that she loved him deeply, even if others insisted she rarely seemed affectionate toward him. In Vegas, out of the corner of her eye, Shirley had caught him taking Ginger's hand and putting it between his shoulder and neck. Then he placed his own hand on top of hers, and patted it. "See Shirley," he said, "she loves me just like you love Joe."

It broke Shirley's heart, but it also worried everyone as to how far Elvis might go. Nothing about his involvement with Ginger indicated rational thinking.

In Palm Springs, especially, Elvis seemed to have almost no control over his impulses. After Larry winged the ceremony and pronounced the Shapiros man and wife, Elvis signed the certificate, and then hurriedly turned to his friend.

"Lawrence, come with me right away," he implored. "Ginger, you, too."

He took them into his bedroom, where Larry chose a chair and Elvis and Ginger sat on the edge of the bed.

"Ginger," Elvis began, "I know we haven't talked about this, but that was the most beautiful ceremony I've ever seen in my life. That's what a real marriage ceremony should be. This is what I want us to have. What do you say?"

Larry couldn't believe his ears. Ginger, too, seemed astonished.

"She very, very demurely, said, 'Yeah. Yes.' Elvis looked at me and said, 'You

can't tell anyone about this yet. We are going to do this later in the year. We'll do it at Graceland.' But in my heart of hearts, I knew there was no way this was going to happen. He was riding a wave of euphoria, and all of the stardust was going to blow away and he was going to realize that she was too young and not for him."

Ginger was a symbol, Larry thought, someone against whom Elvis could project his dreams in relation to what was going on in his life at the time: his health problems, his waning youth, his father's second heart attack in December, his conflicts with Colonel Parker, everything.

She had a ring, though, that was true. On January 26, 1977, Elvis came to her and proposed, she said. "It was like old-fashioned times . . . he was on his knees. He asked me to marry him, and I said, 'Yes.'" She was sitting in his black reading chair in the upstairs bathroom at Graceland, and he pulled out a green velvet box and produced a stunning eleven-and-a-half-carat diamond worth $70,000. He was in such a hurry for it, in fact, that jeweler Lowell Hays took the stone from Elvis's own TCB ring until he could find a replacement. Ginger was now the second woman to whom Elvis had proposed in a bathroom.

Her mother was overjoyed.

"When he flew my family to Las Vegas," Jo Alden says, her voice full of tulle and lace, "he told me he had loved people, but he had never been in love before. He said that when he found Ginger, he found what he had been searching for, and that he knew God had led him to her."

In Mrs. Alden's version of the story, both Elvis and Vernon were so taken with Ginger that they saw her as nearly a celestial being. "His father told him that Ginger was an angel sent from heaven. In fact, Elvis wanted to say that to Ginger, but as he told me, 'How do you go about telling an angel that?'"

However, Elvis didn't seem like a man who was planning a future with a new bride, angel or not. Ginger was a witness to the signing of his Last Will and Testament in early March 1977, and yet the document excluded her.

Shirley believes she knows how the confusion arose, because Ginger sought her advice at the time.

"Ginger and I were sitting next to each other on the bus, and she said, 'Elvis asked me to marry him, but I think he changed his mind, because he hasn't mentioned it anymore. It's like he never said it.'"

"Listen, if he talked about marriage, you better jump on it," Shirley told her. "If he hasn't talked about it, he's probably already forgotten it."

Ginger pressed her for more. "Do you think he really meant it?"

"I don't know, Ginger."

Rosemary Alden shares her mother's gauzy view, and insists that Elvis made his intentions clear to all the Aldens. "My most treasured moment with Elvis occurred when he told our family that he was going to marry Ginger, how happy she made him, and how much he loved us as a family while he placed our TLC necklaces around each of our necks."

Yet Joe Esposito has a more studied opinion. "Elvis liked Ginger very much, but . . . I don't think he was going to marry her. He may have told her that he wanted to marry her, so she would stay around, but after awhile, he started to date other women, too."

Billy Smith echoes Joe's observation, saying Elvis kept buying Ginger jewelry and cars—three in all—to keep her there. And he shares the belief that Elvis was not going to marry her, no matter what he said to Ginger or her family.

"We even took her out window shopping for wedding dresses once, about midnight. We'd drive by a store, and Elvis would say, 'Hey, there's one.' And he would describe what he wanted Ginger to wear on her head—that thing that stands up that Spanish women wear—and he wanted a long train on her dress. And Ginger believed all this. But he'd also say, 'Yeah, and when we get married . . .' and then turn to Jo and me and say, real low, 'Whenever that is.'"

Today, Shirley's opinion is that Elvis was on sleeping pills when he gave Ginger the ring, and probably meant the proposal at the time. As to whether they were actually engaged, "It depends on how you look at it. But there definitely wouldn't have been a wedding. There's no way there would have been a wedding. It was just naiveté on Ginger's part." Besides, Shirley says, since Ginger refused to call things off with her old boyfriend, "It sounds to me like she didn't exactly plan on getting married to EP either, you know?"

Eventually, Elvis would come to call the Aldens "leeches," according to David Stanley, Elvis's stepbrother. "He felt that [Ginger] was just using him. She didn't love him, that was obvious." But Shirley is more sympathetic: "She was just a young, stupid girl who didn't want to be there. It wasn't even her fault. Her Mom had her claws into Elvis and her hand in his back pocket. Everybody knows that. Ginger was her little pawn."

Sometime that spring 1977, Elvis put in a call to Ann Pennington. He had often told her that he thought he would die before he reached his mother's age, and perhaps because he was about to sign his will, he seemed to have the end on his mind.

"I want you to know I had the most fun with you than I did with anybody,"

he told her. "You really liked me for who I am, and you never took anything from me."

．．．．．．

*Right after the signing of the will, Elvis took a gang of thirty to Hawaii, first check-*ing into the Hilton Rainbow Tower, and then after two days, moving with the Alden sisters and others to a beach house at Kailua. In the many pictures that Joe and Shirley took of him there, he looks happy—laughing, playing football, and teasing Shirley, putting his tongue in her ear. "Elvis made dreams come true for so many people, and I do think he had a nice time," she says. "He was so much fun to play with, and it was wonderful."

However, one day he got sand in his eye, and scratched his cornea. After that, he cut the trip short, but not before promising Larry that he was going to make big changes in his life—about his health and diet, about cutting the dead wood from his organization, even about firing the Colonel and getting off of pills. "He was so determined and he had so many plans."

But then he ran into Sherry Williams, and when she asked about all the old group, he let his guard down.

"Baby," he said, "they wrote a book," and his voice cracked on the words.

"I know," she answered.

Then he looked out over the ocean, and he had such a faraway gaze that nothing more needed to be said.

*When they returned to Memphis the third week of March, Ginger refused to accom-*pany Elvis on tour. She had also begged off going to Nashville with him to re-cord in January, when he mostly sat in his hotel room, dialing her number and leaving town without recording a note. Now Billy could barely rouse him from bed. Dr. Nick put Elvis on an IV, and recognized that Ginger was an emotional factor in his malaise.

But again, he rallied. As he stepped out on stage in Tempe, Arizona, on March 23, his first night of the tour, he whispered to Billy, "You didn't think I'd make it, did you?" Billy couldn't believe what a "hell of a show" he put on, and marveled at where he found the energy. Yet when the group reached Baton Rouge, Louisiana, on March 31, Elvis was unable to go on, and canceled the per-formance, as well as the last three sold-out shows of the tour, in Mobile, Alabama, Macon, Georgia, and Jacksonville, Florida.

Back home in Memphis, Elvis checked into Baptist Memorial Hospital on April 1. When Dr. Nick discharged him four days later, Priscilla and Lisa Marie flew in to be with him. Bill Hance of the *Nashville Banner* had written, "The singer's new girlfriend is absolutely running him ragged." Elvis's ex-wife could see it was true.

"For the last six months, he was really preoccupied with trying to make a go with this relationship," Dr. Nick says. "He was very protective of her, and would really treat her like a child. I felt if we could work [things out with Ginger] that we'd be 70 to 80 percent ahead of the game in getting other things accomplished."

But Ginger didn't seem all that keen on moving ahead with any of Elvis's plans. She wouldn't move into Graceland, claiming it was immoral, she didn't like to spend the night, and she certainly didn't appear to be overly fond of making love with her fiancé. Elvis complained to Shirley that Ginger was always in her menses. "He said, 'That damn girl's going to bleed to death.' "

"Why the hell do you put up with her?" Billy Smith asked his cousin. "Because," Elvis answered wearily, "I'm just getting too old and tired to train another one."

Billy was almost as frustrated with the situation as Elvis. He and the guys had to chase her down half the time, and they'd even followed her once. "If Elvis had ever known that, God, he'd have fired all of us. But she was in a nightclub dancing with a guy."

Elvis's pet name for Ginger was "Gingerbread," but Billy was so ticked off at her that he began referring to her as "Gingersnatch."

"Sometimes she wouldn't come up for a few days, and Elvis would get all agitated and sullen and say, 'Where is she, man? Why don't she stay here?' And when she did come, she'd get up and go home after Elvis went to sleep." The night she refused to go to Nashville for Elvis's recording session, he followed her out of Graceland and fired a pistol over her head several times, but still it didn't stop her. Eventually, Elvis resorted to more childish methods, letting the air out of her tires, and once, instructing Billy, "Keep the gate closed! Don't let her out!"

"I said, 'Goddamn, Elvis! Open the gate and let the girl go home, man. This is not a prison!' I was mad and fed up with it. One night, God, they were into it. She hadn't been up there in two or three days, and he was trying to keep her from leaving. Finally, she got to go home, and Elvis asked me, 'What do you think about Ginger? Do you think I should find somebody else?' I said, 'I think

she's everything in a woman that you always hated.' He stayed mad at me for three days."

· · · · · ·

*In April, after another fight with Ginger, Elvis had a new girl at the house, twenty-*year-old bank teller Alicia Kerwin, who received her introduction through George Klein. Alicia, ebony-haired, vibrant, and fresh-faced, had never been a fan, and knew nothing about Elvis other than the fact that he had a daughter. Their first meeting, about 10 P.M. upstairs at Graceland, lasted about two hours. The room was full of people, though the only one she recognized was Charlie Hodge.

"They were fixin' to go on tour, so it was hectic, very hectic. And we just talked."

When she and Elvis next met, in Lisa Marie's bedroom while stylist Arelia Dumont was cutting Elvis's hair, Rosemary Alden walked in. "She was real inquisitive and very rude, and she wanted to know who I was and what I was doing there."

Rosemary was just "bein' a female," as Alicia put it, but it made her feel strange, and the following day, Elvis called and invited her back. "I said no. I had a date. He thought I should break it." When she refused, he hung up on her, and then "two seconds later he calls back and he says, 'Well, what about tomorrow?' " He also asked her if she could get a few days off from work.

On April 13, Alicia accompanied Elvis and Billy and Jo to Las Vegas on a drug run to Dr. Ghanem. Afterward, they went on to Palm Springs. Elvis was in good spirits and bought Alicia a Cadillac, but then, as she remembered, he got a reprimand from his father on the telephone because he'd told neither Vernon nor the Colonel where he was going. "They had been looking for him for three days and couldn't find him. So everybody was upset, and in turn, he got them upset. He was being scolded."

Elvis's way of dealing with it was to load up on Placidyls and muscle relaxers, and when Alicia woke up and thought he wasn't breathing, she quickly summoned the Smiths. Even Billy was alarmed: "It scared me real bad, 'cause you couldn't have stirred him with a stick." For the second time, Dr. Kaplan came and revived him, and Elias Ghanem flew in to take care of him.

Alicia was shaken, and when she later thought Elvis had hemorrhaged—he only fell asleep with red Jell-O in his mouth—she couldn't take it anymore, and began to distance herself from him.

Still, he would call her from the road. On one of her final visits to Graceland, she dropped by after attending a family dinner party for her sister's birthday, and found him in a gloomy mood. "He wished he could go out on Saturday night like everyone else, and he couldn't. He was just depressed about it. He liked you to tell him about places that you'd been, a club you'd go to. He liked you to describe in detail what it's like to walk in there and have nobody really know you. We just talked, and then I went home about three o'clock in the morning."

That June, she cut it off. "It was just too much for a young kid," she said, "just the idea of Elvis Presley. Too much, too fast. Way too much to handle." The last time she saw him, she went over about 4 A.M. and stayed until she went to work. "He looked sad . . . I read to him for a long time till he went to sleep."

The pretty young bank teller would later sob in saying that she and Elvis had never been intimate, especially as he was enmeshed in his troubles with Ginger.

"She came over once, and he wouldn't see her, so she left. She called a lot when . . . she'd know I was there. She would ring the phone off the hook." Alicia could tell that Elvis cared about Ginger, but he told her "he felt like she was more or less after his money than anything else."

Alicia, who had attended Memphis State, was a sweet and unsophisticated young woman with a set of impish dimples. From her high school picture, she seemed destined for little more than a future as a suburban wife and mother. But she had found her first trip to Vegas exhilarating, and after that, west Tennessee proved too dull for her. The pull of the neon soon claimed her, as she would move to the desert, become a blackjack dealer, and get caught up in a lifestyle she could never have imagined, eventually dying of "multiple drug toxicity," combining three of the drugs—Valium, Placidyl, and Elavil—that made her recoil from Elvis.

Yet in the next two months, before any of that happened, Elvis would attempt to keep Alicia on the string. He planned to ask her to go on the August tour if Ginger backed out.

In the meantime, another young bank teller, Debbie Watts, took Alicia's place. But Debbie, who also learned bad habits from Elvis—she would later go to prison for dealing methamphetamine—was merely a passing fancy. It was still Ginger Elvis wanted. At a stage when he could no longer summon beautiful young actresses, she was as close as he could get, and her refusal to cater to his whims only deepened his anxiety about aging.

When he went out on tour the third week of April, Ginger accompanied

him, but it was obvious she tired of the schedule and that she wanted to go home. On April 29, when he played Duluth, Minnesota, he flew in her mother and sister, Rosemary, to help keep her happy.

His frustrations mounted, and everywhere he looked, someone he loved had his hand out.

At the end of April, Elvis issued Priscilla a deed of trust to Graceland for $494,024.49, the amount still owed to her in the divorce settlement. In May, Dr. Nick, Joe Esposito, and an entrepreneur named Mike McMahon sued him over his failure to fund a racquetball franchise (Presley Center Courts), to which he believed he was only lending his name. Though the matter would soon be resolved, it threw him into deeper despair. That same month, he shot out his bedroom window at Graceland, and spent most of two and a half weeks sequestered upstairs. Meanwhile, his health continued to plummet.

On May 20, when he went back out on tour, his fourth of the year, he was so bloated he had to wear the same jumpsuit—another white one with a gold Aztec calendar design—for thirteen days straight. Backstage in Knoxville on the first night, a doctor reported "he was pale, swollen—he had no stamina."

His mood was dark and despondent. Around this time, he told Jerry Schilling that he felt so bad and was so beleaguered with health problems that "I can't wait for 1977 to be over."

Larry Geller wondered why nobody at the top was trying to help him. "You could look at Elvis and see that there was a problem. I used to go to my room and literally cry. I couldn't handle it." Priscilla has said that after the divorce, she was so busy with Lisa Marie and building their new life that she didn't realize what dreadful shape Elvis was in. Maybe nobody wanted to face what was really happening, she admits. But certainly the Colonel had to see it every night. Why hadn't he done anything? On May 21, in Louisville, Larry gleaned a better understanding.

At the hotel, Elvis was barely able to sit up in bed that afternoon, and Larry noticed it took him more and more time to get ready for the show each night. About four o'clock, as Dr. Nick administered the drugs that would transform him from a sick and addled man to an energized performer, Larry watched television in the anteroom of the suite. Suddenly, there was a loud knock at the door. Larry jumped—it startled him—and then answered it to find the Colonel, his face twisted in anger, his wobbly body leaning on his cane. Larry was astonished. He'd never known the Colonel to come to Elvis's room on tour.

"Where is he?" Parker thundered.

Larry said he would let Elvis know he was there. "No," the Colonel said curtly, brushing Geller as he passed. "I'm going in."

Parker opened the door to a devastating sight—Elvis, "in a collapsed state, comatose, not even truly conscious," and moaning. Dr. Nick worked frantically to revive him, kneeling at his bedside, ducking the singer's head into a champagne bucket filled with ice water.

Parker slammed the door behind him. For a moment, Larry's heart raced. Then he felt relieved. Finally, the Colonel had seen Elvis at his worst. Surely now he would pull him off the road, take steps to get him help. Yet ninety seconds later, the manager roared out, "You listen to me!" Parker shouted at Larry, slicing the air with his cane. "The only thing that's important is that he's on that stage tonight! Nothing else matters!"

And then he was gone.

Larry stood in shock, horrified.

"I thought, 'Oh my God!' Why didn't he wait for Elvis to come to and say, 'Son, I'm taking over now. You are in no shape. We've got to get you to a hospital right now'? I can only surmise he acted out of stupidity and denial. But still, how could he be so callous? Where was his humanity?"

Through the years, fans have blamed Priscilla for not staging an intervention. How could she just stand by and watch Elvis kill himself? "People who ask that don't know Elvis," she has written. "Elvis would no more have responded to an intervention than a demand to give up singing. He never considered himself a drug addict. He refused to believe he had a problem. He would have undoubtedly laughed away any attempt at an intervention. There's no one, including his father, who could have pulled that off."

.

*By now, audiences braced themselves for the worst. On May 22 in Landover, Mary-*land, Elvis walked off stage, tossing two microphones to the floor, and announcing he needed to answer "nature's call." ("God went to the toilet!" said Jackie Kahane. "Incredible.") Soon, in Baltimore, he would fall onstage and then again disappear for half an hour. "At the finale," *Variety* wrote, "there was no ovation, and patrons exited shaking their heads and speculating on what was wrong with him."

One thing, of course, was Ginger. On May 26, in Binghamton, New York, they quarreled, as they often did on tour, and he sent her home, telling Larry she was still in communication with her ex-boyfriend, and that she also

couldn't seem to cut the apron strings. "He said, 'I've got to teach her. When we get back after the concert, all she wants to do is get on the phone and talk to her mother. I want her with *me.*' He started to have second and third thoughts about her."

That afternoon, he came out of the bedroom with Dr. Nick and told the guys sitting around the suite's living room that he and Ginger needed a rest from each other, and that while she was young, if she didn't grow up and choose between him and her "whole damn family," there definitely would be no wedding.

Kathy Westmoreland was summoned to stay with him the rest of the tour so he could fall asleep at night and not feel so isolated and alone. But the backup singer, who had always considered Elvis "a long-lost soul I had missed and found," was so worried about him she could hardly sleep herself. Increasingly, he talked of death.

One night, he showed her a blue jumpsuit hanging on the wall. "He was going to have to wear it, and he said, 'I'm going to look fat in that faggy little suit, but I'll look good in my coffin.'" Suddenly, Kathy was unable to utter a word. "I knew that it was inevitable and could come at any moment. He told me that he didn't want me to wear black at the funeral, but white."

In mid-summer, on what was to be his final tour, CBS-TV shot a one-hour special, "Elvis in Concert," in Omaha, Nebraska, on June 19, and in Rapid City, South Dakota, two days later. Ginger once again accompanied him, and on one of the nights, he playfully introduced her to the crowd: "I'd like you to say hello to my girlfriend, Ginger. 'Ginger, stand up, honey.'" She stood briefly to applause. "'Sit down, Ginger.' That's enough for her."

The controversial special, which aired after Elvis's death and in the opinion of many around Elvis, should never have been broadcast at all, revealed a legend colliding with myth. All cartoonish chins, gut and hair, Elvis was often short of breath as he stumbled through his lyrics ("Are You Lonesome Tonight?"), slurred his speech, and perspired like a man on fire. Embarrassed, he poked fun of himself, and while many fans could hardly believe the sad specter that had been their hero, at times, especially on "How Great Thou Art" and "Hurt," he was still able to evoke glimmers of greatness.

"At the beginning of 'Elvis in Concert,'" Todd Slaughter, president of the Official Elvis Presley Fan Club of Great Britain later said, "you see a very shaky Elvis maneuver his way down the steps of a plane, [and] then 'cut.' CBS left out the rest of the scene. I was at the end of the steps, being kept back by Colonel Parker, [who] eventually thrust me forward. What I remember most is the

abrupt manner in which he prodded Elvis with his walking stick and said, 'You give this [award] to him.' I could tell Elvis was very ill. His eyes were bloodshot, his lip was bleeding, and it looked as if he couldn't see too well."

His last night of the tour fell on June 26, the Colonel's birthday, in Indianapolis, where he again wore the Aztec suit, as he had the night before in Cincinnati. He was weary, though upbeat, and afterward on the plane, before the group broke up and went their separate ways, Elvis began giving out gifts, as was his custom at the end of a tour. Shirley, so thin as to appear "almost anorexic," was surprised when he handed her $750.

"What's this?" she asked.

"Go buy yourself some chocolate shakes! You're too darn skinny!"

She wrapped her small arms around him and held him tight. "Oh, Elvis," she said. "I love you."

"I love you, too," he answered, "and I know how much you love Joe." Then he gave her a kiss.

He was to have six weeks off before the next flurry of shows, and while everyone was glad to have the rest, they threw around the casual banter of what they'd do in the interim before they all gathered again for the end of summer tour. Elvis had performances booked through August, and the general assumption was that he would work right up until the end of the year.

Lamar Fike, who worked the road with the Colonel advancing the dates, knew better. "We were on the airplane, on the ground, and Elvis walked off to accept a plaque from RCA. He was so tired. I said, 'Boys, I'm going to give you one of my great speeches. He'll never see the snow fly. I promise you.'"

Priscilla had her last conversation with him late in the summer. They talked frequently, as he conferred with her on almost everything, from what color to paint *The Lisa Marie* to the size of his belt buckle. ("I did say to him, 'You really shouldn't be wearing those jumpsuits anymore . . . it's not looking good.'") Elvis never seemed to have any sense of time, calling her at midnight or two A.M. in California, saying he had a song for her to hear, or a new book he wanted her to read. She complained about the middle-of-the-night calls, but she never refused a visit. She knew he was lonely and needed company.

During their final call, it was wildly apparent how different their lives were now. She was about to go on a safari in New Guinea, while Elvis could barely conceive of such an adventure, let alone allow himself to enjoy one.

The highpoint of their conversation was Lisa Marie's upcoming visit to Memphis, which was to start July 31. But Elvis spoke obsessively to Priscilla about

Red, Sonny, and Dave Hebler's book, *"Elvis: What Happened?,"* which was scheduled to be published on August 4. Elvis feared it would be the end of him as a performer, he said.

"He told me he was thinking of changing fields—becoming a movie or record producer. I don't know if he really would have done it—he was always such a fantasizer—but he was grasping for something."

Two weeks before Lisa Marie arrived, Elvis did his best to corral Ginger, who continued to come and go. On July 13, he gave her a Triumph sports car, and on August 6, he made a trip to the home of her mother. There he sang hymns "and some of the old songs" at the piano. But his real reason for going was to check out the progress of the landscaping of her home and the installment of a swimming pool, which he had agreed to finance, as well as pay off Jo's mortgage. Then in the early hours of August 8, he rented out Libertyland, the renamed Fairgrounds, as a treat for Lisa Marie and Ginger's niece, Amber. Without the old group, the fairgrounds held little allure for him anymore. He started to back out at one point, but Ginger convinced him the kids would be too disappointed.

He was due to start touring again August 17, and he made the most of his last days of leisure, screening movies, and spending time with Lisa. He had his own chair in her bedroom, where he'd sit, watch her TV, and smoke cigars. She was nine now, old enough to recognize that things were not all right with her daddy.

"When I stayed at Graceland, I could see he was struggling. I could feel that he was very sad. He'd come into my room walking so unsteadily that sometimes he'd start to fall and I'd have to catch him."

As the hours dwindled down, he got on the phone with Kathy Westmoreland. "I'm so tired," he told her. "I don't want to go on this trip." But he had to, he said. "The Colonel owes $8 million."

· · · · · ·

On the evening of August 15, 1977, Elvis slipped out of his blue nylon lounging pajamas, and with Billy's help, changed into a white silk shirt, a black sweat suit which boasted a Drug Enforcement Agency patch on the jacket, and a pair of short black patent boots. He reached down to zip up the sides, and found that he couldn't—his ankles were too puffy.

At 10:30 P.M., after a night of motorcycle riding, Elvis stuffed two .45 automatic pistols in the waistband of his pants. Then he donned his blue-tinted, chrome sunglasses and slid behind the wheel of the Stutz. With Ginger beside

him, and Billy and Jo in the backseat, Elvis steered his way to the East Memphis office of his dentist, Lester Hofman. A crown on Elvis's back tooth seemed loose, and he wanted to tend to it before he left the next evening for Portland, Maine, the first stop of his twelve-day tour.

Around midnight, when the foursome returned to Graceland, Elvis and Ginger went upstairs, and the Smiths retired to their trailer. By now, Elvis had managed to gear himself up, and sometime around 2 A.M., he spoke with Larry, who reported he was "in a very good mood, looking forward to the tour, and making plans for the future."

Ginger would later echo that ("He had earlier told me that he had been off too long"), and report that after they returned from the dentist, they sat in Lisa Marie's bedroom, where they had met the previous November. They discussed their wedding then, planning a Christmas ceremony, and Elvis promised he would announce the engagement at his August 27 concert in Memphis. "He and Ginger had wonderful plans," her mother would say.

Around 4 A.M., Elvis went looking for Lisa, who was supposed to be asleep. "He found me," she remembers, "and said, 'Go to bed.' I said, 'Okay,' and I think he kissed me goodnight and I ran off."

Later, he went in her room to tuck her in, and kissed her again.

Afterward, he still felt frisky enough for a game of racquetball, and phoned Billy and Jo to join him and Ginger. As they went out the back door and down the concrete walkway to the racquetball building, a light rain began to slicken their path.

"Ain't no problem. I'll take care of it," Elvis said, and put out his hands as if to stop it. Amazingly, Billy says, the rain let up. "See, I told you," Elvis boasted. "If you've got a little faith, you can stop the rain."

Out on the court, they'd barely gotten into it when Elvis found he didn't have as much energy as he'd thought. He'd been on a Jell-O and liquid protein diet for several days, the latest in a series of desperate attempts to fit into his stage costumes, and he'd had no real food in the last twenty-four hours.

The couples cut up more than they concentrated on their game, and mostly swatted each other with the ball. After ten minutes, they took a break, then returned to the court. But they quit for good when Elvis misjudged a serve and hit himself hard in the shin with his racquet.

He limped into the lounge then, Billy teasing him, and fixed himself a glass of ice water. Then he moved to the piano and began singing softly, ending with "Blue Eyes Crying in the Rain."

Ginger estimates it was about 6 A.M. when they went upstairs in the house, where Billy washed and dried his cousin's hair. Elvis was particular about who saw it up close, as his hair was now as white as his father's, and according to Larry, half an inch of growth poked out from under his last color job.

As they talked, Elvis returned to his constant fixation, *Elvis, What Happened?* First he yelled wildly about the betrayal of his friends, how good he'd been to their families, and how they'd now hurt his own. Then his mood dampened, and he rehearsed a speech he planned to give from the stage if his fans turned on him in concert. "They've never beat me before," he said, "and they won't beat me now." Billy knew what he meant: "Even if I have to get up there and admit to everything."

Now he cried pitifully, shaking. Billy petted him, cooed baby talk to him. "It's okay," Billy soothed. "It's going to be all right." As Billy went out the door, Elvis collected himself again. "Billy . . . son . . . this is going to be my best tour ever."

At 7:45 A.M., Rick Stanley brought Elvis his second "attack," or yellow envelope of sleeping pills. He had already brought the first about 6:30 as the sun rose. Four hours earlier, Elvis sent his twenty-three-year-old stepbrother to Baptist Memorial Hospital's twenty-four-hour pharmacy to pick up six Dilaudid tablets. Dr. Nick had prescribed them after Elvis complained of tooth pain. Dr. Hofman, the dentist, had given him codeine, Elvis said, but it wasn't helping him. At some point, Pauline Nicholson, a cook and maid at Graceland for fourteen years, asked Elvis if he wanted anything to eat, but he declined, saying he wasn't hungry.

Rick found Elvis holding the bodyguard book, and once again, Elvis was in a state of agitation. "How is Lisa Marie gonna feel about her daddy?" he blurted out, his voice heightened, full of despair. He asked Rick to pray with him, and together they got down on their knees.

"God, forgive me for my sins," Elvis pleaded. "Let the people who read this book have compassion and understanding of the things that I have done. Amen."

· · · · · ·

Rick would later say that after he and Elvis prayed together, he went downstairs and got high, zoning out. That left fifty-three-year-old Aunt Delta to deliver the third packet around 9 A.M., and to call over for more medication when Elvis complained he couldn't settle down. Nurse Tish Henley reportedly sent over two Valmids and a Placidyl placebo.

Sometime around 8 A.M., Elvis climbed in bed with Ginger, who hated seeing her aging boyfriend once more under the influence. Over time, though, she had come to realize that "the core problem Elvis had was what most of us take for granted—the ability to simply lie down, close our eyes, and go to sleep at night." Dr. Nick, knowing that Elvis could rest only two or three hours before he'd pop up wide awake, had tried to get him to go to a sleep clinic in Arkansas. But his patient had refused, and asked instead for more sedatives.

Joe Esposito thought Ginger "didn't know Elvis that well . . . she saw him in a period of time when he was drugged out," and certainly she was in no position to stage an intervention. Such confrontations were not commonly done outside the medical community in the late 1970s, and Elvis had already rebuffed Drs. Knott and Fink. But Ginger often questioned Elvis's medication use, she would say later, and tried to get him to not take the packets that Dr. Nick prescribed and Tish Henley doled out like clockwork. It was, in fact, the reason for some of their arguments.

"Although I asked him to try not to use the medication that I thought he did not need, and there were times that he didn't, I truly believed that in time I would be able to convince him."

However, on the morning of August 16, Ginger had no opportunity to reason with him because she was heavily medicated herself. She had menstrual cramps, and about 6:30, Elvis had called Tish Henley and asked her to bring up something so Ginger could sleep. The beauty queen would later say she took Quaalude tablets, but the nurse, who kept her drugs in an overnight bag under lock and key in her trailer, would insist she sent up one Dilaudid pill, though the opiate was far more powerful than anything Ginger could have needed for menstrual pain.

Whichever drug it was, Ginger was unused to taking it, and it plunged her into a deep sleep. Still, she roused when Elvis came to bed, and then again about 9:30 when Elvis got up, too keyed up to sleep, and preoccupied with the tour and the fan reaction to the bodyguard book.

"Precious," he said, "I'm going to go in the bathroom and read for a while."

"Okay," she murmured, "but don't fall asleep."

"Don't worry," he called back. "I won't."

Behind the bathroom door, Elvis paged through a book. But it was not *The Scientific Search for the Face of Jesus*, as is usually reported, but either a slim volume of pornography—a combination of sex and astrology with graphic drawings, as one investigator described it—or as Ginger remembers, the more high-minded

Sex and Psychic Energy, by Betty Bethards. Then he waited for the pills to take effect, at some point calling Marian Cocke to say he had four tickets for her for his August 27 show.

As Elvis's day was winding down in Memphis, the Colonel's was already well along in Portland. At the Dunfey Sheraton, Parker held court to oversee every detail of Elvis's two-day engagement, and barked orders at promoter Tom Hulett, Lamar Fike, RCA's George Parkhill, and Tom Diskin.

Things were still quiet at Graceland, and just before noon, Billy walked over to the house and spoke with Al Strada, who was packing Elvis's wardrobe cases. Billy asked if anyone had seen the boss. Al said no, that Elvis had left orders with David Stanley that he wasn't to be awakened until four P.M. under any circumstances. Billy knew that Ginger didn't watch Elvis like Linda did, and wondered aloud if anyone had checked on him. For a moment, he started up the stairs. "No," he thought. "If they ain't heard from him, God, let him rest. He needs it."

Finally, at 2:20 P.M., Ginger turned over in Elvis's huge bed and found it empty. Had he never come back to sleep? She noticed his reading light was still on, and thought it peculiar. Ginger knocked on the bathroom door.

"Elvis?"

There was no answer, and so she turned the knob. "That's when I saw him in there," she said days later.

Elvis was slumped on the floor, angled slightly to the right. He was on his knees, his hands beneath his face, in a near praying position. His pajama bottoms bunched at his feet. Elvis had seemed to fall off the toilet. But why was he twisted into such a grotesque form? And why hadn't he answered? He laid so still, so unnaturally still.

Now Ginger bent down to touch him. He was cold, his swollen face buried in the red shag carpet, his tongue, nearly bitten in half, protruding from clenched teeth, his beautiful skin now mottled purple-black. Elvis's death had not been quick. Nor had it been painless. But if Elvis had called out, Ginger likely would not have heard him, so deep was her drugged sleep.

At first, she thought he was just unconscious, that he had suffered a seizure of some kind, and had fallen.

"I slapped him a few times and it was like he breathed once when I turned his head." She forced open a shuttered eye. A cloudy blue pupil stared at things that Ginger could not see. She tried to move him, and could not.

Ginger was in a state of shock, and tried to stave off thoughts of the worst. "I didn't want to think he was dead. God wouldn't want to take him so soon." And

so she threw off thoughts of the obvious: Elvis Presley had died of polyphar-macy in the bathroom at Graceland at the age of forty-two.

Now a frightened Ginger picked up the phone, which rang in the kitchen. Nancy Rooks, the afternoon maid, took the call. Breathless, Ginger asked, "Who's on duty?"

"Al is here," Nancy answered, and passed the phone to the bodyguard. "Al, come upstairs!" Ginger cried. "I need you! Elvis has fainted!" Al rushed up-stairs, took one look, and with fear in his voice, called down for Joe. Elvis's old army buddy bounded up the stairs and turned the body over. It was stiff with rigor mortis, though Joe was able to stretch it out a bit and pound on Elvis's chest to try to get him breathing.

Joe already knew the awful truth—Elvis had crawled several feet and vom-ited before dying—but he didn't want Ginger to see any more, and sent her into the other room. Then he called for an ambulance, and got Dr. Nick on the phone and mumbled something about a heart attack. With the ambulance screaming through Whitehaven, Joe called down to Vernon's office.

Suddenly, the upstairs was a mass of people. Charlie was crying and begging Elvis not to die, and Vernon, still recuperating from his own heart attack only months earlier, collapsed on the floor, moaning, "Don't go, son! You're going to be all right!" Now Lisa Marie peered wide-eyed into the scene, and Joe yelled at Ginger: "Get her out of here, quick!" Eighty-eight-year-old Minnie Mae con-soled her, all the while wondering how Elvis could die before his own grand-mother.

"What happened to him?" asked Ulysses Jones, one of the emergency medi-cal techs. Al blurted out the truth. "We think he OD'd."

Dr. Nick attended him all the way to the hospital, performing CPR and screaming *"Breathe for me!"* at a man who was long past hearing. At Baptist Memorial, the Harvey Team attempted every heroic measure, and then, to no few tears, finally gave up. At the end, Marion Cocke, who had been paged to the emergency room, wiped off the once handsome face and kissed Elvis's cheek.

Dr. Nick, his skin ashen, shuffled into the private waiting room where Joe sat with Charlie, Al, Billy, and David Stanley. "He's gone," he said, his voice break-ing. "He's no longer here."

The men cried shamelessly and held on to each other as Dr. Nick asked Mau-rice Elliott, the hospital spokesman, not to make the announcement until he'd informed Vernon. He worried that the old man's heart might not be able to take

the shock, and immediately left for Graceland to perform the grim duty, riding back in the same ambulance that had taken Elvis away.

Jo Smith was there when the doctor walked up to Vernon and shook his head. "I'm sorry," he said, his face a mask of grief. Suddenly, as Jo remembered, the whole world "was at a standstill."

Ginger, too, was struck with "an overwhelming sense of sadness, disbelief, and feeling as if Graceland had also died." But Elvis's fans would cut her no slack, forever branding her as the woman who had not saved him, and despising her mother, Jo, who ultimately filed and won a lawsuit against the estate to pay the mortgage on her home as Elvis had promised.

Later that afternoon, Vernon would leave the chaos inside the house and stand on the steps of Graceland to tell the world, "My son is dead." Already suspecting that Elvis would not be coming home, he had tried to prepare Lisa Marie. But the child was confused, and strangely mimicked the reactions of the media. "She stood there and put her hands on her hips like an adult," reports Larry Geller. "She said, 'I just can't believe it! *Elvis Presley* is *dead!*'"

Yet when Sam Thompson got his sister, Linda, on the line, the child, standing nearby, was simply Elvis's daughter. Sam gave her the receiver. "It's Lisa," the small voice spoke into the phone. Linda cooed. "I know who it is, you goober-nickel." Then came the words that she had dreaded for so long: "Linda," Lisa said, "Daddy's dead."

· · · · · ·

Before he left the hospital, Joe asked Maurice Elliott for some privacy, and the public relations man led him into a conference room off the ER. There, Joe called the Colonel in Portland. George Parkhill answered, and handed the phone to the big man.

"I have something terrible to tell you," Joe began, his voice wavering.

In the moments before the word went out on radio, television, and teletype wire, the women who knew Elvis best heard the news.

In Los Angeles, Priscilla was meeting her sister, Michelle, for lunch on Melrose Avenue. "I left the house knowing something was wrong," Priscilla would remember. "The air was wrong. The sky was wrong. Something was putting me on edge." She saw Michelle's face, and her stomach tightened.

"A call came in from Memphis," Michelle started.

"This *big shock* went through me," Priscilla would say. Lisa was in Memphis, so she was sure something bad had happened to her.

No, Michelle said. "It's Elvis. They have him in the hospital."

When Priscilla got home, she could hear the phone ringing from her front step. "I couldn't get my key in the door fast enough."

It was Joe's voice, delivering the message she never wanted to hear. Suddenly, time stopped. And then, she later said, "The sun went out."

Next Joe called Shirley. "He just said, 'Elvis is dead.' I went, 'That's not a funny joke, Joe.' Then he started to cry. I had never heard Joe cry, so I knew it was no joke. I was out in the alley behind our apartment, just crunched over crying. I scratched my nails against the wall, and just followed it from the top to the bottom."

Joe asked Shirley to help take care of some of the travel arrangements, and to call Ann-Margret. She had opened at the Las Vegas Hilton the night before, and wondered why Elvis's guitar-shaped flower arrangement hadn't arrived. He'd never missed an opening in ten years, and the actress-singer was worried. The switchboard operator told Shirley that the Smiths had a block on their phone. "Well, you need to go through it," Shirley said. "This is an emergency."

Roger picked up, and Shirley told him that Joe just called with the dreadful news. Roger turned to his wife and said simply, "It's Shirley." Then all Shirley heard was screaming in the background.

Joe then called Sheila Ryan. She didn't ask what had happened. She knew: Elvis had died of a broken heart. "I turned the world off—the television, the radio. I wouldn't go to the store. I couldn't deal with it."

Now it was all over the media.

Joyce Bova was driving on I-95 with a friend, Carolyn Russo, while Janice was in another car with their mother. Janice heard it on the radio, and pulled up beside her sister blowing her horn and yelling for her to turn on the news. "The first thing I heard was a deejay announcing, 'The singer of this song is *dead today.*'" Her heart sank when Elvis's voice wafted out. "I couldn't even react. I was just in shock." The family pulled over, got out of their cars, and made a circle, hugging Joyce on the shoulder as traffic whizzed by.

Ann Ellington heard it in a Nashville doctor's office on the loudspeaker. "I was absolutely devastated."

Raquel Welch was in rehearsal for a Vegas show when somebody came running into the room and said, "Elvis is dead!" And "everybody went numb. It was the end of an era."

Suzanna Leigh had just awakened from a dream in which Elvis told her good-bye. Then she got a call from CBS News, wanting comment.

And down in Biloxi, June Juanico was just getting up from a nap. "When I came out of my bedroom, my mother was looking at me really strangely. Finally, she said, *"June!"* And she came over, and she was holding me at arm's length, and she had tears in her eyes. She said, 'I just heard on the television that Elvis Presley has *died.*' I looked at her and said, 'That can't be! That can't *be!*' I went over to the television and just fell to my knees in front of it. All I could do was make grunting sounds. I couldn't breathe. I honestly think if my mother had not been with me, I might have died. In my heart, I always thought that Elvis and I would be together again, somewhere down the road."

EPILOGUE

. .

Nearly thirty-three years after his death, Elvis Presley still holds sway, his musical talents shaping the seminal years of an entire genre, his songs ("Love Me Tender," "Viva Las Vegas") serving as touchstones for American culture, his legacy a cautionary tale of unbridled excess, combined with too little self-knowledge and too much fame.

His tragedy is not simply that he died too soon, without breaking his dependence on prescription drugs and realizing the enormity of his talent in projects that fed his creative muse, but that he was forever trapped in a loop of dissatisfaction and suffering, stemming from the loss of his twin and the premature death of his mother, with whom he had been lethally enmeshed since childhood. Her passing amounted to a "double death," in that it forever cut his immediate tie with Jessie Garon, and brought about an acute anguish that he had never dealt with on a conscious level. When Gladys died, he wildly grieved for both his twin and his mother, and his bereavement opened a chasm of sorrow that he was never able to close.

His symptoms—a preoccupation with his losses, an intense yearning for the departed, persistent thoughts about death, guilt, and unmanageable sieges of sadness—fit what is clinically known as complicated grief, or prolonged grief disorder. Psychiatrists formerly called it "stuck grief," and link it to higher incidences of substance abuse, suicide attempts, and social problems. For Elvis specifically, his debilitating trauma compounded his heightened need for human contact, and stunted his ability to cope and deal emotionally with adult problems and responsibilities. His normal grief symptoms gradually faded, but in time, his prolonged grief grew worse, particularly in the wake of his divorce.

Complicated grief is still being researched, but mental health professionals estimate that it affects more than a million people a year, or 15 percent of the bereaved. It is currently under consideration for addition to the DSM-V, the American Psychiatric Association's handbook, which is used in diagnosing mental disorders.

"Simply put," Dr. M. Katherine Shear, professor of psychiatry at Columbia University, told the *New York Times*, "complicated grief can wreck a person's life."

Elvis would demonstrate varying degrees of prolonged grief throughout his life, but perhaps the most constant manifestation was his interaction with women. Because he could not separate or individuate from his twin and then from his mother, his ability to relate intimately with others was already intricately, neurologically, psychologically, and inexorably established. No room was left for others.

Even when he attempted to replicate his level of intimacy with Gladys and Jessie Garon, as he did with scores of women throughout his life, he could never find a long-lasting, romantic, sexual bond. In looking to one or even two concurrent women or adolescent girls as substitutes who might make him feel complete, Elvis put himself—and his female friends—in an impossible situation.

Still, there were times, particularly with Ann-Margret and Linda Thompson, when he broke through his psychological chains and got close to realizing an ideal relationship. But his extreme addiction to drugs and rampant sexual conquests— grounded in the promiscuous behavior of his father and grandfather, though escalating far beyond what either of those two men could have imagined—amounted to self-sabotage of the first order, and further set him up for romantic failure and continued emotional disappointment. Yet he never seemed to learn from his mistakes, which remained unexamined as he moved on immediately to the next woman, just as he went from doctor to doctor for another supply of pills without investigating ways to quell his urges or take control of his life.

Finally, his parents' directive that he was "special," having survived when Jessie Garon did not, gave him license to indulge in increasingly dangerous behavior without fear of repercussion or death, and encouraged his messianic tendencies as a conduit of a higher power. In allowing him to compartmentalize and build walls, it also left him with no real boundaries as to how to treat other individuals, especially monogamous women who expected a faithful mate, and lovers who he insisted share his drug protocol.

However, Elvis knew full well how to deal with the masses, for it was the

unconditionally adoring fans who shored up his fragile sense of greatness, and allowed him the fleeting perception of fulfilling his psychological imperative to "live for two." With this once-in-a-lifetime system of support, Elvis, a once-in-a-lifetime performer, was propelled to feel as he thought he should. But only while onstage.

"One time in Las Vegas," reports über-fan Robin Rosaaen, "it was so funny. This woman threw her bra and Elvis put it on his head and pretended he was an airline pilot and it was his helmet. He liked that spontaneity with the fans, because he felt that if he was pleasing them and they were having fun, they were going to please him back."

In this setting—onstage—mistakes were simply not in his emotional vocabulary. He could bend and twist the audiences' applause to rationalize whatever he did with his life. He *was* their king, and both sides, the stage and the audience, realized this odd reality. There, and only there, Elvis Presley felt whole, loved, and happy.

ACKNOWLEDGMENTS

Though only one author's name appears on the dust jacket of this book, the process of researching and reporting the facts within its pages was a decidedly collaborative process.

First, I am indebted beyond words to clinical psychologist Peter O. Whitmer, Ph.D. His groundbreaking book, *The Inner Elvis* (out of print, but available in a Kindle edition), moved me to explore the sexual psyche of Elvis, particularly in relationship to his status as a twinless twin, or a twin who survives the death of his sibling at or near birth.

Peter was the first person I interviewed for *Baby, Let's Play House,* and he educated me in many important ways. Furthermore, he became so excited by the book, by the niche he felt it filled ("You have the 'take' that has been missing"), that he shared many transcripts of the original interviews he did for his own book, and read each of my chapters immediately after I wrote them. He not only kept me on point with Elvis's psychological motivations, but he offered editorial advice, caught typos, and kept my spirits buoyed throughout. Nobody writes a funnier e-mail, and no author could ask for a better friend.

Tony Stuchbury, Elvis aficionado and my dear "little brother" in England, was my chief cook and bottle washer. He gathered a myriad of pertinent articles from publications I couldn't find, checked obscure facts, provided screen catches of key moments in Elvis's films, demonstrated that he has more Elvis information rattling around in his brain than I will ever hope to learn, and was always quick to help in any way. Like Peter Whitmer, he kept me going when the journey grew long and lonely. Please see his Web site: http://www.elvispresleyscrapbook.co.uk.

Roy Turner, the celebrated Tupelo, Mississippi, historian, is also the kind of

angel who watches over errant authors. He answered what must have seemed like a thousand questions—never complaining of the drain on his time—and fact-checked the first two chapters twice as new information came to the fore. Then, at the last minute, he provided the amazing Parchman Penitentiary letters. The day he called me "Mate," I felt as though I had earned my first merit badge, and I shone like a new brass button.

Suzanne Finstad, author of *Child Bride: The Untold Story of Priscilla Beaulieu Presley,* was the kind of generous biographer writers dream about. She also fact-checked chapters, and offered telephone time and more while on deadline for a book herself. Her finest compliment came in an e-mail: "We are comrades."

Super-sleuth Patrick Lacy, author of *Elvis Decoded: A Fan's Guide to Deciphering the Myths and Misinformation,* was a constant co-detective, helping me run down rumors and hard to access documents. While I was repeatedly impressed at the depth of his reporting skills, I also found him to be an amazing and indefatigable copyeditor, photo scanner, and friend, always offering help, hope, and long-distance hand-holding, no matter what the hour.

When the project was still in its infancy, Robin Rosaaen, Elvis collector and fan extraordinaire, began offering contact information, insider stories, and much-needed enthusiastic support. She was there at the end, too, opening her vast Elvis photo collection, and providing unusual and never-before-published photographs.

Andreas Roth also demonstrated remarkable kindness in allowing me to reprint a rare photo from his *The Ultimate Elvis in Munich Book.* His exciting e-mails added a new depth to my understanding of Elvis's army years and his off-base activities in Europe.

David Troedson of the terrific Web site Elvis Australia (www.elvis.com.au), likewise provided a number of pictures, and publicized the book at the beginning to help me find interview subjects.

And Nancy Kozikowski was incredibly generous to lend her spectacular photographs and memories of her remarkable 1956 Elvis adventure in Las Vegas, which made my heart beat fast.

Very special thanks go to Randall Elkins, who was both my photography guru—scanning, corralling, and tracking essential images around the globe—and my reality check. Sometimes I would struggle with a paragraph for days, trying to distill a complex idea into a few sentences, only to have him speak it back to me in one concise and poetic sentence that would have me nearly on my knees.

I am also hugely indebted to Shirley Dieu, who after sharing her own memories, encouraged others to speak with me, including Joe Esposito, who continues

to "TCB" after all these years. Joe, in turn, answered more questions than any one man should be burdened with, and also made numerous calls on my behalf. His kindness astonished me, as did Shirley's. She stayed with me 'til the end.

Barbara Hearn Smith became like a big sister to me after our interview, and offered assistance in ways too many to enumerate. Sheila Ryan Caan and June Juanico also won my heart after our talks, and Joyce Bova, Carolyn Bradshaw Shanahan, Barbara Leigh, Jackie Rowland, Regis Wilson Vaughn, Kay Wheeler, Reeca Smith Gossan, and Nita Lynn Zahn, too, proved unforgettable.

Kittra Moore, already a dear friend, suggested a great number of wonderful ideas, and Elizabeth Clifford never failed to take a frantic phone call when the going got rough. Gale Nash Snyder, my sister, and Richard H. Nash Jr., my cousin, taught me to love Elvis at the very start.

My most unsung hero, however, is my neighbor, Carolyn Shircliffe, who transcribed almost all of the interview tapes, and managed to remain both sane and pleasant throughout. She has my undying love, admiration, and gratitude.

Of course, the book would not exist were it not for my editor, Kate Hamill, who put up with more author abuse than anyone dare imagine, fought *hard* for the book to be what I envisioned, and never lost her cool with me, though I wouldn't have blamed her if she had. She is one incredible pro, and an Elvis fan through and through. I cannot thank her enough. Deep appreciation also goes to production editor Andrea Molitor, and to my agent, Amy Hughes, of McCormick & Williams.

Finally, I express my gratitude to everyone who in some way helped to make this book a reality: Lew Allen; Louise Alley; Betty Amos; Troy Atwood; Phillip Barber; Piers Beagley of the Elvis Information Network; Tom Bearden; Jean Beaulne; Steve Binder; Anita Wood Brewer; Michael Brohm; Maxine Brown; Gary Brumburgh; Jeff Burak, Time Inc.; Connie Lauridsen Burk; Trevor Cajiao; Meridel Carson; Imelda Lopez-Casper; Marshall Chapman; Cher; Petula Clark; A. J. Craddock; Yvonne Craig; Tony Curtis; Colonel Eugene Desaulniers; James Dickerson; Martha Ebberman (aka Ann Raye); Barbara Eden; Kevin Eggers; JoCathy Brownlee Elkington; Randy Erdman; Colin Escott; Lamar Fike; Bruce Fretts; David Friend; Lea Frydman, of the Web site Elvis Presley News; Gillian Gaar; Judy Geller; Larry Geller; Chris Giles; Larrian Gillespie; Meg Grant; R. M. Dolores Hart, Pr., O.S.B.; Andrew Hearn; John Heath; Susan Henning; Norma Horvitz; Nick Hunter; Wanda Jackson and Wendell Goodman, Wanda Jackson Enterprises; Joey Kent; Kevin Kern, of Elvis Presley Enterprises; Rich Kienzle; Marty Lacker; Paul Lichter; Maureen Mackey; Michael McMullan,

the *Commercial Appeal;* Larry McMurtry; Rex and Elisabeth Mansfield; Diana Magrann; Constant Meijers; Mindi Miller; Mary Ann Mobley; Herbert C. Moretz; Norma Morris; Kevin Neal; Judy Nettles, Reference Department, Eudora Welty Library, Jackson, Mississippi; Chris Noel; Sally O'Brien; Frank Page; Patti Parry; Jacque Carter Parsley; Cynthia Pepper Pazillo; Jeanne Pellicani; Ann Pennington; Siouxzan Perry; Pallas Pidgeon; Michael Radovanovic; Paul Richey; Bryan Ritter; James V. Roy; Tura Satana; Karen Schoemer; Bob Shatten; Ross Sibert; Bill Sloan; Billy and Jo Smith; Sister Barbara Spencer; Michael Streissguth; Feifei Sun; Marshall Terrill; Linda Thompson; Tanya Tucker; Richard Weitze; Raquel Welch; Al Wertheimer; Kathy Westmoreland; Jan Willis, Director, Lee County Library, and Betty Cagle, of the Mississippi Room Collection, Lee County Library, Tupelo, Mississippi; Rodney Woliver; Ginny Wright; Celeste Yarnall; Fran Zichanowicz; Belle Zwerdling.

I also thank Ginger Alden Leyser for her e-mail correspondence.

In the years since Elvis Presley's death on August 16, 1977, scores of people have contributed to my knowledge of his life, his music, and his career, many of whom, particularly Bill E. Burk and Alan Fortas, have passed on. However, both the quick and the dead continued to be guides as I readied my manuscript.

On the day that Elvis died, my father, Allan Nash, came home, stood in the door, and fixed me with a look that was more of a directive than anything else: "*Now* you have something to write about." Pop passed on in 2005, but his spirit occupied the second chair at the computer as this book took form.

Allan Nash and Elvis Presley were both iconic figures in my life, and in a way, they will always be entwined. Most people would never think of the two in the same sentence. But my tall, erudite, father—always commanding in an impeccably tailored three-piece suit—and Elvis, who looked resplendent in a custom-made jumpsuit, had many of the same invisible tattoos beneath the skin.

Pop, born in 1917 as a contemporary of Gladys and Vernon Presley, grew up in Paris, Tennessee, 138 miles northeast of Memphis, to a rural family that counted two sets of twins among its ten children. Fiercely independent, he went by his middle name, but the fact that his first name was Jesse, and that his birthday was January 9—only one day off from that of Elvis and the lost Jessie Garon—resonated with me from the day in 1956 that Elvis first became a presence in my life.

In many ways, my father, to whom music and poetry were second only to family, inspired this book. I thank him and my mother, Emily Kay Nash, for both my musical and journalistic education, and for realizing that rock and roll was every bit as important as Rachmaninoff.

ENDNOTES

. .

INTRODUCTION

xi *"We heard a woman":* Jean Beaulne to author, 2009.

xii *"There was a row of policemen":* Lew Allen to author, 2003.

xii *"The men don't know":* Lyrics, "Back Door Man," by Willie Dixon.

xii *"Nineteen fifty-six was a great year":* Scotty Moore, in the documentary "Elvis in Hollywood," 1993.

xii *"Elvis's sexual history":* Robert Christgau, *The Village Voice,* June 10, 1997.

xii "attitude, sinking eyelids": Jennings, Peter, and Brewster, Todd, *The Century.*

xiii "reached its lowest depths": Guralnick, Peter, and Jorgensen, Ernst, *Elvis Day by Day: The Definitive Record of His Life and Music.*

xiii *"a message so shocking":* Rodman, *Elvis After Elvis: The Posthumous Career of a Living Legend.*

xiii *"recognized as a threat":* Ibid.

xiii *"few rock and rollers":* Robert Christgau, *The Village Voice,* June 10, 1997.

xiii *"One of the most childish expressions":* Elvis Presley to Paul Wilder for *TV Guide,* August 6, 1956.

xiii *"What remains, unfortunately":* *Miami Herald* article as quoted in Osborne, Jerry, *Elvis Word for Word.*

xiii *"Any answer to that one?"* through *"make the best of it":* Paul Wilder interview of Elvis Presley, *TV Guide,* August 6, 1956.

xiv "charm the pants off a snake," Bobbie Ann Mason, "All Shook Up," *The New Yorker,* March 14, 1994.

xiv *"She touched my hand":* Truncated lyrics to "All Shook Up."

xiv *"He enjoyed the feel":* Alfred Wertheimer to Gary James, on the Web site classicbands.com, 2006.

xiv *"His sneer was all-important":* Whitmer, Peter O., *The Inner Elvis.*

xiv *"wandering" uterus:* Whitmer, Peter O., *The Inner Elvis.*

xiv Hippocrates and hysteria: Wikipedia.

xv *"sexual savagery":* Matt Dellinger, "For the Young Elvis, a Brand New Accompaniment," *The New York Times,* August 11, 2002.

xv *"People wonder":* Kevin Eggers, quoted in "For the Young Elvis, a Brand New Accompaniment," *The New York Times,* August 11, 2002.

xv *"effeminization of the American male":* *Chicago Tribune,* as quoted by the Web site imdb.com.

xv *"like k.d. lang":* Leigh Crow to Kerry Bashford, quoted in *Polare,* 2005.

xv *"He was the total androgynous beauty":* k.d. lang as quoted in *Elvis International Forum* magazine, Vol. 11, #1, Spring 1998.

xvi *"Elvis swims in our minds":* David Lynch, quoted in "Elvis Feared He'd Be Forgotten," on the Web site abcnews.com, 2007.

xvi *"For a dead man":* Rodman, *Elvis After Elvis: The Posthumous Career of a Living Legend.*

xvii *"Bottom line":* e-mail, Kay Wheeler to author, 2009.

ENDNOTES

CHAPTER ONE

1 *"She is always worried . . ."*: Elvis Presley to Robert Carlton Brown, March 24, 1956.

2 *"could make you laugh when nobody else could"*: Annie Presley, quoted in Burk, Bill E., *Early Elvis: The Tupelo Years*.

3 *"she would be carefully carried"*: Whitmer, Peter O., *The Inner Elvis*.

3 *"Bring a bucket"*: Mertice Finley Collins, Mississippi Room Collection, Lee County Library (MRC), probably from the papers of Elaine Dundy.

3 *"Just because you're poor"*: Billy Smith to author, 1992.

3 *"lazy as a hog"*: Lillian Smith Fortenberry, raw interview transcript, Mississippi Room Collection, Lee County Library (MRC), probably from the papers of Elaine Dundy.

3 *"Old Dr. Hunt"*: Janelle McComb to author, 2003.

4 *"This tiny impoverished community"*: Elaine Dundy, on the Web site elvisnews.com, October 6, 2004.

4 *"It seemed like"*: Dundy, Elaine, *Elvis and Gladys*.

4 *"Everybody in that family"*: Lamar Fike to author, 1992.

5 *"getting a little"*: Billy Smith to author, 1992.

5 *"Aunt Gladys was a strong-willed individual"*: Billy Smith to author, 1992.

5 *"very highly strung"*: Lillian Smith Fortenberry, raw interview transcript, Mississippi Room Collection, Lee County Library (MRC), probably from the papers of Elaine Dundy.

5 *"dark things"*: Dundy, *Elvis and Gladys*.

5 *"fast"*: Pid Harris, Mississippi Room Collection, Lee County Library (MRC), probably from the papers of Elaine Dundy.

6 *"Gladys got herself"*: Dundy, *Elvis and Gladys*.

6 *"Conversion hysteria"*: Whitmer, Peter O., *The Inner Elvis*.

7 *"she could not move"*: Annie Presley, quoted in Whitmer, Peter O., *The Inner Elvis*.

7 *"Back in them days"*: Annie Presley to Peter O. Whitmer, raw interview transcript.

7 *"Just a roof"*: Annie Presley, quoted in Burk, Bill E., *Early Elvis: The Tupelo Years*.

7 *"In all of our church services"*: Reverend Frank W. Smith, quoted in Burk, Bill E., *Early Elvis: The Tupelo Years*.

8 *"Gladys was in and out"*: Annie Presley to Peter O. Whitmer, raw interview transcript.

8 *"Your belief in God"*: Whitmer, Peter O., *The Inner Elvis*.

8 *"Gladys didn't like my attitude much"*: Vester Presley, as quoted on the Web site Elvis Australia.

9 *"When Mertice"*: e-mail, Roy Turner to author, 2009.

9 *"She was a very strict disciplinarian"*: Joseph Presley, as quoted in Dundy, Elaine, *Elvis and Gladys*.

10 *"When that was gone"*: Annie Presley to Peter O. Whitmer, raw interview transcript.

10 *"Was he being stingy"*: Tony Stuchbury to author, 2009.

10 *"When he'd get off of work"*: Annie Presley to Peter O. Whitmer, raw interview transcript.

11 *"Roses are red"*: Elvis Presley's poem, Mississippi Room Collection, Lee County Library (MRC), probably from the papers of Elaine Dundy.

12 *"Vernon thought he was a stud"*: Lamar Fike to author, 1993.

12 *"I think it's time"*: Gladys Presley, as quoted in Burk, Bill E., *Early Elvis: The Tupelo Years*.

12 *"Jessie, drunk out of his mind"*: Billy Smith to author, 1993.

13 *"more than half dead"*: Whitmer, Peter O., *The Inner Elvis*.

13 *"Some of the congregation"*: Janelle McComb, quoted in Clayton, Rose, and Heard, Dick, *Elvis Up Close*.

14 *"nobody really knows"*: Joe Savery, quoted in Clayton, Rose, and Heard, Dick, *Elvis Up Close*.

14 *"When I stumbled on"*: e-mail, Roy Turner to author, 2009.

14 *"I was doing a documentary"*: Ibid. Roy Turner to author, 2009.

14 *"People say"*: Billy Smith to author, 1993.

15 *"Gladys had"*: Unnamed cousin of Gladys Presley, Mississippi Room Collection, Lee County Library (MRC), probably from the papers of Elaine Dundy.

15 *"Gladys ruled her house"*: Lamar Fike to author, 1993.

15 *"My mother"*: Elvis Presley, press conference titled "Press Interview with Elvis Presley." Brooklyn, N.Y. Source: "Elvis Sails" EP, September 22, 1958.

15 *"It sounded like"*: Magnolia Clanton, quoted in Dundy, Elaine, *Elvis and Gladys*.

16 *"The services"*: Annie Presley, quoted in Burk, Bill E., *Early Elvis: The Tupelo Years*.

17 *"After about three hours"*: Roy Turner to Piers Beagley, Elvis Information Network, May 2008.

17 *"It was a small church"*: Elvis Presley, quoted in the *Saturday Evening Post*, September 11, 1965.

17 *"Gladys used to laugh"*: Harold Loyd, quoted in Clayton, Rose, and Heard, Dick, *Elvis Up Close*.

17 *"While pregnant"*: Peter O. Whitmer to author, 2009.

18 *"uttering a forged instrument"*: Guralnick, Peter, and Jorgensen, Ernst, *Elvis Day by Day: The Definitive Record of His Life and Music*.

18 *"They were drinking"*: Billy Smith to author, 1993.

18 *"Maybe J.D. thought"*: Ibid.

19 *"The warden made him a trustee"*: This is not precisely clear. A penitentiary record dated February 6, 1939, the day of Vernon's release states, "Sergeant Day says his record is good; not a trusty [sic], but nothing against his record. Maude."

19 *"action nightmares"*: Unnamed Presley relative, quoted in "The Boy Who Would Be King," by Steve Dougherty, *This Is Elvis*: Special Collector's Edition of *TV Guide*, August 2002.

CHAPTER TWO

21 *"The money was repaid"*: Orville Bean, letter to Governor Hugh L. White, December 16, 1938.

 Orville Bean's letter, which was found in the Parchman Penitentiary archives in 2008, also provides the clearest picture of the crime. "An application of Vernon Presley for pardon," as Bean termed it, the letter reads in full:

Dear Governor:

 This young man plead [sic] guilty at the May Term, 1938, of the Circuit Court of Lee County, Mississippi, on a charge of forgery, and was sentenced to serve three years in the State Penitentiary. This young man, who is twenty-three years of age and was raised here, has never been in any trouble whatever until this came up.

 I bought a hog from Mr. Presley and gave him a check for it and he allowed two other young men to see the check and copy the signature and the other men forged checks on me and I understand they paid Presley about $15.00 of the money they got on the forged checks for allowing them to copy the signature of the legitimate check I gave him, and not saying anything about it, but when Presley was asked about the matter he told the whole truth at the very beginning.

 This young man has a wife and one small child that are in financial distress, and they need him very badly. He is not a bad man and has never been. The money was repaid to me and this man realizes the mistake he has made and I believe he has been sufficiently punished. He is a splendid young man and if given a chance I confidently believe he will make a good and useful citizen and for these reasons I respectfully ask you to grant him a pardon.

Yours very truly,
O.S. Bean

21 *"he has never even been drunk"*: Gladys Presley and Minnie Mae Presley, letter, October 29, 1938.

21 *"My health is bad"*: Gladys Presley, letter, November 25, 1938.

22 *"He wouldn't wait"*: Annie Presley to Peter O. Whitmer, raw interview transcript.

22 *"Aunt Gladys"*: Billy Smith to author, 1993.

22 *"crying his eyes out"*: Unnamed Presley relative, quoted in "The Boy Who Would Be King," by Steve Dougherty, *This Is Elvis*: Special Collector's Edition of *TV Guide*, August 2002.

22 *"After [Vernon] went to prison:"* Unnamed Presley friend, quoted in "The Boy Who Would Be King," by Steve Dougherty, *This Is Elvis*: Special Collector's Edition of *TV Guide*, August 2002.

22 *"He'd run up to you"*: Annie Presley, quoted in Whitmer, Peter O., *The Inner Elvis*.

23 *"Twinless twins"*: Whitmer, Peter O., *The Inner Elvis*.

23 *"Elvis was just learning"*: Lillian Smith Fortenberry, raw interview transcript, Mississippi Room Collection, Lee County Library (MRC), probably from the papers of Elaine Dundy.

24 *"Given what is known"*: Whitmer, Peter O., *The Inner Elvis*.

24 *"a real condensed round"*: Billy Smith to author, 1993.

24 *"Elvis would rip"*: Lamar Fike to author, 1994.

25 *"like speaking in tongues"*: Peter O. Whitmer to author, 2009.

25 *"He couldn't do it"*: Ibid.

25 *"Elvis's thing":* Lamar Fike to author, 1992.

25 *"It's not so much":* Peter O. Whitmer to author, 2009.

26 *"Because of this fact":* Ibid.

26 *"Back then":* Billy Smith to author, 1993.

27 *"vaccinated against work":* Aaron Kennedy, quoted in Mississippi Room Collection, Lee County Library (MRC), probably from the papers of Elaine Dundy.

27 *"I remember one night":* Annie Presley, quoted in Clayton, Rose, and Heard, Dick, *Elvis Up Close.*

27 *"When he was four or five":* Billy Smith to author, 1994.

28 *"Elvis used to carry":* Ibid.

29 *"Elvis saw the doctor":* Barbara Hearn to author, 2009.

29 *"I can close my eyes":* Elois Bedford Sandifur, quoted in Clayton, Rose, and Heard, Dick, *Elvis Up Close.*

29 *"I picked him":* Elois Bedford Sandifur, quoted in Burk, Bill E., *Early Elvis: The Tupelo Years.*

30 *"very common clothes":* Ibid.

30 *"What I remember most":* Ibid.

30 *"I was just about":* Elois Bedford Sandifur, quoted in Clayton, Rose, and Heard, Dick, *Elvis Up Close.*

31 *"We would walk in the woods":* Magdalene Morgan, quoted in *TomBigbee Country Magazine.*

31 *"We were so close":* Magdalene Morgan, quoted in Burk, Bill E., *Early Elvis: The Tupelo Years.*

32 *"went and sat":* Annie Presley to Peter O. Whitmer, raw interview transcript.

32 *"One night one of his uncles":* Bobby Roberts, quoted in Burk, Bill E., *Early Elvis: The Tupelo Years.*

32 *"I could wake her up":* Elvis Presley, press conference titled "Press Interview with Elvis Presley." Brooklyn, N.Y. Source: "Elvis Sails" EP, September 22, 1958.

32 *"She didn't walk him":* Annie Presley, quoted in Burk, Bill E., *Early Elvis: The Tupelo Years.*

32 *"Being a neighbor":* Oleta Grimes, quoted in Burk, Bill E., *Early Elvis: The Tupelo Years.*

33 *"I always played":* Harold Loyd, quoted in Clayton, Rose, and Heard, Dick, *Elvis Up Close.*

33 *"My mama never":* Elvis Presley, quoted in the *Saturday Evening Post,* September 11, 1965.

33 *"But he'd climb":* Bobby Roberts, quoted in Burk, Bill E., *Early Elvis: The Tupelo Years.*

33 *"I remember":* Odell Clark, quoted in Clayton, Rose, and Heard, Dick, *Elvis Up Close.*

33 *"He said something":* Christine Roberts Presley, quoted in Clayton, Rose, and Heard, Dick, *Elvis Up Close.*

33 *"We got sun-blistered":* Guy Harris, quoted in Clayton, Rose, and Heard, Dick, *Elvis Up Close.*

34 *"I used to get":* Elvis Presley, press conference titled "Press Interview with Elvis Presley." Brooklyn, N.Y. Source: "Elvis Sails" EP, September 22, 1958.

34 *"Daddy":* Elvis Presley, quoted in "The Boy Who Would Be King," by Steve Dougherty, *This Is Elvis*: Special Collector's Edition of *TV Guide,* August 2002.

34 *"Is this a dangerous thing?"* Gladys Presley, quoted in Burk, Bill E., *Early Elvis: The Tupelo Years.*

34 *"Son, wouldn't you rather":* Gladys Presley, quoted in "The Boy Who Would Be King," by Steve Dougherty, *This Is Elvis*: Special Collector's Edition of *TV Guide,* August 2002.

34 *"The papers always said":* Forrest Bobo, quoted in Dundy, Elaine, *Elvis and Gladys.*

35 *"He got the bike":* Billy Smith to author, 1994.

35 *"From there":* Reverend Frank Smith, quoted in Burk, Bill E., *Early Elvis: The Tupelo Years.*

35 *"a real humble":* Annie Presley to Peter O. Whitmer, raw interview transcript.

35 *"on the hill":* e-mail, Roy Turner to author, 2009.

36 *"Elvis would pick up":* Mertice Finley Collins, Mississippi Room Collection, Lee County Library (MRC), probably from the papers of Elaine Dundy.

36 *"Elvis's biggest fantasy":* e-mail, Bill E. Burk to author, 1999.

36 *"She would dye":* Whitmer, Peter O., *The Inner Elvis.*

37 *"Anyone wishing":* Dundy, Elaine, *Elvis and Gladys.*

37 *"Oh, no!"* Whitmer, Peter O., *The Inner Elvis.*

38 *"They used to play":* Iris Sermon Leftwich to Peter O. Whitmer, raw interview transcript.

39 *"I want to make it on my own":* Jessie Presley, quoted in Nash, Alanna, with Smith, Billy, Lacker, Marty, and Fike, Lamar, *Elvis Aaron Presley: Revelations from the Memphis Mafia.*

39 *"She did all the work":* Lillian Smith Fortenberry, raw interview transcript, Mississippi Room Collection, Lee County Library (MRC), probably from the papers of Elaine Dundy.

39 *"Most people":* Unnamed classmate, quoted in "The Boy Who Would Be King," by Steve Dougherty, *This Is Elvis*: Special Collector's Edition of *TV Guide,* August 2002.

40 *"I didn't expect":* Magdalene Morgan, quoted in *TomBigbee Country Magazine.*

40 *"There's a story:"* Billy Smith to author, 1993.
40 *"Elvis would hear":* Gladys Presley, quoted in "The Boy Who Would Be King," by Steve Dougherty, *This Is Elvis*: Special Collector's Edition of *TV Guide,* August 2002.
40 *"There has to be more":* Vernon Presley, quoted by Billy Smith to author, 1993.
40 *"It broke my heart":* Magdalene Morgan, quoted in *TomBigbee Country Magazine.*

CHAPTER THREE

43 *"was always hugging":* Billie Wardlaw Mooneyham, quoted in Burk, Bill E., *Early Elvis: The Humes Years.*
44 *"Daddy and Vernon":* Billy Smith to author, 1993.
44 *"I remember":* Ibid.
45 *"so nervous he was bug-eyed":* Vernon Presley, quoted in Guralnick, Peter, and Jorgensen, Ernst, *Elvis Day by Day: The Definitive Record of His Life and Music.*
45 *"I was ashamed":* Elvis Presley to Wink Martindale, "Top 10 Dance Party," June 16, 1956.
45 *"He stayed there":* Billy Smith to author, 1993.
46 *"very nice":* Vernon Presley, quoted in Guralnick, Peter, and Jorgensen, Ernst, *Elvis Day by Day: The Definitive Record of His Life and Music.*
46 *"I have this":* Billy Smith to author, 1993.
47 *"Man, we really":* Buzzy Forbess, quoted in Burk, Bill E., *Early Elvis: The Humes Years.*
47 *"I grabbed":* Farley Guy, quoted in Burk, Bill E., *Early Elvis: The Humes Years.*
47 *"Farley said":* Doris Guy Wallace, quoted in Burk, Bill E., *Early Elvis: The Humes Years.*
47 *"knocking him":* Buzzy Forbess, quoted in Burk, Bill E., *Early Elvis: The Humes Years.*
47 *"It's a wonder":* Ibid.
48 *"None of us":* Ibid.
48 *"Finally one night":* Betty McMahan, quoted in Guralnick, Peter, *Last Train to Memphis: The Rise of Elvis Presley.*
48 *"Now, Billie":* Unnamed Wardlaw relative, quoted in Burk, Bill E., *Early Elvis: The Humes Years.*
49 *"All the kids":* Billie Wardlaw Mooneyham, quoted in Burk, Bill E., *Early Elvis: The Humes Years.*
49 *"I opened":* Billie Wardlaw Mooneyham, quoted in Burk, Bill E., *Early Elvis: The Humes Years.*
49 *"Elvis was a great kisser":* Billie Wardlaw Mooneyham, quoted in Burk, Bill E., *Early Elvis: The Humes Years.*
49 *"Elvis didn't like that":* Farley Guy, quoted in Burk, Bill E., *Early Elvis: The Humes Years.*
49 *"I think she just thought":* Doris Guy Wallace, quoted in Burk, Bill E., *Early Elvis: The Humes Years.*
50 *"We really":* Billie Wardlaw Mooneyham, quoted in Burk, Bill E., *Early Elvis: The Humes Years.*
50 *"Look at that":* Unnamed relative of Billie Wardlaw Mooneyham, quoted in Burk, Bill E., *Early Elvis: The Humes Years.*
50 *"About every time":* Fannie Mae Crowder Caldwell, quoted in Burk, Bill E., *Early Elvis: The Humes Years.*
51 *"We were never doing":* Billie Wardlaw Mooneyham, quoted in Burk, Bill E., *Early Elvis: The Humes Years.*
51 *"He may not":* Billy Smith to author, 1992.
52 *"My daddy":* Elvis Presley, quoted in Guralnick, Peter, and Jorgensen, Ernst, *Elvis Day by Day: The Definitive Record of His Life and Music.*
52 *"was having some kind of party":* Farley Guy, quoted in Burk, Bill E., *Early Elvis: The Humes Years.*
52 *"not then":* Billie Wardlaw Mooneyham, quoted in Burk, Bill E., *Early Elvis: The Humes Years.*
52 *"He grabbed it out":* Billie Wardlaw Mooneyham, quoted in Burk, Bill E., *Early Elvis: The Humes Years.*
53 *"I finally had to tell him":* Billie Wardlaw Mooneyham, quoted in Burk, Bill E., *Early Elvis: The Humes Years.*
53 *"at an unconscious level":* Kasl, Charlotte Davis, *Women, Sex, and Addiction: A Search for Love and Power.*
54 *"rather flashily dressed playboy type":* Interviewer notation from Elvis Presley's work application, Tennessee State Employment Security, 1953.
55 *"There were a few laughs":* George Klein to Scott Jenkins, "Interview with George Klein," on the Web site Elvis Australia.

55 *"There's three guys outside":* Elvis Presley, quoted in West, Red, and West, Sonny, and Hebler, Dave, as told to Dunleavy, Steve, *Elvis: What Happened?*

55 *"look of real fear":* Red West, et al., *Elvis: What Happened?*

56 *"They did it":* Red West, "Interview with Red West," on the Web site Elvis Australia.

56 *"I never thought":* Red West, et al., *Elvis: What Happened?*

56 *"crazy":* Buzzy Forbess, quoted in Burk, Bill E., *Early Elvis: The Humes Years.*

56 *"We got a piano":* Billy Smith to author, 1994.

57 *"He was moving":* Fannie Mae Crowder Caldwell, quoted in Burk, Bill E., *Early Elvis: The Humes Years.*

57 *"At first":* Red West, et al., *Elvis: What Happened?*

57 *"It was amazing":* Elvis Presley, quoted in Guralnick, Peter, and Jorgensen, Ernst, *Elvis Day by Day: The Definitive Record of His Life and Music.*

57 *"Not again!":* Billie Chiles Turner, quoted in Burk, Bill E., *Early Elvis: The Humes Years.*

57 *"a gentle soul":* Regis Wilson Vaughn to author, 2009.

57 *"I thought he was cute":* Regis Wilson Vaughn, *People* magazine, July 17, 1989.

57 *"He was a loner":* Regis Wilson Vaughn, *People* magazine, May 27, 1996.

57 *"I didn't have anybody":* Regis Wilson Vaughn to author, 2009.

57 *"I knew I wanted to see him":* Regis Wilson Vaughn, *People* magazine, July 17, 1989.

57 *"the poorest Catholic school":* Regis Wilson Vaughn to Peter O. Whitmer, raw interview transcript.

58 *"Growing up":* Regis Wilson Vaughn to author, 2009.

58 *"My mother had":* Regis Wilson Vaughn to author, 2009.

58 *"He used to say":* Ibid.

58 *"His humor was the type":* Ibid.

58 *"He sang it":* Regis Wilson Vaughn to Peter O. Whitmer, raw interview transcript.

59 *"He was a very simple, sweet person":* Regis Wilson Vaughn, quoted in Burk, Bill E., *Early Elvis: The Humes Years.*

59 *"If you were":* Regis Wilson Vaughn to author, 2009.

59 *"and I wanted to see for myself":* Ibid.

59 *"The nuns":* Regis Wilson Vaughn, *People* magazine, July 17, 1989.

59 *"About two in the morning":* Regis Wilson Vaughn to Peter O. Whitmer, raw interview transcript.

59 *"Some of those spirituals":* Elvis Presley, quoted in the *Saturday Evening Post,* September 11, 1965.

59 *"I would look at him":* Regis Wilson Vaughn, quoted in Burk, Bill E., *Early Elvis: The Humes Years.*

59 *"Sometimes":* Guy Coffey, quoted in Burk, Bill E., *Early Elvis: The Humes Years.*

60 *"I got the impression":* Regis Wilson Vaughn to Peter O. Whitmer, raw interview transcript.

60 *"It was the most exciting thing":* Regis Wilson Vaughn, *People* magazine, May 27, 1996.

60 *"I felt like Cinderella":* Regis Wilson Vaughn, quoted in Burk, Bill E., *Early Elvis: The Humes Years.*

60 *"Just think":* Regis Wilson Vaughn, quoted in Burk, Bill E., *Early Elvis: The Humes Years.*

60 *"he would show up":* Regis Wilson Vaughn to author, 2009.

61 *"That's all right":* Regis Wilson Vaughn, "On His Prom Night, Elvis Didn't Know How to Boogie," by John Hughes, *Fort Lauderdale News & Sun-Sentinel,* as run in the Jackson, Miss., *Clarion-Ledger,* May 24, 1989.

61 *"I jumped at the chance":* Regis Wilson Vaughn to author, 2009.

61 *"girls didn't call boys in those days":* Regis Wilson Vaughn, quoted in Burk, Bill E., *Early Elvis: The Humes Years.*

61 *"I've always regretted that":* Regis Wilson Vaughn to author, 2009.

CHAPTER FOUR

63 *"Negro artists of the South":* Guralnick, Peter, and Jorgensen, Ernst, *Elvis Day by Day: The Definitive Record of His Life and Music.*

63 *"There had never been":* Marion Keisker to Jerry Hopkins, from the Jerry Hopkins Collection, Special Collections, the University of Memphis. Unless noted, all Marion Keisker quotes come from this raw interview transcript.

63 *"Somehow or another":* Sam Phillips to Debra Evans Price, raw interview transcript, 1998.

64 *"Some of my best friends":* Ibid.

64 *"real alive":* Sam Phillips to Constant Meijers, raw interview transcription from the documentary *Looking for Colonel Parker,* 1999.

64 *"the worst thing":* Sam Phillips to Debra Evans Price, raw interview transcript, 1998.

64 *"None of these people"*: Sam Phillips to Constant Meijers, raw interview transcription from the documentary *Looking for Colonel Parker,* 1999.

64 *"I got off my back"*: Sam Phillips to Debra Evans Price, raw interview transcript, 1998.

65 *"worked as an assembler at the M.B. Parker Company"*: One of the oft-repeated fallacies in Presley lore is that Elvis drove a truck for Crown Electric when he first set foot in the Memphis Recording Service. The notion now appears rooted in the American consciousness. A press release from RCA/Legacy Records announcing the 2010 release of *Elvis 75—Good Rockin' Tonight,* a four-CD, one-hundred-song collection, repeats the error, saying the set "begins in 1953, when an eighteen-year-old truck driver fresh out of a Memphis high school recorded a self-financed performance of 'My Happiness.'" Elvis did not begin working for Crown Electric until April 20, 1954. He recorded "My Happiness" in the summer of 1953.

66 *"He tried not to show it"*: Sam Phillips, quoted in Peter Guralnick's liner notes for *Elvis: The King of Rock 'n' Roll: The Complete '50s Masters.*

67 *"He was the most gorgeous"*: Dixie Locke, quoted in *Elvis World* magazine, no. 71.

68 *"I had tried to tell"*: Dixie Locke in the documentary *The Definitive Elvis: The Many Loves of Elvis.*

68 *"My parents"*: Dixie Locke in the documentary *Young Elvis in Colour.*

68 *"adored him"*: Ibid.

68 *"almost a baby talk"*: Dixie Locke to Peter O. Whitmer, raw interview transcript, 1994.

68 *"We knew almost immediately"*: Dixie Locke, quoted in *Elvis World* magazine, no. 71.

69 *"Oh, I just do that"*: Linda Thompson, quoting Elvis Presley to Peter O. Whitmer, raw interview transcript.

69 *"kind of lost himself"*: Dixie Locke, quoted in *Elvis World* magazine, no. 71.

69 *"It was serious right away"*: Dixie Locke to Peter O. Whitmer, raw interview transcript, 1994.

69 *"We knew that that was what was supposed to be"*: Dixie Locke in the documentary *The Definitive Elvis: The Many Loves of Elvis.*

69 *"I got out of school"*: Elvis Presley, quoted in Guralnick, Peter, *Last Train to Memphis.*

69 *"I came out of Tech"*: Billie Wardlaw Mooneyham, quoted in Burk, Bill E., *Early Elvis: The Humes Years.*

69 *"If it was okay"*: Dixie Locke to Peter O. Whitmer, raw interview transcripts, 1994, 1995.

70 *"how high I was up in the church"*: Dixie Locke to Peter O. Whitmer, raw interview transcript 1995.

70 *"She told us several times"*: Ibid.

70 *"But I don't know"*: Ibid.

70 *"Sometimes they would let me help wire"*: Elvis Presley to Robert Carlton Brown, March 24, 1956, from the LP *Personally Elvis.*

71 *"You had to keep your mind"*: Ibid.

71 *"So many"*: Dixie Locke in the documentary *The Definitive Elvis: The Many Loves of Elvis.*

71 *"Man, . . . that sonofabitch"*: Guralnick, Peter, *Last Train to Memphis.*

71 *"She and I were real close"*: Dixie Locke to Peter O. Whitmer, raw interview transcript, 1994.

72 *"I no more"*: Sam Phillips to Debra Evans Price, raw interview transcript, 1998.

72 *"He sang it well"*: Ibid.

72 *"There is not"*: Ibid.

72 *"You're doing just fine"*: Sam Phillips quoted in Guralnick, Peter, *Last Train to Memphis.*

73 *"If you make a mistake"*: Sam Phillips to Debra Evans Price, raw interview transcript, 1998.

73 *"just a lot of hair"*: Scotty Moore, from the LP *Elvis, Scotty and Bill: The First Year,* Sun 1007, 1983.

74 *"Well, the boy sings pretty good"*: Ibid.

74 *"The door to the control room"*: Scotty Moore, from various sources, including his interviews with Jerry Hopkins and with the author, and from the LP *Elvis, Scotty and Bill: The First Year,* Sun 1007, 1983.

75 *"Hell, that's different"*: Sam Phillips, early take, "Blue Moon of Kentucky."

75 *"We just sort"*: Scotty Moore, quoted in Peter Guralnick's liner notes for *Elvis: The King of Rock 'n' Roll: The Complete '50s Masters.*

75 *"I think we all knew"*: Scotty Moore to Jerry Hopkins, from the Jerry Hopkins Collection, Special Collections, the University of Memphis, raw interview transcript.

75 *"I was totally stunned"*: Dixie Locke to Peter O. Whitmer, raw interview transcript, 1994.

75 *"It was almost"*: Dixie Locke, quoted in the Memphis *Commercial-Appeal,* January 5, 2004.

76 *"My wife, Steve"*: Charlie Fisher, quoted in Burk, Bill E., *Early Elvis: The Humes Years.*

76 *"My daughter dates him"*: Dixie Locke in the documentary *Young Elvis in Colour.*

76 *"Why don't you put him on the bill?"* Bob Neal quoting Sam Phillips to author, 1977.
77 *"When Elvis came on"*: Ibid.
77 *"But still he made"*: Bob Neal to Jerry Hopkins, from the Jerry Hopkins Collection, Special Collections, the University of Memphis, raw interview transcript.
77 *"I was like, 'Good grief!'"*: Dixie Locke in the documentary *Young Elvis in Colour*.
77 *"I said, 'I want him to sing'"*: Ibid.
77 *"After his records got so popular"*: Ibid.

CHAPTER FIVE

80 *"electric effect"*: Carl Perkins, *Go, Cat, Go*.
80 *"just boomed"*: Scotty Moore, from the LP *Elvis, Scotty and Bill: The First Year*, Sun 1007, 1983.
80 *"I had problems"*: Bob Neal to author, 1977.
80 *"it was pretty much"*: Ibid.
81 *"Do you think I can make it?"* Bob Neal quoting Elvis Presley to author, 1977.
81 *"He wanted"*: Bob Neal to author, 1977.
81 *"just like one of our kids"*: Ibid.
81 *"When Elvis started along"*: Ibid.
81 *"They were in shock"*: Scotty Moore, from the LP *Elvis, Scotty and Bill: The First Year*, Sun 1007, 1983.
81 *"If we really"*: Ibid.
82 *"It was earth-shattering"*: Ibid.
82 *"Mr. Franks"*: Tillman Franks, quoting Elvis Presley to author, 1998.
82 *"Ginny, . . . how in the world"*: Ginny Wright quoting Elvis Presley to author, 2009.
82 *"Well, . . . you take a deep breath"*: Ginny Wright to author, 2009.
83 *"has skyrocketed up the charts"*: Frank Page, quoted in Guralnick, Peter, and Jorgensen, Ernst, *Elvis Day by Day: The Definitive Record of His Life and Music*.
83 *"looked like he was about to leap"*: Page, Frank, with Kent, Joey, *Elvis: The Louisiana Hayride Years 1954–1956*.
83 *"booed off the stage"*: Ginny Wright to author, 2009.
83 *"He really didn't get much of a hand"*: Tillman Franks to author, 1998.
83 *"He said, 'Ginny'"*: Ginny Wright quoting Elvis Presley to author, 2009.
84 *"The acts they'd come to know"*: Page, Frank, with Kent, Joey, *Elvis: The Louisiana Hayride Years 1954–1956*.
84 *"They reacted"*: Scotty Moore, from the LP *Elvis, Scotty and Bill: The First Year*, Sun 1007, 1983.
84 *"On the second appearance"*: Tillman Franks to author, 1998.
84 *"Those eyes!"*: Jeanette Hicks, quoted in Page, Frank, with Kent, Joey, *Elvis: The Louisiana Hayride Years 1954–1956*.
84 *"Betty, quick"*: Betty Amos quoting Elvis Presley in Page, Frank, with Kent, Joey. *Elvis: The Louisiana Hayride Years 1954–1956*.
84 *"absolutely thrashed"*: Betty Amos to author, 2009.
84 *"I was very fond of Elvis"*: Betty Amos quoting Elvis Presley in Page, Frank, with Kent, Joey. *Elvis: The Louisiana Hayride Years 1954–1956*.
85 *"I was dressed up."* Betty Amos to author, 2009.
85 *"You need to be kissed"*: Betty Amos quoting Elvis Presley to author, 2009.
85 *"We more or less"*: Betty Amos to author, 2009.
85 *"I was as strong as he was"*: Ibid.
86 *"There was a piano"*: Jim Ed Brown to author, 1981.
86 *"were so amazed"*: Dixie Locke to Peter O. Whitmer, raw interview transcript, 1995.
86 *"I felt I was not a part"*: quoted in Guralnick, Peter, *Last Train to Memphis: The Rise of Elvis Presley*.
86 *"Before long, girls were swarming around him"*: Logan, Horace, and Sloan, Bill. *Elvis, Hank & Me: Making Musical History on the Louisiana Hayride*.
86 *"After nineteen years"*: Ibid.
87 *"Everything did"*: Billy Smith to author, 1994
87 *"fourteen or sixteen will get you twenty"*: Lamar Fike, quoting Elvis Presley to author, 1994.
87 *"I sometimes drove"*: Logan, Horace, and Sloan, Bill. *Elvis, Hank & Me: Making Musical History on the Louisiana Hayride*.
87 *"Everybody knew"*: Maxine Brown to author, 2009.

88 *"The rubber busted"*: Moore, Scotty, as told to Dickerson, James, *That's Alright, Elvis.*

88 *"never break a virgin"*: Elvis Presley, quoted by Alan Fortas to author, 1989.

88 *"Many of the mamas"*: Maxine Brown to author, 2009.

89 *"Hi, Babies"*: Telegram from Elvis Presley to his parents, November 26, 1954, as reproduced in Guralnick, Peter, and Jorgensen, Ernst, *Elvis Day by Day: The Definitive Record of His Life and Music.*

89 *"When we started"*: Maxine Brown to author, 2009.

89 *"speculated that J. E."*: Brown, Maxine. *Looking Back to See: A Country Music Memoir.*

89 *"I'm not sure"*: Dixie Locke to Peter O. Whitmer, raw interview transcript, 1995.

90 *"Elvis, . . . don't you have any drawers?"* Brown, Maxine. *Looking Back to See: A Country Music Memoir.*

90 *"Honey, God, he was huge!"*: Maxine Brown to author, 2009.

90 *"I said to him one time"*: Betty Amos to author, 2009.

90 *"He'd have"*: Ibid.

90 *"wanted him to stay at home"*: Maxine Brown to author, 2009.

90 *"because I talked about Jesus and God"*: Betty Amos to author, 2009.

91 *"He was crazy about her"*: Maxine Brown to author, 2009.

91 *"He couldn't get enough"*: Maxine Brown to author, 2009.

91 *"Before morning"*: Ibid.

92 *"On the road"*: Jim Ed Brown to author, 1981.

92 *"One night"*: Maxine Brown to author, 2009.

92 *"Elvis Presley was a highly sexed young guy"*: Bill Randle, from the BBC Documentary *Presley,* part 1, "I Don't Sing Like Nobody," 1987.

92 *"Cute little thing"*: Betty Amos to author, 2009.

92 *"One of the first questions"*: Logan, Horace and Sloan, Bill. *Elvis, Hank and Me: Making Musical History on the Louisiana Hayride.*

93 *"When you come"*: Carolyn Bradshaw to author, 2009. All quotes from Carolyn Bradshaw come from a 2009 interview with the author, unless otherwise noted.

93 *"He was little"*: e-mail, Nita Lynn to author, 2009.

94 *"She really liked him"*: Louise Alley to author, 2009.

94 *"You will never guess"*: Nita Lynn, quoting Carolyn Bradshaw in an e-mail to the author, 2009. She also writes about this in "She Turned Down Elvis!," an article in *Reminisce* magazine, January 2008.

95 *"because he was just madly"*: Nita Lynn to author, 2009.

95 *"All of his romances were short"*: Frank Page to author, 2009.

95 *"After a few times"*: Nita Lynn, e-mail to author, 2009.

96 *"She was very sharp and spunky"*: Ginny Wright to author, 2009.

97 *"She was a beautiful young lady"*: Tom Bearden, e-mail to author, 2009.

97 *"Anybody who's ever claimed"*: Shirley Dieu to author, 2009.

97 *"You're bound to remember me, Mr. Logan"*: Anonymous caller, quoted in Logan, Horace, and Sloan, Bill. *Elvis, Hank and Me: Making Musical History on the Louisiana Hayride.*

CHAPTER SIX

99 *"Bob, this guy is incredible"*: Oscar Davis to Jerry Hopkins, from the Jerry Hopkins Collection, Special Collections, the University of Memphis, raw interview transcript.

99 *"It was really Oscar who found Elvis"*: Charlie Lamb, on tape made for author, 1998.

99 *"We would see him walkin' around"*: D. J. Fontana to author, 1998.

99 *"razzle-dazzle character"*: Bob Neal to author, 1977.

100 *"I always felt"*: Ibid.

100 *"I was just a poor, hungry guy"*: Eddy Arnold, quoted in the documentary *The Life and Times of Eddy Arnold.*

101 *"When Tom was driving"*: David Wilds to author, 1998.

102 *"His energy"*: Roy Orbison, quoted in "Viva Fort Hood," by Michael Hall, *Texas Monthly,* December 2000.

103 *"We went out there"*: Anita Carter, 1998, raw interview transcript, on the Web site msn.com Web Communities/country music.

103 *"a kid with six pair of feet"*: Red West, et al., *Elvis: What Happened?*

103 *"I was so afraid"*: Dixie Locke in the documentary *Young Elvis in Colour.*

104 *"neither one"*: Barbara Hearn to author, 2009.

104 *"It was kind of a mutual thing"*: Dixie Locke, quoted in the Memphis *Commercial Appeal,* January 5, 2004.

104 *"He felt like"*: Dixie Locke to Peter O. Whitmer, raw interview transcript, 1994.

105 *"healthier than a herd of cattle"*: Red West, et al., *Elvis: What Happened?*

105 *"Elvis got a crush"*: June Carter Cash, quoted in Oermann, Robert K., *Behind the Grand Ole Opry Curtain.*

106 *"You would have thought"*: Red West et al., *Elvis: What Happened?*

106 *"I kept praying"*: June Carter Cash to author, 2003.

106 *"I've got two or three"*: Ibid.

106 *"Elvis introduced me to Johnny Cash's music"*: Ibid.

106 *"You know, son"*: June Carter Cash to John Carter Cash, *Anchored in Love.*

106 *"to rest"*: John Carter Cash, *Anchored in Love.*

106 *"Like most children"*: Ibid.

107 *"Hank Snow could follow anybody"*: Colonel Tom Parker, telephone conversation with Ralph Emery, April 7, 1993.

107 *"The Colonel sent"*: Charlie Louvin to author, 1998.

107 *"Girls, I'll see you all backstage"*: Elvis Presley, quoted in Cotton, Lee, *All Shook Up: Elvis Day-by-Day, 1954–1977*

107 *"All of a sudden"*: Mae Boren Axton, public appearance at Memphis State University, 1986.

108 *"I heard all this screaming"*: Ibid.

108 *"I'm sure I must have looked like a giant blueberry"*: Jackie Rowland to author, 2009. All Jackie Rowland quotes come from a 2009 interview with the author, unless otherwise noted.

108 *"They really mobbed him"*: Marty Robbins to author, 1977.

108 *"When we went out on the beach"*: Ibid.

109 *"He had a quick, sensual smile"*: Mae Boren Axton to Sandy Lovejoy, raw interview transcript, 1990.

109 *"When I came back"*: Mae Boren Axton to Joe Allison, for BMI.

110 *"Here we were"*: Kay Wheeler to author, 2009.

CHAPTER SEVEN

113 *"Daddy was booking all these people"*: Martha Ann Barhanovich Ebberman, quoted on the Web site ScottyMoore.net.

113 *"the teenagers just love him"*: Newspaper story, reproduced on the Web site ScottyMoore.net.

113 *"It was so different"*: Salvadore "Penue" Taranto, quoted on the Web site ScottyMoore.net.

114 *"My first thought"*: June Juanico to Peter O. Whitmer, raw interview transcript, 1994.

114 *"I thought he was the most gorgeous thing I'd ever seen."* June Juanico to author, 2007. Portions of the June Juanico material previously appeared in *Ladies' Home Journal,* August 2007.

114 *"Come on, Glenda"*: June Juanico to Peter O. Whitmer, raw interview transcript, 1994.

114 *"Where are you going?"*: June Juanico to author, 2007, and Peter O. Whitmer, raw interview transcript, 1994.

115 *"Biloxi is such a small town"*: June Juanico to Peter O. Whitmer, raw interview transcript, 1994.

115 *"In this business"*: June Juanico to author, 2007.

115 *"I have to go back"*: June Juanico to Peter O. Whitmer, raw interview transcript, 1994.

115 *"the room's a mess"*: Ibid.

115 *"Where did you learn to kiss?"*: June Juanico quoting Elvis Presley to author, 2007.

115 *"Soft, full lips"*: June Juanico to author, 2007.

116 *"Oh, my God"*: June Juanico to Peter O. Whitmer, raw interview transcript, 1994.

116 *"Do you have to go in?"* June Juanico quoting Elvis Presley to Peter O. Whitmer, raw interview transcript, 1994.

116 *"By the way"*: June Juanico quoting Elvis Presley to Peter O. Whitmer, raw interview transcript, 1994.

116 *"I wasn't"*: June Juanico to author, 2007.

117 *"I can't explain it"*: June Juanico quoting Elvis Presley to Peter O. Whitmer, raw interview transcript, 1994.

117 *"I was the first one"*: Wanda Jackson, quoted on the Web site CMT.com.

117 *"getting popular real fast"*: Wanda Jackson to author. Unless noted, all quotes from Wanda Jackson come from two interviews with the author, 2000 and 2007. Portions of the Wanda Jackson material originally appeared in *Ladies' Home Journal,* August 2007.

119 *"I had so much fun":* Tura Satana, quoted in Des Barres, Pamela, *Let's Spend the Night Together.*

120 *"Someday I'm gonna fly":* Ibid.

120 *"for tempting those boys into raping me":* Ibid.

120 *"We had leather motorcycle jackets":* Tura Satana to *Psychotronic Video,* quoted on Wikipedia.com.

120 *"When I was dancing":* Tura Satana quoted on the Web site imdb.com.

121 *"the most honest":* Richard Corliss, quoted in McDonough, Jimmy, *Big Bosoms and Square Jaws: The Biography of Russ Meyer, King of the Sex Film.*

122 *"Okay, where have you got your hands . . ."* Tura Satana, quoted in Des Barres, Pamela, *Let's Spend the Night Together.*

123 *"He was on":* Scotty Moore, from the LP *Elvis, Scotty and Bill: The First Year,* Sun 1007, 1983.

124 *"I had two motorcycles":* Jimmie Rodgers Snow to author, 2003.

124 *"Basically, we were about the same age":* Jimmie Rodgers Snow to author, 2003.

125 *"I'd better not":* Guralnick, Peter, and Jorgensen, Ernst, *Elvis Day by Day: The Definitive Record of His Life and Music.*

125 *"that sizzling, sultry look":* Oberst, Stanley, and Torrance, Lori, *Elvis in Texas: The Undiscovered King 1954–1958.*

125 *"the only serious writers":* Grover Lewis to Peter O. Whitmer, raw interview transcript, 1994. All Grover Lewis quotes come from this interview. In an e-mail to the author in 2009, Larry McMurtry questioned the veracity of the story. "Grover was a liar who fictionalized everything," he wrote.

CHAPTER EIGHT

130 *"I just happened":* Tommy Durden to author, 2002.

130 *"started jumping around":* Chet Atkins to author, 1981.

131 *"My attitude":* Anne Fulchino to author, 1998.

131 *"It scares me":* Guralnick, Peter, and Jorgensen, Ernst, *Elvis Day by Day: The Definitive Record of His Life and Music.*

131 *"a scream":* Ibid.

132 *"We went back":* Chick Crumpacker to author, 1998.

132 *"the lead in a high school play":* Guralnick, Peter, and Jorgensen, Ernst, *Elvis Day by Day: The Definitive Record of His Life and Music.*

133 *"appears to be a dream to me":* Ibid.

133 *"meteoric rise":* Memo, Joe Hazen to Hal Wallis, June 11, 1956, Academy of Motion Pictures Special Collection Library.

133 *"My ambition":* Elvis Presley to Hal Wallis, Academy of Motion Pictures Special Collection Library.

134 *"My mom":* Barbara Hearn to author, 2009.

134 *"What's an Elvis?":* Barbara Hearn, quoted in *Essential Elvis* magazine, no. 63, 2009.

134 *"The first person":* Barbara Hearn to author, 2009.

134 *"It was so huge":* Ibid.

134 *"She was a great old lady":* Ibid.

134 *"certainly not outward":* Ibid.

135 *"standing up and showing off their stuff":* Barbara Hearn, quoted in *Essential Elvis* magazine, no. 63, 2009.

135 *"Elvis came to the window":* Barbara Hearn to author, 2009.

135 *"He said he was going on a tour":* Ibid.

135 *"I wasn't carried away":* Barbara Hearn, quoted in *Essential Elvis* magazine, no. 63, 2009.

135 *"very personable":* Barbara Hearn to author, 2009.

135 *"Often, Elvis would drive up":* Barbara Hearn, quoted in *Essential Elvis* magazine, no. 63, 2009.

136 *"She couldn't actually play":* e-mail: Barbara Hearn to author, 2009.

136 *"She was always neat":* Barbara Hearn to author, 2009.

136 *"I would telephone her":* Ibid.

137 *"She was serious and concerned":* Ibid.

137 *"I wrote most of Elvis's fan letters":* e-mail: Barbara Hearn to author, 2009.

137 *"He just reached":* Barbara Hearn to author, 2009.

137 *"a family of worriers":* Ibid.

138 *"We were having a meal"*: Ibid.

138 *"Elvis broke away"*: Ibid.

138 *"My husband tells everybody"*: Ibid.

138 *"Lots of hugging"*: e-mail, Barbara Hearn to author, 2009.

138 *"He was very, very respectful"*: Barbara Hearn to author, 2009.

139 *"Hell and high water"*: Kay Wheeler to author, 2009.

139 *"Hi, Elvis"*: Harbinson, W. A., and Wheeler, Kay, *Growing Up with the Memphis Flash.*

140 *"He pretty much groped me"*: Kay Wheeler to author, 2009.

140 *"I was on the same page with him"*: Ibid.

140 *"slipping casually"*: Harbinson, W. A., and Wheeler, Kay. *Growing Up with the Memphis Flash.*

140 *"Why buy a cow"*: "Teeners' Hero," *Time,* May 14, 1956.

140 *"because he looks so mean"*: Guralnick, Peter, and Jorgensen, Ernst, *Elvis Day by Day: The Definitive Record of His Life and Music.*

140 *"He should have been under freaking arrest"*: Kay Wheeler to author, 2009.

141 *"Where did you learn how to do that?"*: Kay Wheeler quoting Elvis Presley to author, 2009.

141 *"He couldn't get out of the auditorium"*: Kay Wheeler to author, 2009.

141 *"It was almost"*: Ibid.

141 *"He asked me to show him the steps"*: Ibid.

141 *"I don't know"*: Ibid.

142 *"a nice thing"*: Ibid.

142 *"They got an atom-bomb"*: Colonel Tom Parker, quoted in the *Saturday Evening Post*, September 11, 1965.

142 *"jumped up from their ringside table"*: Crumbaker, Marge, and Tucker, Gabe. *Up and Down with Elvis Presley: The Inside Story.* New York: G. P. Putnam's Sons, 1981.

142 *"After that first night"*: Elvis Presley quoted in Guralnick, Peter, and Jorgensen, Ernst, *Elvis Day by Day: The Definitive Record of His Life and Music.*

143 *"He would sing directly to me"*: Nancy Kozikowski, quoted in "30 Years After Elvis's Death, Local Fan's Tender Memories Linger," by Ollie Reed Jr., the *Albuquerque Tribune,* August 16, 2007.

143 *"If anyone did it earlier"*: Ibid.

143 *"Because I had seen him"*: Ibid.

143 *"It was scary"*: Nancy Kozikowski, quoted in *Elvis World* magazine, no. 50.

144 *"Vegas was where"*: Nancy Kozikowski, quoted in "30 Years After Elvis's Death, Local Fan's Tender Memories Linger," by Ollie Reed Jr., the *Albuquerque Tribune,* August 16, 2007.

144 *"He was always nice and flirty"*: Ibid.

144 *"Very nice and sweet"*: Nancy Kozikowski, quoted in *Elvis World* magazine, no. 49.

144 *"I was only thirteen"*: Nancy Kozikowski, quoted in "30 Years After Elvis's Death, Local Fan's Tender Memories Linger," by Ollie Reed Jr., the *Albuquerque Tribune,* August 16, 2007.

144 *"How could you not know"*: Judy Spreckels, quoted in "Elvis' Gal Pal Shares Memories: Elvis 'Sister' Breaks Silence, Reminisces Life in Inner Circle," by Linda Deutsch, the Associated Press, August 12, 2002. Unless noted, all Judy Spreckels quotes come from this interview.

145 *"Where did you learn"*: Gloria Pall to Elvis Presley, quoted in *Elvis World* magazine, no. 59, in an excerpt of her book, *I Danced Before the King.*

146 *"He went back"*: Joan Adams Shoofey to author, 1999. All quotes from Joan Adams come from this interview with the author.

148 *"sexual self-gratification on stage"*: Guralnick, Peter, and Jorgensen, Ernst, *Elvis Day by Day: The Definitive Record of His Life and Music.*

148 *"I applaud parents"*: Hedda Hopper, in undated item, probably June 1956. Margaret Herrick Library, the Academy of Motion Pictures.

149 *"Oh, by the way"*: June Juanico, quoting her brother to author, 2007.

149 *"Well, let's go take a look"*: June Juanico to Peter O. Whitmer, raw interview transcript, 1994.

150 *"Somebody told me"*: Ibid.

150 *"I think I probably was the first female guest on Audubon Drive"*: June Juanico to author, 2007.

150 *"She saw me as domesticated"*: June Juanico to author, 2007.

150 *"You've got to pick a name"*: June Juanico to Peter O. Whitmer, raw interview transcript, 1994.

151 *"She thought I was a good catch"*: June Juanico to author, 2007.

151 *"Let's go see your room first"*: June Juanico, quoting Elvis Presley to Peter O. Whitmer, raw interview transcript, 1994.

151 *"and we hugged"*: June Juanico to Peter O. Whitmer, raw interview transcript, 1994.

151 *"June, . . . I'm not going to hurt you"*: June Juanico, quoting Elvis Presley to Peter O. Whitmer, raw interview transcript, 1994.

151 *"That's what happened"*: June Juanico to Peter O. Whitmer, raw interview transcript, 1994.

151 *"We'd spent so much time together"*: June Juanico to author, 2007.

CHAPTER NINE

153 *"will not be allowed"*: Guralnick, Peter, and Jorgensen, Ernst, *Elvis Day by Day: The Definitive Record of His Life and Music.*

153 *"a piece of good luck"*: "An Interview with Steve Allen," by Steve Roeser, *Goldmine*, December 11, 1992.

153 *"worked to our advantage"*: Ibid.

153 *"this tall, gangly"*: Ibid.

153 *"I could see"*: Ibid.

153 *"I personally came up with the two ideas"*: Steve Allen, letter to author, 1997.

154 *"talented, hungry kids who'd work cheap"*: Anne Fulchino to author, 1998.

154 *"had the right personality"*: Ibid.

154 *"were probably the first"*: Wertheimer, Alfred, *Elvis '56: In the Beginning.*

154 *"Basically I was covering"*: Al Wertheimer to author, 1998.

154 *"the sexiest picture"*: Al Wertheimer quoting Diane Keaton on the Web site elvispresleynews.com.

155 *"flipping through some of the pages"*: Wertheimer, Alfred, *Elvis at 21: New York to Memphis.*

155 *"continued to be at turns"*: Ibid.

155 *"Do I leave them their privacy"*: Al Wertheimer to author, 1998.

156 *"I think Elvis kissed thousands of girls"*: Ibid.

157 *"I'm planning for seven"*: Elvis Presley to Hy Gardner, July 1, 1956, as quoted in Osborne, Jerry, *Elvis Word for Word.*

157 THE KING IS GONE: Quoted on the Web site roadsideamerica.com.

157 *"He was very awkward in that era"*: Wink Martindale, quoted in *Elvis World* magazine, no. 29.

158 *"several newspaper stories"*: Hy Gardner, July 1, 1956, as quoted in Osborne, Jerry, *Elvis Word for Word.*

159 *"a model of gentility"*: Wertheimer, Alfred, *Elvis '56: In the Beginning.*

159 *"Let's dance"*: Ibid.

159 *"I didn't want"*: Barbara Hearn to author, 2009.

160 *"those people in New York"*: Guralnick, Peter, and Jorgensen. Ernst, *Elvis Day by Day: The Definitive Record of His Life and Music.*

160 *"We didn't get to say anything"*: Carolyn Bradshaw to author, 2009.

163 *"There was a group"*: June Juanico to Peter O. Whitmer, raw interview transcript, 1994.

163 *"You told everybody"*: June Juanico quoting Elvis Presley to Peter O. Whitmer, raw interview transcript, 1994.

163 *"Elvis, how are you?"*: Unknown interviewer to Elvis Presley, WNOE Radio, July 9, 1956, as quoted in Osborne, Jerry, *Elvis Word for Word.*

165 *"She would just dig into him"*: June Juanico to Peter O. Whitmer, raw interview transcript, 1994.

165 *"He said, 'I can't get married right away' "*: June Juanico to Peter O. Whitmer, raw interview transcript, 1994.

165 *"It was very embarrassing"*: Barbara Hearn to author, 2009.

165 *"great care"*: June Juanico to Peter O. Whitmer, raw interview transcript, 1994.

166 *"They said"*: Ibid.

166 *"But I know Elvis"*: Regis Wilson Vaughn, quoted in "Elvis Was My Prom Date—But He Wouldn't Dance," *San Jose Mercury News,* May 23, 1989.

166 *"I just wish"*: Regis Wilson Vaughn, e-mail to author, 2009.

167 *"He was very casual"*: Jay Leviton, in Leviton, Jay B., and Rijff, Ger J., *Elvis Close-Up.*

167 *"aroused fans"*: Guralnick, Peter, *Last Train to Memphis.*

167 *"frozen stiff with outrage"*: Leviton, Jay B., and Rijff, Ger J., *Elvis Close-Up.*

167 *"bizarrely spasmodic and purely sexual"*: Pond, Steve, *Elvis in Hollywood.*

167 *"They really wanted Daddy"*: Marilyn Gooding to Peter O. Whitmer, raw interview transcript, 1993.

167 *"They had me convinced"*: Marion W. Gooding, quoted in "They Said the Boy Was Downright Depraved," by Ann Hyman, *Florida Times-Union,* August 11, 1978.

167 *"impairing the morals"*: Guralnick, Peter, *Last Train to Memphis.*

168 *"I can't figure out what I'm doing wrong"*: Guralnick, Peter, and Jorgensen, Ernst, *Elvis Day by Day: The Definitive Record of His Life and Music.*

168 *"with the sort of good manners"*: Marilyn Gooding to Peter O. Whitmer, raw interview transcript, 1993.

168 *"I'm going to put him in jail"*: Marion W. Gooding, quoted in "They Said the Boy Was Downright Depraved," by Ann Hyman, *Florida Times-Union,* August 11, 1978.

168 *"Wait a minute"*: Elvis Presley, quoted in "They Said the Boy Was Downright Depraved," by Ann Hyman, *Florida Times-Union,* August 11, 1978.

168 *"The kids went nuts"*: June Juanico to Peter O. Whitmer, raw interview transcript, 1994.

168 *"It hurt his feelings"*: Ibid.

168 *"He went back to his chambers"*: Eunice Gooding to Peter O. Whitmer, raw interview transcript, 1993.

168 *"Everybody in the audience"*: Marilyn Gooding to Peter O. Whitmer, raw interview transcript, 1993.

168 *"Baby, you should have been there"*: Guralnick, Peter, *Last Train to Memphis.*

169 *"You've got to get your butt down here!"*: June Juanico quoting Elvis Presley to Peter O. Whitmer, raw interview transcript, 1994.

170 *"Elvis was gone"*: June Juanico to Peter O. Whitmer, raw interview transcript, 1994.

172 *"You know how Elvis"*: Ibid.

173 *"I have to call my mother before I go to sleep"*: June Juanico quoting Elvis Presley to Peter O. Whitmer, raw interview transcript, 1994.

173 *"He told her"*: June Juanico to Peter O. Whitmer, raw interview transcript, 1994.

173 *"Whenever we went to bed"*: Ibid.

173 *"He sat straight up in his bed"*: Ibid.

CHAPTER TEN

175 *"I don't know what it is"*: Elvis Presley, quoted in the *Saturday Evening Post,* September 11, 1965.

176 *"Really, Mr. Berle"*: Elvis Presley quoted in Pond, Steve, *Elvis in Hollywood.*

176 *"I'll admit"*: Debra Paget quoted in Goldman, Albert, *Elvis.*

176 *"When I came back"*: Mildred Dunnock to Jerry Hopkins, from the Jerry Hopkins Collection, Special Collections, the University of Memphis. All Mildred Dunnock quotes come from this raw interview transcript.

178 *"People think"*: Elvis Presley quoted in Guralnick, Peter, and Jorgensen, Ernst, *Elvis Day by Day: The Definitive Record of His Life and Music.*

179 *"I thought it might be"*: Paul Beaulieu, quoted in *Elvis by the Presleys,* Ritz, David, editor.

179 *"I cracked open my door"*: Priscilla Presley, quoted in *Elvis By the Presleys,* Ritz, David, editor.

179 *"A press agent came by"*: Unidentified reporter, quoted in Pond, Steve, *Elvis in Hollywood.*

179 *"The three of us"*: Leonard Hirshan to author, 1999.

180 *"Tell your bosses"*: Byron Raphael quoting Colonel Tom Parker to author, 1998.

180 *"I could tell they were hot for each other"*: Byron Raphael to author, 2005. All quotes from Byron Raphael about Elvis's encounter with Natalie Wood come from this interview. Portions of the Byron Raphael material originally appeared in *Playboy* magazine, in the article "In Bed with Elvis," by Byron Raphael and Alanna Nash, November 2005.

180 *"every time you went to see Elvis"*: Glen Glenn in the documentary *The Definitive Elvis: The Many Loves of Elvis.*

181 *"and just told her"*: Sharon Sheeley in the documentary *The Definitive Elvis: The Many Loves of Elvis.*

181 *"When she got her driver's license"*: Mary Jo Sheeley in the documentary *The Definitive Elvis: The Many Loves of Elvis.* All quotes from Sharon and Mary Jo Sheeley come from this film.

183 *"He always said"*: Debra Paget, quoted in Finstad, Suzanne, *Child Bride.*

183 *"I love 'em all"*: Elvis Presley, quoted in Goldman, Albert, *Elvis.*

183 *"There were stories"*: Debra Paget, quoted in Finstad, Suzanne, *Child Bride.*

183 *"I was very shy then"*: Ibid.

184 *"almost a three-some"*: Natalie Wood quoted in "Natalie Wood: Show-off or Show-Woman?" by Louella Parsons, *Los Angeles Examiner,* December 16, 1956.

184 *"Natalie and I"*: Tab Hunter in the documentary *The Definitive Elvis: The Many Loves of Elvis.*

184 *"He was the first person"*: Natalie Wood, quoted in Goldman, Albert, *Elvis.*

185 *"Elvis handed me something"*: Barbara Hearn to author, 2009.

185 *"America's Number One Entertainer"*: Liner notes from the LP set, *Elvis: A Golden Celebration,* RCA CPM6-5172, 1984.

185 *"The last time"*: Victor, Adam, *The Elvis Encyclopedia.*

186 *"What did I want?"*: Judy Hopper, interview, on the LP set, *Elvis: A Golden Celebration,* RCA CPM6-5172, 1984.

186 *"It made me feel bad"*: Guralnick, Peter, *Last Train to Memphis.*

186 *"I've been looking forward"*: Liner notes from the LP set, *Elvis: A Golden Celebration,* RCA CPM6-5172, 1984.

186 *"How about Natalie?"*: Guralnick, Peter, *Last Train to Memphis: The Rise of Elvis Presley.*

187 *"All of a sudden"*: Ibid.

187 *"all the good people"*: Vernon Presley, interview, on the LP set *Elvis: A Golden Celebration,* RCA CPM6-5172, 1984.

187 *"'Baby, Play House'"*: Gladys Presley, interview, on the LP set *Elvis: A Golden Celebration,* RCA CPM6-5172, 1984.

187 *"And you're a star"*: Jack Cristil, interview, on the LP set *Elvis: A Golden Celebration,* RCA CPM6-5172, 1984.

187 *"the nicest person"*: Nick Adams, interview, on the LP set *Elvis: A Golden Celebration,* RCA CPM6-5172, 1984.

188 *"He was just about broke"*: Barbara Hearn to author, 2009.

188 *"The road was single lane"*: e-mail, Barbara Hearn to author, 2009.

188 *"all of the time"*: Barbara Hearn to author, 2009.

188 *"was disgusting"*: Barbara Hearn quoting Elvis Presley to author, 2009.

189 *"I was mortified"*: Barbara Hearn, quoted in *Elvis World* magazine, no. 41.

189 *"I look so sad and bedraggled"*: Barbara Hearn, quoted in *Essential Elvis* magazine, no. 63, 2009.

189 *"It was really neat"*: Barbara Hearn to author, 2009.

189 *"own sweet self"*: Ibid.

CHAPTER ELEVEN

191 *"Hi, wioole"*: Telegram, Elvis Presley to June Juanico, August 21, 1956, reproduced in Osborne, Jerry, *Elvis Word for Word.*

191 *"I told him no, no, no"*: June Juanico to Peter O. Whitmer, raw interview transcript, 1994.

191 *"Elvis would just look at me"*: June Juanico to Peter O. Whitmer, raw interview transcript, 1994.

192 *"big ol' box of cash"*: Ibid.

192 *"He was constantly stuck up Elvis's butt"*: Ibid.

192 *"Elvis didn't invite Natalie"*: Ibid. However, Natalie Wood told author Albert Goldman, "His parents called my parents and asked if I could be their house guest."

192 *"I said, 'No, Nick'"*: Ibid.

193 *"Elvis felt sorry for him"*: June Juanico to author, 2007.

193 *"Nick was always up"*: June Juanico to Peter O. Whitmer, raw interview transcript, 1994.

193 *"after the show"*: Barbara Pittman, quoted in Clayton, Rose, and Heard, Dick, *Elvis Up Close.*

193 *"A lot of people"*: Barbara Pittman, quoted on the Web site Elvis Information Network.

194 *"they were very congenial to me"*: Phillip Barber to author, 2009. All Phillip Barber quotes comes from this interview.

194 *"I'd just get so giddy"*: Phillip Barber quoting Barbara Pittman to author, 2009.

194 *"I hadn't been around"*: Natalie Wood, quoted in Goldman, Albert, *Elvis.*

195 *"Elvis"*: Barbara Hearn quoting her aunt to author, 2009.

195 *"Man, Gladys was stoned"*: Barbara Pittman, quoted in Clayton, Rose, and Heard, Dick. *Elvis Up Close.*

195 *"We just sang"*: Suzanne Bancroft, quoted in *Elvis World* magazine, no. 29.

195 *"too fond of the men"*: Lillian Smith Fortenberry, raw interview transcript, Mississippi Room Collection, Lee County Library (MRC), probably from the papers of Elaine Dundy.

196 *"she didn't like"*: e-mail, Barbara Hearn to author, 2009.

196 *"new girlfriend"*: Finstad, Suzanne, *Natasha: The Biography of Natalie Wood.*

196 *"She looked like a rat"*: Michael Zimring, quoted in Finstad, Suzanne, *Natasha: The Biography of Natalie Wood.*

196 *"Heaven help us!"* Byron Raphael quoting Elvis to author, 2005.

197 *"Wow. . . . He's beautiful"*: Marilyn Evans Knowles-Riehl, quoted in the *Chicago Tribune*, November 16, 2008. All quotes from Marilyn Evans come from this interview.

197 *"and there was Elvis"*: Dottie Harmony, quoted in Guralnick, Peter, *Last Train to Memphis.*

198 *"I want you"*: Hal Kanter quoting Hal Wallis, Academy Oral History Program, Margaret Herrick Library, the Academy of Motion Pictures. All Hal Kanter quotes come from this interview, except as noted.

199 *"It looked like an elephant"*: Logan, Horace, and Sloan, Bill, *Elvis, Hank & Me: Making Musical History on the Louisiana Hayride.*

199 *"She appeared"*: Hal Kanter, quoted in Guralnick, Peter, *Last Train to Memphis.*

200 *"for refreshments"*: Kanter, Hal, *So Far, So Funny: My Life in Show Business.*

200 *"not saying a word"*: Brown, Maxine, *Looking Back to See: A Country Music Memoir.*

200 *"a souped-up Chevy"*: Kanter, Hal, *So Far, So Funny: My Life in Show Business.*

200 *"It was so successful"*: e-mail, Kay Wheeler to author, 2009.

201 *"the kelly green sport coat"*: The coat seemed lost forever, an Elvis mystery. But in 2009, a swatch of it turned up for sale on eBay. In 1971, the Colonel allowed the coat to be cut up. RCA offered the remnants as promotional pieces placed in envelopes ("Something from Elvis' wardrobe for you") in the four-LP set *Elvis: The Other Sides—Worldwide Gold Award Hits, Vol. 2.*

201 *"sat on their hands"*: Ibid.

201 *"I didn't want"*: Kay Wheeler to author, 2009. All remaining quotes from Kay Wheeler come from this interview unless otherwise noted.

203 *"nearly 10,000 of them"*: Frank Page to author, 2009.

203 *"noise enough to peel paint"*: Logan, Horace, and Sloan, Bill, *Elvis, Hank & Me: Making Musical History on the Louisiana Hayride.*

203 *"I'd wonder"*: Barbara Hearn to author, 2009.

203 *"I never knew"*: Ibid.

204 *"keep me right next to him"*: June Juanico to Peter O. Whitmer, raw interview transcript, 1994.

204 *"But you don't"*: Ibid.

204 *"If it had been Elizabeth Taylor"*: Barbara Hearn to author, 2009.

205 *"It was a pretty shaver"*: e-mail, Barbara Hearn to author, 2009.

205 *"I don't have a record player"*: Georgia Avgeris, quoted in Burk, Bill E., *Early Elvis: The Humes Years.*

CHAPTER TWELVE

207 *"He said I had the worst voice"*: e-mail, Barbara Hearn to author, 2009.

208 *"I said, 'There he is'"*: Barbara Hearn to author, 2009.

208 *"I did* Love Me Tender*"*: Elvis Presley in the documentary *The Definitive Elvis: The Many Loves of Elvis.*

209 *"He didn't pay any attention"*: Frances Forbes, quoted in Clayton, Rose, and Heard, Dick, *Elvis Up Close.*

209 *"He was fascinated with them"*: Lamar Fike to author, 1994.

209 *"When you were in that room"*: Gloria Mowel, quoted in Goldman, Albert, *Elvis.*

210 *"Elvis was always kissing"*: Frances Forbes, quoted in Clayton, Rose, and Heard, Dick, *Elvis Up Close.*

211 *"never again would he completely change it back"*: In such movies as *Follow That Dream* and *Kid Galahad,* he backs off the hard black dye for a warmer brown. In the latter film, a hint of his natural hair, gone to grey, can be seen peeking through at his left temple.

211 *"On lunch hour"*: Tony Curtis to author, 2004.

211 *"Barbara's nose"*: Andrew Hearn, *Essential Elvis* magazine, no. 63, 2009.

212 *"From the age of seven"*: Dolores Hart, "Actress Turned Nun Revisits Hollywood," Associated Press, April 11, 2006.

212 *"I'm positive"*: Dolores Hart to Peter O. Whitmer, raw interview transcript, 1994.

212 *"charming, simple young boy"*: Dolores Hart, "Actress Turned Nun Revisits Hollywood," Associated Press, April 11, 2006.

212 *"I couldn't take myself away from him"*: Ibid.

213 *"my ears started getting purple"*: Dolores Hart, quoted in *Elvis World* magazine, no. 65.

213 *"I've always thought"*: Lizabeth Scott to Peter O. Whitmer, raw interview transcript, 1994.

213 *"I simply decided"*: Lizabeth Scott, quoted in *Film Fan Monthly*, November 1971, no. 125, by Dan Stanke.

213 *"You couldn't have"*: Lizabeth Scott to Peter O. Whitmer, raw interview transcript, 1994.

214 *"They weren't of the same mettle"*: Ibid.

214 *"a bright gold gown"*: Byron Raphael to author, 2005.

215 *"When any girl"*: Byron Raphael, quoting Colonel Parker to author, 2005.

215 *"I want to take your picture, honey"*: Valerie Allen, quoting Elvis Presley in the documentary *The Definitive Elvis: The Many Loves of Elvis.*

216 *"I was at a party"*: Jeanne Carmen in the documentary *The Definitive Elvis: The Many Loves of Elvis.*

216 *"She did not look seriously ill"*: E-mail, Barbara Hearn to author, 2009.

217 *"It was so obvious"*: Lizabeth Scott to Peter O. Whitmer, raw interview transcript, 1994.

218 *"He wanted me"*: June Juanico to author, 2007.

219 *"You don't need any clothes"*: June Juanico to Peter O. Whitmer, raw interview transcript, 1994.

219 *"I can still see him"*: June Juanico to author, 2007.

CHAPTER THIRTEEN

221 *"Son, I wish"*: Barbara Hearn quoting Vernon Presley to author, 2009.

222 *"every decorator in town"*: George Golden, quoted in "The King and I: If Graceland Is Rotten to Decor, Don't Blame it on Elvis' Former Decorator George Golden," *Phoenix New Times*, July 28, 1993.

222 *"all over poor Gladys"*: Ibid.

222 *"the most beautiful house"*: Ibid.

222 *"Mr. Golden"*: Barbara Hearn to author, 2009.

223 *"would get jealous"*: Barbara Hearn, quoted in *Essential Elvis* magazine, no. 63, 2009.

223 *"There wasn't"*: Barbara Hearn to author, 2009.

223 *"I know it's your mother and father"*: Debra Paget quoting Elvis Presley in Finstad, Suzanne, *Child Bride.*

223 *"I wish you could pray"*: Lillian Smith Fortenberry, raw interview transcript, Mississippi Room Collection, Lee County Library (MRC), probably from the papers of Elaine Dundy.

223 *"kind of overwhelmed"*: Iris Sermon Leftwich to Peter O. Whitmer, raw interview transcript.

224 *"the girls from the show"*: All quotes from Tura Satana in this chapter come from an interview with the author, 2009.

226 *"He called me about three one morning"*: Tempest Storm, quoted in *Elvis World* magazine, no. 8.

227 *"Many times there have been"*: The telegram from Elvis Presley to Private Hershel Nixon, March 25, 1957, is reproduced in Guralnick, Peter, and Jorgensen, Ernst, *Elvis Day by Day: The Definitive Record of His Life and Music.* It reads in part: "I got a lucky break in life, and I am very thankful for it, but there are a few people who want to take shots at me. . . . I have talked my way out of trouble so many times that I couldn't even count them. . . . I'm just like you. If a guy can do something to protect himself, he should do it. . . . I'm sorry the whole thing came up."

227 *"Honey, I miss you so much"*: Excerpt from Yvonne Lime's diary, originally published in *Modern Screen* magazine, August 1957. Serialized in *Elvis World* magazine, nos. 76, 77. All Yvonne Lime quotes come from this source.

228 *"Elvis came out with a rash"*: Sam Phillips to Debra Evans Price, raw interview transcript, 1998.

229 *"He said, 'Pastor'"*: Reverend James Hamill, quoting Elvis Presley to author, 1977.

229 *"The change had set him"*: Kay Wheeler to author, 2009.

229 *"They spent almost"*: Gloria Pall, quoted in *Elvis World* magazine, no. 59, in an excerpt of her book, *I Danced Before the King.*

230 *"He watched me"*: Gloria Pall, quoted in *Elvis International Forum* magazine, Fall 1999.

230 *"What are you doing here"*: Ibid.

230 *"I'd love to"*: Ibid.

231 *"Your wife sure is a sweet one, Byron":* Byron Raphael quoting Elvis Presley to author, 2005. All Byron Raphael quotes in this section come from this interview.

232 *"One day I just put an LP on":* Lamar Fike to author, 1992.

232 *"By now I knew":* Ibid.

233 *"She loved sex":* Bill Lecornec quoted in Davis, Stephen, *Say Kids! What Time Is It?: Notes from the Peanut Gallery.*

233 *"I would go out":* Bob Nicholson quoted in Davis, Stephen, *Say Kids! What Time Is It?: Notes from the Peanut Gallery.*

233 *"It really, really upset him":* Lamar Fike to author, 1992.

233 *"Nothing has hurt me":* Elvis Presley to the Associated Press, quoted in Davis, Stephen. *Say Kids! What Time Is It?: Notes from the Peanut Gallery.*

CHAPTER FOURTEEN

235 *"ballistic":* "Interview with Anita Wood," on the Web site Elvis Australia, November 25, 2006.

236 *"He was effervescent":* Anita Wood, quoted in *Elvis World* magazine, no. 58.

236 *"I said, 'Sure,'":* "Interview with Anita Wood," on the Web site Elvis Australia, November 25, 2006.

236 *"Come up":* Ibid.

237 *"his hands moved":* Anita Wood, quoted in *Elvis World* magazine, no. 58.

237 *"I just ate that up":* "Interview with Anita Wood," on the Web site Elvis Australia, November 25, 2006.

237 *"Little":* "Anita Wood Interview," the Web site Elvis Presley News.

237 *"He always invited":* "Interview with Anita Wood," on the web site Elvis Australia, November 25, 2006.

238 *"Lamar, look at her":* Ibid.

238 *"the things that went on in California":* "Interview with Anita Wood," on the Web site Elvis Australia, November 25, 2006.

239 *"Hey, y'all":* Alan Fortas quoting Anita Wood to author, 1991.

239 *"He had a Pepsi":* "Interview with Anita Wood," on the Web site Elvis Australia, November 25, 2006.

239 *"He loved to pull tricks":* Ibid.

239 *"He'd always come to me":* Ibid.

239 *"I love you":* Elvis Presley love note to Anita Wood, reproduced as an illustration in Osborne, Jerry, *Elvis Word for Word.*

239 *"And gullible me":* Anita Wood to author, 2009.

239 *"That got to be":* Lamar Fike to author, 1994.

239 *"One time Anita went out shopping":* Marty Lacker to author, 1993.

240 *"They were all available":* Anita Wood to author, 2009.

240 *"He called me":* "Interview with Anita Wood," on the Web site Elvis Australia, November 25, 2006.

240 *"But really and truly":* Ibid.

241 *"The Colonel had put me on Nipper Control":* From the *Playboy* article "In Bed with Elvis," by Byron Raphael and Alanna Nash, November 2005.

242 *"Elvis did not do":* Gordon Stoker, quoted on the Web site Elvis Presley Music.

242 *"far too indecent":* *New York Journal-American,* quoted in Guralnick, Peter, *Last Train to Memphis: The Rise of Elvis Presley.*

242 *"He was on the floor":* Kevin Eggers to author, 2009.

242 *"Sexhibitionist":* Dick Williams, *Los Angeles Mirror-News,* quoted in Guralnick, Peter, *Last Train to Memphis.*

242 *"group-fucked 10,000 people":* Kevin Eggers, quoting Ricky Nelson to author, 2009.

243 *"You should have been here last night!"* Elvis Presley to the audience, quoted on the Web site Elvis Presley Music.

243 *"I was a goner":* Coplon, Jeff, and Cher, *The First Time.*

243 *"When I saw him":* Cher to author, 2009. All remaining quotes from Cher come from this interview.

244 *"It's a duty":* Elvis Presley, as quoted in Guralnick, Peter, and Jorgensen, Ernst, *Elvis Day by Day: The Definitive Record of His Life and Music.*

244 *"Elvis cried in my lap"*: Barbara Pittman, quoted in Clayton, Rose, and Heard, Dick, *Elvis Up Close.*

244 *"They could not believe"*: "Interview with Anita Wood," on the Web site Elvis Australia, November 25, 2006.

245 *"That whole Christmas"*: Billy Smith to author, 1993.

245 *"It was a fun time"*: "Interview with Anita Wood," on the Web site Elvis Australia, November 25, 2006.

245 *"As kids"*: Lamar Fike to author, 1994.

246 *"Elvis came over"*: June Wilkinson in the documentary *The Definitive Elvis: The Many Loves of Elvis.*

246 *"He was always asking a lot of questions"*: Carolyn Jones, quoted in "El's Leading Ladies," by Gerry McLafferty, *Elvis: The Man and His Music,* issue 83, 2009.

247 *"It was Elvis"*: Dolores Hart, interviewed by Trevor Cajiao, "Young Dreams" in *Elvis: The Man and His Music,* issue 62, 2003.

247 *"like a young animal"*: Dolores Hart, quoted in Schroer, Andreas, *Private Presley.*

247 *"Elvis is a young man"*: Dolores Hart, interviewed by Trevor Cajiao, "Young Dreams," in *Elvis: The Man and His Music,* issue 62, 2003.

247 *"There were some horses around"*: Ibid.

CHAPTER FIFTEEN

249 *"a chartreuse jacket"*: Jimmie Rodgers Snow, quoted in "Viva Fort Hood," by Michael Hall, *Texas Monthly,* December 2000.

249 *"I told him"*: Jimmie Rodgers Snow to author, 2003.

250 *"I just remember"*: Alan Fortas to author, 1990.

250 *"We was sittin'"*: Annie Presley, quoted in Whitmer, Peter O., *The Inner Elvis.*

251 *"The biggest majority"*: Billy Smith to author, 1993.

251 *"I can't see myself"*: Lamar Fike quoting Gladys Presley in Nash, Alanna, with Smith, Billy, Lacker, Marty, and Fike, Lamar, *Elvis Aaron Presley: Revelations from the Memphis Mafia.*

252 *"Congratulations!"*: Major Elbert Turner, quoted in Osborne, Jerry, *Elvis Word for Word.*

252 *"My heart was being torn away"*: "Interview with Anita Wood," on the Web site Elvis Australia, November 25, 2006.

253 *"Good-bye, you long black son of a bitch"*: *Life* magazine, February 10, 1995.

253 *"Let us see him"*: Mansfield, Rex, and Mansfield, Elisabeth, with Terrill, Marshall, and Terrill, Zoe. *Sergeant Presley: Our Untold Story of Elvis' Missing Years.*

253 *"Where's your hound dog?"*: "Viva Fort Hood," by Michael Hall, *Texas Monthly,* December 2000.

254 *"the girls seemed to know"*: Ibid.

254 *"We found him"*: Ibid.

254 *"We had to have guards"*: Ibid.

254 *"They tried to get me clearance"*: Lamar Fike, quoted in Nash, Alanna, with Smith, Billy, Lacker, Marty, and Fike, Lamar, *Elvis Aaron Presley: Revelations from the Memphis Mafia.*

254 *"When you come in my house"*: William Norwood, quoted in "Viva Fort Hood," by Michael Hall, *Texas Monthly,* December 2000.

255 *"When he got her on the line"*: Eddie Fadal, quoted in "Viva Fort Hood," by Michael Hall, *Texas Monthly,* December 2000.

255 *"He would come over"*: "Interview with Anita Wood," on the Web site Elvis Australia, November 25, 2006.

255 *"He put his foot"*: Eddie Fadal, quoted in Clayton, Rose, and Heard, Dick, *Elvis Up Close.*

255 *"My father knew all the doctors"*: Janice Fadal, quoted in "Viva Fort Hood," by Michael Hall, *Texas Monthly,* December 2000.

256 *"I wish they'd let me pick it"*: Elvis Presley on home recordings, quoted in Osborne, Jerry. *Elvis Word for Word.*

256 *"It was the greatest time"*: "Interview with Anita Wood," on the Web site Elvis Australia, November 25, 2006.

256 *"Simple, I'm kinda proud of it"*: "Viva Fort Hood," by Michael Hall, *Texas Monthly,* December 2000.

256 *"It was in the hot summertime":* "Interview with Anita Wood," on the Web site Elvis Australia, November 25, 2006.

257 *"He's working us to death":* "Viva Fort Hood," by Michael Hall, *Texas Monthly*, December 2000.

257 *"He loved the Army":* Rex Mansfield, quoted in "Viva Fort Hood," by Michael Hall, *Texas Monthly*, December 2000.

257 *"One day I looked at her":* Lamar Fike to author, 1994.

257 *"She didn't want to go,"* Ibid.

CHAPTER SIXTEEN

259 *"We were in the room talking":* Dotty Ayers, as quoted in Clayton, Rose, and Heard, Dick, *Elvis Up Close.*

260 *"Mama":* Billy Smith quoting Elvis Presley to author, 1994.

260 *"I don't think Elvis":* Billy Smith to author, 1994. The remaining quotes from Billy Smith in this chapter come from conversations with the author, 1994, or from Nash, Alanna, with Smith, Billy, Lacker, Marty, and Fike, Lamar, *Elvis Aaron Presley: Revelations from the Memphis Mafia.*

260 *"They drained":* Lamar Fike to author, 1994.

262 *"We shot over there":* Ibid.

262 *"Eddie":* "Elvis and Eddie: A Special Friendship," *Elvis International Forum* magazine, vol. 2, no. 2, 1990.

263 *"He was in pitiful shape":* Harold Loyd, as quoted in Clayton, Rose, and Heard, Dick, *Elvis Up Close.*

263 *"liked they wanted":* "Elvis and Eddie: A Special Friendship," *Elvis International Forum* magazine, vol. 3, no. 3, 1990.

263 *"Mama":* Eddie Fadal, as quoted in Clayton, Rose, and Heard, Dick, *Elvis Up Close.*

263 *"Little! Little! Little!"* "Interview with Anita Wood," on the Web site Elvis Australia, November 25, 2006.

263 *"We went in there":* Anita Wood to author, 2009.

264 *"He reacted":* Dixie Locke to Peter O. Whitmer, raw interview transcript, 1994.

264 *"Get all of these people out of here!"* Barbara Pittman quoting Colonel Tom Parker in Clayton, Rose, and Heard, Dick, *Elvis Up Close.*

264 *"Please don't take my baby away!"* Harold Loyd, as quoted in Clayton, Rose, and Heard, Dick, *Elvis Up Close.*

264 *"He said, 'Everything I have is gone'":* Ibid.

264 *"When the funeral director":* Freddy Bienstock to author, 1997

265 *"I've never seen":* J. D. Sumner to Peter O. Whitmer, raw interview transcript, 1994.

265 *"He put his arms around me":* James Blackwood, quoted in Burk, Bill E., *Early Elvis: The Humes Years.*

265 *"Mama . . . I would give every dime":* James Blackwood quoting Elvis Presley in Clayton, Rose, and Heard, Dick, *Elvis Up Close.*

265 *"Good-bye, darling, good-bye":* Elvis Presley, quoted in Guralnick, Peter, and Jorgensen, Ernst, *Elvis Day by Day: The Definitive Record of His Life and Music.*

266 *"They were holding him back":* Barbara Pittman, quoted in Clayton, Rose, and Heard, Dick, *Elvis Up Close.*

266 *"He was in a trance":* e-mail, Barbara Hearn to author, 2009.

266 *"I just wrote my heart":* Mae Boren Axton, public appearance at Memphis State University, 1986.

266 *"I can't go":* Lillian Smith Fortenberry, raw interview transcript, Mississippi Room Collection, Lee County Library

266 *"He walked around":* Arlene Cogan, quoted in Clayton, Rose, and Heard, Dick, *Elvis Up Close.*

266 *"People were screaming":* Barbara Pittman, quoted in Clayton, Rose, and Heard, Dick, *Elvis Up Close.*

267 *"How Elvis loves the snow!":* "Elvis and Eddie: A Special Friendship," *Elvis International Forum* magazine, vol. 2, no. 4, 1989.

267 *"Funny":* Elvis Presley to Lloyd Shearer, "Face to Face with Elvis" (CD), August 1962, Hollywood.

268 *"Psychologists call this":* E-mail, Peter O. Whitmer to author, 2009.

269 *"Once I saw":* Janice Fadal, quoted in "Viva Fort Hood," by Michael Hall, *Texas Monthly*, December 2000.

269 *"Girls, guess what?"*: Ronnie Anagnostis, quoted in "Viva Fort Hood," by Michael Hall, *Texas Monthly*, December 2000.

269 *"things were never"*: Rex Mansfield, quoted in "Viva Fort Hood," by Michael Hall, *Texas Monthly*, December 2000.

269 *"I could not believe it"*: "Interview with Anita Wood," on the Web site Elvis Australia, November 25, 2006.

269 *"I don't like to sit alone"*: Elvis Presley, quoted in Nash, Alanna, with Smith, Billy, Lacker, Marty, and Fike, Lamar, *Elvis Aaron Presley: Revelations from the Memphis Mafia*.

270 *"There wasn't a dry eye"*: "Elvis and Eddie: A Special Friendship," *Elvis International Forum* magazine, vol. 2, no. 2, 1989.

270 *"I really feel"*: Elvis Presley to Eddie Fadal, quoted in Mansfield, Rex, and Mansfield, Elisabeth, with Terrill, Marshall, and Terrill, Zoe. *Sergeant Presley: Our Untold Story of Elvis' Missing Years*.

270 *"I just feel sad"*: Elvis Presley, quoted in "Viva Fort Hood," by Michael Hall, *Texas Monthly*, December 2000.

270 *"I'll starve to death"*: Elvis Presley, press conference titled "Press Interview with Elvis Presley." Brooklyn, N.Y. Source: "Elvis Sails" EP, September 22, 1958.

CHAPTER SEVENTEEN

273 *"the rock 'n' roll matador"*: *Look* magazine, "Elvis and the Frauleins," December 23, 1958.

273 *"I'm just a plain soldier"*: Ibid.

274 *"Classical music"*: Elvis Presley, quoted in Schroer, Andreas, *Private Presley*.

274 *"When we finally found the house"*: Frank Glankler, as quoted in Soocher, Stan, *They Fought the Law: Rock Music Goes to Court*.

275 *"I could hear Elvis"*: "Interview with Charlie Hodge," on the Web site Elvis Australia, April 9, 2005.

275 *"He didn't like it"*: Lamar Fike to author, 1994.

275 *"looked like"*: Red West, quoted in Schroer, Andreas, *Private Presley*.

276 *"weird hours"*: Anita Wood, "Interview with Anita Wood," on the Web site Elvis Australia, November 25, 2006.

276 *"in a hundred years"*: Elvis Presley letter to Anita Wood, October 28, 1958, reproduced in Osborne, Jerry, *Elvis Word for Word*.

276 *"descended on us"*: Lamar Fike to author, 1994.

277 *"I have been dating"*: Elvis Presley letter to Alan Fortas, postmarked November 14, 1958, reproduced in Fortas, Alan, and Nash, Alanna, *Elvis: From Memphis to Hollywood*. London: Aurum Press, 2008.

277 *"She's blond"*: Elvis Presley, quoted in Schroer, Andreas, *Private Presley*.

277 *"Well, I can't blame you"*: Elvis Presley letter to Anita Wood, postmarked November 14, 1958, reproduced in Osborne, Jerry, *Elvis Word for Word*.

278 *"He is shy"*: Margit Buergin, quoted in Schroer, Andreas, *Private Presley*.

278 *"He's so different"*: Margit Buergin, quoted in *Look* magazine, "Elvis and the Frauleins," December 23, 1958.

278 *"She went and got herself"*: Red West to Antony Terry, quoted in Schroer, Andreas, *Private Presley*.

278 *"Elvis dated her"*: Lamar Fike to author, 1994.

278 *"Don't get me wrong"*: Elvis Presley to Keith Sherriff, transcript, Osborne, Jerry, *Elvis Word for Word*.

278 *"I feel mad"*: Margit Buergin, quoted in Schroer, Andreas, *Private Presley*.

278 *"I'm a corporation"*: Margit Buergin quoting Elvis Presley in Schroer, Andreas, *Private Presley*.

279 *"Boy . . . she stalked him like prize game"*: Lamar Fike to author, 1993.

279 *"All the GIs"*: Elisabeth Mansfield, "Rex and Elisabeth Mansfield," by Piers Beagley, on the Web site Elvis Information Network, August 2002.

280 *"voluptuous"*: Joe Esposito, quoting Elvis Presley to author, 2009.

280 *"Everything was 'Yes, ma'am'"*: Elisabeth Mansfield, "Rex and Elisabeth Mansfield," by Piers Beagley, on the Web site Elvis Information Network, August, 2002.

280 *"He was hurt"*: Ibid.

280 *"I assure you"*: Elisabeth Mansfield, quoting Elvis Presley in Mansfield, Rex, and Mansfield, Elisabeth, with Terrill, Marshall, and Terrill, Zoe, *Sergeant Presley: Our Untold Story of Elvis' Missing Years*.

280 *"I can be there in one week":* Elisabeth Mansfield, in Mansfield, Rex, and Mansfield, Elisabeth, with Terrill, Marshall, and Terrill, Zoe, *Sergeant Presley: Our Untold Story of Elvis' Missing Years.*

281 *"We hit it off":* Ibid.

281 *"he was going to see on a regular basis":* "Elvis and Elisabeth," by Bob Graham, *The [London] Sunday Times Magazine,* August 3, 1997.

281 *"He was the man I adored":* Elisabeth Mansfield, in Mansfield, Rex, and Mansfield, Elisabeth, with Terrill, Marshall, and Terrill, Zoe, *Sergeant Presley: Our Untold Story of Elvis' Missing Years.*

281 *"There would be at least a couple of girls each week":* "Elvis and Elisabeth," by Bob Graham, *The [London] Sunday Times Magazine,* August 3, 1997.

282 *"mostly when he would say harsh things":* Elisabeth Mansfield, "Rex and Elisabeth Mansfield," by Piers Beagley, on the Web site Elvis Information Network, August 2002.

282 *"I said, 'Elvis'":* Ibid.

282 *"Elvis . . . had":* Rex Mansfield, quoted in *Elvis World* magazine, no. 65.

282 *"above normal capability":* *Look* magazine, "Elvis and the Frauleins," December 23, 1958.

283 *"It like to drove her crazy":* Lamar Fike to author, 1993.

CHAPTER EIGHTEEN

285 *"a bitch and a half":* Lamar Fike to author, 1994.

285 *"gold comes out of his hot throat":* *Look* magazine, "Elvis and the Frauleins," December 23, 1958.

286 *"Get away from me":* Elisabeth Mansfield, in Mansfield, Rex, and Mansfield, Elisabeth, with Terrill, Marshall, and Terrill, Zoe, *Sergeant Presley: Our Untold Story of Elvis' Missing Years.*

286 *"Truck drivers":* Rex Mansfield quoting Elvis Presley, in Mansfield, Rex, and Mansfield, Elisabeth, with Terrill, Marshall, and Terrill, Zoe, *Sergeant Presley: Our Untold Story of Elvis' Missing Years.*

286 *"After taking my first pill":* Rex Mansfield, in Mansfield, Rex, and Mansfield, Elisabeth, with Terrill, Marshall, and Terrill, Zoe, *Sergeant Presley: Our Untold Story of Elvis' Missing Years.*

287 *"Beautiful girls":* Elisabeth Mansfield, in Mansfield, Rex, and Mansfield, Elisabeth, with Terrill, Marshall, and Terrill, Zoe, *Sergeant Presley: Our Untold Story of Elvis' Missing Years.*

287 *"he just let loose sexually":* Lamar Fike to author, 1994.

287 *"Sometimes":* Rex Mansfield, in Mansfield, Rex, and Mansfield, Elisabeth, with Terrill, Marshall, and Terrill, Zoe, *Sergeant Presley: Our Untold Story of Elvis' Missing Years.*

287 *"I don't know":* George Klein, quoted in Guralnick, Peter, *Last Train to Memphis.*

287 *"Who in the hell":* George Klein, quoting Elvis Presley in Guralnick, Peter, *Last Train to Memphis.*

287 *"That December, she came to Germany":* Jane Wilbanks, who met him at the "Elvis Train," as the girls called it, visited Elvis at his hotel for the holidays, and was his Christmas Eve date in 1958. Having just lost his mother in August, "He was sad and cried a lot, and I didn't know what to say," she told an Associated Press reporter in 2002. In January 1959, she gave him a royal blue velvet robe for his birthday. A teen beauty queen, Jane dated Elvis for about ten months in Germany, and also a few times when they returned to the States. "It was kind of Cinderella-ish," she said. "I think he liked talking with me because most of the time he had all these Hollywood starlets around. Of course, I was from New Albany [Mississippi], which was only about thirty miles from Tupelo."

287 *"instantly jealous":* Elisabeth Mansfield, in Mansfield, Rex, and Mansfield, Elisabeth, with Terrill, Marshall, and Terrill, Zoe, *Sergeant Presley: Our Untold Story of Elvis' Missing Years.*

288 *"They had handwritten notes":* Lamar Fike to author, 1994.

288 *"somehow they were missing":* Vera Tschechowa, quoted in *Elvis World* magazine, no. 69.

288 *"We took these horrible pictures":* Vera Tschechowa, quoted in *Elvis World* magazine, no. 69, and in Schroer, Andreas, *Private Presley.* All Tschechowa quotes come from these sources.

289 *"Vera was a strange girl":* *Elvis World* magazine, no. 69.

289 *"Red and I":* *Elvis World* magazine, no. 69.

290 *"Elvis was after her, all right":* Lamar Fike to author, 1994.

290 *"the answer to a question":* Dave Marsh, quoted in Fortas, Alan, and Nash, Alanna, *Elvis: From Memphis to Hollywood,* London: Aurum Press, 2008.

291 *"Sure, I've got a new girlfriend":* Elvis Presley, quoted in Schroer, Andreas, *Private Presley.*

291 *"Foghorn":* Elisabeth Mansfield, quoting Elvis Presley in Mansfield, Rex, and Mansfield, Elisabeth, with Terrill, Marshall, and Terrill, Zoe, *Sergeant Presley: Our Untold Story of Elvis' Missing Years.*

292 *"I have hated Dee ever since then":* Anita Wood quoting Elvis Presley, "Interview with Anita Wood," on the Web site Elvis Australia, November 25, 2006.

292 *"When they started banging":* Lamar Fike, in Nash, Alanna, with Smith, Billy, Lacker, Marty, and Fike, Lamar, *Elvis Aaron Presley: Revelations from the Memphis Mafia.*

292 *"Chinese coolie":* Rex Mansfield, quoting Red West in Mansfield, Rex, and Mansfield, Elisabeth, with Terrill, Marshall, and Terrill, Zoe, *Sergeant Presley: Our Untold Story of Elvis' Missing Years.*

293 *"going in and out":* Schroer, Andreas, *Private Presley.*

294 *"glittering clouds of sequins":* "Margaret Kelly, 94, Founder of the Bluebell Girls, Is Dead," by Margalit Fox, *New York Times,* July 26, 2005.

294 *"without batting an eyelash":* Rex Mansfield, quoted in *Elvis World* magazine, no. 67.

294 *"We went through":* Lamar Fike, in Nash, Alanna, with Smith, Billy, Lacker, Marty, and Fike, Lamar, *Elvis Aaron Presley: Revelations from the Memphis Mafia.*

294 *"But you don't understand, monsieur!":* Rex Mansfield, quoted in *Elvis World* magazine, no. 67.

295 *"Nevertheless, Elvis felt snubbed":* Rex Mansfield in Mansfield, Rex, and Mansfield, Elisabeth, with Terrill, Marshall, and Terrill, Zoe, *Sergeant Presley: Our Untold Story of Elvis' Missing Years.*

295 *"His hobby":* Ingrid Sauer, quoted in Schroer, Andreas, *Private Presley.*

295 *"In Germany":* Lamar Fike to author, 1994.

CHAPTER NINETEEN

297 *"I knew this would be difficult":* Paul Beaulieu, quoted in *Elvis by the Presleys:* Ritz, David, editor.

297 *"I was crushed":* Priscilla Presley, quoted in *Elvis by the Presleys:* Ritz, David, editor.

297 *"didn't want to be part of the Elvis mania":* Ibid.

298 *"One afternoon":* Priscilla Presley, quoted in *Elvis by the Presleys:* Ritz, David, editor.

298 *"I'm going over there":* Presley, Priscilla, with Harmon, Sandra, *Elvis and Me.*

299 *"Hi, . . . I understand you know Elvis":* Priscilla Presley to Currie Grant, as quoted in Finstad, Suzanne, *Child Bride.*

299 *"just in overdrive":* Currie Grant, quoted in Finstad, Suzanne, *Child Bride.*

299 *"Currie was taking pictures of her":* Lamar Fike to author, 2004.

300 *"If you could have seen his face!":* Currie Grant, quoted in Finstad, Suzanne, *Child Bride.*

300 *"I told Elvis":* Lamar Fike to author, 1994.

300 *"She's young enough":* Rex Mansfield quoting Elvis Presley in Mansfield, Rex, and Mansfield, Elisabeth, with Terrill, Marshall, and Terrill, Zoe, *Sergeant Presley: Our Untold Story of Elvis' Missing Years.*

301 *"What are you":* Presley, Priscilla, with Harmon, Sandra, *Elvis and Me.*

301 *"You":* Priscilla Presley, quoted in *Elvis by the Presleys:* Ritz, David, editor.

302 *"I felt like Cinderella":* Presley, Priscilla, with Harmon, Sandra, *Elvis and Me.*

302 *"She reminded me of a painting":* Elisabeth Mansfield, quoting Elvis Presley in Mansfield, Rex, and Mansfield, Elisabeth, with Terrill, Marshall, and Terrill, Zoe, *Sergeant Presley: Our Untold Story of Elvis' Missing Years.*

302 *"He had Priscilla backed up against the wall":* Currie Grant, quoted in Finstad, Suzanne. *Child Bride.*

303 *"been looking for":* Rex Mansfield, quoted in Finstad, Suzanne, *Child Bride.*

303 *"He looked at me":* "Interview with Charlie Hodge," on the Web site Elvis Australia, April 9, 2005.

303 *"she was so beautiful":* Joe Esposito to author, 2009.

303 *"It's amazing to me":* Peter O. Whitmer to author, 2009.

303 *"There was definitely a pull there":* Priscilla Presley, quoted in Finstad, Suzanne, *Child Bride.*

304 *"the sort of little girl":* Suzanne Finstad to author, 2009.

304 *"She was kinda like a little honeypot":* Mary Clements, quoted in Finstad, Suzanne, *Child Bride.*

305 *"My father was very strict":* Priscilla Presley, "An Interview with Priscilla," by Bill E. Burk, *Elvis World* magazine, no. 23, based on the RUR show on Veronica TV in Amsterdam, Holland, probably 1992.

305 *"a great guy, a fun guy":* Colonel Eugene Desaulniers to author, 2009. All Colonel Eugene Desaulniers quotes come from this interview.

305 *"He said Priscilla said":* e-mail, Marty Lacker to author, 2009.

306 *"I had this unbelievable feeling":* Priscilla Presley, quoted in Finstad, Suzanne, *Child Bride.*

307 *"That's just an incredible kind of displacement":* Suzanne Finstad to author, 2009.

307 *"It was like kissing a table":* Currie Grant, quoted in Finstad, Suzanne, *Child Bride.*

308 *"It actually started":* Ibid.

308 *"May God strike me dead":* Priscilla Presley, quoted in Finstad, Suzanne, *Child Bride.*

310 *"He just played with her":* Currie Grant, quoted in Finstad, Suzanne, *Child Bride.*

310 *"I felt more comfortable":* Priscilla Presley, quoted in Finstad, Suzanne, *Child Bride.*

310 *"Don't play coy with me!":* Currie Grant, quoted in Finstad, Suzanne, *Child Bride.*

310 *"not necessarily for sex":* Joe Esposito to author, 2009.

311 *"I was terrified":* Priscilla Presley, quoted in Finstad, Suzanne, *Child Bride.*

311 *"I don't think he was prepared":* Priscilla Presley, "An Interview with Priscilla," by Bill E. Burk, *Elvis World* magazine, no. 23, based on the RUR show on Veronica TV in Amsterdam, Holland, probably 1992.

311 *"I enjoyed speaking":* Paul Beaulieu, quoted in *Elvis by the Presleys:* Ritz, David, editor.

312 *"When we met Elvis":* Ann Beaulieu, quoted in *Elvis by the Presleys:* Ritz, David, editor.

312 *"Elvis could talk anyone":* Esposito, Joe, with Oumano, Elena, *Good Rockin' Tonight.*

312 *"It was not a question":* Currie Grant, quoted in Finstad, Suzanne, *Child Bride.*

312 *"to consummate our love":* Presley, Priscilla, with Harmon, Sandra, *Elvis and Me.*

312 *"She's a beautiful girl":* Esposito, Joe, with Oumano, Elena, *Good Rockin' Tonight.*

313 *"I was leading two lives":* Priscilla Presley, quoted in *Elvis by the Presleys:* Ritz, David, editor.

313 *"My Dearest Darling 'Little' ":* Elvis Presley letter to Anita Wood, postmarked November 6, 1959, reproduced in Osborne, Jerry, *Elvis Word for Word.*

315 *"he assured me":* "Interview with Anita Wood," on the Web site Elvis Australia, November 25, 2006.

315 *"Anita was a known entity":* e-mail, Peter O. Whitmer to author, 2009.

315 *"It's upstairs on the table":* Unknown girl, quoted in Schroer, Andreas, *Private Presley.*

315 *"when he leaned over":* Priscilla Presley, quoted in *Elvis by the Presleys:* Ritz, David, editor.

316 *"had pores big enough to hide a tank in":* Lamar Fike to author, 1993.

316 *"We just played all night and slept during the day":* Joe Esposito to author, 2009.

316 *"Well, I'll tell you":* Elvis Presley to Johnny Paris, Armed Forces Radio, March 1, 1960.

316 *"He stayed in that dressing room":* Lamar Fike to author, 1994.

316 *"It gave him permission":* Ibid.

317 *"They thought I couldn't take it":* Elvis Presley, quoted in Guralnick, Peter, and Jorgensen, Ernst, *Elvis Day by Day: The Definitive Record of His Life and Music.*

317 *"It was a time of grief for me":* Hill, Wanda June, *We Remember Elvis.*

317 *"cheerfulness and drive":* Guralnick, Peter, and Jorgensen, Ernst, *Elvis Day by Day: The Definitive Record of His Life and Music.*

317 *"a box of twelve bottles":* Joe Esposito to Peter Whitmer, raw interview transcript, 1994.

318 *"We swore undying fidelity":* Priscilla Presley, quoted in *Elvis by the Presleys:* Ritz, David, editor.

318 *"Little One":* Priscilla Presley, quoted in *Elvis by the Presleys:* Ritz, David, editor.

318 *"He was in love with Priscilla":* Joe Esposito to Peter O. Whitmer, raw interview transcript, 1994.

318 *"You think my father":* Priscilla Presley, quoted in Finstad, Suzanne, *Child Bride.*

319 *"in a dream world":* Priscilla Presley, quoted in Finstad, Suzanne, *Child Bride.*

319 *"It was literally the smoking gun":* Suzanne Finstad to author, 2009.

CHAPTER TWENTY

322 *"Have two years of sobering army life":* press conference, Fort Dix, New Jersey, March 3, 1960.

322 *"Are you leaving any special girl":* press conference, Brooklyn, New York, September 22, 1958.

322 *"It was a very difficult parting":* Priscilla Presley, "An Interview with Priscilla," by Bill E. Burk, *Elvis World* magazine, no. 23, based on the RUR show on Veronica TV in Amsterdam, Holland, probably 1992.

322 *"Now, gentlemen":* Elvis Presley, press conference, Graceland, Memphis, Tennessee, March 7, 1960.

323 *"He was standing right there":* "Interview with Anita Wood," on the Web site Elvis Australia, November 25, 2006.

324 *"I want you to do it":* Rex Mansfield, quoting Minnie Mae Presley in "Rex and Elisabeth Mansfield," by Piers Beagley, on the Web site Elvis Information Network, August 2002.

324 *"I was directly behind him":* Mansfield, Rex, and Mansfield, Elisabeth, with Terrill, Marshall, and Terrill, Zoe, *Sergeant Presley: Our Untold Story of Elvis' Missing Years.*

325 *"Daddy, . . . are you sure you want to do this?":* "Interview with Anita Wood," on the Web site Elvis Australia, November 25, 2006.

325 *"She seems pretty nice"*: Elvis Presley, quoted in the Memphis *Press-Scimitar,* July 17, 1960.

325 *"He kept asking me"*: Leticia Roman, from the Web site Glamour Girls of the Silver Screen.

325 *"Man, I'll tell you"*: Sonny West quoting Elvis Presley in West, Sonny, and Terrill, Marshall, *Elvis: Still Taking Care of Business.*

326 *"You don't have to put"*: Norman Taurog, quoted in the *Saturday Evening Post,* September 11, 1965.

326 *"A few days being around him"*: "Interview with Sonny West," by Scott Jenkins, on the Web site Elvis Australia, May 13, 2005.

326 *"Elvis would open that door"*: Sonny West in the documentary *The Definitive Elvis: The Many Loves of Elvis.*

326 *"He said Juliet"*: Lamar Fike to author, 1993.

326 *"He's really"*: Juliet Prowse, quoted in the *Saturday Evening Post,* September 11, 1965.

326 *"He had a wonderful sense of humor"*: Juliet Prowse in the documentary *The Definitive Elvis: The Many Loves of Elvis.*

327 *"Man, you gotta meet Marilyn Monroe"*: Byron Raphael quoting Gene Smith to author, 2005. Portions of the Byron Raphael material originally appeared in the *Playboy* magazine article "In Bed with Elvis," by Byron Raphael and Alanna Nash, November 2005.

328 *"No . . . I've got to go to sleep"*: Sandy Ferra Martindale, quoted in *People* magazine, August 18, 1997.

328 *"I said, 'Elvis, she is only fourteen'"*: Mary Lou Ferra in the documentary *The Definitive Elvis: The Many Loves of Elvis.*

329 *"In school the next day"*: Sandy Ferra Martindale, quoted in *People* magazine, August 18, 1997.

329 *"He loved my mom"*: Sandy Ferra Martindale in the documentary *The Definitive Elvis: The Many Loves of Elvis.*

329 *"I want to ask you something"*: Mary Lou Ferra quoting Elvis Presley in the documentary *The Definitive Elvis: The Many Loves of Elvis.*

329 *"Elvis was quite surprised"*: Sandy Ferra Martindale, quoted in *Elvis World,* no. 44.

329 *"I was making $100"*: Ibid.

329 *"What a great life"*: Sandy Ferra Martindale in the documentary *The Definitive Elvis: The Many Loves of Elvis.*

329 *"We would kiss for hours"*: Ibid.

329 *"There were no expectations"*: Sandy Ferra Martindale, quoted in *Elvis World,* no. 44.

329 *"Don't ever wear pants again!"*: Ibid.

330 *"He pulled this article out"*: Sandy Ferra Martindale in the documentary *The Definitive Elvis: The Many Loves of Elvis.*

330 *"Forget him, honey"*: Ann Beaulieu, quoted in *Elvis by the Presleys:* Ritz, David, editor.

330 *"he was not afraid"*: Tom Muldoon, quoted in Finstad, Suzanne, *Child Bride.*

330 *"She and Tom Stewart"*: Suzanne Finstad to author, 2009.

330 *"this child"*: Suzanne Finstad to author, 2009.

331 *"The parents would say"*: Al Corey, quoted in Finstad, Suzanne, *Child Bride.*

331 *"I stayed with Grandma a lot when he was gone"*: Anita Wood to author, 2009.

331 *"There was a lot to go around"*: Lamar Fike to Larry King, CNN, December 5, 2007.

331 *"Elvis playing guitar"*: Barbara Eden to author, 2007. All Barbara Eden quotes come from this interview. Portions of the Barbara Eden material previously appeared in *Ladies' Home Journal,* August 2007.

332 *"It didn't matter"*: Joe Esposito to Peter O. Whitmer, raw interview transcript, 1994.

333 *"One time we came in"*: "Interview with Charlie Hodge," on the Web site Elvis Australia, April 9, 2005.

333 *"and a lady looked out"*: "Interview with Charlie Hodge," on the web site Elvis Australia, April 9, 2005.

333 *"It was a round house"*: "Interview with Charlie Hodge," on the Web site Elvis Australia, April 9, 2005.

333 *"very sensitive"*: Millie Perkins, quoted in "El's Leading Ladies," by Gerry McLafferty, *Elvis: The Man and His Music,* issue 83, 2009.

334 *"I wasn't that impressed"*: Hope Lange, quoted in *This Is Elvis*: Special Collector's Edition of *TV Guide,* August 2002.

334 *"It hurt so much"*: Alan Fortas to author, 1989.

334 *"What's the problem?"* Hope Lange, quoted in Esposito, Joe, with Oumano, Elena, *Good Rockin' Tonight.*

334 *"She decided to chuck a quart of milk"*: Esposito, Joe, with Oumano, Elena, *Good Rockin' Tonight.*

334 *"dynamite, real dynamite":* Tuesday Weld to Guy Flatley for the *New York Times,* 1971, re: his article, "Tuesday Weld: I Didn't Have to Play Lolita—I was Lolita," on the Web site Moviecrazed.

334 *"She thought Elvis was very emotionally immature":* Kevin Eggers to author, 2009.

335 *"He shouldn't have to light your cigar":* Christina Crawford, quoted in Esposito, Joe, with Oumano, Elena, *Good Rockin' Tonight.*

335 *"an excellent dramatic actor":* Phillip Dunne, Academy Oral History Program, Margaret Herrick Library, the Academy of Motion Pictures.

335 *"a terrible film":* J. R. Salamanca, *Publishers Weekly,* July 24, 2000.

335 *"Whatever he would say":* Barbara Hearn to author, 2009.

336 *"Let's go see who's in that Rolls-Royce":* Patti Parry to Larry King, CNN, December 5, 2007.

336 *"Hey, girls. Hi!":* "Patti Parry Interview," by Piers Beagley, on the Web site Elvis Information Network, August 12, 2003.

337 *"He didn't have a mom or a sister":* Patti Parry to author, 2009.

337 *"and I couldn't give up":* "Patti Parry Interview," by Piers Beagley, on the Web site Elvis Information Network, August 12, 2003.

337 *"He was a good, good man":* Patti Parry to author, 2009.

337 *"which was the greatest honor":* Ibid.

337 *"On Perugia":* Patti Parry to author, 2009.

338 *"But you know what?":* Ibid.

338 *"The way he would look at you":* Lamar Fike to author, 1993.

338 *"Well, he's done thrown up":* Billy Smith to author, 1994.

338 *"We were the first there":* "Interview with Anita Wood," on the Web site Elvis Australia, November 25, 2006.

339 *"He just kept saying":* Guralnick, Peter, and Jorgensen, Ernst, *Elvis Day by Day: The Definitive Record of His Life and Music.*

339 *"It affected Elvis":* Joe Esposito to Peter O. Whitmer, raw interview transcript, 1994.

339 *"We went up":* Billy Smith to author, 1994.

339 *"He would do things":* Joe Esposito to Peter O. Whitmer, raw interview transcript, 1994.

CHAPTER TWENTY-ONE

341 *"To his great credit":* Guralnick, Peter, and Jorgensen, Ernst, *Elvis Day by Day: The Definitive Record of His Life and Music.*

341 "Negro cotton field harmony," *Commercial Appeal,* as quoted in Guralnick, Peter, and Jorgensen, Ernst, *Elvis Day by Day.*

342 *"Here this entity":* Ann Ellington Wagner, in the documentary *The Definitive Elvis: The Many Loves of Elvis.*

342 *"Of course, the people just went bananas":* "Interview with Ann Ellington," on the Web site Elvis Australia, December 21, 2007.

342 *"the finest honor":* Guralnick, Peter, and Jorgensen, Ernst, *Elvis Day by Day: The Definitive Record of His Life and Music.*

342 *"kind of awkward":* Ann Ellington Wagner, in the documentary *The Definitive Elvis: The Many Loves of Elvis.*

343 *"Elvis thought that was so neat":* "Interview with Ann Ellington," on the Web site Elvis Australia, December 21, 2007.

343 *"Please watch your language":* This story comes from Kittra Moore, who heard it from Millie Kirkham. Miss Kirkham alludes to this story in "A Conversation with Millie Kirkham," by Gordon Minto, in *Elvis: The Man and His Music,* issue 84, 2009.

343 *"He always wanted me where he could see me":* "Interview with Ann Ellington," on the Web site Elvis Australia, December 21, 2007.

345 *"not for one minute":* "Joan Blackman Talks," *Essential Elvis* magazine, no. 23, 2002.

345 *lean, hard:* letter, Hal Wallis to Colonel Tom Parker, January 30, 1961, Hal Wallis collection, Margaret Herrick Library, the Academy of Motion Pictures. "It is very important that [he] look lean and hard . . ."

345 *"how encapsulated":* Minnie Pearl to author, 1981.

346 *"His buddies had gone out":* Darlene Tompkins, "Aloha from Elvis' *Blue Hawaii* Co-Star," *Essential Elvis* magazine, no. 58, 2008.

347 *"He was always looking":* Joan Blackman, quoted in *Elvis World* magazine, no. 58.

347 *"We had rooms next to each other":* Joan Blackman, quoted in Brown, Peter Harry, and Broeske, Pat H., *Down at the End of Lonely Street: The Life and Death of Elvis Presley.*

347 *"There was something between us":* Joan Blackman, quoted in *Elvis World* magazine, no. 58.

347 *"was not the kind of person":* Joan Blackman, quoted in *Elvis World* magazine, no. 58.

347 *"He needed to do stuff like that":* Ibid.

347 *"It takes a lot of courage":* Ibid.

347 *"The army calmed him down":* Joe Esposito to Peter O. Whitmer, raw interview transcript, 1994.

348 *"He might have done":* Joan Blackman, quoted in *Elvis World* magazine, no. 58.

348 *"A Presley picture is the only sure thing in show business":* Hal Wallis, quoted in the documentary *Elvis in Hollywood.*

348 *"Elvis was really good in that film":* Anne Helm, *Elvis International Forum* magazine, vol. 8, no. 2, Summer 1995.

349 *"become one of the guys":* Anne Helm, quoted in *Elvis World* magazine, no. 63.

349 *"I really fell for Elvis":* Anne Helm, quoted on the Elvis Information Network, 2009.

349 *"It was so strange":* Anne Helm, quoted in Brown, Peter Harry, and Broeske, Pat H., *Down at the End of Lonely Street: The Life and Death of Elvis Presley.*

350 *"the sweetness and cream in him":* Ibid.

350 *"He was really mad":* Ibid.

350 *"He had many lives":* Anne Helm, quoted on the Elvis Information Network, 2009.

350 *"sure enough":* Esposito, Joe, with Oumano, Elena, *Good Rockin' Tonight.*

351 *"I knew":* Connie Stevens, quoted in *People* magazine, August 18, 1997.

351 *"He was just so beautiful":* Connie Stevens, in the documentary *The Definitive Elvis: The Many Loves of Elvis.*

351 *"Elvis never carried a dime":* Joe Esposito, in the documentary *The Definitive Elvis: The Many Loves of Elvis.*

352 *"you had to follow the crowd":* Connie Stevens, quoted in *People* magazine, August 18, 1997.

353 *"I can't believe":* Alan Fortas to author, 1990.

353 *"Naturally, he did it again":* Billy Smith to author, 1993.

353 *"Believe it or not":* Marty Lacker to author, 1994.

353 *"Listen, you gotta realize":* Patti Parry to author, 2009.

354 *"She fell right over":* Joe Esposito to Peter O. Whitmer, raw interview transcript, 1994.

354 *"Elvis had no parameters":* Lamar Fike to author, 1994.

355 *"He dressed":* Esposito, Joe, with Oumano, Elena, *Good Rockin' Tonight.*

356 *"Elvis did not like this film":* Laurel Goodwin, *Filmfax* magazine, issue 81–82, October 2000/January 2001.

356 *"all treated me like protective big brothers":* Letter, Laurel Goodwin to Randy Erdman, January 19, 1999.

356 *"I was looking":* "Stella Stevens Talks," *Essential Elvis* magazine, no. 44, 2006.

356 *"I was thought of as the bad girl":* Stella Stevens, quoted in *This Is Elvis*: Special Collector's Edition of *TV Guide*, August 2002.

356 *"hang out":* "Stella Stevens Talks," *Essential Elvis* magazine, no. 44, 2006.

356 *"I said, 'Why do you do pictures like this'":* Stella Stevens, quoted in *This Is Elvis*: Special Collector's Edition of *TV Guide*, August 2002.

356 *she couldn't stand him:* *Elvis World* magazine, no. 86.

357 *"I saw it was from Priscilla":* Anita Wood to author, 2009.

357 *She didn't want to talk to him:* "Interview with Anita Wood," on the Web site Elvis Australia, November 25, 2006.

CHAPTER TWENTY-TWO

359 *"two torturous years":* Priscilla Presley, quoted in *Elvis by the Presleys:* Ritz, David, editor.

359 *"When I didn't hear from him":* Ibid.

360 *"When Elvis wanted something":* Ibid.

360 *"they knew that the two of them":* Joe Esposito to author, 2009.

360 *"I want you to know something":* Esposito, Joe, with Oumano, Elena, *Good Rockin' Tonight.*

360 *"She pretty well"*: Esposito to Peter O. Whitmer, raw interview transcript, 1994.

361 *"There she is!"*: Priscilla Presley quoting Elvis Presley in Presley, Priscilla, with Harmon, Sandra, *Elvis and Me.*

361 *"Let me look at you"*: Priscilla Presley, quoting Elvis Presley in *Elvis by the Presleys:* Ritz, David, editor.

361 *"flipped out"*: Ibid.

361 *"I didn't ask you"*: Ibid.

361 *"Up the stairs"*: Priscilla Presley, quoting Elvis Presley in Presley, Priscilla, with Harmon, Sandra, *Elvis and Me.*

361 *"I immediately thought"*: Ibid.

362 *"discovered that I was still as untouched"*: Ibid.

362 *"I was ready"*: Priscilla Presley in *Elvis by the Presleys:* Ritz, David, editor.

362 *"reluctantly"*: Priscilla Presley in Presley, Priscilla, with Harmon, Sandra, *Elvis and Me.*

362 *"I believe that with all my heart"*: "Interview with Charlie Hodge," on the Web site Elvis Australia, April 9, 2005.

362 *"in that big boom-bah"*: Patti Parry to author, 2009.

362 *"She's a nice girl"*: Alan Fortas to author, 1991.

363 *"if my eyes were black, blue, or black and blue"*: Priscilla Presley in Presley, Priscilla, with Harmon, Sandra, *Elvis and Me.*

363 *"That was what Elvis wanted"*: Ibid.

363 *"Elvis wasn't going to let me go home"*: Ibid.

363 *"obviously had been crying"*: Ann Beaulieu, in *Elvis by the Presleys:* Ritz, David, editor.

363 *"Her eyes looked like two piss holes in the snow"*: Paul Beaulieu, in *Elvis by the Presleys:* Ritz, David, editor.

363 *"You're going straight home"*: Prisilla Presley quoting Paul Beaulieu, in Presley, Priscilla, with Harmon, Sandra, *Elvis and Me.*

364 *"It was a tough choice"*: Joe Esposito to author, 2009.

364 *"I heard Elvis say"*: Anita Wood to author, 2009.

364 *"I heard what you just said"*: Ibid.

365 *"I hope to God"*: "Interview with Anita Wood," on the Web site Elvis Australia, November 25, 2006.

365 *"You can't keep me from going!"*: Ibid.

365 *"It doesn't matter"*: Anita Wood to author, 2009.

365 *"Elvis became very upset"*: *Essential Elvis* magazine, no. 15, 2001.

365 *"Well, if you must leave"*: "Interview with Anita Wood," on the Web site Elvis Australia, November 25, 2006.

365 *"I don't know"*: Ibid.

365 *"He caught me in the hall"*: Ibid.

365 *"like a smart"*: Doll, Susan, *The Films of Elvis Presley.*

366 *"The need for uniformity"*: e-mail, Peter O. Whitmer to author, 2009.

366 *"It was not a good film"*: Yvonne Craig to Jerry Hopkins, from the Jerry Hopkins Collection, Special Collections, the University of Memphis.

366 *"He said to one of his men"*: Sandra Giles, in the documentary *The Definitive Elvis: The Many Loves of Elvis.*

367 *"It wasn't predatory"*: Yvonne Craig to author, 2009.

367 *"Elvis wanted me to ask"*: Yvonne Craig quoting Joe Esposito to author, 2009.

367 *"I lived in an apartment"*: Yvonne Craig to Jerry Hopkins, from the Jerry Hopkins Collection, Special Collections, the University of Memphis.

367 *"I said, 'Oh, my!'"*: Yvonne Craig to author, 2009.

367 *"It had deep, deep, deep carpeting"*: Ibid.

368 *"I'm thinking"*: Ibid.

368 *"There was this thing"*: Yvonne Craig to Jerry Hopkins, from the Jerry Hopkins Collection, Special Collections, the University of Memphis.

368 *"He was really obstreperous"*: Yvonne Craig to author, 2009.

368 *"there was kissing and hugging"*: Ibid.

368 *"I said, 'You know, Elvis'"*: Ibid.

368 *"this is a dangerous move for you"*: Yvonne Craig to Jerry Hopkins, from the Jerry Hopkins Collection, Special Collections, the University of Memphis.

368 *"it did occur to me"*: Yvonne Craig to author, 2009.

368 *"I had seen"*: Yvonne Craig to Jerry Hopkins, from the Jerry Hopkins Collection, Special Collections, the University of Memphis.

369 *"He dragged out"*: Ibid.

369 *"Do you have any pills"*: Yvonne Craig to author, 2009.

369 *"Gene was wired"*: Fortas, Alan, and Nash, Alanna, *Elvis: From Memphis to Hollywood.*

370 *"the fact that"*: Elvis Presley to Lloyd Shearer, August 1962, "Face to Face with Elvis," CD.

370 *"At first I said no"*: Ann Beaulieu, quoted in *Elvis by the Presleys:* Ritz, David, editor.

370 *"I want to drive her through the gates"*: Patsy Presley quoting Elvis Presley in *Elvis by the Presleys:* Ritz, David, editor.

371 *"When we drove though those gates"*: Priscilla Presley, quoted in *Elvis by the Presleys:* Ritz, David, editor.

CHAPTER TWENTY-THREE

373 *"The first time I saw Priscilla"*: Patsy Presley, quoted in *Elvis by the Presleys:* Ritz, David, editor.

373 *"Someone's waiting to see you"*: Priscilla Presley quoting Elvis Presley in *Elvis by the Presleys:* Ritz, David, editor.

373 *"I feel like I can confide in you"*: Priscilla Presley, quoted in *Elvis by the Presleys:* Ritz, David, editor.

373 *"These pills will relax you"*: Priscilla Presley quoting Elvis Presley in *Elvis by the Presleys:* Ritz, David, editor.

373 *"It scared the hell"*: Billy Smith to author, 1993.

374 *"You haven't missed anything"*: Priscilla Presley quoting Elvis Presley in *Elvis by the Presleys:* Ritz, David, editor.

374 *"More and more"*: Priscilla Presley, quoted in *Elvis by the Presleys:* Ritz, David, editor.

374 *"You got the idea she was his one true love"*: Patsy Presley, quoted in *Elvis by the Presleys:* Ritz, David, editor.

374 *"Here she comes"*: Billy Smith to author, 1993.

374 *"like a fifteen-year-old kid"*: Ricky Stanley, quoted in Finstad, Suzanne, *Child Bride.*

374 *"We sat and talked"*: Marty Lacker to author, 1994.

375 *"He'd accuse me"*: Priscilla Presley, quoted in *Elvis by the Presleys:* Ritz, David, editor.

375 *"You'll finish your senior year"*: Priscilla Presley quoting Elvis Presley in *Elvis by the Presleys:* Ritz, David, editor.

376 *"I've been talking with my dad"*: Letter, Priscilla Beaulieu to Elvis Presley, reproduced as illustration in *Elvis by the Presleys:* Ritz, David, editor.

376 *"I was enormously resistant"*: Paul Beaulieu, quoted in *Elvis by the Presleys:* Ritz, David, editor.

376 *"You hear about people"*: Ann Beaulieu, quoted in *Elvis by the Presleys:* Ritz, David, editor.

376 *"Elvis pledged to care for her"*: Paul Beaulieu, quoted in *Elvis by the Presleys:* Ritz, David, editor.

377 *"I kissed my father good-bye"*: Priscilla Presley, quoted in *Elvis by the Presleys:* Ritz, David, editor.

377 *"sent her ahead"*: *Commercial Appeal,* April 2, 1963.

377 *"My boss called him Joe"*: Phillip Barber to author, 2009.

378 *"My feelings were mixed"*: Priscilla Presley, quoted in *Elvis by the Presleys:* Ritz, David, editor.

378 *"Her mom more or less"*: Jamie Lindberg, quoted in Finstad, Suzanne, *Child Bride.*

379 *"I come from a background"*: Jackie DeShannon in the documentary *The Definitive Elvis: The Many Loves of Elvis.*

379 *"No chips, no dips"*: Garr, Teri, and Mantel, Henriette, *Speedbumps: Flooring It Through Hollywood.*

380 *"I was embarrassed"*: Alan Fortas to author, 1989.

380 *"He didn't think"*: Mindi Miller to author, 2009. All Mindi Miller quotes come from this interview.

380 *"The only way"*: Ursula Andress, quoted in "El's Leading Ladies," by Gerry McLafferty, *Elvis: The Man and His Music,* issue 83, 2009.

380 *"She went after him"*: "Interview with Sonny West," by Scott Jenkins, on the Web site Elvis Australia, May 13, 2005.

380 *"We had to do"*: Allan Weiss to author, 2001.

380 *"worthless movies"*: "Nashville Skyline: Elvis, Hank, Michael: Killed by Fame," by Chet Flippo, the Web site CMT, July 2, 2009.

380 *"That kid"*: Anne Fulchino to author, 1998.

381 *"She had jet-black hair"*: e-mail, Jacque Carter Parsley to author, 2009.

381 *"Elvis expected her to be totally loyal"*: Billy Smith to author, 1994.

381 *"Somebody said, 'Jim Morrison'"*: Siouxzan Perry to author, 2009. Seventeen-year-old actress Lori Williams, another of the Russ Meyer girls, was one who dated him. She says their "courtship was not some bizarre story. It was very sweet and Elvis was the perfect gentleman." See Lisanti, Tom, *Drive-In Dream Girls: A Galaxy of B-Movie Starlets of the Sixties,* 2003.

381 *"He did not want me in Hollywood"*: Priscilla Presley, quoted in *Elvis by the Presleys:* Ritz, David, editor.

382 *"I would average"*: Priscilla Presley, "An Interview with Priscilla," by Bill E. Burk, *Elvis World* magazine, no. 23, based on the RUR show on Veronica TV in Amsterdam, Holland, probably 1992.

382 *"the place lit up"*: Priscilla Presley, quoted in *Elvis by the Presleys:* Ritz, David, editor.

382 *"Pow! I still feel"*: Priscilla Presley, quoted in *Ladies' Home Journal,* July 2003

382 *"If I looked up"*: Priscilla Presley, quoted in "No Angel," by Peter Conrad, *The Observer,* May 22, 2005.

382 *"I was someone he created"*: Ibid.

382 *"finally making love to me"*: Presley, Priscilla, with Harmon, Sandra, *Elvis and Me.*

382 *"his femme fatale"*: Priscilla Presley, quoted in "No Angel," by Peter Conrad, *The Observer,* May 22, 2005.

383 *"While my classmates"*: Presley, Priscilla, with Harmon, Sandra, *Elvis and Me.*

383 *"You're June, aren't you?"*: June Juanico to author, 2007.

384 *"Elvis Presley"*: Ann-Margret quoting George Sidney in Ann-Margret, with Gold, Todd, *Ann-Margret: My Story.*

385 *"The minute"*: Joe Esposito to author, 2009.

385 *"Rusty"*: Ann-Margret quoting Elvis Presley in Ann-Margret, with Gold, Todd, *Ann-Margret: My Story.*

385 *"Everybody on the movie set"*: Joe Esposito to author, 2009.

385 *"on a bicycle built for double takes"*: *People* magazine, August 18, 1997.

385 *"Ann-Margret really was the love of his life"*: Patti Parry to author, 2009.

385 *"it blew our minds"*: Lamar Fike to author, 1993.

386 *"When I like someone"*: quoted in *Saturday Evening Post,* September 11, 1965.

386 *"aggravated the shit"*: Marty Lacker to author, 1994.

386 *"It was a very strong relationship"*: Ann-Margret, quoted on the Web site Elvis Australia.

386 *"he was very circumspect"*: Yvonne Craig to author, 2009.

387 *"If someone else"*: Colonel Tom Parker, quoted in Nash, Alanna, *The Colonel: The Extraordinary Story of Colonel Tom Parker and Elvis Presley.*

387 *"There was no cut of Ann-Margret"*: Joan Deary to Constant Meijers, raw interview transcription from the documentary *Looking for Colonel Parker,* 1999.

387 *"They hold hands"*: Guralnick, Peter, and Jorgensen, Ernst, *Elvis Day by Day: The Definitive Record of His Life and Music.*

387 *"Is there anything to it?"* Presley, Priscilla, with Harmon, Sandra, *Elvis and Me.*

388 *"That one affected her tremendously"*: Joe Esposito to author, 2009.

388 *"she'd stand"*: Billy Smith to author, 1993.

388 *"She went down to the auditorium"*: Marty Lacker to author, 1993.

388 *"What's going on here?"* Presley, Priscilla, with Harmon, Sandra, *Elvis and Me.*

389 *"It's too expensive to shoot it over"*: Yvonne Craig quoting Sam Katzman to Jerry Hopkins, from the Jerry Hopkins Collection, Special Collections, the University of Memphis.

389 *"He hated that blond wig"*: Cynthia Pepper to author, 2009. All Cynthia Pepper quotes come from this interview.

390 *"I've only seen that"*: Yvonne Craig to author, 2009. All Yvonne Craig quotes in this section come from this interview.

391 *"Not a bit of warmth there"*: Anonymous source to author, 2007.

391 *"I always felt worn out"*: Priscilla Presley, "Viva, Priscilla!" by Kevin Sessums, *Vanity Fair,* July 1991.

CHAPTER TWENTY-FOUR

393 *"Man, she's as pretty as Anita"*: Marty Lacker to author, 1993.

394 *"We were rather attracted to each other"*: Phyllis McGuire in the documentary *The Definitive Elvis: The Many Loves of Elvis.*

394 *"there was a little situation there"*: "Interview with Sonny West," by Scott Jenkins, on the Web site Elvis Australia, May 13, 2005.

395 *"Elvis always said there's room for everybody"*: "Interview with Red West," on the Web site Elvis Australia, May 29, 2008.

395 *"They never go to bed"*: Anonymous MGM spokesman, *Saturday Evening Post*, September 11, 1965.

395 *"When he made movies"*: Felton Jarvis to author, 1977.

395 *"because doing an Elvis movie"*: Sue Ane Langdon, quoted in "Everyone Enjoyed Working with Elvis," by Trevor Cajiao, *Elvis: The Man and His Music*, issue 66, 2004.

396 *"completely gaga"*: Raquel Welch to author, 2007. All Raquel Welch quotes come from this interview. Portions of the Raquel Welch material previously appeared in *Ladies' Home Journal*, August 2007.

397 *"He had a blond wig on"*: Gail Ganley Steele, in the documentary *The Definitive Elvis: The Many Loves of Elvis.*

397 *"I couldn't stand it anymore"*: Gail Ganley Steele quoting Elvis Presley in Brown, Peter Harry, and Broeske, Pat H, *Down at the End of Lonely Street: The Life and Death of Elvis Presley.*

397 *"careful with his hands"*: Gail Ganley Steele, quoting Brown, Peter Harry, and Broeske, Pat H, *Down at the End of Lonely Street: The Life and Death of Elvis Presley.*

397 *"Elvis made me feel like I was a queen"*: Gail Ganley Steele, in the documentary *The Definitive Elvis: The Many Loves of Elvis.*

398 *"I had to ask Elvis"*: Ibid.

398 *"Of all aspects of male sexuality"*: e-mail, Peter O. Whitmer to author, 2009.

399 *"I was styling Johnny Rivers's hair"*: Larry Geller to author, 1998. All Larry Geller quotes come from the author's extensive interviews and e-mails with Mr. Geller, 1998 to 2002, and 2009.

401 *"Elvis's infatuation"*: Marty Lacker to author, 1994.

401 *"I'll give you"*: Lamar Fike to author, 1994.

401 *"She sat in one of those director's chairs"*: Chris Noel to author, 2009. All Chris Noel quotes come from this interview.

402 *"He'd say the P in the song"*: "Interview with Charlie Hodge," on the Web site Elvis Australia, April 9, 2005.

402 *"We never had any kind of romantic association"*: Mary Ann Mobley to author, 2007. All Mary Ann Mobley quotes come from this interview. Portions of the Mary Ann Mobley material previously appeared in *Ladies' Home Journal*, August 2007.

403 *"Elvis was very much into all this unknown stuff"*: Joe Esposito to Peter O. Whitmer, raw interview transcript, 1994.

403 *"You missed your calling, Larry"*: Larry Geller quoting Colonel Tom Parker to author, 1998.

403 *"messing up Elvis's head with all that nonsense"*: Anonymous source to author, 2009.

404 *"There was something wrong with the lights"*: Francine York to Andrew Hearn, *Essential Elvis* magazine, no. 10, 2000.

404 *"The woman spun around"*: Schilling, Jerry, with Crisafulli, Chuck, *Me and a Guy Named Elvis: My Lifelong Friendship with Elvis Presley.*

405 *"I can never forget the longing"*: Elvis Presley to James Kingsley, the Memphis *Commercial Appeal*, March, 1965.

405 *"The money is so big"*: Anonymous source, quoted in the *Saturday Evening Post*, September 11, 1965.

406 *"Elvis could have demanded changes"*: Joan Blackman, quoted in *Elvis World* magazine, no. 58.

406 *"sooner or later"*: Colonel Tom Parker, quoted in the *Saturday Evening Post*, September 11, 1965.

406 *"He was so strong"*: Jo Smith to author, 1993. All Jo Smith quotes come from this interview. Portions of the Jo Smith material previously appeared in *Ladies' Home Journal*, August 2007.

406 *"We'd be sitting around the house"*: Rex Mansfield, quoted in *Elvis World* magazine, no. 65.

409 *"a fifty-fifth cousin to P. T. Barnum"*: Guralnick, Peter, and Jorgensen, Ernst, *Elvis Day by Day: The Definitive Record of His Life and Music.*

409 *"When he was doing"*: Patti Parry to author, 2009.

CHAPTER TWENTY-FIVE

411 *"I am a child-woman"*: Priscilla Presley, in "Viva, Priscilla!" by Kevin Sessums, *Vanity Fair*, July 1991.

411 *"Priscilla has a remarkable interior gyroscope"*: Jack Soden, Elvis Presley Enterprises, in "Viva, Priscilla!" by Kevin Sessums, *Vanity Fair*, July 1991.

412 *"It became like the First and Second Family"*: Lamar Fike to author, 1994.

412 *"and then after they took them"*: Billy Smith to author, 1993.

412 *"He was going to play around"*: Lamar Fike to author, 1994.

412 *"We had to haul"*: Marty Lacker to author, 1993.

413 *"he didn't try to date her"*: Lamar Fike to author, 1994.

413 *"never really taxed"*: Sue Ane Langdon, quoted in "Everyone Enjoyed Working with Elvis," by
 Trevor Cajiao, *Elvis: The Man and His Music*, issue 66, 2004.

414 *"a very detrimental effect"*: Letter, Hal Wallis to Colonel Tom Parker, Hal Wallis Collection, Marga-
 ret Herrick Library, the Academy of Motion Pictures.

414 *"That goddamn old fucking bitch!"*: Marty Lacker quoting Elvis Presley to author, 1994.

415 *"a show business phenomenon"*: Marianna Hill, quoted in Doll, Susan, *The Films of Elvis Presley*.

415 *"We talked a lot about religion"*: Suzanna Leigh to Joe Krein, June 26, 2007, on the Web site Elvis
 2001.

416 *"This won't do your career any harm, baby!"* *Elvis World* magazine, no. 69.

417 *"he did not dig it that [Wallis] was there"*: "Donna Butterworth, "Won't You Please Come Home?"
 by Bill Bram, in *Elvis: The Man and His Music*, issue 68, 2005.

417 *"classy and quiet"*: Donna Butterworth to Joe Krein, May 1, 2008, on the Web site Elvis 2001.

417 *"How can Elvis"*: "Donna Butterworth, Won't You Please Come Home?" by Bill Bram, in *Elvis: The
 Man and His Music*, issue 68, 2005.

418 *"Those guys are still down there"*: Schilling, Jerry, with Crisafulli, Chuck, *Me and a Guy Named Elvis:
 My Lifelong Friendship with Elvis Presley*.

418 *"Do tell me all about Elvis Presley"*: Suzanna Leigh quoting Queen Elizabeth, *Elvis World* magazine,
 no. 69.

418 *"There was a silence"*: Larry Geller to author, 1998.

418 *"We all walked"*: Ibid.

419 *"Jo laughed like crazy, man"*: Billy Smith to author, 1994.

419 *"would succumb that October:"* Bill Black died October 21, 1965. Elvis told the *Commercial Appeal*
 that Bill "was a great man and a person that everyone loved. This comes as such a shock to me that
 I can hardly explain how much I loved Bill."

419 *"In the very beginning"*: Joan Deary, Deary to Constant Meijers, raw interview transcription from
 the documentary *Looking for Colonel Parker*, 1999.

420 *"Priscilla began sobbing"*: Geller, Larry, and Spector, Joel, with Romanowski, Patricia, *If I Can
 Dream*.

420 *"The black was so deep"*: Lamar Fike to author, 1993.

420 *"He called her 'Ma'"*: Billy Smith to author, 1994.

421 *"like getting hit"*: Deborah Walley, in the documentary *The Definitive Elvis: The Many Loves of
 Elvis*.

421 *"We had a very close relationship"*: Deborah Walley, quoted in *Elvis International Forum* magazine,
 vol. 8, no. 2, Summer 1995.

421 *"was a turn-off"*: Deborah Walley to Andrew Hearn, *Essential Elvis* magazine, no. 13, 2000.

421 *"Whew! He spun her head around"*: Lamar Fike to author, 1994.

421 *"he didn't talk much about her"*: Deborah Walley to Andrew Hearn, *Essential Elvis* magazine, no. 13,
 2000.

421 *"Every time we'd stop"*: Marty Lacker to author, 1994.

422 *"It's not so much"*: Doll, Susan, *The Films of Elvis Presley*.

422 *"He insulated himself"*: "Priscilla Presley: Surviving Elvis," by Sheila Weller, *McCall's* magazine,
 May 1979.

422 *"Roger Smith calls her"*: Marty Lacker quoting Elvis Presley to author, 1993.

422 *"Elvis never would have had a superstar as a wife"*: Joe Esposito to author, 2009.

423 *"He was just so sensitive"*: Ann-Margret to Charlie Rose, *The Charlie Rose Show*, Februrary 11, 1994.

423 *"What the hell is wrong with your boss?"* Marty Lacker quoting Ann-Margret to author, 1993.

423 *"Both of us knew"*: Ann-Margret, quoted in *People* magazine, August 18, 1997.

423 *"He got real upset about it"*: Lamar Fike to author, 1993.

423 *"Our relationship was extremely special"*: Ann-Margret to Charlie Rose, *The Charlie Rose Show*,
 February 11, 1994.

424 *"I'd just come to work for RCA"*: Felton Jarvis to author, 1977.

424 *first Grammy*: Elvis won three Grammy Awards, all for his gospel recordings—in 1967 for the album

How Great Thou Art, in 1972 for the LP *He Touched Me,* and in 1974 for a live rendition of "How Great Thou Art."

424 *"I've never seen a performer":* Schilling, Jerry, with Crisafulli, Chuck, *Me and a Guy Named Elvis: My Lifelong Friendship with Elvis Presley.*

425 *"Everyone else":* "Interview with Charlie Hodge," on the Web site Elvis Australia, April 9, 2005.

425 *"He was way too out of control":* Joe Esposito to author, 2009.

425 *"Every night":* Joe Esposito to Peter O. Whitmer, raw interview transcript, 1994.

426 *"We talked, smoked grass":* Esposito, Joe, with Oumano, Elena, *Good Rockin' Tonight.*

427 *"radically wrong":* Letter, Hal Wallis to Colonel Tom Parker, September 6, 1966, Hal Wallis collection, Margaret Herrick Library, the Academy of Motion Pictures.

428 *"Now, just a minute":* Elvis Presley, quoted in Doll, Susan, *The Films of Elvis Presley.*

428 *"Soon, he was stopping at every pay phone":* Marty Lacker to author, 1993.

429 *"My happiest memories":* "Priscilla Presley: Surviving Elvis," by Sheila Weller, *McCall's* magazine, May 1979.

429 *"'Satnin,' we're going to be married":* Presley, Priscilla, with Harmon, Sandra. *Elvis and Me.*

429 *"There was still love there":* "Interview with Sonny West," by Scott Jenkins, on the Web site Elvis Australia, May 13, 2005.

CHAPTER TWENTY-SIX

431 *"he'd put a scarf around his neck":* Lamar Fike to author, 1994.

432 *"The happiest we ever saw him":* Ray Walker to author, 1977.

432 *"You couldn't read the letter":* Patsy Presley, quoted in *Elvis by the Presleys:* Ritz, David, editor.

432 *"Family talk":* Ibid.

433 *"How are you going to break it to the guys?"* Marty Lacker quoting Elvis Presley to author, 1993.

433 *"He started to get very philanthropic":* Larry Geller to author, 1998.

434 *"He had a couple of months":* Marty Lacker to author, 1994.

435 *"He ate out of depression":* Jerry Schilling to Jerry Hopkins, the Jerry Hopkins Collection, Special Collections, the University of Memphis.

435 *"He went above and beyond":* Barbara Klein Bauer to Andrew Hearn, *Essential Elvis* magazine, no. 64, 2009.

436 *"He was healthy then":* George C. Nichopoulos to Peter O. Whitmer, raw interview transcript, 1995.

436 *"We will have":* Letter, Colonel Tom Parker to Marty Lacker, quoted in Guralnick, Peter, and Jorgensen, Ernst, *Elvis Day by Day: The Definitive Record of His Life and Music.*

436 *"Oh, man":* Larry Geller quoting Elvis Presley to author, 1998. The dialogue that follows is based on his account.

437 *"a couple of men in suits":* Larry Geller to author, 1998.

437 *"Goddamn you guys!"* Marty Lacker quoting Colonel Tom Parker to author, 1994.

437 *"Here's the way it is":* This dialogue is based on what Marty Lacker told the author, 1994.

438 *"It was like taking my arm off":* Larry Geller to author, 1998.

438 *"I threw in maybe two or three books":* Larry Geller quoting Elvis Presley to author, 1998.

439 *"There were many times":* George C. Nichopoulos to Peter O. Whitmer, raw interview transcript, 1995.

439 *"He was a private person":* Shelley Fabares, *Elvis International Forum* magazine, August 1992.

439 *"He went after her":* "Interview with Sonny West," by Scott Jenkins, on the Web site Elvis Australia, May 13, 2005.

440 *"He's a clean-cut":* Sam Katzman, quoted in *Saturday Evening Post,* September 11, 1965.

440 *"was absolutely petrified":* Judge David Zenoff, *Life* magazine, February 10, 1995.

440 *"Our little girl":* Paul Beaulieu, quoted in Guralnick, Peter, and Jorgensen, Ernst, *Elvis Day by Day: The Definitive Record of His Life and Music.*

441 *"as we raced":* Presley, Priscilla, with Harmon, Sandra, *Elvis and Me.*

441 *"I was making a motorcycle movie":* "Interview with Sonny West," by Scott Jenkins, on the Web site Elvis Australia, May 13, 2005.

441 *"just doing what he always tried to do":* "Interview with Charlie Hodge," on the Web site Elvis Australia, April 9, 2005.

441 *"We should":* Joe Esposito to Peter Whitmer, raw interview transcript, 1994.

441 *"Well, somebody finally caught him":* Kay Wheeler, e-mail to author, 2009.

442 *"Our eyes met":* Ann-Margret with Gold, Todd, *Ann-Margret: My Story.*

442 *"This is the greatest thing":* Elvis Presley, quoted in Guralnick, Peter, and Jorgensen, Ernst, *Elvis Day by Day: The Definitive Record of His Life and Music.*

442 *"Elvis was always talking":* Priscilla Presley, quoted in "No Angel," by Peter Conrad, *The Observer,* May 22, 2005.

443 *"Did you come yet?"* Nancy Sinatra quoting Elvis Presley in Goldman, Albert, *Elvis.*

443 *"He just got very quiet":* Ibid.

444 *"He just didn't feel comfortable":* Joe Esposito to author, 2009.

444 *"I guess he had a Madonna complex":* Priscilla Presley, quoted in "No Angel," by Peter Conrad, *The Observer,* May 22, 2005.

444 *"Somehow, after a false start":* Schilling, Jerry, with Crisafulli, Chuck, *Me and a Guy Named Elvis: My Lifelong Friendship with Elvis Presley.*

444 *"He never seemed":* George C. Nichopoulos to Peter O. Whitmer, raw interview transcript, 1995.

445 *"I said fine":* Priscilla Presley, quoted in *Elvis by the Presleys:* Ritz, David, editor.

CHAPTER TWENTY-SEVEN

447 *"Hey, don't get yourself all excited":* Schilling, Jerry, with Crisafulli, Chuck, *Me and a Guy Named Elvis: My Lifelong Friendship with Elvis Presley.*

447 *"Where's that box of cigars I bought?"* Priscilla Presley, quoting Elvis Presley in *Elvis by the Presleys:* Ritz, David, editor.

448 *"I've never seen":* Patsy Presley in *Elvis by the Presleys:* Ritz, David, editor.

448 *"I got the feeling":* Schilling, Jerry, with Crisafulli, Chuck, *Me and a Guy Named Elvis: My Lifelong Friendship with Elvis Presley.*

448 *"He was thrilled":* Joe Esposito to Peter O. Whitmer, raw interview transcript, 1994.

449 *"which have been":* Guralnick, Peter, and Jorgensen, Ernst, *Elvis Day by Day: The Definitive Record of His Life and Music.*

450 *"It turned me on":* "Interview with Mac Davis," on the Web site Elvis Australia, August 20, 2005.

451 *"I told him it would be a number one hit":* Celeste Yarnall to author, 2009. All Celeste Yarnall quotes come from this interview.

453 *"It was very awkward":* Susan Henning to author, 2009. All Susan Henning quotes come from this interview, unless otherwise noted.

454 *"there were times":* "Interview with Susan Henning," on the Web site Elvis Australia, October 17, 2008.

455 *"Would TV serve":* TV Guide, November 30, 1968.

456 *"most stars had trailers":* Bob Finkel to author, 1999.

457 *"We didn't know":* Steve Binder to author, 2008.

457 *"He was really involved":* Bones Howe to Jerry Hopkins, the Jerry Hopkins Collection, Special Collections, the University of Memphis.

458 *"show to depart":* Memo, Bob Finkel, as quoted in Guralnick, Peter, and Jorgensen, Ernst, *Elvis Day by Day: The Definitive Record of His Life and Music.*

458 *"with that exterior":* Steve Binder to author, 2008.

458 *"You certainly knew":* Steve Binder to Peter O. Whitmer, raw interview transcript, 1993; supplemented with a quote, "without any weak points," from Steve Binder to author, 2001.

458 *"I felt very, very strongly":* Steve Binder to Jerry Hopkins, the Jerry Hopkins Collection, Special Collections, the University of Memphis.

458 *"You make a record":* Steve Binder to author, 2001.

459 *"once he had the stranglehold":* Ibid.

459 *"He laughed at that":* Steve Binder to Constant Meijers, raw interview transcription from the documentary *Looking for Colonel Parker,* 1999.

459 *"There is a certain strength":* Priscilla Presley, "Viva, Priscilla!" by Kevin Sessums, *Vanity Fair,* July 1991.

460 *"Often Elvis would say":* Esposito to Peter O. Whitmer, raw interview transcript, 1994.

461 *"This is somebody":* Bill Belew, quoted in "One Gorgeous Man!" by Mary Pat Hinds, *Elvis World* magazine, no. 55.

461 *"He looked amazing":* Steve Binder to author, 2001.

461 *"I'm a Jewish kid":* Steve Binder quoting Billy Goldenberg to author, 2001.

461 *"You can do it with a real bluesy feel":* Bones Howe to Jerry Hopkins, the Jerry Hopkins Collection, Special Collections, the University of Memphis.

462 *"When Elvis heard the first note"*: This paragraph is a combination of quotes from Steve Binder to Jerry Hopkins and Peter O. Whitmer. Jerry Hopkins, the Jerry Hopkins Collection, Special Collections, the University of Memphis, and Peter O. Whitmer, raw interview transcript, 1993.

463 *"We got Elvis to take a stand"*: Bob Finkel to author, 1999.

463 *"The string players"*: Bones Howe, as quoted in the booklet for the RCA Records set, *Elvis: From Nashville to Memphis. The Essential '60s Masters.*

463 *"On the outside"*: Steve Binder to Constant Meijers, raw interview transcription from the documentary *Looking for Colonel Parker,* 1999.

464 *"The only way"*: Lamar Fike to Constant Meijers, raw interview transcription from the documentary *Looking for Colonel Parker,* 1999.

464 *"We figured it was about time"*: *TV Guide,* November 30, 1968.

464 *"I have no proof to back this up"*: Steve Binder to Peter O. Whitmer, raw interview transcript, 1993; supplemented with quotes from Binder to the author, 2001.

465 *"People would be shocked"*: Jaime Rogers, quoted in Binder, Steve. *'68 at 40 Retrospective.*

465 *"Elvis ushered young girls"*: Alan Fortas to author, 1991.

465 *"With her blue eyes"*: Steve Binder, e-mail to author, 2009.

465 *"When I walked into the room"*: in the documentary *The Definitive Elvis: The Many Loves of Elvis.*

465 *"I was and still am"*: Steve Binder, e-mail to author, 2009.

465 *"I understand"*: Ibid.

466 *"I almost feel"*: Ibid.

466 *"And certainly we talked about the future"*: "Interview with Susan Henning," on the Web site Elvis Australia, October 17, 2008.

466 *"He had a multitude of women"*: Susan Henning in the documentary *The Definitive Elvis: The Many Loves of Elvis.*

466 *"might offend"*: Binder, Steve. *'68 at 40 Retrospective.*

466 *"Do you think my hair's too black?"*: Steve Binder quoting Elvis Presley to author, 2001.

466 *"He sat in that makeup chair"*: Bones Howe to Jerry Hopkins, the Jerry Hopkins Collection, Special Collections, the University of Memphis.

466 *"If you get out there"*: Steve Binder to author, 2001.

467 *"That . . . is when"*: Steve Binder to author, 2001.

467 *"Bill Masters"*: Peter O. Whitmer to author, 2009.

467 *"What impresses"*: John Bush on the Web site allmusic.com.

467 *"The greatest thrill"*: Steve Binder to author, 2008.

467 *"He watched it"*: Steve Binder to Constant Meijers, raw interview transcription from the documentary *Looking for Colonel Parker,* 1999.

468 *"They had the house"*: "Interview with Charlie Hodge," on the Web site Elvis Australia, April 9, 2005.

468 *"I play a gunfighter"*: Elvis Presley, quoted in Doll, Susan, *The Films of Elvis Presley.*

468 *"I'm sure"*: "Interview with Mac Davis," on the Web site Elvis Australia, August 20, 2005.

468 *"ten weeks of hilarious bliss"*: "The Trouble with Marlyn," by Bill Bram, *Elvis: The Man and His Music,* issue 50, 2000.

468 *"I felt very close to him"*: Marlyn Mason in the documentary *The Definitive Elvis: The Many Loves of Elvis.*

469 *"The saddest thing"*: "The Trouble with Marlyn," by Bill Bram, *Elvis: The Man and His Music,* issue 50, 2000.

469 *"Mrs. Dorothy"*: Elvis Presley, quoted in Guralnick, Peter, and Jorgensen, Ernst, *Elvis Day by Day: The Definitive Record of His Life and Music.*

469 *"You saved his career"*: Steve Binder quoting Priscilla Presley to author, 2008.

CHAPTER TWENTY-EIGHT

472 *"really white music"*: Jerry Leiber, quoted in "An Oral Biography: Elvis Presley," by Peter Cronin, Scott Isler, and Mark Rowland, *Musician,* October 1992.

472 *"saw that it could go"*: Marty Lacker to author, 1994.

473 *"It would have taken a complete fool"*: Chips Moman to author, 2001.

473 *"Their deal"*: Chips Moman to author, 2001.

474 *"new as polyester"*: James Hunter, *Rolling Stone* 874, August 2, 2001.

474 *"Elvis has said"*: Mary Tyler Moore, quoted in *This Is Elvis*: Special Collector's Edition of *TV Guide,* August, 2002.

474 *"Gladys and my mother"*: e-mail, Barbara Spencer to author, 2009.

474 *"He came to Hollywood"*: Ochs, Michael, and Pond, Steve, *Elvis in Hollywood: Photographs from the Making of Love Me Tender.*

475 *"He just loaded"*: Alex Shoofey, in the documentary film *Mr. Rock & Roll,* 1999.

475 *"They looked like riverboat gamblers"*: Joe Moscheo to Beverly Keel for author, 1998.

476 *"to be a complete person"*: Priscilla Presley, quoted in *US* magazine, August 5, 1980.

476 *"I need an equal"*: Priscilla Presley, quoted in *US* magazine, August 5, 1980.

476 *"Elvis brought out this mothering quality"*: Priscilla Presley, quoted in *Ladies' Home Journal,* July 2003.

476 *"It was never about me"*: Ibid.

476 *"We had one suite"*: Joe Esposito to Peter O. Whitmer, raw interview transcript, 1994.

477 *"He would be Billy Eckstine"*: Charlie Hodge, quoted in "An Oral Biography: Elvis Presley," by Peter Cronin, Scott Isler, and Mark Rowland, *Musician,* October 1992.

477 *"helluva big stage"*: Charlie Hodge, quoted in Guralnick, Peter, and Jorgensen, Ernst, *Elvis Day by Day: The Definitive Record of His Life and Music.*

477 *"Our music"*: James Burton, quoted in "An Oral Biography: Elvis Presley," by Peter Cronin, Scott Isler, and Mark Rowland, *Musician,* October 1992.

478 *"The first thing"*: Bill Belew, quoted in "One Gorgeous Man!" by Mary Pat Hinds, *Elvis World* magazine, no. 55.

479 *"Oh, my God"*: June Juanico to author, 2007.

479 *"[The] Colonel"*: Alex Shoofey in the Guardian Ad Litem's Amended Report, July 31, 1981.

479 *"I was convinced"*: Steve Binder to author, 2008.

480 *"a little nervous"*: Elvis Presley, quoted in Guralnick, Peter, and Jorgensen, Ernst, *Elvis Day by Day: The Definitive Record of His Life and Music.*

480 *"It's not secluded"*: Elvis Presley, International Hotel, Las Vegas, Press Conference, as quoted in Osborne, Jerry, *Elvis Word for Word.*

481 *"I wasn't prepared"*: Bova, Joyce, as told to Nowels, William Conrad, *Don't Ask Forever: My Love Affair with Elvis.*

481 *"Pretty girl"*: Joe Esposito to author, 2009.

481 *"surprise and shock"*: Joyce Bova to author, 2009.

482 *"he had many questions"*: Ibid.

CHAPTER TWENTY-NINE

486 *"Everybody is commenting"*: Guralnick, Peter, and Jorgensen, Ernst, *Elvis Day by Day: The Definitive Record of His Life and Music.*

486 *"I can't . . . Elvis you know I can't"*: Bova, Joyce, as told to Nowels, William Conrad, *Don't Ask Forever: My Love Affair with Elvis.*

486 *"The new decade will belong to him"*: Guralnick, Peter, and Jorgensen, Ernst, *Elvis Day by Day: The Definitive Record of His Life and Music.*

486 *"I got the idea from a karate suit:"* Elvis Presley, private audio recording, Press Conference, Astroworld Hotel, Houston, Texas, February 27, 1970.

486 *"male cheesecake"*: "A Gross Top-Grosser: Elvis Presley at Las Vegas," by Albert Goldman, *Life* magazine, March 20, 1970.

487 *"It scares the . . ."*: Elvis Presley, private audio recording, Press Conference, Astroworld Hotel, Houston, Texas, February 27, 1970.

487 *"The promoters"*: "Myrna Smith, the Sweets Talks, Part I," *Essential Elvis* magazine, no. 39, 2005.

487 *"We were so jaded"*: Esposito, Joe, with Oumano, Elena, *Good Rockin' Tonight.*

488 *"He loved it"*: Jerry Schilling to Jerry Hopkins, the Jerry Hopkins Collection, Special Collections, the University of Memphis.

488 *"I was always a little girl to him"*: Priscilla Presley, quoted in *People* magazine, August 21, 1978.

489 *"If he said"*: "Priscilla Presley: Surviving Elvis," by Sheila Weller, *McCall's* magazine, May 1979.

489 *"was like a child"*: Bill Belew, quoted in "One Gorgeous Man!" by Mary Pat Hinds, *Elvis World* magazine, no. 55.

489 *"It's true"*: Priscilla Presley, in "Viva, Priscilla!" by Kevin Sessums, *Vanity Fair,* July 1991.

490 *"was so sheltered"*: Norbert Putnam, quoted in "An Oral Biography: Elvis Presley," by Peter Cronin, Scott Isler, and Mark Rowland, *Musician*, October 1992.

491 *"I thought it would be a party"*: Kathy Westmoreland, quoted in *Elvis World* magazine, no. 61.

491 *"He told me"*: Kathy Westmoreland to Larry King, CNN, December 5, 2007.

491 *"He reminded me"*: Kathy Westmoreland, quoted in *Elvis World* magazine, no. 61.

491 *"We were both"*: Kathy Westmoreland to author, 1997.

491 *"He kept on saying"*: Kathy Westmoreland, quoted in Finstad, Suzanne, *Child Bride.*

492 *"The lights were up"*: "Interview with Red West," on the Web site Elvis Australia, May 29, 2008.

492 *"You must be psychic, honey"*: Bova, Joyce, as told to Nowels, William Conrad, *Don't Ask Forever: My Love Affair with Elvis.*

493 *"Why would he"*: Barbara Leigh, quoted in *Elvis World* magazine, no. 67.

493 *"he couldn't take his eyes off her"*: Joe Esposito quoted in Leigh, Barbara, with Terrill, Marshall, *The King, McQueen, and the Love Machine: My Secret Hollywood Life with Elvis Presley, Steve McQueen, and James Aubrey.*

493 *"Man, that's Venus"*: Sonny West quoting Elvis Presley in West, Sonny, and Terrill, Marshall, *Elvis: Still Taking Care of Business.*

493 *"Elvis swooped in"*: Barbara Leigh, e-mail interview with author, 2009.

493 *"There always were a lot of people"*: "Interview with Red West," on the Web site Elvis Australia, May 29, 2008.

493 *"that it was me shaking"*: "Myrna Smith, the Sweets Talks, Part II," *Essential Elvis* magazine, no. 39, 2005.

494 *"Happens sometimes, baby"*: Bova, Joyce, as told to Nowels, William Conrad, *Don't Ask Forever: My Love Affair with Elvis.*

495 *"I do believe"*: Barbara Leigh, e-mail interview with author, 2009.

495 *"I've been calling"*: Elvis Presley, quoted in Leigh, Barbara, with Terrill, Marshall, *The King, McQueen, and the Love Machine: My Secret Hollywood Life with Elvis Presley, Steve McQueen, and James Aubrey.*

496 *"where all his stuff was"*: Barbara Leigh, e-mail interview with author, 2009.

496 *"Elvis wanted"*: Ibid.

496 *"I'd like you to have this"*: Leigh, Barbara, with Terrill, Marshall, *The King, McQueen, and the Love Machine: My Secret Hollywood Life with Elvis Presley, Steve McQueen, and James Aubrey.*

496 *"His mouth was round, full and soft"*: Ibid.

497 *"He was spontaneous"*: Ibid.

497 *"He was an old soul"*: "Interview with Barbara Leigh," on the Web site Elvis Australia, May 15, 2008.

497 *"I loved him"*: Barbara Leigh, e-mail interview with author, 2009.

497 *"it never stopped him"*: Barbara Leigh, e-mail interview with author, 2009.

497 *"I understood what he wanted"*: Ibid.

497 *"It took him"*: Ibid.

497 *"I loved my little brown Mercedes"*: "Interview with Barbara Leigh," on the Web site Elvis Australia, May 15, 2008.

497 *"had a girl"*: Barbara Leigh, e-mail interview with author, 2009.

498 *"he would be talking"*: Sherry Williams, "Elvis's Secret Love," *Essential Elvis* magazine, no. 33, 2004.

499 *"had on a jumpsuit"*: e-mail, Regis Wilson Vaughn to author, 2009.

500 *"I'll bet"*: Marty Lacker to author, 1993.

500 *"He just had"*: "Interview with Barbara Leigh," on the Web site Elvis Australia, May 15, 2008.

500 *"My TLC"*: Patti Parry to author, 2009.

501 *"There are two reasons"*: e-mail, Peter O. Whitmer to author, 2009.

501 *"He couldn't take care of himself"*: Joyce Bova to author, 2009.

502 *"Jerry, I'm coming into Los Angeles"*: Jerry Schilling quoting Elvis Presley to Jerry Hopkins, from the Jerry Hopkins Collection, Special Collections, the University of Memphis. All Schilling material in this section comes from this interview.

503 *"do not consider me"*: Elvis Presley, letter to Richard Nixon, December 20, 1970.

504 *"My name is Jerry Schilling"*: Bova, Joyce, as told to Nowels, William Conrad, *Don't Ask Forever: My Love Affair with Elvis.*

504 *"Elvis always wanted"*: Joyce Bova to author, 2009.

505 *"You're a beautiful woman"*: Joyce Bova, as told to Nowels, William Conrad, *Don't Ask Forever: My Love Affair with Elvis.*

CHAPTER THIRTY

506　*"Officer, can I help with anything?"* Elvis Presley, quoted in Bova, Joyce, as told to Nowels, William Conrad, *Don't Ask Forever: My Love Affair with Elvis.*

507　*"He'd put on his uniform"*: Billy Smith to author, 1994.

508　*"I don't go along"*: Guralnick, Peter, and Jorgensen, Ernst, *Elvis Day by Day: The Definitive Record of His Life and Music.*

508　*"his private nature"*: Elvis Presley, quoted in Bova, Joyce, as told to Nowels, William Conrad, *Don't Ask Forever: My Love Affair with Elvis.*

509　*"a conversation piece"*: George C. Nichopoulos to Peter O. Whitmer, raw interview transcript, 1995.

509　*"we'd kiss so passionately"*: Sherry Williams, "Elvis's Secret Love," *Essential Elvis* magazine, no. 33, 2004.

509　*"a mistake"*: Ann-Margret, with Gold, Todd, *Ann-Margret: My Story.*

510　*"I held his hand"*: Barbara Leigh, e-mail interview with author, 2009.

510　*"I felt her"*: Ibid.

511　*"I couldn't understand"*: Joyce Bova to author, 2009.

511　*"tremendous in size"*: George C. Nichopoulos to Peter O. Whitmer, raw interview transcript, 1995.

511　*"went ballistic"*: Sonny West quoting Elvis Presley in West, Sonny, and Terrill, Marshall, *Elvis: Still Taking Care of Business.*

512　*"he played the tough part"*: Joe Esposito to Peter O. Whitmer, raw interview transcript, 1994.

512　*"a lovely dancer"*: e-mail, Sally O'Brien to Jacque Parsley for author, 2009.

512　*"nights when he'd come into Lisa's bedroom"*: "Priscilla Presley: Surviving Elvis," by Sheila Weller, *McCall's* magazine, May 1979.

512　*"I took a lover"*: Priscilla Presley, quoted in "No Angel," by Peter Conrad, *The Observer,* May 22, 2005.

512　*"I saw Mommy and Mike:"* Lisa Marie Presley, quoted in Nash, Alanna, with Smith, Billy, Lacker, Marty, and Fike, Lamar, *Elvis Aaron Presley: Revelations from the Memphis Mafia.*

512　*"She wanted some real love"*: Joe Esposito to author, 2009.

513　*"He kissed like a god"*: Lipton, Peggy, with Dalton, David, and Dalton, Coco. *Breathing Out.*

515　*"Boss! Boss, snap out of it!"*: West, Sonny, and Terrill, Marshall, *Elvis: Still Taking Care of Business.*

515　*"He'd say"*: Marty Lacker to author, 1993.

515　*"She's a mama"*: Elvis Presley, quoted in Bova, Joyce, as told to Nowels, William Conrad, *Don't Ask Forever: My Love Affair with Elvis.*

516　*"I was so all-consumed with him"*: Joyce Bova to author, 2009.

516　*"blew my mind"*: Joyce Bova to author, 2009.

516　*"Look at this"*: Bova, Joyce, as told to Nowels, William Conrad, *Don't Ask Forever: My Love Affair with Elvis.*

518　*"He was so out of control"*: Joyce Bova to author, 2009.

519　*"very sexual"*: Ibid.

519　*"resting place of the soul"*: Bova, Joyce, as told to Nowels, William Conrad, *Don't Ask Forever: My Love Affair with Elvis.*

519　*"It drove me crazy"*: Joyce Bova to author, 2009.

519　*"it won't be long until I'm forty"*: Bova, Joyce, as told to Nowels, William Conrad, *Don't Ask Forever: My Love Affair with Elvis.*

520　*"He grabbed me"*: Presley, Priscilla, with Harmon, Sandra, *Elvis and Me.*

520　*"Another man has taken my wife"*: Lamar Fike, quoting Elvis Presley in Nash, Alanna, with Smith, Billy, Lacker, Marty, and Fike, Lamar, *Elvis Aaron Presley: Revelations from the Memphis Mafia.*

520　*"It wasn't so much"*: "Interview with Sonny West," by Scott Jenkins, on the Web site Elvis Australia, May 13, 2005.

520　*"Elvis was very upset"*: Joe Esposito to Peter O. Whitmer, raw interview transcript, 1994.

520　*"he cursed Priscilla and Mike"*: Barbara Leigh, e-mail interview with author, 2009.

520　*"problem"*: Marty Lacker to author, 1994.

520　*"lying down on stage"*: Joe Moscheo to Beverly Keel for author, 1998.

521　*"He loved cuddling and petting"*: Anonymous source to author, 2009.

521　*"Mr. Kahane"*: Jackie Kahane to Peter O. Whitmer, raw interview transcript, 1994.

521 *"so many flashbulbs"*: Joe Guercio to Karen Schoemer, raw interview transcript, 1997.
521 *". . . A Prince from Another Planet"*: Guralnick, Peter, and Jorgensen, Ernst, *Elvis Day by Day: The Definitive Record of His Life and Music.*

CHAPTER THIRTY-ONE

523 *"It was like we were never divorced"*: Priscilla Presley, quoted in *People* magazine, December 4, 1978.
524 *"There was a real nice spray"*: Peggy Selph Cannon, quoted in "Woman with Elvis No Longer a Mystery," by Michael Lollar, *Commercial Appeal,* July 17, 2000.
524 *"Elvis needed more love"*: Linda Thompson to author, 1977.
524 *"intensely lonely at heart"*: Linda Thompson to Peter O. Whitmer, raw interview transcript, 1995.
524 *"I thought Elvis was still married"*: Linda Thompson to author, 1977.
525 *"I said, 'Well, I'll come and meet him'"*: Cybill Shepherd, quoted in *TV Guide,* April 20, 1996.
525 *"The house"*: Shepherd, Cybill, with Ball, Aimee Lee, *Cybill Disobedience.*
525 *"can cause"*: Cybill Shepherd, "She's Still Here, Up for Anything," by Margy Rochlin, *New York Times,* July 26, 2009.
526 *"I don't think"*: Cybill Shepherd, "Shepherd Left Elvis After Late-Night Drugs Offer," WENN News, August 15, 2009.
526 *"He said, 'Here, take these'"*: Ibid.
526 *"Let's put it this way"*: Cybill Shepherd, quoted in *TV Guide,* April 20, 1996.
526 *"it was just a shuttle"*: Anonymous source, quoted in "Love Me Tender," by Tracy McVeigh, *The Observer,* August 11, 2002.
526 *"The Elvis that I got to know in Memphis"*: Cybill Shepherd to Larry King, CNN, 2002.
526 *"Elvis looked almost like Liberace"*: Raquel Welch to author, 2007.
527 *"Once he was onstage"*: Robin Rosaaen to author. All Robin Rosaaen quotes come from the author's interviews in 2007 and 2008. Portions of the Robin Rosaaen material originally appeared in *Reader's Digest,* February 2008.
527 *"Elvis looked at me"*: Larry Geller to author, 2009.
528 *"It's very hard to comprehend"*: Elvis Presley, press conference, Las Vegas Hilton, September 4, 1972.
528 *"Mr. Katane"*: Jackie Kahane, quoting anonymous child to Peter O. Whitmer, raw interview transcript, 1994.
528 *"he began getting acupuncture"*: George C. Nichopoulos to Peter O. Whitmer, raw interview transcript, 1995.
528 *"He would ask"*: George C. Nichopoulos to author, 2007.
529 *"a basket case"*: George C. Nichopoulos to Peter O. Whitmer, raw interview transcript, 1995.
529 *"I think it's wonderful"*: Linda Thompson to author, 1977.
529 *"I felt a responsibility"*: Linda Thompson to Peter O. Whitmer, raw interview transcript, 1995.
529 *"he was like my little boy"*: Ibid.
529 *"We both just naturally talked baby talk"*: Ibid.
529 *"Baby gullion"*: Mailgram, Linda Thompson to Elvis Presley, quoted in Nash, Alanna, with Smith, Billy, Lacker, Marty, and Fike, Lamar. *Elvis Aaron Presley: Revelations from the Memphis Mafia.* It originally appeared in *My Life with Elvis,* by Yancey, Becky, and Linedecker, Cliff.
530 *"it hurt her"*: Marty Lacker to author, 1994.
530 *"It was so easy"*: Ann-Margret with Gold, Todd, *Ann-Margret: My Story.*
530 *"was so pumped up"*: Marty Lacker to author, 1994.
531 *"Finally, Linda came"*: Ibid.
531 *"I miss you"*: Joyce Bova quoting Elvis Presley to author, 2009.
532 *"Jerry, there's something"*: Schilling, Jerry, with Crisafulli, Chuck, *Me and a Guy Named Elvis: My Lifelong Friendship with Elvis Presley.*
532 *"He put both of his arms up"*: Shirley Dieu to author, 2009. All Shirley Dieu quotes come from this interview.
532 *"like he was the last piece of cake"*: Billy Smith to author, 1994.
532 *"I was thinking"*: Marty Lacker to author, 1994.
533 *"and man, he looked so fine"*: "Interview with Anita Wood," on the Web site Elvis Australia, November 25, 2006.
533 *"Little, I wonder if we made a mistake?"* Anita Wood to author, 2009.

533 *"You know why I'm playin' it"*: "Interview with Anita Wood," on the Web site Elvis Australia, November 25, 2006.

533 *"lack of energy and interest"*: Guralnick, Peter, and Jorgensen, Ernst, *Elvis Day by Day: The Definitive Record of His Life and Music.*

533 *"He didn't have breathing room"*: Alex Shoofey, in the documentary film *Mr. Rock & Roll*, 1999.

534 *"I'm sorry, ladies and gentlemen"*: Guralnick, Peter, and Jorgensen, Ernst, *Elvis Day by Day: The Definitive Record of His Life and Music.*

534 *"He really felt that way"*: Joe Esposito to Peter O. Whitmer, raw interview transcript, 1994.

535 *"The man who hired the talent"*: Barbara Eden to author, 2007.

535 *"was wrapped up"*: George C. Nichopoulos to author, 2007.

535 *"One night"*: Lisa Marie Presley, *Life* magazine, December 1988.

536 *"you could have parked"*: Lamar Fike to author, 1993.

536 *"It was the first time"*: Guralnick, Peter, and Jorgensen, Ernst, *Elvis Day by Day: The Definitive Record of His Life and Music.*

536 *"Why are you sitting out here?"* Ray Walker quoting Felton Jarvis to author, 1977.

536 *"one of the most"*: Guralnick, Peter, and Jorgensen, Ernst, *Elvis Day by Day: The Definitive Record of His Life and Music.*

536 *"great, absolutely fantastic"*: Petula Clark to author, 2009.

537 *"He could see no change in his life"*: Mary Ann Mobley to author, 2009.

CHAPTER THIRTY-TWO

539 *"I-I-I-I had a dream"*: Linda Thompson quoting Elvis Presley to Peter O. Whitmer, raw interview transcript, 1995.

540 *"He would be so distended"*: George C. Nichopoulos to Peter O. Whitmer, raw interview transcript, 1995.

540 *"We used to just sit"*: Linda Thompson to Peter O. Whitmer, raw interview transcript, 1995.

540 *"High Flight"*: Elvis would recite J. G. Magee's sonnet right along with it: "Oh! I have slipped the surly bonds of Earth/And danced the skies on laughter-silvered wings . . ."

541 *"He didn't want"*: George C. Nichopoulos to Peter O. Whitmer, raw interview transcript, 1995.

541 *"Elvis thought"*: Billy Smith to author, 1993.

542 *"because the more shows he did"*: George C. Nichopoulos to author, 2007.

542 *"When Dr. Ghanem was there"*: Kathy Westmoreland to author, 1997.

542 *"nervous as a chicken"*: Duke Bardwell to author, 2002.

543 *"It was crazy"*: Linda Thompson to author, 1977.

543 *"the suite was pitch-black"*: Bob Finkel to author, 1999.

543 *"he calmly picked up his utensils"*: Marty Lacker to author, 1994.

543 *"It's better to be unconscious"*: Elvis Presley quoted in Goldman, Albert, *The Last 24 Hours.*

543 *"If we were at home"*: Linda Thompson to Peter O. Whitmer, raw interview transcript, 1995.

544 *"They shot him"*: Jackie Kahane to Peter O. Whitmer, raw interview transcript, 1994.

544 *"There were a good five or six times"*: Lamar Fike to author, 1995.

544 *"the most amazing, kind, sweet Southern gentleman"*: Ann Pennington to author, 2009. All Ann Pennington quotes come from this interview unless otherwise noted.

545 *"slow and draggy"*: "Interview with Anita Wood," on the Web site Elvis Australia, November 25, 2006.

545 *"I felt it was a violation"*: Linda Thompson to Peter O. Whitmer, raw interview transcript, 1995.

546 *"I wondered, 'What's this all about?' "*: Sherry Williams, "Elvis's Secret Love," *Essential Elvis* magazine, no. 33, 2004.

546 *"on a mission"*: Nanette Kuklish, "I Dated the King," by Andrew Hearn, *Essential Elvis* magazine, no. 48, 2006.

546 *"Elvis wanted to be happy"*: Marty Lacker to author, 1994.

546 *"literally twenty-four hours a day"*: Linda Thompson to Peter O. Whitmer, raw interview transcript, 1995.

546 *"She had a peach-colored outfit"*: Jo Smith to author, 1993.

547 *"We discussed sexual things"*: George C. Nichopoulos to Peter O. Whitmer, raw interview transcript, 1995.

547 *"I had grape juice running down my face"*: Sheila Ryan Caan to author, 2009. All Sheila Ryan quotes come from this interview.

552 *"I know"*: Linda Thompson quoting Elvis Presley to Peter O. Whitmer, raw interview transcript, 1995.

553 *"posed like mannequins"*: Judy Geller to author, 2009. All Judy Geller quotes come from this interview.

555 *"I thought, 'Uh-oh, here it is'"*: Susan Anton, quoted in *Elvis World* magazine, no. 84.

555 "She's right here": Elvis Presley, quoted in Guralnick, Peter, *Careless Love: The Unmaking of Elvis Presley.*

556 *"I was in shock"*: Priscilla Presley, quoted in Guralnick, Peter, *Careless Love: The Unmaking of Elvis Presley.*

557 *"He said, 'You've got to come up here now'"*: Patti Parry to author, 2009.

557 *"I kicked the door in"*: "Interview with Red West," on the Web site Elvis Australia, May 29, 2008.

557 *"I don't even know"*: Red West to Sonny West, "Interview with Sonny West," by Scott Jenkins, on the Web site Elvis Australia, May 13, 2005.

557 *"Oh, I was so sad!"* Barbara Hearn to author, 2009.

CHAPTER THIRTY-THREE

559 *"he would be so damn drugged"*: Lamar Fike to author, 1994.

559 *"You probably think it's crazy"*: Reeca Smith Gossan quoting Elvis Presley to author, 2009. All Reeca Smith quotes come from this interview unless otherwise noted.

561 *"I woke up"*: Linda Thompson to author, 1977.

561 *"People aren't going to remember me"*: Kathy Westmoreland quoting Elvis Presley to author, 1997.

562 *"He was really"*: "Priscilla Presley: Surviving Elvis," by Sheila Weller, *McCall's* magazine, May 1979.

562 *"There was never no plan"*: Colonel Tom Parker to Craig Rivera, *Inside Edition,* January, 1993.

562 his Hollywood career: In a 1972 audio interview for the documentary *Elvis on Tour,* Elvis said, "I cared so much until I became physically ill . . . I don't think anyone was consciously trying to harm me. It was just Hollywood's image of me was wrong . . . I was never indifferent. I was so concerned until that's all I talked about . . . but it did not change, it did not change, and so I became very discouraged. They couldn't have paid me no amount of money in the world to make me feel self-satisfaction inside."

566 *"Whoever got the guitar"*: Elvis Presley, quoted in Guralnick, Peter, *Careless Love: The Unmaking of Elvis Presley.*

567 *"That show was such a sad sight"*: e-mail, Joyce Bova to author, 2009.

567 *"I was just so taken aback"*: "Joan Blackman Talks," *Essential Elvis* magazine, no. 23, 2002.

568 *"He kind of held my hand"*: Melissa Blackwood, quoted in Guralnick, Peter, *Careless Love: The Unmaking of Elvis Presley.*

569 *"Is that a real Elvis scarf?"*: JoCathy Brownlee Elkington to Elvis, as told to author, 2009. All JoCathy Brownlee quotes come from this interview.

573 *"He would come into town"*: Tanya Tucker to author, 2009. All Tanya Tucker quotes come from this interview.

574 *"My assistant told me"*: Cher to author, 2009.

575 *"Elvis was really hurt"*: Linda Thompson to author, 1977.

575 *"I grabbed his head"*: Barbara Leigh, e-mail interview with author, 2009.

575 *"He told me"*: Deborah Walley to Andrew Hearn, *Essential Elvis* magazine, no. 13, 2000.

575 *"When he did"*: Billy Smith to author, 1994.

577 *"there's no way"*: Priscilla Presley, quoted in *People* magazine, December 4, 1978.

577 *"She was a terror"*: Priscilla Presley, quoted in *Ladies' Home Journal,* July 2003.

577 *"he'd say"*: Jo Smith to author, 1994.

578 *"we were expected to say"*: Billy Smith to author, 1994.

578 *"That was our intention"*: "Interview with Sonny West," by Scott Jenkins, on the Web site Elvis Australia, May 13, 2005.

578 *"the major turning point"*: Linda Thompson to Peter O. Whitmer, raw interview transcript, 1995.

578 *"Let's just go away"*: Linda Thompson to author, 1977.

579 *"I truly, truly loved him"*: Linda Thompson to author, 1977.

579 *"To this day"*: Linda Thompson, quoted in *Elvis World Magazine,* no. 82.

579 *"The band was afraid"*: David Briggs to author, 1997.

CHAPTER THIRTY-FOUR

581 *"Elvis was so kind":* Rosemary Alden, *Essential Elvis* magazine, March-April, 2002.

581 "I know this sounds funny": Ginger Alden, *Essential Elvis* magazine, March-April, 2002.

582 *"By one account":* Cole, James P., and Thompson, Charles C. II. *The Death of Elvis.*

582 *"All right, listen":* Larry Geller quoting Elvis Presley to author, 2009.

583 *"When we left":* Wink Martindale, quoted in *Elvis World* magazine, #44.

583 *"He was self-conscious":* Michelle Beaulieu Hovey, quoted in *Elvis By the Presleys:* Ritz, David, editor.

583 *"I knew something was different":* Priscilla Presley, quoted in *Elvis By the Presleys:* Ritz, David, editor.

583 *"he didn't want":* Paul Beaulieu, quoted in *Elvis By the Presleys:* Ritz, David, editor.

583 *"Please speak with Cilla":* Ann Beaulieu, quoting Elvis Presley in *Elvis By the Presleys:* Ritz, David, editor.

583 *"I had a sinking feeling":* Ann Beaulieu, quoted in *Elvis By the Presleys:* Ritz, David, editor.

583 *"I'd take Lisa":* "Priscilla Presley: Surviving Elvis," by Sheila Weller, *McCall's* magazine, May 1979.

583 *"We underestimated his emotional pain":* Priscilla Presley, quoted in *Elvis By the Presleys:* Ritz, David, editor.

584 *"I feel so alone sometimes:"* Elvis Presley, private note, as quoted in *Elvis By the Presleys:* Ritz, David, editor. Singer Wayne Newton ultimately bought the note and turned it into a song, "The Elvis Letter." He told *USA Today,* April 17, 1992, "It reflects a man reaching to the ultimate for help. Once I digested it and got over the shock, I realized that it was feelings that I, too, had had at times . . . I realized—that kind of loneliness creeps into everybody's life."

584 "I don't know who I can talk to anymore": Elvis Presley, private note, as quoted in *Elvis By the Presleys:* Ritz, David, editor.

584 *"Sam, I love your sister":* Larry Geller quoting Elvis Presley to author, 2009.

585 *"Elvis found out":* e-mail, Shirley Dieu to author, 2009.

585 *"she doesn't think it was an engagement gift."* Jo Alden, quoted in Guralnick, Peter, and Jorgensen, Ernst: *Elvis Day By Day: The Definitive Record of His Life and Music.*

585 *"One walks away":* quoted in Guralnick, Peter, and Jorgensen, Ernst: *Elvis Day By Day: The Definitive Record of His Life and Music.*

586 *"When Elvis met Ginger":* Larry Geller to author, 2009.

586 *"See Shirley":* Shirley Dieu to author, 2009.

586 *Elvis and Ginger sat on the edge:* Larry Geller to author, 2009.

587 *"It was like old-fashioned times":* Ginger Alden, quoted in "World's at Standstill for Elvis' Fiancee," by Lawrence Buser, *Commercial Appeal,* August 19, 1977.

587 *"When he flew my family to Las Vegas":* Jo Alden to author, 1977.

587 *"Ginger and I":* Shirley Dieu to author, 2009.

588 *"My most treasured moment":* Rosemary Alden, *Essential Elvis* magazine, March-April, 2002.

588 *"Elvis liked Ginger":* Joe Esposito, quoted on the Web site Elvis Australia.

588 *"We even took her out":* Billy Smith to author, 1994.

588 *"It depends on how you look at it":* Shirley Dieu to author, 2009.

588 *"leeches":* *Life* magazine, June 1990.

588 *"He felt that [Ginger] was just using him":* David Stanley, quoted in *Life* magazine, June 1990.

589 *"Elvis made dreams come true":* e-mail, Shirley Dieu to author, 2009.

589 *"Baby, they wrote a book":* Sherry Williams quoting Elvis Presley, "Elvis's Secret Love," *Essential Elvis* magazine, #33, 2004.

589 *"You didn't think I'd make it, did you?"* Billy Smith quoting Elvis Presley to author, 1994.

590 *"The singer's new girlfriend:"* Guralnick, Peter, and Jorgensen, Ernst: *Elvis Day By Day: The Definitive Record of His Life and Music.*

590 *"For the last six months":* George C. Nichopoulos to Peter Whitmer, raw interview transcript, 1995.

590 *"He said, 'That damn girl'":* Shirley Dieu to author, 2009.

590 *"Why the hell do you put up with her?"* Billy Smith to author, 1994.

590 *"If Elvis had ever known that":* Billy Smith to author, 1994.

591 *"They were fixin'":* Alicia Kerwin, quoted in Cole, James P., and Thompson, Charles C. II. *The Death of Elvis.* All Alicia Kerwin quotes come from this source.

591 *"It scared me real bad":* Billy Smith to author, 1994.

592 *"multiple drug toxicity":* Cole, James P., and Thompson, Charles C. II. *The Death of Elvis.* Alicia's marriage to Anthony Albert Cassel was tempestuous, and she began abusing alcohol and the very prescription drugs that had so frightened her when she was in Elvis's presence. On March 12, 1991, ten days after shooting her husband in the leg, a case that was going to trial, she went to sleep on large doses of Valium, Placydil, and Elavil, and never woke up. The coroner listed the cause of death as "multiple drug toxicity." She was 33 years old.

593 *"he was pale, swollen—he had no stamina":* Guralnick, Peter, and Jorgensen, Ernst: *Elvis Day By Day: The Definitive Record of His Life and Music.*

593 *"I can't wait for 1977 to be over":* Jerry Schilling quoting Elvis to Jerry Hopkins, the Jerry Hopkins Collection, Special Collections, the University of Memphis.

593 *"You could look at Elvis":* Larry Geller to author, 1998.

594 *"People who ask that":* Priscilla Presley, quoted in *Elvis By the Presleys:* Ritz, David, editor.

594 *"God went to the toilet!":* Jackie Kahane to Peter Whitmer, raw interview transcript, 1994.

594 *"At the finale":* Guralnick, Peter, and Jorgensen, Ernst: *Elvis Day By Day: The Definitive Record of His Life and Music.*

595 *"He said, 'I've got to teach her'":* Larry Geller to author, 2009.

595 *"whole damn family":* Geller, Larry and Spector, Joel, with Romanowski, Patricia. *If I Can Dream.* New York: Avon Books, 1989.

595 *"a long-lost soul":* Kathy Westmoreland, quoted in *People* magazine, August 18, 1997.

595 *"I'm going to look fat":* Kathy Westmoreland quoting Elvis Presley to author, 1997.

595 *"I knew that it was inevitable":* Kathy Westmoreland to author, 1997.

595 *"At the beginning":* Todd Slaughter, as quoted in the *Irish Times,* January 24, 1997.

596 *"almost anorexic":* Shirley Dieu to author, 2009.

596 *"We were on the airplane":* Lamar Fike to author, 1994.

596 *"I did say to him":* Priscilla Presley, quoted in *Ladies' Home Journal,* July 2003.

597 *"He told me":* "Priscilla Presley: Surviving Elvis," by Sheila Weller, *McCall's* magazine, May 1979.

597 *"and some of the old songs":* Jo Alden to author, 1977.

597 *"When I stayed at Graceland":* Lisa Marie Presley, quoted in *Elvis By the Presleys:* Ritz, David, editor.

597 *"I'm so tired":* Kathy Westmoreland quoting Elvis Presley in *People* magazine, August 18, 1997.

597 *"The Colonel owes":* Kathy Westmoreland quoting Elvis Presley to author, 1997.

598 *"in a very good mood":* Larry Geller to author, 1998.

598 *"He had earlier":* Ginger Alden Leyser, "Elvis Presley's Death: Anniversary Spotlights Similarities with Michael Jackson," by Russell Goldman, on the ABC News Web site, August 16, 2009.

598 *"He and Ginger had wonderful plans":* Jo Alden to author, 1977.

598 *"He found me":* Lisa Marie Presley, quoted in *Elvis By the Presleys:* Ritz, David, editor.

598 *"Ain't no problem":* Billy Smith, quoting Elvis Presley to author, 1994.

599 *"How is Lisa Marie":* Rick Stanley, quoting Elvis Presley in *Life* magazine, June 1990.

600 *"the core problem":* Ginger Alden Leyser, "Elvis Presley's Death: Anniversary Spotlights Similarities with Michael Jackson," by Russell Goldman, on the ABC News Web site, August 16, 2009.

600 *"didn't know Elvis":* Joe Esposito to Peter O. Whitmer, raw interview transcript, 1994.

600 *"Precious, I'm going to go in the bathroom":* Billy Smith quoting Elvis Presley to author, 1994. A similar exchange appears in *Life* magazine, June 1990.

601 *"No, if they ain't heard from him":* Billy Smith to author, 1994.

601 *"That's when I saw him in there":* Ginger Alden, "World's at Standstill for Elvis's Fiancee," by Lawrence Buser, *The Commercial Appeal,* August 19, 1977.

602 *"Who's on duty?"* Ginger Alden, as quoted in Esposito, Joe, with Oumano, Elena. *Good Rockin' Tonight.*

602 *"Don't go, son!":* Billy Smith quoting Vernon Presley to author, 1994.

602 *"Get her out of here, quick!"* Esposito, Joe, with Oumano, Elena. *Good Rockin' Tonight.*

602 *"What happened to him?":* Ulysses Jones, as quoted by Marty Lacker to author, 1994.

602 *"He's gone":* Dr. George C. Nichopoulos, quoted in Esposito, Joe, with Oumano, Elena. *Good Rockin' Tonight.*

603 *"was at a standstill":* Jo Smith, quoted in "World's at Standstill for Elvis's Fiancee," by Lawrence Buser, *Commercial Appeal,* August 19, 1977.

603 *"an overwhelming sense":* Ginger Alden Leyser, "Elvis Presley's Death: Anniversary Spotlights Similarities with Michael Jackson," by Russell Goldman, on the ABC News Web site, August 16, 2009.

603 *"My son is dead":* Vernon Presley, quoted in "Elvis Presley's Death: Anniversary Spotlights Similarities with Michael Jackson," by Russell Goldman, on the ABC News Web site, August 16, 2009.

603 *"She stood there":* Larry Geller to author, 2009.

603 *"It's Lisa":* Lisa Marie Presley, as quoted by Linda Thompson, *Life* magazine, February 10, 1995.

603 *"I have something terrible to tell you":* Joe Esposito to Colonel Tom Parker. Esposito, Joe, with Oumano, Elena. *Good Rockin' Tonight.*

603 *"I left the house":* Priscilla Presley, quoted in *Elvis By the Presleys:* Ritz, David, editor.

603 *"A call came in from Memphis":* Priscilla Presley, quoting her sister in "Priscilla Presley: Surviving Elvis," by Sheila Weller, *McCall's* magazine, May 1979.

604 *"The sun went out":* Priscilla Presley, quoted in *Ladies' Home Journal,* July 2003.

604 *"He just said":* Shirley Dieu to author, 2009.

604 *"I turned the world off":* Sheila Ryan Caan to author, 2009.

604 *"The first thing I heard":* Joyce Bova, e-mail to author, 2009.

604 *"I was absolutely devastated":* Ann Ellington Wagner, in the documentary, *The Definitive Elvis: The Many Loves of Elvis.*

604 *"everybody went numb":* Raquel Welch to author, 2007.

605 *"When I came out of my bedroom":* June Juanico, 2007.

EPILOGUE

608 *"Simply put":* Dr. M. Katherine Shear, quoted in "After a Death, the Pain That Doesn't Go Away," by Fran Schumer, *The New York Times*, September 29, 2009.

BIBLIOGRAPHY

Altschuler, Glenn. *All Shook Up: How Rock 'n' Roll Changed America.* New York: Oxford University Press, 2003.

Ann-Margret, with Gold, Todd. *Ann-Margret: My Story.* New York: Putnam, 1994.

Axton, Mae Boren. *Country Singers As I Know 'Em.* Austin, Texas: Sweet Publishing Co., 1973.

Binder, Steve. *'68 at 40 Retrospective.* Chicago: JAT Productions, 2008.

Bova, Joyce, as told to Nowels, William Conrad. *Don't Ask Forever: My Love Affair with Elvis.* New York: Pinnacle Books, 1994.

Brown, Maxine. *Looking Back to See: A Country Music Memoir.* Fayetteville: The University of Arkansas Press, 2005.

Brown, Peter Harry, and Broeske, Pat H. *Down at the End of Lonely Street: The Life and Death of Elvis Presley.* New York: Dutton: 1997.

Burk, Bill E. *Early Elvis: The Tupelo Years.* Memphis: Propwash Publishing, 1994.

———. *The Humes Years.* Memphis: Red Oak Press, 1990.

Cash, John Carter. *Anchored in Love: An Intimate Portrait of June Carter Cash.* Nashville: Thomas Nelson, 2007.

Cash, W. J. *The Mind of the South.* New York: Alfred A. Knopf, 1941.

Clayton, Rose, and Heard, Dick. *Elvis Up Close.* Atlanta: Turner Publishing, 1994.

Cocke, Marian J. *I Called Him Babe: Elvis Presley's Nurse Remembers.* Memphis: Memphis State University Press, 1979.

Cole, James P., and Thompson, Charles C. II. *The Death of Elvis.* New York: Dell Publishing, 1992.

Copolon, Jeff, and Cher. *The First Time.* New York: Pocket, 1999.

Cortez, Diego. *Private Presley.* Stuttgart, Germany: FEY, 1978.

Cotton, Lee. *All Shook Up: Elvis Day-by-Day, 1954–1977.* Ann Arbor, Michigan: Pierian Press, 1985.

Craig, Yvonne. *From Ballet to the Batcave and Beyond.* Venice, Cal.: Kudu Press, 2000.

Crumbaker, Marge, and Tucker, Gabe. *Up and Down with Elvis Presley: The Inside Story.* New York: G. P. Putnam's Sons, 1981.

Davis, Stephen. *Say Kids! What Time Is It?: Notes from the Peanut Gallery.* New York: Little, Brown and Company 1987.

Doll, Susan. *The Films of Elvis Presley.* Lincolnwood, Ill.: Publications International, Ltd., 1991.

Dundy, Elaine. *Elvis and Gladys.* New York: Macmillan, 1985.

Esposito, Joe, with Oumano, Elena. *Good Rockin' Tonight.* New York: Simon & Schuster, 1994.

Finstad, Suzanne. *Child Bride: The Untold Story of Priscilla Beaulieu Presley.* New York: Berkley Boulevard, 1997.

———. *Natasha: The Biography of Natalie Wood.* New York: Three Rivers Press, 2001.

Fortas, Alan, and Nash, Alanna. *Elvis: From Memphis to Hollywood.* London: Aurum Press, 2008.

Garr, Teri, and Mantel, Henriette. *Speedbumps: Flooring It Through Hollywood.* New York: Hudson Street Press, 2006.

Geller, Larry. *Leaves of Elvis' Garden.* Beverly Hills, Cal.: Bell Rock Publishing, 2008.

Geller, Larry, and Spector, Joel, with Romanowski, Patricia. *If I Can Dream*. New York: Avon Books, 1989.

Goldman, Albert. *Elvis*. New York: McGraw-Hill, 1981.

———. *Elvis: The Last 24 Hours*. New York: St. Martin's Press, 1991.

Guralnick, Peter. *Last Train to Memphis: The Rise of Elvis Presley*. Boston: Little, Brown and Company, 1994.

———. *Careless Love: The Unmaking of Elvis Presley*. Boston: Little, Brown and Company, 1999.

Guralnick, Peter, and Jorgensen, Ernst. *Elvis Day by Day: The Definitive Record of His Life and Music*. New York: Ballantine Books, 1999.

Harbinson, W. A., and Wheeler, Kay. *Growing Up with the Memphis Flash*. Amsterdam, Holland: Tutti Frutti Productions, 1994.

Henning, Susan. *'68*. Lincoln, Cal.: The Rainbow Rhapsody Press, 2008.

Hill, Wanda June. *We Remember Elvis*. Palos Verdes, Cal.: Morgan Press, 1978.

Hitchens, Peter. *The Abolition of Britain: From Winston Churchill to Princess Diana*. New York: Encounter Books, 2000.

Hopkins, Jerry. *Elvis: A Biography*. New York: Warner Books, 1972.

Jennings, Peter, and Brewster, Todd. *The Century*. New York: Doubleday, 1998.

Jorgensen, Ernst. *Elvis Presley: A Life in Music*. New York: St. Martin's Press, 1998.

Juanico, June. *Elvis in the Twilight of Memory*. New York: Arcade Publishing, 1997.

Kanter, Hal. *So Far, So Funny: My Life in Show Business*. Jefferson, N.C.: McFarland & Company, Inc., 1999.

Lacy, Patrick. *Elvis Decoded: A Fan's Guide to Deciphering the Myths and Misinformation*. Bloomington, Indiana: AuthorHouse, 2006.

Leigh, Barbara, with Terrill, Marshall. *The King, McQueen, and the Love Machine: My Secret Hollywood Life with Elvis Presley, Steve McQueen, and James Aubrey*. Philadelphia: Xlibris Corporation, 2001.

Leviton, Jay B., and Rijff, Ger J. *Elvis Close-Up: Rare, Intimate, Unpublished Photographs of Elvis Presley in 1956*. New York: Fireside Books, 1988.

Lipton, Peggy, with Dalton, David, and Dalton, Coco. *Breathing Out*. New York: St. Martin's Press, 2005.

Logan, Horace, with Sloan, Bill. *Elvis, Hank & Me: Making Musical History on the Louisiana Hayride*. New York: St. Martin's Press, 1998.

Mansfield, Rex, and Mansfield, Elisabeth, with Terrill, Marshall, and Terrill, Zoe. *Sergeant Presley: Our Untold Story of Elvis' Missing Years*. Toronto: ECW Press, 2002.

Moore, Scotty, as told to Dickerson, James. *That's Alright, Elvis*. New York: Schirmer Books, 1997.

Morris, Charles G. *Understanding Psychology*. Third Edition. Upper Saddle River, N.J.: Prentice Hall, 1996.

Nash, Alanna. *The Colonel: The Extraordinary Story of Colonel Tom Parker and Elvis Presley*. New York: Simon & Schuster, 2003.

Nash, Alanna, with Smith, Billy, Lacker, Marty, and Fike, Lamar. *Elvis Aaron Presley: Revelations from the Memphis Mafia*. New York: HarperCollins, 1995.

Oberst, Stanley, and Torrance, Lori. *Elvis in Texas: The Undiscovered King 1954–1958*. Plano, Tex.: Republic of Texas Press, 2002.

Ochs, Michael, and Pond, Steve. *Elvis in Hollywood: Photographs from the Making of* Love Me Tender. New York: Plume Books, 1990.

Oermann, Robert K. *Behind the Grand Ole Opry Curtain: Tales of Romance and Tragedy*. New York: Center Street, 2008.

Osborne, Jerry. *Elvis Word for Word*. New York: Gramercy Books, 1999.

Page, Frank, with Kent, Joey. *Elvis: The Louisiana Hayride Years 1954–1956*. Parsippany, N.J.: Louisiana Hayride, Inc., 2006.

Perkins, Carl, and McGee, David. *Go, Cat, Go: The Life and Times of Carl Perkins*. New York: Hyperion, 1996.

Presley, Priscilla Beaulieu, and Harmon, Sandra. *Elvis and Me*. New York: G. P. Putnam's Sons, 1985.

Ritz, David, editor. *Elvis by the Presleys*. New York: Crown Publishers, 2005.

Rodman, Gilbert B. *Elvis after Elvis: The Posthumous Career of a Living Legend*. London: Routledge, 1996.

Roth, Andreas. *The Ultimate Elvis in Munich Book*. Munich: Published by the author, 2004.

Schilling, Jerry, with Crisafulli, Chuck. *Me and a Guy Named Elvis: My Lifelong Friendship with Elvis Presley*. New York: Gotham Books, 2006.

Schroer, Andreas: *Private Presley: The Missing Years—Elvis in Germany.* New York: William Morrow and Co., 1993.

Shepherd, Cybill, with Ball, Aimee Lee. *Cybill Disobedience.* New York: HarperCollins, 2000.

Soocher, Stan. *They Fought the Law: Rock Music Goes to Court.* New York: Schirmer Books, 1998.

Victor, Adam. *The Elvis Encyclopedia.* New York: Overlook Duckworth, 2008.

Wertheimer, Alfred. *Elvis at 21: New York to Memphis.* San Rafael: Insight Editions, 2006.

———. *Elvis '56: In the Beginning.* New York: Collier Books, 1979.

West, Red, and West, Sonny, and Hebler, Dave, as told to Dunleavy, Steve. *Elvis: What Happened?* New York: Ballantine Books, 1977.

West, Sonny, with Terrill, Marshall. *Elvis: Still Taking Care of Business.* Chicago: Triumph Books, 2007.

Westmoreland, Kathy, and Quinn, William G., *Elvis and Kathy.* Glendale, Cal.: Glendale House Publishing, 1987.

Whitmer, Peter O. *The Inner Elvis.* New York: Hyperion, 1996.

Wood, Lana. *Natalie: A Memoir by Her Sister.* New York: G. P. Putnam's Sons, 1984.

Worth, Fred L., and Tamerius, Steve D. *Elvis: His Life from A to Z.* Chicago: Contemporary Books, 1992.

WEB SITES

www.celesteyarnall.com
www.elvis.com.au
www.elvis-express.com
www.elvisinfonet.com
www.elvisnews.com
www.elvispresleynews.com
www.elvispresleymusic.com.au
www.elvispresleyscrapbook.co.uk
www.elvisunlimited.com
www.imdb.com
www.susanhenning.com

INDEX

Aberbach, Jean, 178, 293, 321
actor: Elvis as, 81, 133, 229–30, 331–32, 561–62.
 See also specific film
Acuff, Roy, 36, 100, 101
Adams, Joan, 146–47, 471
Adams, Nick, 176, 180, 184, 185, 187–88,
 192–93, 195, 196, 197, 251, 265, 449, 469
Albuquerque, New Mexico; Elvis's
 performances in, 143
Alden, Ginger, 252, 579, 581–82, 584–93,
 594–95, 597–603
Alden, Jo LaVern, 581, 587, 598, 603
Alden, Rosemary, 579, 581, 585, 588, 591, 593
All-Night Gospel Singings (Memphis,
 Tennessee), 59, 60, 67, 70
Allen, Steve, 153, 156, 457, 458
Allen, Valerie, 215–16
Allied Artists, 389, 404
"Aloha from Hawaii" concert, 528–29, 530–32
American Studio; Elvis's recordings with,
 472–74, 490
Amos, Betty, 84–85, 88, 90–91, 92, 144, 145, 402
Andress, Ursula, 380
Anka, Paul, 478, 480–81
Ann-Margret, 372, 384–89, 398, 400–401, 405,
 422–23, 428, 441–42, 455, 478, 480, 497,
 509–10, 530, 604
Ansara, Michael, 332, 409
Anton, Susan, 555
Apacheland Movie Ranch, 468
Armed Forces Radio, 316, 317
Armed Forces Television, 317
Army, U.S.: certificate of honor for Elvis from,
 317; drafting of Elvis by, 244–45; Elvis's
 advanced training in, 257; Elvis's discharge
 from, 317–19, 321–22, 341; and Elvis's draft
 status, 208; and Elvis's eating habits, 28; and
Elvis's hair color, 211; Elvis in basic training
 in, 251, 253–56, 259, 268; and Elvis in
 Germany, 247, 268, 269–71, 273–83, 285–95,
 297–319; Elvis's induction into, 251–52; Elvis's
 last performances before entering, 244; Elvis's
 promotions in, 282, 317; Elvis's views about,
 254, 257, 317; and Gladys-Elvis relationship,
 251; influence on Elvis of, 255, 347–48, 370
Arnold, Eddy, 45, 99, 100–101, 102, 142, 179, 435
Assembly of God Church: in Memphis, 60,
 67–68, 69, 73, 229, 536; tenets of, 86; in
 Tupelo, 7, 8, 16–17, 31, 35, 132, 463
Atkins, Chet, 101, 130, 424
Aubrey, James, 492–93, 495, 497, 498
Austin, Gene, 36, 100
Avgeris, Georgia, 49, 205
Axton, Mae Boren, 98, 107, 108, 109, 130, 166,
 266
Ayers, Dotty, 259–60

badges; Elvis's interest in, 499–500, 503–4, 505
Bahamas; Elvis's vacation in, 485
Ballard, Hank, 110, 141
Bancroft, Susie, 195, 233
Banner, Penny, 182–83
Barber, Phillip, 193–94, 377–78
Bardot, Brigitte, 270, 277, 294–95, 301
Bardwell, Duke, 542–43
Barrett, Rona, 439, 486
Barris, George, 352, 360, 362, 367, 489
Barris, Shirley, 360, 362
Bean, Orville, 10, 11, 18–19, 21, 22, 30
Beatles, The, 395, 418–19, 420, 458, 544
Beaulieu, Ann, 179, 298, 304–7, 311–13, 318,
 330, 331, 359–60, 363, 364, 370–71, 375–76,
 378, 389, 448, 583